Frank Eugene

Frank Eugene

The Dream of Beauty

Edited by
Herausgegeben von

Ulrich Pohlmann

Nazraeli Press Munich
Fotomuseum im
Münchner Stadtmuseum

Inhalt

Contents

Einführung

Als durch den glücklichen Fund eines Antiquars auf einem Münchner Flohmarkt im Jahre 1988 über 350 Originalphotographien und zahlreiche persönliche Dokumente des deutsch-amerikanischen Photographen und Malers Frank Eugene (Smith) in die Sammlung des Fotomuseums gerieten, war dies zunächst eine kleine photohistorische Sensation. Mit dem Erwerb dieses außergewöhnlichen Nachlasses begann eine detektivische Suche nach den verbliebenen Lebensspuren einer herausragenden Persönlichkeit der künstlerischen Photographie, die zugleich als der bedeutendste und eigenwilligste Vertreter des internationalen Piktorialismus in Deutschland gelten kann. Denn trotz seiner Bekanntheit – der Name Eugene fehlt in keiner photohistorischen Anthologie – ist der Photograph einer der großen Unbekannten in der Geschichte des Mediums geblieben. Selbst in den zahlreichen Publikationen über den nordamerikanischen Piktorialismus, über Alfred Stieglitz und die Photo-Secession blieb Eugene seltsam konturenlos. Gelegentlich drängt sich der Eindruck auf, als habe Frank Eugene Smiths nonkonformistische Lebensweise biographische Spuren eher verwischt, so daß eine adäquate Würdigung seiner künstlerischen Leistung bis heute nicht stattfinden konnte.[1] Frank Eugene Smith war in erster Linie Praktiker und kein Theoretiker, so daß nur wenige dezidierte Äußerungen über ästhetische Aspekte der Photographie überliefert sind.

Erste Nachforschungen sollten nun ergeben, daß der prominente »Maler-Photograph« (Sadakichi Hartmann) seine letzten Lebensjahre in Aufkirchen in der Nähe des Starnberger Sees verbracht hatte. Dort blieb sein künstlerischer Nachlaß bis Anfang der siebziger Jahre – bis zum Abriß seines ehemaligen Wohnhauses – nahezu vollständig erhalten. Große Teile des Nachlasses gingen bei der Zerstörung des Gebäudes verloren, darunter laut Auskunft von Zeitzeugen hunderte Gemälde und Zeichnungen, zahlreiche Kisten mit Photographien sowie vermutlich das gesamte Negativ-Archiv des Photographen. Nur weniges konnte gerettet werden, ein für die Photographie als kulturhistorisches Erbe auch heute noch typisches Schicksal, letztlich Ausdruck der mangelnden Kenntnis und geringen Wertschätzung des Mediums. So ist Eugenes Werk international bis auf wenige immer

wieder gedruckte und in Ausstellungen gezeigte Aufnahmen, die erstmals in *Camera Notes* und *Camera Work* als Photogravüren publiziert worden waren, bald in Vergessenheit geraten. Sogar im Kunsthandel sind Eugenes Photographien in den vergangenen Jahrzehnten kaum in Erscheinung getreten.[2] In Deutschland unternahm L. Fritz Gruber, seit 1950 Organisator der photokina-Bilderschauen in Köln, erste zaghafte Recherchen zu Eugene, den er im Rahmen der Ausstellung ›Grosse Photographen unseres Jahrhunderts‹ 1963 zeigen wollte. Doch die Anfrage nach dem Verbleib des Werkes bei Rudolf Loher, dem Leiter des damals neugegründeten Fotomuseums im Münchner Stadtmuseum, blieb erfolglos.[3] Auch Loher hatte sich mit Frank Eugene kurzzeitig beschäftigt, jedoch primär unter phototechnischen Gesichtspunkten. Auf diese Weise haben sich im Nachlaß Loher ein Dutzend Originalnegative von Eugene erhalten, die mittlerweile im Münchner Fotomuseum aufbewahrt werden.

Heute ist Eugenes photographisches Lebenswerk auf zahlreiche private und öffentliche Sammlungen im In- und Ausland verstreut. Die umfangreichsten Bestände befinden sich im Fotomuseum im Münchner Stadtmuseum mit insgesamt 475 Aufnahmen und in der Photoabteilung (Department of Prints and Photographs) des Metropolitan Museum of Art in New York, wo circa 300 Abzüge durch die Schenkungen der Sammlung Alfred Stieglitz (1933) und des Rogers Fund (1972) Eingang in die Sammlung fanden.

Eine Zusammenführung der weit verstreuten und bisweilen schwer zugänglichen Materialien zu einer Werkmonographie über Frank Eugene sollte sich bald als spannende, aber auch schwierige Unternehmung erweisen. Insbesondere die fehlenden Quellen zum biographischen Werdegang und zur künstlerischen Tätigkeit Eugenes in New York und in München vor 1900 waren die schwer zu füllenden Wissenslücken, da sich beispielsweise nur wenige Dokumente über die Münchner Kunstakademie im 19. Jahrhundert erhalten haben. So konnten die Jahre seines Studiums in München zwischen 1886 und 1894 ebenso wie Eugenes Tätigkeit als Porträtmaler in New York von 1894 bis 1900 nur zum Teil durch die Recherchen erhellt werden.[4] Auch in den

Introduction

It constituted something of a minor sensation in the photography world when in 1988 an antiquarian book-seller was fortunate enough to come upon more than 350 original photographs and numerous personal documents belonging to the German-American photographer and painter Frank Eugene (Smith) at a flea-market in Munich. Once this extraordinary find had been acquired for its collection by the Munich Fotomuseum, a search was then initiated to uncover whatever evidence might still remain of the life of that outstanding figure in art photography, who may also be regarded as one of the most significant and individual representatives of international pictorialism in Germany. For despite his reputation – the name Eugene is mentioned in almost every anthology on the history of photography – the person of the photographer has remained one of the great unknowns in the history of the medium. Even in the numerous publications on pictorialism in North America, on Alfred Stieglitz, or the Photo-Secession, Eugene's person is always somewhat vague in its contours. Occasionally one even gets the impression that Frank Eugene Smith's non-conformist way of life all but erased biographical traces, with the result that an adequate assessment of his artistic achievement has not really been possible up till now.[1] Frank Eugene Smith was primarily a practitioner and not a theoretician, so he has also left us only very few pronouncements on the aesthetics of photography.

Initial investigations revealed that the prominent "painter-photographer" (Sadakichi Hartmann) spent the last years of his life in Aufkirchen near Lake Starnberg in the south of Germany. Until the early 1970s his personal estate remained there in his former home almost completely intact – that is, until the house was demolished. According to witnesses, during demolition work on the building, large portions of that estate went missing, including hundreds of paintings and drawings, numerous crates full of photographs and, presumably, the photographer's complete archive of negatives. Only very few items were saved – a typical fate of much that has to do with photography, even today, and an indication of how little is known about the medium and in how low esteem that part of our cultural heritage is held.

Eugene's work soon fell into oblivion internationally, with the exception of a few photographs first publicized in *Camera Notes* and *Camera Work* as photogravures, and then frequently reproduced or shown in exhibitions. Over the past decades photographs by Eugene have seldom turned up at art auctions.[2] L. Fritz Gruber, organizer of the photokina shows in Cologne since 1950, was one of the first in Germany to undertake some tentative research into Eugene, motivated by a wish to show his work in the context of the 1963 exhibition "Great Photographers of our Century." However, Rudolf Loher, head of the newly founded Fotomuseum in the Munich Stadtmuseum, was not in a position to provide him with any positive responses to his inquiries about the whereabouts of Eugene's works. Loher himself had been briefly preoccupied with Frank Eugene, although primarily from the photo-technical point of view. So it was that a dozen of Eugene's original negatives survived in Loher's estate. These are now preserved in the Munich Fotomuseum.

Today, what remains of Eugene's life's work is scattered throughout numerous private and public photograph collections in Germany and abroad. With a total of 475 photographs, the Fotomuseum in the Munich Stadtmuseum has the most extensive stocks, followed by the Department of Prints and Photographs of the Metropolitan Museum of Art in New York into whose collection about 300 prints found their way thanks to donations by the Alfred Stieglitz Collection (1933) and the Rogers Fund (1972).

It soon transpired that it was going to be an exciting but difficult task for us to bring together the materials necessary for a monograph on the work of Frank Eugene, given that these were dispersed so far and wide, and in some cases were almost inaccessible. In particular the absence of sources on his biographical development and his artistic activities in New York and Munich before 1900 left gaps which were difficult to fill, especially as only very few documents have been preserved on the Munich Kunstakademie in the 19th century. Thus our research work has only been able to partially account for Eugene's study years in Munich between 1886 and 1894 and his activities as a portrait

Dresdner und Leipziger Museen und Archiven haben sich nur wenige Archivalien und leider keine einzige Photographie erhalten, die über die vierzehnjährige Lehrtätigkeit an der Leipziger Hochschule für graphische Künste und Buchgewerbe Auskunft geben könnten. Sicherlich können wir mit der vorliegenden Publikation nicht jede Lücke schließen, wohl aber eine Veröffentlichung vorlegen, die erstmals einen detaillierten Überblick auf die Aktivitäten des Photographen gibt und Zusammenhänge zwischen der Bildwelt, dem Lebenslauf und der zeitgeschichtlichen Situation herzustellen versucht.

Die wesentlichen Grundlagen für die Untersuchungen waren in erster Linie die beiden Photosammlungen zu Eugene in München und New York, wobei die letztere durch die Publikation zur Sammlung Alfred Stieglitz im Metropolitan Museum of Art teilweise erschlossen ist.[5] Gleichwohl beinhaltet auch diese, bislang umfassendste Darstellung zur internationalen Kunstphotographie, einige faktische Fehler. Insbesondere die Identifizierung von Motiven und die Datierung von Aufnahmen können aufgrund der jüngsten Nachforschungen gelegentlich korrigiert werden. Eine weitere wichtige Quelle stellt die ausführliche Korrespondenz zwischen Frank Eugene und Alfred Stieglitz dar, die insgesamt 95 Briefe aus dem Zeitraum von 1900 bis 1927 umfaßt. Dieser Briefwechsel wird heute in der Beinecke Rare Book and Manuscript Library, Yale University in New Haven in Connecticut aufbewahrt und konnte für die Nachforschungen eingesehen werden. Weitere Originalbriefe und Dokumente von Eugene waren in der Handschriftensammlung der Monacensia-Bibliothek München, dem Deutschen Literaturarchiv in Marbach, im Künstlerarchiv des Germanischen Nationalmuseums in Nürnberg sowie in verschiedenen Privatsammlungen zugänglich.

Der Gesamtumfang des Werkes ist auch nach mehrjähriger Rekonstruktionsarbeit und Spurensicherung nicht vollständig feststellbar. Insbesondere in Künstlernachlässen sind während der Nachforschungen immer wieder überraschende Funde aufgetaucht, so daß hier weitere Entdeckungen möglich sind. Unter Berücksichtigung der in den Fach- und Kunstzeitschriften veröffentlichten Aufnahmen, der ausgestellten Arbeiten und sämtlicher bekannter Arbeiten in Photosammlungen umfaßt das Gesamtwerk Eugenes nicht mehr als 600 Motive.

Vor diesem Hintergrund versucht die Publikation, den photographischen und biographischen Werdegang des Künstlers mit seinen wichtigsten Lebensstationen in New York, München und Leipzig nachzuzeichnen. Gegenstand ausführlicher Darstellung ist Eugenes Lehrtätigkeit an der Münchner Lehr- und Versuchsanstalt für Photographie, Lichtdruck und Gravüre, die vor 1914 als wichtigste Ausbildungsstätte in Deutschland die ästhetische Reform der Berufsphotographie gefördert hat, und an der Hochschule für graphische Künste und Buchgewerbe in Leipzig.

Das wechselvolle Spannungsverhältnis zwischen Malerei und piktorialistischer Photographie ist das Thema des Beitrages von Axel Effner, der sich mit den verschiedenen Stilentwicklungen in der Photographie Eugenes beschäftigt und die bildnerische Orientierung an Historismus, Jugendstil, Symbolismus, Japonismus oder an der präraffaelitischen Malerei eingehend analysiert. Andreas Krase hat die wenigen Spuren aus der Leipziger Zeit Eugenes in seinem Aufsatz zusammengetragen und zu einem anschaulichen Bild verdichten können.

Für die intensive Auseinandersetzung mit der Person und dem Werk Eugenes bin ich beiden Autoren zu großem Dank verpflichtet. Ausstellung und Katalog wären in dieser Form nicht ohne die Unterstützung und den Rat von zahlreichen Personen und Institutionen, die auf ganz unterschiedliche Weise weitergeholfen haben, realisiert worden. Ihnen und allen Leihgebern, die Dokumente und Originalphotographien auf großzügige Weise überlassen haben, sei an dieser Stelle ausdrücklich für ihre Hilfe gedankt. Dieser Dank gebührt zunächst den KollegInnen des Fotomuseums und des Münchner Stadtmuseums Thomas Becker, Roman Franke, Monika Gallasch, Barbara Golz, Monika Kaierle-Hoffmann, Rainer Lohmann, Christine Rottmeier, Dr. Volker Duvigneau, Dr. Norbert Goetz, Dr. Hans Ottomeyer, Dr. Gunther Joppig und insbesondere Dr. Wolfgang Till, der das Projekt auch in kritischen Momenten immer gefördert hat. Wertvolle Hinweise für die Recherchen gaben Hans Christian Adam, Göttingen; Dr. Béla Albertini, Budaörs; Elisabeth Angermair, Stadtarchiv München; Beinecke Rare Book and Manuscript Library, Yale University, New Haven, Connecticut; Dr. Christian Brandstätter, Wien; Cheryl Brutvan, Albright-Knox Art Gallery, Buffalo; Prof. Peter C. Bunnell, Princeton University, New Jersey; Dr. Sibylle Dahms, Institut für Musikwissenschaft, Salzburg; Malcolm Daniel, Metropolitan Museum of Art, New York; Dr. Michael Davidis, Schiller Nationalmuseum Deutsches Literaturarchiv, Marbach; Dr. Bodo von Dewitz, Agfa Foto-Historama Köln; Virginia Dodier, Museum of Modern Art, New York; Lynn Ekfelt, St. Lawrence University, Canton, New York; Carolyn Englunder, München; James Enyeart, George Eastman House Rochester, New York; Dr. Heinz Gahn, Rückersdorf; Peter Galassi, Museum of Modern Art, New York; Brigitte Gedon, München; Prof. Rupprecht Geiger, München; Maria Morris Hambourg, Metropolitan Museum of Art, New York; Francis Smith

painter in New York from 1894 to 1900.[4] What is more, only few documents and unfortunately not a single photograph have been preserved in the Dresden and Leipzig museums and archives which might otherwise have provided information on the fourteen years Eugene spent teaching at the Leipzig Akademie für graphische Künste und Buchgewerbe. This present publication has certainly not been able to supply all that missing data, but it does represent one of the first detailed surveys of the photographer's activities, and highlights correlations between his artistic development, his life-style and the social circumstances under which he lived. The foundation on which the main body of our research work was based are the two photograph collections in Munich and New York, whereby the latter collection was already accessible in part through a publication on international art photography and the Alfred Stieglitz Collection in the Metropolitan Museum of Art.[5] However, that particular publication, though it may be the most comprehensive to date, contained some factual errors, and our more recent investigations have been able to make the respective corrections, especially in the identification of motifs and the dating of specific photographs. Another important source of reference is the detailed correspondence between Frank Eugene and Alfred Stieglitz which contains a total of 95 letters dating from the period between 1900 and 1927. This correspondence is preserved in the Beinecke Rare Book and Manuscript Library, Yale University, New Haven, Connecticut, and could be viewed for our research purposes. Other original letters and documents of Eugene's were accessible in the manuscript collections of the Monacensia Library in Munich, the Deutsche Literaturarchiv in Marbach, the artists archives of the Germanische Nationalmuseum in Nuremberg, and in various private collections. Nevertheless, even after several years of collecting and reconstructing all the available evidence, the full extent of Eugene's oeuvre still cannot be established definitively. Again and again our research turned up the most surprising finds, in particular among the contents of artists' personal estates, which fortunately goes to show that further discoveries may still be possible. Taking into account the photographs published in trade and art magazines, the works in exhibitions, and all the known works in photograph collections, Eugene's complete oeuvre contains no more than 600 motifs.

It was against this background that our publication set out to pursue the photographic and personal development of the artist Frank Eugene through its various important stages in New York, Munich and Leipzig. Par-

ticular attention has been paid to his teaching activities, first at the Munich Lehr- und Versuchsanstalt für Photographie, Lichtdruck und Gravüre, which as the most renowned training institute in Germany before 1914 promoted the aesthetic reform of commercial photography, and later at the Akademie für graphische Künste und Buchgewerbe in Leipzig.

The contribution to this catalogue by Axel Effner deals with the strained relationship which existed between painting and pictorialist photography and the various stylistic developments in Eugene's work, providing a detailed analysis of his artistic orientation towards History Painting, Art Nouveau, Symbolism, Japonaiserie and the works of the Pre-Raphaelites. Andreas Krase on the other hand, has been able to shed light on the few remaining pieces of evidence of Eugene's years in Leipzig, fitting them together in such as way as to create a vivid impression of his sojourn there. I am greatly indebted to both of these authors for their intense dedication to the person and work of Frank Eugene.

Without the many and varied kinds of additional support and advice given by numerous other people and institutions, neither the exhibition nor the catalogue would have been possible in this form. My sincerest thanks to them and to all those who generously donated documents and original photographs, in particular to my colleagues at the Fotomuseum and the Munich Stadtmuseum Thomas Becker, Roman Franke, Monika Gallasch, Barbara Golz, Monika Kaierle-Hoffmann, Rainer Lohmann, Christine Rottmeier, Dr. Volker Duvigneau, Dr. Norbert Goetz, Dr. Hans Ottomeyer, Dr. Gunther Joppig, and especially Dr. Wolfgang Till, who stood by the project in its many critical moments. Valuable references for our research were also provided by Hans Christian Adam, Göttingen; Dr. Béla Albertini, Budaörs; Elisabeth Angermair, Stadtarchiv Munich; Beinecke Rare Book and Manuscript Library, Yale University, New Haven, Connecticut; Dr. Christian Brandstätter, Vienna; Cheryl Brutvan, Albright-Knox Art Gallery, Buffalo; Professor Peter C. Bunnell, Princeton University, New Jersey; Dr. Sibylle Dahms, Institut für Musikwissenschaft, Salzburg; Malcolm Daniel, Metropolitan Museum of Art, New York; Dr. Michael Davidis, Schiller Nationalmuseum Deutsches Literaturarchiv, Marbach; Dr. Bodo von Dewitz, Agfa Foto-Historama Cologne; Virginia Dodier, Museum of Modern Art, New York; Lynn Ekfelt, St. Lawrence University, Canton, New York; Carolyn Englunder, Munich; James Enyeart, George Eastman House Rochester, New York; Dr. Heinz Gahn, Rückersdorf; Peter Galassi, Museum of Modern Art, New York; Brigitte Gedon, Munich; Professor

Hendley, New Jersey, New York; Dieter Hinrichs, Akademie für Fotodesign München; Ernst-Otto Holthaus, München; Dr. Reinhard Horn, Bayerische Staatsbibliothek München; Ursula Hummel, Monacensia Literaturarchiv, München; Andrea Inselmann, Gernsheim Collection at Harry Ransom Humanities Research Center/ The University of Texas, Austin, Texas; Claus Kaelber, München; Sabine Knüttel, Stadtarchiv München; Gudrun Köhl, Valentin-Musäum, München; Olaf Kriszio, Köln; Rosel Kurz, München; Hans Dieter Lange, Berlin; Reiner Leist, New York; Ingeborg Th. Leijerzapf, Prentenkabinet/Rijksuniversiteit Leiden; Klaus Liebich, Liebertwolkwitz; Sandra Limbacher, München; Peter Mesenhöller, Rautenstrauch-Joest-Museum, Köln; Andreas Meyer, Städtische Galerie, Würzburg; Dr. Marina Miraglia, Calcografia Nazionale, Rom; Dr. Ulrich Montag, Handschriften-Abteilung, Bayerische Staatsbibliothek, München; Margarete Müller, Radebeul; Kristin S. Nagel, The Art Institute, Chicago; Dr. Alfred Neven DuMont, Köln; Dr. Claudia Gabriele Philipp, Museum für Kunst und Gewerbe, Hamburg; Dr. Hans Puchta, Bayerisches Hauptstaatsarchiv, München; Pam Roberts, Royal Photographic Society, Bath; Franz Schmid, Freiburg im Breisgau; Marie-Theres Schwandner, Wien; Dietmar Siegert, München; Timm Starl, Frankfurt am Main; Ullstein Bilderdienst, Berlin; Raymond Wemmlinger, The Hampden-Booth Theatre Collection, New York; Arthur Wenzel, Minusio/Schweiz; Sebastian Winkler, München; John Wood, Lake Charles, Louisiana; Ruth Würdig, Dippoldiswalde.

Für die Zusammenarbeit und Hilfestellung bei der Realisation von Ausstellung und Katalog danke ich ausdrücklich der Benno und Therese Danner-Stiftung in München und ihrem Geschäftsführer Dr. Herbert Rüth. Dem Verleger Chris Pichler, der das Buch mit großem Engagement begleitet hat, gilt ebenfalls ein herzliches Dankeschön. Während der langjährigen Vorbereitungen hat meine Lebensgefährtin Stefanie Unruh immer wieder Geduld und Verständnis bewiesen. Ihr widme ich meinen Anteil an diesem Buch.

Ulrich Pohlmann

1

Frank Eugene Smith hat ab circa 1895 den Künstlernamen ›Frank Eugene‹ angenommen und seine Gemälde und Photographien mit ›Eugene‹ signiert.

2

Innerhalb des vergangenen Jahrzehnts wurden auf internationalen Auktionen einzig die Porträts von Richard Berndl, Dr. Emanuel Lasker und Eugenes Bruder Frederick Smith sowie eine unvollständige HAWE-Mappe und ›The Song of the Lily‹ angeboten.

3

Brief L.F. Gruber an Rudolf Loher vom 3.1.1962, Archiv Fotomuseum im Münchner Stadtmuseum.

4

Ein Lebenslauf Eugenes, der 1907 anläßlich seiner Einstellung als Lehrer an der Lehr- und Versuchsanstalt für Photographie an die Regierung von Oberbayern, Kammer des Innern, zugesandt wurde, ist heute nicht mehr auffindbar. Vgl. Staatsarchiv München RA 56948. Schreiben vom 23.11.1907.

5

Vgl. Weston J. Naef (Hrsg.), *The Collection of Alfred Stieglitz. Fifty Pioneers of Modern Photography*, New York 1978. Die 133 Aufnahmen des Jacob S. Rogers Fund, die 1972 in die Sammlung kamen, sind noch unpubliziert.

Rupprecht Geiger, Munich; Maria Morris Hambourg, Metropolitan Museum of Art, New York; Francis Smith Hendley, New Jersey, New York; Dieter Hinrichs, Akademie für Fotodesign Munich; Ernst-Otto Holthaus, Munich; Dr. Reinhard Horn, Bayerische Staatsbibliothek Munich; Ursula Hummel, Monacensia Literaturarchiv, Munich; Andrea Inselmann, Gernsheim Collection at Harry Ransom Humanities Research Center, The University of Texas, Austin, Texas; Claus Kaelber, Munich; Sabine Knüttel, Stadtarchiv Munich; Gudrun Köhl, Valentin-Musäum, Munich; Olaf Kriszio, Cologne; Rosel Kurz, Munich; Hans Dieter Lange, Berlin; Reiner Leist, New York; Ingeborg Th. Leijerzapf, Prentenkabinet, Rijksuniversiteit, Leiden; Klaus Liebich, Liebertwolkwitz; Sandra Limbacher, Munich; Peter Mesenhöller, Rautenstrauch-Joest-Museum, Cologne; Andreas Meyer, Städtische Galerie, Würzburg; Dr. Marina Miraglia, Calcografia Nazionale, Rome; Dr. Ulrich Montag, Manuscript Section, Bayerische Staatsbibliothek, Munich; Margarete Müller, Radebeul; Kristin S. Nagel, The Art Institute, Chicago; Dr. Alfred Neven DuMont, Cologne; Dr. Claudia Gabriele Philipp, Museum für Kunst und Gewerbe, Hamburg; Dr. Hans Puchta, Bayerisches Hauptstaatsarchiv, Munich; Pam Roberts, Royal Photograhic Society, Bath; Franz Schmid, Freiburg im Breisgau; Marie-Theres Schwandner, Vienna; Dietmar Siegert, Munich; Timm Starl, Frankfurt am Main; Ullstein Bilderdienst, Berlin; Raymond Wemmlinger, The Hampden-Booth Theatre Collection, New York; Arthur Wenzel, Minusio, Switzerland; Sebastian Winkler, Munich; John Wood, Lake Charles, Louisiana; Ruth Würdig, Dippoldiswalde. For their cooperation and support in the realization of this exhibition and the publication of this catalogue, I would like to express my sincerest gratitude to the Benno and Therese Danner Foundation in Munich and its director Dr. Herbert Rüth. A special word of thanks too to the publisher Chris Pichler who personally accompanied the completion of this book. My partner Stefanie Unruh has displayed great resources of patience and understanding during my years of work on this project and it is to her that I would like to dedicate my contribution to this book.

Ulrich Pohlmann

1

From about 1895 onwards Frank Eugene Smith adopted the name "Frank Eugene" and used it to sign his paintings and photographs.

2

During the past decade only the portraits of Richard Berndl, Dr. Emanuel Lasker and Eugene's brother Frederick Smith, plus an incomplete HAWE-portfolio and "The Song of the Lily" have turned up at international auctions.

3

Letter from L. F. Gruber to Rudolf Loher, January 3, 1962, archives of the Fotomuseum in the Munich Stadtmuseum.

4

A résumé of Eugene's sent to the department of the interior of Upper Bavaria in 1907 on the occasion of his appointment as a teacher at the Lehr- und Versuchsanstalt für Photographie can no longer be found. Cf. Munich Municipal Archives RA 56948, letter of November 23, 1907.

5

Cf. Weston J. Naef (ed.), "The Collection of Alfred Stieglitz. Fifty Pioneers of Modern Photography," New York 1978. The 133 photographs from the Jacob S. Rogers Fund, which were donated to the collection in 1972, have not been published.

The Dream of Beauty

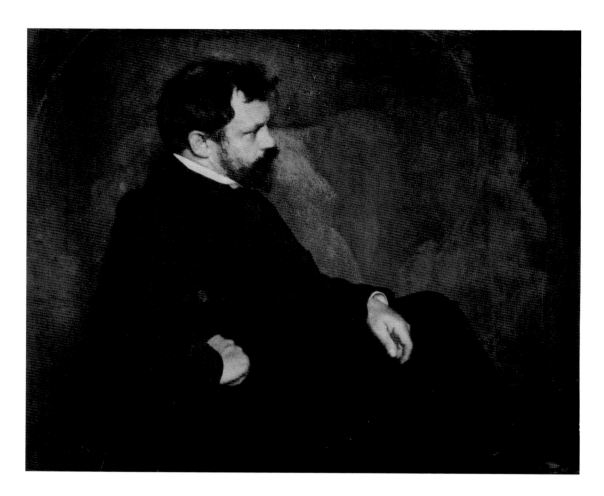

1. *Heinrich Kühn*
Frank Eugene Smith, c. 1910
Gum print, 36.5 x 43.8 cm
Fotomuseum im Münchner
Stadtmuseum (88/50)

Beauty is Soul[1]
The Life and Work of the Photographer Frank Eugene Smith
by Ulrich Pohlmann

Childhood and Youth in "Little Germany" in New York

Frank Eugene Smith was born in New York City on September 12, 1865, the third child of a Catholic German immigrant family. His mother, Hermine Selinger,[2] came from a large farming family which had lived in the village of Gottenheim in Baden since the 18th century.[3] According to Eugene's birth certificate his father Frederick (Friedrich) Schmid was born in Bavaria.[4]

Harvest failures, population growth, and high unemployment were the primary causes of mass emigration from Germany to North America in the 1850s, with small farmers, craftspeople and day-laborers being the groups most affected. As a result of the enormous debt burden caused by maintenance for the poor, many communities even provided some financial support for anyone "willing to emigrate," in the interest of avoiding social and political tension. More than any other German state, the Grand Duchy of Baden went to great lengths to encourage the impoverished to emigrate by giving them financial assistance for their passage.[5] Often whole family groups emigrated, with the result that complete villages and districts became depopulated. In 1854 more than 215,000 mostly impoverished people left Germany for North America. In 1856 the figure was 71,000. Most of these German immigrants settled in large cities such as New York, Philadelphia, Baltimore, Cincinnati, St. Louis and Chicago. On February 25, 1856, Hermine Selinger applied to the mayor of Gottenheim for permission to emigrate to North America: "The unmarried, 17-year-old Hermine Selinger ... is willing, and has her father Johann Selinger's consent, to emigrate to America and therefore requests that the necessary travel documents be issued."[6] Once she had received permission from the Grand Ducal district authority, she gave her travel destination as New York. Presumably Hermine Selinger, like her later husband, whose exact date of emigration is not known, crossed the Atlantic from the French port of Le Havre on a cargo ship, arriving in Castle Garden in New York after a journey of several weeks. At first she stayed with relatives of the Selinger family who had emigrated from Gottenheim some years previously.[7]

It is more than likely that Frank Eugene's parents met in New York between 1856 and 1860. Their first child, Karlina ("Kal"), was born in 1860, followed two years later by another daughter Annie. Their next three children were sons, first Frank Eugene, then Robert and Frederick Lorenz.[8] Like many other immigrants at that time, Hermine and Frederick Smith hoped for a better life on the American continent.

The prevailing image of America at the time was that of a land of abundance, of unlimited possibilities, of equality, a social utopia, an Arcadian dream come true, in which an honest worker could make an honest living, and religious and political freedom were guaranteed. However, the young married couple found anything but conducive living conditions in their new homeland. Due to a world economic crisis at the end of the 1850s, New York was also experiencing high unemployment, as a result of which social conflict and strife were rampant. Yet Hermine Selinger seems to have approached this difficult situation with great ambition and élan. While she worked successfully as a singer in German beer halls, her husband attempted to secure a living for his family as a baker. This was a typical occupation among the 120,000 German immigrants living in New York in 1860.[9] In that year alone Manhattan recorded 5,020 bakers, of which more than 2,700 were Germans. As a rule, the bakeries were small and often located in cellars, with at the most two or three employees, or else organized as family businesses. Working conditions in these cellar bakeries in the Lower East side were said to be the worst in the whole city. As ascertained by the Bakers Trade Union, the majority of baker's apprentices had to work more than 100 hours a week, and often on Sundays, for poor wages, and because of the long hours many slept on flour sacks in the bake-houses. The hard physical work damaged their health, especially as there was no ventilation in the bake-houses despite the great heat. The hygienic conditions in the flour stores were also a catastrophe: open drains, dirt from the streets, and plagues of rats were quite common. Under these working conditions scarcely any of the employees were able to survive the strenuous physical work for more than twenty years. Frederick Smith seems to have had

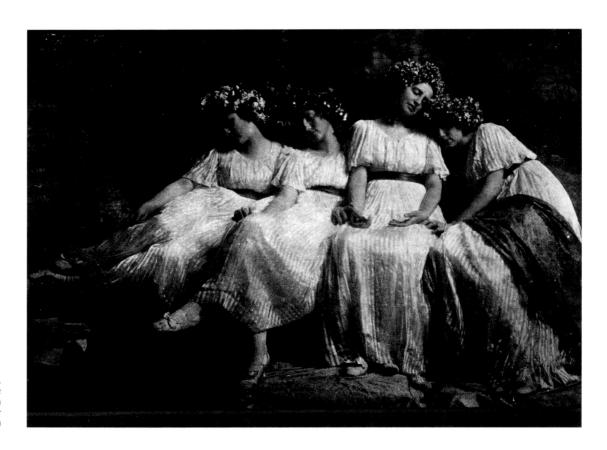

2. Slumbering Vestal Virgins,
c. 1912
Platinum print, 12.0 x 17.1 cm
Fotomuseum im Münchner
Stadtmuseum (88/26-15)

Schönheit ist Seele[1]
Leben und Werk des Photographen Frank Eugene Smith

von Ulrich Pohlmann

Kindheit und Jugend in ›Klein-Deutschland‹ in New York

Frank Eugene Smith wurde am 12. September 1865 als drittes Kind einer deutschen Einwandererfamilie katholischen Glaubens in New York City geboren. Seine Mutter Hermine Selinger[2] stammte aus einer kinderreichen Bauernfamilie aus Gottenheim, die seit dem 18. Jahrhundert in dem badischen Dorf ansässig war.[3] Laut Geburtsurkunde Eugenes war sein Vater Frederick (Friedrich) Schmid aus Bayern gebürtig.[4]

Mißernten, Bevölkerungswachstum und hohe Arbeitslosigkeit waren in Deutschland in den 1850er Jahren die wichtigsten Ursachen für Massenauswanderungen nach Nordamerika, von denen vor allem Kleinbauern, Handwerker und Tagelöhner betroffen waren. Infolge der enormen Schuldenlast, die durch die Armenversorgung verursacht wurde, hatten viele Gemeinden die ›Auswanderungslustigen‹ finanziell unterstützt, um sich auf diesem Wege der sozialen und politische Spannungen zu entledigen. Wie kein anderer deutscher Staat bemühte sich das Großherzogtum Baden, die verarmte Bevölkerung mit Reisezuschüssen zur Auswanderung zu bewegen.[5] Häufig wanderte man im Familienverband aus, so daß auf diese Weise ganze Ortschaften und Landkreise regelrecht entvölkert wurden. 1854 kamen über 215.000, 1856 71.000 meist mittellose Auswanderer aus Deutschland, von denen sich der größte Teil in den Metropolen New York, Philadelphia, Baltimore, Cincinnati, St. Louis und Chicago niederließ.

Am 25. Februar 1856 suchte Hermine Selinger beim Bürgermeister von Gottenheim in Baden um Erlaubnis zur Auswanderung nach Nordamerika nach: »Die ledige 17 Jahre alte Hermine Selinger (...) ist willens mit Zustimmung ihres Vaters Johan Selinger nach Amerika auszuwandern, und bittet deshalb um Erteilung der benötigten Reiseurkunden.«[6] Nachdem ihr die Erlaubnis vom großherzoglichen Bezirksamt erteilt wurde, hieß ihr Reiseziel New York. Vermutlich überquerte Hermine Selinger wie ihr späterer Mann, dessen genaues Auswanderungsdatum unbekannt ist, vom französischen Seehafen Le Havre auf einem Frachtschiff den Atlantik, um nach mehrwöchiger Überfahrt in Castle Garden in

New York anzukommen. Dort konnte sie zunächst bei Angehörigen der Familie Selinger aus Gottenheim wohnen, die in den Jahren zuvor ausgewandert waren.[7] Vermutlich zwischen 1856 und 1860 lernten sich die Eltern von Frank Eugene in New York kennen. Die erstgeborene Tochter Karlina (›Kal‹) kam im Jahre 1860 zur Welt, zwei Jahre später folgte ihre Schwester Annie. Neben dem ältesten Sohn Frank Eugene wurden noch Robert und Frederick Lorenz geboren.[8] Wie viele Auswanderer erhofften sich auch Hermine und Frederick Smith auf dem amerikanischen Kontinent ein besseres Leben. Das Bild von Amerika als Land des Überflusses, der unbeschränkten Möglichkeiten, als Ort der sozialen Utopie und der gesellschaftlichen Gleichheit dominierte – es war der Traum von einem irdischen Arkadien, in dem jeder redliche Arbeiter sein Auskommen hatte, wie auch die religiöse und politische Freiheit garantiert waren. Doch fanden die jungen Eheleute in der neuen Heimat alles andere als günstige Lebensverhältnisse vor. Aufgrund einer Weltwirtschaftskrise herrschte in New York Ende der fünfziger Jahre hohe Arbeitslosigkeit, in deren Folge es immer wieder zu sozialen Konflikten kam. Hermine Selinger muß diese schwierige Situation mit grossem Ehrgeiz und Elan angegangen sein. Während sie erfolgreich als Sängerin in deutschen Bierhallen auftrat, versuchte ihr Mann, den Lebensunterhalt der Familie als Bäcker zu sichern. Dieses war 1860 unter den 120.000 in New York lebenden Deutschen[9] ein typischer Einwandererberuf, allein im Jahre 1880 wurden in Manhattan unter 5.020 Bäckern mehr als 2.700 deutsche gezählt. In der Regel handelte es sich um Kleinbäckereien, die im Kellergeschoß untergebracht waren und höchstens über zwei oder drei Angestellte verfügten oder als Familienbetrieb organisiert waren. Die Arbeitsbedingungen in den Kellerbäckereien in der Lower Eastside zählten zu den schlechtesten der ganzen Stadt. Wie die Bakers Trade Union herausfand, mußten die meisten Bäckergesellen über 100 Stunden in der Woche, auch häufig am Sonntag, bei schlechter Bezahlung arbeiten, so daß viele wegen der langen Arbeitszeit ihr Nachtquartier gleich auf Mehlsäcken in den Backstuben aufschlugen. Die schwere körperliche Arbeit schädigte die Gesundheit, zumal jegliche Ventilation der Backstube bei

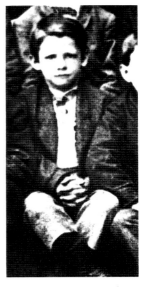

3. Frank Eugene as a young boy, c. 1875
Platinum print
The Metropolitan Museum of Art, Rogers Fund, 1972.
(1972.633.180)

großer Hitze fehlte und die hygienischen Verhältnisse in den Mehlstuben katastrophal waren: offene Abwasserleitungen, Straßendreck und Rattenplagen waren durchaus üblich. Unter diesen Arbeitsbedingungen konnte kaum einer der Beschäftigten die den Körper auslaugende Arbeit länger als zwanzig Jahre durchhalten. Frederick Smith muß diesen Beruf nur mit mäßigem Erfolg ausgeübt haben, bevor er als ›Privatier‹ in der Bronx in einem von deutschen Schwestern betriebenen Altersheim seine letzten Lebensjahre verbrachte und vermutlich in den 1890er Jahren starb.[10]

Während ein Großteil der deutschen Immigranten in den primitiven ›Tenement Houses‹ meist ohne sanitäre Einrichtung, Wasser und Strom lebte, wohnte die Familie Smith in einem kleinen mehrstöckigen Gebäude in der King Street. Dieses Wohnhaus lag mitten in ›Klein-Deutschland‹ oder ›Little Germany‹, in dem die Hälfte aller Deutschen lebte und das sich in den 1850er Jahren im südlichen Manhattan in Lower East Side und Upper West Side zwischen der 40. und 86. Straße erstreckte.[11] Hier spielte sich das soziale und gesellschaftliche Leben der Amerika-Deutschen in zahllosen Wohltätigkeits-, Turn-, Schützen- und Sängervereinen ab, die sich der Literatur, Musik, dem Theater oder dem Sport widmeten, vor allem aber jene von den Amerikanern als ›teutonisch‹ angesehene Vorliebe für ›Gemütlichkeit‹ kultivierten. Hier wurden Feste gefeiert, in denen die Traditionen des Heimatlandes wieder lebendig wurden. Das Bedürfnis nach Informationen aus der deutschen Heimat befriedigte ein breitgefächertes Zeitungswesen, das in deutscher Sprache für Berichte aus sämtlichen Bereichen sorgte. Allen voran stand die 1834 gegründete *New Yorker Staats-Zeitung*, die sich auch ausführlich mit Literatur, Theater und Kunst beschäftigte und deren Herausgeber sich zu der Aufgabe bekannten, deutsche Sprache und Traditionen zum Zwecke der kulturellen Identitätsfindung zu erhalten und ausführlich über die aktuelle politische Situation in Deutschland zu berichten. Hier trafen sich die wichtigsten deutschen Intellektuellen und arbeiteten deutschsprachige Journalisten wie z.B. der Deutsch-Amerikaner Sadakichi Hartmann, mit dem Eugene Ende der neunziger Jahre in enge Verbindung treten sollte.[12] Firmen wie der berühmte Verlag Georg Westermann, der sich seit 1848 in New York etabliert hatte, versorgten die Bewohner von ›Little Germany‹ mit Büchern der Klassiker Goethe, Schiller und Lessing, aber auch Uhland, Heine, Wieland, Klopstock oder Hoffmann von Fallersleben. Weiterhin existierten in New York City 1854 mit der ›Hofburg‹, ›Hugo's deutschem Volkstheater‹, dem ›Nationaltheater‹ und ›New Yorker Stadt-Theater‹ vier große Schauspielhäuser, die Stücke von den deutschen Klassikern bis hin zu modernen Dramatikern auf die Bühne brachten. Zu den typischen kulturellen Ereignissen gehörte auch die Veranstaltung von musikalischen Darbietungen, Sängerfesten und aufwendigen Inszenierungen von deutschsprachigen-Opern.[13]

In diesem Klima war es möglich, leicht Anschluß an andere Deutsche zu finden, ohne die eigene Herkunft vollkommen aufgeben und sich an die amerikanische Lebensform anpassen zu müssen. Die in ›Klein-Deutschland‹ lebende Bevölkerung bemühte sich um die Aufrechterhaltung deutscher Lebenstraditionen, was im Alltag in der weiten Verbreitung von deutschen Esslokalen, Lebensmittelgeschäften, Buchhandlungen bis hin zu jüdischen Synagogen seinen Ausdruck fand. »»Auf jedes vierte Haus kommt eine Wirtschaft und auf je hundert Menschen ein Ausschank. Biersalon! Biersalon!, nichts als Biersalon!, denkt ein Fremder, wenn er zum erstenmal in diesen Stadtteil kommt.‹ In den großen Bierhallen hatten Hunderte von Menschen Platz. Orchester spielten deutsche Volkslieder und Walzer, burleske Schwänke und regional-landsmannschaftliches Dekor taten ein übriges, nostalgisch-romantische Heimatgefühle zu nähren.«[14]

Auf der anderen Seite repräsentierte New York City eine der modernsten Städte der Erde. Moderne Kommunikations- und Transportmittel waren hier weiter entwickelt als anderswo — so wurde im August 1858 das Atlantik-Kabel zwischen Europa und Amerika eingeweiht, seit 1878 gab es elektrische Hochbahnen. Dichter Verkehr auf den großzügigen, breit angelegten Straßen, die einladenden Grünanlagen des Central Park und gewaltige Eisenkonstruktionen wie die 1883 erbaute Brooklyn Bridge über den East River sorgten für ein weltstädtisches Gepräge. Seit 1886 begrüßte die von elektrischem Licht an Haupt und Fackel illuminierte Freiheitsstatue des französischen Bildhauers Bartholdi auf Bedloe Island die Neuankömmlinge der Stadt.

Auch kulturell hatte die Stadt New York einiges zu bieten, nachdem das Metropolitan Museum of Art im Jahre 1880 offiziell eröffnet worden war. Die im Jahre 1881 erbaute Metropolitan Opera machte mit Aufführungen von Wagners Musikdramen von sich reden, die erst von Leopold Damrosch und seinem Sohn Walter Damrosch, später dann von Anton Seidl als Dirigenten geleitet wurden. Seit 1891 existierte der von Andrew Carnegie gestiftete Konzertsaal Carnegie Music Hall.

Inmitten dieses lebendigen Treibens, dessen Erscheinungsbild von der wechselseitigen Durchdringung der deutschen und amerikanischen Kultur geprägt war, wuchs Frank Eugene Smith in den 1870er Jahren auf. Es ist anzunehmen, daß er an dem kulturellen Leben in

only average success in this business. He spent his last years as a "man of private means" in an old people's home run by German nuns in the Bronx, dying in the 1890s.[10]

Whereas most of the German immigrants lived in primitive tenement houses, usually without sanitation, running water or electricity, the Smith family lived in a smaller building only a few floors high in King Street. This apartment block was in the center of "Little Germany" in which half of all the Germans lived and which in the 1850s stretched from 40th to 86th Street in southern Manhattan, Lower East Side and Upper West Side.[11] Here the social life of the American-Germans took the form of innumerable charity, sporting, shooting and singing events and of club activities dedicated to literature, music, theater and, above all, to the cultivation of a particular "Gemütlichkeit," or cozy atmosphere, which the Americans regarded as "Teutonic." The festivals which took place here revived the traditions of the homeland. A wide assortment of German-language newspapers satisfied the need for information about that homeland and all its various regions. The most popular of these was the *New Yorker Staats-Zeitung*, founded in 1834, which not only covered economic and political topics but also carried extensive articles on literature, theater and art. Its editors saw it as their task to preserve the German language and traditions in the interests of their cultural identity, and to report in detail on the political situation in Germany. It was here that the most important German intellectuals met, and it was here that German-speaking journalists such as Sadakichi Hartmann, with whom Eugene was to come into close contact at the end of the 1890s, worked.[12] Publishers such as the famous Georg Westermann, established in New York since 1848, supplied the inhabitants of "Little Germany" with books by the classical German writers Goethe, Schiller, Lessing, Uhland, Heine, Wieland, Klopstock and Hoffmann von Fallersleben. In 1854, New York also had four large theaters, the Hofburg, Hugo's deutsches Volkstheater, the Nationaltheater, and the New Yorker Stadt-Theater, all staging performances of plays by German dramatists from the classical to the modern era. Other typical cultural events included concerts, singing festivals and expensive productions of German operas.[13]

In such a social climate it was easy to make contact with other Germans and not have to break completely with one's own roots and adapt fully to the American way of life. The inhabitants of "Little Germany" did much to preserve German traditions and this found its everyday expression in a large number of German res-

taurants, grocery shops, bookshops, even Jewish synagogues. "'For every four houses there is a restaurant, and for every hundred people a bar. Beer halls! Beer halls! Nothing but beer halls!, is what an outsider would think when seeing this part of town for the first time.' There was room in the large beer halls for hundreds of people. Orchestras played German folk music and waltzes, with burlesque comedians and a rustic decor making their contribution towards nourishing nostalgic-romantic sentiments about the homeland."[14]

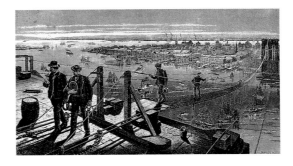

4. The Temporary Footpath between Brooklyn and Manhattan, New York 1877

On the other hand, New York City was also the most modern city in the world where the progressive-mindedness of high capital had been given free rein. Modern means of communication and transport were better in New York than anywhere else, with the Atlantic cable between Europe and America, inaugurated in August 1858, and elevated electric railways in existence since 1878. Heavy traffic on the wide streets, inviting greenery in Central Park, and powerful metal constructions such as the Brooklyn Bridge over the East River, constructed in 1883, gave the city a cosmopolitan flair.

The Statue of Liberty, designed by the French sculptor Bartholdi, its head and torch illuminated by electric lights, had been greeting the new arrivals to the city on Bedloe Island since 1886. Culturally too, the city had a lot to offer. The Metropolitan Museum of Art was officially opened in 1880 and the Metropolitan Opera, built in 1881, was the talk of the town in the 1880s with its performances of Wagner's musical dramas, conducted and directed first by Leopold Damrosch and his son Walter, and later by Anton Seidl. In 1891 Andrew Carnegie donated the famous concert hall which bears his name.

Frank Eugene Smith grew up in the middle of this lively scene of bustling activity, a scene marked in the 1870s by a mutual interaction of German and American culture. It can be assumed that he participated in the cultural life of "Little Germany," for example in the local choral society.[15] He was also bilingual, speaking and writing both German and English in an odd but characteristic

›Klein-Deutschland‹ wie z.B. den Liederkränzen teil-
nahm.[15] Auch wuchs er zweisprachig auf, wobei er die
deutsche und englische Sprache in einem unverwechsel-
baren kauzigen Dialekt sprach und schrieb.

Frank Eugenes Ausbildungsweg und sein künstlerischer
Werdegang in den Vereinigten Staaten sind nur bruch-
stückhaft bekannt. Nach dem Besuch der Primary und
Secondary School hatte er nach eigenen Angaben am
City College in New York studiert, das vorzugsweise
von deutschgebürtigen Lehrern und Schülern frequen-
tiert wurde, unter ihnen Alfred Stieglitz oder der Dozent
für Zeichnung, Geometrie und Ästhetik Hermann
Koerner, der zu den intellektuellen Freidenkern der 1848er
Bewegung um Carl Schurz gehört hatte.[16]

Nach Auskunft der Matrikelbücher hat sich Eugene,
wohnhaft in der Christopher Street 47, nach dem Besuch
der Elementary School als vierzehnjähriger 1879 am City
College eingeschrieben.[17] Obgleich er die Aufnahmeprü-
fung bestanden hatte, wurde der junge Smith jedoch im
Jahresbulletin der Schule weder in diesem Jahre noch in
den nachfolgenden unter den Schüler- und Kurslisten
aufgeführt.

In diesen Jahren fand Eugenes künstlerische Begabung
ihr erstes Tätigkeitsfeld. Nachdem er als Junge als Lauf-
bursche in der Hartford Carpet Company, einer New Yor-
ker Teppichfirma, gearbeitet hatte, wandte er sich ab
1883/84 dem Kunstgewerbe zu. Er begann Teppiche ge-
meinsam mit dem Engländer Arthur Llewellen Halliday
für verschiedene amerikanische Firmen wie John & James
Dobson, T.J. Neveney und Bigelow Carpet Co. zu ent-
werfen, die wiederum zahlreiche Teppichhändler mit
Eugenes Entwürfen belieferten. Mit einem jährlichen Ge-
halt von 1.000 Dollar verfügte Eugene über ein beachtli-
ches Auskommen.[18]

Studium der Malerei in München 1886–1894

Wohl in dieser Zeit mußte bei Eugene ernsthaft der
Wunsch nach einer künstlerischen Ausbildung gereift
sein. Als Folge dieser Überlegungen entschied er, sich
in Europa als Künstler weiterzubilden. So schrieb sich
der 21jährige im Dezember 1886 an der Königlich Bayeri-
schen Akademie der Bildenden Künste in München ein,
um Malerei in der Mal- und Komponierklasse bei Wil-
helm von Diez (1839–1907) und in der Naturzeichen-
klasse von Karl Raupp (1837–1918) und Johann Caspar
Herterich (1843–1905) zu studieren.[19] Zunächst besuchte
Eugene den ersten Kurs der Vorschule, in der das Zeich-
nen nach Gipsmodellen und anatomischen Lehrobjekten
vermittelt wurde, wie er auch mit der Geometrie und
Ornamentzeichnung vertraut gemacht wurde.

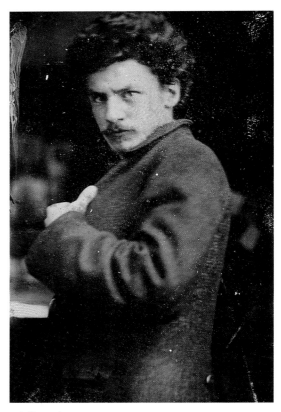

5. Self portrait, c. 1890
Ferrotype, 8.5 x 6.1 cm
Fotomuseum im Münchner Stadtmuseum (89/192)

Insbesondere die Lehrtätigkeit von Diez, der Pilotys Füh-
rungsrolle als Lehrer an der Akademie übernommen hat-
te, und sein am Realismus orientierter Malstil sorgten im
Ausland und auch in Nordamerika für den hervorragen-
den Ruf der Münchner Kunstakademie. Dies mag für Eu-
genes Entscheidung ausschlaggebend gewesen sein, in
dem von Gottfried von Neureuther entworfenen Neubau
der Akademie in der Nähe des Siegestores zu studieren.
Darüberhinaus bot München mit den herausragenden
Kunstsammlungen in den beiden Pinakotheken, den Gale-
rien und dem Kunstverein einen idealen Nährboden für
die Auseinandersetzung mit den künstlerischen Traditio-
nen und zeitgenössischen Strömungen der Malerei. Die
vier internationalen Kunstausstellungen von 1869, 1879,
1883 und 1888, die unter Beteiligung von Künstlern aus
Nordamerika, Belgien, Holland, Italien, Österreich, Un-
garn, Schweden und Spanien im Glaspalast stattfanden,
hatten Münchens Ruf als Kunstmetropole und europäi-
sches Zentrum des internationalen Kunsthandels mitbe-
gründet.[20] 1888 waren herausragende Vertreter des Pleinai-
rismus wie Max Liebermann und Fritz von Uhde mit ihren
Arbeiten oder die realistische Genremalerei eines Hugo
von Habermann zu sehen, während die Historienmalerei

style. His schooling and artistic training in the United States are only partially documented. After attending primary and secondary school he claims to have then attended the City College in New York, which was mainly frequented by teachers and students of German origins, among them Alfred Stieglitz and Hermann Koerner, a teacher of drawing, geometry and aesthetics and one of the intellectual freethinkers in the political movement centered around Carl Schurz.[16]

According to the student registers, Eugene, who lived in 47 Christopher Street in Manhattan, enrolled at the City College in 1879 at the age of 14, having completed elementary school.[17] Although he passed the entrance examination, he was not listed in the school's annual bulletin either that year or in the years that followed.

It was in those years that Eugene's artistic talent found its first expression. Having worked as a messenger for the Hartford Carpet Company in New York, in 1883/84 he turned his attentions to arts and crafts. Together with the Englishman Arthur Llewellen Halliday, he began to design carpets for different American companies such as John & James Dobson, T. J. Neveney and Bigelow Carpet Co., who in turn supplied numerous carpet traders with their designs. With 1,000 dollars a year Eugene had quite a good salary at his disposal.[18]

Munich 1886–1894: Studies in Painting

Eugene desire for serious formal training must also have ripened in that period. As a consequence, he decided to go to Europe to train as an artist. Thus in December 1886, at 21 years of age, he enrolled at the Königlich Bayerische Akademie der Bildenden Künste (Royal Bavarian Academy of Arts) in Munich to study painting and composition under Wilhelm von Diez (1839–1907) and nature drawing under Karl Raupp (1837–1918) and Johann Caspar Herterich (1843–1905).[19] But first Eugene attended an introductory course in the preparatory school where he learned to draw from plaster models and anatomical teaching materials and familiarized himself with geometry and ornamental drawing.

There is no doubt that Eugene's decision to study in Munich was considerably influenced by the excellent reputation which the Academy of Arts had in Europe and in North America. This reputation was based mainly on the painting and teaching style of Wilhelm von Diez, who had taken over Piloty's leading role at the Academy. The Academy was located in a new building designed by Gottfried von Neureuther near the Siegestor in Munich. Furthermore, with its outstanding art collections in the two Pinakotheken, its galleries and its Art

Association, Munich was an ideal place in which to come to grips with artistic traditions and contemporary trends in painting. The four international art exhibitions of 1869, 1879, 1883 and 1888, which took place in the Crystal Palace there and included artists from North America, Belgium, Holland, Italy, Austria, Hungary Sweden, and Spain, had consolidated Munich's reputation as an art metropolis and the center of the European art market.[20] Whereas in 1888 history painting receded into the background giving way to the such prominent representatives of plein air painting as Max Liebermann and Fritz von Uhde or the realistic genre painting of Hugo von Habermann,[21] from 1889 onwards the comprehensive annual exhibition of the Munich Artists Co-operative familiarized the public with the art of Arnold Böcklin, Wilhelm Leibl, Hans von Marées and the painters of the Barbizon School.

As illustrated by an excellent study on American artists at the Academy of Arts, Munich was considered the Mecca of art studies in the second half of the 19th century by some hundreds of students from American cities such as New York, Philadelphia, Boston or Cincinnati.[22] "In those days, anyone who wanted to learn to paint either went to Paris or to Wilhelm von Diez."[23] Diez's class included numerous American students, about half of whom were of German extraction.

It can be assumed that Eugene was attracted to Diez not only because of his artistic reputation but also because of his non-academic teaching style and his whole way of life which was characterized by a "strange attraction to all sorts of rugged and carefree vagabond types"[24] in the bars in Munich's suburbs. Diez cultivated a certain air of camaraderie towards his students, despite occasional outbursts of rudeness. The artist Hermann Stockmann, who studied with Eugene in Diez' class, recalls: "At that time (1888–1894) the art school was divided into two studios, the so-called upper and lower Diez schools, and there was also the composition school. The upper school included, among others, the talented Herter, of whom Diez had great expectations but who died young, Gebhardt, Tafel, Gabelsberger, van Hees, Weinholdt, who also died young, then later Slevogt, Anetsberger, Damberger, Faber du Faur, Smith, C. Egersdörfer and the two talented colleagues Raders and Hetze, both of whom also unfortunately died young. The lower school brought together Hengeler, Leffler from Vienna, Schrag, Robert Schmidt, Dasio and my humble self. Later we were joined by the Tyrolean Overstolz, Bruno Dressler, Werle, Correggio and the Mexican Gedovius. A lot of others came just for a short while, whereas those named above were the regulars.

"When I was still a young man and, accordingly, keen to learn, the painter-photographer Frank Eugene Smith ... showed me a series of small sketches in oil he had done after frescos by famous masters in Assisi during a trip to Italy. What I noticed in particular was that the color in his sketches was quite different to that of the original. When I inquired, for example, why the background of a Madonna in his sketch was green although I knew it to be blue in the original, he replied that from the position from which he had done the sketch, the background appeared to him to be as he had painted it. And these differences were in all of his sketches. They were very beautiful in their atmospheric coloration but they did not correspond to the originals. He had painted what he had seen and was not too worried about faithfulness to the original. Whether it was due to the prevailing light conditions or to his position, or whether there were some other influences to which his eyes reacted, he was only seriously concerned to reproduce his own experience." Walter Hege, "Individuelle Beeinflussungsmöglichkeiten bei Reproduktionen nach Kunstwerken mit der Agfacolor-Photographie," in: Fortschritt und Leistung. 9, 1953, Vol. 3, pp., 24–28.)

merklich in den Hintergrund trat.[21] Ab 1889 anläßlich der Jahresausstellungen der Münchner Künstlergenossenschaft machten umfassende Gemäldepräsentationen mit der Kunst Arnold Böcklins, Wilhelm Leibls, Hans von Marées und der Maler von Barbizon vertraut.

Wie eine aufschlußreiche Studie über die amerikanischen Künstler an der Münchner Kunstakademie eindrucksvoll belegt, galt München in der zweiten Hälfte des 19. Jahrhunderts für einige hundert Studenten aus amerikanischen Großstädten wie New York, Philadelphia, Boston oder Cincinnati als Mekka des Kunststudiums.[22] »Wer damals malen lernen wollte, der ging entweder nach Paris oder er ging zu Wilhelm von Diez.«[23] Ungefähr die Hälfte der amerikanischen Schüler in seiner Klasse war deutscher Abstammung.

Vermutlich fühlte sich Eugene neben der künstlerischen Reputation auch von Diez' unakademischen Wesen und einer Lebensweise hingezogen, die sich durch eine »merkwürdige Neigung zu allerlei derbem und ungebundenem Vagabundenvolk«[24] in den Münchner Vorstadtkneipen auszeichnete. Diez pflegte trotz gelegentlicher Grobheiten mit den Schülern einen kameradschaftlichen Umgang und Ton. Der Maler Hermann Stockmann, der gemeinsam mit Eugene in der Klasse von Diez studierte, erinnerte sich: »Damals waren (1888–1894) die Malschule in zwei Ateliers verteilt, in die obere und die untere Diez-Schule, und außerdem existierte noch die Komponierschule. In der oberen war zuerst unter anderen der früh verstorbene, talentvolle Herter, auf den Diez sehr viel hielt. Gebhardt, Tafel, Gabelsberger, van Hees, Weinholdt, der auch schon gestorben ist, später kamen Slevogt, Anetsberger, Damberger, Faber du Faur, Smith. C. Egersdörfer und die beiden talentvollen, leider auch früh verstorbenen Kollegen Raders und Hetze. In der unteren Schule waren vereint Hengeler, der Wiener Leffler, Schrag, Robert Schmidt, Dasio und meine Wenigkeit. Später kamen noch der Tiroler Overstolz, Bruno Dreßler, Werle, Correggio und der Mexikaner Gedovius. Es kamen ja viele, die nur kurze Zeit da waren. Die oben Genannten waren doch der eigentliche Stamm. Diez kam jede Woche ein- bis zweimal zu uns, und er war nie ein trockener Lehrer, immer anregend und begeisternd. Er war in erster Linie auch unser Freund und behandelte uns stets als Kollegen. Wie oft sind wir mit ihm nach den alten, schönen Kellern Münchens gewandelt: Kochelbräu, Stubenvoll, Eberl, Sternecker und Augustinerkeller sind lauter Zauberwörter, und daß man da nicht trocken sitzen blieb, glaube ich nicht erwähnen zu dürfen. Diese Plauderstunden waren ein großer Genuß, denn wie konnte dieser Mann anregend erzählen. Seine Phantasie leuchtete überall durch (…)«[25]

Berühmt waren die ausgelassenen Feiern der Diez-Klasse, die für die Münchner Kostüm- und Künstlerfeste wie das ›Waldfest‹ mit der ›Erstürmung von Burg Schwaneck‹ (1879) wegweisend waren.[26] Lebendiger Ausdruck der kreativen Atmosphäre in der Diez-Klasse ist eine andere von Hermann Stockmann überlieferte Anekdote: »So waren in der oberen Schule ein paar alte Filzschuhe, woher sie kamen, wußten wir nicht; sie waren eben da und wurden zu folgendem Streich verwendet: Zuerst wurden sie leicht mit der Sohle in Farbe getaucht und damit an der Wand in die Höhe Fußspuren bis an die Decke fabriziert, dann quer über den Plafond bis zur ungefähren Mitte, allwo, in Schrittweite voneinander entfernt, die Schuhe festgenagelt wurden (natürlich mit der Sohle nach oben). Hierauf malte man sorgfältig, ganz naturalistisch, die nackten Fußspuren weiter bis an die gegenüberliegende Wand und an derselben wieder herunter.«[27]

Das Innovative der Lehre Wilhelm von Diezs bestand vor allem im direkten Naturstudium und der Vermittlung eines leuchtenden Kolorismus, der vom maltechnischen Standpunkt den Prinzipien von Wilhelm Leibls Malerei nahekam. Nach den Notizen des Diez-Schülers Ernst Zimmermann bemühte sich Diez, seine Schüler zu einer »wahren, ehrlichen Malerei« anzuleiten, »bei der in nur einer Malschicht naß in naß gearbeitet und nicht etwa nach traditioneller Manier vielschichtig übermalt werden durfte.«[28] Charakteristisch für viele Arbeiten der Diez-Schule war die Betonung des Stofflichen in den »Darstellungen von Interieurs mit feinen Lichtabstufungen«.[29] Insbesondere das intensive Studium der alten Meister Rembrandt, Frans Hals, van Dyck und Velázquez sah Diez als wichtige Grundlage seiner Malerei und Lehre an, und so kam es, daß in der Akademieklasse mit Hilfe des reichen Kostümfundus gelegentlich berühmte Bilder aus der holländischen oder spanischen Malerei nachgestellt wurden.[30]

Näheren Aufschluß über Diezs Lehrmethode gibt auch eine Atelieranekdote, die von einem seiner Schüler überliefert ist: »Diez kam und stellte das lebende Modell, nach dem gearbeitet werden sollte, ins Halblicht, er ließ noch die Vorhänge am Fenster hier und dort zuziehen, so daß nur ein schmaler Hauch von Licht das Antlitz des Modells streifte und aus ihm die wirkliche Vulgarität löschte. Das Modell schien keine armselige, proletarische Münchner Physiognomie mehr geblieben zu sein – von silbrig flutendem Licht in seinen beleuchteten Teilen zart berührt, im Schatten durch weißlich ermittelte Reflexe aufgehellt, übte das Gesicht des Modells eine Wirkung aus, als ob es aus einem Bilde der Alten Pinakothek herausschaute. Und die Schüler begeisterten sich

Diez came into our class once or twice a week and was anything but a dry teacher, always encouraging and inspiring. He was primarily our friend and always treated us as colleagues. How often we strolled with him to the lovely old beer cellars of Munich – Kochelbräu, Stubenvoll, Eberl, Sternecker and Augustinerkeller were magic words for us, and needless to say we did not sit there high and dry. Those hours full of chat were thoroughly enjoyable, for the man was a great talker. His fantasy shone through in everything he said....[25] The lively festivals organized by the Diez class enjoyed a certain fame in Munich and set the tone for such fancy dress and artists festivals as the "Waldfest" which involved the "storming of Burg Schwaneck" (1879).[26] An amusing example of the imaginative atmosphere in the Diez class has been recorded by Hermann Stockmann: "In the upper school there was a pair of old felt shoes, where they came from no one knew; they were just there and were used for the following trick: first the soles were dipped in paint and then foot prints marked all the way up the wall to the ceiling and then across it, to about the middle, where they were then nailed (with the soles to the ceiling of course) at a distance of one pace from each another. Carefully and very naturalistically, footprints of naked feet were then painted from that point on across the ceiling to the opposite wall and down same."[27]

What was innovative about Wilhelm von Diez' teaching method was above all his direct nature studies and the glowing colorism he imparted which came close, technically, to the principles behind Wilhelm Leibl's painting. According to one of his pupil's Ernst Zimmermann, Diez was interested in guiding his pupils towards a "true and honest technique of painting, whereby the work was completed in one layer only, alla prima, and could not be painted over with several layers in the traditional manner."[28] Characteristic of many of the works of the Diez school was an emphasis on texture in the "depiction of interiors with fine light gradations."[29] Above all, Diez considered an intensive study of the Old Masters, Rembrandt, Frans Hals, Van Dyck and Velázquez, to be the very basis of his painting technique and theory of art, and thus occasionally famous paintings from the Dutch or Spanish schools were imitated in his Academy class, taking advantage of the rich stores of costumes available in the various departments and the professors' studios.[30] An anecdote about his studio recorded by one of his pupils gives some insight into Diez' working method: "Diez arrived with the person who was to model for us and positioned him in a half light. He had the curtains on the windows drawn here and there so that only a mere suggestion of light fell on the model's face, extinguishing its actual vulgarity. The model no longer seemed to have a poor, proletarian Munich physiognomy – now, with its high-lighted parts caressed gently by a silvery flow of light, its shadowy parts slightly brightened by whitish reflections, the face almost seemed as if it were looking out of a painting in the Alte Pinakothek. And the students became quite enthusiastic about their work, each one convinced he was a new Wouwerman."[31]

This sensitive and intuitive approach is also inherent in the photographer Eugene's arrangements of his models, as we will learn later on from Sadakichi Hartmann's observations. Sometimes Diez' influence can even be detected in the selection of photographic motif, as for example when Eugene approaches Diez' own favorite motif in his photograph "The Horse."[32] Eugene completed his studies at the Academy in the maximum number of eight years, with an interruption of three semesters when he took leave of absence, presumably to return to New York. By today's standards, courses at the Academy were strictly regulated. There were eight to ten hours of class-work on weekdays and supplementary lectures on the history of art, architecture, perspective, and anatomy. "Supervision of activities was the responsibility of the inspector, the professors usually appeared in the upper classes twice a week to make corrections."[33]

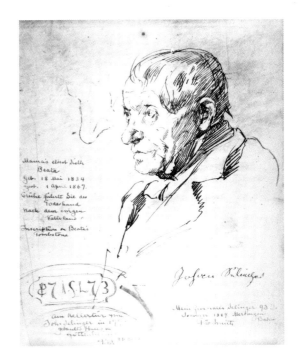

6. Johann Selinger, Merdingen 1887
Drawing, 11.2 x 9.0 cm
Fotomuseum im Münchner Stadtmuseum (93/758. 2)

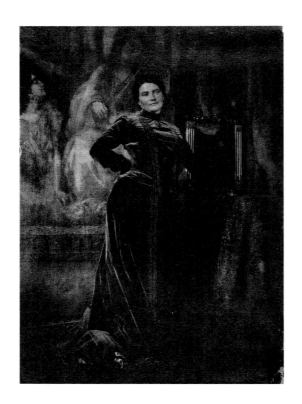

7. Portrait of a Woman, c. 1890
Platinum print on Japan tissue,
16.8 x 12.0 cm
Fotomuseum im Münchner
Stadtmuseum (88/26-33)

an ihrer Arbeit und hatten die Idee, daß sie neue Wou-
wermans würden.«[31]
Dieser feinfühlige und intuitive Zugang im Arrangement
der Modelle ist auch Eugene als Photograph zu eigen
gewesen, wie wir aus den Ausführungen von Sadakichi
Hartmann später erfahren werden. Bisweilen läßt sich
der Einfluß von Diez auch in der Wahl der photo-
graphischen Bildmotive nachvollziehen, wenn etwa
Eugene in der Aufnahme ›The Horse‹ dem Lieblingsthe-
ma von Diez nahekommt.[32]
Eugene hat die Höchststudiendauer von acht Jahren an
der Akademie mit einer Unterbrechung von drei Seme-
stern absolviert, in denen er sich beurlauben ließ und
vermutlich nach New York zurückkehrte. Der Unterricht
an der Kunstschule war nach heutigen Maßstäben
streng geregelt. Es wurde werktags zwischen acht und
zehn Stunden in den Klassen gearbeitet und es wurden
ergänzend Vorlesungen über Kunstgeschichte, Architek-
tur, Perspektive und Anatomie besucht. »Die Überwa-
chung des Betriebs oblag dem Inspektor, die Professo-
ren der oberen Klassen erschienen gewöhnlich zweimal
wöchentlich zur Korrektur.«[33]
Während seiner Studienzeit, die bis Juli 1894 dauerte,
reiste Eugene gelegentlich zu seinen Verwandten nach
Merdingen und Gottenheim in Baden, wo sein Großva-
ter Johan Selinger noch im Kreise der Verwandtschaft
aus den Familien Bärmann, Kern, Schmid und Selinger

lebte. So hielt sich Eugene im Sommer 1887 gemeinsam
mit seiner Mutter Hermine in Merdingen auf, wo auch
eine Federzeichnung von seinem 93jährigen Großvater
Johann Selinger entstand: »Während ich ihn mit Tinte
und Feder zeichnete, hat er allerlei Fliegen mit der Hand
gefangen – nun, so was gab es im Überfluss da im
Sommer 1887«.[34]
Über seine künstlerischen Aktivitäten als Maler wäh-
rend des Studiums, das er laut Diplom mit der Note
›sehr gut‹ abschloß, haben wir mit Ausnahme einiger
Photographien von Atelierwänden aus dem Nachlaß
kaum konkrete Anhaltspunkte. Zwar bescheinigte ihm
die Akademieleitung, daß seine »vortrefflichen Arbeiten
mehrmals mit Belobigungen« ausgezeichnet wurden,[35]
doch sind Ausstellungen seiner Werke in München für
seine Studienzeit nicht verbürgt. Sicherlich gehörte
Eugene nicht zu den Begabtesten der Diez-Schule wie
Wilhelm Trübner, Max Slevogt, Paul Hoecker, Gotthard
Kuehl, Fritz Mackensen, Ludwig Löfftz, Ernst Zimmer-
mann, Karl Stauffer-Bern, Bruno Piglhein, Adolf Hengeler,
Carl Becker-Gundahl, Maximilian Dasio, Gustav
Laeverenz oder Franz Marc. Doch zählte Eugene zum
festen Schülerstamm, so daß er in der anläßlich des
Todes von Diez im Jahre 1907 organisierten Gemälde-
ausstellung in der Galerie Heinemann auch mit drei
Werken vertreten war.[36]

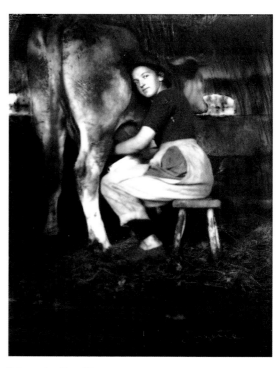

8. Farmer's wife, milking, c. 1914
Modern print from original negative, 12 x 9 cm
Fotomuseum im Münchner Stadtmuseum

During the course of his studies, which lasted until July 1894, Eugene occasionally visited his relatives from the Bärmann, Kern, Schmid and Selinger families in Merdingen and Gottenheim in Baden, where his 93-year-old grandfather Johann Selinger still lived. Thus in 1887

and Franz Marc. But he was one of Diez' regular students, as is indicated by the fact that on the occasion of Diez' death in 1907 three works of Eugene's were included in the commemorative exhibition of paintings by Diez' students in the Heinemann Gallery.[36]

9. Halali, before 1908
Modern print from original negative, 12 x 9 cm
Fotomuseum im Münchner Stadtmuseum

Eugene and his mother Hermine spent the summer together in Merdingen where he did a sketch of his grandfather: "While I was drawing him with pen and ink, he caught all sorts of flies with his hand – there were more than enough of them around that summer of 1887."[34] As for Eugene's artistic activities during his studies, which according to his diploma he completed with the assessment "very good," we have scarcely any concrete evidence, except for some photographs of his studio walls found in his personal estate. The Academy direction confirmed that his "excellent works" had been received "with great praise several times"[35] but there is no evidence of exhibitions of his works in Munich during his study period there. Eugene was certainly not one of the most gifted of the Diez school, they being Wilhelm Trübner, Max Slevogt, Paul Hoecker, Gotthard Kuehl, Fritz Mackensen, Ludwig Löfftz, Ernst Zimmermann, Karl Stauffer-Bern, Bruno Piglhein, Adolf Hengeler, Carl Becker-Gundahl, Maximilian Dasio, Gustav Laeverenz

A Career as a Portrait Painter in New York 1894–1899

The reasons for Eugene's return to New York are unclear. Despite the fact that in 1894 the American President Theodore Roosevelt had declared that "the American nation does not need 'hyphened Americans,' that is to say, German-Americans, but just plain Americans,"[37] Eugene's decision to return to New York was probably influenced by family circumstances or else by the difficult prospect of surviving in Munich as a freelance artist. Competition was enormous among the 2,000 artists living in Munich around 1890, and reference was occasionally made to an artistic proletariat for whom it was simply impossible to bridge the gap to the elite of the successful "princes among painters" Franz Lenbach, Ferdinand Wagner, Franz von Stuck and Eduard von Grützner. The graphic artist and "Simplicissimus" collaborator Hermann Schlittgen paints a depressing picture

Eine Karriere als Porträtmaler in New York 1894–1899

Die Hauptfigur des Theaterstücks Rip van Winkle ist ein zügelloser Mann, der sein Vermögen vertrunken hat und seiner Familie zur Last fällt. Als seine Frau Gretchen ihn aus dem Haus wirft, zieht er sich mit seinem Hund Schneider in eine Höhle in den Catskill Mountains zurück. Dort betrinkt er sich bis zur Bewußtlosigkeit. Nachdem er einige Jahre später wieder erwacht und in sein Haus zurückkehrt, wird er von seiner Frau nicht mehr erkannt. Gretchen, die ihn für einen Bettler hält, hat jedoch Mitleid mit ihm und schenkt ihm ein Almosen. Nachdem ihn seine Tochter wiedererkannt hat, schwört Rip van Winkle dem Alkohol ab und der Versöhnung zwischen den Eheleuten steht nichts mehr im Wege.

Die Gründe für die Rückkehr Eugenes nach New York liegen weitgehend im Dunkeln. Obgleich im Jahre 1894 der amerikanische Präsident Theodore Roosevelt erklärt hatte, »die amerikanische Nation brauche keine ›Bindestrich-Amerikaner‹, also auch keine Deutsch-Amerikaner, sondern allein Amerikaner«[37], so waren für Eugene wohl primär familiäre Gründe oder die schwierige Aufgabe, sich als freischaffender Künstler in München durchzusetzen, für die Übersiedlung nach New York ausschlaggebend gewesen. Bei mehr als 2.000 Malern, die um 1890 in München lebten, war der Konkurrenzdruck enorm, so daß bereits von einem Künstlerproletariat die Rede war, dem die Überwindung der Kluft zur Elite der erfolgreichen ›Malerfürsten‹ Franz Lenbach, Ferdinand Wagner, Franz von Stuck oder Eduard von Grützner unmöglich gemacht wurde. Eine deprimierende Schilderung dieses ›Kunstdarwinismus‹ im München des Fin-de-Siècle gibt der Zeichner und Mitarbeiter des *Simplicissimus*, Hermann Schlittgen: »Traurige Bilder einer Künstlerstadt, in der zu viele Maler zusammensitzen. Neben der glänzenden Lebensführung einiger besonders Begabter und Glücklicher und der breiten Bourgeoisie des künstlerischen Mittelstandes so viele unten, als Proletariat, von denen man nicht wußte, wovon sie lebten, sie darbten und denn hindämmerten, mit glühenden Augen hinauf sahen auf die Erfolgreichen, traurig sich an eine kleine Hoffnung anklammernd, an einen Gedanken, ein Werk, das noch entstehen und den Urheber mit einem Schlag berühmt machen würde.«[38] Daran änderte auch die Gründung der Münchner Secession nichts, die sich 1892 von der traditionellen Münchner Künstlergenossenschaft abspaltete, sich aber als Elite-Vereinigung verstand, die nur ausgewählten Mitgliedern offenstand. Viele der führenden Secessions-Mitglieder waren ehemalige Diez-Schüler wie Paul Hoecker und Bruno Piglhein oder sie stammten wie Hugo von Habermann und Benno Becker aus traditionellen Künstlergemeinschaften wie der Allotria. Eugenes Name findet sich weder unter den Gründungsmitgliedern noch unter den Ausstellern der Jahresschauen, die weniger der Artikulation eines konkreten künstlerischen Programms sondern primär dem Vertrieb der Werke an die finanzkräftige Aristokratie und das wohlhabende Bürgertum dienten.[39]

Der Erfolg, der Eugene in München verwehrt geblieben war, sollte sich bald in New York einstellen. Als ehemaliger Student der Diez-Schule, die wegen ihres ›historischen Realismus‹ in Nordamerika hoch angesehen war, verfügte Eugene über eine gute Empfehlung. Dennoch

überrascht es, daß Eugene sich in kurzer Zeit einen Namen als Maler mit Rollenporträts berühmter Theaterschauspieler, Musiker und Opernsänger sowie als Bühnendekorateur machen konnte; hatte er doch weder besondere Vorleistungen vorzuweisen noch gehörte er dem Kunst-Establishment an. Bemerkenswert ist seine Aufgeschlossenheit gegenüber den ›etablierten‹ Kreisen, aber auch sein Bemühen um Verbindung mit jener Gruppe der ›second generation Germans‹, die auf den kosmopolitischen Charakter der amerikanischen Kultur um die Jahrhundertwende maßgeblichen Einfluß nahmen.[40]

10. Sir Henry Irving as King Arthur, c. 1897/98
Oil on canvas, 12.5 x 90.0 cm
The New York Historical Society, New York

Zeugnisse dieser Entwicklung repräsentieren mehrere Gemälde Eugenes, die sich heute als Stiftungen von Eugenes jüngerem Bruder Frederick Lorenz Smith in der New York Historical Society und dem Club The Players in New York befinden. Es handelt sich um die Porträts von Emma Calvé, Joseph Jefferson, Mrs. James Brown Potter und Anton Seidl. Eugenes Rollenporträt von Sir Henry Irving als Becket stammt aus dem Besitz des bekannten Schauspielers Joseph Jefferson (1829–1905), der von 1893 bis zu seinem Tod den Players Club als Präsident leitete.

of this "art Darwinism" in fin de siècle Munich: "Sad images of an artists' city with too many artists. Besides the sparkling lifestyle of a few highly gifted and lucky ones, and the broad middle class of bourgeois artists, there were so many below that, the proletariat, about whom no one knew much, what they lived on. They went hungry and daydreamed, gazing up with eyes aglow at the successful, clinging sadly to a small hope, an idea, a work which had yet to be created but which would make its creator famous over night."[38] The foundation of the Munich Secession, which in 1892 split with the traditional Munich Artists Co-operative, did nothing to change this state of affairs as it saw itself as an elite association open only to selected members. Many of the leading Secession members were former Diez pupils, like Paul Hoecker and Bruno Piglhein, or else like Hugo von Habermann or Benno Becker they came from traditional artists groups such as "Allotria." Eugene's name is not to be found either among those of the founder-members or among the exhibitors at their annual shows, which served not so much to articulate a concrete aesthetic program as primarily to display the works for sale to the high aristocracy and the wealthy bourgeoisie.[39]

But the success denied Eugene in Munich was to come soon after his return to New York. As a former student of the Diez school, highly regarded in North America for its "historical realism," Eugene had good credentials. Yet it is still somewhat of a surprise that he succeeded in making a name for himself in such a short time painting portraits of famous theater actors, musicians and opera singers, not to mention stage sets. After all, he had no particular achievements to show, nor did he belong to the art establishment. His openness towards the "established" circles was remarkable, as were his efforts to make contact with that group of second generation Germans who exercised a decisive influence on the cosmopolitan character of American culture at the turn of the century.[40]

Several paintings by Eugene donated by his younger brother Frederick Lorenz Smith and today on show both in the New York Historical Society and New York Players Club bear witness to this development. They are portraits of Emma Calvé, Joseph Jefferson, Mrs. James Brown Potter and Anton Seidl. Eugene's portrait of Sir Henry Irving in the role of Becket was the property of the famous actor Joseph Jefferson (1829–1905) who was president of the Players Club from 1893 until his death. The elegant club house The Players on Gramercy Park in New York was an important meeting point for actors, artists and literary people. It was founded in 1889 by the American actor Edwin Booth, famous for his tragic roles, in particular his Hamlet. "The 'Players Club' is one of the most pleasant locations in New York for anyone who likes stimulating intelligent conversation or wants to rest for a few hours in exciting company from the monotony of a routine life, from which not even the artist can totally free himself. And any stranger who stays there once as a guest will think back with fondness and gratitude on that delightful community in which one can talk refreshingly and freely about art, without being constantly reminded of material interests, where one need not shy away from even merciless criticism and satire, as long as its whips are swung with elegance and humor and without the barb of personal enmity."[41] This club was richly furnished and decorated with paintings. It was frequented by famous writers such as Mark Twain, architects and artists like the book designer Charles Scribner, painters like William Merritt Chase, Edward Simmons and Childe Hassam, the photographers Alfred Stieglitz, Arnold Genthe and Paul B. Haviland, or the composer Walter Damrosch. In the 1890s this exclusively male club had about 800 members, among them wealthy business men such as the bankers J. Pierpont Morgan and Cornelius Vanderbilt and high-ranking politicians such as the American president Theodore Roosevelt.[42] One of the exceptional occasions on which women were invited to the club was, for example, Sarah Bernhardt's visit in 1911.

Thanks to his long friendship with Joseph Jefferson, Eugene came into close contact with the circles frequenting The Players. Jefferson, who came from an established actor family, was himself an ambitious amateur painter and occasionally used Eugene's studio in West 4th Street, Manhattan.[43] As an art lover he had acquired quite a collection of paintings from the Barbizon School, among them works by Corot, Troyon, Daubigny, Diaz, Dupré, Decamps, and also some works by Sir Joshua Reynolds and Sir Thomas Lawrence.[44] Eugene painted portraits of his friend in various theatrical poses. One of the first dating from 1894 was of Jefferson in his most successful role, that of the vagabond Rip van Winkle.

The theater play, which was specially adapted for Irving by Dion Boucicault, became one of the most popular in North America. After its premiere in London in 1863, Jefferson played in it again and again with triumphal success and his performance in the Olympic Theater in New York was to establish his popularity as a character actor, along with other roles such as Bob Acres in Sheridan's "The Rivals." The portrait, which was probably painted in Jefferson's summer home in "Crow's

Das elegante Klubhaus von The Players am Gramercy
Park in New York war ein wichtiger Treffpunkt für Schau-
spieler, Künstler und Literaten, der im Jahre 1888 von
dem berühmten amerikanischen Trägödien- und Hamlet-
Schauspieler Edwin Booth begründet worden war. »Der
›Players Club‹ ist einer der gemüthlichsten Aufenthaltsor-
te in New York für Jeden, der eine pikante geistreiche
Unterhaltung liebt oder sich auf einige Stunden in anre-
gender Geselligkeit von der Monotonie des Routine-
lebens, von welcher sich selbst der Künstler nicht ganz
befreien kann, auszuruhen wünscht. Und jeder Fremde,
welcher dort einst als Gast geweilt, wird mit Liebe und
Dank jener lebensfrohen Gemeinde gedenken, in welcher
man frisch und frei, ohne fortwährend an materielle In-
teressen erinnert zu werden, über Kunst reden kann, wo
man sich selbst unbarmherziger Kritik und Satire nicht
zu scheuen braucht, so lange ihre Geißel mit Eleganz
und Humor, ohne den Stachel persönlicher Feindschaft
geschwungen wird.«[41] Im reich möblierten und mit Ge-
mälden dekorierten Club verkehrten so bekannte Schrift-
steller wie Mark Twain, Architekten und Künstler wie der
Buchgestalter Charles Scribner, die Maler William Merritt
Chase, Edward Simmons und Childe Hassam, die Photo-
graphen Alfred Stieglitz, Arnold Genthe und Paul B.
Haviland oder der Komponist Walter Damrosch. Zu den
circa 800 Mitgliedern des Clubs, dessen Zutritt nur Män-
nern vorbehalten blieb und der nur in Ausnahmen wie
anläßlich des Besuches von Sarah Bernhardt 1911 eine Frau
einlud, gehörten in den 1890er Jahren aber auch wohlha-
bende Geschäftsleute wie die Bankiers J. Pierpont Morgan
und Cornelius Vanderbilt und hochrangige Politiker wie
der amerikanische Präsident Theodore Roosevelt.[42]
Dank der langjährigen Freundschaft mit Joseph Jefferson
kam Eugene mit den elitären Kreisen von The Players in
nähere Verbindung. Jefferson, der aus einer alten
Schauspielerfamilie stammte, war selber ein ambitionier-
ter Amateurmaler, der gelegentlich Eugenes Atelier in
West 4th Street in Manhattan benutzte.[43] Als Kunstlieb-
haber hatte der Schauspieler eine respektable Sammlung
von Gemälden aus der Schule von Barbizon erworben,
darunter Arbeiten von Corot, Troyon, Daubigny, Diaz,
Dupré, Decamps sowie Werke von Sir Joshua Reynolds
und Sir Thomas Lawrence.[44] Eugene porträtierte seinen
Freund in verschiedenen Schauspielerposen. Am Anfang
stand wohl das 1894 entstandene Bildnis Jeffersons in
seiner bedeutendsten und bekanntesten Bühnenrolle des
Vagabunden Rip van Winkle.
Das Theaterstück, das in einer speziellen Version von
Boucicault für Irving existierte, entwickelte sich zu ei-
nem der populärsten Stücke in Nordamerika. Nach der
Uraufführung in London 1863 hatte Jefferson dieses

11. Joseph Jefferson as Rip van Winkle, 1894
Oil on canvas, 120.6 x 85.0 cm
The New York Historical Society, New York

Stück immer wieder mit triumphalem Erfolg gespielt und
es sollte nach seiner Präsentation im Olympic Theatre in
New York die Popularität Jeffersons als Charakterdarstel-
ler neben anderen Rollen wie Bob Acres in Sheridans
›The Rivals‹ begründen. Das Gemälde, das vermutlich in
Jeffersons Sommerhaus ›Crow's Nest‹ (Krähennest) in
Buzzard's Bay in Massachusetts entstanden war, erfaßte
den gealterten Schauspieler in der Rolle des jungen Rip
van Winkle, der seine Tochter auf dem Rücken trägt und
damit ikonographische Assoziationen an die Legende
des heiligen Christophorus weckt. Bezeichnenderweise
hatte Smith dieses Gemälde mit seinem Künstlernamen
›Frank Eugene‹ signiert, mit dem er auch seine Photogra-
phien im Negativ kennzeichnete.
Ein weiteres Rollenporträt von Jefferson zeigt den Schau-
spieler in der Rolle des Caleb Plummer, das im Sommer
1898 in einer Ausstellung der Knoedler's Gallery in New
York neben dem Porträt Anton Seidls mit großem Erfolg
gezeigt wurde.[45] Jefferson war von dem Bildnis so begei-
stert, daß er es sofort erwarb. Eugene schilderte die Ent-
stehung des Porträts: »Was für eine Freude es war, Mr.
Jefferson zu malen! Die ganze Zeit über interessierte er
sich für die Arbeit, war fröhlich und bester Laune! Er
posiert nicht wie andere, er kann einfach nicht lange

Nest" in Buzzard's Bay, Massachusetts, shows the aging actor in the role of the young Rip van Winkle carrying his daughter on his back, thus awakening associations with the legend of Saint Christopher. Interestingly enough, Eugene signed this painting with his artist's name "Frank Eugene." Another portrait of Jefferson shows the actor in the role of Caleb Plummer and was exhibited with great success in summer 1898 in the Knoedler Gallery in New York beside the portrait of Anton Seidl.[45] Jefferson was so taken by the portrait that he bought it. Eugene describes the genesis of the portrait: "It was a delight to paint Mr. Jefferson. He was so interested all the time in the work, and so full of gaiety and good humor! He does not pose as anyone else does; he cannot keep still long enough. He would sit down, assume the attitude I wanted, and hold it for a few moments, asking me with great precision whether his head and hands were just right, etc. Then, suddenly, he would jump up and disarrange everything by running over to where he could see the canvas. 'How is it getting on, Eugene? Ah, yes; that's good, very good,' and he would be back again in his chair. It was somewhat like painting a child, for I had to be quick at catching pose and expression, and constantly alert as he changed his position and talked."[46] Another portrait in the exhibition showed Jefferson as the aged Rip van Winkle with long white hair and a tattered appearance, a reference to a concrete situation in the play: "He has just awakened from his long sleep and, with faltering step and intent expression betrays his bewilderment."[47] As confirmed by a notice in *The Critic*, a monthly journal for literature, art and life which reproduced the portraits of Jefferson and Anton Seidl, Eugene was not unknown in New York at that time. He was in close contact with the American painters Robert Loftin Newman (1827–1912)[48] and Albert Pinkham Ryder (1847–1919),[49] whose works he greatly admired.[50] In March 1897 Eugene showed a selection of twenty-two paintings in the Blakeslee Galleries. In this exhibition too, portraits of Joseph Jefferson were of central importance, in the roles of Rip van Winkle and Bob Acres (duel scene in "The Rivals"). The other works were portraits of Sir Henry Irving as King Arthur, Emma Calvé as Carmen, Miss Connie Jackson as Tilly Slowboy in the play "Cricket on the Hearth," and Mrs. Potter as Charlotte Corday. The show also included several paintings with Christian motifs, "Flight to Egypt," "Christ," and "St. George," with mythological motifs, "Leda and her children" and "Leda and Cupid," plus a few history and still-life paintings.[51] Joseph Jefferson also bought Eugene's portrait painting of Sir Henry Irving in the role of Becket. Henry (Brodribb)

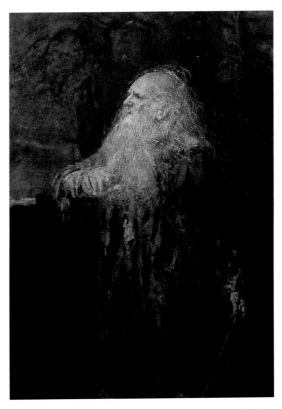

12. Joseph Jefferson as
Rip van Winkle, c. 1894
Oil on canvas, 135.0 x 92.5 cm
The New York Historical Society,
New York

Irving (1838–1905) was certainly the best known English actor in the second half of the 19th century and the first actor to be knighted by Queen Victoria in 1895. In 1883 he began a series of extended tours of the United States where he was also known to a wide public.
A further portrait dated 1895 shows the actress Cora Urquhart, better known as Mrs. James Brown Potter (1859–1936), who was married to a New York banker from 1877 to 1900. After initial amateur performances, Cora Potter made her professional debut in 1887 in London's Haymarket Theater. She returned to New York in the same year and advanced to international fame with stage engagements in London and New York. Eugene painted her in the role of Charlotte Corday from the play of the same name.[52]
Other portrait paintings are of members of the New York Metropolitan Opera to which Eugene had presumably got an introduction through his brother Frederick ("Fredy") who was a violinist in the New York Philharmonic Orchestra. Just as American music between 1870 and 1920 was influenced by German immigrants,[53] so too the New York Philharmonic Orchestra of 1892 was made up almost exclusively of German-born musicians. It was conducted by Leopold Damrosch and Anton Seidl who performed works by mainly German composers such as Wagner, Beethoven, Bach, Liszt, Brahms

»Der Malerphotograph Frank Eugen Smith (...) zeigte mir, als ich noch ein junger Mann war und dementsprechend lernbegierig, eine Serie von kleinen Ölskizzen, die er während einer Italienreise in Assisi nach Freskogemälden berühmter Meister gemacht hatte. Dabei fiel mir auf, daß er die Farben oft ganz anders auf seiner Skizze hatte, als sie im Original waren. Auf meine Frage, daß z.B. der Hintergrund bei einer Madonna, von dem ich wußte, daß er im Original blau war, auf seiner Skizze doch grün sei, behauptete er, daß von dem Standpunkt aus, von dem er seine Skizze gemacht hatte, der Hintergrund ihm so erschienen sei, wie er ihn gemalt habe. Und diese Veränderungen waren auf all seinen Skizzen vorhanden, sie waren sehr schön

stillsitzen. Er setzte sich hin, nahm die von mir gewünschte Pose ein, hielt sie für einige Minuten und fragte mich immer wieder, ob sein Kopf, seine Hände so richtig wären, etc. Dann sprang er plötzlich auf und brachte alles durcheinander, indem er wegrannte, um auf die Leinwand zu schauen. ›Wie geht es voran, Eugene? Ach ja, das ist gut, sehr gut‹, dann ging er zurück zu seinem Stuhl. Es war, als wenn ich ein Kind porträtierte, denn ich mußte Pose und Ausdruck schnell aufnehmen und immer auf der Hut sein, weil er seine Position dauernd änderte und die ganze Zeit über redete.«[46] Ein anderes Rollenporträt in der Ausstellung bei Knoedler's Gallery das auf eine konkrete Situation im Theaterstück verweist zeigte Jefferson als gealterten Rip van Winkle mit langem weißen Haar und abgerissenen Kleidern: »Er war soeben aus tiefem Schlaf erwacht, mit unsicherem Gang und starre Miene, die seine Verwirrung offenbarte.«[47] Wie eine Notiz in dem Monatsjournal für Literatur, Kunst und Leben, *The Critic*, bezeugt, wo die Porträts von Jefferson und Anton Seidl veröffentlicht wurden, war Eugene zu diesem Zeitpunkt bereits kein unbekannter Maler mehr in New York. Er stand mit den amerikanischen Malerkollegen Robert Loftin Newman (1827–1912)[48] und Albert Pinkham Ryder (1847–1919)[49] in näherer Verbindung, deren Arbeiten er sehr schätzte.[50] Bereits im März 1897 hatte Eugene in den Blakeslee Galleries in New York eine Auswahl von 22 Gemälden zeigen können. Auch in dieser Ausstellung kam dem

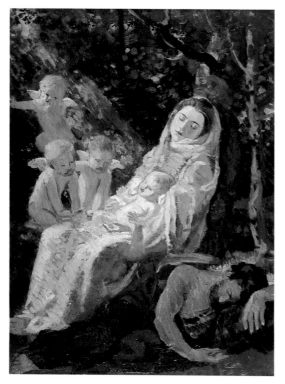

14. Ruhe auf der Flucht, c. 1905
Oil on canvas, 30 x 45 cm
Rosel Kurz, München

13. Maria mit Jesuskind und Johannes, c. 1905
Oil on canvas, 35 x 50 cm
Rosel Kurz, München

Modell Joseph Jefferson mit vier Rollenporträts als Rip van Winkle und als Bob Acres (Duell-Szene von ›The Rivals‹) zentrale Bedeutung zu. Die anderen Werke stellten Schauspieler- und Sängerporträts von Sir Henry Irving als König Arthur, Emma Calvé als Carmen, Miss Connie Jackson als Tilly Slowboy in dem Stück ›Cricket on the Hearth‹ sowie Mrs. Potter als Charlotte Corday dar. Außerdem waren mehrere Gemälde christlicher Ikonographie wie ›Flucht nach Ägypten‹, ›Christus‹, ›St. George‹ nebst mythologischen Szenen wie ›Leda und ihre Kinder‹, ›Leda und Cupido‹ sowie wenige Historienbildern und Stilleben zu sehen.[51] Joseph Jefferson hatte ebenfalls Eugenes Porträtgemälde von Sir Henry Irving erworben, das den Schauspieler in der Rolle des Becket darstellte. Henry Irving (1838–1905) war der wohl bekannteste englische Mime in der zweiten Hälfte des 19. Jahrhunderts, der 1895 als erster Schauspieler von der englischen Königin Victoria zum Ritter geschlagen wurde. Ab 1883 unternahm er wiederholt ausgedehnte Tourneen durch die USA, wo er dann einem größeren Publikum bekannt wurde. Ein weiteres Rollenporträt Eugenes aus dem Jahre 1895 stellt die Schauspielerin Cora Urquhart dar, besser bekannt als Mrs. James Brown Potter (1859–1936), die mit

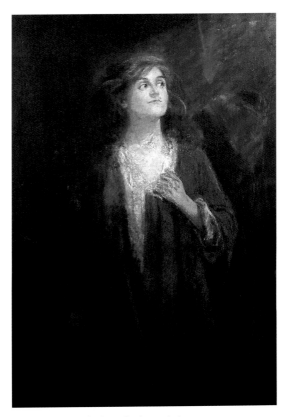

15. Cora Potter as Charlotte Corday, c. 1898
Oil on canvas, 151.0 x 100.0 cm
The New York Historical Society,
New York

a detailed account of the genesis of the pose in Eugene's Seidl-portrait: "The picture of Seidl, which Mrs. Seidl says is the only one ever painted of her husband from life, represents him standing in front of his score, turned half round toward the left, so that he can look over the audience. His right arm rests upon the music rack, and in his hand he holds his baton, which, however, for the moment hangs idly from between his fingers. The expression on his face is firm – almost severe – and is that of a man under a considerable nervous strain. He is waiting for perfect quiet before giving the signal to the orchestra to begin. The idea of this attitude was suggested to Mr. Eugene, the artist, one evening in Carnegie Hall. In speaking of it he says: 'Mr. Seidl was conducting at a concert, and the particular number in which the incident occurred was a Beethoven symphony in which there was a short pause. Just at the end of this, when the next movement was about to begin, there was a great deal of noise in the hall. Several chairs banged in the rear of the room, and Mr. Seidl, baton in hand, turned partly, resting his arm on the rack, and looked over the audience, showing plainly by the action and the expression on his face that he could not go on until

and Haydn. One of Eugene's portrait paintings shows the internationally famous Spanish opera singer Emma Calvé (1858–1942)[54] who had given impressive performances at Milan's Scala and London's Royal Opera. "Her secure technique, her strong chest voice and light higher registers, her richness of vocal color and dramatic nuance, made Calvé one of the great opera personalities of her time."[55] Eugene painted her between 1895 and 1900 in her most famous role, Carmen, from the opera of the same name by George Bizet. She had appeared in this role in Moscow, St. Petersburg, London, Madrid, Milan, Vienna and Berlin: "In this three-quarter-length portrait she is shown in her colorful operatic costume and in a saucy and provocative attitude. The style of painting is loose and impressionistic, but also rather labored in places."[56]

A further portrait painted in the year 1896 shows the composer Anton Seidl (1850–1898). Seidl was born in Pest and was an assistant to Richard Wagner before becoming conductor of German operas at the Metropolitan Opera in New York in 1885. In 1891 Seidl became leader of the Philharmonic Society. *The Critic* provides

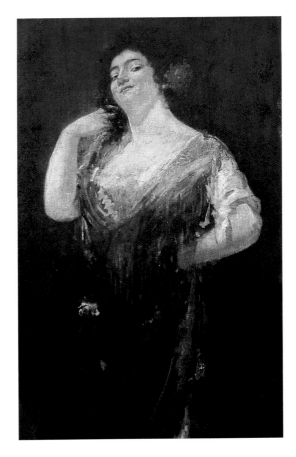

16. Emma Calvé as Carmen,
c. 1897
Oil on canvas, 115.0 x 77.5 cm
The New York Historical Society,
New York

einem New Yorker Banker verheiratet war. Cora Potter hatte nach anfänglichen Amateur-Auftritten ihr professionelles Debüt 1887 im Londoner Haymarket Theatre gehabt. Nach ihrer Rückkehr nach New York im selben Jahr sollte sie mit Bühnenengagements in London und New York zu einer der international bekanntesten Schauspielerinnen avancieren. Eugene malte sie als Charlotte Corday im gleichnamigen Stück.[52]

Andere Porträtgemälde stammen von Mitgliedern der New Yorker Metropolitan Opera, wo Eugene vermutlich durch seinen Bruder Frederick (›Fredy‹), der als Violinist im New York Philharmonic Orchestra spielte, eingeführt wurde. Wie die amerikanische Musik zwischen 1870 und 1920 von deutschen Immigranten wesentlich mitgeprägt wurde,[53] so bestand auch das New Yorker Philharmonic Orchestra 1892 nahezu ausschließlich aus deutschgebürtigen Musikern. Das Orchester wurde geleitet von Dirigenten wie Leopold Damrosch und Anton Seidl, die vornehmlich deutsche Komponisten, Wagner, Beethoven, Bach, Liszt, Brahms und Haydn, aufführten. Eines dieser Musikerporträts stellt die spanische Opernsängerin Emma Calvé (1858–1942) dar,[54] die als international berühmte Sopranistin an der Mailänder Scala und an der Royal Opera in London beeindruckende Auftritte hatte. »Ihre sichere Technik, die kräftige Bruststimme und leichte Höhe, der Reichtum ihrer Farben und dramatischen Nuancen machte die Calvé zu einer der grossen Persönlichkeiten der Oper ihrer Zeit.«[55] Eugene porträtierte sie zwischen 1895 und 1900 in ihrer bekanntesten Rolle, der Carmen in der gleichnamigen Oper von George Bizet, in der sie in Moskau, Petersburg, London, Madrid, Mailand, Wien und Berlin aufgetreten war: »Dieses Dreiviertel-Porträt zeigt sie in ihrem farbenprächtigen Opernkostüm und in einer kessen, provokativen Pose. Der Malstil ist locker und impressionistisch, aber an manchen Stellen auch konkret.«[56]

Ein weiteres Porträtgemälde aus dem Jahre 1896 zeigt den in Pest geborenen Komponisten Anton Seidl (1850–1898), der als ehemaliger Assistent von Richard Wagner ab 1885 als Dirigent deutscher Opern an der Metropolitan Opera in New York wirkte und ab 1895 das Philharmonic Orchestra leitete. Über den Entstehungsprozeß des Gemäldes gibt ein Bericht in *The Critic* ausführlich Auskunft: »»Das Porträt von Herrn Seidl, welches, wie Frau Seidl sagt, das einzige ist, zu dem ihr Mann Modell gesessen hat, zeigt ihn vor seiner Partitur stehend, halb nach links gewendet und über die Zuschauer hinweg schauend. Sein rechter Arm ruht auf dem Notenpult, in der Hand hält er den Taktstock, der jedoch nur untätig zwischen den Fingern baumelt. Sein Gesichtsausdruck ist ernst – fast streng. Es ist der Ausdruck eines Mannes,

der unter beträchtlicher nervlicher Anspannung steht. Er wartet, bis absolute Ruhe herrscht, bevor er dem Orchester den Einsatz gibt. Die Idee für diese Pose kam dem Maler, Mr. Eugene, eines Abends in der Carnegie Hall.

Er selbst beschreibt die Situation so: ›Herr Seidl dirigierte ein Konzert. Nach einer kurzen Pause zwischen zwei Sätzen einer Beethoven Symphonie gab es viel Lärm im Saal. Einige Stühle wurden lautstark hin- und hergerückt. Herr Seidl, den Taktstock in der Hand, drehte sich ein wenig um, seinen Arm auf das Pult gestützt, und schaute die Zuschauer an, wobei seine Bewegung und sein Gesichtsausdruck klar zeigten, daß er nicht weitermachen konnte, bis wieder Ruhe im Saal war. Sein ausdrucksstarker Blick beeindruckte mich sehr. Obwohl ich schon ein Porträt von ihm auf einem Stuhl sitzend angefangen hatte, ließ ich sofort davon ab und wählte diese Pose. Ich machte noch vor Ort eine grobe Bleistiftskizze, um den Eindruck festzuhalten und brachte danach Herrn Seidl dazu, so für mich zu posieren. Er saß nur ein paar mal für mich und auch dann nur kurze Zeit, denn er war sehr beschäftigt. Vor ungefähr einem Jahr, kurz bevor er nach Bayreuth ging, wurde das Bild fertig.‹ Auf dem Porträt erkennt man auf Herrn Seidls Gesicht einige Altersfalten, die in den sorgfältig retuschierten Photographien, die es sonst von ihm gibt, nicht zu sehen sind. Es zeigt also ein realistischeres Bild von ihm in seinen letzten Jahren als die meisten anderen Darstellungen, die von ihm in Umlauf sind.«[57]

Malerei und Photographie im Dialog: »Painter-Photographer«

Mit großer Wahrscheinlichkeit hat Eugene für die szenischen Schauspieler- und Musikerporträts gelegentlich die Photographie als Hilfsmittel benutzt. Dafür spricht, daß in seiner ersten Einzelausstellung als Photograph im Camera Club auch Bildnisse von Henry Irving, Kyrle Bellew, Joseph Jefferson, Emma Calvé und Cora Urquhart-Potter präsentiert waren. Einige dieser Photographien könnten als Vorstudien entstanden sein, um das wechselvolle Mimenspiel besser zu erfassen und in eine ›beruhigte‹ Komposition zu übertragen. Zu diesem Zeitpunkt war Eugene bereits mit den technischen Anforderungen des Mediums wohl vertraut, denn er photographierte seit seinem Aufenthalt in München in den 1880er Jahren.[58] Da es keine Hinweise dafür gibt, daß Eugene Unterricht oder eine Ausbildung erhalten hatte, wird er sich die Phototechnik autodidaktisch angeeignet haben. Damit befindet er sich in einer Traditionslinie, die im 19. Jahrhundert so illustre Namen wie Thomas

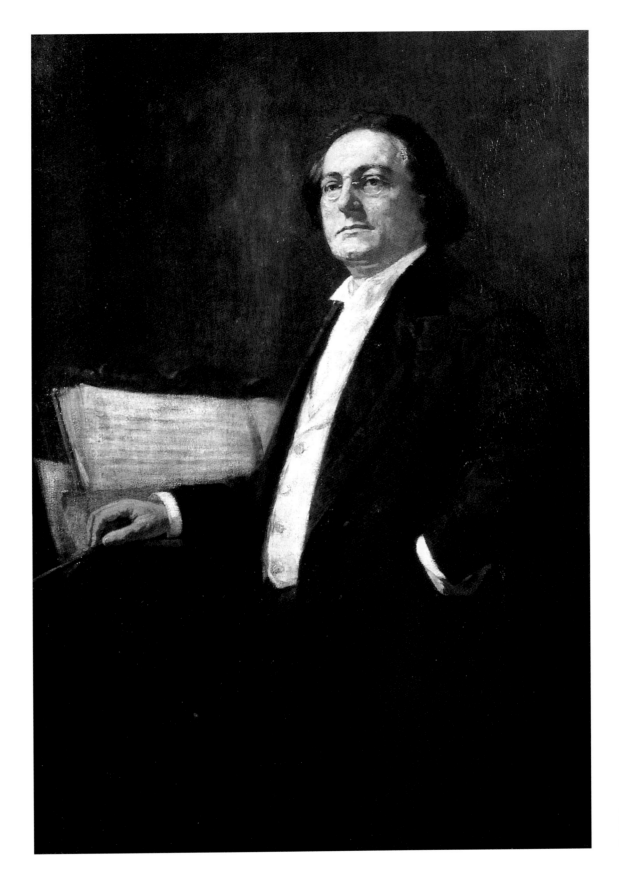

17. Anton Seidl, 1896
Oil on canvas, 125.0 x 85.6 cm
The New York Historical Society,
New York

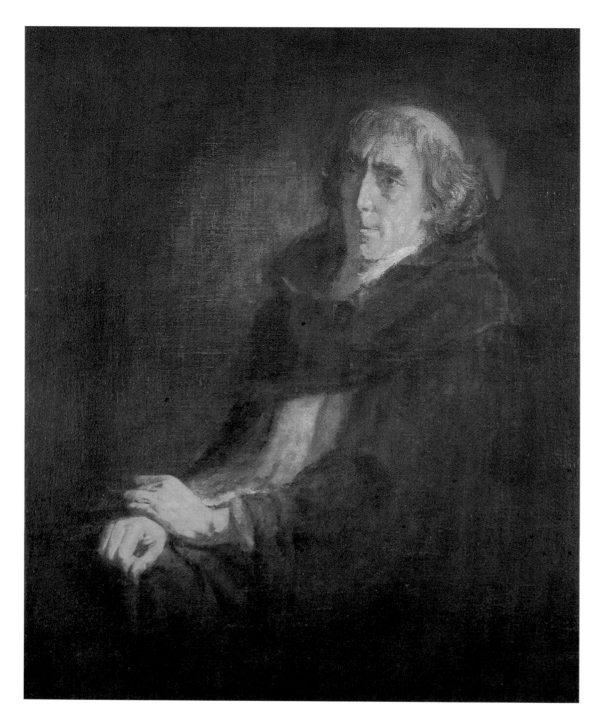

18. Sir Henry Irving as Becket,
c. 1895
Oil on canvas
The Hampden-Booth Theatre
Collection, New York

the hall was quiet. The commanding eloquence of his look impressed me greatly, and, although I had already started a portrait of him seated in a chair, I at once decided to drop it and take this attitude. I made a rough pencil sketch then and there to impress it on my mind, and afterward got Mr. Seidl to pose that way for me. He did not give me many sittings, and those few were short ones, for he was busy. It was about a year ago just before he went to Bayreuth, that the picture was finished.' Mr. Seidl's face in the portrait shows certain lines of age which are not generally to be observed in the carefully retouched photographs of him commonly seen. It is therefore a more realistic likeness of him as he appeared in late years than most of the pictures shown."[57]

"Photo-Etching" –
"Unphotographic Photography" –
Frank Eugene's First Exhibitions and Publications

It is more than probable that Frank Eugene occasionally used photographs as supports when painting his portraits of actors. The photographs of Henry Irving, Kyrle Bellew, Joseph Jefferson, Emma Calvé and Cora Urquhart-Potter in his first exhibition as a photographer in the Camera Club would seem to speak in favor of this assumption. Some of these photographs could have been taken as preliminary studies, in order to catch the changing facial expression better and transfer it into a "settled" composition. At this point in time, Eugene was already very familiar with the technical requirements of photography, for he had been taking photographs since his first stay in Munich in the 1880s.[58] As there is no indication that Eugene ever took lessons or had any formal training, he obviously taught himself the techniques of photography. In this he was following a tradition which in the 19th century includes such illustrious names as Thomas Eakins, Pierre Bonnard and Edgar Degas.

In Munich it was common knowledge that above all the painters Franz von Lenbach, Friedrich August von Kaulbach and Franz von Stuck frequently used photographs as preliminary studies and as "canned images" for drawings or paintings.[59] But in the last quarter of the 19th century photography had become an indispensable tool even among the lesser known painters in Munich. We know, for example, that the painter Gabriel von Max used a photographic model for his painting "A Vision" (1889). Members of the Secession such as Leo Putz, Karl Raupp, Paul Hoecker and Hugo von Habermann resorted again and again to photographs as models for their paintings. The proximity of photographs to nature

and reality inspired Habermann, for example, to use photographic models for his most famous painting "Sorgenkind," dated 1886, which depicts the agonizing medical examination of a frail young boy for tuberculosis and his worried mother. Critics were outraged by the authenticity and the sadness of the theme, rejecting this expression of social reality and existential anxiety.[60] Paul Hoecker (1854–1910), former Diez pupil and professor at the Munich Academy of Arts from 1891, was well known for his predilection for photography and even published his photographs of Pierrot motifs in specialist journals.[61]

On the occasion of the annual exhibition of the Munich Artists Co-operative in the Crystal Palace in 1889, the magazine *Die Kunst für Alle* published a remarkable

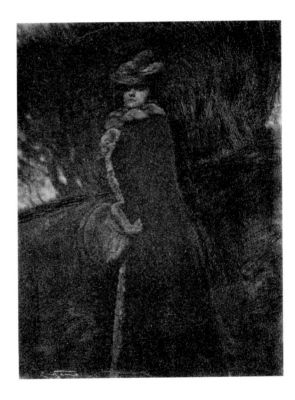

19. Woman with Muff, 1898
Platinum print, 17.6 x 12.6 cm
Metropolitan Museum of Art,
Alfred Stieglitz Collection, 1933
(33.43.95)

article, "Photographie in der modernen Kunst," by Karl Raupp, professor of art and painter of "Chiemsee." Raupp had been giving a nature classes at the Munich Academy since 1886 and Eugene had been a pupil of his. In his article, Raupp makes a distinction between photographic art reproduction, which allowed the artist a mass distribution of his own works and the close study of others, and the active use of the medium, which he calls a "reliable corrective of our vision of nature."[62] "Photography complements and extends the wide range of art study aids; in the most instructive way possible

Eakins, Pierre Bonnard oder Edgar Degas aufweist. In München waren es vor allem die Maler Franz von Lenbach, Friedrich August von Kaulbach und Franz von Stuck, bei denen eine intensive Nutzung von Photographien als skizzenhafte Vorstudie und als »Bildkonserve« für Zeichnungen oder Gemälde festgestellt wurde.[59] Doch auch unter den weniger bekannten Münchner Malerkollegen war die Verwendung von Photographien im letzten Viertel des 19. Jahrhunderts häufig zum unentbehrlichen Werkzeug geworden. Von dem Maler Gabriel von Max weiß man, daß er für das Gemälde ›Eine Vision‹ (1889) eine photographische Vorlage verwendete. Mitglieder der Secession wie Leo Putz, Karl Raupp, Paul Hoecker oder Hugo von Habermann haben immer wieder auf die Photographie als Bildvorlage zurückgegriffen. Die Natur- und Wirklichkeitsnähe hatte beispielsweise Habermann dazu inspiriert, für sein 1886 entstandenes und bekanntestes Gemälde ›Sorgenkind‹ (Konsultation), das die peinigende medizinische Untersuchung eines schmächtigen Jungen auf Tuberkulose im Beisein seiner sorgenvollen Mutter darstellt, photographische Vorlagen zu verwenden. Kritiker empörten sich über die realistische Darstellung und über das Thema als Ausdruck trister sozialer Wirklichkeit und existentieller Ängste.[60] Paul Hoecker (1854–1910), ehemaliger Diez-Schüler und seit 1891 Professor an der Münchner Kunstakademie, war für seine Photographie-Vorliebe stadtbekannt und hatte seine Aufnahmen von Pierrot-Motiven sogar in der Fachpresse veröffentlicht.[61] Über die »Photographie in der modernen Kunst« erschien anläßlich der Jahresausstellung der Münchner Künstlergenossenschaft im Glaspalast 1889 in der Zeitschrift Die Kunst für Alle eine bemerkenswerte Studie des ›Chiemsee-Malers‹ Karl Raupp, der als Professor der Münchner Kunstakademie seit 1886 eine Naturklasse leitete, die auch Eugene besuchte. Raupp unterschied zwischen der photographischen Kunstreproduktion, die dem Künstler die massenhafte Verbreitung seiner Werke und das Studium anderer erlaubte, und dem aktiven Umgang mit dem Medium als »untrügliche(s) Korrektiv der Naturanschauung«.[62] »Den weiten Kreis der malerischen Studien und Hilfsmittel ergänzt und vermehrt die Photographie; für den Maler in lehrreichster Weise gibt der Apparat das Bild der ziehenden Wolken, das bewegte Meer, Wald und Feld, Mensch und Tier, ganzes und einzelnes, dem Künstlerauge tausend köstliche Winke bietend. Jene Studien, welche der Handel bot und dem Künstler als unentbehrlich und nützlich sich erwiesen, drängten diesem von selbst den photographischen Apparat auf. Für den eigenen intimen Gebrauch photographische Naturaufnahmen herzustellen,

nicht mehr auf das jedem gebotene angewiesen zu sein, war zu einleuchtend und praktisch offenbar, als daß die selbstthätige Ausübung in den Kreisen der Künstler nicht massenhaft Eingang gefunden hätte.« Der technische Fortschritt wie die Verkürzung der Belichtungszeiten, die bessere Handhabbarkeit der Kameras und vor allem die fabrikmäßige Herstellung der Gelatine-Trockenplatte boten die Voraussetzung für eigene photographische Experimente. »Der Apparat gehört nunmehr zum notwendigen Atelierinventar, neben dem Malschirm steht jetzt im Freien die Camera, und wenn der Künstler früher nur unter dem Schirm fleißig gewesen, so steckt er jetzt ebenso oft den Kopf unter das schwarze Tuch, um ›einzustellen‹. Und in hundert Fällen betritt man des modernen Malers Atelier – der Inhaber ist in der Dunkelkammer, dumpf nur klingt sein Gruß und die Bitte um Geduld daraus hervor. Bereits sind die Künstler, denen noch der photographische Apparat fremd geblieben, in der Minderheit. Dagegen ist er, und besonders bei vielen der jüngern, darunter schon häufig genannte Namen, gleichsam zur rechten Hand geworden, mit seiner Hilfe setzt sich das Kunstwerk in allen seinen Teilen zusammen. Der Apparat hilft den Entwurf des Bildes vorzubereiten, leitet und stützt die Vollendung in allen ihren Phasen.«[63] Man mag manche Argumente dieses Beitrages für feuilletonistische Übertreibungen halten. Tatsache bleibt jedoch, daß dieser Aufsatz das Ausmaß der tiefgreifenden Durchdringung der Photographie im Arbeitsalltag des Künstlers Ende des 19. Jahrhunderts sichtbar machte.

Acht Jahre später erschien in dem selben Kunstjournal ein weiterer Artikel über die Nutzung der »Photographie für Maler« von Julius Raphaels. Obwohl er den Gebrauch billigte, kritisiert Raphaels die allzu frühe Verwendung von Photographien bei ungeübten Malern oder Zeichnern, weshalb nur ausgebildete Maler darauf zurückgreifen dürften. Raphaels nennt Lenbach, Menzel und Liebermann als positive Vorbilder für das Zeichnen nach Momentaufnahmen. Für Porträtgemälde empfiehlt er technisch unvollkommene Photographien herzustellen, um eine naturalistische Porträtähnlichkeit zu vermeiden.[64]

Sicherlich werden die genannten Beispiele Eugene ermutigt haben, während seiner Studienzeit bei Raupp, Herterich und Diez die Photographie zur Schärfung der Beobachtungsgabe einzusetzen. Wie aus den erhaltenen Dokumenten im Nachlaß hervorgeht, hat er seine Gemälde und Zeichnungen auch photographisch reproduziert. Ein weiterer Arbeitsschritt, der auf die eigentliche bildnerische Methode Eugenes als Photograph verweist, dürfte die Bemalung bzw. Überzeichnung der

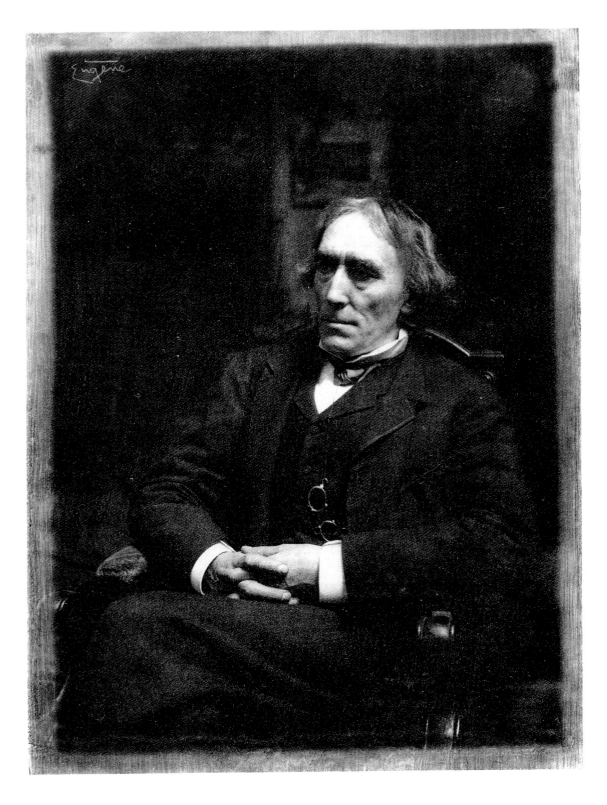

20. Sir Henry Irving, 1898
Photogravure, 17.5 x 12.5 cm
Fotomuseum im Münchner
Stadtmuseum (88/26-3)

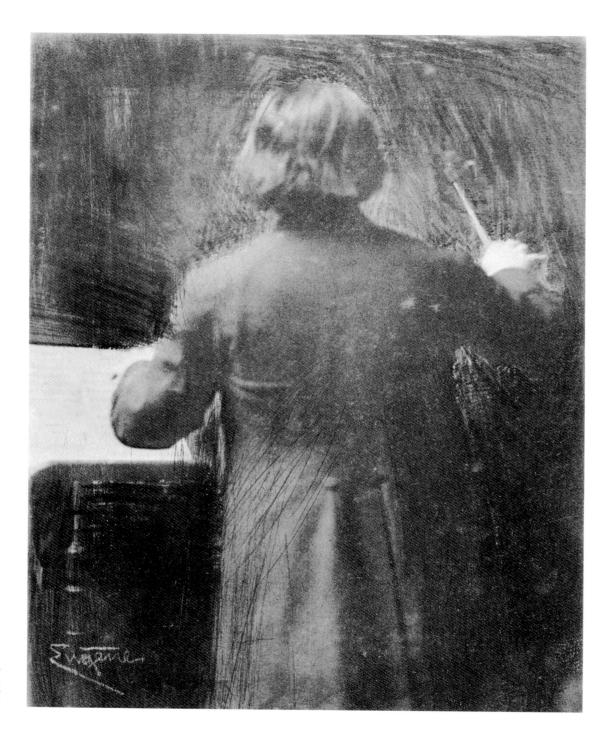

21. Anton Seidl, c. 1897
Platinum print, 11.8 x 9.0 cm
Fotomuseum im Münchner
Stadtmuseum (88/27-20)

the apparatus provides the painter with images of the clouds, the moving sea, the forest and the field, man and beast, all together or singularly, offering the artistic eye a thousand delightful hints. It was those studies on offer commercially, and which had proved to be indispensable and beneficial to the artist, which forced the photographic apparatus on him. To produce nature photographs for one's own private use, to no longer be dependent on what was on offer generally, this was too obviously plausible and practical for it not to become a wide-spread practice in art circles." Technical advances such as shorter exposure time, cameras which were easier to handle, and above all the industrial production of gelatin dry plates were the prerequisites for independent experiments with photography. "The apparatus is now a necessary part of a studio inventory; outdoors, beside the painting umbrella now stands the camera, and whereas formerly the artist used only to be busy under the umbrella, now he just as often puts his head under the black cloth in order to 'make adjustments.' And as often as not, when you enter the studio of a modern painter, the owner is in the dark-room and from there sounds his muffled greeting and the request for your patience. Artists unfamiliar with the photographic apparatus are already in a minority. On the contrary, it has become a right-hand-man, especially for many of the younger ones, some of whom are already being much talked about. With its aid, the work of art is constituted in all its parts, the apparatus helping to prepare a draft of the painting, guiding and supporting its completion through all its various phases."[63] Many of the formulations in this article may be felt to be journalistic exaggeration, but they certainly illustrate the extent to which photography had penetrated the everyday life of the artist.

Eight years later, the same art journal published another article on the use of "Photography for Painters" by Julius Raphael. Although he was generally in favor, Raphael criticized its all too early use by inexperienced painters and graphic artists, for which reason he argued that only trained painters should resort to it. Raphael mentions Lenbach, Menzel and Liebermann as positive models of how to sketch from snapshots. For portrait paintings he recommended taking technically imperfect photographs so as to avoid an all too naturalistic similarity in the portrait.[64]

No doubt the above mentioned examples encouraged Eugene to use photography so as to sharpen his powers of observation during his study years under Raupp, Herterich and Diez. As proved by the works preserved in his personal estate, he also took photographs of his paintings and drawings. A further step, and one which constitutes Eugene's specific working method as a photographer, was surely the moment when he first painted and/or drew over the reproductions. It was possibly from this more playful treatment of photographs that this stronger interest in the medium grew.

Eugene was to achieve his sudden breakthrough as an art photographer with his first, highly-praised solo exhibition of photographs in the New York Camera Club from November 15–30, 1899. The Camera Club, founded in 1896 as an amalgamation of the Society of Amateur Photographers and the New York Camera Club, became one of the most important forums for American pictorialism, especially after April 1897 and under its vice-president Alfred Stieglitz. Between 1898 and 1903 the club's premises were used for exhibitions by Fred Holland Day, Zaida Ben-Yusuf and Francis Benjamin Johnston, Gertrude Käsebier, Alfred Stieglitz, Clarence H. White, Eva L. Watson, Rudolph Eickemeyer Jr., Joseph T. Keiley, Alvin Langdon Coburn and Frank Eugene. A similarly high standard was aimed at by the association's journal Camera Notes, edited by Stieglitz, which between July 1897 and 1902 not only reported extensively on the national and international exhibitions of art photography but, with the aid of photogravures as illustrations, also provided a qualitatively high publicity forum for the art photographs themselves. Frank Eugene was introduced to these circles by the American critic and writer Sadakichi Hartmann who can be said to have actually discovered him. Presumably Hartmann's attention was only drawn to Eugene by his exhibition in Knoedler's gallery in summer 1898, for in Hartmann's first ever article on art photography which appeared in the Sunday edition of the New Yorker Staats-Zeitung in January of that year, he does not mention Eugene.[65]

Hartmann, whose mother was Japanese and whose father was a German merchant, was one of the most colorful figures in American art photography and art at the turn of the century. A restless bohème, he had got to know Stieglitz in 1898 and through him had become motivated to work towards gaining recognition for art photography. He did this via numerous articles for Camera Notes and later for Camera Work. He is of eminent significance for the development of photographic journalism in North America, and his articles occasionally appeared in German trade magazines for amateur and professional photographers who in this way were informed about the state of the art in North America.[66] As Hartmann claims, for Eugene photography was just one of many different artistic modes of expression: "He etches, makes monotypes, draws in pen and ink and

Kunstreproduktionen gewesen sein. Aus diesem eher spielerischen Umgang könnte ein stärkeres Interesse an der Photographie erwachsen sein.

Seinen plötzlichen Durchbruch als Kunstphotograph sollte Eugene mit der ersten vielbeachteten Einzelausstellung seiner Aufnahmen im New Yorker Camera Club vom 15. bis 30. November 1899 erleben. Der Camera Club war 1896 als Zusammenschluß der Society of Amateur Photographers und dem New Yorker Camera Club

The Camera Club
New York
3 West 29th Street

An Exhibition of Prints
by

Frank Eugene

New York City

Nov. 15th to 30th, 1899

22. Catalogue Frank Eugene, Camera Club, New York 1899

gegründet worden und hatte sich mit dem Vizepräsidenten Alfred Stieglitz seit April 1897 zu dem wichtigsten Forum des amerikanischen Piktorialismus entwickelt. In den Klubräumen fanden zwischen 1898 und 1903 Ausstellungen von Fred Holland Day, Zaida Ben-Yusuf und Francis Benjamin Johnston, Gertrude Käsebier, Alfred Stieglitz, Clarence H. White, Eva L. Watson, Rudolph Eickemeyer Jr., Joseph T. Keiley, Alvin Langdon Coburn und Frank Eugene statt. Ein ähnlich hohes Niveau nahm das von Stieglitz redaktionell betreute Vereinsjournal *Camera Notes* zwischen Juli 1897 und 1902 ein, das nicht nur ausführlich über die nationalen und internationalen Ausstellungen der Kunstphotographie berichtete, sondern mit Photogravüren als Illustrationen auch für eine drucktechnisch hochwertige Verbreitung der Photographien sorgte.

Eingeführt in diesen Kreis wurde Frank Eugene durch den amerikanischen Kritiker und Schriftsteller Sadakichi Hartmann, der als eigentlicher Entdecker von Eugene bezeichnet werden kann. Vermutlich wurde Hartmann auf Eugene über dessen Ausstellung in Knoedler's Gallery im Sommer 1898 aufmerksam, denn in Hartmanns erstem Artikel über die künstlerische Photographie überhaupt, erschienen in der Sonntagsausgabe der *New Yorker Staats-Zeitung* im Januar 1898, fand Eugene noch keine Erwähnung.[65]

Hartmann, Sohn einer Japanerin und eines deutschen Kaufmanns, gehört zu den schillerndsten Figuren der amerikanischen Kunstphotographie und Kunst im Fin-de-siècle. Als rastloser Bohémien hatte er auch Stieglitz kennengelernt und, durch diesen inspiriert, sich für die Anerkennung der künstlerischen Photographie in zahlreichen Artikeln in *Camera Notes* und später in *Camera Work* eingesetzt. Seine Bedeutung für die Entwicklung der Photopublizistik in Nordamerika ist eminent. Gelegentlich erschienen seine Beiträge auch in den deutschen Fachzeitschriften der Amateur- und Berufsphotographen, die auf diese Weise über den Stand der Entwicklungen in Nordamerika unterrichtet wurden.[66]

Wie Hartmann zu berichten weiß, war die Photographie für Eugene nur eines von verschiedenen künstlerischen Ausdrucksmitteln: »Er macht Radierungen, Monotypien, zeichnet mit Stift, Tinte und Kohle, malt in Öl und Wasserfarben, modelliert in Ton, spielt Gitarre und Horn wie ein professioneller Musiker, schauspielert auf Laienbühnen und züchtet Dachshunde; zeigt sich auf der Straße auch immer mit einem Paar dieser Rasse und ist in der Nachbarschaft, nahe Union Square, wo er wohnt, zu einer ziemlich bekannten Figur geworden.«[67] Die ›Entdeckung‹ Eugenes als Photographen hat Hartmann in seinen eigenen Worten festgehalten: »Eines Tages zeigte er mir seine photographischen Arbeiten, und ich muss gestehen, dass sie mich sehr enthusiastisch stimmten, aber ich erkannte auch sofort, dass sein Verfahren kaum mehr den Namen Photographie verdiente. (...) Am Anfang wollte man auch wenig von ihm wissen, selbst Stieglitz, dessen Wort hier allmächtig ist, und Woodbury, der damalige Redakteur der *Photographic Times* und in betreff der photographischen Technik eine wahrhaftige Encyklopädie des Wissens, schienen sich nicht besonders für den Neuling zu begeistern, dessen Namen in photographischen Kreisen absolut unbekannt war. Aber ich gab die Suche nicht auf – seine Absonderlichkeit schien mir interessant genug, um befürwortet zu werden – und ich verwendete mich für ihn in den hiesigen Zeitungen und Fachschriften. Auch gelang es mir, Mr. Stieglitz zu einer Eugeneschen Ausstellung zu überreden.«[68]

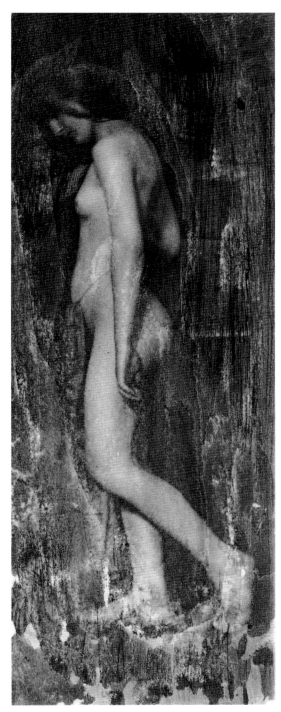

23. Nude study, c. 1899
Platinum print, 17.2 x 6.3 cm
Metropolitan Museum of Art, Alfred Stieglitz Collection,
1933 (49.55.243)

ways seen in the streets, and consequence of which he has become quite a typical figure in the neighborhood around Union Square in which he lives."[67] The "discovery" of Eugene the photographer is documented in Hartmann's own words: "One day he showed me his photographic works, and I must confess that I was very enthusiastic about them, but I also recognized at once that his procedure scarcely deserved the name photography.... At first no one wanted to know much about him, neither Stieglitz, whose word is gospel here, nor Woodbury, the former editor of *Photographic Times* and a veritable encyclopedia of knowledge on photographic technique, seemed to be especially enthusiastic about the new-comer, whose name was absolutely unknown in photographic circles. But I did not give up the search – to me his strangeness seemed interesting enough to be promoted – and I used my influence for him in the local newspapers and special magazines. I also succeeded in persuading Mr. Stieglitz to go to an exhibition of Eugene's."[68]

At that time, Eugene already had an archive of several hundred photographs.[69] The first exhibition in the Camera Club showed 77 of these, among them portraits of actors and artists such as Joseph Jefferson, Kyrle Bellew, Robert Loftus Newman, Daniel Chester French, Sadakichi Hartmann, Emma Calvé, Mrs. Potter, Anton Seidl and Glen McDonough, untitled portraits of women, some self-portraits, nude photograph such as "La Cigale," and depictions of literary and religious motifs such as "The Novice," "Launcelot and Guinevere" and "Nirvana."[70] It is not known what became of most of these early photographs, but other motifs and the portraits of Henry Irving and Master Frank Jefferson, "Lady of Charlotte" and "The Song of the Lily" are considered to be his most famous works.

"Unphotographic Photography"

Thanks to Hartmann's informative and detailed description, we know something about the genesis of many of Eugene's early photographic compositions: "His routine as a portrait painter gives him the advantage of posing his subjects at once in adequate surroundings that are in themselves artistic. Like most studios, his contains all sorts of paraphernalia, the use of which no ordinary mortal can solve, but which lend the place that atmosphere, apparently indispensable to the production of a work of art. It is interesting to watch Mr. Eugene manipulate these odds and ends. He places for instance, a lady sitter against a most unconventional background, formed of a gobelin or painting, throws an old piece of

charcoal, paints in oils and watercolors, models in clay, plays the guitar and French horn like a professional musician, performs in amateur theatricals, and is a breeder of dachshunds besides, with a pair of which he is al-

24. Nirvana, 1899
from: *Camera Notes*, 3,
April 1900, no. 4, p.197

Zu diesem Zeitpunkt verfügte Eugene bereits über ein Archiv von mehreren hundert Aufnahmen.[69] Davon zeigte die erste Ausstellung im Camera Club insgesamt 77 Motive, darunter Schauspieler- und Künstlerporträts von Joseph Jefferson, Kyrle Bellew, Robert Loftus Newman, Daniel Chester French, Sadakichi Hartmann, Emma Calvé, Cora Potter, Anton Seidl und Glen McDonough, nicht näher bezeichnete Frauenbildnisse und einige Selbstporträts. Aktaufnahmen wie ›La Cigale‹, Darstellungen literarischer und religiöser Motive wie ›The Novice‹, ›Launcelot and Guinevere‹ oder ›Nirvana‹ vervollständigten die Präsentation.[70] Der Verbleib des größten Teils dieser frühen Aufnahmen ist heute unbekannt, andere Motive wie die Porträts von Henry Irving oder Master Frank Jefferson, ›Lady of Charlotte‹ oder ›The Song of the Lily‹ zählen zu den bekanntesten Photographien Eugenes.

25. Self portrait at the sea,
c. 1900
D.O.P., 15.3 x 11.2 cm
Fotomuseum im Münchner
Stadtmuseum (93/1056-3)

»Unphotographic Photography«

Über den photographischen Entstehungsprozeß vieler Kompositionen aus Eugenes Frühzeit sind wir dank Hartmanns aufschlußreicher Schilderung hinreichend informiert: »Seine Routine als Porträtmaler hat den Vorteil, daß er sofort weiß, wie er seine Figuren in dem entsprechenden künstlerischen Ambiente plaziert. Wie die meisten Ateliers ist auch seines voller Accessoires, de-

ren Nutzen kein normaler Mensch erraten kann, die aber dem Ort jene Atmosphäre verleihen, die für künstlerisches Schaffen unentbehrlich ist. Es ist interessant zuzuschauen, wie Mr. Eugene mit diesen Dingen umgeht. Zum Beispiel setzt er eine zu porträtierende Dame vor den höchst ungewöhnlichen Hintergrund eines Gobelins oder Bildes, wirft ihr ein altes Stück Dekorationsstoff über den Schoß und umgibt sie mit Gipsabgüssen, Fächern, großen verwelkten Blumen, Bilderrahmen, Büchern, kurzum, mit allem, was ihm in die Hände fällt oder ihm in dem Augenblick gerade in den Sinn kommt. Dabei unterhält er sich aufs amüsanteste mit der Dame, damit sie ja nicht in Verlegenheit gerät, wenn sie plötzlich merkt, in welchem künstlerischen Kuriositätenladen sie sich befindet; dauernd fügt er das eine oder andere seinem Arrangement hinzu und wartet geduldig den Moment ab, indem die Dame eher zufällig den Ausdruck zeigt, der ihm gefällt. Dann bittet er jemanden, einen Spiegel in einem bestimmten Winkel hochzuhalten, sodaß ein Lichtreflex auf die Schattenseite des Gesichts fällt – den Rest überläßt er der Kamera.«[71]

Da die Ergebnisse dieser Inszenierungen infolge gravierender phototechnischer Fehler wie Überbelichtung oder Verzeichnung der Proportionen durch falschen Abstand nur selten befriedigten, überarbeitete Eugene die Negative häufig mit Ölfarbe, Radiernadel und Zeichenstift. Der schlechte Zustand der Negative bildete somit die Voraussetzung für die zeichnerischen Eingriffe, die Eugene als künstlerische Herausforderung begriff. Auf diese Weise verwandelte sich eine Zimmerwand im Hintergrund in einen Wald wie in ›Launcelot and Guinevere‹. Oder ein Sofa geriet durch Übermalung zu einem strudelnden Wasserwirbel wie in ›Nirvana‹. Im Falle der Aufnahme ›The Horse‹ wurde eine Person, die die Zügel des Pferdes hielt, am rechten Bildrand vollständig übermalt und überzeichnet.

Diese Methode hatte nur wenig mit der herkömmlichen Positiv- oder Negativretusche gemein, wie sie von Franz Hanfstaengl erstmals anläßlich der Weltausstellung in Paris 1855 eindrucksvoll vorgeführt worden war. Der expressive Pinselduktus und der gewagte Einsatz der Radiernadel und Farbe widersprachen der Praxis der Berufsphotographen, ein Bild durch Retusche zu ›verschönern‹. »Eugene deckt auf dem Negativ den Hintergrund ab, um genau wie Steichen die Silhouette zur Wirkung zu bringen. Er verwendet auch mitunter das Radiermesser um seine Art Tiefe in das Bild zu bringen, die Einzelheiten verschlucken oder bestimmte Teile heben sollen. Auch vor seinen Arbeiten beklagen wir nicht die Vermengung von Photographie und Zeichnung. Die Art und Weise zu schaffen entspricht seinem Charak-

drapery over her lap, and surrounds her with plaster casts, fans, large faded flowers, picture frames, books, in short, whatever falls into his hands or impresses his fancy for the moment. While doing so he keeps up a most entertaining conversation, in order to make his fair sitter feel in no way embarrassed at finding herself suddenly in such an artistic curiosity shop; he continually adds one thing or another to his pictorial arrangement, and patiently watches for the moment when the lady, by accident, assumes a pose that pleases him. Thereupon he lets somebody hold a mirror at a certain angle, so as to throw a reflex of light on the shadowy side of the face, and then relies upon the camera to do the rest."[71]

As the results of these sittings were often unsatisfactory due to serious technical mistakes such as over-exposure or distortion as a result of the wrong distance, Eugene frequently reworked the negatives with oil paint, etching-needle and pen. Thus the poor state of the negatives was the prerequisite for interventions which Eugene understood as an artistic challenge. In this way the wall of a room in the background was turned into a forest, as in "Launcelot and Guinevere," or a sofa was painted over to become a bubbling whirlpool, as in "Nirvana." As for the photograph "The Horse," a figure originally on the right edge of the photograph holding the horse's reins has been painted over and totally blotted out.

This procedure had little in common with the accepted form of retouching positives and negatives which had been demonstrated impressively by Franz Hanfstaengl for the first time at the 1855 World Fair in Paris. Eugene's expressive thrust of the brush and daring use of etching-needle and paint contradicted the current practice whereby professional photographers "improved" a photograph by retouching it. "Eugene covers over the background in a negative so as to emphasize the effect of a silhouette, as in Steichen. He occasionally uses an etching knife in order to introduce his kind of depth into the image with the aim of swallowing details or emphasizing certain sections. In view of his achievements we can scarcely lament his mixing of photography and drawing. This creative way of working is in keeping with his character,"[72] to quote the Dresden photographer Hugo Erfurth from his review of the history of portrait photography.

This kind of manipulation of negatives and positives was in no way a discovery of Eugene's but goes back to the very beginnings of photography. It was normal practice in portrait and travel photography to paint over daguerreotypes and salted and albumen paper prints. Photographers such as Alois Löcherer, Felice Beato and

Giorgio Sommer used this technique again and again, but most commercial studio photographers in the 19th century simply altered the backgrounds by using stencils. The cliché-verre technique, developed in 1839 and taken up again in 1853 by the French amateur photographers Constant Dutilleux and Adalbert Cuvelier, is a special form of negative "manipulation" which comes closer to Eugene's way of working. It enjoyed particular favor among the painters of the Barbizon School such as Charles-François Daubigny, Théodore Rousseau, Paul Huet, Jean François Millet and Camille Corot, especially for depictions of landscapes.[73] It is not so much a photographic reproduction process as a photo-mechanical printing process in the course of which a glass plate is first given a covering of light proof emulsion and this layer then worked with an etching-needle. Numerous prints – usually on albumen or salt paper – could be made from the glass negative.

Eugene's unusual and radical working method led to heated discussions among the New York photographers often giving rise to total dismay, although it did motivate Hartmann to characterize him as a "painter-photographer." In his review of the exhibition, the painter J. Wells Champney called the works "unphotographic photography" and particularly praised Eugene's ability to use the camera as an artistic tool. The photographer Dallett Fuguet criticized the hatching in works such as "Lady of Charlotte" regarding it as determined by bad photographic technique: "Mr. Eugene does not work on the prints in any way, but his negatives must be in a state which the ordinary photographer would consider shocking. He apparently rubs away and scratches the secondary high-lights that he desires to subdue; and he uses pencil and paint on the shadows he would lessen or lighten. He modifies and changes details in the same way, and all with a frank boldness which is very interesting and instructive to the photographer, and would be very suggestive and pleasing to the searcher after beauty if it were not for the obtrusive conflict of methods by which he thus endeavors to make pictures."[74]

The exhibition offered a clear demonstration of Eugene's method, particularly in the portrait of Daniel Chester French which he presented in six difference stages of its genesis: "A frame of prints like an etcher's different "states of the plate" showed the portrait of a well-known sculptor as the negative recorded it, and five other prints from the negative in varying states of manipulation until the white coat and very commonplace background had disappeared in darks almost as rich and beautiful as a mezzotint of one of Reynold's pictures."[75]

ter,«[72] stellte der Dresdner Photograph Hugo Erfurth in einem Rücklick auf die Entwicklungsgeschichte der Bildnisphotographie fest.

Die graphische Manipulation der Negative und Positive war keineswegs eine Erfindung von Eugene, sondern läßt sich auf die Anfänge der Photographie zurückverfolgen. Die farbige Übermalung von Daguerreotypien und Salz- bzw. Albuminpapierabzügen war übliche Praxis bei der Porträt- und Reisephotographie. Photographen wie Alois Löcherer, Felice Beato oder Giorgio Sommer haben sich dieser Technik immer wieder bedient, aber letztlich haben die meisten gewerblichen Atelierphotographen im 19. Jahrhundert Hintergründe mit Hilfe von Schablonen verändert.

graphisches Abbildverfahren als vielmehr um ein photomechanisches Druckverfahren, bei dem eine Glasplatte zunächst mit einer lichtundurchlässigen Emulsion versehen wurde. Anschließend wurde diese Schicht mit einer Radiernadel bearbeitet. Von dem Glasnegativ konnten schließlich beliebig viele Abzüge – gewöhnlich auf Albumin- oder Salzpapier – angefertigt werden.

Unter den New Yorker Photographen löste Eugenes ungewöhnliche und radikale Technik, wegen der Hartmann den Künster auch als »Painter-Photographer« charakterisierte, heftige Diskussionen und gelegentlich auch blankes Unverständnis aus. Während der Maler J. Wells Champney in seiner Ausstellungsrückschau die Arbeiten als »unphotographic photography« lobte und

26. The Misses Ide in Samoa,
c. 1903
Platinum print
Metropolitan Museum of Art,
Rogers Fund, 1972 (1972.633.69)

Eine Sonderform der Negativbearbeitung, die Eugenes Arbeitsmethode näher kommt, stellt die Technik des Cliché-verre dar, die bereits 1839 entwickelt war und 1853 von den französischen Amateurphotographen Constant Dutilleux und Adalbert Cuvelier wieder aufgegriffen wurde. Insbesondere die Maler der Schule von Barbizon wie Charles-François Daubigny, Théodore Rousseau, Paul Huet, Jean François Millet oder Camille Corot schätzen diese Technik für Landschaftsdarstellungen.[73] Es handelte sich dabei weniger um ein photo-

Eugenes Fähigkeit, die Kamera als künstlerisches Instrument zu nutzen, besonders hervorhob, kritisierte der Photograph Dallett Fuguet die Einzeichnungen bei Arbeiten wie ›Lady of Charlotte‹ als Resultat der schlechten photographischen Technik: »Herr Eugene bearbeitet die Abzüge überhaupt nicht, seine Negative müssen jedoch in einem Zustand sein, der einen normalen Photographen schockieren würde. Anscheinend kratzt und ritzt er auf den Negativen herum, wenn er z.B. Spitzlichter abschwächen möchte. Schatten, die er reduzie-

The critical positions taken by Champney and Fuguet in *Camera Notes* were illustrated with photogravures of "The Lady of Charlotte," "A Portrait (Miss Jones)," and "La Cigale," and half-tone reproductions of "Sadakichi Hartmann," "Nirvana," "Song of the Lily," "Master Howard Keim," "Nude" and "A Decorative Panel."

Despite these contradictory reactions to Eugene's works, the exhibition in the Camera Club brought him immediate notoriety and recognition far beyond the boundaries of New York. According to Hartmann, Fred Holland Day, Rudolf Eickemeyer and Gertrude Käsebier recognized in Eugene "a master of portrait photography."

real achievement and one which lent his compositions a three-dimensional quality.[77] According to Hartmann, Eugene was the first American pictorialist whose works achieved a convincing synthesis of painting and artistic photography. But despite his fascination with them, Hartmann also regarded Eugene's works as limited and not very original iconographically, even as mere imitations of symbolist or Pre-Raphaelite paintings.[78] On the other hand, in his emphasis on the silhouette of full-length figures and his use of a narrow rectangular upright format which came close to the "hashira-e" of Japanese woodcuts, some of Eugene's photographs show the influence of Japonaiserie.[79] Successful photographs taken by Eugene with no retouching were re-

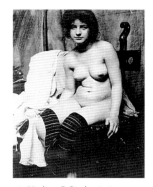

28. Nude – A Study, 1898
Platinum print, 16.8 x 11.6 cm
Metropolitan Museum of Art,
Alfred Stieglitz Collection, 1933
(49.55.247)

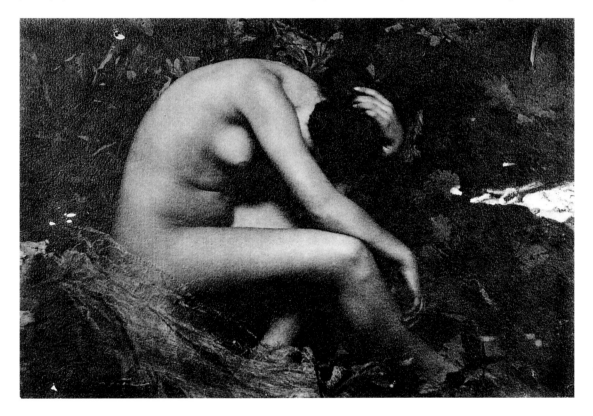

27. La Cigale (Dido), 1898
Photogravure, 12.1 x 17.0 cm
from: *Camera Notes*, April 1900,
p. 199

It was also Hartmann who was essentially responsible for making Eugene's photographs known internationally, even though he was openly critical of his artistic method. In December 1899 *The Photographic Times* published an essay by Hartmann which constituted the most detailed and informative description ever published during the photographer's lifetime and was illustrated with "The Lady of Charlotte," "Miss Jones," "Sir Henry Irving," "Miss Lilian," "Man in Armor," "The Sisters," and "Summer."[76] Hartmann considered Eugene's depiction of the texture and color of fabrics to be his

garded by Hartmann as pure chance, more the expression of the artist's intuition, mood and vitality than the result of a conceptual procedure. As a convinced supporter of a purist photography (straight photography) Hartmann was to become a harsh critic of Eugene's eccentric photographic method in the following years: "His method attracts by its novelty, by its purely artistic, almost colorist intentions. But he is too great a despiser of perspective and truth to be able to continually produce valuable works. Sometimes his energetic but reckless painting and etching method

ren oder aufhellen möchte, deckt er mit Stift und Farbe zu. Einzelheiten modifiziert und ändert er auf gleiche Weise, und all das mit einer unverhohlenen Kühnheit, die für einen Photographen sehr interessant und lehrreich ist und für jemanden, der auf der Suche nach Schönheit ist, sehr verführerisch und gefällig wäre, gäbe es da nicht diesen hinderlichen Zwiespalt der Metho-

29. Miss Gene W., c. 1900
Platinum print
Metropolitan Museum of Art,
Rogers Fund, 1972 (1972.633.51)

den, mit denen er versucht, seine Bilder herzustellen.«[74]
Die Arbeitsweise war in der Ausstellung am Bildnis von Daniel Chester French anschaulich demonstriert worden, das Eugene in sechs verschiedenen Bildstadien vorstellte. »Eine Reihe von Abzügen, auf denen ein bekannter Bildhauer porträtiert war, zeigte – ähnlich wie bei Radierungen – verschiedene ›Zustände‹ des Motivs, angefangen von der Originalwiedergabe, gefolgt von fünf weiteren Abzügen mit unterschiedlichen Eingriffen. Auf dem letzten Abzug sind der weiße Mantel und ein ganz gewöhnlicher Hintergrund in einer Skala von dunklen Tönen verschwunden: ein Bild, satt und schön wie ein Reynolds mit seinen Helldunkel-Effekten.«[75] Die Stellungnahmen von Champney und Fuguet in Camera Notes waren mit den Bildmotiven ›The Lady of Charlotte‹, ›A Portrait (Miss Jones)‹, ›La Cigale‹ als Photogravüren und ›Sadakichi Hartmann‹, ›Nirvana‹, ›Song of the Lily‹, ›Master Howard Keim‹, ›Nude‹, ›A decorative Panel‹ als Halbtonabbildungen illustriert.

Ungeachtet dieser widersprüchlichen Reaktionen sorgte die Ausstellung im Camera Club für die sofortige Bekanntschaft und Anerkennung des Photographen weit über die Grenzen von New York hinaus. Fred Holland Day, Rudolf Eickemeyer und Gertrude Käsebier hatten nach Bekunden von Hartmann Eugene »als Meister der Portrait-Photographie« anerkannt.

Hartmann war es auch, der für die internationale Verbreitung von Eugenes Aufnahmen wesentliches beitrug, obgleich er dessen bildnerischer Methode durchaus kritisch gegenüberstand. Im Dezember 1899 erschien in The Photographic Times ein ausführlicher Aufsatz von Hartmann, der die ausführlichste und informativste Beschreibung zu Lebzeiten des Photographen darstellt und mit Aufnahmen wie ›The Lady of Charlotte‹, ›Miss Jones‹ ›Sir Henry Irving‹ ›Miss Lilian‹, ›Man in Armor‹, ›The Sisters‹ und ›Summer‹ bebildert war.[76] Als eigentliche Errungenschaft Eugenes sah Hartmann die Wiedergabe von stofflicher Textur und Farbe an, die der Komposition ein hohes Maß an Plastizität verleihe.[77] Eugene repräsentierte für Hartmann den ersten amerikanischen Piktorialisten, dessen Arbeiten eine überzeugende Synthese aus Malerei und künstlerischer Photographie verkörperten. Trotz aller Faszination sah Hartmann die Arbeiten von Eugene als limitiert und ikonographisch wenig originär an. Er verstand sie als bloße Nachempfindungen von symbolistischen oder präraffaelitischen Gemälden.[78] Andere Aufnahmen Eugenes wiederum dokumentierten den Einfluß des Japonismus in der Betonung der Silhouette bei ganzfigurigen Darstellungen und der Verwendung des länglichen Hochformates, das dem ›hashira-e‹ von japanischen Holzschnitten nahekommt.[79] Gelungene Photographien ohne jegliche zeichnerischen Eingriffe bezeichnete Hartmann als reine Zufallsprodukte, die eher Ausdruck von Intuition, Stimmungen und Vitalität des Künstlers denn das Ergebnis

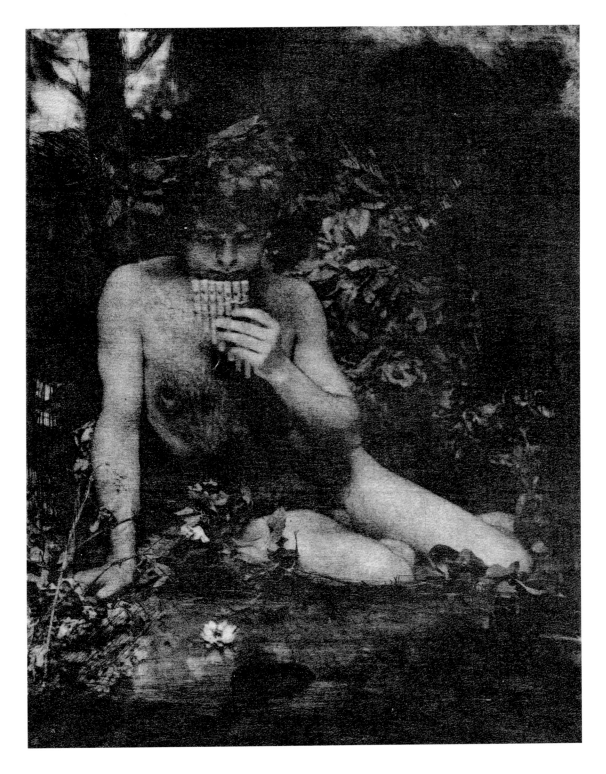

30. The Song of the Lily, 1897
Platinum on tissue, 17.0 x 12.1 cm
Metropolitan Museum of Art,
Alfred Stieglitz Collection, 1933
(33.43.162)

31. Study (Die Maske), c. 1900
Platinum print on Japan paper,
17.0 x 6.2 cm
Fotomuseum im Münchner Stadtmuseum (88/27-124)

eines konzeptionellen Vorgehens seien. Als ausgesprochener Anhänger einer puristischen Photographie (›straight photography‹) sollte sich Hartmann in den kommenden Jahren zu einem rigorosen Kritiker von Eugenes für exzentrisch befundenen Technik entwickeln: »Seine Methode reizt durch ihre Neuigkeit, durch die rein künstlerischen, man möchte fast sagen, koloristischen Absichten. Aber er ist ein zu grosser Perspektiv- und Wahrheitsverachter, um dauernd Wertvolles zu leisten, seine energische, aber rücksichtslose Mal- und Kratzmethode wirkt zuweilen sogar unkünstlerisch.«[80] Gleichwohl wurde Eugene auch in Deutschland zunächst durch Aufsätze Hartmanns in den Fachzeitschriften *Photographische Rundschau* und *Photographischer Motivenschatz der Allgemeinen Photographischen Zeitung* einer größeren Öffentlichkeit bekannt.[81]

Ausstellungen in London, Paris und Philadelphia

In der Folgezeit war Eugene an sämtlichen wichtigen internationalen Ausstellungen zur künstlerischen Photographie beteiligt. Als bedeutendste Vereinigung des internationalen Piktorialismus hatte sich in London 1893 unter dem Wahlspruch ›Beauty, Truth and Nature‹ der Linked Ring von dem Traditionsverein Royal Photographic Society abgespalten, um bis 1910 jährliche Salonausstellungen zu veranstalteten.[82] Obwohl erst im Oktober 1900 offiziell zum Mitglied der Brotherhood of the Linked Ring ernannt, stellte Eugene bereits seit 1899 regelmäßig im Photographic Salon in London, aber auch in den Jahresschauen der Royal Photographic Society seine Arbeiten aus. Zentrale Bedeutung für die Verbreitung seiner Arbeiten kam der Beteiligung an der von Fred Holland Day organisierten Ausstellung der New School of American Photography zu, die zuerst im Oktober/November 1900 in den Räumen der Royal Photographic Society in London und anschließend im Photo Club de Paris zu sehen war. Die Ausstellung, die von Stieglitz boykottiert wurde, repräsentierte mit mehr als 400 Werken von Steichen, Coburn, Käsebier, Eugene, Day und anderen Photographen eine erste eindrucksvolle Demonstration symbolistischer Einflüsse auf die photographische Bildästhetik. In der englischen Fachpresse wurde die ›Invasion‹ der amerikanischen Photographen mit gemischten Reaktionen kommentiert. Während sie bei den Berufsphotographen auf völliges Unverständnis stieß und als »Cult of the Spoilt Print«, »Fuzzyography« und »Oscar Wilde School« verhöhnt wurde, wurde ihr visionärer Charakter im Umkreis des Linked Ring hoch gelobt und von Steichen als »a bombshell exploding in the photographic world of London« gewürdigt.[83]

even seems inartistic."[80] Nevertheless, it was through Hartmann's essays in the magazines *Photographische Rundschau* and *Photographischer Motivenschatz der Allgemeinen Photographischen Zeitung* that Eugene became known to a wider public in Germany.[81]

more than 400 works by Steichen, Coburn, Käsebier, Eugene, Day and others. This "invasion" of American photographers met with mixed reactions in the English special press. The commercial photographers were completely dismayed by the exhibition and ridiculed

32. Friedel wearing a kimono, 1911
Platinum print
Metropolitan Museum of Art,
Rogers Fund, 1972 (1972.633.160)

Exhibitions in London, Paris and Philadelphia

As a consequence, Eugene participated in all the important international art photography exhibitions. In London in 1893, under the motto "Beauty, Truth and Nature," the most important association of international pictorialism, the Linked Ring, split with the traditional Royal Photographic Society and until 1910 organized annual salon exhibitions.[82] Although he was only officially nominated a member of the Brotherhood of the Linked Ring in October 1900, Eugene had not only been exhibiting regularly in the Photographic Salon in London since 1899 but also in the annual shows of the Royal Photographic Society. Of major importance for the acclaim of his works was his participation in the New School of American Photography exhibition organized by Fred Holland Day and first shown in October/November 1900 in the rooms of the Royal Photographic Society in London, then in the Photo Club de Paris. The exhibition, which Stieglitz boycotted, represented a first impressive display of symbolist influences on the aesthetics of photography and included

it as a "cult of the spoilt print," "fuzzyography" and the "Oscar Wilde School," whereas those connected with the Linked Ring praised its visionary character. Steichen even deemed it to be "a bombshell exploding in the photographic world of London."[83]

It was in this exhibition that Eugene first presented one of his most famous photographs, "Adam and Eve," which he took in 1898. Perhaps the reason for presenting this work so late was that the original negative had broken in three pieces and Eugene had tried to disguise the cracks with paintbrush and paint. The torso is a pictorial motif used repeatedly in symbolist art to focus on the incomplete, the fragmentary character of creation. Eugene's photograph "Adam and Eve," which has formal analogies with comparable depictions by Rodin or Stuck, was interpreted as the photographer's strategy for legitimating the presentation of a male and female nude despite restrictive moral attitudes. This interpretation, however, neglects the actual theme of the photograph, namely, the representation of the first human couple. From the iconographical point of view, the modest turning of the head, which

49

»Zu Ehren der Ankunft seines Freundes F. Holland Day aus Boston gab Edward J. Steichen ein Weihnachts-Diner in seinem Studio auf dem Boulevard Montparnasse 83. Gedeckt war für sechs Personen. Außer ihm selbst und Day waren zugegen: Mr. Frank Eugene aus New York, Mrs. William E. Russel und Miss Mary Devins, beide aus Cambridge, und Mrs. Elise Pumpelli Cabot aus Boston. Die Gruppe repräsentiert die neue amerikanische Schule der künstlerischen Photographie, soweit sie sich gerade auf dieser Seite des Antlantik aufhält. Lampions mit roten Seidenschirmen erleuchteten das Studio, die Mr. Steichen von einem Vertreter der japanischen Regierung auf der Ausstellung hatte erwerben können. Ilex- und Mistelzweige vervollständigten die Dekoration.« (*New York Herald*, 27.12.1900, zitiert nach Dennis Longwell, »Steichen Meisterphotographien 1895–1914. Die symbolistische Periode«, Tübingen 1978, S.56)

33. *Alvin Langdon Coburn* Three noted American photographers as seen by a friend in Paris, Paris 1901 (l-r: Frank Eugene Smith, F. Holland Day, Edward Steichen) from: *Photo Era*, July 1902

Im Rahmen der Ausstellung stellte Eugene erstmals eine seiner bekanntesten Aufnahmen mit ›Adam and Eve‹ vor, die bereits im Jahre 1898 entstanden war. Der Grund für die verspätete Präsentation mag in der Tatsache begründet sein, daß das Originalnegativ in drei Teile zerbrochen war, dessen Bruchstellen Eugene mit Pinsel und Farbe zu kaschieren versuchte. Die Darstellung des Torsos ist ein in der symbolistischen Kunst häufig wiederkehrendes Bildmotiv, in dem das Unvollendete und Fragment der Schöpfung im Mittelpunkt der Bildidee steht. Eugenes Aufnahme ›Adam and Eve‹, die

formale Analogien zu vergleichbaren Darstellungen bei Rodin oder Stuck aufweist, wurde gewöhnlich als Legitimation des Photographen gegenüber den restriktiven Moralvorstellungen interpretiert, um die Darstellung eines männlichen und weiblichen Aktes überhaupt salonfähig zu machen. Diese Deutung läßt jedoch das eigentliche Bildthema – die Darstellung des ersten Menschenpaares – unberücksichtigt. Das schamhafte Abwenden des Kopfes, der durch Radierstriche im Negativ überzeichnet wurde, verweist wohl ikonographisch eher auf die Darstellung des Sündenfalls. So gesehen,

50

is etched over on the negative, hints more at a depiction of the Fall. Seen in this way, Eugene's photograph can be interpreted as a symbolic expression of the irretrievable loss of paradise and the fateful beginning of the sexual entanglements between human beings. Eugene was on a close footing both with Fred Holland Day and with Edward Steichen, who lived in Paris. Day, a famous collector of manuscripts and memorabilia of the poet John Keats, was the wealthy owner of the Boston publishing house Copeland & Day which had published, among other things, the first American edition of *The Yellow Book* and Oscar Wilde's *Salomé* (1894), illustrated by Aubrey Beardsley, as well as poems by Dante Gabriel Rossetti and Mallarmé. He had close contacts with the decadent movement through his friendship with Wilde and Beardsley, and alongside Stieglitz was an outstanding personality in American art photography around the turn of the century. Having spent Christmas 1900 in Paris with Day and Steichen, Eugene then traveled with Day for about four months to Egypt at the end of January 1901. Several photographs, such as the full-length portrait of an oriental shepherd, the background of which has been turned into a tree landscape by highly expressive hatching, or the view of the Gizeh pyramid by moonlight, date from this period. Eugene shared this preference for twilight and mysterious night scenes with other art photographers such as Steichen, whose forest studies at twilight or sequence of photographs of Rodin's Balzac sculpture, all taken at around the same time, should also be mentioned here.[84] Technically, night photographs were not easy to produce as they often required exposures of up to several hours. For this reason photographs taken by daylight were occasionally turned into night scenes in the copying process or altered by manual hatching. However, there are no such manipulations to be found in Eugene's photograph of the pyramid.

The third Photographic Salon in Philadelphia, which was one of the most famous events of its kind in North America, aroused similarly strong reactions as the exhibition of the New American School. This salon took place in October/November 1900 and Eugene was actively involved in its conception. The jury was composed of Eugene, Gertrude Käsebier, Clarence H. White, Eva Watson and Alfred Stieglitz, and their selection was vehemently opposed by the conservative members of the Photographic Society of Philadelphia who were organizing the event. Their spokesman Charles L. Mitchell described a large portion of the works as "monotonous," even as "trash" and as "photographic Os-

car Wildes," echoing the English critic.[85] Despite the reactionary polemics it is worthwhile taking a closer look at Mitchell's arguments as they throw some light on the controversial discussion around the artistic value of pictorialist photography and in particular Eugene's style: "The majority of the pictures exhibited seem to strive to imitate the work of the painter, or of the engraver and etcher. They seem more anxious, however, to represent the defects and peculiarities of their processes than they do to develop their artistic feelings, and, in consequence, their imitations, like all imitations, fall far behind the original.... Instead of striving to express the artistic feeling of a Diaz or a Millet, they seem only to be interested in reproducing the texture of the canvas, the grain of the paper, the mark of the brush, or the scratch of the graver. They forget entirely the tonality of color, and seem to think that when they show a few brilliant lines in high-light on a wide expanse of black they express fully all the art of a Rembrandt. In fact, the good work in the Salon, the pictures that are pictures, are those in which the veriest tyro can recognize that true, honest photographic skill forms the groundwork on which all else is based, while the rest is bad photography "faked" with brush and pencil."[86] Mitchell's polemic reached a high-point in his criticism of the jury: "five of the United States' most representative cranks and freak photographers who for the past few years have been inundating the photographic public with their bad photography." The jury members each had a maximum of ten photographs on show and had also invited befriended photographers like James Craig Annan, Robert Demachy, Theodor and Oscar Hofmeister and Puyo to take part without a jury selection, with the result that almost half of the exhibits were shown without being previewed by the jury. In reaction, and in protest against the attitude of the Philadelphia Photographic Society, the American, English and French members of the Linked Ring refused to take part in the salon in future.[87] In a letter to the editor, Alfred Stieglitz rejected Mitchell's criticism, defending Eugene's work in particular: "I might also add, for the sake of your readers, that Mr. Eugene, whose work is condemned as "no art" by Dr. Mitchell, is a painter of no mean ability, who has recently been called to Europe to paint some portraits. Do you not suppose that he should know a little more about "art" than Charles L. Mitchell, M.D.? What would the latter think if Mr. Eugene were to write upon medicine, because he had happened to read some patent medicine circulars, or had dabbled in medicine in an amateur way?"[88]

kann Eugenes Darstellung als symbolischer Ausdruck für den unwiederbringlichen Verlust des Paradieses und zugleich als schicksalshafter Ausgangspunkt für die sexuellen Verstrickungen der menschlichen Natur gelesen werden.

Mit Fred Holland Day und Edward Steichen, der in Paris lebte, pflegte Eugene eine nähere Bekanntschaft. Day, der als Sammler von Manuskripten und Memorabilia des Dichters John Keats bekannt geworden war, war wohlhabender Eigentümer des Bostoner Verlages Copeland & Day, der u.a. die amerikanischen Erstausgaben von *The Yellow Book* und Oscar Wildes *Salomé* (1894), illustriert von Aubrey Beardsley, sowie Gedichte von Dante Gabriel Rossetti und Mallarmé, veröffentlicht hatte. Er stand der Bewegung der Décadents durch die Freundschaft mit Oscar Wilde und Beardsley nahe und repräsentierte neben Stieglitz die herausragende Persönlichkeit in der amerikanischen Kunstphotographie um 1900. Nachdem Eugene mit Day und Steichen Weihnachten in Paris verbracht hatte, reiste er Ende Januar 1901 gemeinsam mit Day für mehrere Monate nach Ägypten. Aus dieser Zeit stammen einige Aufnahmen wie das ganzfigurige Porträt eines orientalischen Hirten, dessen Bildhintergrund durch expressive Einzeichnungen in eine Baumlandschaft verwandelt worden war, oder die Ansicht der Pyramide von Gizeh bei Mondlicht. Diese Vorliebe für das Zwielicht und mysteriöse Nachtstimmungen teilte Eugene mit anderen Kunstphotographen wie Steichen, dessen ungefähr zeitgleich entstandene Waldstudien bei Dämmerung oder die Bildsequenz von Rodins Balzac-Skulptur an dieser Stelle beispielhaft erwähnt seien.[84] Vom technischen Standpunkt waren Nachtaufnahmen nicht einfach herzustellen, da sie häufig Belichtungszeiten von mehreren Stunden erforderten. Deshalb wurden gelegentlich auch Tageslichtaufnahmen im Kopierprozess zu Nachtstücken verwandelt oder durch manuelle Einzeichnungen verändert. Es läßt sich jedoch eine entsprechende Manipulation in Eugenes Pyramiden-Ansicht nicht feststellen.

Ähnlich heftige Reaktionen wie die Ausstellung der New American School löste auch der dritte Photographic Salon in Philadelphia, der zu den renommiertesten Veranstaltungen seiner Art in Nordamerika zählte, im Oktober/November 1900 aus. Eugene gehörte neben Gertrude Käsebier, Clarence H. White, Eva Watson und Alfred Stieglitz zur Jury, deren Bildauswahl unter den konservativen Mitgliedern der veranstaltenden Photographic Society of Philadelphia auf großen Widerstand stieß. Deren Wortführer Charles L. Mitchell bezeichnete einen Großteil der Arbeiten als »monoton«, als »trash« und in Anknüpfung an die englischen Kritiker als »photographic Oscar Wildes«.[85]

Trotz der reaktionären Polemik lohnt es sich, Mitchells Argumente näher zu betrachten, da sie die kontroverse Diskussion über den Kunstwert der piktorialistischen Photographie und insbesondere über den Stil Eugenes schlaglichtartig beleuchten: »Auf den meisten Bildern erkennt man ein Bemühen, die Techniken eines Malers, Steinschneiders oder Radierers nachzuahmen. Jedoch sieht es so aus, als ob sie eher bestrebt sind, die Schwächen und Eigentümlichkeiten der jeweiligen Verfahren sichtbar zu machen, als ihre eigenen künstlerischen Gefühle zum Ausdruck zu bringen. Folglich fallen Ihre Nachahmungen, wie alle Nachahmungen, weit hinter das Original zurück. (...) Anstatt zu versuchen, die künstlerischen Gefühle eines Diaz oder eines Millet nachzuempfinden, scheinen sie sich nur für die Wiedergabe der Textur der Leinwand, der Struktur des Papiers, der Pinselstriche oder der Strichung des Radierers zu interessieren. Sie kümmern sich überhaupt nicht um Farbnuancierungen und scheinen zu glauben, daß es genügt, ein paar glänzende Linien durch Spitzlichter auf schwarzen Grund zu setzen und zu glauben, so im Stil eines Rembrandt zu arbeiten. Die guten Arbeiten im Salon, die Aufnahmen, die wirklich welche sind, sind tatsächlich die, in denen auch der blutige Anfänger erkennen kann, daß ein reines handwerkliches fotografisches Können die Voraussetzung ist für alles andere. Der Rest ist schlechte Photographie, ›verfälscht‹ mit Pinsel und Stift.«[86] Mitchells Polemik gipfelte in seiner Kritik an der Jury: »fünf der besonders typischen Spinner und Sonderlinge unter den Photographen der Vereinigten Staaten, die in den letzten Jahren den Markt mit ihren schlechten Photographien regelrecht überschwemmt haben«. Die Jury hatte sich sich mit der Höchstzahl von zehn Aufnahmen an der Ausstellung beteiligt und befreundete Photographen wie James Craig Annan, Robert Demachy, Theodor und Oscar Hofmeister und Puyo eingeladen, so daß nahezu die Hälfte der Ausstellungsexponate ohne Vorjurierung gezeigt wurde. Im Gegenzug verweigerten die amerikanischen, englischen und französischen Mitglieder des Linked Ring aus Protest gegen die Haltung der Philadelphia Photographic Society die zukünftige Teilnahme an dem Salon[87] und Alfred Stieglitz wies in einem offenen Leserbrief Mitchells Kritik zurück, wobei er insbesondere Eugenes Arbeiten verteidigte: »Ich sollte vielleicht im Interesse Ihrer Leser darauf hinweisen, daß Mr. Eugene, dessen Arbeit von Dr. Mitchell als ›keine Kunst‹ verurteilt wird, ein nicht unbegabter Maler ist, der neulich nach Europa berufen wurde, um einige Porträts zu malen. Glauben Sie nicht, daß er wohl etwas

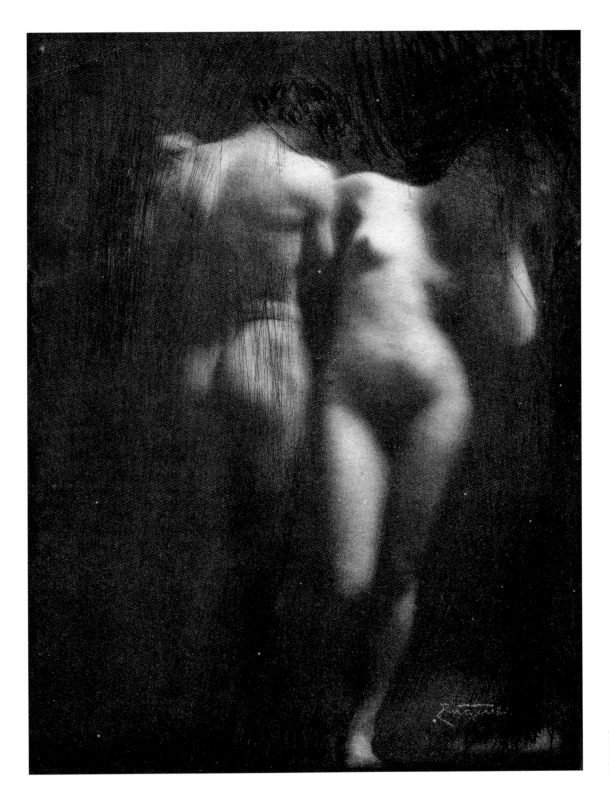

34. Adam and Eve, 1898/99
Photogravure, 17.7 x 12.8 cm
Fotomuseum im Münchner
Stadtmuseum (88/26-56)

35. The shepherd, 1901
Platinum print, 11.7 x 9.5 cm
Fotomuseum im Münchner
Stadtmuseum (88/26-24)

Alfred Stieglitz and the Photo-Secession

Alfred Stieglitz had become Eugene's second promoter, alongside Sadakichi Hartmann. But whereas Hartmann was soon to express criticism of Eugene's method and his initial admiration turn into open rejection, Stieglitz and Eugene were linked by an intensive and life-long friendship. An outward sign of that relationship was the reproduction of a portrait of Stieglitz by Eugene in *The Amateur Photographer* in July 1900 to illustrate an article by Hartmann on Stieglitz' services to the Camera Club.[89] Like Eugene, Stieglitz was the son of German immigrants and had begun to acquire works of Eugene's for his private collection of art photography in 1900.[90] As editor of *Camera Notes* he had frequently had Eugene's works reproduced in that magazine. In 1901 a selection of motifs including "La Cigale," "Lady of Charlotte," "Portrait of Miss Jones" and the "Portrait of Alfred Stieglitz" also appeared as photogravures in the portfolio "American Pictorial Series II," edited by *Camera Notes*. From the beginning Stieglitz, as curator, had tried to integrate Eugene's photographs into exhibitions in New York, Glasgow and Turin. Alongside Heinrich Kühn, Ernst Juhl and Fritz Matthies-Masuren, Eugene was Stieglitz' most important contact person in Germany,

in a position to supply him with information on the European photography scene. In 1901, when Stieglitz requested Eugene's views on whether an exhibition of American art photography would be meaningful in Munich, the latter expressed grave doubts about the success of such an undertaking. On the other hand, Stieglitz kept Eugene up to date on the latest developments in New York and supplied him with magazines such as *Camera Notes* and later *Camera Work*.

Due to differences of editorial opinion, Stieglitz had given up his functions as editor of *Camera Notes* in 1902 and had founded the legendary Photo-Secession, an association of American pictorialists in New York. Without having a concrete aesthetic program, the Photo-Secession saw itself primarily as an elitist community whose members were professed art photographers and regarded themselves as its best representatives: "To hold together those Americans devoted to pictorial photography; to uphold and strengthen the position of pictorial photography; to exhibit the best that has been accomplished by its members or other photographers, and, above all, to dignify that profession until recently looked upon as a trade."[91]

As of November 1905, the Photo-Secession had its own exhibition forum in the new rooms of the Little Galleries

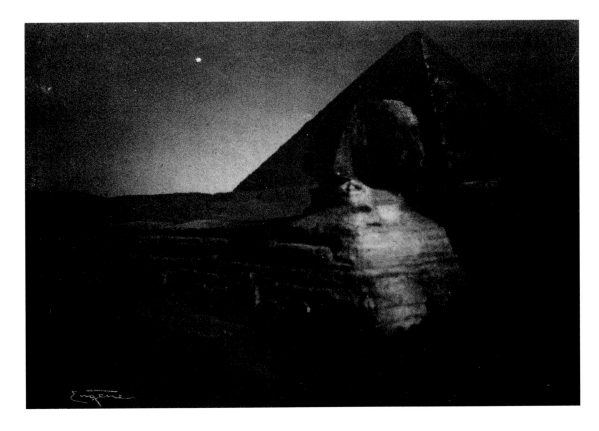

36. The Sphinx from Giza, Egypt, midnight, 1901
Platinum print, 12.0 x 17.1 cm
Metropolitan Museum of Art,
Alfred Stieglitz Collection, 1933
(33.43.64)

mehr von Kunst versteht als Charles L. Mitchell, M.D.? Was würde dieser sagen, wenn Mr. Eugene über Medizin schreiben würde, nur weil er zufällig ein paar pharmazeutische Rundschreiben gelesen und in ein paar medizinischen Bereichen herumgestümpert hatte??«[88]

Alfred Stieglitz und die Photo-Secession

Neben Sadakichi Hartmann war Alfred Stieglitz der zweite Förderer Eugenes. Während sich Hartmann bald kritisch über Eugenes Methode äußerte und die anfängliche Sympathie in offene Ablehnung umschlug, verband Stieglitz und Eugene eine intensive und lebenslange Freundschaft. Äußeres Zeichen dieses Verhältnisses war die Veröffentlichung eines Stieglitz-Porträts von Eugene in *The Amateur Photographer*, das im Juli 1900 einen Beitrag Hartmanns über Stieglitz Verdienste im Camera Club illustrierte.[89] Stieglitz war wie Eugene Sohn deutscher Einwanderer und hatte schon um 1900 damit begonnen, Arbeiten von Eugene für seine Privatsammlung von Kunstphotographien zu erwerben.[90] Als Redakteur von *Camera Notes* hatte er Eugenes Arbeit durch die Veröffentlichung in der Zeitschrift großzügig präsentiert; eine Auswahl der Motive – ›La Cigale‹, ›Lady of Charlotte‹, ›Portrait of Miss Jones‹ und ›Portrait of Alfred Stieglitz‹ – erschien zudem in dem von *Camera Notes* edierten Portfolio *American Pictorial Series II* 1901 als Photogravüren. Von Anfang an versuchte Stieglitz, als Kurator Eugenes Aufnahmen in Ausstellungen in New York, Glasgow und Turin zu integrieren. Neben Heinrich Kühn, Ernst Juhl und Fritz Matthies-Masuren war Eugene für Stieglitz die wichtigste Bezugsperson im deutschsprachigen Raum, die ihn gleichzeitig auch mit Auskünften und Informationen über die europäische Photoszene versorgen konnte. Als etwa Stieglitz 1901 Eugene um seine Einschätzung bat, ob er eine Ausstellung amerikanischer Kunstphotographie in München für sinnvoll erachte, bestritt Eugene die Erfolgsaussichten einer derartigen Veranstaltung. Auf der anderen Seite wurde Eugene durch Stieglitz über die jüngsten Entwicklungen in New York unterrichtet, erhielt Zeitschriften wie *Camera Notes* oder später *Camera Work*. Aufgrund inhaltlicher Differenzen hatte Stieglitz 1902 seine Tätigkeit als Herausgeber von *Camera Notes* aufgegeben und als Zusammenschluß der amerikanischen Piktorialisten in New York die mittlerweile legendäre Photo-Secession gegründet. Ohne über ein konkretes ästhetisches Programm zu verfügen, verstand sich die Photo-Secession in erster Linie als elitäre Gemeinschaft, deren Mitglieder sich zur künstlerischen Photographie bekannten und als die besten Vertreter ihrer Zunft be-

trachteten: »Diejenigen Amerikaner zusammenhalten, die sich als Kunstphotographen verstehen, in der Kunstphotographie das Erreichte zu erhalten und zu festigen, die besten Arbeiten ihrer Mitglieder oder anderer Photographen auszustellen und vor allem, darauf hinzuwirken, daß der Kunstphotographie jene Anerkennung zuteil wird, die sie über das bloße Handwerk erhebt.«[91] Ab November 1905 besaß die Photo-Secession in den neugeschaffenen Räumen der Little Galleries ein eigenes Ausstellungsforum, das als »protest against the conventional conception of pictorial photography«[92] wirken sollte. Zu den Mitgliedern der ersten Stunde zählte auch Frank Eugene, der in den folgenden Jahren nahezu auf sämtlichen Ausstellungen der Photo-Secession in Nordamerika und Europa beteiligt

37. Alfred Stieglitz, Esquire, Photographer and Truthseeker, 1899
Platinum print, 16.5 x 11.7 cm
Metropolitan Museum of Art, Alfred Stieglitz Collection, 1933 (49.55.246)

war. Die Teilnahme an diesen Ausstellungen sollte Eugenes Bekanntheitsgrad ständig mehren, wobei es bezeichnenderweise immer dieselben vier oder fünf Motive waren, die präsentiert wurden und auf diese Weise zu einer Art Markenzeichen des Photographen gerieten. Die Vermutung liegt nahe, daß es sich hierbei um Bilder aus der Sammlung Stieglitz handelte, die jener für die ›Loan Exhibitions‹ zur Verfügung stellte. Diese eher hermetische Selbstdarstellung Eugenes wurde einzig anläßlich seiner

38. Alfred Stieglitz, Esquire, Photographer and Truthseeker, 1899
Platinum print, 16.5 x 11.8 cm
Metropolitan Museum of Art,
Alfred Stieglitz Collection, 1933
(49.55.246)

39. Alfred Stieglitz, c. 1900
Platinum print, 17.2 x 12.2 cm
Metropolitan Museum
of Art, Alfred Stieglitz
Collection, 1933 (55.635.5)

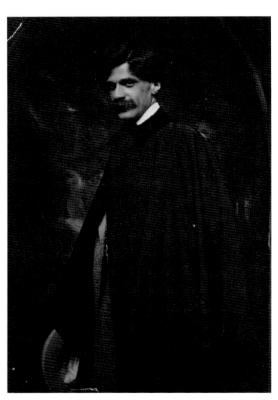

41. Alfred Stieglitz, 1899
Platinum print, 16.4 x 11.0 cm
Metropolitan Museum of Art, Rogers Fund, 1972 (1972.633.140)

40. Alfred Stieglitz, c. 1900
Platinum print, 16.1 x 11.6 cm
Metropolitan Museum of Art,
Alfred Stieglitz Collection, 1933
(55.635.6)

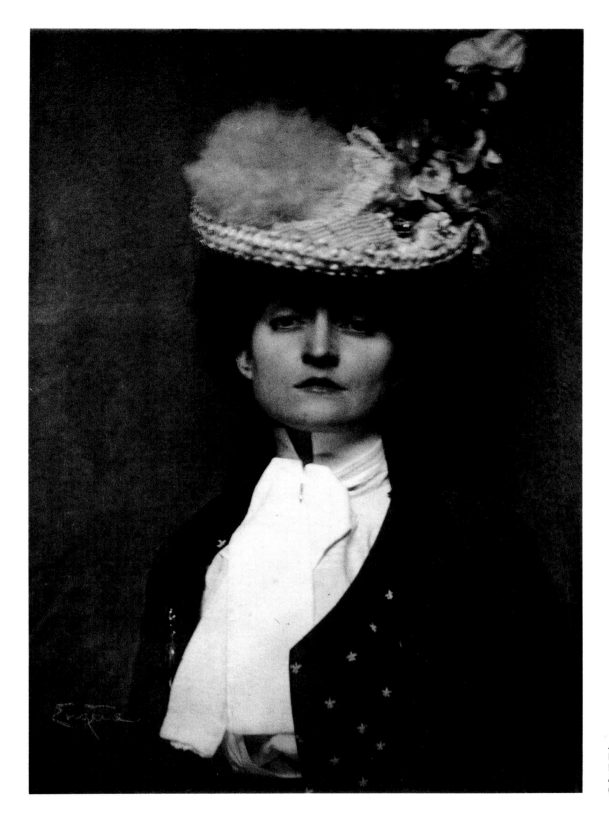

42. Miss Convere Jones, 1899
Platinum print, 16.6 x 11.5 cm
Metropolitan Museum of Art,
Alfred Stieglitz Collection, 1933
(33.43.78)

43. Edward Steichen
Poster of the Photo Secession, 1905
Color woodcut, 18.3 x 6.7 cm
Dietmar Siegert, München

gen zu kontrollieren, die mit seinen Qualitäts- und Hegemonieansprüchen unvereinbar schienen, so geschehen 1904 anläßlich des First American Salon in New York, dessen Beschickung Stieglitz per Rundschreiben untersagte.[93] Eugene hat sich diesen und anderen Dekreten stets loyal und ohne Widerspruch gefügt und auch sonst Stieglitz um seinen Rat bei organisatorischen Fragen gebeten.[94] Nachdem sich Eugene seit 1901 in München niedergelassen hatte, sahen sich die Freunde regelmäßig dort oder in Tutzing auf den Europareisen von Stieglitz wie in den Jahren 1904, 1907 und 1909.
In München lebte er zunächst bei Margaretha Willer[95], einer engen Freundin und wohlhabenden Witwe eines verstorbenen Zahlmeisters, in der Luisenstraße 57. Eugene porträtierte Margaretha Willer wiederholt und verbrachte mit ihr auch die letzten Lebensjahre in München und Aufkirchen. In Briefen an Stieglitz erwähnte Eugene gelegentlich seine »Braut«, ohne den Namen der Lebensgefährtin zu nennen. Nach Auskunft von Zeitzeugen handelte es sich um Margaretha Willer,[96] obwohl aus den Münchner Meldeunterlagen eine eheliche Verbindung Eugenes nicht bekannt ist und Eugene als ›eingefleischter‹ Junggeselle zu einer festen Bindung keine besondere Neigung verspürt haben soll.

»Münchens Niedergang als Kunststadt«

Frank Eugene Smiths Rückkehr nach München im Jahre 1901 geschah zu einem Zeitpunkt, als ein erbitterter Streit zwischen Berlin und München über die Vorrangstellung als führender ›Kunststadt‹ Deutschlands tobte. Seit den Artikeln des Berliner Kunstkritikers Hans Rosenhagen in der Zeitschrift Der Tag im April 1901 war von »Münchens Niedergang als Kunststadt« die Rede, deren ursprüngliche Position als Mekka der Kunst durch die Metropole Berlin in Frage gestellt sei. Vor allem der Hang zum Retrospektiven, oberflächlich Dekorativen und zur selbstgefälligen protzigen Festkultur galten als dominierende Merkmale des öffentlichen Münchner Kunstlebens, das in den Worten von Hermann Obrist einem »Dauerkostümfest« glich. Eine eindringliche Schilderung vom Mythos der »Kunststadt« München um 1900 gibt auch Thomas Manns Novelle Gladius Dei (1902), die die konservativen Stileklektizismen von Neo-Renaissance bis zu Neo-Barock ironisch kommentiert wie auch die fortschrittlichen Strömungen des modernen Kunstgewerbes als der Stadt zugehöriges Phänomen beschreibt.[97]
Gleichwohl übte München auch nach der Jahrhundertwende auf viele Künstler und insbesondere auf großstadtmüde Kunstinteressierte, die einen ›gemütlichen‹

Ausstellungsbeteiligungen in Wiesbaden 1903, München 1907 und 1908, Dresden 1909, Budapest und Buffalo 1910 sowie Frankfurt 1924 durchbrochen, wo sich Möglichkeiten für eine umfassendere Präsentation ergeben hatten. Wie bei den anderen Photo-Secession-Mitgliedern versuchte Stieglitz auch Eugenes Beteiligung an Ausstellun-

which was to function as a "protest against the conventional conception of pictorial photography."[92] Its earliest members included Frank Eugene who in the subsequent years participated in almost all of the Photo-Secession exhibitions in North America and Europe.

Eugene's participation in these exhibitions was to enhance his fame, whereby it was almost always the same four or five motifs which were shown, thus becoming a kind of trademark. It would seem that these photographs were part of Stieglitz' private collection which he placed at the disposal of "loan exhibitions." This more or less hermetic self-presentation of Eugene's was breached during his participation in exhibitions in Wiesbaden 1903, Munich 1907 and 1908, Dresden 1909, Budapest and Buffalo 1910, and Frankfurt 1924,

quality or his understanding of managerial leadership. Thus in 1904 on the occasion of the First American Salon in New York, Stieglitz sent a circular letter prohibiting the members to participate.[93] Eugene always obeyed such decrees loyally and willingly, and generally sought Stieglitz' advice on organizational matters.[94] After Eugene had settled in Munich, the friends met regularly there or in Tutzing during Stieglitz' trips to Europe in 1904, 1907 and 1909.

Back in Munich, Eugene first lived in Luisenstrasse 57, at the home of Margaretha Willer,[95] a close friend and wealthy paymaster's widow. Eugene did numerous portraits of Margaretha Willer. He also spent the last years of his life with her in Munich and Aufkirchen. In letters to Stieglitz Eugene occasionally mentioned his "bride," but without mentioning the name of his

45. Exhibition opening of the Photo-Secession at Little Galleries, New York, 1905 from: *Camera Work*, 14, April 1906, p.46

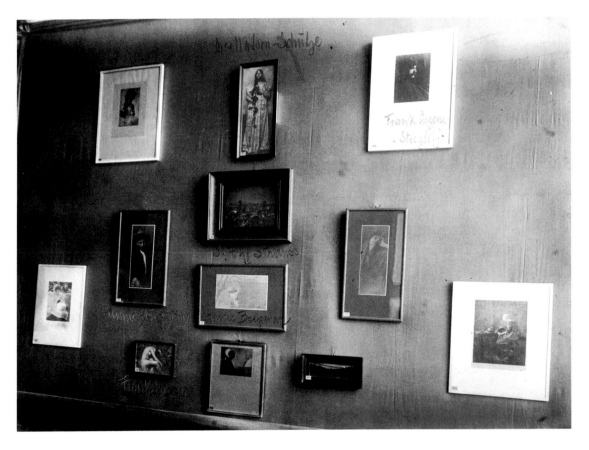

44. Exhibition wall with photographs by Anne W. Brigman, Frank Eugene Smith, Eva Watson-Schütze, John Francis Strauss and others, Hamburg 1903
Museum für Kunst und Gewerbe, Hamburg

which provided scope for more comprehensive presentations.

As was the case with other Photo-Secession members, Stieglitz also tried to monitor Eugene's participation in exhibitions, especially when they did not seem to him to be in keeping with his aspirations about

partner. According to contemporaries he was referring to Margaretha Willer,[96] although there is no evidence of the conclusion of a marital contract between them in the Munich registers, and Eugene is said to have been a "thorough-going bachelor" with no particular inclination to form a long-term attachment.

Lebensstil inmitten einer überschaubaren, bäuerlich-landstädtischen Umgebung der dynamischen Atmosphäre einer Metropole vorzogen, große Anziehungskraft aus. Man traf sich in dem traditionellen Künstlerverein Allotria im 1900 errichteten Künstlerhaus, der zugleich ein beliebter Aufenthaltsort der Akademieprofessoren und der herrschenden Elite der Münchner Künstlerschaft war. Hier wurden regelmäßig Feste gefeiert, wie 1902 das ›Don Juan-Fest‹ unter Beteiligung von Franz Lenbach oder 1908 der 60. Geburtstag des Allotria-Mitbegründers und Künstlerhaus-Architekten Gabriel von Seidl. Diese Künstlerfeste sollten demonstrieren, daß man den Künstlern vergangener Kunstepochen an Kreativität und Lebenslust in nichts nachstand. Als soziales Ereignis sorgten die Künstlerfeste für die kurzweilige Versöhnung jener in München konkurrierenden Künstler, die sich beispielsweise unter dem Motto »In Arkadien« 1898 gemeinsam in ein zeitloses Elysium begaben.

46. *Anonymous*
Café Stefanie, c. 1900
Postcard
Sebastian Winkler, Munich

Auch Frank Eugene verkehrte in den Kreisen der Allotria, zu dessen Vereinslokal ausschließlich männliche Mitglieder Zutritt hatten und wo man die arrivierten Münchner Künstler wie »Hengeler, Stuck, Oberländer, Seidl, Littmann, Bartels, Gedon, Rudolf Seitz, Ludwig Herterich, Benno Becker«[98] oder auch Prinz Rupprecht von Bayern in Unterhaltung oder beim ›Tarocken‹ am Biertisch antreffen konnte. Insbesondere die führenden Mitglieder der Allotria standen in der Münchner Künstlerschaft im Ruf der Elitenbildung und Cliquenwirtschaft, die bei öffentlichen und privaten Aufträgen gegenüber den nachdrängenden jüngeren Künstlern immer die Nase vorn hatten, wie Josef Ruederer in seinen *Münchener Satiren* (1907) ironischbissig kommentierte: »Ihr Programm ist die Kunst, ihr Zweck gegenseitige Protektion. Wer nicht zu ihr gehört, wer in der großen Vettern- und Basenschaft der Bäcker und Müller nicht wenigstens einen Bekannten hat, bekommt in Bierheim nie einen Auftrag, wenigstens keinen offiziellen für Reiterstandbilder verstorbener Pfahlbauern, für patriotische Brunnen oder Staatsgebäude.«[99]

Für das Erscheinungsbild der ›Kunststadt‹ München war aber auch eine widersprüchliche Mischung aus progressiven und traditionellen Kräften charakteristisch. Die Gegensätze zwischen Künstlerfürstentum einerseits und Pauperismus andererseits, zwischen traditionsorientierter Neo-Barock- oder Neo-Renaissancestilistik und modernen Ausdrucksformen sorgten für den Nährboden einer Kultur, in der so unterschiedliche Figuren wie der anarchistische Schriftsteller Erich Mühsam und der neoklassizistische Dichter und Nobelpreisträger Paul Heyse gleichzeitig nebeneinander leben und gelegentlich sogar in ähnlichen Kreisen verkehren konnten, wie Franz Blei zu berichten weiß: »Du verläßt einen Kreis, und der nächste nimmt dich auf. (...) Jeder ist zugleich wo er ist und überall. Jeder ist bei jedem. Jeder hat alle Kreise. Alle Kreise haben jeden und keinen. Wenn man zu Ende ist, ist man wieder am Anfang. Wenn man sein Kleid nicht mehr zeigen kann, verkleidet man sich. Wenn man keine Verkleidungen mehr hat, verkleidet man sich in das Kleid, das man gestern glaubte nicht mehr zeigen zu können. So beschrieb Borchardt das Münchnerische. Und so war München die Stadt einer gefühlsmäßigen Demokratie und auch des Karnevals.«[100] Frank Eugene hat sich in dieser Umgebung ausgesprochen heimisch gefühlt, die einschlägigen Künstlerlokale wie das Café Stefanie und den Simplizissimus besucht, wie der Schriftsteller Hans Brandenburg, der uns ein lebendiges Porträt von Eugene als rastloses und beliebtes Mitglied der Schwabinger Bohème überliefert hat, in seinen 1953 erschienenen Jugenderinnerungen *München leuchtete* zu berichten weiß: »Er war ein Mann von unbestimmbarem Alter. Seine kleine breite Gestalt in bequemem, meist dunkelblauem Sakko, stand und lief auf kurzen, aber überaus beweglichen, behenden Beinen, die in weiten grauen Hosen ohne Bügelfalten steckten. Ein grauer Bart und Schnurrbart umbuschte Kinn und Mund, die feste Schädelkuppe war über der runden Stirn blank gelichtet, aber zu Seiten der netten dicken Nase blitzten unter stachligen Brauen prachtvolle blaue Augen wie die ewige Jugend. Sie lachten das Leben an und schienen überall nur Schönes zu sehen. Obwohl er, allerdings bei flüssiger Ausdrucksweise in seinem angloamerikanischen Jargon kauderwelschte, war er mit Leib und Seele Münchener geworden (...) Er duzte jeden, der ihm gefiel, Männlein wie Weiblein, freilich mehr in englischer als in Conrads plump vertraulicher Art, und es gefielen ihm alle wahrhaften Menschen, und wenn er ein lustiges Wort vernahm, so faßte er den Sprecher derb und warm um die Schultern und warf den Oberkörper zurück unter einem hellen Prusten, das zwischen Nase und Schnauz hervorsprühte.«[101]

The Decline of Munich as an Art Center

Frank Eugene Smith's return to Munich in 1901 took place at a time when a bitter battle was raging between Berlin and Munich as to which of them was the leading "art city" in Germany. Since the articles by the Berlin art critic Hans Rosenhagen in the magazine *Der Tag* in April 1901, there had been a lot of talk about "Munich's decline as an art city" and about its status as an art Mecca being put into question by the metropolis of Berlin. A leaning towards the retrospective and the superficially decorative, not to mention a self-sufficient showy festival culture were considered to be the most dominant features of Munich's art world, resembling, in the words of Hermann Obrist a "permanent fancy-dress ball." A perceptive depiction of the myth of Munich the "art city" around 1900 is to be found in Thomas Mann's novella *Gladius Dei* (1902) which comments ironically on the city's conservative stylistic eclecticism which ranged from Neo-Renaissance to Neo-Baroque, but also describes the simultaneous progressive trends in the arts and crafts there.[97]

Yet even after the turn of the century Munich exercised a strong attraction on many artists, particularly on people interested in art but tired of large cities and more inclined towards a "cozy" lifestyle in manageable country-town surroundings, as against the dynamic atmosphere of a large city. One traditional meeting place in Munich was the artists club Allotria. It was located in the Artists House built in 1900, and was a favorite of professors from the Academy and the dominant elite of Munich's art scene. Festivities were held there regularly, for example in 1908 the 60th birthday of Gabriel von Seidl, founder-member of Allotria and architect of the Artists House, or in 1902 the "Don Juan Festival" in which Franz Lenbach also participated. The aim of these artists festivals was to demonstrate that the participants were in no way inferior to the artists of past epochs as regards creativity and zest for life. As social events these festivals brought about a temporary "reconciliation" between the various competing artists groups, offering the possibility in 1898, for example, of coming together in a timeless Elysium under the motto "In Arcadia." Frank Eugene also moved in Allotria circles. At the group's club house, which was only open to men, it was possible to meet Munich's star artists "Hengeler, Stuck, Oberländer, Seidl, Littmann, Bartels, Gedon, Rudolf Seitz, Ludwig Herterich, Benno Becker"[98] or Prince Rupprecht of Bavaria in conversation or playing tarot over a glass of beer. The leading members of Allotria had the reputation among Munich artists of being elitist and clannish, always a step ahead of the eager younger artists when it came to public or private commissions, as Josef Ruederer ironically comments in his "Munich Satires" (1907): "Their agenda is art, their aim mutual patronage. Anyone who does not belong to their circle, anyone who does not at least have an acquaintance among all the cousins and cousins' cousins of the bakers and millers, never gets a commission in Bierheim, at least not an official one, for an equestrian statue of a prehistoric pile-dweller, or for a patriotic fountain or a municipal building."[99]

Also characteristic of the image of the "art city" Munich was a contradictory mixture of progressive and traditional forces. The conflict between high-class successful artists on the one hand, and impoverished artists on the other, between traditionally-orientated Neo Baroque or Neo Renaissance styles and modern forms of expression, produced a cultural humus on which such dissimilar figures as the anarchistic writer Erich Mühsam and the neo-classicist poet and Nobel prize winner Paul Heyse could thrive side by side and occasionally even move in the same social circles, as Franz Blei reports: "You leave one circle, and the next circle takes you in.... Everyone belongs where they are, and everywhere else. Everyone visits everyone else. Everyone is a member of all the circles or of none. When you have come to the end of the social round, you start at the beginning again. When you cannot appear in one particular suit anymore, you simply dress up. When you have no more costumes left to dress up in, you dress up in that suit which you recently thought you could not appear in anymore. That is how Borchardt described the essence of social life in Munich. And thus Munich was the city of an instinctive democracy and of carnival."[100]

Frank Eugene felt totally at home in these surroundings, visiting the fashionable artists' haunts such as Café Stefanie and Simplizissimus, just like the writer Hans Brandenburg, who has left us a vivid portrait of Eugene as a restless and much-loved member of the Schwabing bohème. In his memoirs of his youth, published in 1953 under the title "München leuchtete," he says of Eugene: "He was a man of indeterminate age. His small broad figure in comfortable, usually dark blue jackets, stood and moved about on short but decidedly agile and nimble legs in wide gray trousers with no crease. A bushy gray beard and mustache surrounded chin and mouth, the strong skull above a round forehead was shiny and the hair thinning. But to the sides of his nice chubby nose, under thorny brows, sparkled magnificent blue eyes, like eternal youth. They laughed at life

Kunstphotographie in München um 1900

München war erstmals 1898 anläßlich der Internationalen Elite-Ausstellung künstlerischer Photographien in der Secession, die von dem Maler und Photographen Fritz Matthies-Masuren organisiert worden war, mit den Zielen der Kunstphotographie in Berührung gekommen. Hier waren gemeinsam mit Plakaten, Lithographien, Aquarellen von Felicien Rops, Aubrey Beardsley, Eugène

Lenbach, die nach Besuch »der Ausstellung die höchste Anerkennung zollten«,[104] und erst in zweiter Linie an die ortsansässigen Photographen.

Gleichwohl war seitdem das Interesse an der künstlerischen Photographie auch in den Kreisen der Münchner Atelierphotographen spürbar gewachsen. So wurde im Oktober 1900 auf Initiative des 1894 gegründeten Süddeutschen Photographen-Vereins eine reformorientierte Ausbildungsstätte für Berufsphotographen, die Lehr-

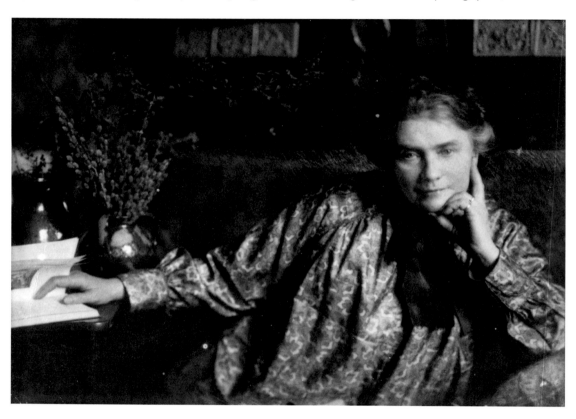

47. Margaretha Willer, c. 1903
D.O.P., 12.2 x 17.1 cm
Fotomuseum im Münchner
Stadtmuseum (93/1056-2)

Carrière, Alphonse Mucha, Henri Toulouse-Lautrec und Edouard Vuillard auch großformatige Gummidrucke des österreichischen ›Trifoliums‹ Hans Watzek, Hugo Henneberg und Heinrich Kühn sowie Arbeiten von nordamerikanischen, französischen, englischen und deutschen Piktorialisten wie Alfred Stieglitz, Robert Demachy, James Craig Annan, Theodor und Oskar Hofmeister und vielen anderen zu sehen.[102] »Der Hauptzweck der Ausstellung in der Secession ist aber der, dass diejenigen ausgewählten Werke (...) als künstlerische Leistungen anerkannt und Maler angeregt werden, sich dieses neuen und selbständigen Ausdrucksmittels zu bedienen.«[103] Folglich richtete sich die Ausstellung vornehmlich an die Secessions-Mitglieder in München wie Habermann, Stuck, Uhde, Zügel, Herterich und

und Versuchsanstalt für Photographie, mit Unterstützung des bayerischen Staates, der Stadt München und der süddeutschen Photoindustrie in München eröffnet. In Anbetracht der tiefgreifenden ästhetischen und ökonomischen Krise der Atelierphotographie, die durch die massenhafte Herstellung von Porträts in der sogenannten ›Warenhausphotographie‹ ausgelöst worden war, bemühte sich die Münchner Lehranstalt um eine grundlegende Reformierung der Bildästhetik.[105] Analog zu der Reformbewegung des Kunstgewerbes, an dessen englischen Vorbildern William Morris, Walter Crane oder Lewis Day sich die Schulgründer orientierten, versuchte man, sich vom gründerzeitlichen Stilvokabular des Historismus zu befreien und auch für die Photographie »Materialechtheit« einzufordern: »Nicht die mechanisch

and seemed to see beauty everywhere. Although he spoke gibberish, however fluently in his Anglo-American slang, he was a Munich character through and through.... He used the familiar "du" form to address people he liked, be it man or woman, but more in an English manner than in that over-familiar manner typical of Conrad. And he liked genuine people. Whenever he perceived a humorous tone he would grasp the speaker brusquely but warmly by the shoulders and throw back the upper part of his body with a bright snort of laughter which escaped out between his nose and his mustache."[101]

Art Photography in Munich around 1900

Munich first came into contact with the aims of art photography in 1898 through the International Elite Exhibition of Art Photographs in the Secession, organized by the artist and photographer Fritz Matthies-

North American, French, English and German pictorialists such as Alfred Stieglitz, Robert Demachy, James Craig Annan, Theodor and Oskar Hofmeister and many others.[102] "The main aim of the exhibition in the Secession, however, is to gain recognition for these works as artistic achievements ... and to provide encouragement for painters to avail themselves of this new and independent means of expression."[103] Consequently, the exhibition was directed primarily at the Munich Secession members such as Habermann, Stuck, Uhde, Zügel, Herterich and Lenbach, who after their visits "bestowed the greatest of praise on the exhibition."[104] The local photographers were only the secondary addressees. However, as a result of the exhibition interest in art photography among studio photographers in Munich increased noticeably. Thus in October 1900, at the initiative of the Süddeutscher Photographen-Verein (South German Photographers' Association), founded in 1894, a reform-orientated training center for professional pho-

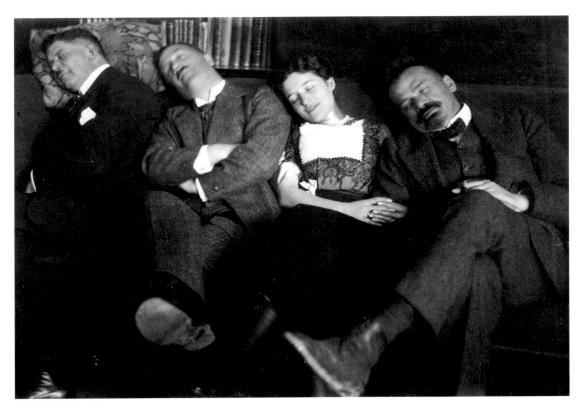

48. Untitled, c. 1910
(Julius Diez, 2nd from left;
Adolf Hengeler, right)
D.O.P., 12.2 x 17.1 cm
Fotomuseum im Münchner
Stadtmuseum (93/1056-2)

Masuren. Among the exhibits were posters, lithographs, and watercolors by Felicien Rops, Aubrey Beardsley, Eugène Carrière, Alphonse Mucha, Henri Toulouse-Lautrec and Edouard Vuillard, large-format gum platinum prints by the Austrian "Trifolium" Hans Watzek, Hugo Henneberg and Heinrich Kühn, and works by

tographers was inaugurated in Munich under the name of the Lehr- und Versuchsanstalt für Photographie (training and research institute of photography). It was funded by the State of Bavaria, the City of Munich and the photography industry in southern Germany. In view of the profound aesthetic and economic crisis in studio

erlernbare seelenlose Technik, die den früheren Erzeugnissen der Berufsphotographie den Stempel der künstlerischen Bedeutungslosigkeit aufdrückte, sondern individuelles Erfassen charakteristischer Momente und eigene Empfindungen in photographischen Werken zum Ausdruck zu bringen, die Erkenntnis dieser zum künstlerischen Schaffen unentbehrlichen Grundsätze in jedem einzelnen Schüler zu wecken: das ist die Aufgabe, deren Durchführung die Anstaltsleitung in erster Linie erstrebt.«[106] Die klassischen Accessoires der Photoateliers

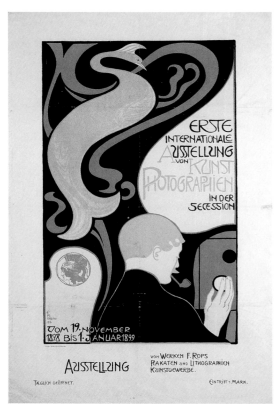

49. *Emil Rudolph Weiss*
Poster for the "Erste Internationale Ausstellung von Kunst Photographien in der Secession," Munich 1898
Lithograph, 107.5 x 70 cm
Graphiksammlung im Münchner Stadtmuseum (B 1/116)

wie Säulen aus Pappmaché oder illusionistische Hintergründe wurden als falscher Zierat abgelehnt. Stattdessen bemühte man sich in der Bildnisdarstellung um eine ›natürlichere‹ Umgebung, die vor allem im Freien oder im bürgerlichen Wohnrauminterieur gesucht wurde.
Der Lehranstalt stand ein beratendes Kuratorium voran, dem neben Vertretern der Stadt München und der bayerischen Staatsregierung auch bekannte Personen aus dem Druckgewerbe, der Berufsphotographie und den Reproduktionsanstalten angehörten. Der eigentliche ›spiritus rector‹ war der Photohändler und Journalist Georg Heinrich Emmerich, der die ästhetischen Maximen der Ausbildung weitgehend prägte und definierte, obwohl er keine praktische Lehrtätigkeit ausübte. In seiner Position als Direktor verstand er es, seine organi-

satorischen und kaufmännischen Fähigkeiten immer wieder geschickt einzusetzen, so daß er zwischen 1897 und 1914 als Juror und Organisator von zahlreichen Photoausstellungen im In- und Ausland wirkte. Neben den Ausstellungen des Süddeutschen Photographen-Vereins leitete Emmerich kommissarisch die deutschen Abteilungen ›künstlerische Photographie‹ auf der ›Internationalen Ausstellung für moderne dekorative Kunst‹ in Turin 1902, der Weltausstellung in Turin 1911 und der baltischen Ausstellung in Malmö 1914. Auf der Internationalen Photographischen Ausstellung in Dresden 1909 war Emmerich für die Zusammenstellung der Abteilung Berufsphotographie und die Konzeption des ›Fürstensaales‹ zuständig, in dem Photoamateure aus der europäischen Hocharistokratie ihre Bilder zeigten.[107] Emmerich plädierte für eine »universelle Bildung«, um die enggesteckten Grenzen der berufsphotographischen Ausbildung zu durchbrechen. Dazu zählten die Fächer »Zeichnen, Kompositionslehre, Vignettenmalerei, die Elemente der Perspektive, Uebungen im perspektivischen Zeichnen, Schattenlehre, Physik, photographische Optik, Photochemie, die Geschichte der Photographie und Reproduktions-Techniken, praktische Photographie, Negativprozeß, Operationsfach, Retouche, landschaftliche Photographie, Positivprozeß, Kopierverfahren, Vergrößerungsverfahren, gewerbliche Buchführung« und auch das Studium der Kunst und des Kunstgewerbes.[108] Eine Studie über die Situation des Kunstgewerbes in München konstatierte, daß »Leute, die allgemein künstlerisch vorgebildet sind, sich einige Fähigkeiten im Zeichnen geholt haben und in der Kunstgeschichte nicht ganz unbewandert sind, (...) einen wesentlichen Vortritt vor den übrigen Photographen haben.«[109]
Zu den Lehrmitteln der Photoschule gehörte auch eine umfangreiche Bibliothek mit über 1000 Bänden und Fachzeitschriften aus Deutschland, England, Frankreich und Nordamerika sowie eine Kollektion von Arbeiten der deutschen und internationalen Kunstphotographie, die von Heinrich Kühn, Hugo Henneberg, Hans Watzek, Alfred Stieglitz und Frank Eugene stammten und den Schülern als »Vorbildersammlung« dienten. Schon bald nach der Gründung erfreute sich die Schule regen Zulaufes und sie konnte sich als eines der führenden Institute ihrer Art in Europa etablieren, deren Schüler meist aus Deutschland, aber auch aus dem Ausland kamen. Während im ersten Jahr zwanzig Schüler den Unterricht frequentierten, konnten 1901 bereits eine zweite Klasse geschaffen und zwei weitere Fachkräfte für Photographie und Zeichnen berufen werden. 1902 fand die erste Schülerausstellung statt, 1903 wurden der erste Meisterkurs für Photographen abgehalten und eine

photography, brought about by the mass production of portraits through so-called "department store photography," the Munich institute was concerned with bringing about a fundamental reform in photographic aesthetics.[105] Similar to the reform movement in the arts and crafts, the English representatives of which, William Morris, Walter Crane and Lewis Day, served as models for the institute's founders, efforts were to be made to abandon the stylistic vocabulary of Gründerzeit historicism and to demand of photography "authenticity" in its choice of materials: "Not to acquire the mindless mechanical technique which gave the early productions of commercial photography the stamp of artistic insignificance, but to lend photographic expression to individual perceptions of characteristic moments and to personal emotions, and to awaken in each individual pupil an awareness of these principles, so indispensable for artistic creativity: that is the primary task which the directors of the institute are striving to fulfill."[106] The classical accessories used in photographers' studios, such as papier maché columns or illusionistic backdrops, were to be abandoned as false ornamentation. Instead, efforts were to be made to have more "natural" surroundings in portrait photographs. These could be sought outdoors, or in bourgeois living-room interiors. The Lehr- und Versuchsanstalt had an advisory board made up of well-known personalities from the fields of printing, commercial photography and reproduction processes, not to mention representatives of the City of Munich and the Bavarian State Government. But the real "spiritus rector" was the journalist and photographic dealer Georg Heinrich Emmerich, who to a great extent influenced and defined the aesthetic principles adhered to in the syllabus, although he himself did not do any actual teaching. In his position as director he understood how to bring his organizational and business talents to bear, with the result that between 1897 and 1914 he was decisively involved in numerous national and international photographic exhibitions both as a juror and as organizer. In addition to the exhibitions of the Süddeutsche Photographen-Verein, Emmerich was acting curator for the German Art Photography sections at the "International Exhibition of Modern Decorative Art" in Turin in 1902, the World Fair in Turin in 1911, and the Baltic exhibition in Malmö in 1914. At the "International Photographic Exhibition" in Dresden in 1909 Emmerich was responsible for putting together the Professional Photography section and for the conception of the "Royal Room" in which amateur photographers from Europe's aristocracy showed their works.[107] Emmerich advocated a "universal education" so as to break out of

the narrow confines of traditional training for professional photographers. That education was to include "drawing, composition, painting vignettes, the elements of perspective, practice in perspective drawing, the principles of silhouettes, physics, photographic optics, photochemistry, the history of photography and reproduction techniques, practical photography, negative processing, retouching, landscape photography, positive processing, copying processes, enlarging, bookkeeping," and the study of art and the arts and crafts.[108] A report on the status of the arts and crafts in Munich showed that "people who already have some general artistic training, have developed a certain ability in drawing, and are not totally new to the history of art ... have a considerable advantage over the other photographers."[109]

The teaching materials at the Lehr- und Versuchsanstalt included an extensive library of more than 1,000 volumes and special magazines and journals from Germany, England, France and North America, as well as a collection of works by German and foreign art photographers, among others, by Heinrich Kühn, Hugo Henneberg, Hans Watzek, Alfred Stieglitz and Frank Eugene, which served as "a collection of models" for the students. The Lehr- und Versuchsanstalt enjoyed great popularity from the moment of its inauguration and was able to establish itself as one of the leading institutes of its kind in Europe. The majority of its students came from Germany, but many came from abroad as well. In its first year, twenty students attended classes, by 1901 a second class had to be created and two additional teachers appointed for photography and drawing. The first exhibition of students' works took place in 1902, and in 1903 the first master class for photography was given and a portfolio of fifteen studies produced. In 1904 a department for collotype printing and photogravure was set up making the study of reproduction processes possible.[110]

Once he had decided in 1903 to settle in Munich, Frank Eugene's subsequent professional fate was closely bound up with the progress of the Lehr- und Versuchsanstalt.[111] At that time Eugene was known in Germany above all as an American art photographer and member of the Photo-Secession, whereby his artistic method gave rise to controversial debates. His artful manipulations of the negative and positive were strictly rejected as inappropriate for the media of photography by the leading German theoreticians of art photography Willi Warstat and Fritz Matthies-Masuren. They were regarded as an illegitimate recourse to the techniques of painting and graphics and linked above all with the pictorial language

50. *James Craig Annan*
Two Ladies of Verona, 1897
Photogravure, 21.6 x 28.7 cm
from: William Buchanan, *The
Art of The Photographer J. Craig
Annan 1864–1946*, Edinburgh
1992, III. 14

Studienmappe mit fünfzehn Arbeiten herausgegeben.
Als 1904 eine graphische Abteilung für Lichtdruck und
Photogravüre eingerichtet wurde, war auch das Studium
der Reproduktionsverfahren möglich geworden.[110]
Frank Eugenes zukünftiges berufliches Schicksal sollte
mit der Entwicklung der Schule eng verbunden sein,
nachdem er 1903 entschieden hatte, sich dauerhaft in
München niederzulassen.[111] Zu diesem Zeitpunkt war
Eugene in Deutschland vor allem als amerikanischer
Kunstphotograph und Mitglied der Photo-Secession
bekannt geworden, wobei seine bildnerische Methode
wie in Nordamerika kontroverse Diskussionen auslöste.
Von den führenden deutschen Theoretikern der Kunst-
photographie Willi Warstat und Fritz Matthies-Masuren
wurden zeichnerische Eingriffe im Negativ und Positiv
als nicht mediengerecht strikt abgelehnt. Man sah darin
einen nicht legitimen Rückgriff auf die Bildtechniken der
Malerei und Graphik und brachte sie vor allem mit sym-
bolistischen Bildinhalten in Verbindung: »Der Photo-
graph«, so Fritz Matthies-Masuren, »der Lichtbildner
kann die engeren Grenzen der Kunst aber, innerhalb
deren die Phantasie ein unbeschränktes Regiment führt,
nicht überschreiten. Er kann keinen Heiligenschein fest-
halten, weil unser sterbliches Auge so wenig wie die
Linse des Apparates einen solchen aus der Wirklichkeit
wahrnehmen kann. (...) Er kann keine Madonnen, Dry-
aden, Bacchanten, nicht die Welle symbolisch darstel-
len. (...) Die Kunstphotographie ist an die Gegenständ-
lichkeit der Dinge gebunden. Die Aufgabe der im
engeren Sinne frei schöpferischen, der gestaltenden
Kunst sind ihr zu lösen versagt. (...) Kommen nun aber
Symbolismus, Griffel und Pinsel für den Lichtbildner in
Wegfall, sinkt dann mit ihnen auch seine Ausdrucksfä-
higkeit? Nein. (...) Der Kunstphotograph halte sich an
die Natur. Alle Projekte und Ideen nützen ihm wenig. Er
braucht seine Bilder nicht zu erfinden. Fertig findet er sie
vor, er hat nur nötig, sie aus der Natur herauszu-
schälen.«[112]
Die selbe Diskussion fand gleichzeitig in Nordamerika
ihren Höhepunkt. Hatte Edward Steichen in einem 1902
veröffentlichten Beitrag »Grenzen« noch für die völlige
gestalterische Freiheit des Photographen plädiert,[113] so
wurde insbesondere Sadakichi Hartmann mit seinem
»Plea for straight photography« anläßlich der Ausstel-
lung der Photo-Secession in Pittsburgh 1904 zum Wort-
führer jener Kritiker, die sich gegen den Subjektivismus
der »Whistlers of Photography« Coburn, Eugene,
Steichen und Demachy richteten: »Was diese Arbeiter
verbindet, scheint nur eine allgemeine Vorliebe für das
Mysteriöse und Abwegige zu sein, sie gefallen sich im
Verwischen sämtlicher Umrisse und Details, die sich in

diffusen Schatten verlieren, sodaß ihre Bedeutung und
Aussage schwer zu entdecken sind.«[114] Ungeachtet dieser
Kritik sollte Eugene unverändert Anerkennung finden
und seine Bildtechnik von bekannten Piktorialisten wie
Joseph Keiley und Anne Brigman aufgegriffen werden.[115]

Geniekult und Musenkuß: Porträts aus Aristokratie und Bürgertum

Zwischen 1901 und 1906 unternahm Eugene ausgedehnte
Reisen nach Holland, England, Frankreich, Italien, Grie-
chenland, in die Karibik auf die Bermuda-Inseln und
nach New York, wo er sich ab Februar 1906 für ein Jahr
aufhielt.[116] Schon bald nach seiner Rückkehr nach Mün-
chen konnte Eugene Ende im Mai 1907 eine nicht näher
bekannte Auswahl seiner Porträt-, Landschafts- und Akt-
photographien im Kunstverein vorstellen, die parallel zu
einer Gedächtnisausschau des im März 1907 verstorbe-
nen Malers Karl Gussow stattfand. »Nicht weniger Inter-
esse als die malerischen Darbietungen dieser Woche
wird man einer Kollektion ›künstlerischer Photographien‹
von Eugene Frank Smith entgegenbringen. Eine Reihe
hervorragender Münchener Künstler hat Frank Smith
eine Porträtsitzung bewilligt und wir sehen sie in unge-
mein malerisch anmutenden Bildnissen vor uns. Man
kann sich manchmal des Gefühls der Verwunderung und
des Staunens nicht erwehren, sieht man, was dieser
Lichtbildner für eigenartige an Radierungen und Schab-
kunstblätter gemahnende Wirkungen erzielt. Man mag
seine Bedenken gegen die ›künstlerische Photographie‹
haben; vor diesen Blättern wird man ohne weiteres zu-
geben, daß gewisse künstlerische Faktoren bei dieser
Herstellung beteiligt sind.«[117]
Während Eugenes Aktstudien mit den sizilianischen
Freilichtakten von Wilhelm von Gloeden verglichen wur-
den, erregte die eindrucksvolle Porträtserie der bekannte-
sten Münchner Künstler, von denen die Berichterstat-
tung in den *Münchner Neuesten Nachrichten* die
Bildnisse Franz von Defregger, Gabriel und Emanuel von
Seidl, F. August von Kaulbach, Hugo von Habermann,
Adolf Oberländer, Adolf von Hildebrand, Adolf
Hengeler, Franz von Stuck, Benno Becker, Toni Stadler,
Fritz von Uhde, Ernst Possart und Georg Hirth hervor-
hob, das besondere Interesse des Publikums. Auf den
ersten Blick überrascht diese Galerie prominenter Vertre-
ter aus der Münchner Künstlerschaft, da nicht ein einzi-
ges der genannten Bildnisse auf den vorhergegangenen
Ausstellungen Eugenes gezeigt worden war. Auf der er-
sten Internationalen Ausstellung für künstlerische
Bildnisphotographie in Wiesbaden 1903, an der Eugene
immerhin mit dreiundzwanzig Arbeiten beteiligt war,

of symbolism: "The photographer or "Lichtbildner" may not, "according to Fritz Matthies-Masuren", go beyond the narrower confines of art, within which, however, his fantasy enjoys unlimited freedom. He cannot introduce a halo, because our mortal eye is as unable to perceive such a halo in reality as the lens of the apparatus.... He cannot symbolically depict Madonnas, dryads, and Baccantes, or even a wave.... Art photography is bound to the concreteness of things. It is not entitled to solve the task of art, which in the narrow sense is freely creative, productive..... Should symbolism, pen and brush be denied the photographer, would his powers of expression decrease? No.... The art photographer should rely on nature. All projects and ideas are of little use to him. He does not need to invent his images. He finds them out there, complete. All he has to do is peel them away from nature."[112]

The same discussion was also taking place in North America. In an article entitled "Boundaries" published in 1902, Edward Steichen had advocated complete artistic freedom for the photographer.[113] This was followed in 1904 by Sadakichi Hartmann's "plea for straight photography" which he made on the occasion of the Photo-Secession exhibition in Pittsburgh and which made him the spokesman of those critics opposed to the subjectivism of the so-called "Whistlers of Photography," Coburn, Eugene, Steichen, and Demachy: "It is only a general tendency towards the mysterious and bizarre which these workers have in common; they like to suppress all outlines and details and lose them in delicate shadows, so that their meaning and intention become hard to discover."[114] Despite this criticism, Eugene was to continue to receive recognition, and his technique was taken up by renowned pictorialists such as Joseph Keiley and Anne Brigman.[115]

The Cult of the Genius and the Kiss of the Muse: Portraits of the Aristocracy and the Bourgeoisie

Between 1901 and 1906, Eugene undertook extended trips to Holland, England, France, Italy, Greece, the Caribbean and the Bermuda islands. He also spent a year in New York as of February 1906.[116] Soon after his return to Munich he was able to organize an exhibition of his portraits and landscape and nude photographs, about which unfortunately few details have survived. It took place in May 1907 in the Art Association, parallel to a commemorative exhibition for the painter Karl Gussow who died in March of that year: "A collection of "art photographs" by Eugene Frank Smith is also destined to attract as much attention this week as the paintings on

offer. A series of prominent Munich artists agreed to sit for Smith and here we see them before us in highly artistic portraits. It is often not possible to resist a feeling of admiration and astonishment when one see what this photographer has achieved in the way of unique effects reminiscent of etchings and mezzotint engravings. Whatever one's reservations about "art photography," confronted with these portraits one has to confirm that their production involves certain artistic factors."[117] Whereas some of Eugene's nude studies were compared with the Sicilian plein air nudes of Wilhelm von Gloeden, the public was particularly taken by his impressive portrait series of famous Munich artists. The *Münchner Neueste Nachrichten* made special mention of the portraits of Defregger, Gabriel and Emanuel von Seidl, Fritz August von Kaulbach, Hugo von Habermann, Adolf Oberländer, Adolf von Hildebrand, Adolf Hengeler, Franz von Stuck, Benno Becker, Toni Stadler, Fritz von Uhde, Ernst Possart and Georg Hirth. At first glance, this gallery of prominent representatives of Munich's art circles came somewhat as a surprise, as not one of the portraits mentioned had been shown at previous exhibitions. At the first "International Exhibition of Art Photography Portraits" in Wiesbaden in 1903, the twenty-three works by Eugene on show had included almost

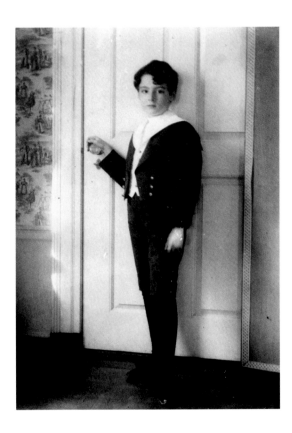

51. Master Bliss-Lane, c. 1903
Platinum print, 16.6 x 11.3 cm
Fotomuseum im Münchner
Stadtmuseum (93/756-33)

hatte er fast ausschließlich amerikanische Porträts von Zeitgenossen wie Stieglitz, Irving, Anton Seidl oder Dr. Peder Bruguière, den älteren Bruder des mit ihm befreundeten Photographen Francis Bruguière, vorgestellt. Auch anläßlich der nachfolgenden Ausstellungsbeteiligungen in Washington, Dresden, Den Haag, Bradford, Pittsburg, Wien, Berlin, London oder New York trat Eugene mit Porträts Münchner Künstler nicht in Erscheinung. So liegt die Vermutung nahe, daß die Ausstellung im Münchner Kunstverein das Ergebnis mehrjähriger Vorbereitungen und gezielter Vorarbeit darstellte. Gleichwohl sind manche Porträts vermutlich erst in den Monaten unmittelbar vor der Ausstellung zwischen Februar und Mai 1907 entstanden, wie ein Brief von Adolf Hengeler an den Präsidenten der Münchner Sezession Hugo von Habermann veranschaulicht: »Herr Smith (ein alter Freund von mir aus der Malschulzeit) möchte hier eine Ausstellung seiner sehr künstlerischen Photographien veranstalten. Nun liegt ihm aber sehr viel daran, daß die Collection auch Porträts hiesiger bekannter Persönlichkeiten enthält. Ich möchte Dich nun freundlichst ersuchen, die ausgezeichnete Sache des Herrn Smith dadurch zu unterstützen, daß Du ihm ein paar Minuten zu einigen Aufnahmen gewährst. Herr S. wird sich bei seinem Besuche auf mich berufen und eventuell Dich schon vorher antelefonieren.«[118] Dank der Protektion und Vermittlung einflußreicher Freunde wie Hengeler oder Emanuel von Seidl konnte Eugene vermutlich weitere Kontakte zu bekannten Münchner Künstlern knüpfen, denen er im Tausch für die Bereitschaft, sich porträtieren zu lassen, einige Bildproben als Anerkennung und Dank überließ, so geschehen bei Hugo von Habermann.[119]

Der größte Teil der Dargestellten war als Professoren an der Akademie der bildenden Künste, der Königlichen Kunstgewerbeschule oder den Künstlervereinigungen Allotria und Secession zugehörig und zählte zu den etablierten Kreisen der Münchner Künstlerschaft. Mit diesem Porträtatlas von Prominenten aus Aristokratie, Großbürgertum und Künstlerschaft stand Eugene in Deutschland keineswegs einzig da. Mit Rudolf Dührkoop in Hamburg, Nicola Perscheid in Berlin und Hugo Erfurth in Dresden sind die bekanntesten Berufsphotographen in Deutschland vor 1914 genannt, die sich als Künstler- und Prominentenporträtisten etablieren konnten.[120] Aber auch der aus München gebürtige und in London lebende Photograph Emil Otto Hoppé hatte ein respektables Pantheon von Wissenschaftlern, Schauspielern, Politikern, Künstlern und Adeligen vorzuweisen, das Namen wie F.A. von Kaulbach, G. Hirth oder Prinz Ludwig von Bayern beinhaltete.[121] In Mün-

52. Hugo von Habermann, 1907
Autotype
Fotomuseum im Münchner
Stadtmuseum

chen zählten zu den bekanntesten Photoateliers, die im Stile der internationalen Kunstphotographie porträtierten und mit Bildnissen prominenter Persönlichkeiten warben, die Studios von Wanda von Debschitz-Kunowski[122], Stephanie Ludwig-Held (Atelier Veritas)[123], Elisabeth Hecker (Atelier Elisabeth), Elias van Bommel, Franz Grainer[124], Eduard Wasow und Gebrüder Lützel. Aber auch Malerphotographen wie Fritz Matthies-Masuren waren in München als Künstlerporträtisten hervorgetreten.[125] Ob Eugene plante, ein regelrechtes Mappenwerk mit Darstellungen prominenter Künstler und Intellektueller herauszugeben, wie dieses zur selben Zeit von Rudolf Dührkoop mit seiner Sammelmappe bekannter Persönlichkeiten *Hamburgische Männer und Frauen am Anfang des XX. Jahrhunderts* (1905) oder von Alvin Langdon Coburn mit Porträts von englischen Intellektuellen wie Bernhard Shaw, G.K. Chesterton, George Meredith oder H.G. Wells in *Men of Mark* (1913)[126] verwirklicht wurde, muß angesichts fehlende Zeugnisse wohl eher bezweifelt werden.

Eugenes Konzentration auf ›Herrenbildnisse‹ spiegelt auf verschiedene Weise das gesellschaftliche Bedürfnis nach Persönlichkeits- bzw. Geniekult und das traditionelle Geschlechterverhältnis vor 1914 wieder. Die porträtierten Männer aus Künstlertum, Aristokratie und Großbürgertum werden als ausgeprägte Charakterköpfe mit markanten individuellen Zügen und in psychologischer Tiefe häufig als Brustbild dargestellt, während die Frauen aus der gehobenen Gesellschaft vor allem als Verkörperung eines dekorativen Schönheitsideals wiedergegeben sind. Mit Hilfe weniger Accessoires wie Muschel, Perlenkette und Blütenzweig wird diese Absicht unterstützt, wie Eugene auch auf die Wiedergabe der Stofflichkeit des Gewandes großen Wert legte. Gelegentlich werden die Frauen als Personifikation von Musik dargestellt, meist als Geigen- oder Lautenspielerin in der Pose des empfindsamen, introvertiert verträumten Charakters, dessen seelischer Ausdruck das verfeinerte Lebensgefühl der ›Dame‹ aus höheren Gesellschaftskreisen widerspiegelt. Diese repräsentiert, um in den Worten von Fritz von Ostini zu sprechen, »das Weib in der feinsten, differenziertesten und anziehendsten Form, die unsere Zeit ausbildete, durchgeistigt durch Erziehung, körperlich veredelt durch Zuchtwahl und Kultur, gehoben durch geschmackvolle Kleidung und Umgebung.«[127] Damit unterscheidet sich Eugenes Bildwelt nur unwesentlich von der des Malers Friedrich August von Kaulbach, den gefeierten Porträts des Adels und Großbürgertums, dessen Porträtatlas eine konservative und stark patriarchalisch geprägte Gesellschaft dokumentierten, in der die Frauen die Rolle der seelenvollen Muse einnahmen.

exclusively portraits of American contemporaries such as Stieglitz, Irving, Anton Seidl and Dr. Peder Bruguière, the older brother of his photographer friend Francis Bruguière. Furthermore, in the subsequent exhibitions in Washington, Dresden, The Hague, Bradford, Pittsburg, Vienna, Berlin, London and New York, Eugene did not show any portraits of Munich artists, so presumably the exhibition at the Munich Art Association was the result of several years of deliberate preparation. At the same time, several of the portraits were obviously only done in the months prior to the exhibition, i.e., between February and May 1907, as indicated by a letter which Adolf Hengeler wrote to the president of the Munich Secession Hugo von Habermann: "Mr. Smith (an old friend of mine from our art school days) would like to organize an exhibition here

Munich artists to whom he later gave copies of the photographs as a gesture of thanks and in exchange for their willingness to sit for him, as in the case of Hugo von Habermann.[119]

The majority of the sitters were from the Akademie der bildenden Künste (Academy of Fine Arts), the Königliche Kunstgewerbeschule (Royal College of Arts and Crafts), or the artists societies Allotria and Secession, or were from the established Munich art circles. Eugene was not alone in Germany with this kind of portrait portfolio of prominent figures from among the aristocracy, the haute bourgeoise and art circles. Rudolf Dührkoop in Hamburg, Nicola Perscheid in Berlin and Hugo Erfurth in Dresden were the most established professional photographers in Germany before 1914 and were renowned as portrait pho-

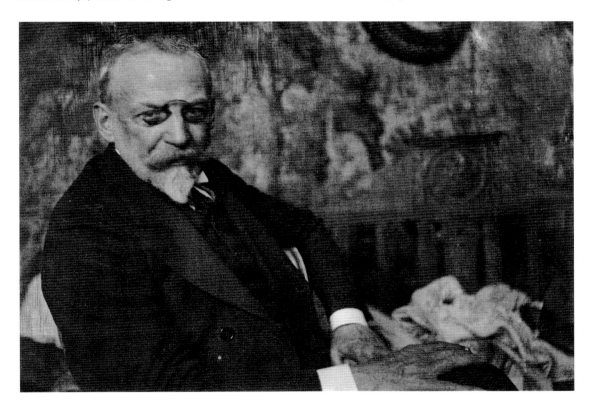

53. Hugo von Habermann, 1907
Platinum print, 11.4 x 16.3 cm
Fotomuseum im Münchner
Stadtmuseum (88/27-36)

of his highly artistic photographs. He is particularly concerned that the collection should also contain portraits of renowned local personalities. Thus I would like to ask if you would support this excellent project of Mr. Smith's by granting him a few moments of your time for some photographs. Mr. Smith will mention my name on the occasion of his visit and may even telephone you beforehand."[118] Thanks to this kind of patronage and mediation by influential friends such as Hengeler or Emanuel von Seidl, Eugene was obviously able to contact other famous

tographers of artists and prominent social figures.[120] The photographer Emil Otto Hoppé, born in Munich but living in London, also had a respectable pantheon of scholars, actors, politicians, artist and nobility to show, including such names as F. A. von Kaulbach, G. Hirth and Prince Ludwig of Bavaria.[121] Wanda von Debschitz-Kunowski,[122] Stephanie Ludwig-Held (Atelier Veritas),[123] Elisabeth Hecker (Atelier Elisabeth), Elias van Bommel, Franz Grainer,[124] Eduard Wasow and the brothers Lützel owned some of Munich's best known photographic studios.

54. Thomas Knorr, c. 1908
Platinum print, 12.0 x 16.5 cm
Fotomuseum im Münchner
Stadtmuseum (88/27-82)

55. Georg Hirth, c. 1907
Photogravure, 17.0 x 12.0 cm
Valentin Musäum, Munich

56. Rudolf Gedon, c. 1907
D.O.P., 17.0 x 12.3 cm
Dietmar Siegert, Munich

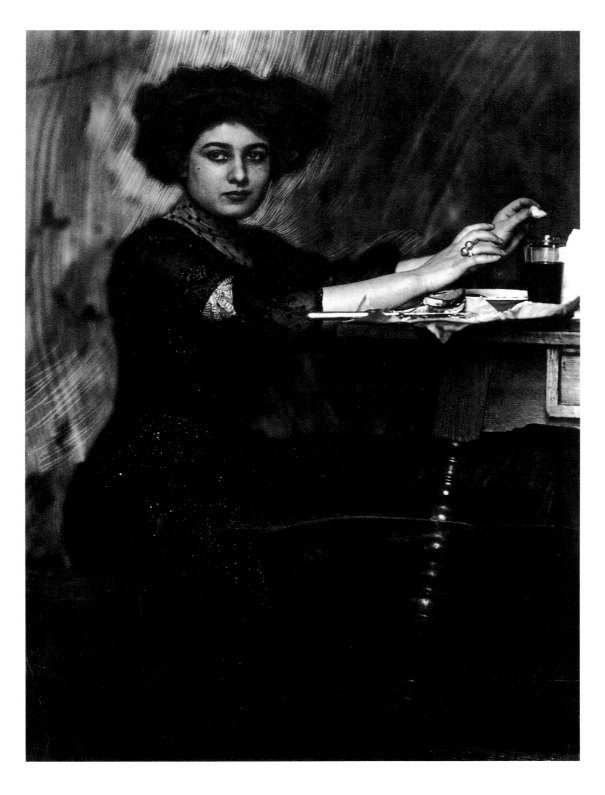

57. The Diva at Home, c. 1905
Platinum print
Metropolitan Museum of Art,
Rogers Fund, 1972 (1972.633.86)

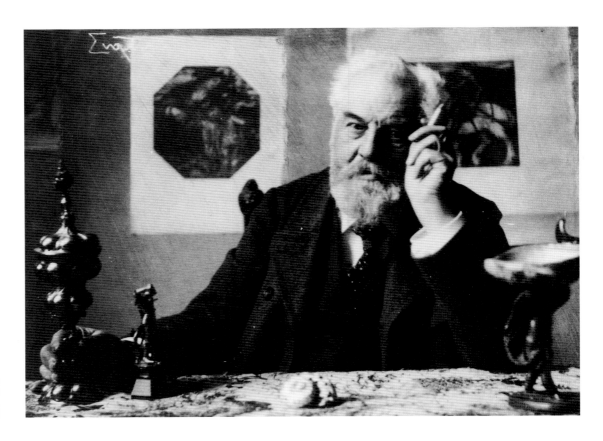

58. Fritz von Miller, c. 1907
Platinum print
Metropolitan Museum of Art,
Rogers Fund, 1972 (1972.633.127)

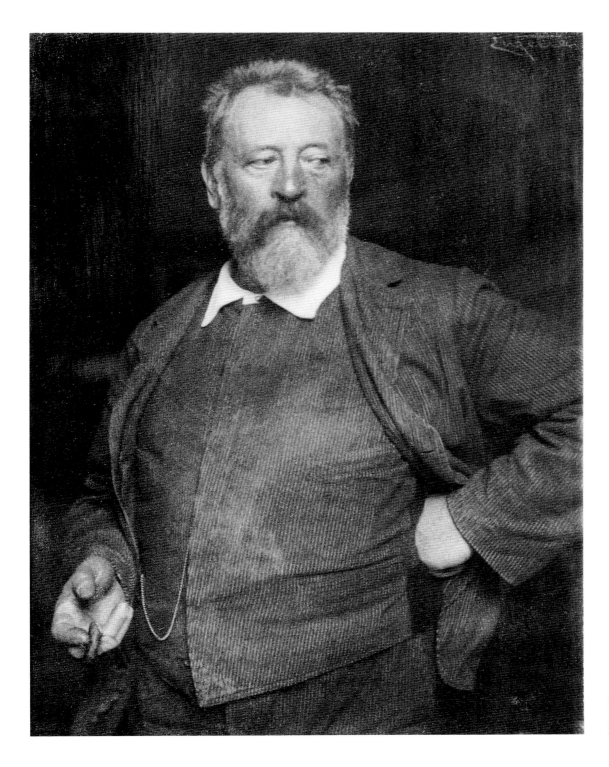

59. Adolf von Hildebrand, c. 1907
Platinum print, 17.0 x 12.0 cm
Fotomuseum im Münchner
Stadtmuseum (93/631-4)

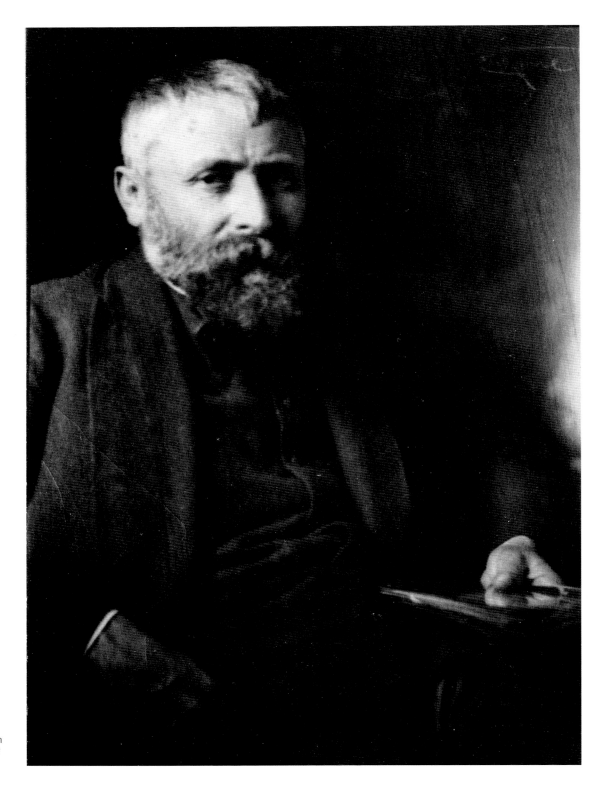

60. Carl Johann
Becker-Gundahl, c. 1907
Photogravure, 16.8 x 11.9 cm
Fotomuseum im Münchner
Stadtmuseum (93/131-3)

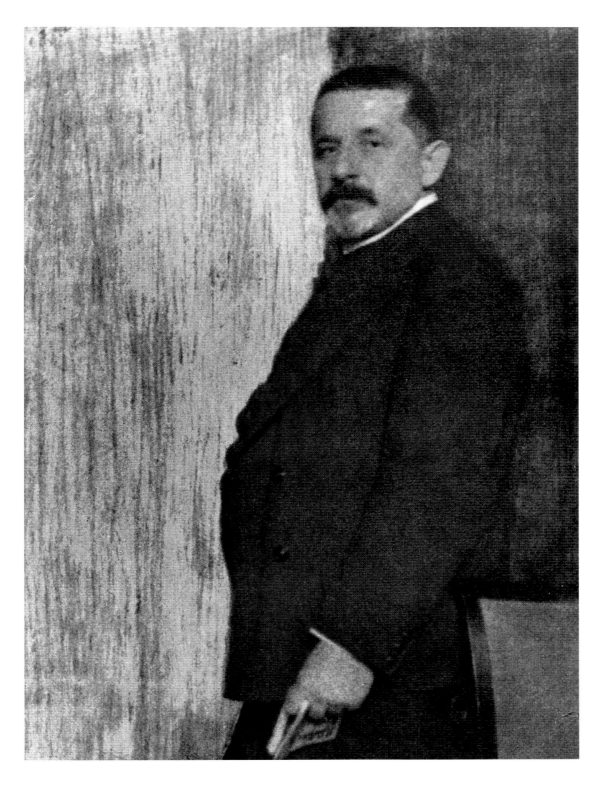

61. Benno Becker, c. 1907
from: *Photographische Kunst*,
1907/08, plate 55

62. Adolf Oberländer, 1906/07
Platinum print, 16.6 x 11.6 cm
Fotomuseum im Münchner
Stadtmuseum (88/26-5)

63. Rudolf von Seitz, 1906/07
Photogravure, 16.8 x 12.0 cm
Fotomuseum im Münchner
Stadtmuseum (88/26-19)

»Uhde hat die religiöse Malerei
aus der Erstarrung in Corneli-
anischem Klassizismus befreit,
hat das Leben des Alltags
getränkt mit Ideen eines tiefge-
fühlten, edelmenschlichen Chri-
stentums – und das verstanden
die Frommen nicht, die die Reli-
gion in Generalentreprise haben.
Man weiß, welcher Art Uhdes
religiöse Malerei ist: Seine Bilder
vereinigen Göttliches und
Menschliches, sie rücken die
fernen Geschichten des Evangeli-
ums in die greifbare Nähe der
Wirklichkeit, die ohne Kostüme
und Faltenwürfe, ohne Posen
und Attitüden ist. Christus lebt
noch unter Euch, die christliche
Grundidee ist noch nicht tot in
dieser Zeit – das wollte Uhde auf
seinen Bildern verkünden, und
das nannten seine Widersacher
ein frevles Spiel mit Sensation
und Skandal!« (G.J. Wolf, ›Ne-
krolog F. v. Uhde 1848–1911‹, in:
Die Kunst, 12, 1910/11, o.S.)

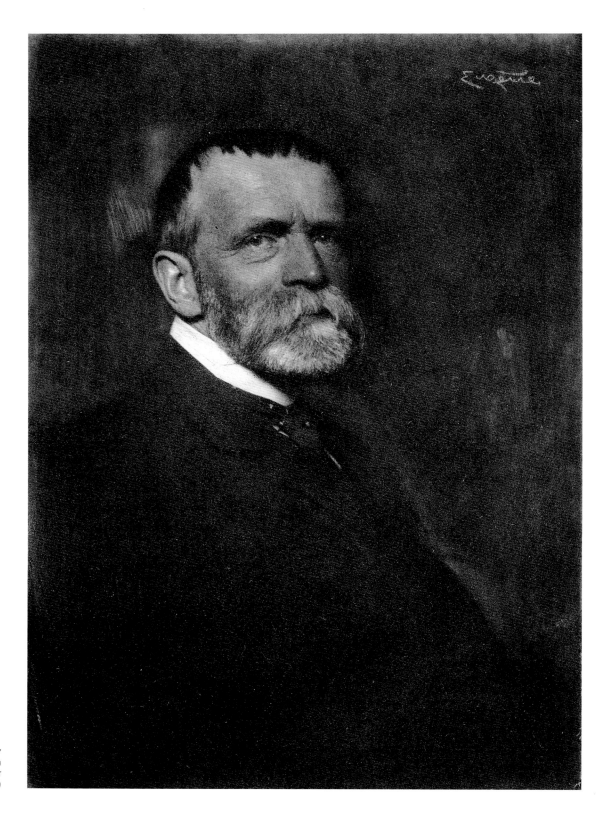

64. Fritz von Uhde, c. 1907
Photogravure, 17.8 x 12.6 cm
Fotomuseum im Münchner
Stadtmuseum (88/26-17)

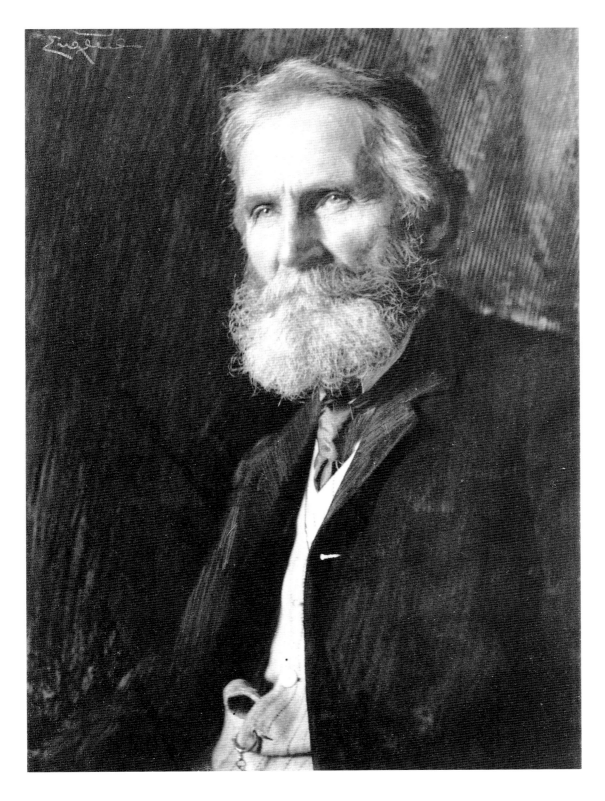

65. Franz von Defregger, c. 1907
Platinum print, 17.0 x 12.0 cm
Fotomuseum im Münchner
Stadtmuseum (88/26-2)

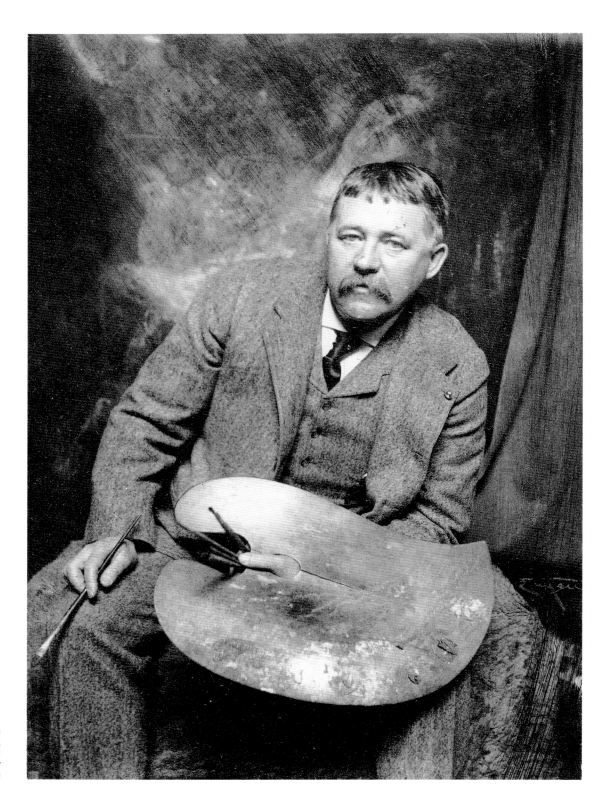

66. Portrait of an unknown
painter, c. 1905
Platinum print, 16.3 x 11.7 cm
Fotomuseum im Münchner
Stadtmuseum (88/27-84)

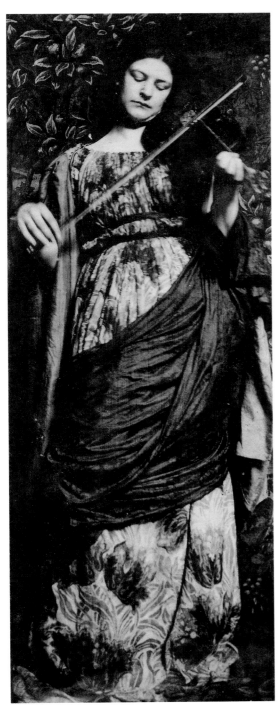

Whether Eugene planned to produce a regular portfolio of prominent artists and intellectuals, as had already been done around that time by Rudolf Dührkoop or Alvin Langdon Coburn, is doubtful in view of the lack of evidence. Dührkoop's *Hamburgische Männer und Frauen am Anfang des XX. Jahrhunderts* (1905) had included well-known Hamburg personalities, and Coburn's "Men of Mark" (1913) portraits of English figures such as George Bernard Shaw, G. K. Chesterton, George Meredith and H. G. Wells.[126]

Eugene's concentration on "portraits of gentlemen" mirrors not only the personality cult of the time but also the traditional roles of the sexes in the period up to 1914. The male sitters are represented, often in half-length photographs, as striking heads with marked individual features and psychological depth, whereas the women are depicted mainly as the embodiment of a decorative ideal of beauty. This intention is supported by the addition of a few accessories such as shells, strings of pearls and sprays of flowers, and by Eugene's particular attention to the reproduction of the texture of their clothing. Occasionally the women are also presented as the personification of music, mostly as violin or lute players in the pose of sensitive introverted, dreamy figures whose spiritual expression mirrors the refined awareness of life of the "lady" from high social circles. To quote Fritz von Ostini, this kind of figure represented "the most delicate, differentiated and attractive form of the female that our

67. Joachim's Daughter (Music), 1899
Platinum print, 18.7 x 7.3 cm
Fotomuseum im Münchner Stadtmuseum (88/26-21)

They did portraits of prominent personalities in the international art photography style and even advertised with them. Painter-photographers such as Fritz Matthies-Masuren were also successful as portraitists of artists.[125]

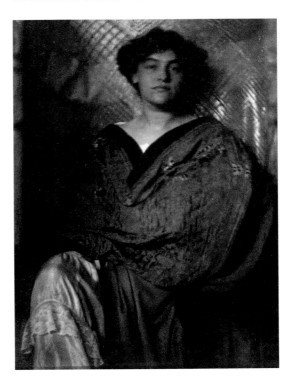

68. Untitled, c. 1900
Platinum print, 15.7 x 11.8 cm
Fotomuseum im Münchner Stadtmuseum (88/27-9)

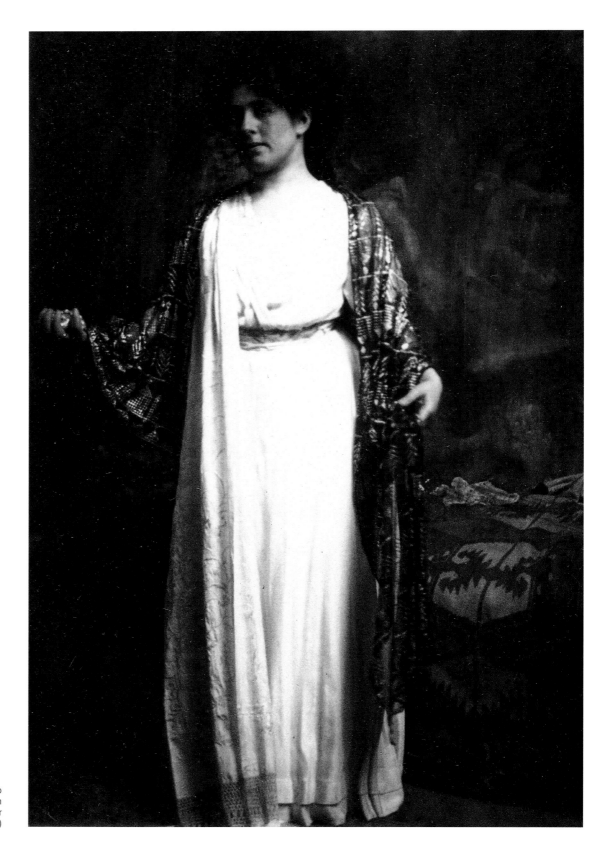

69. Frida von Kaulbach, c. 1910
Platinum print, 17.0 x 11.5 cm
Fotomuseum im Münchner
Stadtmuseum (88/27-130)

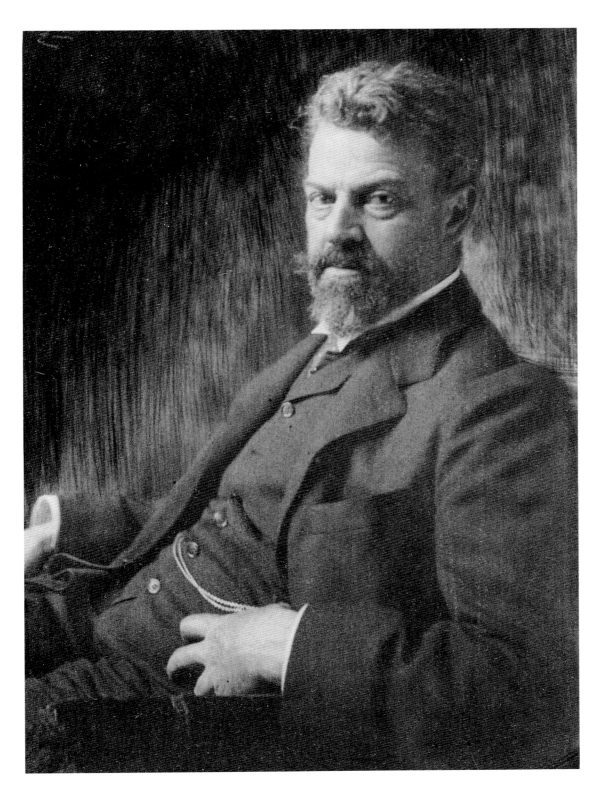

70. Friedrich August von
Kaulbach, c. 1907
Platinum print, 16.6 x 11.8 cm
Fotomuseum im Münchner
Stadtmuseum (88/27-87)

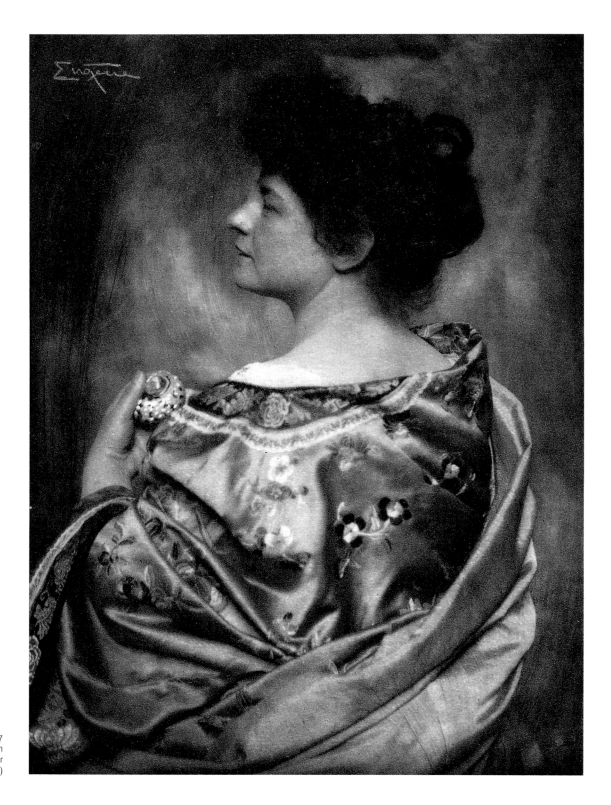

71. Kimono – Frl. v. S., c. 1907
Photogravure, 17.5 x 12.5 cm
Fotomuseum im Münchner
Stadtmuseum (26-49)

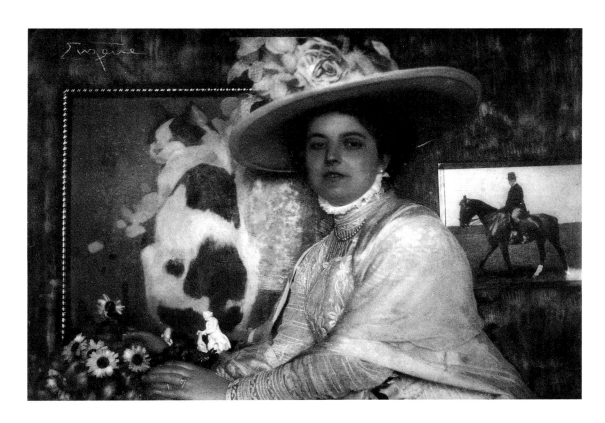

72. Léonie Hohlwein, c. 1908
Photogravure, 12.4 x 17.7 cm
Fotomuseum im Münchner
Stadtmuseum (88/26-37)

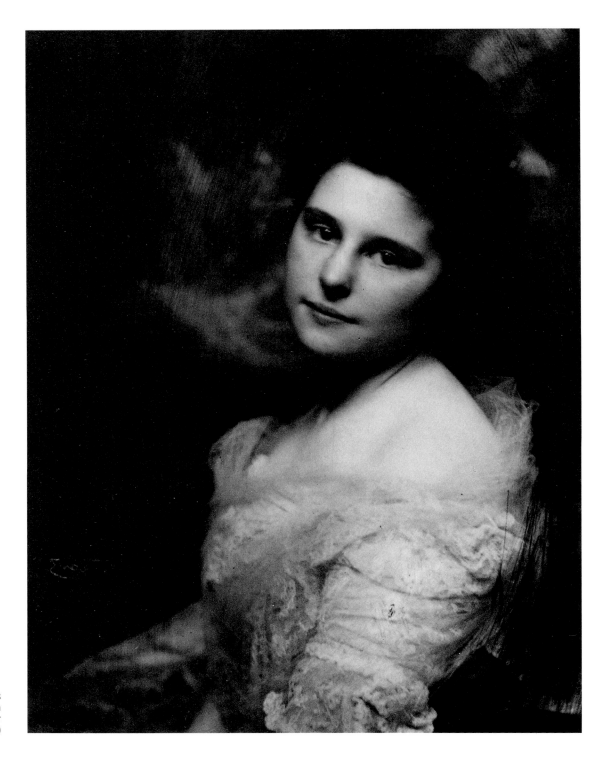

73. Marie Plinthers, c. 1908
Platinum print, 14.7 x 11.2 cm
Fotomuseum im Münchner
Stadtmuseum (88/27-86)

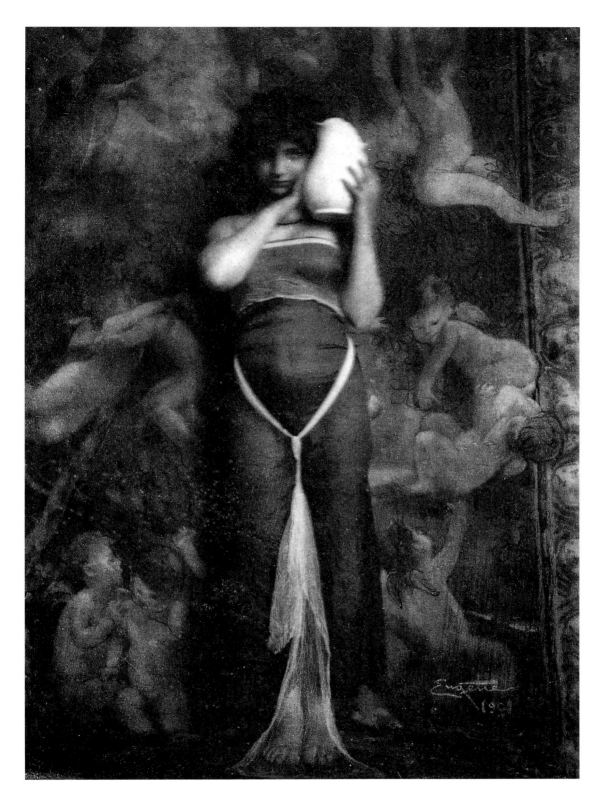

74. Rebeckah, 1901
Photogravure, 17.3 x 12.3 cm
Fotomuseum im Münchner
Stadtmuseum (88/26-68)

Frank Eugene und die Lehr- und Versuchsanstalt für Photographie, Lichtdruck und Gravüre in München 1907–1913

Die Ausstellung im Kunstverein hatte Eugene schlagartig einer größeren Öffentlichkeit in München bekannt gemacht. Auch bei dem Kuratorium der Münchner Photoschule und bei Georg Heinrich Emmerich, der Eugenes Arbeiten schon durch die Ausstellungen in Turin 1902, Wiesbaden 1903 oder Dresden 1904 gekannt haben mag, blieb die Präsentation nicht unbeobachtet. Da die Ausbildungssituation an der Lehranstalt eher stagnierte, bemühte sich Emmerich um neue Impulse, die er in der Person von Frank Eugene verkörpert fand: »Nun ist in München ein Deutsch-Amerikaner, Frank Eugene Smith im Mai dieses Jahres im Kunst-Verein mit photographischen Arbeiten von einer künstlerischen Auffassung hervorgetreten, welche die Bewunderung der Fachleute (vom Kuratorium haben die Münchener Mitglieder Grainer, Frau Dr. Ludwig, Hoffmann die Arbeiten gese-

bindliche Besprechung mit ihm herbeigeführt und ihm den Vorschlag gemacht, einen Unterricht in praktischer Photographie, insbesondere in seiner künstlerischen Aufnahmetechnik, im Umfang von 3 Vormittagen zu übernehmen; seine Ansprüche dafür wären Mark 200.– pro Monat. Es ist klar, dass eine solche ausgezeichnete Kraft eine verhältnismässig höhere Besoldung verlangt. – Die Tätigkeit dieser Lehrkraft ist in der Art gedacht, dass ihr aus der jeweilig aufsteigenden Klasse die besonderen künstlerisch veranlagten Schüler und Schülerinnen überwiesen werden, mit der Aufgabe, diese möglichst bis zum Ziele der Smith'schen Darstellungskunst zu führen. – Im weiteren wird auch eine befruchtende Beeinflussung der Arbeitstätigkeit der beiden anderen Lehrer zu erwarten sein.«[128] Die offizielle Berufung Eugenes durch das Kuratorium, in dem sich mit Frederick Goetz, dem Freund und technischen Leiter der Kunstanstalt Bruckmann in München, ein weiterer Fürsprecher Eugenes befand, war nur noch reine Formsache, so daß *Camera Work* die Ernennung Eugenes als

75. *Anonymous*
Working rooms of the Lehr- und Versuchsanstalt für Photographie, Lichtdruck und Gravüre Munich, 1907
from: *Jahrbuch der Lehr- und Versuchsanstalt für Photographie*, Munich 1906/07, plate 16

hen) hervorriefen und gleichzeitig den vollen Beifall der Presse fanden. Eine Anzahl der Arbeiten werden am Tage der Kuratoriumssitzung ausgestellt. Dieser Herr, der in New York City bereits eine Malschule leitete, wäre bereit, an der Anstalt lehrend zu wirken. Ich habe eine unver-

Lehrer für »pictorial photography« in München vermelden konnte.[129]
Frank Eugene begann seine Lehrtätigkeit mit dem Wintersemester Mitte September 1907. Zu diesem Zeitpunkt gehörten sechzehn Personen zur Verwaltung und zum

time has moulded; spiritual through education, physically ennobled through selective breeding and culture, elevated through tasteful clothing and surroundings."[127] Thus Eugene's pictorial world was not essentially different from that of a painter such as Friedrich August von Kaulbach, the much acclaimed portraitist of the nobility and the haute bourgeoisie whose portraits record a conservative and highly patriarchal society in which women assumed the role of the sensitive soulful muse.

Frank Eugene and the Lehr- und Versuchsanstalt für Photographie, Lichtdruck und Gravüre in Munich 1907–1913

The exhibition in the Artists Association made Eugene known to a wider Munich public overnight. That presentation of his work also did not go unnoticed by the advisory board of the Munich Lehr- und Versuchsanstalt, or by Georg Heinrich Emmerich, who may well have known Eugene's work already from the exhibitions in Turin in 1902, Wiesbaden in 1903 or Dresden in 1904. As training at the institute was beginning to stagnate, Emmerich was on the look-out for new impulses, and he found these in the person of Frank Eugene: "A German-American, Frank Eugene Smith, has come to our attention in Munich, and the artistic conception of his photographic works, exhibited in May of this year in the Artists Association, elicited both the admiration of the experts (the Munich advisory board members Grainer, Dr. Ludwig, and Hoffmann have seen them) and the unambiguous praise of the press. Several of those works will be exhibited on the day of the advisory board meeting. This gentleman, who already headed his own art school in New York, would be willing to teach at the institute. I arranged a non-binding discussion with him and suggested that he take on a class comprising 3 mornings in practical photography, especially in his own technique of art photography; for this he would be entitled to 200 marks per month. It is natural that a teacher of such excellence should demand a relatively higher payment. – What is envisaged with regard to his teaching obligations is that the particularly gifted pupils from the respective higher classes would be passed on to him, his task then being to guide them in achieving a kind of artistic presentation similar to his own. – Furthermore, it is also expected that he have a fruitful influence on the work of the two other teachers."[128] Eugene's official nomination by the board, which had another supporter of his in the person of Frederick Goetz, a friend and technical director of the Kunstanstalt Bruckmann in Munich, was a pure

formality, so that without much delay *Camera Work* could announce his appointment as a teacher of "pictorial photography" in Munich.[129]

Frank Eugene took up his teaching post in the middle of September 1907, in the winter semester. At that time, the institute's administrative and teaching body was comprised of sixteen people, of which the six full-time teachers were Emil Fichtl, for collotype printing, Rudolf Lähnemann and Hans Spörl for photography, Otto Ludwig Naegele for drawing, Richard Rothmaier for reproduction photography and chemigraphy, and the photochemist Wilhelm Urban, who directed the financially lucrative research laboratory. Until 1911 classes were held in a former school barracks, a provisional wooden structure near the Theresienwiese. In autumn 1906, when the photography school was given the name "Lehr- und Versuchsanstalt für Photographie, Lichtdruck und Gravüre zu München," an extension was built providing additional space. Thus in the year of Eugene's appointment the photography department was made up of "two large workshops with about 45 complete work benches each, an enlarging room divided into two, with two large working sinks, two enlargement apparatuses on columns, a 70 square meter dark-room with electric ventilation and 22 working sinks, washing facilities and copying equipment for transparencies, a 110 square meter studio, divided into two sections, with two photographic apparatuses and all the necessary studio accessories, a printing room with 40 square meters of surface area, with carbon-developing and loading room, warm water and corresponding developing and washing sinks; in the extension building there were also a dry-preparation room for chrome papers, a sidelight studio, 90 square meters of storage space for exhibition and teaching materials and the administration offices."[130] The reproduction technology department consisted of large rooms for the machines and for taking photographs; there was also a lecture hall which was mainly used for lectures in chemistry and physics.

A solid training in all aspects of the craft of photography formed the basis of the two-year course. From 1905 on, female students were also admitted to the courses but only on reaching their 17th year, whereas the male students could enroll from their 15th year. The tuition fees per semester were between 50 and 100 Reichsmarks. In the first semester there were a total of 42.5 hours of classes per week in "elementary drawing" from plaster models, objects etc. (12 hours), "physics" (2 hours), "photochemistry" (3 hours), "practical photography" with negative and positive processing (24 hours), and bookkeeping (1.5 hours). The second semester had 49.5

76. Medaille des Süddeutscher Photographen-Vereins Fotomuseum im Münchner Stadtmuseum

ständigen Lehrpersonal der Schule, darunter die sechs hauptamtlichen Lehrkräfte für Lichtdruck Emil Fichtl, für Photographie Rudolf Lähnemann und Hans Spörl, für kunstgewerbliches Zeichnen Otto Ludwig Naegele, für Reproduktionsphotographie und Chemigraphie Richard Rothmaier und der Photochemiker Wilhelm Urban, der die finanziell lukrative Versuchsstation leitete. Der Unterricht fand bis 1911 in einer ehemaligen Schulbaracke statt, einem provisorischen Holzbau nahe der Theresienwiese. Im Herbst 1906, als die Photoschule den Namen ›Lehr- und Versuchsanstalt für Photographie, Lichtdruck und Gravüre zu München‹ annahm, wurden durch einen Erweiterungsbau zusätzliche Lokalitäten für ein Seitenlichtatelier, einen Chromierungs- und Trockenraum, Verwaltungsräume sowie einen Zeichen-, Ausstellungs- und Lehrmittelsammlungssaal gewonnen. So umfaßte die photographische Abteilung im Jahr der Berufung Eugenes »zwei Arbeitssäle mit je zirka 45 kompletten Arbeitseinrichtungen, einen Vergrößerungssaal, in sich zu zwei Räumen aufgeteilt, mit zwei großen Arbeitsbecken, zwei Vergrößerungsapparaten mit Schieneneinrichtung, eine 70 Quadratmeter große Dunkelkammer mit elektrischer Ventilation und 22 Arbeitsbecken, Wässerungsgelegenheit und Kopiereinrichtung für Diapositive, ein 110 Quadratmeter großes Atelier zum Arbeiten, in zwei Arbeitsstätten aufzuteilen, mit zwei Aufnahmeapparaten und allem für ein Atelier notwendigem Zubehör, ein Kopierhaus mit 40 Quadratmeter Flächenraum mit Kohle-Entwicklungs- und Einlegeraum, Warmwassereinrichtung und entsprechenden Entwicklungs- und Wässerungsbecken; im Erweiterungsbau befinden sich ferner ein Trocken-Präparationsraum für Chromatpapiere, ein Seitenlichtatelier, ein 90 Quadratmeter großer Ausstellungs- und Lehrmittelsammlungsraum und die Verwaltungsräume.«[30] Die Abteilung Reproduktionstechnik bestand aus großen Räumen für die Maschinen und die Aufnahme; weiterhin stand ein Hörsaal zur Verfügung, der hauptsächlich für den Chemie- und Physik-Unterricht genutzt wurde. Grundlage des zweijährigen Studiums, zu dem ab 1905 auch Frauen zugelassen waren, bildete eine solide handwerkliche Lehre. Aufnahmeberechtigt waren Schüler ab dem 15. und Schülerinnen ab dem 17. Lebensjahr, die pro Semester zwischen 50 und 100 Reichsmark Studiengebühren zu entrichten hatten. Der Unterricht im ersten Semester mit insgesamt 42.5 Wochenstunden gliederte sich in die Fächer ›elementares Zeichnen‹ von Gipsabgüssen, Gegenständen etc. (12 Std.), ›physikalischer Unterricht‹ (2 Std.), ›photochemischer Unterricht‹ (3 Std.), ›praktische Photographie‹ mit Negativ- und Positivverfahren (24 Std.) und gewerbliche Buchführung

(1.5 Std.). Im zweiten Semester mit 49.5 Wochenstunden wurde der Anteil der ›praktischen Photographie‹ auf 32 Stunden erweitert und Übungen in den Platin- und Pigmentdruckverfahren vorgenommen. Das dritte Semester verlief wieder wie das erste, jedoch erweitert um den Unterricht in dem Fach ›Perspektive‹, während in der praktischen Photographie die Techniken des Gummidrucks und das Photographieren im Wohnraumatelier nahe gebracht wurden. Im Abschlußsemester verminderte sich die Stundenzahl auf 48.5 Wochenstunden, und es wurden Kopierverfahren wie der Kombinationsgummidruck und die Retusche gelehrt, wobei ein möglichst selbständiges Arbeiten der Schüler erwartet wurde. Die Ausbildung schloß den regelmäßigen Zeichenunterricht ebenso mit ein wie Ausstellungsbesuche im Kunstverein und den in Kunstgalerien wie Heinemann und Littauer sowie Studienbesuche mit den Fachlehrern im Nationalmuseum, in der Alten und Neuen Pinakothek, dem Kupferstichkabinett und der Gemäldegalerie in Schleißheim. Außerdem fanden seit 1906 regelmäßig einstündige Vorlesungen über Stilepochen der Kunst statt, wie auch das Studium von Rubens, van Dyck, Rembrandt, Raphael, Reynolds, Teniers, Tizian, Franz Hals, Wouvermann, Velázquez, Holbein und insbesondere Whistler empfohlen wurde, deren Werke den Schülern als Kunstreproduktionen zur Verfügung standen. Bei der Abschlußprüfung wurde die Anfertigung von künstlerischen Landschaftsaufnahmen und Porträtaufnahmen im Atelier oder Innenraum in verschiedenen Formaten verlangt, die auch als ›künstlerische Wandbilder‹ verwendbar sein sollten, sowie Reproduktionen von Zeichnungen und farbigen Vorlagen in den unterschiedlichen Positivverfahren. Ab 1907 wurden die Ergebnisse des Schuljahres in einem Jahrbuch veröffentlicht, dessen sorgfältige typographische Gestaltung mit Jugendstil-Ornamenten von Otto Ludwig Naegele stammte und das neben Informationen zum Ablauf des vergangenen Schuljahres auch zahlreiche Bildproben in verschiedenen Druckverfahren wie Kupferdruck, Radierung, Lichtdruck etc. sowie Beiträge von Mitgliedern des Lehrkörpers zu photographischen Techniken und Fragen der Ästhetik enthielt.

Mit diesem Lehrplan stand die Münchner Photoschule in Deutschland und auch im europäischen Vergleich nahezu konkurrenzlos da, obwohl vergleichbare Lehrinstitute in Leipzig, Weimar, Hannover, Dresden, Düsseldorf und Berlin existierten, wie auch an diversen Technischen Hochschulen Fortbildungskurse und Seminare für Photographen ausgerichtet wurden. Einzig die in Wien ansässige k.k. Lehr- und Versuchsanstalt für Photographie und Reproduktionsverfahren unter Leitung

hours of classes per week with the portion for "practical photography" increased to 32 hours and including practical training in platinum and pigment printing processes. The third semester was similar to the first but extended to include classes in "perspective," and practice in the techniques of gum printing and living-room studio photography. In the final semester the number of hours decreased again to 48.5 weekly, with classes in copying processes such as combination gum printing and retouching. At this stage the students were expected to work as independently as possible. Training also included regular drawing classes and visits to exhibitions in the Art Association and the Heinemann and Littauer art galleries, not to mention study visits to the National Museum, the Alte and Neue Pinakothek, the copper-

77. Otto L. Naegele
Title page of the *Jahrbuch der Lehr- und Versuchsanstalt für Photographie*, Munich 1910/11

plate engraving cabinet and the Schleissheim picture gallery, accompanied by the respective teachers. From 1906 on there were additional one-hour lectures on stylistic epochs in art and the students were recommended to study Rubens, van Dyck, Rembrandt, Raphael, Reynolds, Teniers, Titian, Franz Hals, Wouvermann, Velázquez, Holbein, and in particular, Whistler. Their works were available for study in the form of art reproductions. For the final examination the students were expected to produce artistic landscape photographs and photographic portraits, taken in the studio or indoors

and in various formats which should also be utilizable as "artistic wall decorations," also reproductions in the various positive processes from drawings and color images. As of 1907, the results of each school year were published in a yearbook, with Otto Ludwig Naegele responsible for its careful typographical design and art nouveau ornamentation. It contained information about the events of the past school year and numerous samples of different printing processes such as copperplate printing, etching, collotype process etc., plus written contributions by members of the teaching staff on photographic techniques and aesthetic issues.

With this teaching syllabus the Munich Lehr- und Versuchsanstalt was unrivaled in Germany, even in Europe, although similar teaching institutes did exist in Leipzig, Weimar, Hannover, Dresden, Dusseldorf and Berlin, not to mention the courses and seminars in photography offered at various technical high schools. The only institute in a position to offer a comparable syllabus was the Viennese k.k. Lehr- und Versuchsanstalt für Photographie und Reproduktionsverfahren (Imperial and Royal Training and Research Institute of Photography and Reproduction Processes), directed by Josef Maria Eder, which had at its disposal laboratories and studios for portrait, scientific, and reproduction photography.[131] Nevertheless, the Munich institute's ambiguous position between artistic and commercial training was regarded with suspicion by commercial photographers, and Emmerich too was a controversial figure among the experts, as Eugene indicated in a letter to Stieglitz.[132]

Unlike his colleagues Spörl, Lähnemann and Urban, Frank Eugene does not seem to have found his teaching obligations particularly demanding, especially as he had only 36 hours a month distributed over three mornings a week. He enjoyed certain "artistic" freedoms, so that he had sufficient time left to pursue his other activities as a freelance portraitist in Munich's wealthier circles. It was Eugene's duty to teach advanced students and to see to their "training with regard to the artistic concept of their photographs,"[133] whereas Lähnemann and Spörl taught the basics of photographic technique. Eugene's two colleagues held their classes in the glass-roofed studios, while he occupied the spacious living-room-studio with its large sidelight windows, designed by the architect Hanns Maria Friedmann and decorated in the Munich art nouveau style, somewhat like a private living-room with only a few items of furniture, plants, paintings and small pieces of sculpture.[134] Eugene taught there even during the master classes in "lighting practice" and "model photography" which lasted several

95

von Joseph Maria Eder, die über Ateliers für die Porträt-
photographie, die wissenschaftliche Photographie, für
Reproduktionsaufnahmen und Laboreinrichtungen ver-
fügte, konnte ein ähnliches Lehrangebot bieten.[131] Trotz
des Erfolges war die Zwitterstellung der Münchner Schu-
le zwischen künstlerischer und gewerblicher Ausbildung
von den gewerbetreibenden Fachphotographen nicht
ohne Argwohn beobachtet worden, und auch Emmerich
war in der Fachwelt keineswegs unumstritten, wie
Eugene in einem Brief an Stieglitz andeutete.[132]
Im Unterschied zu seinen Kollegen Spörl, Lähnemann
und Urban schien Frank Eugene vom Schulbetrieb weni-
ger beansprucht gewesen zu sein, denn seine Arbeitszeit
umfaßte nur 36 Stunden im Monat, verteilt auf drei hal-
be Tage pro Woche. Er genoß gewisse ›künstlerische‹
Freiheiten, so daß ihm neben der Lehrtätigkeit genügend
Zeit verblieb, um seinen Aktivitäten als freier Porträtist in
wohlhabenden Münchner Gesellschaftskreisen nachzu-
gehen. Eugenes Aufgabe war es, die fortgeschrittenen
Schüler zu unterrichten und diese »hinsichtlich künstleri-
scher Auffassung bei deren Aufnahmen weiter zu füh-
ren«,[133] während Lähnemann und Spörl die Grundlagen
der Phototechnik vermittelten. Unterrichteten seine bei-
den Kollegen in den Glasdachateliers, so übernahm
Eugene das geräumige Wohnraumatelier mit großem
Seitenlichtfenster, das von dem Architeken Hanns Maria
Friedmann entworfen und mit wenigen Möbeln, Pflan-
zen, Bildern und Kleinplastik wie ein privater Wohnraum
im Münchner Jugendstil eingerichtet worden war.[134] Hier
lehrte Eugene auch während der mehrtägigen Meister-
kurse ›Beleuchtungsübungen‹ und ›Aufnahmen an Mo-
dellen‹. Dabei schien er sich schnell und erfolgreich in
den Unterrichtsbetrieb integriert zu haben,[135] denn er
entfaltete bald die von ihm erwarteten regen Aktivitäten,
in deren Folge die Schule einen regen Neuzugang an
Schülern erleben sollte.[136] Außerdem war Eugene maß-
geblich an der Organisation der Jahresausstellungen von
Schülerarbeiten beteiligt. Repräsentierte vor seiner Beru-
fung vor allem der deutsche Porträtphotograph Rudolf

Dührkoop das große Vorbild für die Schüler, so sollte
Eugene nunmehr diesen Platz einnehmen, wie er an
Stieglitz berichtete: »My pupils are very enthusiastic
about the methodless method of my pedagogical
effort.«[137]

München 1908

Anläßlich der Ausstellung ›München 1908‹, die die Be-
deutung Münchens als führende ›Kunststadt‹ Deutsch-
lands und als Zentrum des modernen Kunstgewerbes
unter Beweis stellen sollte, hatte Eugene wieder Gelegen-
heit zur adäquaten Selbstdarstellung. Nach dem Vorbild
der Dresdner Kunstgewerbeausstellungen hatten die Ver-
anstalter sich entschlossen, die Photographie in einer
eigenen Abteilung zu integrieren, an der sich siebzehn
Aussteller in drei Räumen beteiligten. Während sich der
größte Teil der Münchner Photographen mit der Präsen-
tation weniger, ausgewählter Arbeiten begnügen mußte,
die sich als dekorativer Wandschmuck in dem Ensemble
mit Biedermeiermöbeln nicht behaupten konnten, nahm
Frank Eugene eine exponierte Stellung ein. Er hatte ne-
ben Obergassner und dem Warenhaus Hermann Tietz
als einziger Kunstphotograph eine Einzelausstellung zu-

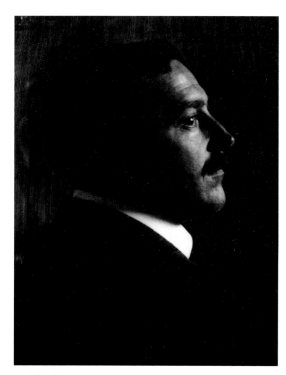

days. At the same time, he seems to have become integrated into the teaching program quickly and successfully,[135] for he was soon quite preoccupied with the activities expected of him and which were to result in the institute attracting a significant number of new students.[136] Furthermore, Eugene had a decisive influence on the annual exhibitions of students' works. Before his appointment, the main model for the students had been

the organizers had decided to give photography its own section in which seventeen exhibitors were to share three rooms. While most of the Munich photographers had to make do with presenting a few selected works – which as decorative wall embellishments in an ensemble with Biedermeier furniture made very little impression – Frank Eugene had a place of prominence. He was the only art photographer granted a solo exhibition,

80. *Hanns Friedmann*
The photo atelier of Frank Eugene Smith at the Lehr- und Versuchsanstalt für Photographie Munich, 1907
from: *Jahrbuch der Lehr- und Versuchsanstalt für Photographie*, Munich 1906/07, plate 15

the German portrait photographer Rudolf Dührkoop, but Eugene seems to have taken his place, as indicated in a letter to Stieglitz: "My pupils are very enthusiastic about the methodless method of my pedagogical effort."[137]

Munich 1908

The exhibition "Munich 1908," which was to confirm Munich's position as the leading "art city" in Germany and center of modern arts and crafts, provided Eugene with another occasion to promote his own work. As was the case at the Dresden arts and crafts exhibitions,

located between Obergassner and the Hermann Tietz store, in which he was able to present almost 100 of his portraits of artists and a number of "artistic studies." The majority of the portraits were of that elite of Allotria and Secession members who were certainly not to be counted among the progressive or even revolutionary elements on the Munich cultural scene, especially personalities like Ernst von Possart, director general of the Munich theaters, or the artist Christian Landenberger, Secession member and professor at the Stuttgart Academy since 1905, or the Piloty pupil Gabriel Schachinger, or the monument sculptor Cipri Adolf Bermann. Other

gestanden bekommen, in der er nahezu 100 seiner Künstlerporträts und »künstlerischen Studienblätter« präsentieren konnte. Ein Großteil der Bildnisse zeigte wiederum die Elite jener Münchner Künstlerschaft, die in der Allotria und der Secession organisiert war und den fortschrittlichen oder gar revolutionären Kräften in der Münchner Kultur nicht zuzurechnen sind, denkt man an Persönlichkeiten wie den Generalintendanten der Münchner Bühnen Ernst von Possart oder den Maler Christian Landenberger, Mitglied der Secession und seit 1905 Professor an der Akademie Stuttgart, den Piloty-Schüler Gabriel Schachinger oder den Monumental-Bildhauer Cipri Adolf Bermann. Andere Künstler wie Richard Riemerschmid, Emanuel von Seidl, Ludwig Herterich, Julius Diez oder Carl Johann Becker-Gundahl, die Eugene porträtiert hatte, waren bei der Errichtung und Ausführung der Ausstellungsbauten maßgeblich beteiligt gewesen.

Zweifellos erregte die Bevorzugung Eugenes den Neid der Münchner Berufsphotographen, doch erntete die Einzelausstellung aufgrund ihrer herausragenden Qualität auch positive Resonanz wie beispielsweise durch Franz Grainer: »Ich habe dieselben gesehen und muss sagen, dass sie meiner Meinung nach kaum zu übertreffen sind. Wer dem photographischen Apparat derartige Kunstwirkungen abzugewinnen weiss, muss in höchster Weise befähigt sein, vorbildlich und Begeisterung weckend auf seine Schüler zu wirken.«[138]

Gemessen an der Zahl von drei Millionen Besuchern repräsentierte die Ausstellung ›München 1908‹ einen großen Erfolg. Eugene konnte zahlreiche seiner käuflichen Arbeiten an Interessenten veräußern. »The result is very satisfactory for it has caused a good deal of commendatory, talk ec ec and I've covered expenses which besides the advertisement given my work is nerve-quieting – I've sold quite a number of prints exhibited – my prices Kuehn says are far too modest.«[139] Einer der Käufer war der englische Photograph Alvin Langdon Coburn, der Eugene gemeinsam mit seiner Mutter 1908 anläßlich der Ausstellung in München besuchte und einige Aufnahmen erwarb, die sich heute in der Sammlung der Royal Photographic Society in Bath befinden.[140]

Internationale Photographische Ausstellung in Dresden 1909

Eugenes Verpflichtung an die Münchner Lehr- und Versuchsanstalt für Photographie geschah auch in Hinblick auf die Internationale Photographische Ausstellung in Dresden 1909, für deren Organisation Emmerich als stellvertretender Vorsitzender des Arbeitsausschusses

mitverantwortlich war. Im Rahmen der Veranstaltung war die Münchner Photoschule in der Abteilung für Photographie, in der sich die verschiedenen photographischen Lehranstalten aus dem In- und Ausland präsentierten, mit einer Ausstellung von 70 meist kleinformatigen Schülerarbeiten vertreten. Stilistisch unterschieden sich die piktorialistischen Porträt- und Landschaftsstudien deutlich von den Ausstellungsstükken der anderen Schulen wie dem Berliner Lette-Verein und der Leipziger Akademie für graphische Künste und Buchgewerbe, da sich diese auf die Demonstration der wissenschaftlichen Photographie und der Reproduktionstechniken konzentriert hatten. An die Leistungen der Münchner Photoschule konnten auch die ausländischen Institute wie die Londoner Lehranstalt für das künstlerische Kamerabildnis und für die wissenschaftliche Photographie unter Leitung von E.O. Hoppé, die American School of Art and Photography in Scranton, Pennsylvania und die k.k. Graphische Lehr- und Versuchsanstalt in Wien nicht herankommen.[141]

In der graphischen Abteilung der Münchner Schulausstellung waren 42 Photogravüren und Lichtdrucke zu sehen, davon stammten sechzehn Arbeiten aus einer Studienmappe, die eigens für die Dresdner Ausstellung angefertigt worden war. Diese Studienmappe sollte die variable drucktechnische Umsetzung von photographischen Vorlagen demonstrieren, und sie enthielt neben Kunstreproduktionen von Gemälden aus der Schleißheimer Galerie und Velázquez-Kopien von Willi Geiger auch mehrere Aufnahmen Frank Eugenes, die als großformatige Photogravüren und Lichtdrucke (bis 22 x 44 cm) auf Japan-, Kupferdruck- oder Kreidepapier vervielfältigt worden waren. Es handelte sich um Eugenes Photographien ›Prinz Luitpold von Bayern‹, ›Prinzessin Rupprecht von Bayern‹, ›Menuett‹, ›Hortensia‹ und die Aktstudie ›Am Bach‹. Die Drucke waren in der Kupferdruckerei Heinrich Wetteroth in München vervielfältigt worden und wurden in limitierter Ausgabe für den Betrag von 50 Mark zum Kauf angeboten.[142] Die Mappe und insbesondere Eugenes Motive fanden in der Tages- und Fachpresse ein positives Echo, und die *Münchner Neueste Nachrichten* schrieb, daß die Mappe »ohne den geringsten Anflug von lokalpatriotischen Gefühlen (...) den allerbesten Leistungen in Deutschland mindestens ebenbürtig« sei.[143]

Gleichzeitig hatte Eugene in Dresden eine Einzelausstellung seiner »Lichtradierungen« in der Abteilung Berufsphotographie und er war als Gründungsmitglied an der von Heinrich Kühn organisierten Ausstellung der International Society of Pictorial Photographers beteiligt.[144] Er war also zweifellos die zentrale Lehrergestalt auf der

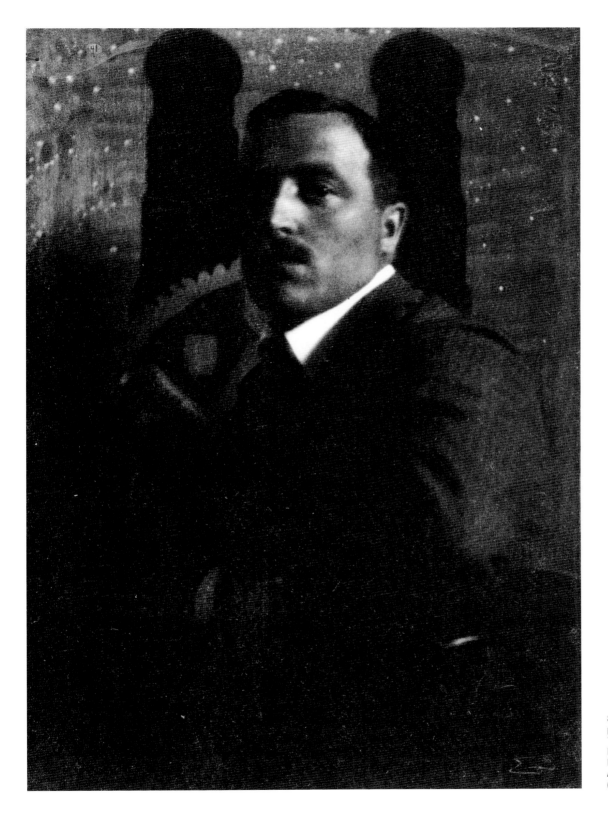

81. Julius Diez in front of the
poster of the exhibition
"München 1908"
Platinum print, 16.9 x 12.1 cm
Metropolitan Museum of Art,
Alfred Stieglitz Collection, 1933
(33.43.93)

82. Alvin Langdon Coburn, 1908
D.O.P., 11.8 x 16.5 cm
Fotomuseum im Münchner
Stadtmuseum (88/27-41)

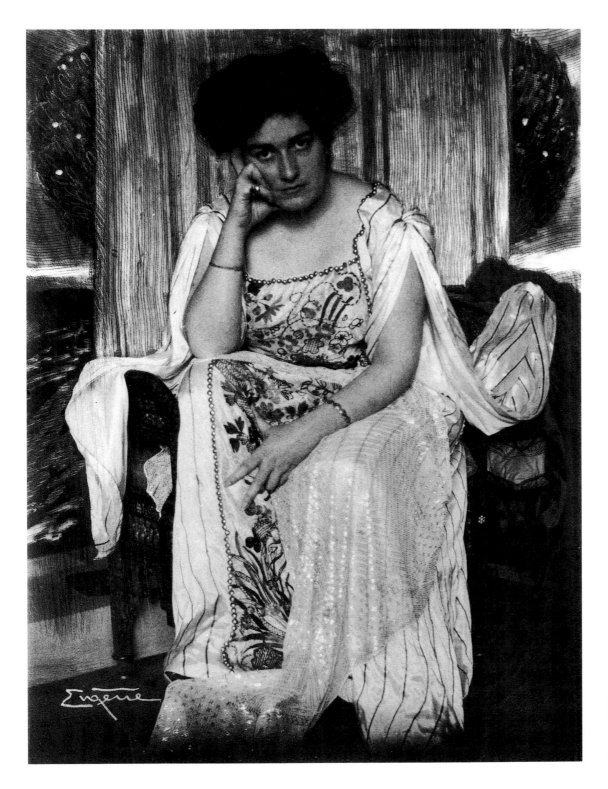

83. Bertha Morena in "The
Jewess" by Fromental Halévy,
c. 1908
Platinum print
Metropolitan Museum of Art,
Rogers Fund, 1972 (1972.633.80)

84. Martin Feuerstein, c. 1908
Platinum print, 15.4 x 11.9 cm
Fotomuseum im Münchner Stadt-
museum (88/26-6)

85. Untitled, c. 1908
Platinum print, 16.8 x 12.0 cm
Fotomuseum im Münchner
Stadtmuseum (88/26-117)

86. Ohne Titel, c. 1907
Platinum print,
Fotomuseum im Münchner
Stadtmuseum (93/631-5)

87. Untitled, c. 1907
Platinum print
Fotomuseum im Münchner
Stadtmuseum (93/631-5)

88. Heinrich Scherrer, c. 1910
Photogravure, 8.4 x 12.2 cm
Fotomuseum im Münchner
Stadtmuseum (88/26-26)

89. Josef Geis, c. 1910
Platinum print, 16.6 x 12.0 cm
Fotomuseum im Münchner
Stadtmuseum (88/26-95)

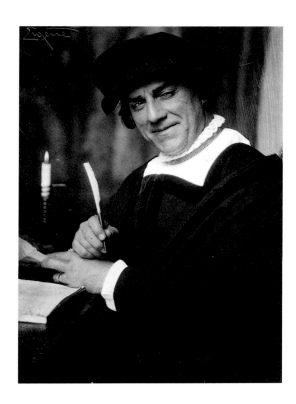

90. Josef Geis as Sixtus
Beckmesser in "Meistersinger
von Nürnberg" by Richard
Wagner, c. 1910
Platinum print, 16.9 x 11.9 cm
Fotomuseum im Münchner
Stadtmuseum (88/26-87)

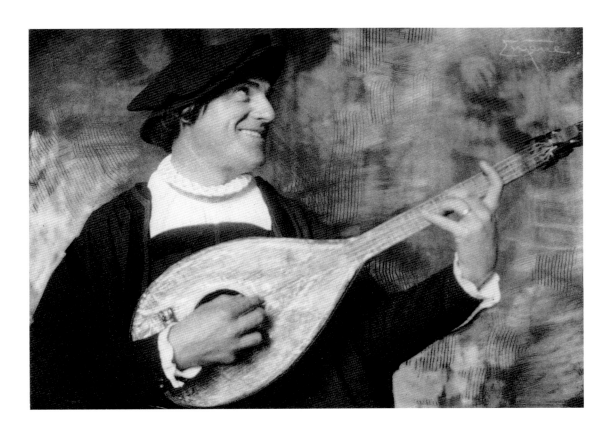

91. Josef Geis, c. 1910
Platinum print, 12.3 x 17.0 cm
Fotomuseum im Münchner
Stadtmuseum (88/26-27)

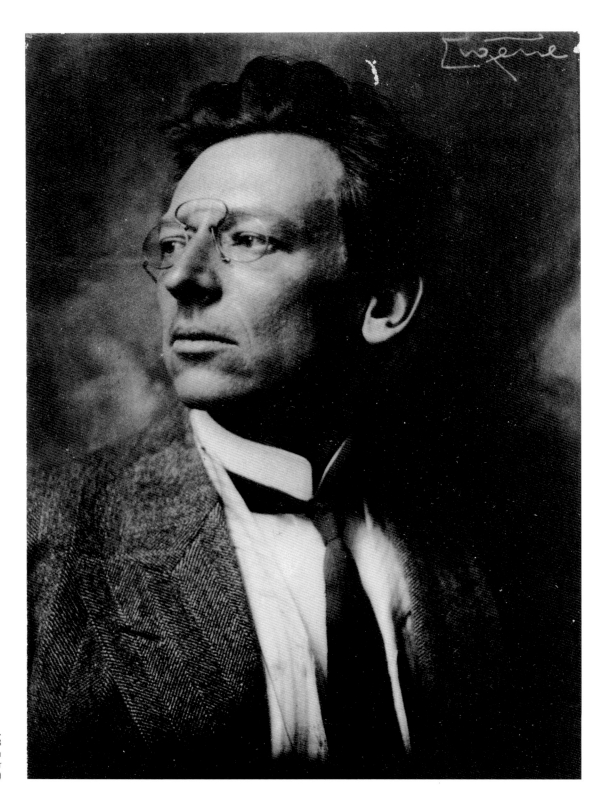

92. Siegmund von Hausegger,
c. 1908
Platinum print, 16.9 x 12 cm
Fotomuseum im Münchner
Stadtmuseum (88/27-40)

artists whose portraits Eugene took, such as Richard Rie-
merschmid, Emanuel von Seidl, Ludwig Herterich, Julius
Diez or Carl Johann Becker-Gundahl, played a leading role
in the design and construction of the exhibition pavilions.
Without a doubt, Eugene's preferential treatment incited
the envy of Munich's commercial photographers, but due
to its excellent quality the solo exhibition itself elicited
positive reactions, for example, from Franz Grainer: "I
have seen it and I must admit that in my view it is unbeat-
able. Anyone who is able to charm such artistic effects
from a photographic apparatus must be more than quali-
fied to have an exemplary and inspiring influence on his
pupils."[138] With a total of three million visitors, the Mu-
nich 1908 exhibition was an enormous success, and quite
a number of Eugene's purchasable works were sold to
interested parties: "The result is very satisfactory for it has
caused a good deal of commendatory, talk ec ec and I've
covered expenses which besides the advertisement given
my work is nerve-quieting – I've sold quite a number of
prints exhibited – my prices Kuehn says are far too mod-
est."[139] One of the buyers was the English photographer
Alvin Langdon Coburn who together with his mother
visited Eugene in 1908 on the occasion of the exhibition
and purchased several photographs which are now in the
collection of the Royal Photographic Society in Bath.[140]

The International Photographic Exhibition
in Dresden 1909

The appointment of Frank Eugene to the Munich Lehr-
und Versuchsanstalt was also made with a view to the
"International Photographic Exhibition" in Dresden in
1909, the organization of which was part of Emmerich's
responsibility in his capacity as deputy chairman of the
working committee. In the Photography Section of the
Dresden exhibition, where the various other national and
international photographic institutes also had their pres-
entations, the Munich institute showed 70 mostly small-
format photographs by students. The pictorialist portraits
and landscape studies were very different in style to the
exhibits from other schools such as the Berlin Lette-Verein
(Lette Association) and the Leipzig Akademie für graphi-
sche Künste und Buchgewerbe (Academy of Graphic Arts
and Book Design), as the latter concentrated more on
scientific photography and reproduction techniques. Not
even the works from the foreign institutes, such as the
London Institute of Artistic Camera Portraits and Scientific
Photography, directed by E.O. Hoppé, the American
School of Art and Photography in Scranton, Pennsylvania,
or the Viennese k.k. Graphische Lehr- und Versuchs-
anstalt (Imperial Teaching and Research Institute of

93. The Diva and her most trusty
friend and companion (Bertha
Morena), c. 1908
Platinum print, 17.0 x 12.2 cm
Metropolitan Museum of Art,
Alfred Stieglitz Collection, 1933
(33.43.381)

Graphic Arts) could compare with the achievements of
the Munich institute.[141]
The students from the Graphics Department exhibited 42
photogravures and collotypes, of which 16 were from a
study portfolio produced specially for the Dresden exhibi-
tion. This portfolio was intended to demonstrate the vari-
ous technical alternatives for making prints from photo-
graphic models, and it contained not only reproductions
of paintings from the Schleissheim Gallery and of
Velázquez copies by Willi Geiger, but also several photo-
graphs by Frank Eugene which had been reproduced as
large-format (up to 22 x 44 cm) photogravures and collo-
types on Japan tissue, copperplate printing paper and
chalk paper. Among these were Eugene's "Prince

94. *Anonymous*
Exhibition of the Münchner Lehr-
und Versuchsanstalt für Photo-
graphie, Dresden 1909 from:
*Jahrbuch der Lehr- und Ver-
suchsanstalt für Photographie,*
Munich 1908/1909, plate 9

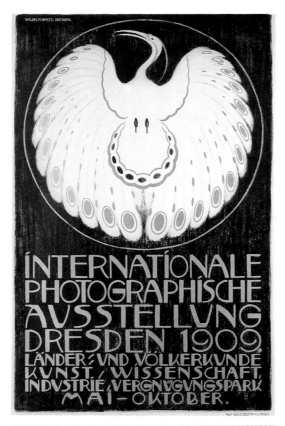

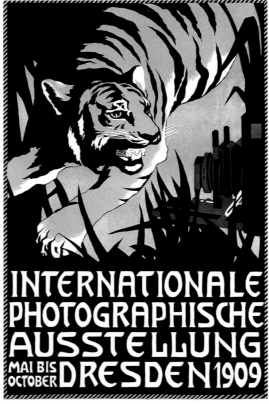

95. *Wilhelm Hartz*
Poster "Internationale Photographische Ausstellung Dresden,"
1909
Lithograph, 100.0 x 62.0 cm
Graphiksammlung im Münchner Stadtmuseum (B 1/118)

96. *Helene Baumeyer*
Poster design for the "Internationale Photographische Ausstellung Dresden," 1909
Linolschnitt, 103.0 x 64.5 cm
Graphiksammlung im Münchner Stadtmuseum (B 1/117)

Dresdner Schau und wurde für seine Leistungen mit der höchsten Auszeichnung, der Stadtmedaille, prämiert, während von Lähnemann und Spörl nur wenig zu hören und zu sehen war. Auch auf die Arbeitsweise seiner Schüler muß sich Eugenes Lehrtätigkeit ausgesprochen anregend ausgewirkt haben, denn in den Berichten über die Beteiligung der Lehranstalt an der Dresdener Ausstellung 1909 wurde seine Leistung stets hervorgehoben: »In allen Arbeiten sieht man den fördernden Antrieb, den besonders der feinfühlige Frank Eugène Smith auf die künstlerische Entwicklung der Schüler der Anstalt ausgeübt hat.«[145] Und an anderer Stelle hieß es: »Daß unter den Schülern der Anstalt, die, wie ich weiß, für ihren Lehrer Smith begeistert sind, nicht einer sich vorfindet, der in schwächlichem Replizieren der Arbeitsweise des Lehrers sich gefällt, sondern daß alle sich nur bemühen, vom Geiste seiner Auffassung zu profitieren, spricht mehr wie Bände für die Tüchtigkeit der Lehrmethoden an diesem Institut.«[146] So überrascht es nicht, daß Eugene nach zweijähriger Lehrtätigkeit seiner Leistung durch neue Gehaltsforderungen anerkannt sehen wollte, die ihm auch zugebilligt wurden.[147]

Repräsentationsbildnisse im ›Reformatelier‹

Tiefgreifende Veränderungen zeichneten sich für die Münchner Lehr- und Versuchsanstalt für Photographie ab, als im Stadtteil München-Schwabing in der Bismarckstrasse 9 das ehemalige städtische Krankenhaus vakant wurde und das Kuratorium der Photoschule das Gebäude für den Unterricht sichern konnte. Während die Schule von der Stadt München für zehn Jahre mietfrei überlassen wurde, übernahmen der bayerische Staat und private Förderer die Kosten für den Umbau und die Neueinrichtung der Räumlichkeiten.[148] Die neue Schule, die von einer parkartigen Anlage umgeben war, die für Freilichtaufnahmen genutzt werden konnte, bestand aus einem zweistöckigen Hauptgebäude und einem nördlich gelegenen Flügelbau[149] mit insgesamt 90 Räumen. Die beiden Klassen für Photographie waren mit jeweils fünfzehn Räumen, davon jeweils zwei Wohnraum-Ateliers mit Seitenlicht, Dunkelkammern, Vergrößerungsräumen, Retusche-, Chromierungs- und Trockenräumen und einem Kopierhaus,[150] im westlich gelegenen Flügelbau untergebracht. Die Innenausstattung sämtlicher Seitenlichtateliers hatte wiederum der Architekt Hanns Friedmann übernommen.[151]
Die offizielle Eröffnung des neuen Schulgebäudes erfolgte am 9. Mai 1911 unter Anwesenheit zahlreicher Repräsentanten des öffentlichen Lebens wie der Wittelsbacher Familie, dem bayerischen Ministerpräsidenten

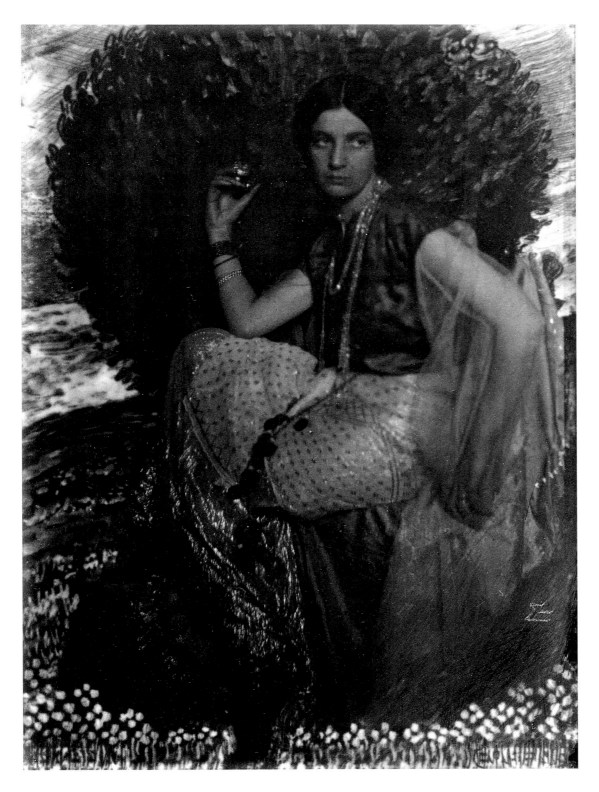

97. The poster – Dora Gedon,
1907/08
(Poster design for the Internatio-
nale Photographische Ausstel-
lung Dresden 1909)
D.O.P., 17.8 x 12.8 cm
Fotomuseum im Münchner
Stadtmuseum (88/27-8)

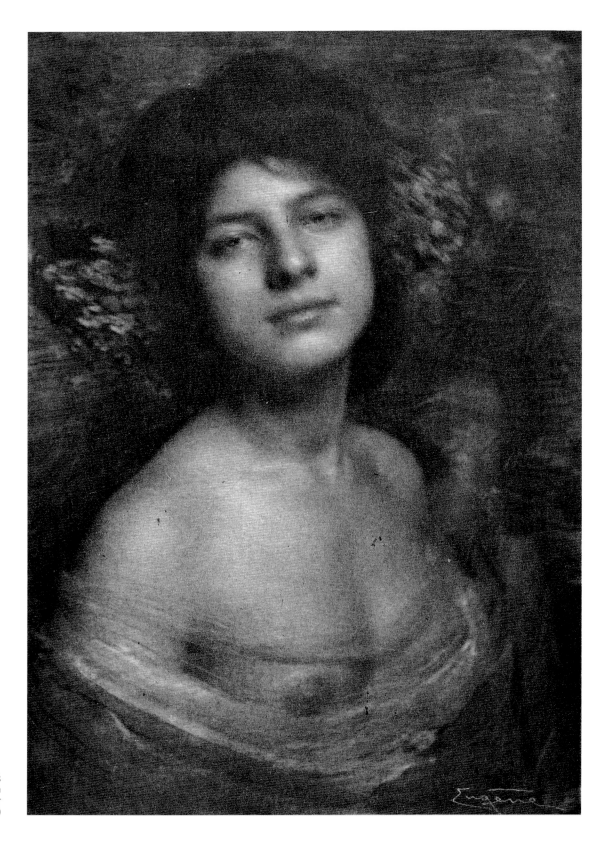

98. Hortensia, 1898
Platinum print, 17.5 x 12.5 cm
Fotomuseum im Münchner
Stadtmuseum (93/756-1)

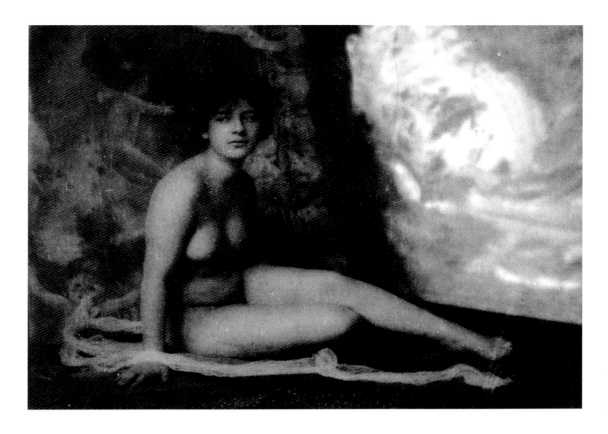

99. Die weisse Wolke, c. 1900
Photogravure, 12.0 x 16.7 cm
Fotomuseum im Münchner
Stadtmuseum (88/26-36)

100. Ground plan of the Lehr-
und Versuchsanstalt für Photo-
graphie, Munich 1911

Graf von Podewils und dem Kultusminister Dr. von
Wehner, dem Stadtschulrat Dr. Georg Kerschensteiner
und Vertretern der Münchner Kunstakademie, Museen
und Archive. Zahlreich vertreten waren auch Abordnun-
gen der Fachvereine in Deutschland und Photographen
wie Hugo Erfurth, Wanda von Debschitz-Kunowski und
Joseph Pécsi. Andere Photographen stifteten für die
›Vorbilder‹-Sammlung eigene Arbeiten oder übersandten
wie Heinrich Kühn drei Originalphotographien von
James Craig Annan. Die umfangreichste Schenkung
überließ Alfred Stieglitz, der zur Eröffnung eine Kollekti-
on von 200 Aufnahmen der Photo-Secession[152] aus
New York zusandte. Vermutlich handelte es sich um
Photogravüren aus der *Camera Work*, die jedoch in den
Wirren nach Ende des Zweiten Weltkrieges verloren
gingen. Dank ihrer Größe und Modernität war die
Münchner Unterrichtsstätte einzigartig in Deutschland
und zog in der Folgezeit viele prominente Besucher aus
dem In- und Ausland an. Verbürgt sind Besuche von
Madame d'Ora, Edward Steichen, Heinrich Kühn, Alfred
Stieglitz, Eduard Arning, E.O.Hoppé, Dr. Robert Luther
und Elfriede Reichelt.[153]
Auch nach Bezug der neuen Räumlichkeiten wurde
Eugenes Lehrtätigkeit unverändert positiv hervorgeho-

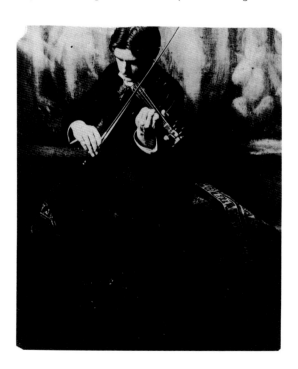

101. Fredy Smith, 1901
Platinum print
Metropolitan Museum of Art,
Rogers Fund, 1972 (1972.633.144)

ben. So hieß es in einem Bericht des Franzosen C.
Brissy aus Paris anläßlich des ›V. Congrès Nationale de
la Photographie professionelle‹ im November 1912: »Eine
der besten Seiten der Münchener Schule ist, daß man

sich dort nicht einfach darauf verlegt, den Künstlern die
Technik der Photographie beizubringen, sondern daß
man vor allem ihren Kunstsinn zu entwickeln sucht und
ihnen lernt, künstlerisch zu schaffen, ein sehr glücklicher
Verbindungsversuch der Photographie mit den anderen
Kunstzweigen und vorzüglich mit der Helio-Gravüre-
kunst und der Malerei. Von diesem Gesichtspunkte aus
bin ich glücklich, hier zu erinnern, daß der Unterricht in
der Münchener Schule unter dem energischen und ge-
klärten Antrieb des Kunstmalers Smith eine solche
Richtung genommen hat, welcher einer der ersten war,
der die Photographie aus den Pfaden gesetzt hat, die sie
seit zu langer Zeit gegangen war, und daraus macht,
was sie sein soll, eine echte Kunst.«[154]
Zu Eugenes bekanntesten Schülern zählen der ungari-
sche Photograph Joseph Pécsi[155] oder Theodor Schaf-
gans (1892–1976) aus Bonn, der nach dem Besuch der
Lehr- und Versuchsanstalt 1911 das im Jahre 1854 gegrün-
dete väterliche Geschäft übernahm und ähnlich wie
Smith die Negativplatten mit Radiernadel und Zeichen-
stift überarbeitete. Andere Schülerinnen wie die Bres-
lauerin Elfriede Reichelt oder die Münchnerin Anne
Königer, die während ihres Studiums Eugenes Bruder
Frederick in München kennenlernte und heiratete, um
später in New York ein Photoatelier zu eröffnen, entwik-
kelten wie der größte Teil der ehemaligen Studenten
Eugenes einen eigenständigen Stil. Davon zeugt auch
ein Artikel von K.W. Wolf-Czapek über die Münchner
Photoschule, der mit Photographien von Wanda von
Debschitz-Kunowski (München), Hans Grubenbecher
(Düsseldorf), Fritz Joelsohn (München), Hermann Brühl-
meyer (Wien), Elias van Bommel (München), Elfriede
Reichelt (Breslau), Joseph Pécsi (Budapest), E.Brissy
(Paris), Friedrich Feleki (München), Alb. Renggli (Mün-
chen) und Vollinger (München) illustriert war: »Lassen
wir die Bilder in ihrer Gesamtheit auf uns wirken, so
haben wir den Eindruck einer gewissen Stileinheit-
lichkeit, ohne daß in uns doch die Empfindung aufstei-
gen würde, daß die Bilder nur von der bedeutenden
Persönlichkeit des Lehrers den einzelnen, ohne ihnen
artverwandt zu sein, suggeriert wären; denn bei aller
Verwandtheit des Stiles sind doch so viele persönliche
Unterschiede bei den einzelnen Schaffenden festzustel-
len, daß die naheliegende Gefahr des bloßen
Nachahmens glücklich überwunden erscheint. Es war
von außerordentlicher Bedeutung für die Münchner
Lehranstalt, schon in frühen Jahren ihrer Tätigkeit in
Frank Eugène Smith einen Lehrer zu finden, der durch
photographische Konventionen und Schablonen
unbeengt, mit einem außerordentlich starken maleri-
schem Gefühl begabt und auch technisch voller Phanta-

Luitpold of Bavaria," "Princess Rupprecht of Bavaria," "Menuett," "Hortensia" and the nude study "Am Bach." The prints had been made at Heinrich Wetteroth's in Munich and a limited number were for sale at 50 marks each.[142] The portfolio, and in particular Eugene's motifs, were received very positively by both the daily and the trade press. The *Münchner Neueste Nachrichten* even claimed that "without the slightest hint of local patriotism," the portfolio "was at least on a par with Germany's best achievements."[143]

Eugene also had a solo exhibition of his "Lichtradierungen" or photo-etchings in the Commercial Photography Section of the Dresden show. As a founder-member of the International Society of Pictorial Photographers he also participated in that society's exhibition, which was organized by Heinrich Kühn.[144] There can be no doubt that Eugene's works were the most outstanding of those presented at the Dresden exhibition by the staff-members of the Munich institute, and in recognition of his achievements he was awarded the Medal of the City of Dresden. Very little was seen or heard of his colleagues Lähnemann and Spörl. Eugene's classes also seem to have had an inspiring effect on his students work, for in the various reports on the Lehr- und Versuchsanstalt's participation at the 1909 "Dresden Exhibition," reference was repeatedly made to his influence: "In all the students works one can recognize the supportive inspiration on their artistic development exercised by the sensitive Frank Eugene Smith, their teacher at the Lehr- und Versuchsanstalt."[145] And at another point we read: "Of all the institute's students – who, as I know, are very enthusiastic about their teacher Mr. Smith – there is not one who is content to simply imitate their teacher's working method. Instead they are obviously more concerned to profit artistically from the spirit of his work, something which speaks volumes for the effectiveness of the teaching methods at that institute."[146] It is no surprise therefore that after two years service, when Eugene applied for what he felt was an appropriate salary increase, this was granted.[147]

Official Portraits taken in the "Reform Studio"

Considerable changes were ushered in at the Munich Lehr- und Versuchsanstalt when the former municipal hospital building on Bismarckstrasse 9 in München-Schwabing became vacant and the institute's advisory board was able to acquire it. The City of Munich placed the building at the disposal of the institute for ten years rent free, while the Bavarian State and private sponsors bore the costs for its restoration and renovation.[148] The

new institute building, which was surrounded by park-like grounds admirably suitable for outdoor photography, consisted of a two-storey main building and an additional wing to the north.[149] It had a total of 90 rooms. The two photography classes were housed on the side of the wing which faced west and had fifteen rooms at their disposal, including two living-room studios with side-light, darkrooms, enlarging rooms, rooms for retouching, chromatizing, drying, and copying.[150] The architect Hanns Friedmann was again responsible for the interior decoration of all the side-light studios.[151] The new institute premises were officially opened on May 9, 1911 in the presence of numerous personalities from public life, members of the Wittelsbach family, the Bavarian Prime Minister Graf von Podewils and the Minister of Culture Dr. von Wehner, the Inspector of Schools Dr. Georg Kerschensteiner and representatives of Munich's Kunstakademie, museums and archives. There were also a large number of delegates from the trade associations throughout Germany, not to mention photographers such as Hugo Erfurth, Wanda von Debschitz-Kunowski and Joseph Pécsi. Other photographers donated samples of their work for the institute's "model" collection, and Heinrich Kühn sent three original photographs by James Craig Annan. To mark the occasion, Alfred Stieglitz made the most extensive donation, a collection of 200 photographs from the Photo-Secession in New York.[152] Presumably these were photogravures from *Camera Work*, which in the overall confusion after the end of the Second World War all seem to have gone missing. The premises of the Munich Lehr- und Versuchsanstalt were renowned throughout Germany on account of their size and their modernity, and in the following years attracted a lot of prominent visitors from at home and abroad, among them Madame d'Ora, Edward Steichen, Heinrich Kühn, Alfred Stieglitz, Eduard Arning, E. O. Hoppé, Dr. Robert Luther and Elfriede Reichelt.[153]

After the move to the new premises Eugene's classes continued to have a positive echo. Thus in a report by C. Brissy from Paris on the "V. Congrès Nationale de la Photographie professionelle" in November 1912 we read: "One of the best things about the Munich institute is that the teaching syllabus is not simply geared towards teaching the technique of photography but makes an attempt to develop the students' aesthetic sense and teach them to work artistically – a very pleasing fusion of photography and the other arts, especially of the art of heliogravure and painting. In this context I am happy to be able to report that classes in the Munich institute have taken this particular direction under the energetic

102. *Anonymous*
Georg Kerschensteiner, c. 1905
from: Marie Kerschensteiner,
Georg Kerschensteiner, Munich-Berlin 1939

sie, keine älteren Vorbilder brachte, sondern aus sich heraus ganz original und originell seine Kompositionen schuf und seine Ideen der Bildgestaltung seinen Schülern beizubringen wußte.«[156]

Frank Eugene arbeitete mit seinen Schülern vorzugsweise in dem neuen ›Reformatelier‹ mit Seiten- und Oberlicht, das sich im Dachgeschoß des Anbaus nach Norden befand und für die Ausbildung der fortgeschritteneren Semester genutzt wurde: »Dieser Raum verbindet in idealer Weise alle Vorzüge der Oberlicht- und Seitenlichtateliers. Es ist nicht der altmodische Glaskasten mit seiner schädlichen und für heutige Verhältnisse nur störenden Überfülle an Lichtmassen, der aber gleichwohl in seinen Lichtmengen zu allen in der Porträtpraxis vorkommenden Arbeiten vollkommen genügt.« Das Atelier war so konstruiert, daß »bei gedämpftem Oberlicht selbst Gruppen von 6 m Breite und darüber noch gleichmäßige Beleuchtung erfahren können. Bei dieser Anordnung steht für Einzelaufnahmen die denkbar vielseitigste Lichtqualität zur Verfügung. Vom Seitenfenster an bis zur ganzen Tiefe stuft das Licht von der härtesten Wirkung bis zur Flauheit ab, so daß für jeden einzelnen Fall, selbst ohne Gardinenregulierung, jede Beleuchtungsart herausgesucht werden kann. Es ist möglich, mit Oberlicht zu arbeiten oder dieses auszuschließen, so daß man wohl mit Recht von einem Universalatelier sprechen kann, das geeignet sein dürfte, als Reformatelier für die gesamte Porträtpraxis betrachtet zu werden.«[157] Das Atelier war mit einem großen Wandteppich nach einem Motiv von Hans von Marées dekoriert, der auch in Eugenes Studio in Leipzig wiederholt als Bildhintergrund Verwendung finden sollte, sowie mit einigen Photographien Eugenes ausgestattet, die auch in anderen Räumlichkeiten des neuen Schulgebäudes als Wandschmuck dienten. Während die Wohnraum-Ateliers mit Photographien wie ›Adam and Eve‹ oder ›Rebeckah‹ geschmückt waren, befanden sich im Konferenzzimmer von Eugene aufgenommene Repräsentationsbildnisse der Staatsminister von Landmann und von Wehner, des Regierungspräsidenten von Blaul, dem Referenten des bayerischen technischen Fachschulwesens K. Preger, des Verwaltungsgerichts-Hofrates K. Brinz, Regierungsrates Loritz, des Schulrates Georg Kerschensteiner und Franz Grainer.[158]

In dem ›Reformatelier‹ der Lehr- und Versuchsanstalt entstanden auch offizielle Repräsentationsbilder von Angehörigen der Wittelsbacher Familie. So statteten am 29. April 1912 Prinz Ludwig, seine Frau und Prinzessin Gundelinde der Lehranstalt einen Besuch ab, um während der 5/4 stündigen Besichtigung der Räumlichkeiten auch »im großen Reformatelier Fachlehrer Kunstmaler

Frank Smith vorgestellt« zu werden, »der zahlreiche seiner Arbeiten und derjenigen seiner Schüler aufgestellt hatte. Prinz und Prinzessin Ludwig gestatteten hier auch einige Aufnahmen.«[159] Ein weiterer Besuch des Prinzregenten Ludwig von Bayern fand am 24. Februar 1913 statt, um auf Wunsch des Kulturministeriums »für die Zwecke der Mittelschulen ein Repräsentationsbild des allerhöchsten Herrn herzustellen«.[160] Von dieser Porträtsitzung haben sich mehrere Aufnahmen des in Uniform und reich mit Orden dekorierten Prinzregenten erhalten, die den Wittelsbacher als Brustbild oder Ganzfiguren-Studie vor dem Hintergrund eines Wandteppichs wiedergeben. Obwohl sich die Porträtphotographien stilistisch und inszenatorisch von den populären von Kaulbach gemalten Herrschaftsporträts des späteren König Ludwig III. kaum unterscheiden,[161] haben Eugenes Bildnisse kaum Verbreitung gefunden. Es ist unbekannt, ob sie jemals für die vorgesehene Funktion verwendet wurden, zumal sie weder in der Illustriertenpresse noch in den Fachzeitschriften veröffentlicht wurden. Als offizielle Photoporträts bevorzugte der Wittelsbacher Aufnahmen der traditionellen Münchner Hofphotographen Friedrich Müller, Gebrüder Hirsch und Bernhard Dittmar, die anläßlich seiner Ernennung zum Prinzregenten und zum König in der *Münchner Illustrierten Zeitung* ihre Öffentlichkeit fanden.[162]

Bereits 1908 hatte Eugene den Sohn Ludwigs, Prinz Rupprecht von Bayern, und seine Familie mit Ehefrau Prinzessin Marie Gabriele und den Söhnen Prinz Luitpold und Prinz Albrecht vermutlich in den Wohnräumen des Schlosses Nymphenburg bzw. der Münchner Residenz photographiert. Charakteristisch für die Bildserien ist die familiäre, geradezu privat anmutende Umgebung, in der auf herrschaftliche Insignien weitgehend verzichtet wurde. Stattdessen legte Eugene Wert auf eine menschliche atmosphärische Darstellung der Wittelsbacher Familie. Insbesondere die Aufnahmen von Prinzessin Marie Gabriele inmitten ihrer Kinder vermitteln den Eindruck inniger Verbundenheit und damit unterscheidet sich das Familienbild mit Prinz Rupprecht im wesentlichen nicht von gleichgearteten Familienporträts hochrangiger Militärs oder wohlhabender Persönlichkeiten. Im Gegensatz dazu stehen die klassischen Dynastiedarstellungen der Wittelsbacher Familie, wie sie beispielsweise von Franz Grainer oder Friedrich August von Kaulbach bekannt sind, um die Kontinuität der Erbfolge anzudeuten.[163] Sicherlich ist die privatisierte Darstellung der Wittelsbacher Königsfamilie der zeitspezifische Ausdruck für die Übertragung bürgerlicher Wertkategorien in die Lebenswelt der Hocharistokratie.

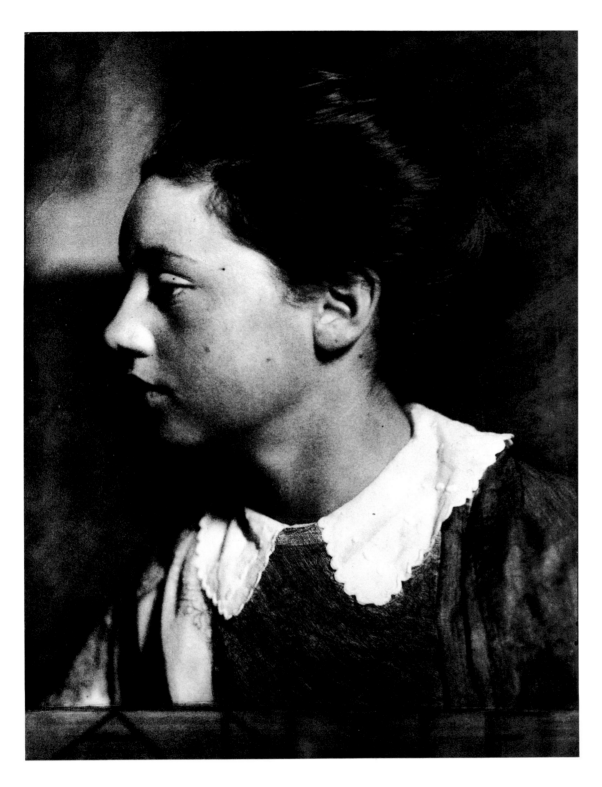

103. Anne Königer, 1911
Platinum print
Metropolitan Museum of Art,
Rogers Fund, 1972 (1972.633.157)

104. Prinzregent Ludwig von Bayern (König Ludwig III.). 1913
Platinum print, 23.8 x 17.5 cm
Fotomuseum im Münchner Stadtmuseum (88/26-77)

Autotypie und insbesondere der Photogravüre, deren stoffliche Tonalität Eugenes Bildtechnik von Platinabzügen auf Japanpapier sehr entgegenkam. Während Frank Eugenes Aufnahmen in den ersten Jahren noch erhebliche phototechnische Mängel besaßen, so konnte er seine Technik soweit perfektionieren und verfeinern, daß die Porträtaufnahmen kaum noch optische Verzeichnungen der Proportionen aufwiesen. Obwohl er unverändert an den Negativmanipulationen durch Einzeichnung und Übermalung festhielt, waren viele Bildnisse im Stile der ›straight photography‹ entstanden. Diese Entwicklung spiegelte sich auch in den Veröffentlichungen seiner Arbeiten in den Zeitschriften der Kunstphotographie und des Kunstgewerbes *Camera Work, Photographische Kunst,*[165] *Dekorative Kunst* oder *Deutsche Kunst und Dekoration*[166] wieder. In der *Camera Work* waren von 1904 bis 1916 insgesamt achtundzwanzig Aufnahmen erschienen, davon der größte Teil in zwei Eugene gewidmeten Ausgaben. Im April-Heft 1910 befanden sich die Motive ›Mosaic‹, ›Adam and Eve‹, ›Man in Armor‹, ›Princess Rupprecht of Bavaria

Das familäre Herrschaftsporträt hatte sich mit dem Zeitalter der Aufklärung Mitte des 18. Jahrhunderts durchgesetzt und gestattete dem untergebenen Volk sich mit den »menschlichen« Aspekten der Herrschaft zu identifizieren.[164] In der Münchner Prinzregentenzeit war dieser Bildtypus ausgesprochen populär, so daß einzelne Motive Eugenes als Postkarten in hohen Auflagen im Josef Böhm-Verlag in München vertrieben wurden und für den Photographen wohl ein einträgliches Geschäft darstellten. Darunter befand sich auch ein Porträt des jungen Prinzen Luitpold mit Schaukelpferd, ursprünglich ein Doppelporträt mit seinem Bruder Albrecht, dessen Figur in Folge der Übermalung des Bildhintergrundes verschwand.

Ein eher klassisches Repräsentationsbildnis nahm Eugene von Prinz Rupprecht von Bayern in der Profilansicht des mit Orden dekorierten Wittelsbacher auf. Diese Aufnahme, die auch in *Camera Work* 1910 veröffentlicht wurde, war so populär, daß sie zu Beginn des Ersten Weltkrieges mit dem Untertitel ›Handeln, nicht Trauern!‹ als Photogravüre im F. Bruckmann-Verlag vertrieben wurde.

Veröffentlichungen in *Camera Work* 1904–1916

Wie wirkte sich die Lehrtätigkeit Eugenes an der Münchner Lehr- und Versuchsanstalt für Photographie auf sein eigenes künstlerisches Schaffen aus? Zunächst eröffneten sich Eugene neue gestalterische Möglichkeiten dank der Beschäftigung mit den verschiedenen Reproduktions- und Druckverfahren wie Lichtdruck,

105. Prinz Luitpold and Prinz Albrecht. 1908
Postcard, 13.7 x 9.0 cm
Verlag Joseph Böhm, München
Fotomuseum im Münchner Stadtmuseum (93/365-4)

and enlightened influence of the painter Smith, who was one of the first to lead photography away from the path it had been following for much too long, and making of it what it should be, namely a real art."[154] Among Eugene's most famous students were the Hungarian photographer Joseph Pécsi[155] and Theodor Schafgans (1892–1976) from Bonn. After completing his training at the Lehr- und Versuchsanstalt in 1911, the latter took over the business founded by his father in 1854 and, like Smith, specialized in manipulating his negative plates with etching needles and pencils. The vast majority of Eugene's students went on to develop their own independent styles. This was especially the case with Elfriede Reichelt from Breslau and Anne Königer from Munich. Anne Königer got to know Eugene's brother Frederick during her studies, married him, and later opened a photography studio in New York. An article by K.W. Wolf-Czapek on the Munich institute emphasized that particular point: "If we take the photographs as a whole then the impression we get is that of a certain unity of style, but without the suspicion that this was suggested to the individual students by the outstanding personality of their teacher alone, and was not akin to their individual personalities; for despite all the similarity in style, we can still ascertain so many personal differences in the individual works that, fortunately, the obvious danger of mere imitation seems to have been overcome. It has been a great advantage to the Munich Lehr- und Versuchsanstalt to have had a teacher like Frank Eugene Smith with them from the very beginning. Unhampered by photographic conventions and clichés, endowed with an extraordinarily broad artistic awareness, and technically imaginative, he has not brought along old models with him, but instead has created original and unusual compositions of his very own and has been able to communicate his ideas on pictorial composition to his students."[156]

To illustrate his article Wolf-Czapek chose photographs by Wanda von Debschitz-Kunowski (Munich), Hans Grubenbecher (Dusseldorf), Fritz Joelsohn (Munich), Hermann Brühlmeyer (Vienna), Elias van Bommel (Munich), Elfriede Reichelt (Breslau), Joseph Pécsi (Budapest), E. Brissy (Paris), Friedrich Feleki (Munich), Alb. Renggli (Munich) and Volinger (Munich).

Frank Eugene preferred to hold his classes in the new so-called "reform studio." This had both side- and overhead-light, was located on the top floor of the wing extension to the north, and was used for teaching the advanced courses: "This room is an ideal combination of all the advantages of a studio with overhead- and a studio with side-light. It is no old-fashioned glass box

with an over-abundance of light, which is hazardous and merely troublesome by today's standards. The conditions are totally sufficient for all the types of work involved in the practice of portrait photography." The studio was constructed in such a way that "even with reduced overhead-light, it was still possible to achieve adequate lighting for groups up to 6 meters wide and more. Under these circumstances, the most varied qualities of lighting could be achieved for each specific photograph. From the side window right into the depth of the room, the light nuances range from the hardest effect right down to a fuzzy effect, so that every imaginable kind of lighting can be found for each individual

case, even without altering the curtains. It is possible to work with overhead-light or without, so one can justifiably speak of a universal studio, one which can function as a model for the practice of portraiture."[157] The studio was decorated with a large tapestry based on a motif by Hans von Marées. Eugene was to use this tapestry again and again as a backdrop, even in his Leipzig studio. The walls were also decorated with photographs by Eugene, as were the walls of other rooms in the new institute building. His "Adam and Eve" and "Rebeckah" were in the living-room studios, while the conference

108. Prince Regent Ludwig von
Bayern (King Ludwig III), 1913
Platinum print, 23.0 x 16.0 cm
Fotomuseum im Münchner
Stadtmuseum (88/26-76)

room was allocated the representative portraits he had taken of the State Ministers von Landmann and Dr. von Wehner, the district president Dr. von Blaul, the adviser to the Bavarian Department of Technical Education Dr. K. Preger, privy councilor K. Brinz, senior civil servant Loritz, Inspector of Schools Georg Kerschensteiner, and Franz Grainer.[158]

Official representative portraits of members of the Wittelsbach family were also taken in this "reform studio." Thus on April 29, 1912 Prince Ludwig, his wife, and Princess Gundelinde paid a visit to the Lehr- und Versuchsanstalt. In the course of a brief tour of the premises they were introduced to "the teacher and painter Frank Smith in the large reform studio," where Eugene had positioned "a large number of his own works and works of his students. Prince and Princess Ludwig allowed him to take some photographs of them while they were there."[159] On February 24, 1912, the Prince Regent paid another visit to the studio in order, at the request of the Ministry of Culture, to have a representative photograph taken "for use in secondary schools."[160] Several photographs from this sitting have been preserved. They are half-length and full-length portraits of Prince Ludwig in uniform and with his various decorations, taken against a tapestry background. Although these portrait photographs are not essentially different either in style or in setting from the popular portraits of the later King Ludwig III painted by von Kaulbach,[161] they did not have a very wide circulation.

It is not known whether they were ever used for the envisaged purpose, especially as they were never reproduced either in the press or in the respective special magazines. The Wittelsbachers preferred the official portraits taken by the traditional Munich court photographers Friedrich Müller, the Hirsch brothers, and Bernard Dittmar, which were reproduced in the *Münchner Illustrierte Zeitung* on the occasion of Ludwig's investiture both as Prince Regent and as King.[162]

Eugene had already photographed Ludwig's son, Prince Rupprecht of Bavaria, with his wife Princess Marie Gabriele and their sons Prince Luitpold and Prince Albrecht in 1908, presumably in the residential section of Schloss Nymphenburg or at their Munich residence. Two particular features of this series of photographs are the private, almost intimate atmosphere, and the almost complete absence of any kind of royal insignia. Instead, Eugene's particular presentation of the Wittelsbach family emphasized the human aspect. More especially the photographs of Princess Marie Gabriele with her children communicate an impression of deep emotional attachment. Thus the family portrait with Prince Rupprecht does not differ essentially from other similar family por-

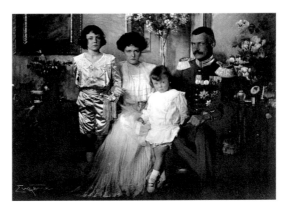

109. Crown prince Rupprecht von Bayern and family, 1908 Platinum print, 12.3 x 16.5 cm Geheimes Hausarchiv der Wittelsbacher, Bayerisches Hauptstaatsarchiv Munich

traits of high-ranking military or wealthy social figures. By contrast, the classical dynastic representation of the Wittelsbach family, for example by Franz Grainer or Friedrich August von Kaulbach, underline the continuity of the succession.[163] Eugene's more private presentation of the Wittelsbach royal family is no doubt a contemporary expression of the superimposition of bourgeois values on the life world of the aristocracy. It had become common in the Age of the Enlightenment in the mid 18th century to distributed family portraits of royal rulers as these allowed their subjects to identify with the "human" aspects of their royal rulers.[164] In the Regency period in Munich this type of portrait was extremely popular, with the result that some of Eugene's motifs were published as postcards by the Josef Böhm Verlag and sold in large numbers, representing a considerable source of income for the photographer. Among these motifs was a portrait of the young Prince Luitpold and his rocking-horse. This had originally been a double portrait with his brother Albrecht who disappeared totally from view when Eugene painted over the background of the photograph.

But Eugene also took a more classically representative photograph of Prince Rupprecht of Bavaria, in profile, his decorations and medals clearly visible. This photograph, which was reproduced in *Camera Work* in 1910, was so popular that is was distributed as a photogravure by the F. Bruckmann Verlag at the beginning of the First World War bearing the caption "Action not Sorrow."

Publications in *Camera Work* 1904–1916

What effect did Eugene's teaching activities at the Munich Lehr- und Versuchsanstalt have on his own creative work? To begin with, whole new artistic horizons were opened up for him thanks to his preoccupation with the different reproduction and printing processes such as collotype, half-tone photoengraving and in particular photogravure, especially as the textural tonality which

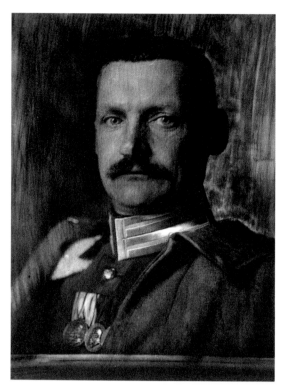

110. Crown Prince Rupprecht
von Bayern, 1908
Platinum print, 23.0 x 16.3 cm
Fotomuseum im Münchner
Stadtmuseum (88/26-80)

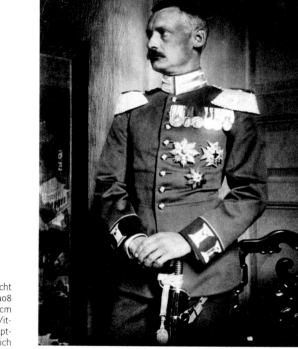

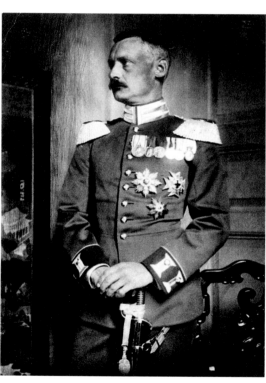

112. Crown Prince Rupprecht
von Bayern, 1908
Platinum print, 16.5 x 11.8 cm
Geheimes Hausarchiv der
Wittelsbacher, Bayerisches
Hauptstaatsarchiv, Munich

111. Crown Prince Rupprecht
von Bayern, 1908
Platinum print, 16.4 x 11.3 cm
Geheimes Hausarchiv der Wit-
telsbacher, Bayerisches Haupt-
staatsarchiv, Munich

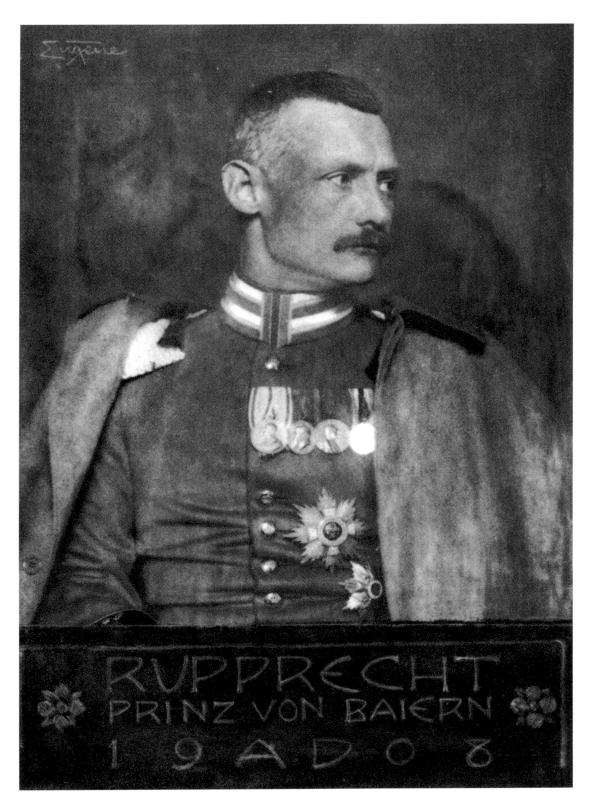

113. Crown Prince Rupprecht
von Bayern, 1908
Photogravure, 23.5 x 16.5 cm
Fotomuseum im Münchner
Stadtmuseum (88/26-55)

114. Crown Prince Rupprecht
von Bayern, 1908
Platinum print, 17.0 x 11.8 cm
Fotomuseum im Münchner
Stadtmuseum (88/26-82)

115. Princess Marie Gabriele
von Bayern with her sons
Albrecht and Luitpold, 1908
Photogravure, 16.9 x 12.1 cm
Fotomuseum im Münchner
Stadtmuseum (88/26-47)

116. The Princes Luitpold and
Albrecht von Bayern, 1908
D.O.P., 11.8 x 16.6 cm
Fotomuseum im Münchner
Stadtmuseum (88/27-34)

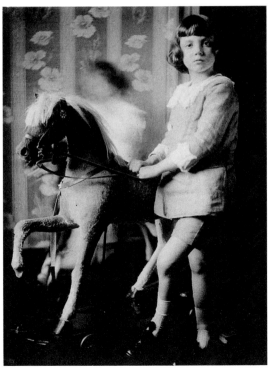

117. The Princes Albrecht and
Luitpold with rocking horse, 1908
Platinum print
Fotomuseum im Münchner
Stadtmuseum

118. Prince Luitpold von Bayern
with rocking horse, 1908
Platinum print, 17.0 x 12.0 cm
Fotomuseum im Münchner
Stadtmuseum (88/26-57)

119. Prince Luitpold von Bayern,
1908
Platinum print, 17.0 x 12.0 cm
Fotomuseum im Münchner
Stadtmuseum (88/26-59)

with Prince Luitpold and Prinz Albrecht Johann‹, ›Re-beckah‹, ›Sir Henry Irving‹, ›Brigitta‹, ›Frank Jefferson‹, ›Minuet‹ und ›The Horse‹. Das Juli-Heft 1910, in dem ursprünglich ein Text von Maximilian K. Rohe erscheinen sollte, beinhaltete die Aufnahmen ›Direktor F. Goetz‹, ›Dr. Emanuel Lasker and His Brother‹, Dr. Georg Hirth‹, ›Frau Ludwig von Hohlwein‹, ›Fritz von Uhde‹, ›Prince Rupprecht of Bavaria‹, ›Hortensia‹, ›Kimono-Frl. v. S‹, ›Nude - A Child‹, ›Nude - A Study‹, ›Prof. Adolf Hengeler‹, ›Prof. Rudolf v. Seitz‹, ›Prof. Franz v. Stuck‹ und ›Willi Geiger‹.[167]

Sämtliche Photogravüren waren bei der Münchner Kunstanstalt Friedrich Bruckmann gedruckt worden, die seit 1904 regelmäßig Werbeanzeigen in *Camera Work* geschaltet und wiederholt den Druck der Gravüren über-

Farbbuchdruck galt. Von 1901 bis 1919 war Goetz als technischer Direktor bei der Kunstanstalt Bruckmann beschäftigt, bevor er einen Ruf als Professor an die Akademie für graphische Künste und Buchgewerbe in Leipzig annahm. Stieglitz kannte Goetz bereits seit den 1880er Jahren aus Berlin und er setzte großes Vertrauen in dessen Fähigkeiten der drucktechnischen Wiedergabe von Originalphotographien, weshalb Stieglitz der Firma Bruckmann den Druck der Portfolios von Eugene, Kühn, de Meyer und Steichen übertrug.[170] Auch Eugene war mit Goetz befreundet, so daß die *Camera Work* im Juli 1910 wohl nicht zufällig als Hommage ein Porträt von Frederick Goetz enthielt.

Die Photogravüren der beiden Ausgaben der *Camera Work* waren mit Ausnahme des Porträts von Prinz

120. Publication on the photographer Frank Eugene Smith, in: *Dekorative Kunst*, October 1908, pp. 2–3

nommen hatte. Als traditionsreiches, 1858 gegründetes Unternehmen galt Bruckmann als führend im Bereich der Kunstreproduktion und verfügte als erste deutsche Firma seit 1885 über eine Lichtdruckmaschine, um ab 1890 die ersten Mehrfarbendrucke herzustellen.[168] Die intensive Zusammenarbeit zwischen Bruckmann und Stieglitz war vor allem dem Sachverstand des Deutsch-Amerikaners Frederick Goetz zu verdanken, der bei Dr. Eugen Albert in der 1883 gegründeten photographischen Kunst- und Verlagsanstalt gearbeitet hatte,[169] die als führend in der Herstellung von Heliogravüren und im

Rupprecht von Bayern nach dem Originalnegativ im selben Format reproduziert und gedruckt worden:[171] »Ich habe mich entschieden, keinerlei Eingriffe von Hand auf der Kupferplatte zuzulassen – und wenn die Lichtpunkte und andere mechanische Fehler entfernt worden sind, müßte der Druck einen ziemlich guten Eindruck von meinen Sachen geben.«[172] Nach dem Druck wurden die Gravüren nach New York transportiert und in die Hefte eingebunden. Stieglitz teilte Eugene im Februar 1910 mit, daß er von der Druckqualität angetan sei. Eugene war ebenfalls mit dem Ergebnis und den Reaktio-

these made possible complied with his own technique of making platinum prints on Japanese tissue. Whereas on his initial attempts Eugene's photographs had considerable technical weaknesses, he was soon able to perfect and refine his technique so that the proportions in his portrait photographs show scarcely any optical distortions. Although he persisted in manipulating the negatives by drawing or painting on them, many of his portraits were in the "straight photography" style. This development is also mirrored in the reproductions of his works in the magazines *Camera Work, Photographische Kunst,*[165] *Dekorative Kunst* or *Deutsche Kunst und Dekoration,*[166] each a major forum for art photography and the arts and crafts. Between 1904 and 1916 a total of twenty-eight photographs were reproduced in *Camera Work,*

mono-Miss v. S.," "Nude – A Child," "Nude – A Study," "Prof. Adolf Hengeler," "Prof. Rudolf v. Seitz," "Prof. Franz v. Stuck," and "Willi Geiger."[167]

All of the photogravures were done at the Munich Kunstanstalt Friedrich Bruckmann which had been placing regular advertisements in *Camera Work* since 1904 and had repeatedly been commissioned to print their photogravures. The Bruckmann company was founded in 1858 and was looked upon as a leader in the field of art reproductions. It was the first German company to acquire a collotype machine in 1885, so that from 1890 onwards it was in a position to produce the first color prints.[168] The close cooperation between Bruckmann and Stieglitz was due primarily to the discernment of the German-American Frederick Goetz. Goetz had worked with Dr. Eugen Albert

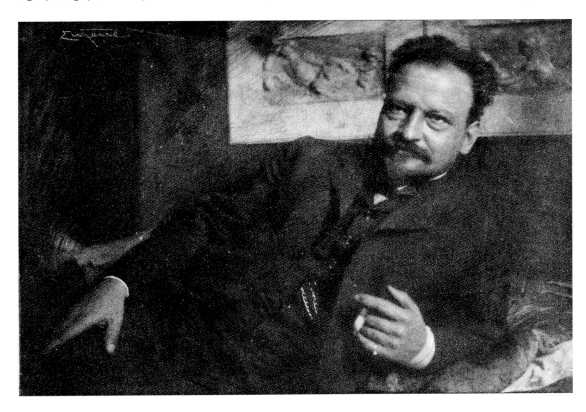

121. Frederick Goetz, c. 1907
Photogravure, 12.7 × 17.7 cm
Fotomuseum im Münchner
Stadtmuseum (88/26-73)

of which the largest number were in two special editions devoted to Eugene. The 1910 April issue contained the motifs "Mosaic," "Adam and Eve," "Man in Armor," "Princess Rupprecht of Bavaria with Prince Luitpold and Prince Albrecht Johann," "Rebeckah," "Sir Henry Irving," "Brigitta," "Frank Jefferson," "Menuett" and "The Horse"; the 1910 July issue contained the photographs "Director F. Goetz," "Dr. Emanuel Lasker and His Brother," "Dr. Georg Hirth," "Mrs. Ludwig von Hohlwein," "Fritz von Uhde," "Prince Rupprecht of Bavaria," "Hortensia" "Ki-

in the Kunst- und Verlagsanstalt, founded in 1883,[169] which was a leading producer of photogravures and printer of books in color. From 1901 to 1919 Goetz was employed as a technical director at the Kunstanstalt Bruckmann, before accepting an appointment as professor at the Leipzig Akademie. Stieglitz got to know Goetz in the 1880s in Berlin and had confidence in his technical ability to reproduce prints from original photographs. For this reason he commissioned Bruckmann to print the portfolios of Eugene, Kühn, de Meyer and Steichen.[170] Eugene and

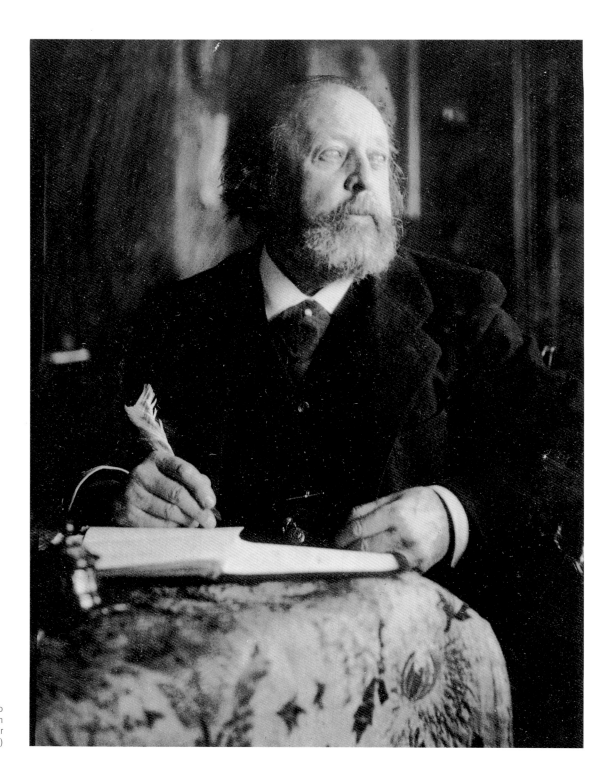

122. Paul Heyse, c. 1910
Platinum print, 16.5 x 12.5 cm
Fotomuseum im Münchner
Stadtmuseum (88/26-88)

123. Paul Heyse, c. 1910
Photogravure, 17.0 x 12.0 cm
Christian Brandstätter, Vienna

124. Mina Gedon, c. 1908
Platinum print, 11.4 x 16.0 cm
Brigitte Gedon, Munich

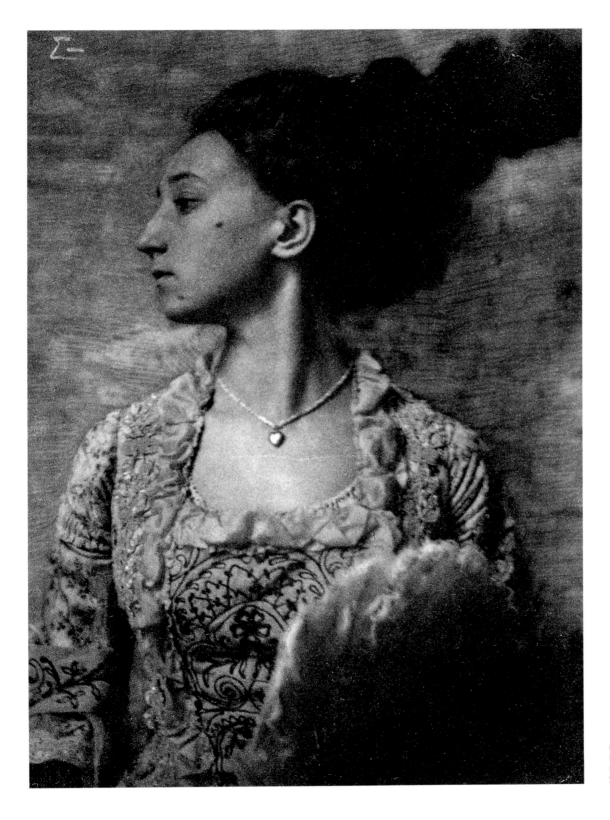

125. Emmy Geiger, c. 1908
Platinum print, 16.9 x 12.0 cm
Fotomuseum im Münchner
Stadtmuseum (88/27-130)

nen in München hochzufrieden, zumal allein vierzehn von Eugenes Schülern die Ausgabe bestellten: »Die Leute, denen ich ›Camera Work‹ gezeigt habe, waren sehr begeistert, und ich wünschte, Du hättest hören können, was Direktor F.A. v. Kaulbach zu der Ausgabe gesagt hat, in der Du mich für die Zukunft verewigt hast – ›einfach unerhört schön‹ – hat er ständig wiederholt.«[173] Immer wieder hat Eugene seiner Begeisterung für *Camera Work* Ausdruck verliehen und für die Zeitschrift neue Abonnenten gewinnen können wie z.B. Georg Heinrich Emmerich, Leopold von Glasersfeld, Nicolaj Petrov, den Vorsitzenden des Photoclubs Daguerre in Kiew, der 1911 die erste Ausstellung der Photo-Secession in Russland zeigen konnte: »Die Leute im ›Allotria‹, die sie gesehen haben, sind ganz begeistert davon – Rohe und Geiger haben sich auch gefreut – ganz egal, wo ich hingehe, ich habe immer eine Nummer der *Camera Work* unterm Arm, und meist ist Enttäuschung im Blick der andern, wenn ich mal mit leeren Händen auftauche.«[174]

Kurioserweise stammte die letzte Veröffentlichung von Eugene in *Camera Work* 1916 – eine Tieraufnahme mit dem Titel ›The Cat‹ – gar nicht von Eugene sondern von einer Münchner Schülerin der Lehr- und Versuchsanstalt für Photographie. Sie hatte das Motiv war bereits 1911 in der Zeitschrift *Deutsche Kunst und Dekoration* veröffentlicht.[175]

Tanzphotographie und Freundesbilder

Neben seiner beruflichen Lehrtätigkeit blieb Eugene genügend Zeit, um Privataufträgen als Porträtist der wohlhabenden Münchner Gesellschaft und Künstlerschaft nachzugehen und seine Galerie berühmter Zeitgenossen zu vervollständigen. Von einem geregelten Atelierbetrieb konnte gleichwohl keine Rede sein, denn Porträtsitzungen fanden nur nach mündlicher oder schriftlicher Vereinbarung statt, wie auch eine Anmeldung Eugene als Berufsphotograph für den Zeitraum von 1901 bis 1913 weder in den Münchner Adressbüchern noch in den Akten des Gewerbeamtes nachweisbar ist.[176] Man würde Eugenes Tätigkeit mißverstehen, setzte man diese mit der Praxis der gewerblichen Atelierphotographie gleich. Über seine unkonventionelle Arbeitsweise gab er anläßlich einer Umfrage in der *Photographischen Kunst*, die sich auch an die bekannten deutschen Berufsphotographen Rudolf Dührkoop (Berlin), Hugo Erfurth (Dresden), Franz Grainer und Henry Traut (München) richtete, bereitwillig Auskunft: »Ich arbeite überall; mir ist es ganz gleich, ob im Atelier, im Garten, auf einem Kirchturm, im Speicher oder im Kel-

ler. – Ich brauche nur das nötige Licht und meine ehrwürdige Camera mit dem französischen Aplanaten, der mich seiner Zeit 40 Mark gekostet hat. – Nord- und Südlicht, Oberlicht, Seitenlicht und Unterlicht ist alles kolossal brauchbar. Ein Glashaus oder ein sogenanntes Oberlichtatelier halte ich für einen famosen Platz, um exotische Pflanzen zu züchten.«[177] Mit dieser drastischen Polemik machte Eugene seine ästhetischen Prämissen als Porträtphotograph deutlich. Während die Atelierphotographen in Studios mit Ober- und Seitenlicht arbeiteten, war Eugene eigentlich jeder Schauplatz recht. Zahlreiche Aufnahmen sind in den Atelierräumen der Lehr- und Versuchsanstalt oder auf dem Dachgarten seiner Wohnung in der Theresienstraße in Schwabing entstanden, einem vornehmen Neubau der Jahrhundertwende.[178]

126. *Georg Pettendorfer*
View of Theresienstraße 74-78a, Munich 1905
Stadtarchiv München

Gelegentlich durfte Eugene auch das Atelier von Habermann für Aufnahmen nutzen, als er beispielsweise die Ausdruckstänzerin Ruth St.Denis photographieren wollte.[179] Andere Tanzstudien stellen die portugiesische Tänzerin Friderica Derra de Moroda (von Eugene ›Fritzi von Derra‹ genannt) dar, die, wie Senta M'Ahesa, Vera Fokina oder Edith von Schrenck, versuchte, den klassischen Tanz durch freie Improvisationen im griechischen, orientalischen oder exotischen Stil zu erweitern.

132

Goetz also became friends, so it was no coincidence that the July 1910 issue of *Camera Work* contained a homage to Frederick Goetz in the form of a portrait. With the exception of the portrait of Prince Rupprecht of Bavaria, the photogravures in these two issues of *Camera Work* were reproduced and printed from the original negatives and in the same format:[171] "I have determined to not permit any manual manipulation on the copper-plate – and when the light sports and a few other mechanical faults are removed, the print ought to give one rather a favorable idea of what my stuff looks like."[172] After printing, the photogravures were transported to New York and integrated into the magazines. In February 1910 Stieglitz informed Eugene that he was impressed by the printing quality. Eugene was also very satisfied not only with the result but also with the reactions in Munich's art circles: "*Camera Work* has caused the people to whom I have shown it intense enjoyment and I wish you could have heard what Director F. A. v. Kaulbach said about the number in which you have handed me down to future ages – "Einfach unerhört schön" – was a remark which he simply kept repeating."[173] To Eugene's great satisfaction, fourteen of his students placed orders for the issue.

Eugene made no secret of his enthusiasm for *Camera Work* and succeeded in getting new subscribers for the magazine including Georg Heinrich Emmerich, Leopold von Glasersfeld, and Nicolaj Petrov, the chairman of the Daguerre photography club in Kiev, the first to show a Photo-Secession exhibition in Russia in 1911: "The fellows at the 'Allotria' that have seen it are simply all enthusiasm – Rohe and Geiger are delighted too – A copy of *Camera Work* is under my arm wherever I go – and generally there is a look of disappointment if I happen to come empty handed."[174]

Oddly enough, the last reproduction of a Eugene work in *Camera Work* in 1916 – a photograph called "The Cat" – is not by Eugene at all but by a female student of the Lehr- und Versuchsanstalt, and had already been reproduced in the magazine *Deutsche Kunst und Dekoration* in 1911.[175]

Dance Photographs and Photographs of Friends

Parallel to his teaching obligations Eugene had adequate time to devote to private commissions for portraits from wealthy members of Munich's art circles, and to completing his gallery of famous contemporaries. He did not run a regular studio in the general sense, as portrait sittings only took place by verbal or written appointment. There is also no evidence either in the Munich

directories or in the files of the Board of Trade of Eugene having been registered as a professional photographer during the period from 1901 to 1913.[176] Indeed, it would be a misrepresentation to equate Eugene's activities with the practices of commercial studio photographers. He himself willingly gave some information about his unconventional way of working for a survey undertaken by *Photographische Kunst* to which the famous professional German photographers Rudolf Dührkoop (Berlin), Hugo Erfurth (Dresden), Franz Grainer (Munich), and Henry Traut (Munich) also contributed: "I work anywhere; it is all the same to me whether it is in a studio, a garden, up a church tower, in an attic or a cellar. All I need is the necessary light, and of course my trusty camera with the French aplanatic lens, which cost me 40 marks at the time. Light from the north, light from the south, overhead-light, side-light or light from below, they may all be tremendously useful. In my view, a glass house, or a so-called overhead-light studio, is an excellent place for growing exotic plants."[177] With this drastic polemic Eugene illustrated his aesthetic principles as a portrait photographer. While studio photographers worked in studios with overhead and side-light, almost any location was acceptable to Eugene. However, many of his photographs were taken in the studio rooms of the Lehr- und Versuchsanstalt or in the roof garden of his flat in Theresienstrasse in Schwabing, an elegant new turn of the century building.[178] Occasionally Habermann allowed Eugene to use his studio, for example, when he wanted to photograph the expressive dancer Ruth St. Denis.[179] His other dance studies show the Portuguese dancer Friderica Derra de Moroda (Eugene called her "Fritzi von Derra") who, like Senta M'Ahesa, Vera Fokina or Edith von Schrenck sought to expand the scope of classical dance to include free improvisation in the Greek, oriental or exotic manner. A series of photographs by Eugene, which he published as individual photographs under the title "Mosaic," constituted a high point in dance photography. It was with this particular motif that Eugene's radical and "unphotographic" method of "photo-etching" attained a high degree of expressivity. It was originally assumed that the model in these photographic studies of movement was the dancer Friderica Derra de Moroda, but a comparison with other known studies of her contradict this. What is more probable is that the dance studies show Dora Gedon, daughter of the famous Munich sculptor Lorenz Gedon.[180] The composition, which awakens formal associations with the dancing Salomé, achieves its dynamism not so much as a result of the dancer's pose as of the photograph's rich background

Den Höhepunkt der Tanzphotographien repräsentierte eine Bildserie, die Eugene als Einzelbilder unter dem Titel ›Mosaik‹ veröffentlichte. In diesem Motiv erreichte Eugenes radikale und ›unphotographische‹ Methode der ›Photo-Radierung‹ ein Höchstmaß an Ausdruckskraft. Ursprünglich wurde angenommen, daß es sich bei dem Modell für photographische Bewegungsstudie um die Tänzerin Friderica Derra de Moroda handelte, wogegen ein Vergleich mit den anderen bekannten Studien der Tänzerin spricht. Stattdessen agierte mit großer Wahrscheinlichkeit Dora Gedon, die Tochter des bekannten Münchner Bildhauers Lorenz Gedon für die Tanzstudien.[180] Die Komposition, die formal Assoziationen an Darstellungen der tanzenden Salomé weckt, erlangt ihren Dynamismus nicht so sehr durch die Tanzhaltung als vielmehr durch die reiche Ornamentierung des Bildhintergrundes. Herzförmige Punkte in konzentrischen spiralförmigen Linien formieren sich zu dynamischen Kraftlinien, deren rhythmische Struktur an vergleichbare ornamentale Strukturen in den Gemälden von Klimt, Moreau, Stuck oder Spillaert (›Les Pieux‹) erinnert.

Zu Eugenes Klientel als Porträtphotograph gehörten Lolo von Lenbach, die Witwe des Malers Franz von Lenbach, und ihre Kinder Gabriela und Marion[181] oder der Herausgeber der *Insel* Alfred Walter von Heymel, den er im Januar 1912 in München photographierte. Von dieser Porträtsitzung haben sich mehrere Aufnahmen erhalten, die heute im Deutschen Literaturarchiv in Marbach aufbewahrt werden. Heymel war von den Resultaten so überzeugt, daß er eine größere Anzahl von Abzügen bestellte und Eugene zugestand, die Bilder uneingeschränkt für Ausstellungen und Veröffentlichungen zu nutzen.[182]

Andere Porträtaufnahmen stellen Personen aus Eugenes Freundeskreis dar, den Hans Brandenburg eindringlich zu beschreiben vermag: »Unter seinen Kumpanen waren lauter lose oder doch umherstreichende Vögel wie er: Geiger vor allem, dann der schwarze, biederbärtige Kunsthistoriker Maximilian K. Rohe, von dem niemand auch nur die Wohnung kannte, obgleich er verheiratet war, der junge römische Student Gino, dem selbst ein leichtes Schielen feurig stand und der, an München leidenschaftlich verschworen, ein harmlos-heiterer Hansdampf in allen Gassen war, der ebenso junge reiche Ingenieur Otto, Schöpfer der später berühmten Otto-Flugzeugwerke, deren anfänglicher Bankrott ihn doch aus dem Leben treiben sollte. Diese beiden brachten wohl meine Freundin Emi mit, die sie umschwärmten und die ja auch in aller ihrer sanften Bravheit etwas unrastig Heimatloses hatte, der schönste

Strichvogel, der aus der Hand zu fressen schien und sich doch nicht fangen ließ. Sonst sah man wohl auch noch die Malerin Käthe Hoch in dieser Gesellschaft, eine scharmante Bucklige, und ihren Mann Rudolf, der von der Malerei noch spät zum Theater umsattelte und ein gefeierter Komiker und Charakterspieler wurde. In größeren oder kleineren Streifen tauchte man bald hier, bald dort auf, immer überraschend und immer fröhlich begrüßt, sei es an einem schönen Sommerabend unter den Bäumen der Schleißheimer Schloßwirtschaft, sei es auf einem Faschingsfest, wo Frank Eugene Smith ein rotes Halstuch zu einem blauen Kittel trug, anzusehen wie ein vergnügter Seebär.«[183]

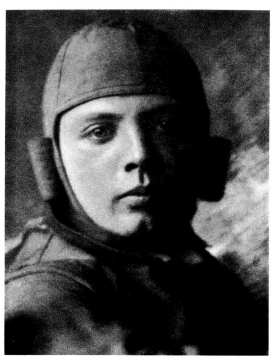

127. Gustav Otto, c. 1910
from *Braunbeck's Sportlexikon* 1912/13, p. 304

Selbstverständlich gehörten auch Hans Brandenburg und seine spätere Frau Dora Polster, die als eine der ersten Schülerinnen die 1902 von Hermann Obrist und Wilhelm von Debschitz gegründeten Lehr- und Versuchs-Ateliers für angewandte und freie Kunst (Debschitz-Schule) in der Hohenzollernstraße in München besuchte, zu diesem lockeren Freundeskreis. Einige Einzel- und Doppelporträts Eugenes von Dora Polster und Hans Brandenburg anläßlich ihrer Hochzeit, deren Entstehung im Jahre 1911 Brandenburg festgehalten hat, dokumentieren diese Freundschaft: »Mit seiner phantasievollen Improvisation raffte er in sie hinein,

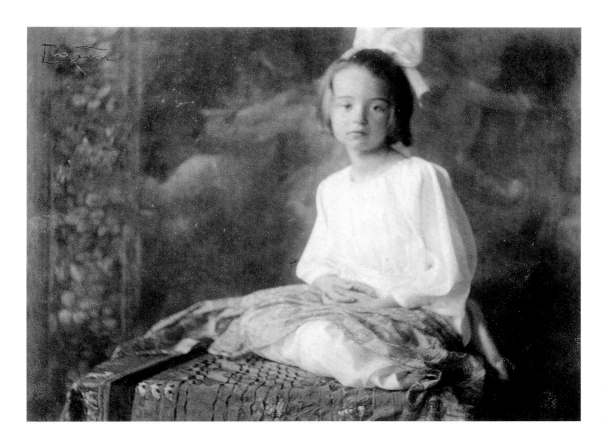

128. Maidie Hesselberger, c. 1908
Platinum print, 12.1 x 16.4 cm
Fotomuseum im Münchner
Stadtmuseum (88/26-38)

129. Baron v. B. and his wife,
c. 1908
Platinum print, 11.3 x 16.5 cm
Fotomuseum im Münchner
Stadtmuseum (88/26-103)

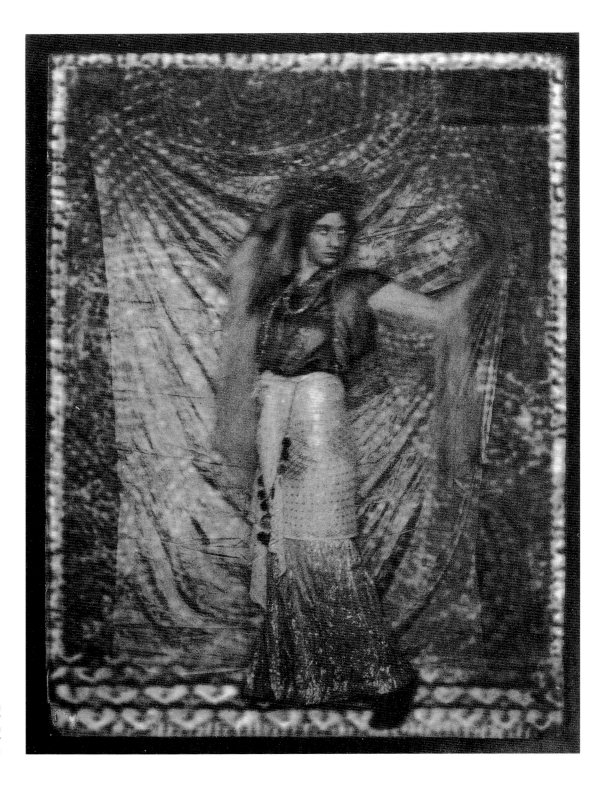

130. Mosaic (Dancer Dora
Gedon), c. 1907
Platinum print, 16.0 x 11.5 cm
Fotomuseum im Münchner
Stadtmuseum (88/26-51)

ornamentation. Heart-shaped points in concentric spirals joint up to form dynamic lines of force whose rhythmic structure is reminiscent of comparable ornamental structures in paintings by Klimt, Moreau, Stuck or Spillaert ("Les Pieux"). Among Eugene's clients for portrait photographs were Lolo von Lenbach, widow of the artist Franz von Lenbach, her children Gabriela and Marion,[181] and the editor of *Insel* Alfred Walter von Heymel, whom he photographed in Munich in January 1912. Several photographs from this sitting have survived

Otto, subsequently creator of the famous Otto-Flugzeugwerke, whose early bankruptcy was to lead him to suicide. These two brought my friend Emi with them, who made a great fuss and who in all her gentle pleasantness had something restless, misplaced about her, the most beautiful flocking bird who appeared to eat from your hand but did not allow herself to be caught. Otherwise you would see the artist Käthe Hoch in this company, a charming hunchbacked woman, and her husband Rudolf who late in life turned from painting

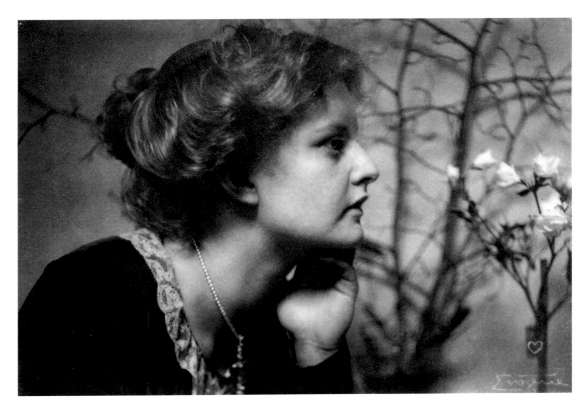

131. Marion Lenbach, c. 1910
Platinum print, 11.6 x 16.6 cm
Fotomuseum im Münchner
Stadtmuseum (88/27-74)

and are preserved in the Deutsche Literaturarchiv (German Literary Archives) in Marbach. Heymel was so pleased with the results that he ordered a larger number of prints and gave Eugene full permission to use the photographs for exhibitions and publications.[182] Other portrait photographs show people from Eugene's circle of friends, a circle which Hans Brandenburg so vividly describes: "His companions included a number of unattached or unsettled types like himself: Geiger above all; then the black-bearded art historian Maximilian K. Rohe, whose flat no one had ever seen although he was married; the young Roman student Gino whose slight squint gave him an additional vitality and who was a harmless jolly Jack of all trades, passionately devoted to Munich; the equally young and rich engineer

to the theater, becoming a celebrated comic and character actor. In larger or smaller detachments, they turned up here and there, always by surprise, but always sure of a warm welcome, be it on a lovely summer evening under the trees in the Schleissheim Castle beer garden or at a pre-Lenten carnival party with Frank Eugene Smith dressed in a red necktie and a blue overall and having all the appearances of a cheerful sea dog."[183] Hans Brandenburg was also a member of that loose circle of friends, as was his later wife Dora Polster, who was one of the first students to attend the Debschitz-School in the Hohenzollernstrasse in Munich, founded in 1902 by Hermann Obrist and Wilhelm von Debschitz and officially called the Lehr- und Versuchs-Atelier für angewandte und freie Kunst (Teaching and Research

»Mein lieber Herr Smith!
Tausend Dank für die Uebersendung der Photographien,
die ich ganz ausgezeichnet finde und die mir eine grosse
Freude bereiten. Das lesende Bild ist wirklich sehr lustig. Ich
möchte aber keine Kopie davon haben, sondern sandte es
an die Persönlichkeit, deren Brief ich gerade in dem Augen-
blick mit grösstem Vergnügen lese. Bei den anderen dreien
wird mir die Wahl so schwer, dass ich am liebsten, wenn es
angängig wäre, von jedem sechs Kopien hätte. Ich sende die
drei, die mir im Ton am allerbesten gefallen, zurück und
frage an, ob Sie die grosse Liebenswürdigkeit haben wollen,
mir mehrere Kopien dieser wahren Kunstwerke zu machen.
Für Ihre und Herrn Stieglitz freundliche Grüsse danke ich
sehr und erwider sie auf das lebhafteste.
Haben Sie wohl schon eine Photographie von Behns Büste
von mir gemacht, oder warten Sie, bis sie in Bronze ausge-
führt ist?
In frohester Erwartung nun endlich bald Photographien zu
besitzen, deren man sich beim Schenken nicht zu schämen
braucht, bin ich Ihr dankbar ergebener
Alfred Walter von Heymel

Brief vom 7. Februar 1912, Hotel Bristol Berlin.

»Vielen herzlichen Dank für die schnelle Uebersendung der
prachtvollen Bilder. Selbstverständlich habe ich nichts
dagegen Ausstellung und Reproduktion. Ich würde mich
sogar freuen, wenn Stieglitz in der Camera Work eine
Reproduktion brächte. Das aufgestützte Bild und das, auf
dem ich die Hände über den Knien falte, finde ich die be-
sten.«

Brief vom 2. März 1912, Hotel Bristol Berlin

Beide Briefe befinden sich im Schiller Nationalmuseum,
Deutsches Literaturarchiv, Marbach.

"Dear Mr. Smith,
Many thanks for sending me the photographs, which I
was delighted to receive and which I think are really
excellent. I find the reading photograph very amusing.
However, I do not wish to have a copy of it, instead I
have sent it to the person whose letter I was reading at
the time with the greatest of pleasure. As for the other
three, I find it very difficult to choose and would prefer,
if it is at all permissible, to have six copies of each. I
am sending you back the three which appeal to me
most in tone, and would like to ask whether you
would be so kind as to make several copies of these
true works of art for me.
Thanks also for your and Mr. Stieglitz's regards which I
reciprocate most cordially.
Have you taken a photograph of Behn's bust of me
already, or are you waiting until it is cast in bronze?
In great anticipation of finally having photographs in
my possession which I need not be ashamed to present
to people, I remain your most grateful
Alfred Walter von Heymel

Letter from February 7, 1912, Hotel Bristol, Berlin

"Many many thanks for the speedy delivery of the
splendid photographs. Naturally I have nothing
against exhibitions and reproductions. In fact I would
be delighted if Stieglitz published a reproduction in
Camera Work. I think the photograph of me with my
head resting on my hands and the one with my hands
folded on my knees are the best."

Letter from March 2, 1912, Hotel Bristol, Berlin

Both letters are in the collection of the Schiller
Nationalmuseum, Deutsches Literaturarchiv, Marbach.

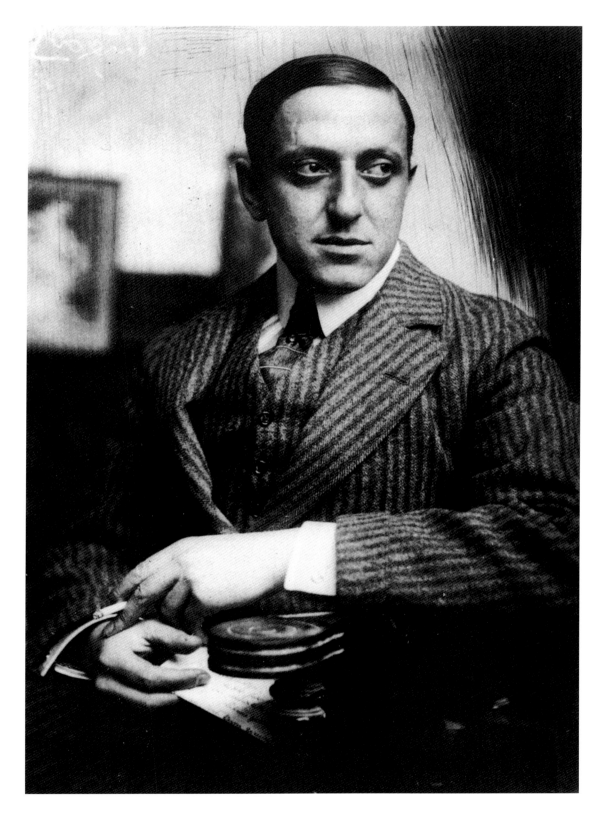

132. Alfred Walter von Heymel,
1911
Platinum print
Schiller-Nationalmuseum Deut-
sches Literaturarchiv, Marbach

133. Emmy Geiger, c. 1910
Platinum print, 14.8 x 10.3 cm
Estate of Hans Brandenburg,
Monacensia Literaturarchiv,
Munich (31/81)

was gerade zur Hand war, indem er knospende Früh-
lingszweige wie ein feines Gitter aufstellte und gegen
die Wand eine Maréeskopie umlegte, daß der Hinter-
grund unbestimmt in hohen Gestalten verdämmerte.«[184]
Eugene dokumentierte auch das Faschings-Künstlerfest
in der Eichenau, an dem die Brandenburgs teilnahmen,
in mehreren Aufnahmen: »Das wurden keine zufälligen
Momentbilder, sondern bedachtsam durchgekostete
Zeitaufnahmen, die den Ausschnitt zum Bilde runde-
ten, zum Helldunkel des Raumes, welcher samtige Hin-
tergründe in den malerisch verteilten Flecken der Ge-
sichter und im Schimmer der Stoffe auflichtete. Alles
war komponiert und doch nichts gestellt: die festgehal-
tene Bewegung schwang im Linienschwung aus. Zutts
lachendes Gesicht, eulenspiegelhaft unterm Federhute,
biegt sich mit dem derben Leib in den Vordergrund, wie
von Franz Hals oder Jordaens erschaut, und ich beiße
aus verdunkelnder Tiefe in eine der Würste, die ihm an
blankem Metallring über der Schulter hängen.
Falckenbergs Freundin thront königlich in der ausgebrei-
teten Seide ihres gestreiften Rockes. Krommes, später
ein närrischer Schwabinger Prophet, hier tritt er noch als
junger fröhlicher Geselle mit der herbfrischen Frau Zutt
in ihrer geblümten Schweizer Tracht zum Tanz an und
Maximilian Ahrens, dunkelgelockt über ritterlichem
Wams, mit Dora in hellem Pagenkostüm, Paare wie aus
der Renaissance.«[185]

Künstlerfeste in Murnau

Zu den engsten Freunden Eugenes zählten die bereits
genannten Künstler Willi Geiger, den Stuck als einen
seiner begabtesten Schüler bezeichnet hatte, und der
Maler Adolf Hengeler, der zwischen 1884 und 1889 bei
Diez studiert hatte und ab 1912 eine Professur an der
Münchner Kunstakademie innehatte. Weiterhin war
Eugene mit dem Radierer und Kunsthistoriker Hubertus
Wilm, dem Bildhauer Fritz Behn und dem wohlhaben-
den Diplomaten und Amateurphotographen Leopold
von Glasersfeld[186] befreundet, die auch Stieglitz persön-
lich bekannt waren.[187]
Mit dem Architekten Emanuel von Seidl, den er vermut-
lich über Adolf Hengeler kennengelernt hatte, verband
Eugene eine besonders enge Freundschaft. Aber auch
mit Emanuels Bruder Gabriel von Seidl, dem Architekten
des Bayerischen Nationalmuseums und der Lenbach-
Villa, stand Eugene in Verbindung, wie einige Bildnis-
aufnahmen des Künstlers bezeugen. Emanuel Seidl, wie
Eugene auch Sohn eines Bäckers, hatte es als Villen-
architekt für wohlhabende Industrielle und Aristokraten
im süddeutschen Raum zu beträchtlichem Wohlstand
gebracht und zählte laut *Jahrbuch des Vermögens und
Einkommens der Millionäre in Bayern* (1914) neben F.A.
von Kaulbach, Fritz von Miller, Franz von Stuck, Franz
von Defregger, Benno Becker und Adolf von Hildebrand
zu den Großverdienern unter den Münchner Künstlern.
1902 hatte er sich neben seinem Stadthaus in Murnau
eine prächtige Landvilla innerhalb eines weiträumigen
Parkgeländes erbaut, das nach dem Vorbild der engli-
schen Gartenkunst mit Wirtschaftsgebäude, Gästehaus,
Badepavillon (›Gloriettl‹), zwei Weihern, Gartenanla-
gen, Promenadewegen, Terrassen, Lauben, (Hirsch-)
Skulpturen und Birkenallee ausgestattet war und eine
harmonische Synthese von Architektur und idyllischer
Natur darstellte. Nach den Vorstellungen Seidls »galt es
Landschaftsbilder zu erdichten und architektonisch zu
schmücken«[188], die beim Rundgang durch die Anlage
vor der Kulisse der Alpenlandschaft vor dem Auge des
Betrachters entstehen sollten.[189] Auf dem Parkgelände
war auch ein ›Freundschaftshügel‹ errichtet worden,
den, über eine steinerne Treppe begehbar, der ›Altar der
Freundschaft‹ krönte, auf dem Goethes Sinnspruch
»Uns gaben die Götter auf Erden Elysium!«[190] und die
Namen der treuesten Freunde Seidls, unter diesen auch
Eugene, eingraviert waren.
Die Murnauer Villa entwickelte sich zu einem der Mit-
telpunkte des gesellschaftlichen Lebens in der
Prinzregentenzeit, der neben den Freunden Seidls auch
Prominenz aus Politik, Wirtschaft und Kultur anzog.

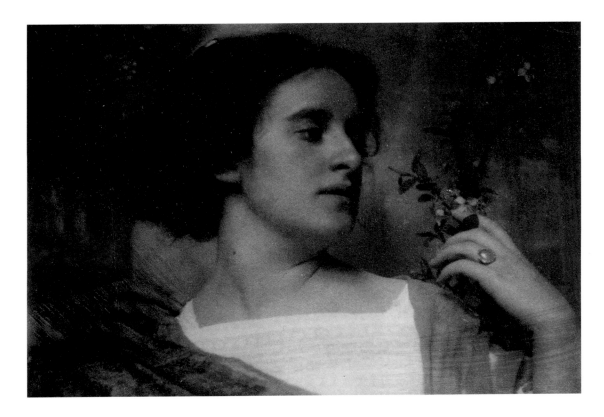

134. Clara Geiger, c. 1907
Platinum print, 11.7 x 16.9 cm
Fotomuseum im Münchner
Stadtmuseum (88/27-17)

135. Mother Geiger and
Willi Geiger, 1908–10
Platinum print, 11.9 x 16.3 cm
Rupprecht Geiger, München

136. Friedrich Adolph
Brandenburg, c. 1908
Autotype, 11.2 x 17 cm
Estate of Hans Brandenburg,
Monacensia Literaturarchiv,
Munich

137. Hans Brandenburg and Dora
Polster-Brandenburg, 1911
Platinum print, 11.9 x 17.2 cm
Estate of Hans Brandenburg,
Monacensia Literaturarchiv,
Munich

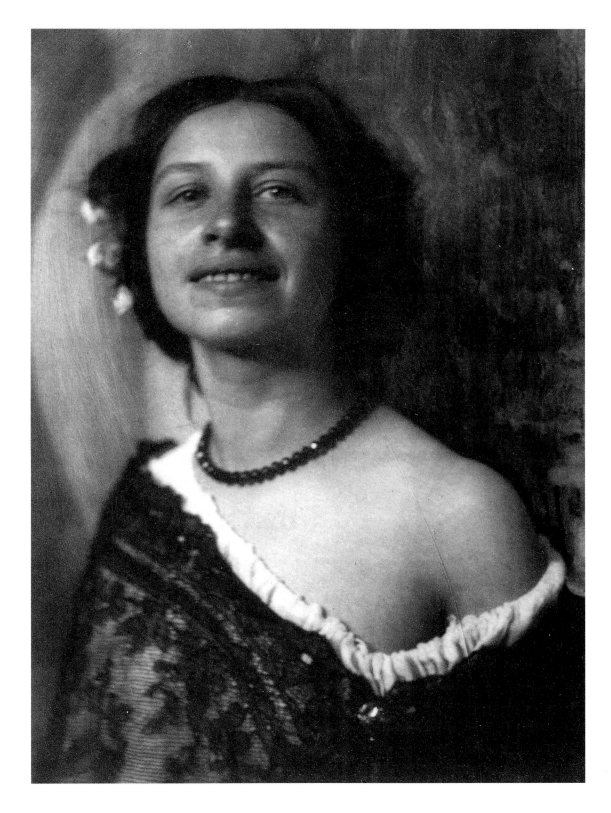

138. Dora Polster, c. 1908
Platinum print, 16.8 x 12.0 cm
Fotomuseum im Münchner
Stadtmuseum (88/27-5)

139. Schwabing artists' festival
in Eichenau, 1911
(l-r: Hans Brandenburg, sculptor
Zutt, Bodo Wolf, Krommes,
publisher Martin Mörike, Maxi-
milian Ahrens, unknown)
Platinum print
Estate of Hans Brandenburg,
Monacensia Literaturarchiv,
Munich

140. Schwabing artists' festival
in Eichenau, 1911
D.O.P., 12 x 15.8 cm
Estate of Hans Brandenburg,
Monacensia Literaturarchiv,
Munich

141. Schwabing artists' festival
in Eichenau, 1911
(l-r: Dora Brandenburg-Polster,
Krommes, Frau Zutt)
Platinum print, 16.3 x 11.3 cm
Estate of Hans Brandenburg,
Monacensia Literaturarchiv,
Munich

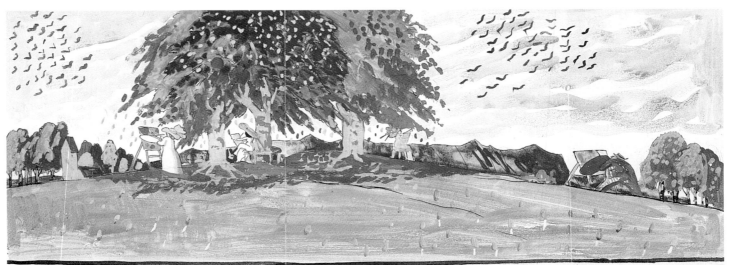

VORNEHMSTE VND SCHÖNSTGELEGENSTEMALSCHULE: E.vSEIDL.MURNAU
INDIVIDUELLE BEHANDLUNG IN BEZUG AUF KOST VND LOGIS.-GARANTIERT SCHÖNE HERBST-
TAGE – CORRECTUR SELTEN –ABER DANN, WIRKLICH KOLLOSSAL!!!!!

142. *Frank Eugene Smith* (attr.)
The painting school E. v. Seidl in
Murnau, from: *Gästebuch
Emanuel von Seidl*, Vol. 2
Handschriften-Abteilung Bayeri-
sche Staatsbibliothek, Munich

Beredtes Zeugnis davon geben die Gästebücher von
Emanuel von Seidl aus dem Zeitraum von 1902 bis 1919.
Hier finden sich neben Zeichnungen, Aquarellen und
Photographien auch zahllose Eintragungen von führen-
den Künstlern der Epoche wie Lenbach, Stuck, Kaulbach
oder Becker-Gundahl und von Seidls Auftragsgebern, die
regelmäßig an den Geburtstagsfeiern, Festspielen oder
jahreszeitlichen Anlässen wie Fasching, Ostern, Pfing-
sten, Weihnachten und Sylvester teilnahmen.[191]
Ständiger Gast in Murnau war ebenfalls Frank Eugene,
dessen so typische Signaturen und Widmungen wie »Es
lebe die Freude« oder »Joy«, mit einem Glückskleeblatt
oder Herz verziert, sich in den Murnauer Gästebüchern
neben den Namen von Hermann Stockmann, Julius und
Rosina Diez, Dr. Franz und Lisi Staeble, Emmy Smith
Palmer, Ludwig Herterich, Dr. Fritz Schaefer, Olaf
Gulbransson, Felix Schlagintweit oder Siegmund von
Hausegger häufig wiederfinden.[192] Erstmals trug sich

Eugene am 26. September 1904 ein,[193] um von nun an bis
1919 auf kaum einer der Festivitäten in der Seidlschen Villa
zu fehlen, sei es anläßlich der Aufführung des Singspiels
›Die Fischerin‹ nach Johann Wolfgang Goethe am 29.Juli
1905 oder der Inszenierung von Shakespeares ›Sommer-
nachtstraum‹ von Max Reinhardt nach der Musik von
Mendelssohn-Bartholdy anläßlich des Besuches der Köni-
gin Elisabeth von Belgien am 28.August 1910.[194] Auch nach
seiner Übersiedlung nach Leipzig blieb Eugene ein gern
gesehener Gast in Murnau, wie seine Anwesenheit an
dem Festbankett anläßlich der Feier zum 60.Geburtstag
von Emanuel von Seidl am 22.August 1916 demonstriert.
Gelegentlich hat Eugene bei diesen Zusammenkünften
auch photographiert. Eugene war wie Emanuel von Seidl
ein leidenschaftlicher Schachspieler. Ausdruck dieser
Schachbegeisterung war auch ein Schachturnier, das zu
Ostern 1908 in Murnau unter Beteiligung von Ludwig
Hess, Prof. Hofer, Dr. Franz und Lisi Staeble, Eugene und
Hengeler stattfand und von Eugene in einer Photogra-
phie und von Hengeler in einer Karikatur dokumentiert
wurde. Mit lebhaftem Interesse verfolgten Emanuel von
Seidl und seine Freunde die Wettkämpfe um die Schach-
weltmeisterschaft zwischen Emanuel Lasker und seinem
Herausforderer Tarrasch. Als die zweite Runde des Wett-
kampfes, den Lasker überlegen für sich entscheiden
konnte, im Winter 1908 in München ausgetragen wurde,
nutzte Eugene die Gelegenheit, um Emanuel und seinen
Bruder, den Mediziner Berthold Lasker, zu porträtieren.
Mit dem Ergebnis hochzufrieden, schrieb Eugene an
Stieglitz, daß die Photographien »as mathematical as can
be in conception« geraten sein.[195]

143. Emanuel von Seidl and his
wife Maria (née Luberich),
c. 1916
Platinum print, 12.4 x 17.4 cm
Fotomuseum im Münchner
Stadtmuseum (88/27-19)

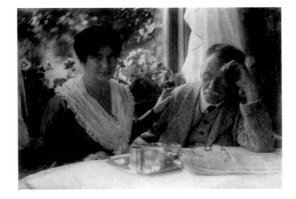

144. Baby Rupprecht Geiger, c. 1909
Platinum print, 14.6 x 12.0 cm
Rupprecht Geiger, Munich

Studio of Applied and Free Art). Their friendship with Eugene is documented in some individual and double portraits of Dora Polster and Hans Brandenburg on the occasion of their wedding, dated by Hans Brandenburg as 1911: "With his imaginative powers of improvisation he gathered up everything that was around the place, positioning budding branches like a fine trellis and placing a copy of a Marées against the wall so that the background became indeterminate, tall figures in a dusky light."[184] Several other photographs by Eugene document the artists festival held at carnival time in Eichenau and in which the Brandenburgs took part: "They were not just chance snapshots but carefully devised slow takes which rounded the frame off into a picture, blending it into the half-darkness of the room, lit up by the glow of the faces and the shimmer of the fabrics picturesquely distributed against velvety backgrounds. Thoroughly composed and yet not forced: the movement fixed in the photograph lingered in the sweep of the lines. Zutt's face, smiling like a joker under a feather hat, the sturdy body leaning into the foreground, as if in a Franz Hals or Jordaens painting. And from out of the darkened depths I bite into one of the sausages hanging around his shoulders on a shiny metal ring. Falckenberg's girlfriend is enthroned regally on the opulent silk of her stripped skirt. Krommes, later a crazy Schwabing prophet, appears here dressed as a merry young journeyman dancing with the severely fresh Mrs.

Zutt in her florid Swiss national costume, and Maximilian Ahrens, dark curly locks over a knight's doublet, with Dora in her bright page's costume – like couples from Renaissance times."[185]

Artists' Festivals in Murnau

Among Eugene's closest friends were the above mentioned artist Willi Geiger, whom Stuck described as one of his most gifted students, and the artist Adolf Hengeler, who had studied under Diez between 1884 and 1889 and became a professor at the Munich Kunstakademie in 1912. Eugene was also friends with the etcher and art historian Hubertus Wilm, the sculptor Fritz Behn, and the wealthy diplomat and amateur photographer Leopold von Glasersfeld,[186] with whom Stieglitz was also personally acquainted.[187]

The friendship which bound Eugene and the architect Emanuel von Seidl, whom he presumably got to know through Adolf Hengeler, was a particularly close one. Emanuel von Seidl's brother Gabriel, architect of the Bavarian National Museum and the Lenbach Villa, was also on a close footing with Eugene as can be seen from several of his portrait photographs. Emanuel von Seidl, like Eugene the son of a baker, had earned considerable sums of money designing villas for wealthy industrialists and aristocrats throughout the south of Germany. According to an official register of millionaires, the *Jahrbuch des Vermögens und Einkommens der Millionäre in Bayern* (1914) Seidl was one of Munich's highest earning artists, alongside F. A. von Kaulbach, Fritz von Miller, Franz von Stuck, Franz von Defregger, Benno Becker and Adolf von Hildebrand.

In addition to his city house, Seidl built himself a magnificent country villa in Murnau in 1902. This house was surrounded by a wide expanse of parkland and, modeled on the English landscaped garden, also had outhouses, a guest house, a bathing pavilion ("Gloriettl"), two ponds, gardens, walks, terraces, bowers, sculptures (of red deer), and birch lined avenue. It represented a harmonious synthesis of architecture and idyllic nature. Seidl's principle was "to compose and architecturally embellish landscape images"[188] which during a tour of the grounds would become visible to the eye of the beholder against the backdrop of the Alps.[189] A "hill to friendship" was also thrown up in the park, accessible by stone steps and crowned by an "altar to friendship" on which were engraved Goethe's saying "Uns haben die Götter auf Erden Elysium!" (The Gods gave us Elysium here on earth!)[190] and the names of Seidl's most faithful friends, among them that of Eugene. The villa at Murnau became a center of social life during

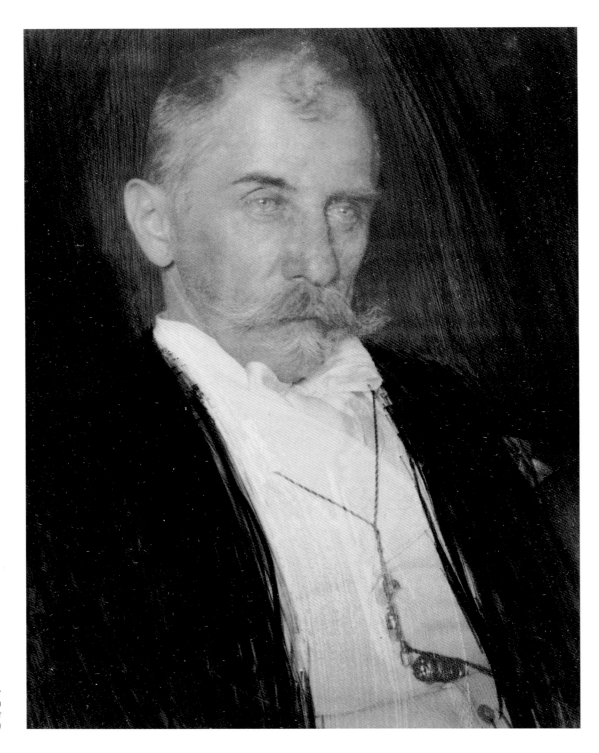

145. Gabriel von Seidl, 1906/07
Platinum print, 15.5 x 11.5 cm
Fotomuseum im Münchner
Stadtmuseum (88/27-2)

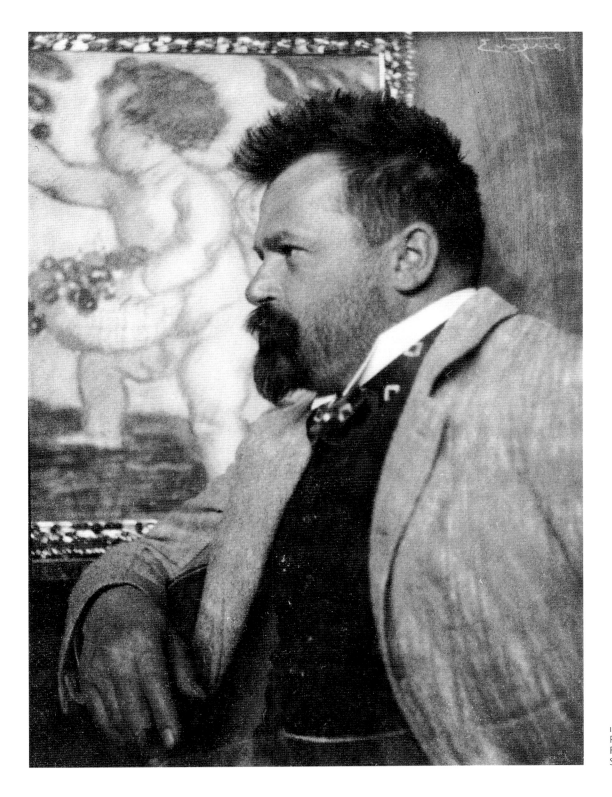

146. Adolf Hengeler, c. 1907
Platinum print, 16.5 x 11.9 cm
Fotomuseum im Münchner
Stadtmuseum (88/26-91)

147. "Hymne auf die Freund-
schaft," 1904
from: *Gästebuch E. v. Seidl,*
Vol. 1, p. 41
Handschriften-Abteilung Bayeri-
sche Staatsbibliothek, Munich

148. *F. A. von Kaulbach*
Guests at the villa of Emanuel
von Seidl (Gabriel von Seidl,
Franz von Lenbach, 1st and 3rd
from the right), Murnau
c. 1904
from: *Gästebuch E. v. Seidl,*
Vol. 1, p.4
Handschriften-Abteilung Bayeri-
sche Staatsbibliothek, Munich

149. *Olaf Gulbrannson*
Julius Diez, 1912
Drawing from *Gästebuch
E. v. Seidl,* Vol. 2, p. 74
Handschriften-Abteilung Bayeri-
sche Staatsbibliothek, Munich

helm von Gloeden hatte auch Frank Eugene eine Vorlie-
be für die photographische Darstellung dieser Mytholo-
gie, wie die Aufnahmen ›The Song of the Lily‹ (1898),
›Der Kleine Faun‹ oder das Selbstporträt als Pan anläß-
lich des Murnauer Singspiels 1908 demonstrieren. Dabei
war er von der Bildwelt Arnold Böcklins, dessen künst-
lerisches Werk dem Photographen durch Besuche in der
Schack-Galerie in München vertraut war, aber auch von
Stuck inspiriert. Doch ging es Eugene weniger um Pan
als dionysische Verkörperung eines liebestollen, exzessi-
ven Fruchtbarkeitskultes als um jene idyllische Ver-
schmelzung von Natur und Lebensfreude, in der die
Figur des Pan bisweilen auch zum komischen Anti-Hel-
den wurde.

Es scheint, als hätte Eugene über die geselligen Treffen
und den Murnauer Freundeskreis berufliche Kontakte
herstellen können. Gäste wie die Musiker und Künstler

Andere Aufnahmen Eugenes dokumentieren das von
Friedrich Schäfer komponierte Festspiel mit der Musik
von Schubert und der ›Faunmusik‹ des Münchner Diri-
genten Siegmund von Hausegger, das eine Beschwö-
rung des Freundschaftskultes und -ideals zum Inhalt
hatte. Das Schauspiel fand am 21.August 1908 in Murn-
au statt, unter Mitwirkung von zahlreichen Freunden
Seidls, u.a. dem Bildhauer und Afrikareisenden Fritz
Behn und Frank Eugene, der einen geilen Pan namens
›Mopsus‹ im Faunkostüm mimte.[96] Der Kult des Pan
war um die Jahrhundertwende insbesondere in Mün-
chens Künstlerschaft als Ausdruck bukolischer Lebens-
freude weit verbreitet, wovon die Kunstzeitschrift *Pan*
oder Künstlerfeste wie ›In Arkadien‹ (1898) zeugen, das
von Emanuel von Seidl erdacht und ausgestattet worden
war. Wie Fred Holland Day, Clarence White oder Wil-

Siegmund von Hausegger, Franz von Defregger, Maximi-
lian Dasio, Rudolf Chillingworth, Fritz Behn, Carl
Becker-Gundahl, Julius Diez und Dr. Friedrich Schäfer
wurden von ihm ebenso porträtiert wie die wohlhaben-
den Industriellen und Bauherren von Seidlschen Villen
Frau Wolf-Neger, Dr. Georg Wolf aus Zwickau und Wil-
helm Kestranek (1863–1925) aus St. Gilgen, Generaldi-
rektor der Prager Eisenindustrie-Gesellschaft und Protegé
des Philosophen Ludwig Wittgenstein.[97] So erwähnte
Eugene in einem Brief an Stieglitz 1910 einen lukrativen
Auftrag, den Präsidenten und acht Direktoren einer
Kohlenmine im Erzgebirge zu photographieren, wobei
es sich um den Montanindustriellen Dr. Georg Wolf
gehandelt haben muß, dessen Schloß Wolfsbrunn 1911
nach Plänen von Emanuel von Seidl gebaut wurde.[98]

OLAF G,
29 JULI 1912

150. *Olaf Gulbransson*
Franz von Stuck, 29.7.1912
Drawing from *Gästebuch*
E. v. Seidl, Vol. 2, p. 72
Handschriften-Abteilung, Bayeri-
sche Staatsbibliothek, Munich

the Munich Regency period and attracted not only Seidl's close friends but also prominent figures from the worlds of politics, economics and culture. Eloquent witness is born to this by Seidl's guest books from the period between 1902 and 1919. Not only do they contain drawings, watercolors and photographs, but also numerous written entries by leading contemporary artists such as Lenbach, Stuck, Kaulbach and Becker-Gundahl, not to mention Seidl's clients who were regularly invited to birthday parties, festivals, or on seasonal occasions such as at Fasching or carnival time, Easter, Whitsun, Christmas or New Year's Eve.[91]

Needless to say, Frank Eugene was also a regular guest in Murnau and his signature and typical dedications, such as "Long live friendship" or "Joy" accompanied by a four-leaf clover or a heart, are to be found in the guest books alongside names such as Hermann Stockmann , Julius and Rosina Diez, Dr. Franz and Lisi Staeble, Emmy Smith Palmer, Ludwig Herterich, Dr. Fritz Schaefer, Olaf Gulbransson, Felix Schlagintweit and Siegmund von Hausegger.[92] Eugene's name first turns up on September 26, 1904[93] and after that he was scarcely ever missing from any of the festivities in Seidl's villa, be that at the performance of the singspiel "Die Fischerin" after Johann Wolfgang Goethe on July 29, 1905, or at the production of Shakespeare's "Midsummer Night's Dream" by Max Reinhardt with music by Mendelssohn-Bartholdy, performed on the occasion of the visit of Queen Elisabeth of Belgium on August 29, 1910.[94] Even after he moved to Leipzig, Eugene continued to be a welcome guest in Murnau, as is indicated by his presence at the festival banquet there on the occasion of

151. Das Horoskop, 22.8.1912
(Emanuel von Seidl on ladder,
Frank Eugene Smith second
from left)
from: *Gästebuch Emanuel
von Seidl*, Vol. 2, p. 79
Handschriften-Abteilung
Bayerische Staatsbibliothek,
Munich

152

152. Self portrait on roof garden,
Munich 1911
Autochrome
John Wood, Lake Charles,
Louisiana

153

Der Physiker Albert Einstein bezeichnete Lasker als einen »der interessantesten Menschen, die ich in meinen späteren Jahren kennengelernt habe«. »Für mich hatte diese Persönlichkeit trotz ihrer im Grunde lebensbejahrenden Einstellung eine tragische Note. Die ungeheure geistige Spannkraft, ohne welche keiner ein Schachspieler sein kann, war so mit dem Schachspiel verwoben, daß er den Geist dieses Spieles nie ganz loswerden konnte, auch wenn er sich mit philosophischen und menschlichen Problemen beschäftigte. Dabei schien es mir, daß das Schach für ihn mehr Beruf als eigentliches Ziel seines Lebens war. Sein eigentliches Sehnen schien auf das wissenschaftliche Begreifen und auf jene Schönheit gerichtet, die den logischen Schöpfungen eigen ist, eine Schönheit, deren Zauberkreis keiner entrinnen kann, dem sie einmal irgendwo aufgegangen ist. Spinozas materielle Existenz und Unabhängigkeit war auf das Schleifen von Linsen gegründet; entsprechend war die Rolle des Schachspieles in Laskers Leben. Spinoza aber war das bessere Los beschieden, denn sein Geschäft ließ den Geist frei und unbeschwert, während das Schachspielen eines Meisters diesen in seinen Banden hält, den Geist fesselt und in gewisser Weise formt, so daß die innere Freiheit und Unbefangenheit auch des Stärksten darunter leiden muß. Dies fühlte ich in unseren Gesprächen und beim Lesen seiner philosophischen Bücher immer durch. Von diesen Büchern war es *Die Philosophie des Unvollendbaren*, die mich am meisten interessierte; dies Buch ist nicht nur sehr originell, sondern gibt auch einen tiefen Einblick in Laskers ganze Persönlichkeit.« (Geleitwort von Albert Einstein, in: J. Hannak, *Emanuel Lasker*, Berlin 1952, S. 3–4).

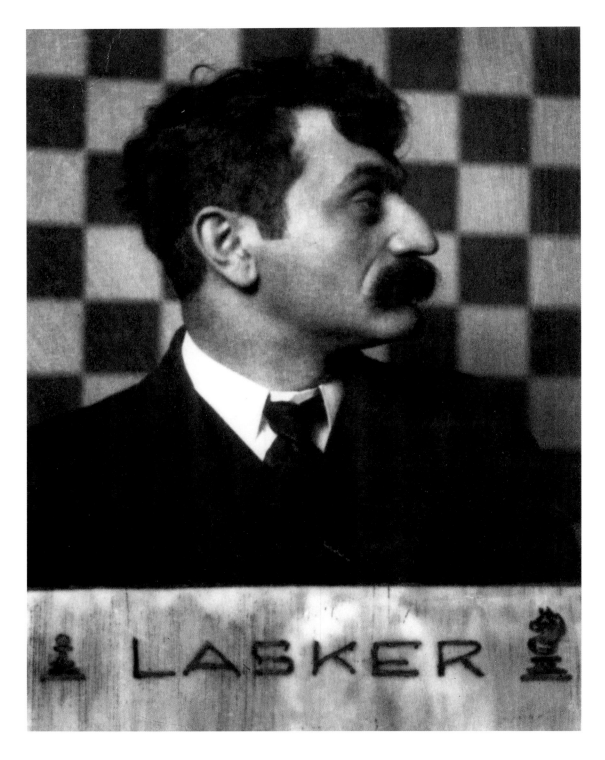

153. Dr. Emanuel Lasker
Platinum print, 11.1 x 14.9 cm
Dietmar Siegert, Munich

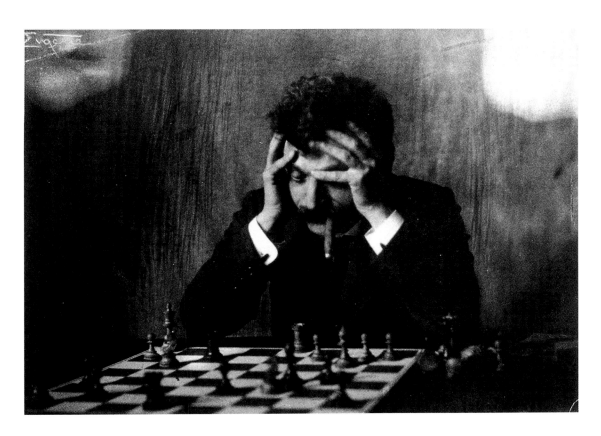

154. Dr. Emanuel Lasker, 1908
D.O.P., 15.0 × 20.4 cm
Ullstein Bilderdienst, Berlin

Emanuel von Seidl – *Mein Landhaus*

Ein verläßliches Dokument der Künstlerfreundschaft und gleichzeitig schöpferischer Höhepunkt dieser Beziehung war zweifelsohne die Illustration von Seidls Band *Mein Landhaus* mit Photographien von Eugene. Der Photograph hatte 1909 und 1910 den Park und die Gebäude in 54 Interieur- und Außenaufnahmen festgehal-

ten, darunter auch einigen Farbphotographien im Autochrome-Verfahren. »Viele der Blätter sind wahre Perlen künstlerisch empfundener Naturausschnitte«, urteilte 1910 die Zeitschrift *Photographische Kunst*[199] über Eugenes Illustrationen, von denen sich nur wenige Originalabzüge erhalten haben. Eugenes einfühlsame Wiedergabe der idyllischen Symbiose aus Architektur und Natur kann geradezu als kongeniale Interpretation angesehen werden, die dem Ansinnen des Architekten überzeugend entsprochen haben muß. Die Zeitschrift *Innen-Dekoration* lobte Eugenes Aufnahmen als »vollendete Kunstwerke«, »die den Stimmungsgehalt völlig unvermindert« wiedergeben würden.[200] Die idyllische Natur als Gegenbild zur bedrohlichen Welt der modernen Großstadt und Industrialisierung ist das eigentliche Leitmotiv der Bildserie, mit der Eugene die neoromantischen Traditionen des Topos ›Natur als Seelenlandschaft‹ im Fin-de-Siècle weiterführt. Insbesondere die Kunstphotographen Coburn, Stieglitz und Käsebier haben der Landschaft als Quelle einer sowohl geheimnisvollen als auch positiven Lebenskraft und Inspiration gehuldigt: »Landschaft! Wie das Wort und seine Verbindungen einen aus sich herausgehen lassen und hinein in eine köstliche Welt versetzen, wo Bäume traumwebend zum Wald werden, von gluckernden und gurgelnden Bächen, von duftenden Blumen, reich an

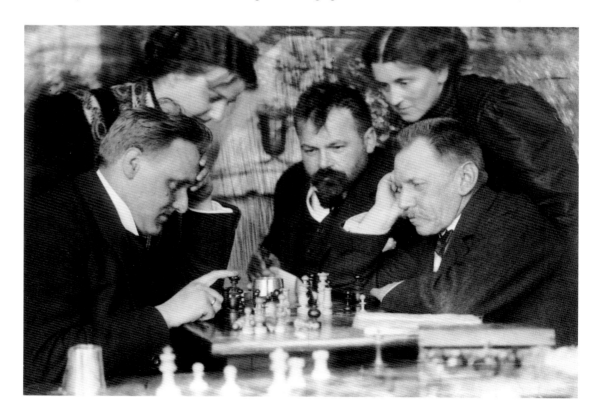

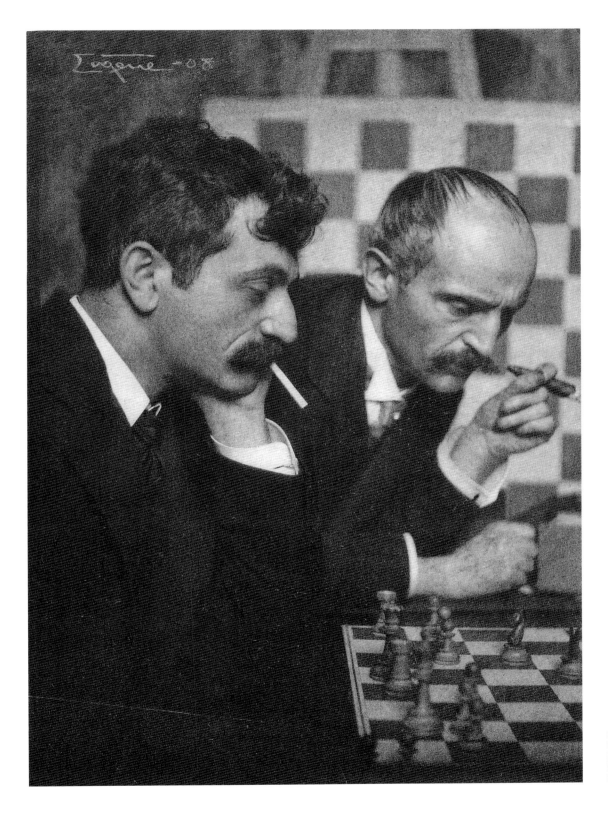

157. Dr. Emanuel Lasker and his
brother Dr. Berthold Lasker, 1908
Photogravure, 17.6 x 12.5 cm
Fotomuseum im Münchner Stadt-
museum (88/26-7)

157

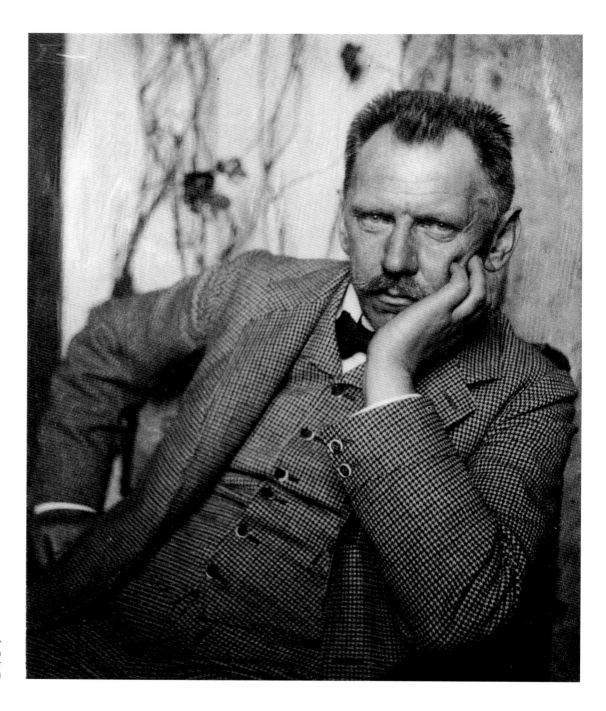

158. Emanuel von Seidl, 1906/07
Platinum print, 16.4 x 11.6 cm
Fotomuseum im Münchner
Stadtmuseum (93/631-2)

Emanuel von Seidl's 60th birthday on August 22, 1916. At some of these social gatherings Eugene also took photographs. Like Emanuel von Seidl, Eugene was a very keen chess player. Evidence of this passion was a chess championship held in Murnau at Easter 1908 in which Ludwig Hess, Professor Hofer, Dr. Franz and Lisi Staeble, Eugene and Hengeler took park. That occasion also gave rise to a photograph by Eugene and a caricature by Hengeler. Emanuel von Seidl and his friends followed the world chess championship matches between Emanuel Lasker and his challenger Tarrasch very closely. When the second round of the championship was played in Munich in the winter of 1908, which Lasker won outright, Eugene availed himself of the opportunity to take a portrait of Emanuel Lasker and his brother Berthold, who was a doctor. Thoroughly pleased with the result, he wrote to Stieglitz that the photographs were "as mathematical as can be in conception."[195]

White or Wilhelm von Gloeden, Frank Eugene too had a preference for the myth of Pan, as can be seen from his photographs "The Song of the Lily" (1898), "The Little Faun," and his self-portrait as Pan on the occasion of the singspiel in Murnau. Here he was inspired not only by the pictorial world of Arnold Böcklin, whose

160. *Adolf Hengeler*
Schach – Chess, 1912/13
Drawing from: *Gästebuch E. v. Seidl*, Vol. 2, p. 108
Handschriften-Abteilung Bayerische Staatsbibliothek, Munich

work was familiar to him from visits to the Schack gallery in Munich, but also by von Stuck. However, Eugene was less concerned with Pan as the Dionysian embodiment of a love-crazed excessive fertility cult, than with Pan as the idyllic fusion of nature and a joie de vivre, a fusion in which at times the figure of Pan became a comical anti-hero. It would appear that Eugene was able to make some professional contacts through these social gatherings and in the Murnau circles. He took photographs of guests such as the musicians and artists Siegmund von Hausegger, Franz von Defregger, Maximilian Dasio, Rudolf Chillingworth, Fritz Behn, Karl Becker-

159. *Adolf Hengeler*
Gardé, 1912/13
Drawing from: *Gästebuch E. v. Seidl*, Vol. 2, p. 107
Handschriften-Abteilung Bayerische Staatsbibliothek, Munich

Other photographs by Eugene document another festival conceived by Friedrich Schäfer to the music of Schubert and the "Faun music" of the Munich conductor Siegmund von Hausegger. This festival constituted a homage to the ideal and the cult of friendship. It took place on August 21, 1908 with the collaboration of a number of Seidl's friends, among them the sculptor and Africa-traveler Fritz Behn and Frank Eugene in a faun's costume playing the part of a lascivious Pan character called "Mopsus."[196] The Pan cult was widespread at the turn of the century, especially in Munich art circles where it expressed a bucolic zest for life. The art magazine *Pan* and artists festivals such as "In Arcadia" (1898), conceived of and produced by Emanuel von Seidl, bear witness to its popularity. Like Fred Holland Day, Clarence

161. *Franz Widman* (attr.)
Lasker versus Tarrasch, 1909
Drawing from: *Gästebuch E. v. Seidl*, Vol. 1, p. 133
Handschriften-Abteilung Bayerische Staatsbibliothek, Munich

Gundahl, Julius Diez and Dr. Friedrich Schäfer, and of the wealthy industrialists and commissioners of Seidl-villas Mrs. Wolf-Neger, Dr. Georg Wolf from Zwickau, and Wilhelm Kestranek (1863–1925) from St. Gilgen, chairman of the Prague Iron Industry Association and a protégé of the philosopher Ludwig Wittgenstein.[197] In a

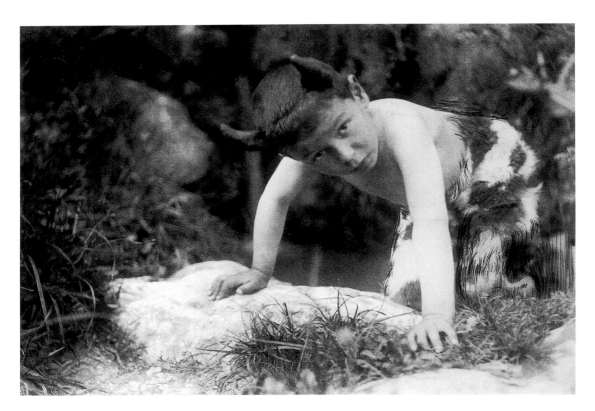

162. The Little Faun, 1908
Platinum print
Metropolitan Museum of Art,
Rogers Fund, 1972 (1972.633.58)

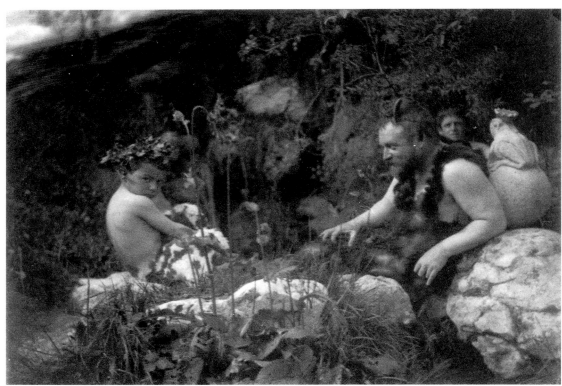

163. The Little Faun and Frank
Eugene Smith as ›Mopsus‹, 1908
Platinum print
from: *Gästebuch E. v. Seidl*,
Vol.1, p. 104
Handschriften-Abteilung Bayeri-
sche Staatsbibliothek, Munich

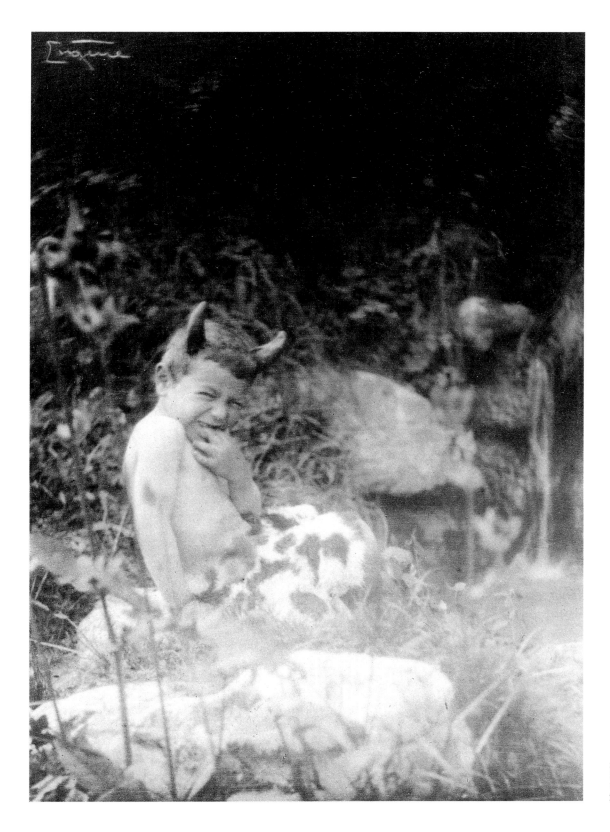

164. The Little Faun, 1908
Platinum print, 16.7 x 11.9 cm
Fotomuseum im Münchner
Stadtmuseum (88/27-89)

Formen und wundervollen Farben, von sonnendurchfluteten Lichtungen und schattigen Lauben, von Hügeln in der Ferne, von in Purpur getauchten Bergen im Abendrot, von denen die Nacht auf schöne, stille, monddurchflutete Täler niedersinkt ... Silbernebel. Sogar die müde Natur regt sich wieder unter dem Zauber eines bloßen Traumes von Landschaft, die Vorstellungskraft erwacht: Satyrn, Elfen und die Waldgeister von ehedem kommen hervor aus ihren Verstecken und haben Freude an ihrem Flötenspiel und ihren bukolischen Weisen. Der Symbolgehalt und die dahinter liegende Bedeutung dieser uralten Mythen bekommt für den heutigen Menschen in seiner beengten Lebensweise einen tieferen Sinn.«[201]

165. Stairway to the vegetable- and flowergarden, Murnau 1909 from: E. v. Seidl, *Mein Landhaus*, Darmstadt 1910, p. 13

Mit der eindrucksvollen Illustration des Buches *Mein Landhaus* hatte Eugene sich für vergleichbare Aufgaben empfohlen und so überrascht es nicht, daß er auch mit einer Dokumentation über die Stadtvilla des ›Malerfürsten‹ Franz von Stuck befaßt war, die angeblich 1910 gleichzeitig mit den Arbeiten zur Seidl-Villa vollständig abgeschlossen war.[202] Eugenes Aufnahmen von der Villa Stuck sind jedoch aus unbekannten Gründen unveröffentlicht geblieben und müssen heute als verschollen gelten. Fraglich bleibt, ob einzelne Motive in der Architekturmonographie über die Villa Stuck abgebildet wurden. Obwohl Eugenes Porträtaufnahme von Stuck das Eingangsblatt des Sonderdrucks zierte und einzelne Außenansichten der Villa stilistisch von Eugene stammen könnten, so ist doch eine eindeutige Zuschreibung wegen fehlender Angaben nicht möglich.[203]

Scheinbar unberührt und unbehelligt von dem Treiben in der Seidlschen Villa blieben Wassily Kandinsky, Gabriele Münter und die anderen Künstler des Blauen Reiters, die nicht weit entfernt in einem kleinen Haus in Murnau lebten. Die Kluft zwischen der etablierten Künstlerschaft des Seidlschen Kreises und der Avantgarde war unüberbrückbar und wenn man sich überhaupt zur Kenntnis nahm, dann wohl in gegenseitiger verhaltener Antipathie. Davon zeugt auch eine Gouache von Paul Rieth mit dem Titel ›Fliehe aus München dem expressionistischen – übel wird es Dir nur – Herrlich ist Murnau – Dort kehrt Dir Ruhe und Frohsinn zurück‹[204] – im Seidlschen Gästebuch Juli 1918, die eine naturalistisch gemalte Bäuerin einem weiblichen Akt im expressionistisch-kubistischen Stil gegenüberstellt. Eugene kam über den amerikanischen Maler und Photographen Francis Bruguière, dem er die Grundelemente des photographischen Sehens beigebracht hatte,[205] in näheren Kontakt zu den Protagonisten der modernen abstrakten Malerei. Auf einer gemeinsamen Reise nach Italien lernten sie den Futuristen Prestini in Venedig kennen und aus dieser Zeit stammen mehrere Postkarten von Eugene, die in Wortspielen die Strömungen der modernen Malerei ironisch kommentieren: »Cezannistically, Matisseistically, Picassoistically, Hartleyisticly, Steichenistically, Cubistically, Futuristically and Stieglitzistically Sumosmatistively yours«, lautete der Text einer Karte.[206] Obwohl die Malerei des Kubismus, Fauvismus und Futurismus in seiner Photographie keine erkennbaren Spuren hinterließ, blieb Eugene generell an Kontakten zu Vertretern der abstrakten Malerei interessiert. So war er mit dem expressionistischen Künstler Adolf Erbslöh, dem Mitbegründer der Neuen Künstlervereinigung München,[207] und dem amerikanischen Maler Marsden Hartley befreundet. Als Hartley im Februar 1913 auf seiner Europareise nach München kam, um Wassily Kandinsky und Franz Marc kennenzulernen, stellte Eugene den Kontakt über Erbslöh her und begleitete Hartley bei seinen Besuchen in die Kunsthandlung Golz.[208]

Autochrome

Nur wenig bekannt sind Eugenes Versuche in dem ersten praktikablen Verfahren der Farbphotographie, den Autochrome-Platten, die von Louis und Auguste Lumière bereits 1904 öffentlich vorgestellt worden waren und ab Sommer 1907 im Handel erhältlich waren. Von den Kunstphotographen hatte Edward Steichen als erster mit dem Verfahren experimentiert, nachdem er am 10. Juni 1907 im Photo Club in Paris eine Demonstration der Lumières besucht hatte. Stieglitz, der sich ebenfalls in Paris aufhielt, aber durch Krankheit an der Teilnahme verhindert war, wurde von Steichen informiert, um anschließend selber Eugene und Heinrich Kühn im Juli 1907 mit der neuen Bildtechnik vertraut zu machen.[209] Die vier Piktorialisten hatten sich im Hotel Simson in Tutzing am Starnberger See getroffen, wo sie mit großer Euphorie mit den Experimenten begannen. Als Modelle

166. *Fritz Widman*
The landhouse in Murnau as
chess villa, 1907
from: *Gästebuch Emanuel von
Seidl*, Vol. 1, pp. 95–96
Handschriften-Abteilung Bayeri-
sche Staatsbibliothek, Munich

letter to Stieglitz written in 1910 Eugene mentioned a
lucrative commission to photograph the president and
eight directors of a coal mine in the Erzgebirge. This can
only have been Dr. Georg Wolf whose castle Wolfs-
brunn, built in 1911, was the architectural work of
Emanuel von Seidl.[198]

Emanuel von Seidl – *Mein Landhaus*

Seidl's book *Mein Landhaus* illustrated with photo-
graphs by Eugene is a reliable document of their friend-
ship and surely the creative high point of their relation-
ship. Eugene had photographed the grounds and the
buildings between 1901 and 1910, and this resulted in
54 views of interiors and outdoor settings, among them
some color photographs produced in the autochrome
process: According to the magazine *Photographische
Kunst* in 1910: "Many of these illustrations are genuine
pearls, artistically perceived nature scenes."[199] Unfortu-
nately only a few of the original prints have been pre-
served.
Eugene's sensitive reproduction of the idyllic symbiosis
of architecture and nature may be regarded
as a sympathetic interpretation which must have consti-
tuted a convincing equivalent of the architect's own
intention. The magazine *Innen-Dekoration* lauded
Eugene's photographs as "complete works of art" which
reproduce "the whole atmosphere to perfection."[200] The
real leitmotif in this series of photographs was the idyll
of nature as opposed to the threatening world of the
modern metropolis and of industrialization. Thus in
these works Eugene took up a traditional Neo-Romantic
topic of "nature as a landscape of the soul" prevalent at

the turn of the century. The art photographers Coburn,
Stieglitz and Käsebier paid particular tribute to land-
scapes as a source of both supernatural and positive
vitality and inspiration: "Landscape! How the word and
its associations take one out of oneself into a delicious
world of sylvan dreams of trees, of trickling, gurgling
streams, of odorous flowers of many forms and won-
drous colors, of sunlit lawns and leaf-shaded bowers,
of distant hills, of purple-hued mountains against sunset
skies, of night creeping down beautiful, silent valleys
flooded with moon – silvered mist. Even tired nature
revives under the spell of a mere dream of landscape,
imagination awakens, satyrs and elfin peoples and the
wood-gods of old come forth from hiding and disport
themselves, playing upon their pipes, singing mystic
rural songs. The symbolism of all these old-time myths
and their deeper meaning is made clear to us through
our imprisonment and takes on a new and more human
significance."[201]
Eugene's impressive illustrations of Seidl's *Mein
Landhaus* functioned as a recommendation for other
similar tasks, so it comes as no surprise that he was
also involved in a documentation on the city residence
of that "prince among painters," Franz von Stuck,
which he apparently completed in 1910 at the same time
as the work on the Seidl villa.[202] For reasons which are
unknown, his photographs of the Stuck villa were never
published and must be assumed to have gone missing.
One question which remains is whether certain motifs
reproduced in an architectural publication on the Stuck
villa are by Eugene. Although his portrait photograph of
von Stuck graces the first page of that book, and al-
though stylistically some of the outside views of the

167. Garden on the upper pond, Murnau 1909
from: E. v. Seidl, *Mein Landhaus*, Darmstadt 1910, p. 30

168. Building in the park of the landhouse of E. v. Seidl, Murnau 1909
D.O.P., 11.9 x 16.4 cm
Fotomuseum im Münchner Stadtmuseum (93/1056-29)

169. Entrance to the vegetable garden, Murnau 1909
Platinum print, 29.5 x 40.3 cm
Fotomuseum im Münchner Stadtmuseum (93/757-6)

170. Vegetable- and flower gar-
den with a view to the Bavarian
Alps, 1909/10
Autochrome
from: E. v. Seidl, *Mein Landhaus*,
Darmstadt 1910, p.16

171. "Gloriettl," Murnau 1909
from: E. v. Seidl, *Mein Landhaus*,
Darmstadt 1910, p. 27

172. Interior of the Seidl-Villa,
Murnau 1909
from: E. v. Seidl, *Mein Landhaus*,
Darmstadt 1910, p.46

173. Entrance to the music salon,
Murnau 1909
from: E. v. Seidl, *Mein Landhaus*,
Darmstadt 1910, p. 6

174. Driveway to the villa,
Murnau 1909
from: E. v. Seidl, *Mein Landhaus*,
Darmstadt 1910, p. 22

 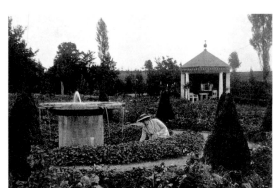

175. Guest room, Murnau 1909
from: E. v. Seidl, *Mein Landhaus*,
Darmstadt 1910, p. 51

176. Vegetable- and flower gar-
den, Murnau 1909
from: E. v. Seidl, *Mein Landhaus*,
Darmstadt 1910, p. 15

177. Seidl-Villa, Murnau 1909
from: E. v. Seidl, *Mein Landhaus*,
Darmstadt 1910, p. 1

178. Promenaden-Weg, Murnau
1909
from: E. v. Seidl, *Mein Landhaus*,
Darmstadt 1910, p. 12

179. Entrance to the "gelobte
Land," Murnau 1909
from: E. v. Seidl, *Mein Landhaus*,
Darmstadt 1910, p. 23

180. "Orchesterbank," Murnau
1909
from: E. v. Seidl, *Mein Landhaus*,
Darmstadt 1910, p. 54

181. Seidl-Villa, Murnau 1909
from: E. v. Seidl, *Mein Landhaus*,
Darmstadt 1910, p. 31

Verfahren habe ich persönlich gründlich geprüft, und meine Begeisterung wuchs, obwohl die Schwierigkeiten zahlreich waren und die Fehler nicht minder.«[213] Auf der Rückreise nahm Stieglitz eine Auswahl der entstandenen Autochrome von Steichen und Eugene mit nach New York, um diese zusammen mit seinen Aufnahmen am 27. und 28. September 1907 in der Galerie der Photo-Secession vorzustellen. Dabei handelte es sich um die erste öffentliche Präsentation des Farbverfahrens in Nordamerika, da die Autochrome-Platten trotz der großen Nachfrage und des Interesses in den USA noch nicht erhältlich waren. Unmittelbar nach der Abfahrt von Stieglitz, Steichen und Kühn setzte Eugene seine Autochrome-Versuche fort. Obgleich er gewisse technische Schwierigkeiten hatte, fertigte er schon bald erste farbige Porträts im Auftrag an, wie aus einem Brief vom 18. September 1907 an Stieglitz ersichtlich wird: »»Farbphotographie! Bis gestern hatte ich ein wunderbares Ding, dann verwandelte es sich in ein prächtiges Grün - es ist herzzerreißend. Zwei, die ich von der russischen Dame gemacht habe, sind wahre kleine Wunder, für 100 Mark das Stück. Sogar meine Krämerseele war zu Tränen gerührt, als sie weggingen.«[214]

Das Ausmaß von Eugenes Beschäftigung mit Autochromen läßt sich heute nicht mehr vollständig rekon-

dienten die Familien Stieglitz und Dr. Raab, der in Tutzing ein Wohnhaus besaß und den mit Stieglitz eine alte Freundschaft verband. Zu den erhaltenen Bildnissen der Familie Raab zählt auch ein biedermeierliches Silhouettenbild von Fritz und Käti Raab.[210] Weitere Porträts von Emmeline (Emmy) und Kitty Stieglitz sind bei der selben Gelegenheit entstanden.[211]

Eugene hatte das legendäre Tutzing-Treffen der vier bekannten Kunstphotographen in verschiedenen Gruppenbildern festgehalten, die er mit ›Stieglitz, Steichen, Smith and Kuehn admiring the Work of Frank Eugene‹ betitelte. Stieglitz, der den Ablauf des Treffens beschrieb, hatte sich jedoch dieser ›Interpretation‹ insofern widersetzt, als er eine Variante des Motives mit dem neutralen Titel ›The Tutzing Trio‹ versah.[212] »Eugene und ich führten unsere Experimente in Tutzing fort, aber aus Gründen, auf die wir keinen Einfluß hatten, waren sie von verhältnismäßig kurzer Dauer und nur unter großen Schwierigkeiten auszuführen. Nichtsdestotrotz trösteten wir uns damit, daß die Unberechenbarkeit der Platten fast so erstaunlich war wie die Erfindung selbst. In unseren Experimenten sorgten wir für konstante Testbedingungen und gleichbleibende Qualitätsstandards. Meiner Meinung nach ist die wichtige Sache mit dem Firniss noch nicht gelöst. Kurzum, das

182. Ex Libris: Käti Raab, c. 1910
Platinum print, 16.2 × 11.9 cm
Fotomuseum im Münchner Stadtmuseum (88/26-13)

183. Der Freundschaftshügel in
Murnau, 1909/10
Autochrome
from: E. v. Seidl, *Mein Landhaus*,
Darmstadt 1910, p. 25

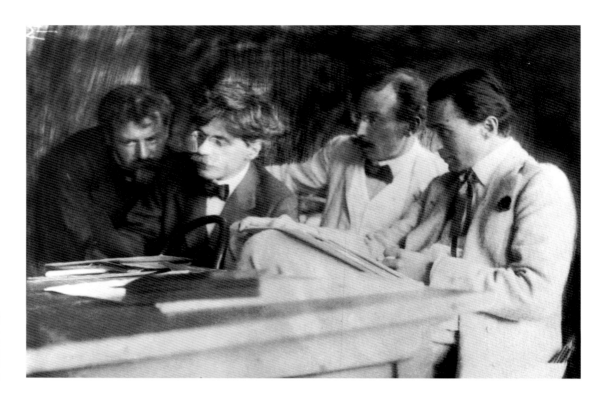

184. Eugene, Stieglitz, Kühn,
Steichen – admiring the work of
Frank Eugene Smith,
Tutzing 1907
Platinum print
The Royal Photographic Society
of Great Britain, Bath

struieren. Eine ähnlich intensive und systematische Auseinandersetzung mit dem Verfahren wie bei Coburn oder Steichen läßt sich jedoch nicht feststellen. Gelegentlich, wie in der englischen Kunstzeitschrift *The Studio*, wurden Autochrome Eugenes wie ›The Sisters‹ veröffentlicht, die vermutlich die Geschwister Simson des gleichnamigen Hotels in Tutzing darstellen.[215] In einer Rezension hieß es: »Mr. Eugenes brilliante Fensterszene ›Die Schwestern‹ ist ›knochenhart‹, aber sie hat den Vorteil, daß sie doch zeigt, daß selbst im Druck, von einem Autochrome nur die weniger differenzierten Farben der Natur wiedergegeben werden können. Leider sind die Gegensätze zwischen Licht und Schatten so gravierend, daß alles entweder leuchtend farbig oder tief schwarz ist. Eines ist klar, der Fehler liegt nicht im Verfahren. Das lästige ›Muster‹ auf dem dunklen Hintergrund des Zimmers, hinter den beiden Figuren, ist wahrscheinlich auf die Körnigkeit der drei Auszüge zurückzuführen.«[216] Auf den Ausstellungen in München 1908 und Budapest 1910 waren insgesamt sechzehn verschiedene Autochrome zu sehen, von denen bei der Rücksendung der Ausstellung aus Budapest drei der besten Autochrome fehlten und eines zerbrochen zurückkehrte.[217] Der größte Teil der Bilder gilt heute als verschollen und in öffentlichen und privaten Sammlungen dürften sich nicht mehr als zwölf Arbeiten erhalten haben.

Eugene verlor, ähnlich wie die meisten Piktorialisten, bald das Interesse an dem Farbverfahren. Bereits am 15.9.1908 teilte er Stieglitz mit. »Ich habe so gut wie keine Autochrome gemacht.«[218] Ab 1910 finden sich keine Autochrome mehr in Ausstellungen oder in Veröffentlichungen Eugenes. Der Grund dafür lag wohl in der mangelhaften Praktikabilität des Verfahrens, bei dem keine farbigen Positive hergestellt werden konnten. Das letzte bekannte Autochrome Eugenes entstand im April 1911 in München auf dem Dachgarten seiner Wohnung und zeigt ein Selbstporträt des Photographen, der inmitten von Lampions und Blumen deutlich sichtbar den Selbstauslöser der Kamera betätigt. Es ist zu vermuten, daß diese Aufnahme ausschließlich als privates Erinnerungsbild entstand und aufbewahrt wurde.[219]

HAWE-Mappe – 1914

Neben der Bildnisphotographie hat sich Eugene immer wieder mit der Darstellung des Aktes beschäftigt, der Ende des 19. Jahrhunderts ein populäres Sujet in der Kunstphotographie repräsentierte. Motive wie ›Adam and Eve‹, ›La Cigale/Dido‹ oder ›Hortensia‹ zählten in Ausstellungen und Publikationen zu seinen besten und wirkungsvollsten Arbeiten, wie bereits Dallet Fuguet anläßlich der Einzelausstellung Eugenes im New Yorker Camera Club 1899 feststellte. Einen Höhepunkt dieser

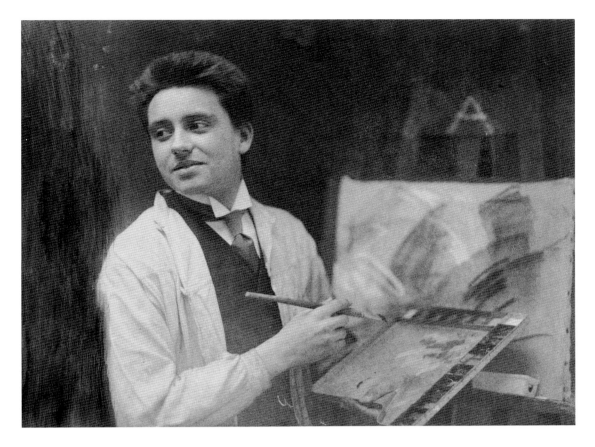

185. Portrait (Adolf Erbslöh?),
c. 1905
Platinum print, 12.4 x 16.2 cm
Fotomuseum im Münchner
Stadtmuseum (88/27-29)

villa could be by him, it is not possible to attribute them to him definitively due to the absence of information.[203]

It would seem that Wassily Kandinsky, Gabriele Münter and the other Blaue Reiter artists who lived close by in a small house in Murnau were unimpressed and undisturbed by the goings-on in the Seidl villa. The chasm between the established artists in Seidl's circle and the avant-garde artists was insuperable, and if they took notice of one another at all, then in an attitude of subdued antipathy. A gouache by Paul Rieth in Seidl's July 1918 guest book, accompanied by an admonition to "Flee from Munich and its expressionism – it will do you no good – Murnau is splendid – there you will find peace and gaiety again,"[204] shows a naturalistic depiction of a peasant woman beside an expressionist-cubist female nude. Eugene came into closer contact with the protagonists of modern abstract painting through the American artist and photographer Francis Bruguière, to whom he had taught the basic elements of photography.[205] On a trip they together made to Italy they got to know the futurist Prestini in Venice. Several postcards dating from this period show Eugene indulging in some ironic commentary on current trends in modern paint-

ing. In one case he signed himself "Cezannistically, Matisseistically, Picassoistically, Hartleyisticly, Steichenistically, Cubistically, Futuristically and Stieglitzistically Sumosmatistiviely yours."[206] Although there are no recognizable traces of cubism, fauvism or futurism in his photography, Eugene was generally interested in making contact with representatives of abstract painting. Thus he was friends with the expressionist artist Adolf Erbslöh, co-founder of the Neue Künstlervereinigung München (New Munich Artists Association),[207] as well as with the American painter Marsden Hartley. When Hartley visited Munich in February 1913 on a European tour, with the express intention of getting to know Wassily Kandinsky and Franz Marc, it was Eugene who established the contact through Erbslöh and also accompanied Hartley on his visits to the art dealer Golz.[208]

Autochromes

Only very little is known about Eugene's experiments with the first practicable color process, autochrome plates, introduced to the public in 1904 by the Lumière brothers and available for sale as of summer 1907.

186. The Sisters, 1907/08
from: Charles Holme (Ed.),
Colour Photography. The Studio,
London 1908, p. 45

Edward Steichen was the first of the art photographers to experiment with the process after attending a demonstration given by the Lumières on June 10, 1907 in the Photo Club in Paris. Stieglitz, who was also in Paris at the time but could not attend the demonstration due to illness, got all the necessary information from Steichen and in turn introduced the new technique to Eugene and Heinrich Kühn in July 1907.[209] The four pictorialists met in the Simson Hotel in Tutzing on Lake Starnberg and set about experimenting in a state of great euphoria. Their models were members of the Stieglitz and the Raab family. Dr. Raab was an old friend of Stieglitz' and had a house in Tutzing. Among the photographs of the Raab family which have survived is a Biedermeier-style silhouette photograph of Fritz and Käti Raab.[210] Portraits of Emmeline (Emmy) and Kitty Stieglitz were also taken on that same occasion.[211]

Eugene captured the legendary Tutzing meeting of the four famous art photographers in various group photographs which he entitled "Stieglitz, Steichen, Smith and Kuehn admiring the Work of Frank Eugene." Stieglitz, who has left us a more sober account of the meeting, contradicts this particular "interpretation" in as far as he calls one variation of the motif "The Tutzing Trio":[212] "Eugene and I continued our experiments in Tutzing, but owing to circumstances over which we had no control, they were only of a comparatively short duration and made under great difficulties. We satisfied ourselves, nevertheless, that the scope of the plates was nearly as remarkable as the invention itself. The tests-permanency, and for keeping qualities, were all considered in the experiments. The varnishing question, an important one, is still unsettled in my mind. In short, the process received a thorough practical test in my hands, and my enthusiasm grew greater with every experiment, although the trials and tribulations were many, and the failures not few."[213] On his return to New York Stieglitz took a selection of Steichen's and Eugene's autochromes with him so as to exhibit them alongside his own photographs in the gallery of the Photo-Secession on September 27 and 28, 1907. That exhibition represented the first public presentation of the color process in North America. Autochrome plates were not yet available there despite the widespread interest and the great demand. After Stieglitz, Steichen and Kühn had departed, Eugene continued his autochrome experiments. Although he still had certain technical difficulties, he was soon able to complete his first color portrait commissions, as indicated by a letter to Stieglitz dated September 18, 1907: "Color-photography! I had a splendid thing till yesterday and then it turned a very

glorious Green – its heart-breaking. Two I did of the Russian lady are marvels at 100 Marks each – even my mercenary soul being moved to pity … at the parting."[214]

It is not possible to fully reconstruct the extent of Eugene's preoccupation with autochromes, but there is no evidence to indicate that it was anything as intensive and systematic as that of Coburn or Steichen. Occasional one of his autochromes was published, for example, "The Sisters" in the English art magazine *The Studio*. Said "Sisters" are presumably the Simson sisters from the hotel of the same name in Tutzing.[215] In one review we read: "Mr. Frank Eugene's brilliant window

187. *Heinrich Kühn* (attr.)
(l-r: Edward Steichen, Katherina Raab, Emmeline Stieglitz, Frank Eugene Smith, Alfred Stieglitz), Tutzing 1907
Platinum print, 6.1 x 7.5 cm
Fotomuseum im Münchner Stadtmuseum (88/27-123)

scene called "The Sisters" is "as hard as nails," but it has the virtue of showing how nearly, even through the medium of printer's ink, the Autochrome can seize the less subtle colors of nature. Unfortunately, the light and shade is in such violent contrast that what is not brilliant color in this example is unmitigated black. That fault is not due to the process at any rate. The distressing "patterning" in the dark distance of the room beyond the two figures is probably due to the grain of the three blocks."[216] At the exhibitions in Munich in 1908 and Budapest in 1910, Eugene showed a total of sixteen different autochromes. Unfortunately, on their return from the Budapest exhibition three of the best ones went missing and one arrived in pieces.[217] Today the majority of the color photographs are considered to be missing, and probably no more than twelve have been preserved in public and private collections. Like most of the pictorialists, Eugene soon lost interest in the color process. On September 15, 1908 he wrote to Stieglitz: "I've done practically no autochromes."[218] From 1910 onwards there were no more autochromes in his exhibitions or publications. One reason for this was undoubtedly the

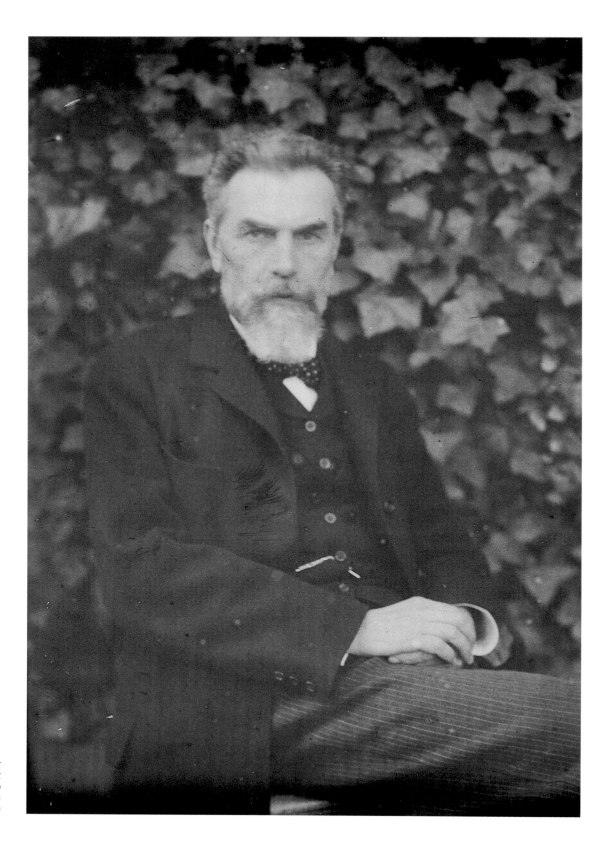

188. *Frank Eugene or*
Alfred Stieglitz
Fritz Raab, 1907–09
Autochrome, 12.0 x 9.0 cm
Private collection

189. Fritz and Käti Raab. 1907-09
Autochrome, 12.0 x 9.0 cm
Private collection

190. Katherina and Fritz Raab
playing chess, 1907-09
Autochrome, 13.0 x 18.0 cm
Private collection

191. Käti Raab, 1907–09
Autochrome, 12.0 x 9.0 cm
Private collection

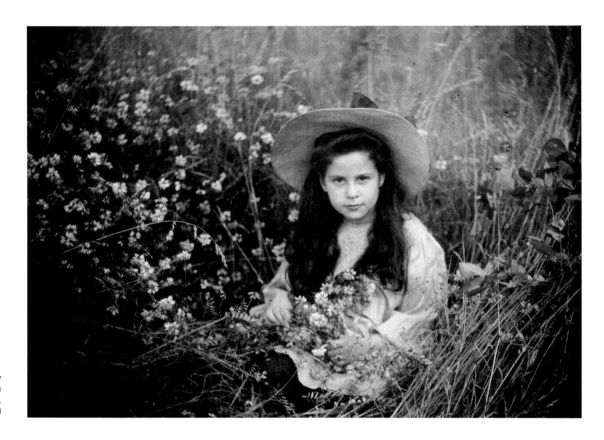

192. Kitty Stieglitz, Tutzing 1907
Autochrome, 10.8 x 14.9 cm
The Art Institute of Chicago,
Chicago (1952.309)

193. Emmeline Stieglitz, Tutzing
1907
Autochrome, 12.0 x 16.6 cm
The Art Institute of Chicago,
Chicago (1952.308)

Entwicklung stellte die sogenannte ›Smith-HAWE‹-Mappe mit zwölf Photogravüren von Aktstudien männlicher Modelle dar, die Ende des Jahres 1914 von Hans Wittmann herausgegeben wurde. Nicht näher bekannt sind die Auflage und der Vertrieb des Mappenwerkes, das von Texten Wittmanns und des Kunsthistorikers Maximilian K. Rohe sowie Äußerungen bekannter und befreundeter Schriftsteller und Künstler, zumeist Professoren der Münchner Kunstakademie und Kunstgewerbeschule, über die Motive begleitet wurde. Diese Stellungnahmen stellen ein interessantes Dokument dar, das über die Position der künstlerischen Photographie im Verhältnis zur Malerei und Graphik Auskunft gibt. Der Architekt Emanuel von Seidl, die Maler Adolf Hengeler, Albert von Keller, Hermann Hahn, Julius Diez, Kunz-Meyer, Friedrich August von Kaulbach und die Schriftsteller Georg Schaumberg und Fritz von Ostini äußerten sich sehr anerkennend über die ›HAWE‹-Mappe: »Sie wirken wie echte graphische Kunstwerke und können in der Schönheit ihres Tons und ihrer Modellierung meiner festen Überzeugung nach Künstlern wertvolle Anregungen geben und ihnen auch direkt als Hilfsmittel dienen. Obszöne Gedanken lässt sowohl die durchaus keusche Auffassung, wie die hervorragende

Qualität der Arbeiten wohl auch beim Prüdesten nicht aufkommen.«[220]

In verschiedener Hinsicht entsprachen Eugenes Aktbilder dem herrschenden moralischen Kanon, denn die in den Fachzeitschriften allgegenwärtigen Artikel und Diskussionen über den ›erzieherischen‹ Wert der Aktphotographie forderten die Wahl einer ›natürlichen‹ Umgebung ›en plein air‹, eine sorgfältige Auswahl der Modelle und deren idealisierende Darstellung. Im Gegensatz zur akademischen Aktdarstellung, die als Modellersatz und Bildvorlage für Künstler seit Mitte des 19. Jahrhunderts Verbreitung fand, erlebten die Piktorialisten die Darstellung des weiblichen und männlichen Aktes gleichermaßen als Befreiung von puritanischen Moralvorstellungen und als Rückkehr zu einer ursprünglichen Lebensweise. Gerne wurden die Vorbilder in den antiken Mythologien gesucht und photographisch in Szene gesetzt.

Auch Eugene war die einschlägige Aktliteratur wohl vertraut; er besaß beispielsweise die rassenbiologischen Schriften von Carl Heinrich Stratz, die sich mit den Erscheinungsformen der menschlichen Schönheit beschäftigten.[221] Ikonographisch knüpften die Aktstudien der ›HAWE‹-Mappe an antike Traditionen an, vergleicht

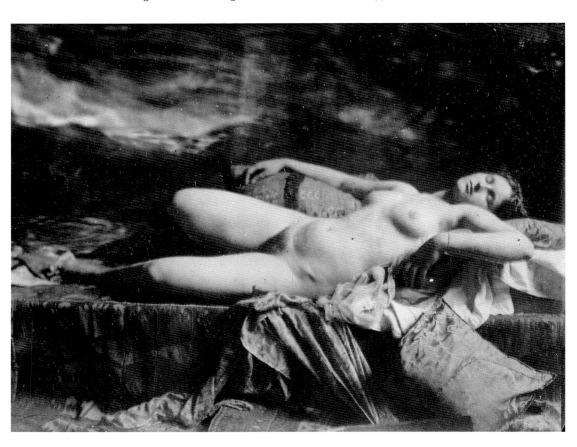

194. Nude, c. 1910
D.O.P., 8.8 x 11.8 cm
Fotomuseum im Münchner
Stadtmuseum (88/26-112)

182

general impracticability of the process which did not allow the production of color positives. Eugene's last known autochrome dates from April 1911. It is a self-portrait of the photographer taken in the roof garden of his flat in Munich, surrounded by lanterns and flowers and clearly activating the camera's delayed action shutter release. Presumably this portrait was preserved purely as a private memento.[219]

195. Baby Bonsels, c. 1907
Photogravure, 17.2 x 12.0 cm
Fotomuseum im Münchner Stadtmuseum (88/26-34)

The HAWE Portfolio – 1914

Alongside portrait photography Eugene was also preoccupied with nude studies which were a popular subject in art photography at the end of the 19th century. Motifs such a "Adam and Eve," "La Cigale/Dido" and "Hortensia" were regarded as his most accomplished and most effective nude photographs, an opinion expressed by Dallet Fuguet on the occasion of Eugene's solo exhibition in the New York Camera Club in 1899. The so-called "Smith-HAWE" portfolio represents a high point in this genre. It contains twelve photogravures of nude studies of male models and was published at the end of 1914 by Hans Wittmann. Nothing is known about the size of the print-run or the sales of the portfolio, but

the studies were accompanied by texts written by the publisher Wittmann and by the art historian Maximilian K. Rohe, as well as statements by famous writer and artist friends of Eugene's, most of them professors from the Munich Kunstakademie and the Kunstgewerbeschule. These statements represent an interesting document about the relationship between art photography and painting and graphics. The architect Emanuel von Seidl, the artists Adolf Hengeler, Albert von Keller, Hermann Hahn, Julius Diez, Kunz-Meyer, Friedrich August von Kaulbach, and the writers Georg Schaumberg and Fritz von Ostini were very enthusiastic about the "HAWE" portfolio: "They have all the graphic features of genuine works of art, and in their beauty and their vividness of tone and form could, in my opinion, provide artists with valuable impetuses and even serve them as direct supports in their work. The thoroughly modest conception and the outstanding quality of the work are such that they are unlikely to give rise to obscene thoughts even in the minds of the most prudish."[220]
In many ways Eugene's nudes reflect a certain conformity with the predominant moral canon. Myriad articles and intense debates in the specialist magazines of the time on the "educative" value of nude photography had demanded the selection of "natural" surroundings, "en plein air," a prudent choice of model, and an idealized presentation. By comparison with academic nude paintings in widespread use by artists since the middle of the 19th century as pictorial substitutes for models, the pictorialists experienced the depiction of female or male nudes both as a liberation from puritanical moral constraints and as a return to a more natural way of life. They had a preference for scenes and figures from ancient mythology which they re-staged for their photographs.
Eugene was obviously familiar with the relevant literature on nudes; for example, he had in his possession the biological writings of Carl Heinrich Stratz, which deal with various racial manifestations of human beauty.[221] Iconographically, the nudes in the "HAWE" portfolio have recourse to ancient traditions. One only has to compare the photographs with depictions of Discobolos, the Aeginetan figures or Orpheus. The figure of the great poet of Greek mythology Orpheus exercised a particular fascination on symbolist writers, painters and photographers at the turn of the century. A study of the works of Franz von Stuck, Alexandre Séon, Gustave Moreau, Fred Holland Day or Clarence White, shows that Orpheus seems to have embodied both a serene symbiosis of man and nature and an unfulfilled yearning and melancholy in the face of the vanity of human endeavor.

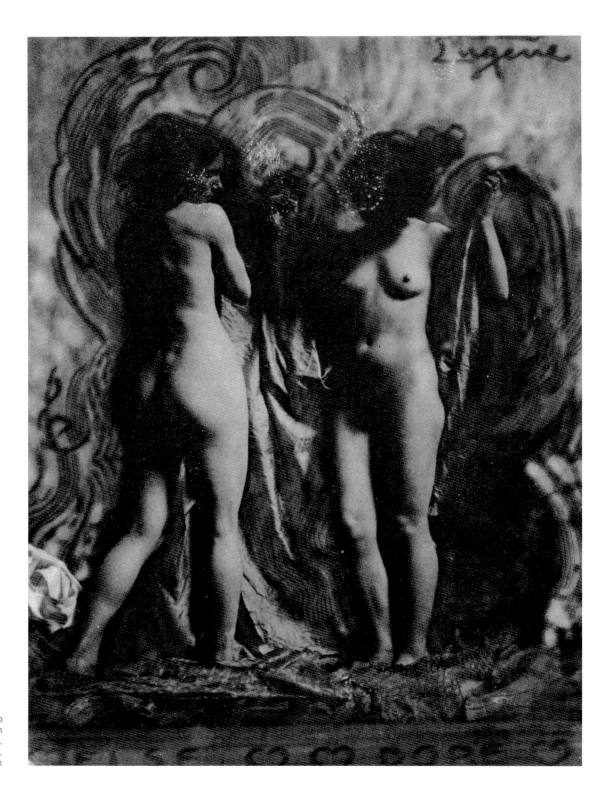

196. Else and Dora, c. 1910
D.O.P., 16.2 x 12 cm
Estate of Hans Brandenburg,
Monacensia Literaturarchiv,
Munich

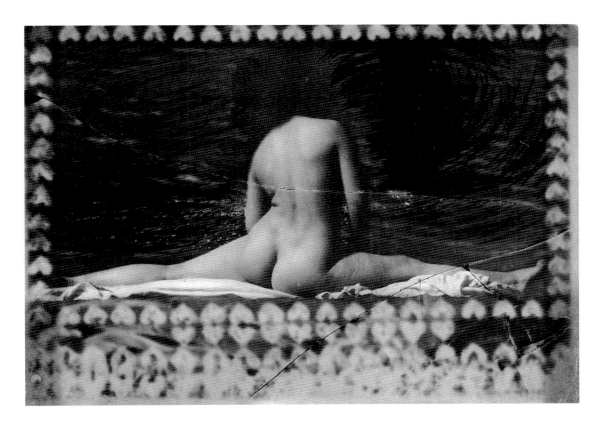

197. Nude, c. 1910
D.O.P., 12.6 x 17.7 cm
Rupprecht Geiger, Munich

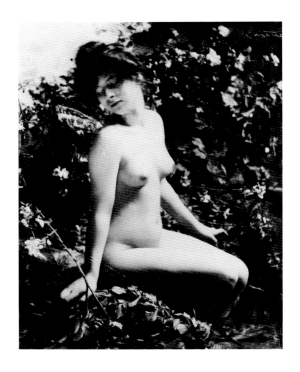

198. Psyche, c. 1909
Platinum print
Metropolitan Museum of Art,
Rogers Fund, 1972 (1972.633.47)

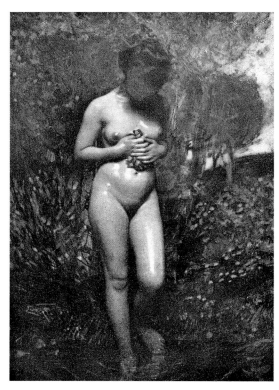

199. Nude, c. 1910
from: *Die Schönheit*, 1920, p. 543

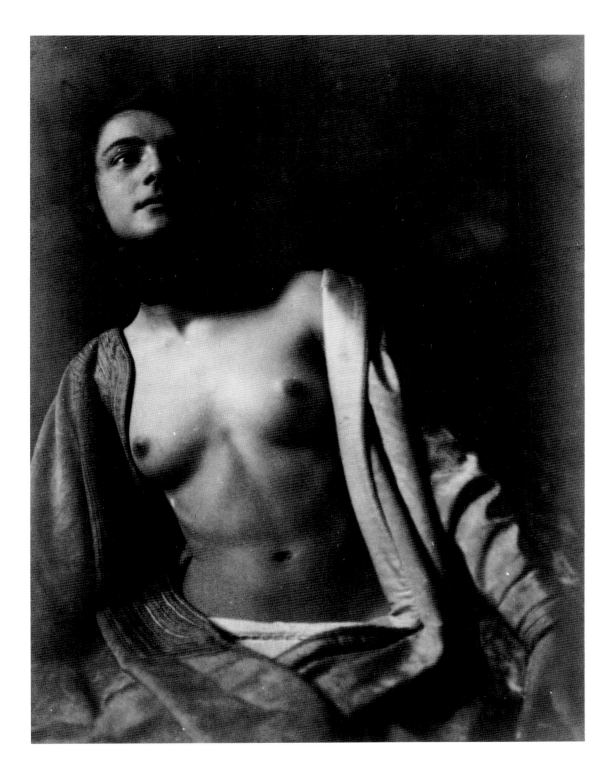

200. Juventas, c. 1908
Platinum print
Metropolitan Museum of Art,
Rogers Fund, *1972* (1972.633.54)

187

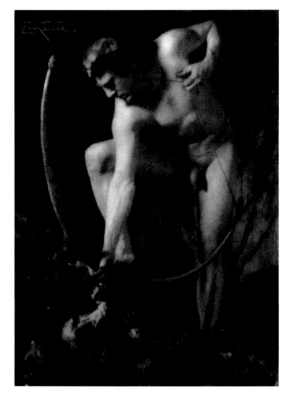

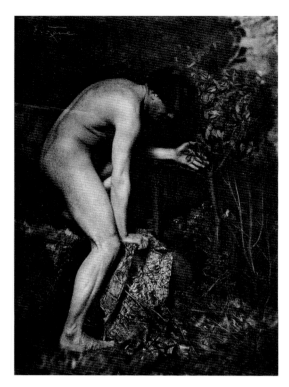

201. Nude, 1914
from: HAWE-Mappe 5
Photogravure, 17.9 x 12.3 cm
Fotomuseum im Münchner
Stadtmuseum (76/2-5)

202. Nude, 1914
from: HAWE-Mappe 12
Photogravure, 18.2 x 13.3 cm
Fotomuseum im Münchner
Stadtmuseum (76/2-12)

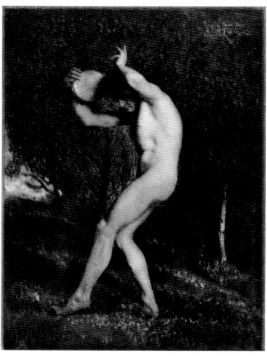

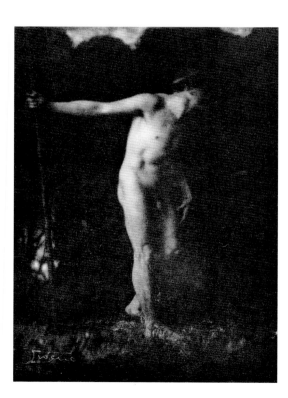

203. Nude, 1914
from: HAWE-Mappe 1
Photogravure, 17.5 x 12.3 cm
Fotomuseum im Münchner
Stadtmuseum (76/2-1)

204. Nude, 1914
from: HAWE-Mappe 3
Photogravure, 17.4 x 12.5 cm
Fotomuseum im Münchner
Stadtmuseum (76/2-3)

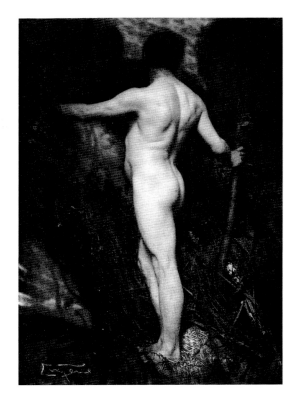

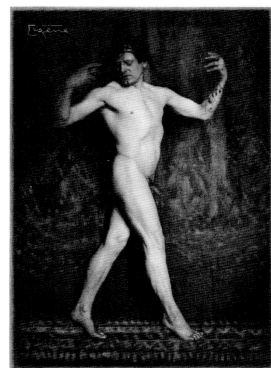

205. Nude, 1914
from: HAWE-Mappe 2
Photogravure, 17.1 x 12.2 cm
Fotomuseum im Münchner
Stadtmuseum (76/2-2)

206. Nude, 1914
from: HAWE-Mappe 10
Photogravure, 18.2 x 12.3 cm
Fotomuseum im Münchner
Stadtmuseum (76/2-10)

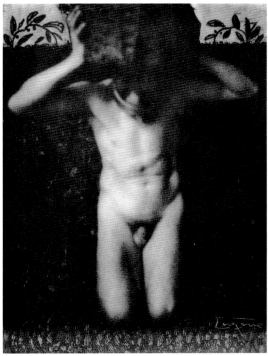

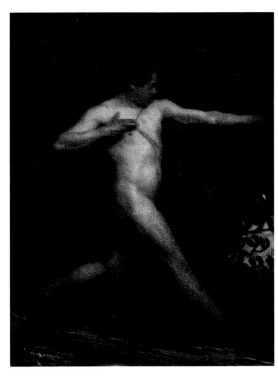

207. Nude ("Caryatide"), 1914
from: HAWE-Mappe
Photogravure, 16.9 x 12.1 cm
Fotomuseum im Münchner
Stadtmuseum (88/27-33)

208. Nude, 1914
from: HAWE-Mappe 6
Photogravure, 16.9 x 12.2 cm
Fotomuseum im Münchner
Stadtmuseum (76/2-6)

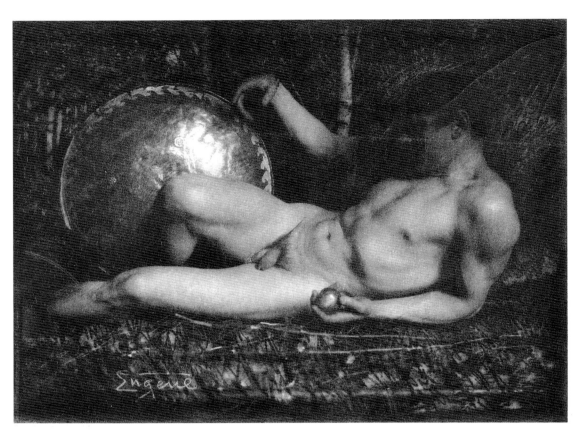

209. Nude, 1914
from: HAWE-Mappe 7
Photogravure, 13.2 x 17.4 cm
Fotomuseum im Münchner
Stadtmuseum (76/2-7)

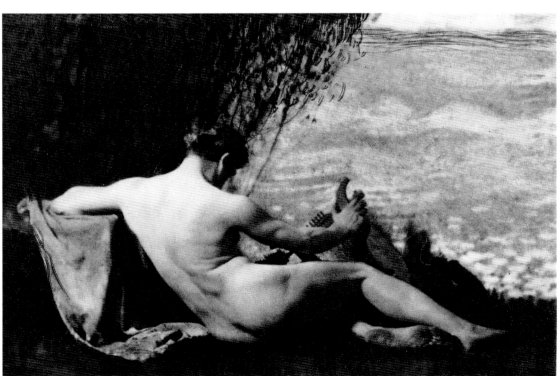

210. Nude ("Orpheus"), 1914
from: HAWE-Mappe 8
Photogravure, 12.5 x 17.4 cm
Photomuseum im Münchner
Stadtmuseum (76/2-8)

190

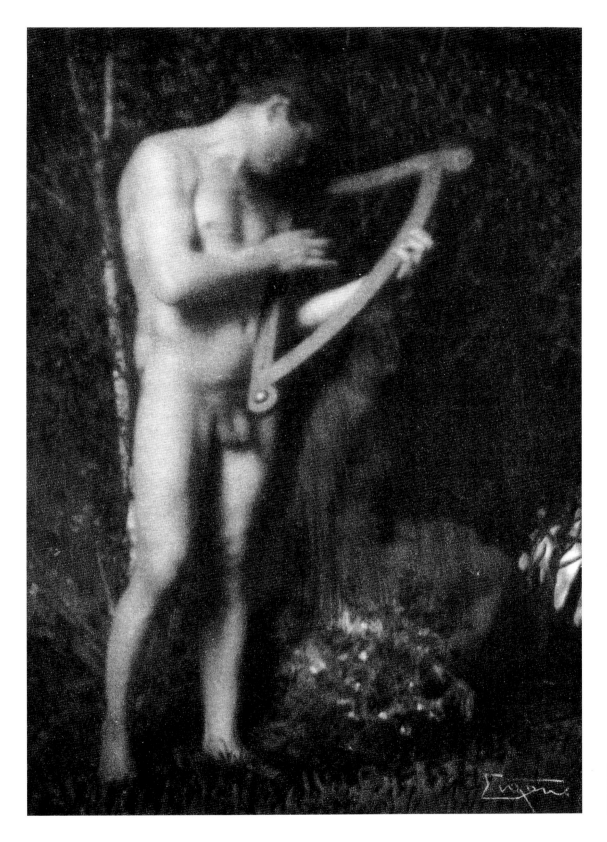

211. Orpheus, 1914
from: HAWE-Mappe 4
Photogravure, 17.5 x 11.9 cm
Fotomuseum im Münchner
Stadtmuseum (76/2-4)

man die Aufnahmen mit Darstellungen des Diskobols, der Ägineten oder von Orpheus. Insbesondere die Figur des Orpheus, des größten Sängers in der griechischen Mythologie, übte auf Schriftsteller, Maler und Photographen im symbolistischen Fin-de-Siècle besondere Faszination aus. Vergegenwärtigt man sich die Werke eines Franz von Stuck, Alexandre Séon, Gustave Moreau, Fred Holland Day oder Clarence White, schien Orpheus die friedliche Symbiose von Mensch und Natur, aber auch die unerfüllte Sehnsucht und Trauer über die Vergeblichkeit des menschlichen Strebens zu versinnbildlichen. Charakteristisch ist Eugenes Verzicht auf eine realistische Darstellung zugunsten der sphärisch-lyrischen Wiedergabe des Aktes. Die Bildhintergründe hatte er in bewährter Art durch Einzeichnungen in düstere Waldlandschaften verwandelt, aus denen die Figuren als helle Silhouette in dramatischer Beleuchtung hervortreten. Diese leicht verschwommene ›malerische‹ Wiedergabe des Körpers erzielte Eugene mit Hilfe eines weichzeichnerischen Objektives, über das er wie Day, Kühn, White oder Coburn seit November 1907 verfügte, nachdem er von Stieglitz ein Smith-Objektiv als Geschenk erhalten hatte: » (...) Ich hatte bis dahin keine Ahnung von seiner Größe, Schönheit und mechanischen Raffinesse.«[222] Dieses technische Hilfsmittel ließ die männlichen Modelle femininer und ungeschlechtlicher zugleich erscheinen. Eugenes Huldigung an das androgyne Schönheitsideal war in der Kunst des Fin-de-Siècle weit verbreitet, da das Androgyne die Sehnsucht nach einem körperlichen Idealzustand verkörperte, der die Befreiung vom Geschlechterkampf und von gesellschaftlichen Antagonismen symbolisierte.[223]

Gleichwohl muten die akademischen Posen der Modelle in Eugenes Aufnahmen gelegentlich künstlich und geziert an, was auch die Kritik des Bildhauers Adolf von Hildebrand herausforderte, der von dem Verleger Wittmann ebenfalls um eine (unveröffentlicht gebliebene) Äußerung über die ›HAWE‹-Mappe gebeten worden war: »Ich halte das angestrebte Ziel an sich für verfehlt und durch die mit so viel Liebe und künstlerischem Sinn ausgeführten Bilder als unlösbar bewiesen. Es kommt über den Wert des lebenden Bildes nicht hinaus. Arrangierte Natur wird eben nie ein wirkliches Kunstwerk, weil alles Arrangement eben nur bis zu einem gewissen Punkt möglich ist und ein grosser Teil der Formgebung unbeeinflusst und von der zufälligen Natur festgehalten bleibt. Da und dort bleiben unbeeinflußbare Stellen zurück, die wie Dissonanzen stehen bleiben und sich dem Zusammenhang nicht fügen, weil sie eben von der Natur gezeichnet sind, wo die Hand des Künstlers sie erst zu einheitlichem Zusammenklang umzuschaffen hätte.

Auf diese Weise können wohl Bilder entstehen, sie behalten aber das Gepräge zweier unvereinbarer Elemente. Ihre photographischen Bilder beweisen wohl, dass auch auf rein photographischem Wege durch künstlerische Leitung etwas sehr ähnliches erreicht werden kann wie es die Malerei tut, wenn sie an Stelle eines selbst geschaffenen zeichnerischen Grundstockes eine Photographie direkt benutzt. Dieser Beweis lässt sich als sehr verdienstvolle Klarlegung ansehen, im Grunde wird es aber zu einer unbewussten Satyre auf diese Art von Kunst. (...)«[224]

In Deutschland fanden Eugenes Aktstudien vor allem in den Zeitschriften der Freikörperkultur wie *Die Schönheit* Verbreitung.[225] In Nordamerika hingegen blieben die Aktstudien der ›HAWE‹-Mappe unveröffentlicht, da die Sendung einer Mappe an Alfred Stieglitz vom amerikanischen Zoll zurückgewiesen wurde.[226]

Die letzten Lebensjahre 1927–36

Als Eugene die Lehr- und Versuchsanstalt für Photographie in München verließ, um die neue Lehrtätigkeit an der Leipziger Hochschule aufzunehmen, rief diese Entscheidung allgemeines Bedauern hervor, da »München wieder eine wertvolle künstlerische Kraft verliert.«[227] In Leipzig begründete Frank Eugene kein durch Theoriebildung fundiertes Lehrprogramm, wie beispielsweise von Lászlo Moholy-Nagy oder Hans Finsler überliefert ist. Die ursprüngliche Radikalität seiner Bildtechnik war zu einer Art Dekorationstil geraten, denn Eugene sollte in Leipzig seine einmal gefundene Bildsprache kaum noch variieren und weiterentwickeln können.[228] Zwar porträtierte er gelegentlich die Lehrer der Akademie und Leipziger Künstler und Gelehrte in bewährter Manier, doch fanden diese Bilder kaum Widerhall in der Öffentlichkeit. Nach 1918 hatten sich die Ausdrucksformen der Kunstphotographie – und insbesondere in der Porträtdarstellung – zu einer unter Berufsphotographen etablierten Bildsprache entwickeln können, doch mangelte es dieser sichtlich an Innovationskraft und an Möglichkeiten, die gesellschaftlichen Veränderungen der Zeit adäquat bildhaft umzusetzen. Da Eugene sich in den zwanziger Jahren den Impulsen des ›Neuen Sehens‹ weitgehend verschließen sollte, wirkte seine Photographie für die Protagonisten einer puristischen, neusachlich orientierten Richtung sicherlich antiquiert bzw. bereits historisch. Auch ist Eugene zeitlebens kein Mitglied der Gesellschaft Deutscher Lichtbildner (GDL) geworden, die sich als traditionsorientierte Elitevereinigung der deutschen Berufsphotographie unter Vorsitz von Franz Grainer 1919 in Eisenach konstituiert hatte.

Characteristic of Eugene's approach to the nude is a rejection of a realistic in favor of a more ethereal, lyrical presentation. In his well-tried hatching method he transformed the backgrounds of his photographs into dusky forest landscapes from out of which the bright, dramatically lit silhouettes of figures emerge. The slightly blurred "pictorial" rendering of the figures was achieved by Eugene's soft-focus lens, something which, like Day,

spite having been taken with so much ardor and aesthetic sense. The value of the natural, living image cannot be surpassed. An arranged nature scene will never become a true work of art because all arrangements are only feasible up to a certain point. A large part of what is captured by the photographic composition is in fact uninfluenced, pure chance. Here and there bits remain which cannot be influenced, which are like dissonances and do not inte-

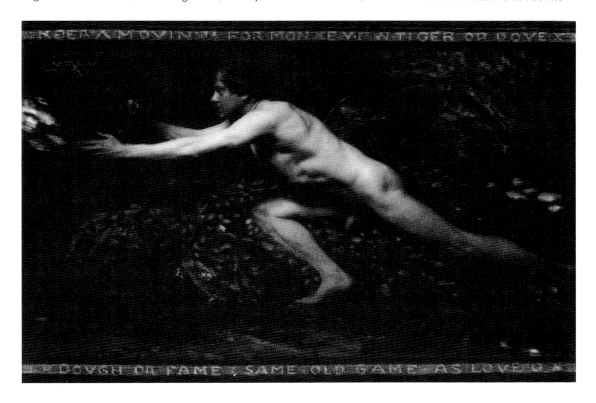

212. Nude (Keep a Movin'! For Monkey * Fan * Tiger or Dove: Dough or Fame: Same Old Game as Love.) from: Hawe-Mappe Photogravure 12.2 x 17.9 cm Valentin-Musäum, Munich

Kühn, White and Coburn he had had at his disposal since November 1907. He had received a gift of a Smith lens from Stieglitz: ".... I had no notion of the size, the beauty and at the same time the mechanical nicety of the thing."[222] This technical device caused the male models to appear more feminine, even asexual. Such a homage to an androgynous vision of beauty was very widespread in art at the time, the androgynous embodying a yearning for an ideal physical state and symbolizing a deliverance from the battle of the sexes and from social antagonisms.[223] Yet the academic poses of the models in Eugene's photographs occasionally seem artificial and forced. This elicited criticism from the sculptor Adolf von Hildebrand, from whom the publisher Wittmann had also requested a written contribution (which was not published) to the "HAWE" portfolio: "I consider the envisaged goal as in itself wrong, and what is more, unattainable, something which the photographs themselves provide proof of, de-

grate themselves into the whole because they are painted by the hand of nature – whereas the hand of the artist ought merely to rearrange them into a unified harmony. Photographs may well be taken in this way, but they will always retain traces of two incompatible elements. What these photographs prove is that under artistic direction and in a purely photographic mode something similar can be achieved as in painting when the latter works directly from a photograph instead of from a self-created sketch. This proof can be regarded as constituting a very worthy clarification of that point, but basically what it becomes is an unconscious satire on that type of art...."[224] In Germany, Eugene's nude studies were reproduced mainly in magazines such as *Die Schönheit* which propagated nudism.[225] The "HAWE" portfolio was not published in North America at all as the package dispatched to Alfred Stieglitz was returned by the American customs.[226]

193

Nach seiner Rückkehr nach München 1927 führte Eugene das Leben eines relativ wohlhabenden Privatiers. Seine Rente erlaubte ihm, in Aufkirchen, einem in der Nähe des Starnberger Sees gelegenen kleinen Dorf, ein geräumiges Bauernhaus zu erwerben, in dem er einen Großteil seiner Zeit verbrachte. Seine Versuche, mit Hilfe des Verkaufes von Gemälden und Photographien zusätzliche Gelder zu erwirtschaften, blieben mehr oder weniger erfolglos. Auch die Ausstellung seiner Werke in den Jahren 1925 und 1926 hatte gezeigt, daß sich mit seinen Bildmotiven keine größeren Geschäfte machen ließen. Ebenso begrenzt blieb der Versuch, seine Photographien, Gemälde und Bibliothek über einen Leipziger Kunstantiquar Ende der zwanziger Jahre als Kommissionsgut zu veräußern.

In den photographischen Fachkreisen war Eugene nach seiner Übersiedlung nach München weitgehend in Vergessenheit geraten. Zu der Gruppe um Paul Renner, Wolfgang von Wersin und Franz Roh,[229] den wichtigsten Förderern einer neusachlichen Photographie in München, hatte Eugene offensichtlich keine Verbindung, so daß seine Aufnahmen in der ›Internationalen Ausstellung Das Lichtbild‹ in München von Juni bis September 1930 fehlten. Eugenes ›Lichtradierungen‹ waren dort nicht einmal in der von Franz Roh zusammengestellten Abteilung zur Geschichte der Photographie präsent.[230]

In seinen letzten Lebensjahren hatte Eugene wohl nur noch selten Abzüge von seinen Negativen hergestellt, obwohl er wiederholt entsprechende Versuche mit Unterstützung von Francis Bruguière unternahm: »Ich habe eine Reihe von Negativen, von denen ich nie Kopien gezogen habe – und jetzt, wo ich Ende sechzig bin, möchte ich gern dann und wann ein paar Abzüge machen. Ich mag aber keines der gebräuchlichen Papiere, die hier hergestellt werden und bin aber auch zu bequem, um mein eigenes Papier herzustellen, obwohl ich Mengen von Platinsalz und Japanpapier habe. Würdest Du so freundlich sein und herausfinden, wo in London die Platinotype Company sitzt und sie bitten, mir verschiedene Proben der von ihnen sensibilisierten Papiere und eine kleine Dose mit Salzen, Preisliste etc. zu schikken?«[231]

Als im Sommer 1935 eine Anfrage der Direktion der Staatlichen Graphischen Sammlung in München erfolgte, Bildnisse berühmter Münchner Persönlichkeiten für die kulturgeschichtliche Sammlung des Porträtarchives zu überlassen, übersandte Eugene neun seiner bekanntesten Bildnisse.[232] Zu diesem Zeitpunkt war sein Gesundheitszustand so labil, daß er im Herbst 1935 in ein Münchner Krankenhaus eingeliefert wurde, das er erst im Mai 1936 verlassen konnte. Nachdem seine alte Freundin Margaretha Willer im März 1936 verstorben war, hatte sie Eugene zum Universalerben ihres Besitzes ernannt.[233] Doch schien auch Eugene nunmehr die Lust am Leben verlassen zu haben, und er starb am 16. Dezember 1936 an den Folgen eines Herzleidens.[234]

Eugene's Last Years, 1927–36

Eugene's decision to leave the Munich Lehr- und Ver-
suchsanstalt and take up a new post at the Academy
in Leipzig was met with general dismay, as "Munich
was thus losing another valuable artistic force."[227] In
Leipzig, however, Eugene was neither to vary nor de-
velop his particular pictorial language.[228] He occasion-
ally took portraits in his proven manner of teachers at
the Academy and of Leipzig artists and scholars but
these elicited little response from a wider public. After
1918 the expressive forms of art photography – in par-
ticular of portrait photography – developed into an es-
tablished pictorial language widely used by professional
photographers. That language, however, obviously
lacked the innovative power and the possibilities to give
adequate pictorial shape to contemporary changes in
society. As Eugene more or less closed his eyes to the
impulses of the "new vision" in the 1920s, his photog-
raphy must have seemed antiquated if not already his-
torical to the protagonists of a purist objective style.
What is more, Eugene never became a member of the
Gesellschaft Deutscher Lichtbildner (Society of German
Photographers) which had been founded in Eisenach in
1919 under the chairmanship of Franz Grainer and was a
more traditionally-orientated elite association.

After his return to Munich in 1927, Eugene led the com-
fortable life of a man of private means. His pension al-
lowed him to purchase a spacious farmhouse in Auf-
kirchen, a small village near Lake Starnberg, in which he
spent most of his time. His attempts to acquire addi-
tional funds by selling some of his paintings and photo-
graphs were more or less unsuccessful. Exhibitions of
his works in 1925 and 1926 had shown that there was
no longer a market for his kind of pictorial motif. An
attempt to sell his photographs, paintings and library
on commission through a Leipzig art antiquarian in the
late 1920s also had only limited success.

By the time he returned to Munich Eugene had been
more or less forgotten in photographic circles there. He
obviously had no connections to the group around Paul
Renner, Wolfgang von Wersin and Franz Roh,[229] the
most important adherents of the new objective photog-
raphy. Thus his works were not included in the "Inter-
national Exhibition The Photograph" which took place
in Munich from June to September 1930. The History of
Photography Section of that exhibition, put together by
Franz Roh, did not even contain samples of his "photo-
etchings."[230]

During the last years of his life Eugene only seldom
made prints from his negatives although he took re-
peated initiatives in that direction: "I've a number of
negatives that I've never made copies from – and now
that I'm growing on toward the end of the sixtiess I
would like to do a little printing now and then – and
I don't like any of the popular papers made here and
I'm too comfortable to prepare my own paper although
I've loads of platinum salts and lots of Japanpaper. Will
you kindly find out where "The Platinotype Company"
are located in London and ask them to send me various
samples of the papers they sensitize with a small tine of
salts – price lists etc."[231]

In summer 1935 the governing body of the Staatliche
Graphische Sammlung (Municipal Graphic Collection)
in Munich made an appeal for portraits of famous Mu-
nich personalities to be donated to the cultural history
collection of their portrait archives and Eugene sent
along nine of his most famous portraits.[232] At that time
his health had become so precarious that he was admit-
ted to a Munich hospital in autumn 1935 and only dis-
charged in May 1936. When his old friend Margaretha
Willer died in March 1936 she named Eugene as the
sole heir to her estate.[233] Unfortunately, Eugene's zest
for life was not to return. He died on December 16, 1936
of a heart disease.[234]

213. Frank Eugene Smith's studio
in Leipzig, 1913–27
D.O.P., 9.0 x 12.0 cm
Fotomuseum im Münchner
Stadtmuseum (93/758.4)

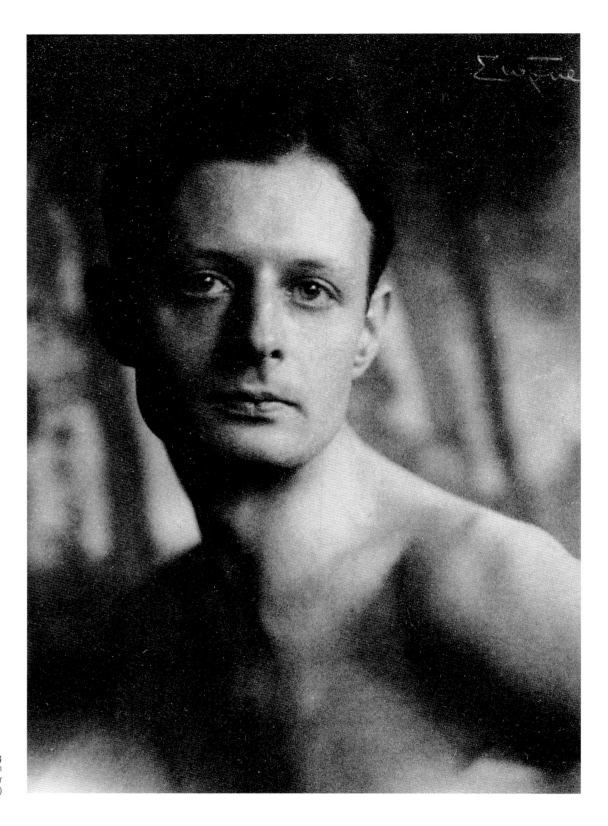

214. Jesko von Puttkamer, c. 1914
Platinum print, 16.7 x 11.7 cm
Fotomuseum im Münchner
Stadtmuseum (88/27-31)

"that I ... felt emotionally at one with this position"[1]
Frank Eugene Smith at the Leipzig Academy 1913–1927

by Andreas Krase

The appointment of Frank Eugene Smith to the chair of Nature Photography at the Königliche Akademie für graphische Künste und Buchgewerbe zu Leipzig (Royal Academy of Graphic Arts and Book Design in Leipzig) has often been referred to, retrospectively, as having instituted the first ever professorship of art photography in Europe.[2] The fact is that the Academy had great expectations of Smith and of his appointment, especially as regards improvements in training standards. The artist's move from the Munich teaching institute known as the Lehr- und Versuchsanstalt für Photographie, Chemigraphie, Lichtdruck und Gravüre to the Academy in Leipzig was expected to mark a real new beginning,[3] despite the fact that he was appointed to refill an already existing position. The traditional view of Smith's post as being the "first professorship" of its kind still preserves something of the expectant anticipation which prevailed at the time of his appointment. The sparse personal traces which Smith left behind in Leipzig and the later discontinuation of his teaching courses may well have contributed to the traditional view of his professorship becoming so restricted to this one aspect of him as an initiator. In Smith's biography, the fourteen years he spent at the Leipzig Academy will continue to represent a chapter with several question marks, a circumstance which is not just the result of the somewhat unhappy state of the available sources.

215. View of the Hochschule für graphische Künste und Buchgewerbe, Leipzig 1914
D.O.P., 15.9 x 22.7 cm
Fotomuseum im Münchner Stadtmuseum (93/759. 7)

The Appointment of Frank Eugene Smith as Professor of Nature Photography

The endeavors leading up to the final appointment of Frank Eugene Smith betrayed all the features of top-secret negotiations. Immediately after the death of Professor Felix Naumann (1858–1913), who had held the position until then, the director of the Academy, Max Seliger (1865–1920), sent off letters to several experts he knew requesting them to make some recommendations. "We are interested in recruiting a person who is first class, both artistically and technically, and who is in a position not only to keep our department of Nature Photography (portrait and landscape photography etc.) completely up to the minute but also to do credit to our institute's reputation, in particular at the great 1914 exhibition,[4] and to gain an edge on the competition through innovation, experimentation etc."[5]

Very soon Smith became the sole focus of Max Seliger's attentions. He commissioned his assistant Dr. Morton Bernath to travel to Munich "so as to be able to negotiate with a gentleman who might be considered for this position."[6] A conspiratorially-sounding postcard which Bernath sent from Munich soon after his arrival reads: "I have finally arranged a meeting with our man today. One way or the other, I shall write to you as soon as a definite result has been achieved."[7] A few weeks later Smith wrote triumphantly to Alfred Stieglitz: "... I finally accepted a position which has so many advantages that I am highly pleased.[8]

Max Seliger had soon begun to reject recommendations from other quarters.[9] He opposed most decisively the unconcealed attempts at intervention made by the Sächsische Photographen-Bund (Saxon Photographers Association) in the person of its first chairman, R. A. Schlegel from Dresden, and his deputy Adolf Sander from Leipzig. As a consequence, a correspondence ensued which would certainly be difficult to equal as regards the sharpness of its tone. The clash between the aspirations to power of the commercial photographers' association and those of the director of the Academy was irreconcilable. Like Smith, the candidate

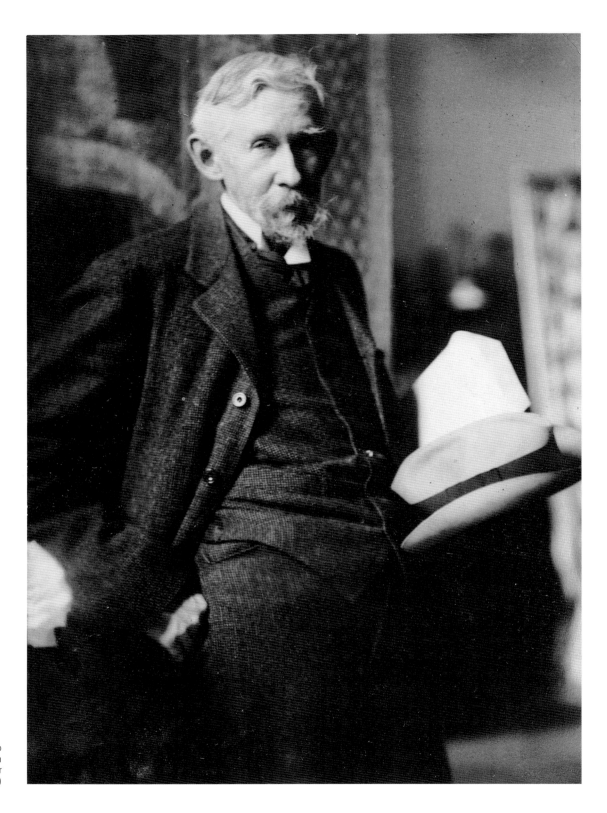

216. Joseph Pennell, c. 1910
D.O.P., 17.7 x 12.6 cm
Fotomuseum im Münchner
Stadtmuseum (88/27-76)

»daß ich ... innerlich mit dieser Stellung so verwachsen bin«[1]
Frank Eugene Smith an der Leipziger Akademie 1913–1927

von Andreas Krase

Die Berufung von Frank Eugene Smith auf den Lehrstuhl für Naturphotographie an der Königlichen Akademie für graphische Künste und Buchgewerbe zu Leipzig wurde retrospektiv mehrfach mit dem Hinweis kommentiert, daß seine Professur die erste für künstlerische Photographie in Europa gewesen sei.[2]

Die Akademieleitung hegte tatsächlich größte Erwartungen bezüglich der Verbesserung der Ausbildung durch die Berufung von Smith. Der Wechsel des Künstlers von der Lehr- und Versuchsanstalt für Photographie, Chemigraphie, Lichtdruck und Gravüre zu München nach Leipzig sollte einen wirklichen Neubeginn markieren,[3] auch wenn es sich im Grunde nur um die Wiederbesetzung einer bereits vorhandenen Stelle handelte. In der Überlieferung von der »ersten Professur« leben jene Ausgangserwartungen als ferner Reflex fort.

Die spärlichen Spuren, die Smith in Leipzig persönlich hinterließ, und die Auflösung seines Lehrgebietes mögen dazu beigetragen haben, die Überlieferung auf diesen einzigen Aspekt zu beschränken. Die vierzehn Jahre an der Leipziger Akademie werden in der Biographie von Smith nicht nur aufgrund der ungünstigen Quellenlage ein Kapitel mit mehreren Fragezeichen bleiben.

Die Berufung von Frank Eugene Smith zum Professor für Naturphotographie

Die Bemühungen um die Berufung von Frank Eugene Smith begannen im Stil von Geheimverhandlungen. Unmittelbar nach dem Tod des vormaligen Amtsinhabers, Prof. Felix Naumann (1858–1913), schickte der Direktor der Akademie Briefe an mehrere ihm bekannte Fachleute, um Empfehlungen einzuziehen.

»Es handelt sich darum, eine in künstlerischer sowohl als in technischer Beziehung erstklassige Kraft zu bekommen, die imstande ist, unsere Abteilung für Naturphotographie (Porträt- und Landschaftsaufnahmen etc) nicht nur vollständig auf der Höhe der Zeit zu halten, sondern eventuell auch durch Neuerungen, Versuche etc unserer Anstalt auf dem Gebiete der Konkurrenz und besonders auf der grossen Ausstellung 1914[4] Ehre zu machen.«[5]

Sehr bald richtete sich das Interesse Max Seligers (1865–1920) ganz auf Smith. Sein Direktorial-Assistent Dr. Morton Bernath beantragte auf seine Weisung eine Reise nach München, »um mit einem für diese Stellung eventuell in Betracht kommenden Herrn verhandeln zu können.«[6]

»Ich treffe unseren Mann heute erst. Jedenfalls schreibe ich Ihnen sobald irgend ein bestimmtes Resultat erzielt ist«,[7] hieß es in konspirativem Ton auf einer Karte, die bald darauf von Bernath aus München kam. Triumphierend schrieb Smith einige Wochen darauf an Alfred Stieglitz: » ...Jetzt habe ich doch eine Stelle angenommen, die so viele Vorteile bietet, daß ich sehr froh darüber bin.«[8] Max Seliger hatte Empfehlungen von anderer Seite sehr bald abgewiesen.[9]

Mit großer Entschiedenheit widersetzte er sich dem unverhohlen massiven Einmischungsversuch des Sächsischen Photographen-Bundes in Gestalt seines Ersten Vorsitzenden, R.A. Schlegel aus Dresden und seines Stellvertreters, Adolf Sander aus Leipzig.

Im Folgenden entspann sich ein Briefwechsel, der in der Schärfe des Tons kaum zu überbieten war. Die Machtansprüche der gewerblichen Vereinigung und des Akademiedirektors trafen unversöhnlich aufeinander. Der Kandidat des Sächsischen Photographen-Bundes, Hans Spörl, war ebenso wie Smith an der Lehr- und Versuchsanstalt für Photographie in München tätig. Seliger war aber offenbar fest entschlossen, die früheren Verbindlichkeiten mit dem Photographen-Verein zu beenden.

Sowohl die 1888 auf Anregung von Joseph Maria Eder geschaffene k.k. Höhere Graphische Lehr- und Versuchsanstalt für Photographie und Reproduktionsverfahren in Wien als auch die 1900 gegründete Lehr- und Versuchsanstalt für Photographie in München standen in direkter oder indirekter Beziehungen zur Tätigkeit von Photographen-Vereinen.[10]

Der Sächsische Photographen-Bund beharrte 1913 auf einem Mitspracherecht, da »die Klasse für Naturphotographie (...) seiner Zeit, auf Veranlassung unseres Sächsischen Photographen-Bundes, der Akademie für graphische Künste und Buchgewerbe Leipzig, angegliedert« sei worden sei.[11]

217. Max Seliger, 1914
Fotomuseum im Münchner
Stadtmuseum

Die Vorgeschichte

Damit war ein Urheberanspruch erhoben, der sich auf die durchaus komplizierten Vorgänge bei der Integration der Photographie als gestalterischem Unterrichtsfach bezog.

Max Seliger hatte, nachdem er 1901 von der Berliner Kunstgewerbeschule kommend als Akademiedirektor angetreten war, die Neuorganisation der Ausbildung durchgesetzt. Die im Jahre 1902 verabschiedete neue Verfassung der Akademie sah auch eine Erweiterung der photographischen Ausbildung vor. Nunmehr sollte die Photographie-Abteilung nicht mehr auf die photographische Reprotechnik beschränkt bleiben, sondern auch mit dem »Aufnehmen von Natur-und Kunstmodellen« betraut werden.[12]

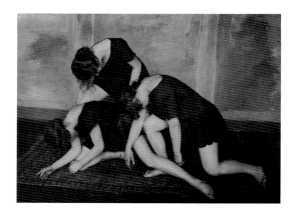

218. Dance studay, after 1918
D.O.P., 7.6 x 10.1 cm
Fotomuseum im Münchner
Stadtmuseum (93/756, 25)

Um das Zusammenwirken der Photographie mit den anderen graphischen Gewerben besser kennenzulernen und Vergleiche über die Ausbildung an ähnlichen Lehreinrichtungen anstellen zu können, hatte Seliger eine ausgedehnte Erkundungsreise unternommen. Zusammen mit dem Leiter des 1893 eröffneten Photomechanischen Instituts an der Kgl. Sächsischen Kunstakademie und Kunstgewerbeschule Prof. Dr. C.W. Georg Aarland (1849–1907) und dem Zeichenprofessor Richard Berthold besuchte er die Kunstanstalt UNIE in Prag, die Lehr- und Versuchsanstalten in Wien und München und verschiedene Verlags- und graphische Anstalten in München, Mainz und Frankfurt/Main. Nunmehr auch mit dem neuesten technologischen Stand vertraut, setzte Seliger seine Bemühungen um die Zusammenführung aller gestalterischen und drucktechnischen Produktionselemente des Buchgewerbes unter dem Dach der Akademie fort.

Seine Reformvorstellungen waren von der seit den 90er Jahren aufkommenden Buchkunstbewegung und der kunstgewerblichen Reformbewegung geprägt und sahen die Umwandlung der Akademie in eine Lehranstalt der Graphik, des Buchgewerbes und der Reproduktionstechniken vor. Die Umbenennung der Akademie war dafür ein äußeres Zeichen.[13]

Die von Seliger geplante Aufgabenerweiterung der Photographie war von dem Grundsatz bestimmt, daß die Aufgabe des Akademieunterrichts »nicht vornehmlich in der Erzeugung selbständiger graphischer Bildkunstwerke«, sondern in der »künstlerischen Gestaltung des Buches mit seinem graphischen Zubehör« zu bestehen habe.[14]

Die Photographie, sofern nicht als Reprotechnik eingesetzt, sollte also Buchillustrationen liefern wie andere graphische Techniken auch, und dazu war eine weitere Unterrichtswerkstatt einzurichten.

Seligers Überlegungen waren über diesen funktionalen Aspekt wahrscheinlich noch nicht hinausgegangen, als er durch eine Eingabe an das Königliche Ministerium in Dresden unter Zugzwang gesetzt wurde. Der Sächsische Photographen-Bund schlug im Juli 1904 die Gründung einer »Sächsischen Photographenschule« unter Leitung des Photographen Arthur Ranft in Dresden vor und unterbreitete detaillierte Vorschläge »bezüglich Veredelung der photographischen Erzeugnisse nach künstlerischer Seite«.[15]

Da man das Münchner Modell als Beispiel anführte und sich außerdem der Mitwirkung des greisen Hermann Krone versichert hatte, wurde das Vorhaben vom Ministerium durchaus ernst genommen. Wohl um den Plan in eigene Bahnen zu leiten, schaltete sich in diesem Moment der Leipziger Vereinsvorsitzende Adolf Sander ein. Er schlug vor, an der Leipziger Akademie »unter der Leitung eines tüchtigen Fachmannes als Portraitphotographen, wie z.B. des Herrn Hofphotographen Felix Naumann, eine Abteilung für den Naturphotographen, wie ich ihn der Einfachheit und im Gegensatz zum Reproduktionsphotographen nennen will«, zu schaffen.[16]

Seliger, der sich vor dem Ministerium keine Blöße geben wollte, sah sich unter Hinweis auf seine eigenen Entwürfe genötigt, diesen Vorschlag zu unterstützen. Die schon zum Ende des Jahres konkretisierten Pläne für den Ausbau der Abteilung für Naturphotographie und die Unterrichtsgestaltung wurden bereits von Naumann entworfen und mit der Akademie und dem Landbauamt abgestimmt.

Seliger hatte allerdings einigen Grund, sich überrumpelt zu fühlen. Der Photographen-Bund hatte in seiner Eingabe die schlechte wirtschaftliche Lage der Atelierphotographen mit der Konkurrenz durch das Großkapital und der fehlenden ästhetischen Schulung seiner Mitglieder begründet und daraus die Notwendigkeit einer erweiter-

put forward by the Sächsische Photographen-Bund, Hans Spörl, was also active at the Munich Lehr- und Versuchsanstalt für Photographie. Seliger, however, was obviously quite determined to put aside any former obligations he may have felt towards the photographers' association. Both the corresponding teaching institution in Vienna, the k.k. Höhere Graphische Lehr- und Veruschsanstalt für Photographie und Reproduktionsverfahren, which was founded in 1888 at the instigation of Joseph Maria Eder, and the Lehr- und Versuchsanstalt für Photographie in Munich, founded in 1900, had direct or indirect links with the activities of the photographers' associations.[10] Since 1913, the Sächsische Photographen-Bund had been insisting on a share in decision making at the Leipzig Academy because of the fact that "at the time, the nature photography class ... had been integrated into the Akademie für graphische Künste und Buchgewerbe on the recommendation of our Sächsische Photographen-Bund."[11]

schule (Berlin School of Arts and Crafts) in 1901, he pushed through a reorganisation of training courses in photography. The new constitution which the Academy adopted in 1902 envisaged a broadening of training in the field of photography. Accordingly, photography as a subject was not to be restricted to photographic reproduction techniques but should also involve "taking photographs of models from nature and art."[12]

In order to familiarize himself more with the interaction between photography and the other graphic arts and to be better able to make comparisons between courses at similar teaching establishments, Seliger had undertaken an extended exploratory tour. Together with Professor Dr. C. W. Georg Aarland (1849–1907), head of the photomechanical institute at the Kgl. Sächsischen Kunstakademie und Kunstgewerbeschule (Royal Saxon Academy of Arts and Crafts), founded in 1893, and Richard Berthold, a professor of drawing, he visited the

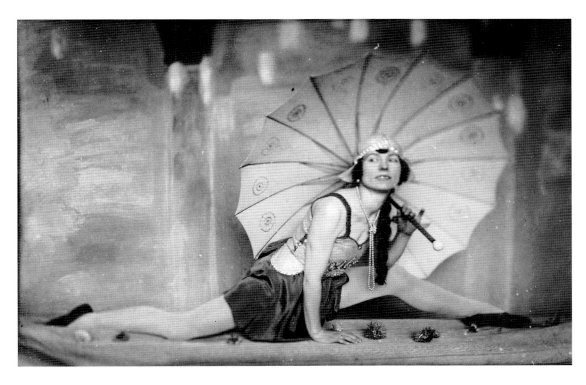

219. The dancer Gertrude Schilling, after 1918
D.O.P., 12.3 × 17.9 cm
Fotomuseum im Münchner Stadtmuseum (93/1056,19)

The Background

With this insistence, the photographers' association was claiming to have initiated the highly complex procedures which eventually led to the integration of photography as an art subject into the Academy's curriculum. When Max Seliger assumed the post of director of the Academy upon leaving the Berliner Kunstgewerbe-

UNIE art institute in Prague, the Lehr- und Versuchsanstalten in Vienna and Munich, not to mention various publishers and graphics institutions in Munich, Mainz and Frankfurt/Main. Thus acquainted with the latest state of technical affairs, Seliger pursued his aim of bringing together under the roof of the Academy all the artistic and technical elements involved in book design and printing.

ten Ausbildung abgeleitet. Die Verbesserung der Situation dieser Berufsgruppe hatte Seliger aber bei seinen schulbezogenen Reformplänen nicht verfolgt. Zudem hatte er keinerlei Einfluß auf die Besetzung der Lehrstelle gehabt. Zwar galt der aus einer renommierten Photographen-Familie stammende Naumann als »ein in Leipzig hochangesehener Portraitphotograph«,[17] seine Praxis blieb jedoch biederer Durchschnitt.

Ostern 1905 wurde die neue Klasse eröffnet und Naumann als Lehrer eingestellt. Die Verbindung von Photographie und Buchgewerbe bei deutlicher Aufwertung der gestalterischen Anleitung, die Seliger anstrebte, ließ sich aber mit Felix Naumann offenbar nicht in ausreichendem Maße bewerkstelligen. Die Lehrsätze und Techniken der piktorialistischen Photographie wurden von Naumann recht ausführlich, aber ohne erkennbare Eigenständigkeit vermittelt. Erst nach mehreren Jahren, wahrscheinlich 1912, wurde Naumann zum Professor befördert.

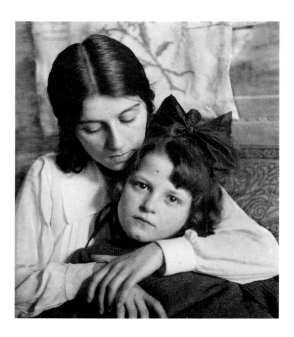

220. Untitled, c. 1914
D.O.P., 11.3 x 8.7 cm
Fotomuseum im Münchner
Stadtmuseum (93/756-47)

Die völlig unbedeutende Beteiligung der Klasse für Naturphotographie an der ›Internationalen Photographischen Ausstellung Dresden‹ 1909 mochte das spätere Urteil Seligers über den Photographen besiegelt haben. Die Klasse für Naturphotographie zeigte nur einige Proben verschiedener Aufnahmetechniken. Naumann war lediglich in der Gruppe Amateurphotographie mit einem Exponat vertreten.

Frank Eugene Smith hatte zur gleichen Zeit seinen bisher größten Erfolg. Der Katalog der erwähnten Ausstellung führte seinen Namen gleich in drei Abteilungen

auf: Bei den Lehranstalten und der Internationalen Vereinigung der Kunstphotographen sowie in der Gruppe der Einzelaussteller. Von den acht Photographen in dieser Gruppe waren außer Smith nur Rudolf Dührkoop, Franz Grainer und Hugo Erfurth mit größeren Werkgruppen beteiligt. Wenig später wurde Smith für seine hervorragenden Leistungen die ›Silberne Ehrendenkmünze der Stadt Dresden‹ verliehen.[18] Max Seliger hatte als Mitglied des Ausstellungsdirektoriums und als Betreuer der Ausstellungsteile Kunstschulen und Originale und Reproduktionen die Arbeit von Smith unmittelbar zur Kenntnis nehmen können.

Als es nach dem Ableben Naumanns mit der Personalfrage auch um die künftige Profilierung des photographischen Unterrichts an der Akademie ging, zögerte Seliger nicht, seine Enttäuschung über Naumanns Leistungen zugespitzt zu formulieren.[19] Die Einsprüche des Photographen-Bundes, der auch während der Amtszeit von Naumann mehrfach seine Unzufriedenheit mit der Lehre bekundet hatte, wies er mit besonderer Heftigkeit zurück: Diesmal wollte er sich eine souveräne Entscheidung nicht nehmen lassen.

Nachdem sich Smith persönlich ein Bild von den Bedingungen am Ort gemacht hatte, übermittelte er Max Seliger am 19. April 1913 seine offizielle Bewerbung für die Lehrstelle Naturphotographie und schloß auch gleich mehrere Forderungen an, die er mit seinem Wechsel verknüpfte.[20]

Seliger unterstützte die Bewerbung von Smith vehement. »Um die ziemlich wenig bedeutende Fachklasse für Naturphotographie an der Akademie wieder in die Höhe zu bringen, brauchen wir einen Mann von Smith's Art, der mit Energie, Originalität und durchaus sicherem künstlerischem Geschmack (...) für die Schüler eine wirkliche Anziehungskraft bedeutet«,[21] schrieb Seliger im Begleitschreiben nach Dresden.

Dieser Argumentation widerstand man im Königlichen Ministerium nicht, zumal Seliger ganz offen die empfindliche Schwächung anführte, die Smiths Abwerbung bei der Münchner Konkurrenz bewirken würde.[22]

Gleichzeitig war von einer »Eliteklasse« die Rede, zu der die Fachklasse für Naturphotographie auszubilden wäre.

Bereits Ende Mai 1913 übermittelte das Dresdner Ministerium der Akademieleitung den Beschluß, Frank Eugene Smith als Hochschullehrer anzustellen und ging damit nach kurzen Verhandlungen gleichzeitig auf die Mehrzahl seiner Bedingungen ein.[23]

Als Smith im September 1913 sein Amt antrat, konnte er mit dem Doppelten seines Münchner Gehalts und einem extra für ihn eingestellten Lehrbeistand rechnen,

His reform concept was influenced both by the book art movement which had been emerging since the 90s, and by the reform movement in the arts and crafts. It envisaged the transformation of the Academy into a teaching institute for the graphic arts, book design, and reproduction techniques. The recent renaming of the Academy had already been an outward sign of this objective.[13] Seliger's plan also aimed at broadening the scope of photography as a subject at the Academy. This plan was determined by the principle that the goal of the Academy's teaching endeavors ought to lie "not primarily in the creation of independent graphic pictorial works" but in the "artistic design of the book in all its graphic aspects."[14] Photography, therefore, in so far as it is not utilized as a mere reproduction technique, ought to provide book illustrations just like other graphic techniques, and for this purpose, an additional workshop was to be set up.

Seliger's ideas had probably not gone much further than this functional aspect when a petition to the Royal Ministry in Dresden put pressure on him to take action. In July 1904 the Sächsische Photographen-Bund proposed the establishment of a "Sächsische Photographenschule" (Saxon Photography School) in Dresden, to be headed by the photographer Arthur Ranft. This proposal was accompanied by detailed suggestions "related to the improvement of the artistic aspects of photographic products."[15]

Their suggestion was taken very seriously by the ministry, given that it made special reference to the example of the Munich institute, and that the association had already secured the cooperation of the aged Hermann Krone. In order to direct this plan more along his own lines, the chairman of the photographers' association in Leipzig, Adolf Sander, intervened at this juncture. He suggested the establishment at the Leipzig Academy of "a department for the nature photographer, as I would like to call him for simplicity sake, as opposed to process photographer, under the directorship of an industrious and expert portrait photographer such as, for example, the court photographer Mr. Felix Naumann."[16]

In the light of his own reform plans, Seliger saw himself forced to support Sander's proposal so as not to display any signs of weakness in the eyes of the ministry. Naumann had already drafted concrete plans for the expansion of the department of nature photography, scheduled for the end of the year, and for the restructuring of the courses to be offered, and these had been agreed with the Academy and the local planning department.

Seliger had every reason to feel he had been passed over in the whole matter. The Photographen-Bund had justified its petition with reference to the difficult economic situation of commercial photographers in the face of wealthy competition and to the lack of aesthetic schooling among its members, and from this had inferred the need for a more comprehensive training. Seliger's plan for teaching reforms, on the other hand, had not envisaged the improvement of the situation of this particular professional group. What is more, he had no influence whatsoever on the appointment to the teaching post. Naumann, who came from a famous family of photographers, may well have been generally regarded as "a highly respected portrait photographer in Leipzig,"[17] but in practice his work was unsophisticatedly average.

At Easter 1905 the new course was included in the curriculum and Naumann appointed to teach it. However, it soon became clear to Seliger that the envisaged interlinking of photography and book design, with a clear upgrading of artistic guidance and supervision was not going to be adequately achieved by Felix Naumann. He mediated the theories and techniques of pictorialist photography in detail but without any recognizable independence of spirit. It was also a number of years, probably in 1912, before he was finally promoted to the rank of professor.

The nature photography class' totally unspectacular participation in the "Dresden International Photographic Exhibition" in 1909 more than likely put the seal on Seliger's later assessment of Naumann as a photographer. The nature photography class exhibited merely a few samples of different photographic techniques. Naumann himself was represented in the Amateur Photography section with only one exhibit.

At the very same moment in time, Frank Eugene Smith was enjoying his greatest success to date. The catalogue of the aforementioned exhibition in Dresden listed his name in no less than three different sections: the training institutions, the International Association of Art Photographers, and the individual exhibitors section. Among the eight photographers to participate in the last section with larger groups of works were, apart from Smith, Rudolf Dührkoop, Franz Grainer and Hugo Erfurth. A short time later, Smith was awarded the "Honorary Commemorative Silver Coin of the City of Dresden."[18]

As a member of the exhibition committee and as the person responsible for the exhibition sections "Art Schools" and "Originals and Reproductions," Seliger had been in an ideal position to study Smith's work at

der die technische Seite des Unterrichts regeln sollte. Wunschgemäß war dies der Photograph Georg Bobien, der ebenfalls von der Münchner Lehranstalt kam.[24] Außerdem wurde Smith ein Privatatelier in der Akademie eingeräumt und der Ausbau und die Neugestaltung der Abteilung in Aussicht gestellt. Lediglich sein Wunsch, zum Professor ernannt zu werden, wurde nicht gleich erfüllt. Erst nach Ablauf eines Probejahres erfolgte mit Wirkung vom 1. Oktober 1914 ab die Ernennung von Frank Eugene Smith zum Professor für Naturphotographie und wurde seine Aufnahme in den Staatsdienst damit endgültig geregelt.[25]

Frank Eugene Smith' Leben in Leipzig

Wahrscheinlich zog Smith gleich zu Anfang in die großbürgerliche Wohngegend in unmittelbarer Nachbarschaft der Akademie, unweit des alten Stadtzentrums. Bis zu seinem Weggang lebte Smith im 4. Stock des Hauses Beethovenstraße 14, das heute nicht mehr existiert.[26]

München blieb immer ein wichtiger Bezugspunkt auch wegen des Freundeskreises und wurde von Smith über die Jahre hinweg regelmäßig aufgesucht.

Dennoch waren es nicht nur das Renommee eines akademischen Titels und die pekuniären Vorteile gewesen, die Smith nach Leipzig gezogen hatten. Die reiche Bürgerstadt Leipzig, als alter Messe-und Handelsstandort von ausgeprägt merkantilem Charakter, verfügte zwar über kein bedeutendes Kunstmuseum, da es keinen Fürstensitz und damit keinen Kristallisationspunkt einer repräsentativen Sammlung gegeben hatte.

Das kulturelle Klima Leipzigs war jedoch traditionsgesättigt und von eigener Anziehungskraft. Die alte Leipziger Universität als geistiges Zentrum, die Musikpflege im Leipziger Gewandhaus und vor allem die Tätigkeit zahlreicher bekannter Buch- und Musikverlage bildeten dafür die Grundlage.

In Leipzig befand sich der Sitz zahlreicher Vereinigungen des Buchgewerbes und der Druckereiindustrie. Zwischen 1912–16 wurde in der Stadt die deutsche Zentralbibliothek, die Deutschen Bücherei errichtet. So wie Frankfurt/Main und München konnte Leipzig als Zentrum des deutschen Buchgewerbes gelten, auch von der wirtschaftlichen Seite her. Die Transformation der Kunstakademie in eine Ausbildungsstätte des Buchgewerbes und verwandter Künste durch Max Seliger, seine erfolgreiche Berufungspolitik, die der Akademie eine anhaltende Entwicklungsdynamik sicherte, mußten Smiths Schritt nach Leipzig objektiv begünstigen.

Akademiedirektor Seliger blieb Smith bis zu seinem Tode freundschaftlich verbunden. Über die persönliche Umgebung von Smith ist ansonsten nur wenig bekannt. 1913, im Zusammenhang mit einem nachhaltig eingeforderten Wohngeldzuschuß, sprach Smith davon, in einem Vorort von Leipzig, »in Quasnitz in einem kleinen Häuschen wohnen« zu wollen.[27] Vermutlich war dies nur ein kurzzeitiger Wunsch, der seiner Vorliebe für die ländliche Umgebung entsprach.

Möglicherweise hatte der Buchgraphiker Prof. Walter Tiemann (1876–1951) ihn in Lützschena/Quasnitz eingeführt, wo der Kunstfreund und Leipziger Rechtsanwalt Bruno Peglau eine Villenkolonie und eine Gartenstadtsiedlung errichtet hatte. Das Ehepaar Peglau versammelte einen Kreis von Künstlern um sich, zu dem auch Tiemann gehörte.[28] In der Gartenstadt wohnte der Maler und Kunstphotograph Walter Hartwig,[29] der sich mehrfach an größeren Ausstellungen, so auch der ›Bugra‹, beteiligte. Ein ähnlicher Freundeskreis wie in München stellte sich aber auf Dauer nicht ein. An der Akademie war Smith offenbar ein Außenseiter. Arthur Wenzel, als Hilfslehrbeistand von 1922–24 an der Akademie tätig, beschreibt ihn als »typischen Bohemien«, der schon vom Habitus her nicht zur bürgerlich-konservativen Lehrerschaft an der Akademie paßte.[30]

221. Margarete and Paul Trietschler, c. 1918
Platinum print, 33.0 x 24.0 cm
Private collection

Die persönliche Lebensgeschichte von Smith und sein Verhalten als Akademielehrer und Künstler waren in Leipzig untrennbar verbunden. Bereits 1914 lernte Smith eine junge Leipzigerin kennen, die als seine Schülerin, seine Assistentin, Geliebte und Ehefrau in seinem Denken und Fühlen einen wichtigen Platz finden sollte. Johanna Trietschler,[31] die aus wohlhabenden Verhältnissen kam, war erstmals im Frühjahr 1914 in den Eintragungslisten der Klasse für Naturphotographie vermerkt und

close quarters. Later, after Naumann's death, when the staff issue was being discussed again in connection with the future reputation of photography courses at the Academy, Seliger did not hesitate to formulate his disappointment with Naumann's achievements in very pointed terms.[19] He also vehemently rejected any reservations harbored by the Photographen-Bund which had frequently expressed its dissatisfaction with the courses even while Naumann was still in office. This time Seliger was not willing to let anyone interfere with him making an independent decision.

Once Smith had formed his own personal impression of the working conditions in Leipzig he presented his official application for the teaching post in nature photography to Seliger on April 19, 1913, to which he also added several demands, the fulfilment of which he made conditional for his move.[20] Seliger was unwavering in his support of Smith's application. In an accompanying letter to Dresden he wrote: "In order to raise the level of the somewhat insignificant nature photography class at the Academy we require a man of Smith's abilities, who with his energy, originality and sovereign artistic taste ... will constitute a genuine attraction for students."[21]

The people responsible at the Royal Ministry were unable to resist this argument, especially as Seliger made an unambiguous reference to the sensitive weakness it would inflict on the competition in Munich if Smith were to be enticed away to Leipzig.[22] He also made mention of an "elite class," to which level the nature photography class at the Academy was to be raised. At the end of May 1913 the Dresden Ministry made known its decision to appoint Frank Eugene Smith as a teacher to the director of the Academy, and after brief negotiations even accepted most of Smith's specific conditions.[23]

When Smith took up the position in September 1913 he was able to reckon with double his Munich salary and an assistantship specially instituted for him. This assistant was to take charge of the technical side of the course. In compliance with Smith's own wishes, the assistantship was given to the photographer Georg Bobien who had been a pupil of Smith's at the Munich Lehranstalt.[24] In addition, a private studio was installed for Smith at the Academy and a promise made to extend and redecorate the whole department. What was not fulfilled at once was his wish to be appointed professor. Only after completion of a probationary year, on October 1, 1914, was Frank Eugene Smith appointed Professor of Nature Photography[25] and his acceptance into the civil service thus finally regularized.

Frank Eugene Smith's Life in Leipzig

It is more than likely that Smith moved to Leipzig immediately, taking up residence in the upper middle class district close to the Academy, not far from the old city center. Until his final departure from Leipzig, Smith lived on the fourth floor of Beethovenstrasse 14,[26] a house which no longer exists today.

222. Frank Eugene Smith's living room, Leipzig 1913–27 D.O.P., 9.0 x 12.0 cm Fotomuseum im Münchner Stadtmuseum (93/758. 4)

Munich remained an important point of reference for him, however, especially as his circle of friends was still there. This meant that over the years Smith made regular visits back to Munich. Yet it was not just the renown of an academic title or the pecuniary advantages which had drawn Smith to Leipzig. The rich bourgeois city was an old established fair and trade center with a markedly mercantile character. It may not have had an important museum – as it was not the residence of a prince and therefore not the crystallization point of a representative collection – but cultural life in Leipzig had a long and rich tradition and thus its own power of attraction. The basis of this attraction was constituted by the intellectual center of the old Leipzig university, the musical tradition of the Leipzig Gewandhaus concert hall, and above all, the activities of numerous well-known book and music publishers.

Leipzig was also the headquarters of many associations of the book trade and the printing industry. The German national library, the Deutsche Bücherei, was set up in Leipzig between 1912 and 1916. Like Frankfurt/Main and Munich, Leipzig constituted a center of the German book trade, in particular from the commercial point of view. Max Seliger's transformation of the art academy into a training center for book design and the related arts and crafts, and his successful appointments policy, which guaranteed the academy a dynamic development, were destined to exercise a positive influence on Smith's decision to move to Leipzig. Until his death, Seliger, as

erschien dort kontinuierlich bis zum Sommer 1917.[32]
Die besondere Hinwendung von Smith zu seiner Studentin ist in zahlreichen Postkarten und Briefen dokumentiert. Begünstigt wurde diese Beziehung durch den Umstand, daß Johanna Trietschler[33] fließend Englisch sprach[34] und Smith mit ihr in seiner Heimatsprache korrespondieren konnte.

Unmittelbar nach Beendigung des Studiums bemühte sich Smith um eine Anstellung Johanna Trietschlers als

Hilfslehrbeistand für den Unterricht in Naturphotographie, nachdem sein früherer Lehrbeistand vermutlich wegen des Kriegsdienstes nicht mehr zur Verfügung stand. Er vergaß weder, die Zustimmung der Eltern Trietschler einzuholen, noch der Geliebten sein Interesse an ihrer künstlerischen Entwicklung eindrücklich vor Augen zu führen.[35]

Anfang 1918 trat Johanna Trietschler ihre Stellung als Assistentin an[36] und behielt diese mindestens bis zu

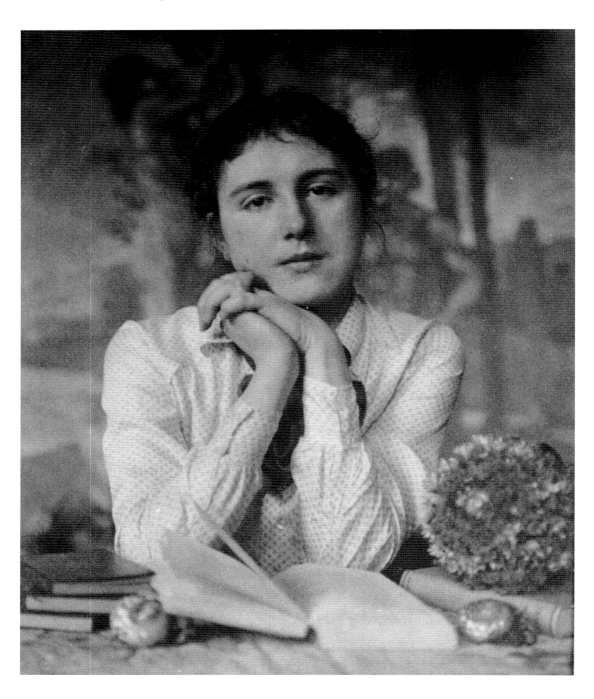

223. Johanna Trietschler, 1919
D.O.P., 36.0 x 26.0 cm
Private collection

director of the Academy, remained on friendly terms with Smith, but otherwise little is known about Smith's other private contacts.

In 1913, in connection with his repeated demand for a housing allowance, Smith spoke of wanting to "live in a little house in Quasnitz,"[27] a suburb of Leipzig. This was presumably a short-lived wish awakened by a certain preference on his part for rural surroundings. It is possible that Walter Tiemann (1876–1951), a professor of book graphics, had introduced Smith to Lützschena/ Quasnitz, where the Leipzig art enthusiast and lawyer Bruno Peglau had built up a colony of villas and a garden city.

Peglau and his wife had gathered around them a circle of artists to which Tiemann belonged.[28] The artist and art photographer Walter Hartwig[29] also lived in the garden city and took part in several large-scale exhibitions,

During Smith's Leipzig period his personal life history and his whole demeanor as a teacher at the Academy and as an artist could scarcely be separated from one another. As early as 1914 he became acquainted with a young Leipzig woman who was to occupy an important place in his thoughts and feelings in her subsequent capacities as his pupil, his assistant, his lover and his wife. Johanna Trietschler,[31] who came from a wealthy family, is first mentioned in the spring of 1914 in the enrollment lists for the nature photography class. She continued to be listed there until the summer of 1917.[32] The particular attention which Smith paid to this student is documented in numerous postcards and letters. Their relationship was promoted by the fact that Johanna Trietschler[33] spoke fluent English,[34] so Smith could correspond and converse with her in his native tongue.

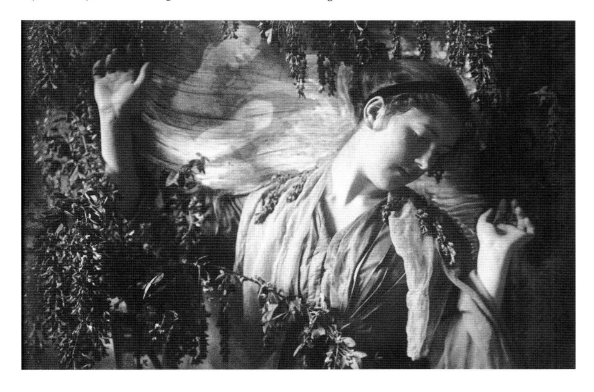

224. Johanna Trietschler, 1917
Photogravure, 21.5 x 35.7 cm
Private collection

among them the so-called "Bugra," a book design and graphics exhibition. Smith, however, was never able to gather together a circle of friends in Leipzig comparable to the one he had in Munich. He apparently remained somewhat of an outsider at the Academy. Arthur Wenzel, who was an assistant teacher there from 1922 to 1924, describes Smith as a "typical bohème" whose whole lifestyle made him unsuited to the bourgeois-conservative teaching body at the Academy. [30]

Immediately after she had finished her studies and once his former assistant was no longer available, presumably due to military service, Smith went to a lot of trouble to have Johanna Trietschler appointed as his teaching assistant for nature photography. In the course of these efforts Smith did not neglect to secure her parents' approval, nor to impress upon his lover his special interest in her artistic development.[35] Johanna Trietschler took up the position of assistant at the beginning of 1918[36]

209

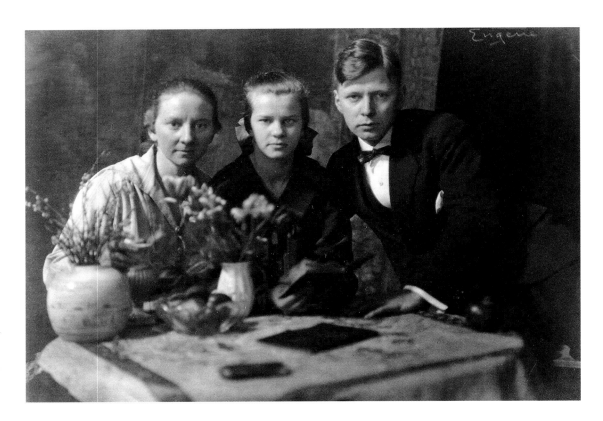

225. Martha Wenzel, Arthur Wenzel and Marianne Wenzel in Eugene's academy studio, April 1924
Platinum print, 12.8 x 18.0 cm
Marianne Müller, Dresden-Radebeul

ihrer Trennung von Smith im Jahre 1923. Noch im Sommer 1918 glaubte Smith, seine Liaison vor dem Akademiedirektor geheimhalten zu müssen.[37] Seine ekstatisch – schwärmerischen, gelegentlich in die christliche Mystifizierung seiner Liebesempfindungen übergehenden Briefe zeugen von der anhaltend leidenschaftlichen Bindung von Smith an Johanna Trietschler.

Diese Briefe wurden vor allem zwischen 1917–21 versandt und enthalten ausnahmsweise auch drastischen Anspielungen auf die erotischen Bedürfnisse des immer als sinnesfroh beschriebenen Smith. Die Zusammenarbeit von Smith und Trietschler in der Akademie wurde in diesen persönlichen Zeugnissen kaum berührt. Die Verquickung privatester Beziehungen mit dem Lehramt mag die berufliche Strebsamkeit von Smith aber nicht sonderlich gefördert haben, ganz abgesehen von den Ablenkungen, die durch die besonderen Rücksichten der Geheimhaltung entstanden.

Erst zu Ostern 1922, am Geburtstag Johanna Trietschlers, wurde das Verhältnis von Smith und seiner 30 Jahre jüngeren Frau offiziell durch die Eheschließung legitimiert.[38] Die feste Verbindung kam wahrscheinlich auf Druck der Eltern von Johanna Trietschler zustande. Die Aussichten dieser Ehe wurden in der persönlichen Umgebung Johanna Trietschlers jedoch skeptisch beurteilt.[39]

Bereits im folgenden Jahr, am 20. Juni 1923, erging das Urteil zur Scheidung der einzigen Ehe[40] von Frank Eugene Smith. Die Hintergründe dieser ungewöhnlichen Vorgänge sind nicht dokumentiert worden. Die eigentlich Beteiligten wie auch die Akademieleitung wahrten darüber Stillschweigen, so daß auch mögliche Auswirkungen auf Smiths Reputation an der Akademie nicht bezeugt sind. Smith scheint seine Eheschließung über ein pflichtgemäßes Minimum hinaus nicht weiter publik gemacht zu haben. Auch das Scheitern der Verbindung blieb deshalb ohne sonderlichen Widerhall.[41]

Eine ausreichende Erklärung für die geringe künstlerische Produktivität von Smith über die ganze Leipziger Zeit hinweg ergibt sich aus diesen Geschehnissen allerdings nicht. Die Tatsache, daß die bisher aufgefundenen Photographien überwiegend aus dem persönlichen Umfeld von Smith stammen, bestätigt indirekt den Eindruck seiner künstlerischen Inaktivität.

Die Bildnisse von Martha Wenzel[42] entstanden im Zusammenhang des täglichen Umgangs an der Akademie. Die Porträts der Geschwister Wenzel[43] aus dem Jahre 1924 sollten vermutlich deren Zusammensein vor der Auswanderung Arthur Wenzels festhalten. Durch diesem Umstand wurde die Aufnahmesituation im Akademieatelier von Frank Eugene Smith bis in die Gegenwart überliefert.[44]

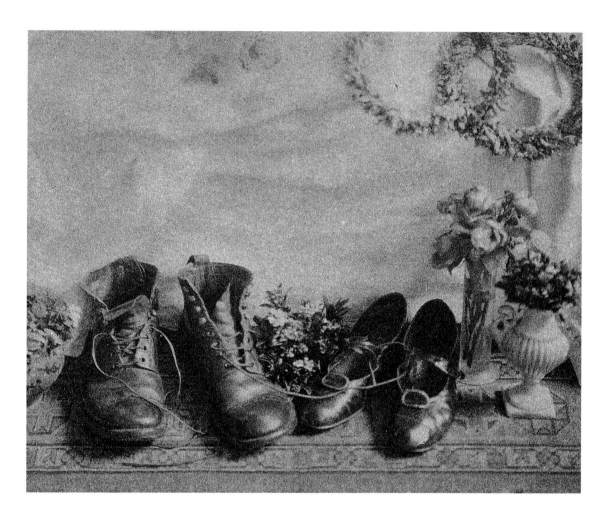

226. Still life with the shoes of
Frank Eugene Smith and Johanna
Tritschler, 1923
Platinum print, 12.4 x 14.2 cm
Private collection

Die photographische Ausbildung an der Akademie

Nach seinem Eintritt in die Akademie bemühte sich
Smith um die Reorganisation der Ausbildung. Die Werk-
statt für Naturphotographie arbeitete unter beengten
räumlichen Verhältnissen in einem größen Tageslicht-
atelier mit angrenzenden Laboratorien im dritten Stock
des Hauses. Die materielle Ausstattung des Ateliers war
durch die dürftige Finanzlage geprägt. Als im Jahre 1912
noch unter dem Werkstattleiter Naumann der Umbau
des Dachgeschosses begann und auch die dringend
erforderliche Erweiterung der Werkstatt in Angriff ge-
nommen wurde, lehnte die zuständige Behörde die In-
stallation elektrischer Leuchten unter Verweis auf die
geringeren Kosten für eine Gasbeleuchtung ab.
Smith ließ wiederum einen Teil der bisherigen Verände-
rungen als unzweckmäßig korrigieren. Die Umbauten
und Neuanschaffungen benötigten längere Zeit. Noch
im Frühjahr 1916 bat Smith Alfred Stieglitz um die Zu-
sendung von Preiskatalogen für photographische Appa-
raturen, Chemikalien und sonstige Materialien und teilte
ihm mit, daß die Umgestaltung und Erweiterung der
Photographie-Abteilung in den Sommerferien endlich
beendet sein solle.[45]
Der Inhalt der Lehre entsprach noch den Vorgaben bei
Gründung der Klasse:[46] Die Bezeichnung ›Natur-
photographie‹ drückte die Abgrenzung von den Aufga-
ben der reproduktionstechnischen Abteilung aus, die
seit 1907 unter der Leitung des renommierten Chemikers
Prof. Dr. Emanuel Goldberg stand.
Die Studenten von Smith widmeten sich besonders den
Themen Bildnis, Landschaft sowie Architektur und der
photographischen Wiedergabe von Plastiken. Smith gab
anfangs neun Wochenstunden Werkstattunterricht für
den Lehrgegenstand ›Naturphotographieren und Retu-
schieren‹ in der Fachschule (Hauptunterricht) und bot
einen gleichnamigen Sommerkursus für die Besucher der
Hilfsschule (Ergänzungsunterricht) an.[47] Die Teilnehmer
an der Hilfsschule kamen aus den anderen künstlerischen
Fachbereichen, aber auch aus Goldbergs reprotechnischer
Abteilung.
Die Ausbildung endete in der Regel nach vier Semestern
ohne Abschlußprüfung; nebenher absolvierten die Stu-
denten regelmäßig Unterrichtsstunden im Zeichnen,
Unterweisungen in druckgraphischen Verfahren und
buchbinderischen Techniken, photographischen Repro-
duktionstechniken und den technischen Grundlagen der
Photographie. Ihr offizieller Fachname lautete wie schon
unter Naumann ›Lichtbildner‹.
Der Zusammenhang der Ausbildung war vom »Konzept
eines allumfassenden Werkunterrichts gleichermaßen

für technische wie kunsthandwerklich-künstlerische
Fächer im Bereich der Photographie« bestimmt.[48] Mit
der Berufung von Smith waren die übergreifenden
Lehrziele »Förderung der graphischen und buch-
gewerblichen Künste und Techniken«, »Veredelung des
Buches für die breiten Volksschichten« nicht revidiert.[49]
Smith sollte diese Programmpunkte als Vertreter der
künstlerischen Photographie und Grenzgänger zwi-
schen graphischen und photographischen Techniken
konkret ausgestalten, nachdem der erste Versuch nicht
den gewünschten Erfolg gebracht hatte.
Als beispielgebend konnten in dieser Beziehung nur die
Wiener und die Münchner Lehranstalt gelten – allerd-
dings mit dem Unterschied, daß diese sich von der
Photographie und Reprophotographie her definierten
und ihr Lehr- und Forschungsgebiet in Richtung der
photomechanischen Druckverfahren und verschiedener
Spezialanwendungen erweitert hatten.
Die Leipziger Akademie war praktisch den umgekehrten
Weg gegangen, indem die Ausbildung von den graphi-
schen Künsten und dem Buchgewerbe ausgehend in
Richtung der photographischen Reproduktionsverfahren
und der bildmäßigen Photographie erweitert worden war.
Bis 1914 hatten sich an diesen Lehranstalten durchaus
vergleichbare Strukturen gebildet: Photographie und
Reproduktionsverfahren, Buch- und Illustrationsgewerbe
sowie photomechanische Druckverfahren mit begleiten-
der Forschung existierten in funktionaler Bezogenheit.[50]
Smiths Position in Leipzig bildete schon deshalb eine
Ausnahme, weil an keiner anderen Einrichtung des sel-
ben institutionellen Ranges die bildmäßige Photogra-
phie mit einer ähnlich hohen Wertschätzung bedacht
wurde. Die reale Einbindung von Smiths Lehre in das
Gesamtkonzept der Akademieausbildung erfolgte aller-
dings nur im Ansatz, womit eine Vorbedingung des
Scheiterns bereits gegeben war.
Die gestalterischen Grundsätze der Kunstphotographie
wurden ansonsten vor allem durch die persönliche Un-
terweisung in den Ateliers der professionellen Kunst-
photographen weitervermittelt (z.B. durch Erfurth,
Perscheid, Rudolf Dührkoop), bzw. durch vereinsnahe
Ausstellungen und Publikationen verbreitet. Ein Blick in
die Geschichte der photographischen Lehranstalten und
Kunstschulen, die 1929 auf der Internationalen Werk-
bundausstellung ›Film und Foto‹ in Stuttgart vertreten
waren, zeigt, daß die Photographie zur Zeit des hoff-
nungsvollen Beginns von Smith überwiegend den Rang
einer technischen Hilfsdisziplin innehatte. Bei der Ver-
mittlung einfacher Gestaltungsmethoden geriet sie gar
nicht erst in die Problemzone künstlerischer Gestal-
tung.[51]

and most probably kept it until she and Smith were divorced in 1923.

Up until the summer of 1918 Smith still believed he ought to keep his liaison with Johanna Trietschler a secret from the director of the Academy.[37] His ecstatic, rapturous letters to her, which sometimes echoed an almost Christian mystification of his emotions, bear witness to a persistent and highly passionate relationship between them.

Smith, who had always been described as a sensual man, wrote these letters to Trietschler mainly between 1917 and 1921, and they occasionally included somewhat drastic allusions to his erotic needs. These highly personal testimonies scarcely touched upon their joint working obligations at the Academy. The entanglement of his most private affairs with his teaching duties, to say nothing of the distraction involved in the careful maintenance of secrecy, may not have particularly promoted Smith's professional zeal.

The relationship between Smith and his lover, who was 30 years younger than he, was officially legitimated in marriage on Johanna Trietschler's birthday, Easter 1922.[38] It was more than likely Johanna's parents who insisted on their relationship being regularized. The prospects of this marriage, however, were regarded with some scepticism by Johanna's personal friends.[39] In June of the following year, more precisely on June 20, 1923, this one and only marriage entered into by Frank Eugene Smith was terminated by a divorce.[40] The background to these unusual events has not been documented for posterity. The parties to the events as well as the Academy director maintained absolute silence on the issue so that there is no evidence of possible negative effects it may have had on Smith's reputation at the Academy. Smith does not seem to have made his marriage known particularly widely, so that the failure of the relationship did not cause any particular stir.[41]

These events, however, do not provide an adequate explanation of Smith's limited artistic productivity all during his years in Leipzig. The fact that the photographs relating to this period which have been preserved are mainly of people from his personal surroundings indirectly confirms the impression of artistic inactivity. The portraits of Martha Wenzel[42] were taken in the context of his work at the Academy. The portraits of the Wenzel children[43] dated 1924 were no doubt intended to mark their last gathering before Arthur Wenzel emigrated. It is thanks to this circumstance that we have an authentic description of the scenario in Frank Eugene Smith's studio.[44]

Training in Photography at the Academy

On taking up his position at the Leipzig Academy Smith went about reorganizing his department. The nature photography workshop functioned under somewhat cluttered conditions on the third floor of the building in a large daylight-studio with adjoining laboratories. The studio equipment was sparse due to the difficult financial situation at the time. When the conversion of the attic and the urgently required extension of the workshop were begun in 1912, under the directorship of Naumann, the responsible local authority refused to finance the installation of electric lighting, for example, referring as a justification to the lower costs of gas lighting.

On the other hand, Smith again altered some of the existing changes which he considered impractical. Extensions and new acquisitions required more time. In spring 1916 Smith asked Alfred Stieglitz to send him price catalogues for photographic equipment, chemicals and other materials, and informed him that the restructuring and expansion of the photography department were due to be completed in the summer holidays.[45] The content of the courses, however, still corresponded to that laid down when the class was first established:[46] the designation "nature photography" lent expression to a wish to be distinguishable from the department specialising in reproduction techniques which had been headed by the renowned chemist Professor Dr. Emanuel Goldberg since 1907.

Smith's students devoted particular attention to the themes of portrait, landscape, and architecture studies and the photographic rendition of sculpture. At first Smith gave nine workshop classes weekly under the heading "Nature Photography and Retouching" as part of the department's Major Course (main classes) and offered a summer school under the same heading for people attending the Minor Course (supplementary classes).[47] Participants in the Minor Course came from other art departments and also from Goldberg's department of technical reproduction processes.

As a rule, training was complete after four semesters, but there was no final examination. Alongside this training, the students attended regular classes in drawing, an introductory class on printing processes and bookbinding techniques, photographic reproduction techniques and the technical fundamentals of photography. Their official designation was still "Lichtbildner," literally light image makers, as they had been called under Naumann.

The binding concept behind the overall training was determined by "the principle of a comprehensive course

Erst nach 1925 wurden vor dem Hintergrund eines funktionalen Wandels der Photographie qualitativ neue Anforderungen an die Ausbildung gestellt. Der an der kunstphotographischen Ästhetik orientierte Unterricht von Smith wurde damit endgültig überflüssig. Die Zeitzeugen Johannes Widmann und Arthur Wenzel, die zur Ausbildungssituation in den 20er Jahren befragt werden konnten, bestätigten, daß der Unterricht von Smith an der Akademie zu dieser Zeit kaum noch wahrgenommen wurde.[52]

Die Teilnahme der Klasse für Natur-Photographie am Akademiejubiläum und an der ›Bugra‹ 1914

Im Jahre 1914 beging die Akademie ihr 150jähriges Bestehen. Smith wurde mit der Herstellung von Porträts der Lehrerschaft beauftragt, die in mehreren Publikationen erschienen.[53] Die Akademie gab außerdem einen prächtigen Folianten mit einer Darstellung zur Geschichte der Lehreinrichtung heraus. Der Band enthielt auch Proben der aktuellen künstlerischen und buchkünstlerischen Produktion, darunter eine Original-Photographie von Smith.[54] Die offiziellen Jubiläumsfeierlichkeiten fanden am 6. und 7. März 1914 in der Akademie und im Alten Theater Leipzig statt.[55] Smith und seiner Klasse fiel die Aufgabe zu, einen Festumzug zu photographieren, der »darstellend ›Künstlers Erdenwallen‹« – ein Künstlerfest im Leipziger Palmengarten abschloß.[56]
Die Aufnahmen vom Festumzug waren bereits auf der wenig später eröffneten ›Internationalen Ausstellung für Buchgewerbe und Graphik Leipzig 1914‹ im Beitrag der Klasse für Naturphotographie zu sehen.[57] Vermutlich in diesem Zusammenhang erging an Smith der besonders ehrenvolle Auftrag, das sächsische Königshaus zu porträtieren. Der sächsische König war Schirmherr der ›Bugra‹, die wegen ihrer gigantischen Größe mehrfach zur ›Weltausstellung‹ erklärt wurde.
Die Ausstellung war auf Anregung des Akademieprofessors und Graphikers Hugo Steiner-Prag (1880–1945) zu Ehren des Akademiejubiläums zustandegekommen und wurde unter Führung des Deutschen Buchgewerbevereins veranstaltet. Die Akademie stellte sich mit ihrem gesamten Ausbildungsprofil in einer besonderen Ausstellungshalle vor, die vom Börsenverein der Deutschen Buchhändler mitgenutzt wurde.[58]
Einen der sieben Räume teilten sich die Fachklasse für Naturphotographie und die Abteilung für Reproduktionstechnik. Frank Eugene Smith und seine Klasse zeigten neben den Festzugsbildern nicht näher bezeichnete Porträtaufnahmen, Genrestudien sowie Autochromaufnahmen und überarbeitete Negative.

Eine zeitgenössische Beschreibung der Materialien, die Prof. Dr. Goldberg als Leiter der reproduktionstechnischen Abteilung und der seit 1912 bestehenden Versuchsanstalt für wissenschaftliche Photographie in Vielzahl ausgebreitet hatte, verdeutlicht, daß der inhaltliche Schwerpunkt bei der technischen Ausbildung lag.[59] Der Amtliche Katalog der Ausstellung erwähnt Goldberg außerdem als Verantwortlichen für die eigenständige Gruppe Reproduktionstechnik und die Abteilung wissenschaftliche Photographie. Frank

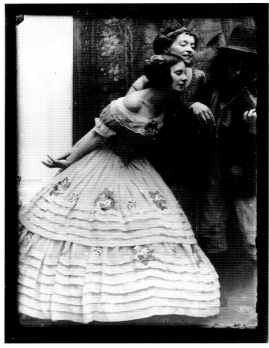

227. Festive procession during the Academy jubilee, Leipzig 1914
D.O.P., 18.0 x 13.2 cm
Fotomuseum im Münchner Stadtmuseum (88/26-29)

Eugene Smith wurde in der Liste der Bildautoren nicht erwähnt. Er war demzufolge auch nicht unter den zahlreichen Preisträgern der Ausstellung. Die Verantwortung für die Zusammenstellung der Gruppe Photographie trugen der von Seliger abgewiesene Adolf Sander und der als Promotor der Kunstphotographie bekannte Friedrich Matthies-Masuren (1873–1938) aus Halle. Der alte Dresdner Konkurrent Arthur Ranft veröffentlichte in der Zeitschrift *Photographische Kunst* einen prinzipiellen Verriß.[60]
Für den Akademiedirektor gab es also wenig Anlaß, mit der Beteiligung seines Kandidaten zufrieden zu sein. Im Grunde war der unbedeutende Auftritt von Klasse und Lehrer für Naturphotographie in Dresden 1909 auch mit dem neuen Klassenleiter wiederholt worden.

of practical instruction in both technical and arts and crafts subjects within the field of photography."[48] With the appointment of Smith, no revision was made of this overall teaching objective which aimed to "promote the art and craft of graphics and book design" and "to embellish books destined for broader sections of the public."[49] As the first attempt to achieve this aim had not been crowned with the desired success, Smith was now expected to give concrete form to these program points,

being as he was a representative of art photography, creatively active on the borderline between graphic and photographic techniques.
In this context only the teaching establishments in Vienna and Munich could serve as models – the main difference being that these two institutions defined themselves originally from the perspective of photography and process photography and had only later expanded their teaching and research in the direction of

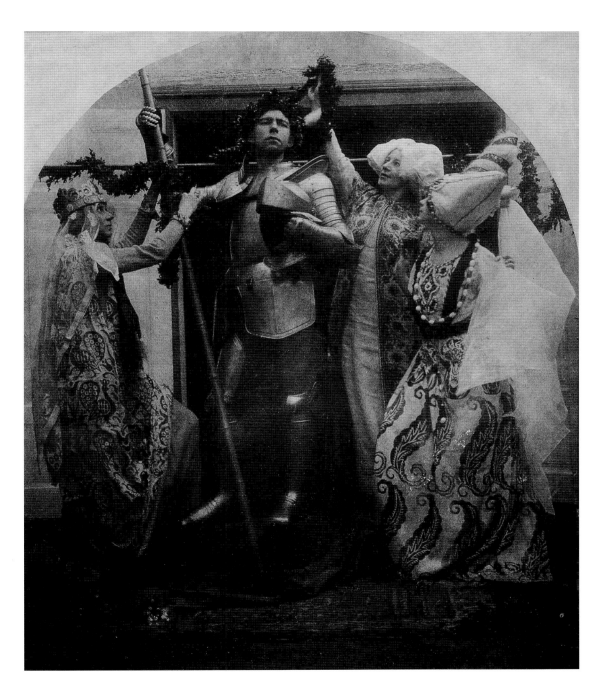

228. Festive procession during the Academy jubilee, Leipzig 1914
Platinum print, 37.5 x 27.5 cm
Fotomuseum im Münchner Stadtmuseum (93/759. 13)

229. King Friedrich August von
Sachsen, c. 1914
Platinum print
Metropolitan Museum of Art
Rogers Fund, 1972 (1972.633.124)

photomechanical printing processes and various special applications. Practically speaking, the Academy in Leipzig had taken the reverse path, training there having been expanded from graphic arts and book design in the direction of photographic reproduction and pictorial photography. By 1914 these three establishments had developed quite comparable course structures: photography and reproduction processes, book design and illustration, as well as photomechanical printing processes with accompanying research, all being viewed and taught as functioning in relationship to one another.[50] Smith's position in Leipzig, however, constituted an exception given that no other establishment of an equivalent institutional rank had granted pictorial photography a similarly high priority. The actual integration of Smith's courses into the overall training concept at the Academy was only achieved in part, which is one reason for his final failure. The creative principles of art photography were otherwise being communicated through personal instruction in the studios of the professional art photographers (for example, Erfurth, Perscheid, Rudolf Dührkoop) and through the exhibitions and publications of the various photographers' associations.

A glance at the history of the teaching establishments which specialized in photography and the arts, and which participated in the international Werkbund exhibition entitled "Film und Foto" in Stuttgart in 1929, shows that at the time of Smith's hopeful beginnings in Leipzig, photography only had the rank of a supporting technical discipline. Restricted as its teaching was to the mediation of simple production methods, it in no way fell within the problem zone of artistic creativity.[51] Only after 1925, and against the background of a change in the whole function of photography, were greater demands to be made of training in that field, and with this change Smith's courses finally became superfluous, orientated as they still were around the aesthetics of art photography. Two contemporaries, Johannes Widmann and Arthur Wenzel, were asked about the situation at the Academy in the 1920s and confirmed that scarcely any students attended Smith's classes.[52]

The Nature Photography Class's Participation in the Academy Jubilee and the 1914 "Bugra"

In 1914 the Academy celebrated its 150th anniversary. For this occasion Smith was commissioned to take portraits of the academy staff which were required by several publications.[53] In addition, the Academy issued a splendid folio containing a presentation of its history as a teaching establishment. This folio also included samples of the artistic works and book designs currently being carried out there, among them an original photograph by Smith.[54]

The official jubilee celebrations took place on March 6 and 7, 1914 both on the Academy premises and in the Old Theatre in Leipzig.[55] Smith and his class were given the task of photographing a festive procession which formed the culmination of an artists festival in the botanical gardens in Leipzig and which represented "the artist's earthly pilgrimage."[56] The photographs of the procession could be seen a short time later as part of the contribution by the Nature Photography class to the "Bugra," the "1914 Internationalen Exhibition of Book Design and Graphic Arts in Leipzig."[57] Presumably it was in this context that Smith was given the particularly honorable task of taking portraits of the Saxon royal family. The Saxon king was the patron of the "Bugra," which on account of its gigantic size has often been described as a "world exhibition." The exhibition had come about at the instigation of Hugo Steiner-Prag (1880–1945), a graphic artist and professor at the Academy. It was mounted in honor of the Academy's jubilee under the supervision of the German Book Design Association. The Academy gave a presentation of itself and the complete range of its training programme in a special exhibition hall which was also used by the Association of the German Book Trade.[58]

The nature photography class and the department of reproduction techniques shared one of the seven exhibition rooms. Alongside the photographs of the festive procession, Frank Eugene Smith and his class also showed unspecified portrait photographs, genre studies, autochromes and re-worked negatives. That the main point of emphasis was clearly on technical training is proven by a contemporary description of the myriad materials exhibited by the technical reproduction department and the institute of scientific photography.[59] Professor Dr. Goldberg was head of this department and of the institute, which was set up in 1912. The official exhibition catalogue also mentions Goldberg as the person responsible for the independent sections on reproduction techniques and scientific photography. Frank Eugene Smith is not mentioned in the list of photographers and was therefore not among the numerous prize winners at the exhibition.

Those responsible for putting together the photography section were Adolf Sander, who had been rebuffed by Seliger, and Friedrich Matthies-Masuren (1873–1938) from Halle, renowned as a promoter of art photography. As a matter of principle, the critique of this section

Zwar hatte alles dafür gesprochen, auf den bereits länger als arriviert geltenden Smith zu setzen, tatsächlich war es aber nicht gelungen, ihn strategisch als Repräsentanten der Akademie und Leipzigs auf der gleichen Höhe wie die kleine Gruppe von Photographen zu plazieren, die als Hauptvertreter der Kunstphotographie gelten konnten. Dazu gehörten Hugo Erfurth aus Dresden, Franz Grainer aus München, Wilhelm Weimer aus Darmstadt, der von Leipzig nach Berlin abgewanderte Nicola Perscheid, Rudolf Dührkoop in Berlin und Hamburg und die Brüder Hofmeister aus Hamburg. Auf die Stadt Leipzig als neuem Wohn- und Arbeitsort von Smith entfiel kein Glanz, was bei den Vorhergenannten im Vergleich der Fall war. Dies hatte einige Bedeutung, da die Akademie mit Zustimmung der sächsischen Landesregierung[61] auf eine geschlossene Selbstdarstellung bei der ›Deutschen Werkbund Ausstellung Cöln 1914‹ verzichtet hatte und dort nur mit Einzelstücken einiger Lehrer vertreten war.[62] Auch die photographische Abteilung blieb ohne Beitrag der Akademie; wieder war es Matthies-Masuren, der die Auswahl zusammengestellt hatte.[63]

Die Tätigkeit von Smith während der Kriegszeit

Der Krieg griff bald auch in das Leben an der Akademie ein. Smith, der als sächsischer Staatsdiener amerikanischer Bürger geblieben war, reagierte mit einer übertriebenen Ergebenheitsadresse, als er in München vom Ausbruch des Krieges erfuhr.[64] »Deutschlands viele Feinde möchte ich mithelfen zu bekämpfen ...«, schrieb Smith emphatisch an die Akademiedirektion – und schien die anfängliche Kriegsbegeisterung ehrlich zu

teilen, da er auch an Alfred Stieglitz ähnliche Worte richtete.[65]

Die Schülerlisten der Akademie wiesen nun immer häufiger auf die Abwesenheit männlicher Studenten wegen der Einberufung zum Heeresdienst hin. Die von Seliger gewünschte Erweiterung der Klasse trat nicht ein. Stattdessen sank die Zahl der Schüler, die kaum jemals mehr als zehn betragen hatte, weiterhin ab. Der Anteil von Frauen nahm stetig zu. Außerdem gehörte Smith als Amerikaner bald einer feindlichen Macht an. Daß dies eigene Gefahren mit sich brachte, erwies sich sehr bald. Anfang Mai 1915 mußte der Akademiedirektor bei der Königlichen Staatsanwaltschaft in Merseburg vorstellig werden, um einen Irrtum aufzuklären. Smith, der das Deutsche wendig, aber mit deutlich amerikanischem Akzent sprach, war in den Verdacht geraten, ein englischer Spion zu sein. Während eines Ausfluges war er bei Merseburg in die Nähe eines Lagers mit gefangenen Franzosen gelangt und hatte u.a. »von einer Gruppe gefangener Franzosen, die einen Wagen zogen und schoben, gereizt durch die Schönheit der Bewegungen der ziehenden Gestalten«,[66] Aufnahmen gemacht. Diese waren sofort beschlagnahmt worden; sein Assistent und eine Studentin – bei der es sich gewiß nicht zufällig um Johanna Trietschler handelte – wurden kurzzeitig verhaftet.

Obwohl das Ermittlungsverfahren eingestellt wurde und die Platten größtenteils zurückgegeben wurden, sah sich Seliger veranlaßt, darauf hinzuweisen, daß Smith bereits um seine Entlassung aus der amerikanischen Staatsangehörigkeit nachgesucht habe. Tatsächlich verzichtete Smith unmittelbar darauf auf seine amerikanischen Bürgerrechte[67] und wurde sächsisch-deutscher Staatsbürger.[68]

Für die Zeit bis zum Ende des Krieges weisen die erhaltenen Akten keine weitere Nachricht über Smith aus. Daß seine Position an der Akademie nicht ganz unproblematisch war, reflektiert indirekt ein Brief seines ehemaligen Direktors an die Münchner Lehr- und Versuchsanstalt. Noch im September 1917 erreichte ihn das diskret vermittelte Angebot, unter der Versicherung besserer Konditionen wieder nach München zurückzukehren.[69]

Presseveröffentlichungen von und über Frank Eugene Smith

Veröffentlichungen zur künstlerischen Arbeit von Smith erschienen nur in größeren zeitlichen Abständen. In den zwanziger Jahren standen sie im direkten Zusammenhang mit der Verteidigung seiner künstlerischen und beruflichen Position.

published in the magazine *Photographische Kunst* and written by Arthur Ranft, the old competitor in Dresden, was devastating.[60]

Thus the director of the Academy had little cause to be satisfied with his candidate's participation in this exhibition. The insignificant performance of the nature photography class under its old teacher in Dresden in 1909 had been more or less repeated under the new teacher. Smith's reputation to date had given cause for placing great hopes in him. The fact was, however, that the exhibition had not succeeded in placing him strategically, as the representative of the Academy and of Leipzig, on a par with that small group of photographers regarded as the main representatives of German "art photography" and including Hugo Erfurth from Dresden, Franz Grainer from Munich, Wilhelm Weimer from Darmstadt, Nicola Perscheid, who had drifted from Leipzig to Berlin, Rudolf Dührkoop in Berlin and Hamburg, and the Hoffmeister brothers from Hamburg. No great honor was forthcoming from the exhibition for the city of Leipzig as Smith's new home and work place, whereas this was certainly the case with those other photographers and cities mentioned above.

This state of affairs was all the more grave as, with the agreement of the Saxon State Government, the Academy had decided to abstain from a unified self-presentation at the "1914 German Werkbund Exhibition" in Cologne.[61] As a result, only individual works by some of its teachers were entered.[62] The photography section did not contain a single work from the Academy. Once again it was Matthies-Masuren who had made the selection.[63]

Smith's Activities during the War

The war very soon affected life at the Academy. Smith, who had remained an American citizen although he was a Saxon civil servant, reacted to the news of the outbreak of war in Munich with a somewhat exaggerated declaration of loyalty.[64] "I would like to help to fight Germany's many enemies ...," he wrote emphatically to the director of the Academy and seemed to genuinely share the initial enthusiasm for the war, as he made a similar pronouncement to Alfred Stieglitz.[65] The Academy's enrollment lists at that time continually illustrated the absence of male students in the photography class, a result no doubt of their being called up for military service. Thus the expansion of the class which Seliger had hoped for did not take place. Instead the overall number of students, which had scarcely ever been more than ten, continued to decline and the pro-

portion of women students to increase. Furthermore, as an American, it was not long before Smith became identified with a hostile power, a fact which promptly brought its own dangers with it.

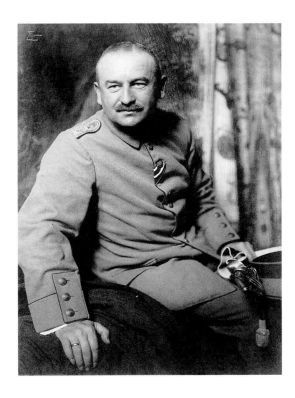

231. Portrait of an officer, 1914/15
Platinum print, 17.9 x 12.8 cm
Fotomuseum im Münchner Stadtmuseum, (93/625, 15)

At the beginning of May 1915 the director of the Academy was obliged to present himself at the office of the Royal Public Prosecutor in Merseburg to clear up a misunderstanding. Smith, who spoke passable German but with a distinctly American accent, had become suspected of being an English spy. During an outing in the vicinity of Merseburg he had come suspiciously close to a camp containing French prisoners and, "inspired by the beauty in the movements of these figures" had taken photographs, among other things, "of a group of French prisoners who were pushing and pulling a cart."[66] The photographs were immediately seized and his assistant and a female student – who was none other than Johanna Trietschler – were taken into custody for a brief period. Although the preliminary inquiry was abandoned and most of the plates returned, Seliger felt obliged to assure the authorities that Smith had already sought release from his American citizenship. In fact, Smith did eventually renounce his American civil rights[67] and became a Saxon-German citizen.[68]

The official files which have survived contain no further references to Smith for the period up to the end of the

Gleich nach seiner Berufung wurde in der Zeitschrift *Deutsche Kunst und Dekoration* ein längerer Bildbeitrag von Smith abgedruckt. Er enthielt hauptsächlich einige bereits bekannte Prominentenporträts, darunter auch das ganzfigurige Bildnis des Prinzregenten Ludwig von Bayern sowie die Aktstudie ›Weisse Wolke‹. Zuvor hatte die Akademieleitung den Künstler wärmstens bei der Redaktion empfohlen.[70] Der kurze Einführungstext ging aber auf die neue Position von Smith nicht ein. Er charakterisierte vor allem die differenzierte Art der Lichtbehandlung in den Bildnisstudien und unternahm eine sehr schmeichelhafte Deutung anhand eines Selbstporträts von Smith.[71]

merische Lobrede auf den »Lichtpoeten« Smith verband Zeitler mit einem Entwurf zum künstlerischen Prozeß der Photographie.[73] Zur Illustrierung seiner Thesen dienten einige Kinderbildnisse, die Porträts von Jesko von Puttkamer und des Leipzigers Prof. Georg Witkowski sowie ein neueres Porträt des bayerischen Königs. Ein Bildnis von Johanna Trietschler leitete den Text ein.

Über die ›Ausstellung von Naturphotographien‹ von 1924 und ihre verschiedenen Ausstellungsstationen wurde eine größere Anzahl zustimmender Zeitungsberichte publiziert, die Smith sorgfältig sammelte.[74]

Im Januar 1927, als die Werkstatt für Naturphotographie akademieintern längst zur Disposition stand, ergriff Smith

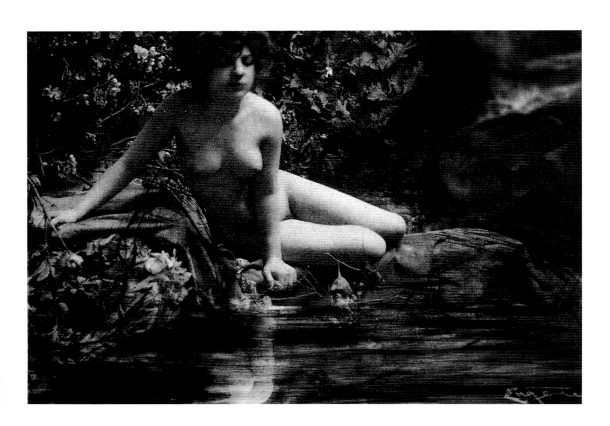

232. Am Bach, c. 1910
Photogravure
Valentin Musäum, Munich

Vier Jahre später veröffentlichte der Verleger und Kunstgeschichtslehrer an der Akademie, Dr. Julius Zeitler, in derselben Zeitschrift einen längeren Text zur ›Neuen Lichtbildkunst von Frank Eugen Smith‹.[72] Mit Blick auf die Ausbildungsstruktur an der Akademie schilderte er das gleichberechtigte Nebeneinander der künstlerischen Photographie, der Reproduktionskünste und der graphischen Künste und vertrat die Ansicht, die Photographie sei von ihrem Abstraktionsgrad her viel eher mit der Graphik zu vergleichen als mit der Malerei. Seine schwär-

selbst das Wort und äußerte sich im *Photo-Spiegel*, der Wochenschrift des *Berliner Tageblattes*, zu seiner Sicht der Photographiegeschichte.[75] Er folgte dabei lange bekannten Argumenten zur Genese der »Liebhaberphotographie« und stellte die im »Kampf um die Jahrhundertwende«[76] durchgesetzte Ästhetik der Kunstphotographie ohne jedes Zeichen von Verunsicherung als aktuellen Stand dar. Abschließend wies er auf die führende Stellung der englischen und amerikanischen Photographie hin, um eine »Mahnung an unsere Regierung« zu erlas-

war. That his position at the Academy was not totally unproblematic is reflected indirectly in a letter from his former director at the Munich institute. In September 1917 Smith received a discretely communicated offer of a teaching post with a guarantee of better conditions were he to return to Munich.[69]

Press Publications by and on Frank Eugene Smith

Articles dealing with Smith's creative work were only published at considerable intervals. In the 1920s they were more concerned with a direct defence of his artistic and professional position at the Academy. Immediately after Smith's appointment, however, the magazine *Deutsche Kunst und Dekoration* published a longer, illustrated article on him which included some of his already famous portraits of prominent personalities, among them the full length portrait of the prince regent Ludwig of Bavaria and a nude study entitled "White Clouds." Prior to the publication of this article, the Academy had warmly recommended the artist to the editors.[70] The article's short introductory text did not deal with the new position which Smith held, preferring instead

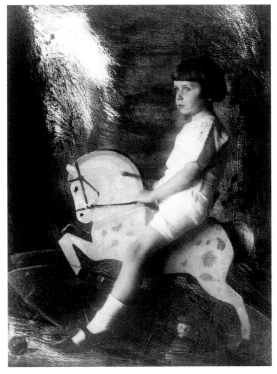

233. Child on a rocking horse, c. 1914
Platinum print, 16.8 x 11.9 cm
Fotomuseum im Münchner Stadtmuseum
(85/937)

to go into the nuances in his handling of lighting in his portrait studies, and proffering a highly complimentary interpretation of Smith's personality on the basis of a self portrait.[71]

Four years later, Dr. Julius Zeitler, publisher and teacher of art history at the Academy, published a longer article in the same magazine on "Frank Eugene Smith's new photographic work."[72] With reference to the training structure at the Academy, Zeitler described the equal status given to art photography, reproduction techniques and the graphic arts, and expressed the opinion that given its level of abstraction, photography was more comparable with graphic art than with painting. Zeitler combined his enthusiastic praise of the "light poet" Smith with a brief outline of the artistic process of photography.[73] To illustrate his theses he selected some of Smith's child portraits, his portraits of Jesko von Puttkamer and of the Leipzig professor Georg Witkowski, and a more recent portrait of the Bavarian king to accompany the article, which was preceded by a portrait of Johanna Trietschler.

There were a large number of positive reactions published in the newspaper about the "Exhibition of Nature Photographs" of 1924 and the different stops it made on its tour, and Smith made a careful collection of all these.[74] In January 1927, when the future of the workshop for nature photography had already been under discussion for some time within the Academy, Smith himself took the floor with an article which was published in *Photo-Spiegel*, the weekly magazine of the *Berliner Tageblatt*. In it he expressed his view of the history of photography,[75] adhering to the long-familiar arguments on the genesis of "hobby photography" and, without the slightest hint of a doubt, pronouncing the aesthetics of art photography as being the current state of the art – having won through in the "battle at the turn of the century."[76] In his conclusion he referred rather pointedly to the leading position of English and American photography, more by way of an "admonition to our government to continue to pursue the path taken before the war and, with a view to the artistic training of our contemporary photographers, create places in our state schools." This was doubtless an indirect plea for the maintenance of his own teaching post. Smith chose several photographs by David Octavius Hill to illustrate this article.

In March 1927 Smith followed up that article with a similarly orientated and highly anecdotal essay on the relationship between photography and painting[77] – published together with some older photographs and with his photogravure "The Horse."

234. Frank Eugene Smith on
"Photographie und Malerei," in:
Photo-Spiegel, 9, March 1, 1927
Fotomuseum im Münchner
Stadtmuseum

235. Frank Eugene Smith on
"Linsen und Linsensysteme," in:
Photo-Spiegel, 19, May 12, 1927
Fotomuseum im Münchner
Stadtmuseum

Yet another article of Smith's[78] was accompanied by six of his own works. This article dealt with lenses and lens systems and went into the photographic achievements made possible by technical innovations. However, Smith categorized these inventions as counterproductive for the aesthetic quality of a photograph. In his opinion what was being expressed in the manipulation of the optical sharpness of the image by means of different technical tricks was a drive "to give an individual character to the source of the image production, in as far as this was possible." Here too he was speaking for himself when he referred to the development of photography as being a spiral shaped movement between

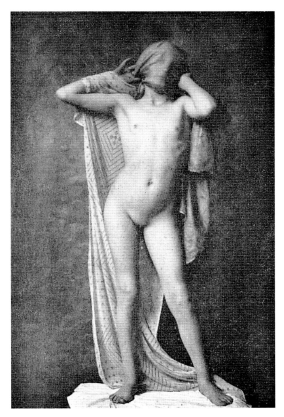

236. Nude, c. 1920
from: *Die Schönheit*, 1920, p. 549
Fotomuseum im Münchner Stadtmuseum

extreme points, a movement forwards and backwards. From the very start, Frank Eugene Smith did not feature much in either the daily press or the usual magazines as an "author of photographs." During his years in Leipzig he was never once mentioned in the list of illustrations of the *Leipziger Illustrierte Zeitung*. Between 1912 and 1915 the *Berliner Illustrirte Zeitung* only published five portraits which Smith had taken of Munich artists[79] al-

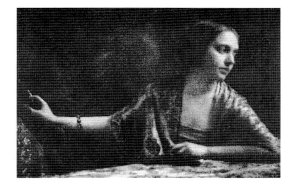

237. Mrs. Wilm (The Cigarette), 1909
from: *Reclams Universum*, 36, March 31, 1920

though it did avail itself of the works of a whole series of well-known photographers such as Perscheid, Grainer, Dührkoop, d'Ora etc. Compared with these, Smith simply had not succeeded in establishing himself as a portraitist of particular circles of people, or in having his photographs classified as standard works. Between 1914 and 1919 reports on the war superseded all other topics. After that period, there are no works of Smith's at all to be found in the *Berliner Illustrirte Zeitung*, although Perscheid, Dührkoop, Erfurth, Titzenthaler and others did make a reappearance there.[80] In this context it must be remembered that with the general change in themes, the use of photography had also undergone changes. What is more, Smith did not have contacts to the same kind of prominent artists' circles in Leipzig as he had had in Munich. His rare appearances in the print media cannot be adequately explained by a lack of demand on the part of those media. Smith is sure to have declined to work professionally in that particular direction, something which may also have been a symptom of passivity. Scattered publications of his works, as in *Reclams Universum* and *Die Schönheit* of 1918–1920, merely confirm this impression.[81]

The Re-Organization of Photography Courses after 1919

In 1919, right after the end of the war, Smith undertook the reorganization of his photography department anew and finally had the planned construction work and the extensions to the premises carried out, all of which had been neglected due to the war.[82] Given the prevailing circumstances, the dire necessity to save money had a negative effect on these works and they often had to be forced through by means of tedious negotiations and skillful account balancing.[83] Finally, however, the department of nature photography did in fact seem to have more space at its disposal than before. Smith listed fifteen rooms in all, of which six were darkrooms.

sen, »auf dem Weg vor dem Krieg fortzufahren und Plätze an unseren staatlichen Schulen zu schaffen, die die künstlerische Erziehung unserer heutigen Photographen im Auge haben.« Damit warb er zweifellos für die Beibehaltung seines eigenen Lehramtes. Einige Photographien von David Octavius Hill bebilderten den Artikel.

Im März 1927 folgte ein ähnlich orientierter, stark anekdotischer Aufsatz zum Verhältnis von Photographie und Malerei[77] – zusammen mit einigen älteren Bildbeispielen, sowie seiner Photogravüre ›Das Pferd‹. Mit sechs eigenen Photographien war ein Artikel über Linsen und Linsensysteme ausgestattet,[78] in dem Smith die Verbesserung der photographischen Abbildungsleistung durch technische Erfindungen schilderte, diese jedoch als kontraproduktiv für die ästhetische Qualität der Photographie einstufte. Nach seiner Meinung äußerte sich in der Manipulation der optischen Abbildungsschärfe durch verschiedene technische Tricks das Bestreben, »die Bilderzeugungsquelle, soweit es möglich erschien, zu individualisieren«. Auch hier sprach er pro domo, wenn er die Entwicklung der Photographie als spiralförmige Bewegung

zwischen Extrempunkten, als Wechsel von vor und zurück beschrieb.

In der Tagespresse und den gängigen Illustrierten war Frank Eugene Smith als Bildautor von Anfang an wenig in Erscheinung getreten. Das Bildverzeichnis der *Leipziger Illustrierten Zeitung* vermerkte Smith während der Leipziger Jahre kein einziges Mal. Die *Berliner Illustrirte Zeitung* (*BIZ*) brachte zwischen 1912–15 nur fünf Porträts von Smith aus der Münchner Künstlerschaft,[79] versammelte ansonsten aber eine ganze Reihe bekannter Photographennamen wie Perscheid, Grainer, Dührkoop, d'Ora usw. Im Vergleich zu diesen war es Smith nicht gelungen, sich als Porträtist bestimmter Personenkreise durchzusetzen bzw. seine Bildnisse zu Standards werden zu lassen. Zwischen 1914–19 hatte die Kriegsberichterstattung alle anderen Themen verdrängt. Danach waren Bildnisse von Smith in der *BIZ* überhaupt nicht mehr zu finden, obwohl Perscheid, Dührkoop, Erfurth, Titzenthaler u.a. wieder vertreten waren.[80]

Hierbei ist in Rechnung zu stellen, daß sich mit den Themen auch der Einsatz der Photographie gewandelt hatte und Smith in Leipzig in keinem ähnlich prominen-

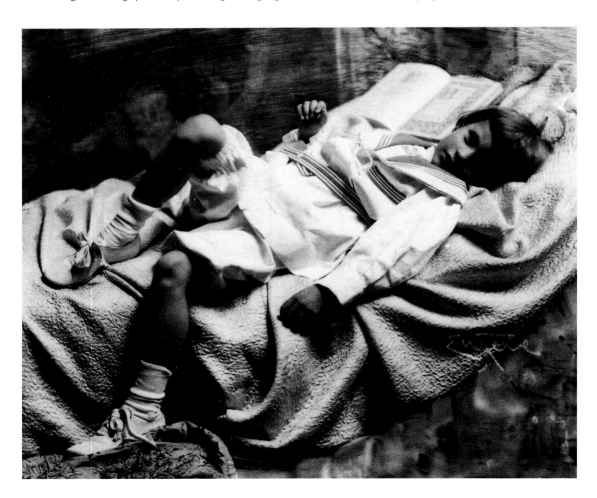

238. Portrait of a child, c. 1910
Platinum print, 11.1 x 13.2 cm
Fotomuseum im Münchner
Stadtmuseum (88/27-47)

After Max Seliger's death in 1919 the Academy was without a director for a while, until Walter Tiemann took over the position in 1920. Tiemann had already been appointed by Seliger as a teacher for the "overall sector of book design, illustration, and free and applied graphic arts" in 1903. His greatest achievements were in the field of book design and typography and this had brought him into contact with the famous printing type designer Karl Klingspor in Offenbach/Main. He also worked together with some of the most ambitious publishers in Leipzig, for example, Janus Press, Insel, and the art historian Julius Zeitler's publishing house.[84]

As had been the case when Max Seliger took up the post, Tiemann's appointment as director of the Academy also resulted in new statutes being drawn up.[85] On the one hand, these statutes took into consideration the new form of government, but on the other, they merely continued the direction which Seliger had given to teaching and training at the Academy. In 1921, as was his duty, Tiemann organized that the teaching staff at the now State Academy take an oath of allegiance to the constitution of the Deutsche Reich.[86] Tiemann's efforts were concentrated mainly on the updating and expansion of the teaching curriculum for printing and related subjects, his aim being to keep abreast of new technical developments.

In autumn 1919, Fritz Goetz (1861–1927) was appointed to replace Emanuel Goldberg who had already given up his chair at the photomechanical institute in 1917 in favor of a lucrative position in Dresden in the photographic industry which had become so important during the war. Frank Eugene Smith exercised considerable influence on the decision in favor of Goetz's appointment. Early in 1918 he had brought about the first contact between the director of the Academy and the long-time director of the technical department of the Graphische Kunstanstalten (Graphic Arts Institute) F. Bruckmann in Munich. Goetz, who was a friend and peer of Smith's and like him a German-American, was regarded as quite an authority in the field of photomechanical printing, in particular color printing.

Negotiations between the respective ministry, the Academy and Goetz took quite some time because, initially, Goetz resisted the necessity of giving up his American citizenship. The course of the war also brought additional difficulties with it. During a meeting in Munich Goetz and Smith witnessed some of the revolutionary unrest there. "Professor Smith experienced some of the fighting during his visit here and I hope that his trip back to Leipzig went off well," wrote Goetz to Seliger.[87] It was thanks to the latter's persistent efforts in his

favor that Goetz was finally appointed by the new state government.

Tiemann and Goetz worked jointly to expand the scope of training in their field of photomechanics. A lot of things had changed in the printing industry since the outbreak of war. New developments in the world of newsprint, in advertising and in book design had all been accompanied by an upgrading of the status of visual information, a phenomenon for which photomechanical printing processes were responsible. However, due to the currency crisis, new acquisitions of technical equipment at the Academy were very limited. Although Goetz succeeded in persuading partners from industry to donate material, nevertheless, by 1922 he was obliged to restrict his wishes for changes to a few special sectors, above all offset printing.

239. *Frank Eugene Smith* (attr.)
Walter Tiemann, c. 1914
D.O.P., 12.5 x 18.0 cm
Private collection

The technical duplication of the Manesse manuscript was one of the most ambitious tasks which Goetz was practically involved in at that time. It would seem that as a result of this renunciation his enthusiasm waned. The stabilization of the currency in 1924 did not immediately bring about significant improvements. At the end of 1925, after the death of his wife, Goetz retired from teaching altogether, visibly dissatisfied and in a very bad state of health.[88] But he had already succeeded in

ten Künstlerkreis verkehrte, wie in München. Seine geringe Präsenz in den Druckmedien läßt sich aber kaum durch mangelnden Bedarf erklären. Smith wird bewußt darauf verzichtet haben, in dieser Richtung professionell tätig zu werden, was im Einzelnen Passivität bedeutete. Verstreute Bildabdrucke, wie in *Reclams Universum* und in *Die Schönheit* 1918–20, bestätigen diesen Eindruck nur.[81]

Die Neuorganisation der photographischen Ausbildung ab 1919

Schon 1919, gleich nach Beendigung des Krieges, leitete Smith die Neuorganisation der photographischen Ausbildung ein und ließ endlich jene baulichen Veränderungen und Ergänzungen der Einrichtung vornehmen, die wegen des Krieges unterblieben waren.[82] Diese waren nach Lage der Dinge von großen Sparzwängen geprägt und mußten durch langwierige Erörterungen und Aufrechnungen durchgesetzt werden.[83] Zumindest schien die Abteilung Naturphotographie inzwischen über mehr Platz zu verfügen. Smith zählte fünfzehn Räume auf, von denen sechs Dunkelkammern waren.

Nach dem Tode von Max Seliger im Jahre 1919 war die Akademie einige Zeit führungslos, bis Walter Tiemann 1920 das Direktorat übernahm. Tiemann war schon 1903 von Seliger in ein Lehramt für das »Gesamtgebiet des Buchgewerbes, der Illustration, der freien und angewandten Grafik« berufen worden. Seine Verdienste lagen auf dem Gebiet der buchkünstlerischen Arbeit und der typographischen Gestaltung, die ihn u.a. mit dem bedeutenden Typengestalter Karl Klingspor in Offenbach/Main zusammenführten. Einige der anspruchsvollsten Leipziger Verlage waren seine Arbeitspartner, z.B. die Janus-Presse, der Insel-Verlag und der Verlag des Kunsthistorikers Julius Zeitler.[84]

Wie auch nach dem Amtsantritt von Max Seliger erhielt die Akademie ein neues Statut,[85] das einerseits die neue Staatsform berücksichtigte, andererseits die durch Seliger geschaffene inhaltliche Ausrichtung der Akademieausbildung fortsetzte. Tiemann unternahm 1921 pflichtgemäß die Neuvereidigung der Lehrer an der nunmehr Staatlichen Akademie auf die Verfassung des Deutschen Reiches.[86]

Seine Bemühungen waren vor allem auf die Aktualisierung und Vervollkommnung der drucktechnischen Ausbildungsfächer gerichtet, um den Anschluß an die technologische Entwicklung nicht zu verlieren.

Im Herbst 1919 erfolgte die Berufung von Fritz Goetz (1861–1927) zum Nachfolger von Emanuel Goldberg, der seinen Lehrstuhl am photomechanischen Institut schon

1917 zugunsten eines lukrativen Postens in der kriegswichtigen Photoindustrie Dresdens verlassen hatte. An der Entscheidung für Goetz war Frank Eugene Smith indirekt beteiligt. Er hatte Anfang 1918 den ersten Kontakt zwischen Akademiedirektor Seliger und dem langjährigen Direktor der Technischen Abteilung der Graphischen Kunstanstalten F. Bruckmann in München vermittelt. Goetz, Altersgefährte von Smith und Deutschamerikaner wie dieser, galt als herausragende Autorität auf dem Gebiet photomechanischer Druckverfahren, besonders des farbigen Bilddrucks.

Die Verhandlungen zwischen dem zuständigen Ministerium, der Akademie und Goetz zogen sich allerdings lange hin, weil sich Goetz zunächst sträubte, die amerikanische Staatsbürgerschaft aufzugeben und der Kriegsverlauf zusätzliche Schwierigkeiten brachte. Die revolu-

240. Frederick Goetz, c. 1920
D.O.P., 12.0 x 17.3 cm
Marianne Müller, Dresden-Radebeul

tionären Unruhen wurde von Goetz und Smith in München gemeinsam erlebt. »Professor Smith hat bei seinem Besuch hier auch ein wenig von der Kämpferei miterlebt und hoffe ich, dass seine Reise nach Leipzig doch noch gut verlaufen ist«,[87] schrieb Goetz an Seliger, dessen anhaltenden Bemühungen es schließlich zu verdanken war, daß Goetz von der neuen Landesregierung berufen wurde. Tiemann und Goetz setzten gemeinsam den Ausbau der photomechanischen Ausbildung fort. Seit dem Ausbruch des Krieges hatte sich in der Druckindustrie einiges geändert. Die Entwicklungen im Zeitungswesen, in der Reklame und im Buchgewerbe waren sämtlich mit einer Aufwertung der visuellen Information verbunden, deren Übermittlung den photomechanischen Druckverfahren zukam.

Die Erneuerung der technischen Ausrüstung in der Akademie konnte wegen der Währungskrise nur sehr eingeschränkt erfolgen. Obwohl Goetz Arbeitspartner aus der

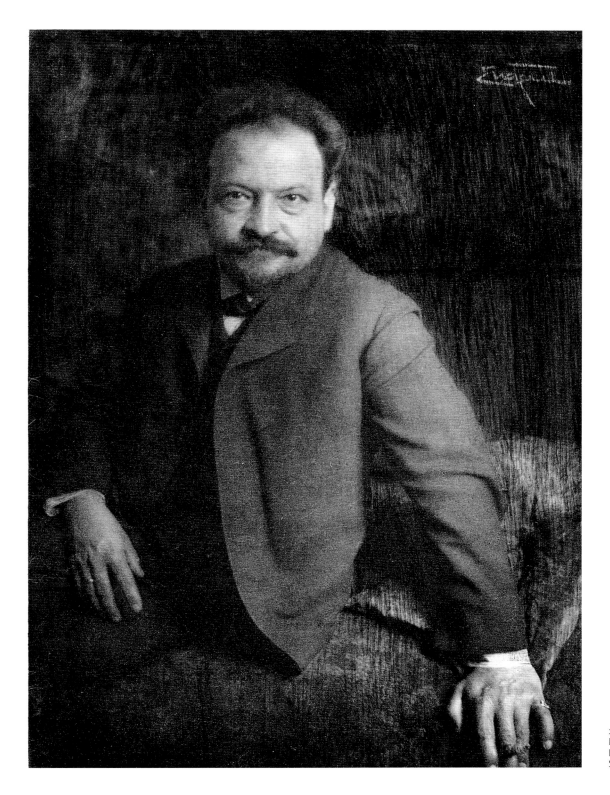

241. Frederick Goetz, c. 1907
Photogravure, 17.3 x 12.6 cm
Fotomuseum im Münchner
Stadtmuseum (88/26-35)

Industrie für Materialspenden gewann, mußte er seine Änderungswünsche 1922 offiziell auf einige Spezialgebiete, vor allem den Offsetdruck, beschränken. Die drucktechnische Vervielfältigung der Manessischen Liederhandschrift war eine der anspruchsvollsten Aufgaben, die Goetz in dieser Zeit praktisch umsetzte.

Nach diesen Anstrengungen schien seine Energie zu erlahmen. Auch die Währungsstabilisierung 1924 brachte nicht gleich eine Wende in der schwierigen ökonomischen Situation der Akademie. Schon Ende 1925 ging Goetz sichtlich unzufrieden und nach dem Tod seiner ersten Frau gesundheitlich stark angegriffen in den Ruhestand.[88] Dennoch hatte er in der photomechanischen Ausbildung wichtige Verbesserungen erreicht und zog dadurch einige später berühmte Namen an die Akademie.[89]

Der gesteigerte Bedarf an photographischen Illustrationen, der neue Typus der Bildberichterstattung fanden in der Ausbildungsstruktur der Akademie keinen Widerhall.

Frank Eugene Smith ließ sich durch die Aktivitäten von Goetz, die die Attraktivität seines Unterrichts weiter schmälern mußten, nicht beunruhigen und führte seine Meisterklasse und Werkstatt für Naturphotographie unbeirrt weiter. Veränderungen im Ausbildungsinhalt bzw. seiner kunstphotographischen Ausrichtung nahm er nicht vor.[90] Eine kurze Selbstdarstellung der Werkstatt wiederholte immer noch die Richtlinien, die bereits bei ihrer Gründung verkündet worden waren.[91] Die Schüler von Smith übten sich nach wie vor im Verfertigen kunstphotographischer Edeldrucke, stimmungsvoller Landschaften und Innenraumporträts.

Während der Inflation um 1923 wechselten die Notverordnungen der sächsischen Landesregierung einander ab und wurden die Monatsgehälter der Lehrer in hektischer Eile bis in Millionenhöhe getrieben. Nur die beamtenrechtliche Stellung der Professoren schien noch eine Wertgarantie in sich zu bergen und wurde als Unterpfand des sozialen Überlebens unter Zuhilfenahme verschiedener persönlicher Strategien verteidigt.

Frank Eugene Smith fiel schließlich 1923 unter die Personalabbauverordnung des Deutschen Reiches, die ihn ziemlich unverblümt aufforderte, seine Stellung an der Akademie zu räumen:

»Sie wollen sich deshalb bis zum 28. Dezember ds.Js. erklären, ob Sie die Absicht haben, einen Antrag auf Versetzung in den Ruhestand von sich aus zu stellen. Im Verneinungsfalle muß sich das Wirtschaftsministerium Ihre Versetzung in den einstweiligen Ruhestand unter Gewährung des gesetzlichen Wartegeldes – evtl. vom 1. Februar ab – vorbehalten.«[92]

242. *Anonymous*
Studio interiors of the Kgl. Akademie für graphische Künste und Buchgewerbe, Leipzig c. 1916
D.O.P., 16.5 x 22.6 cm
Fotomuseum im Münchner Stadtmuseum (88/27-121)

243. *Heinz Kühnemann*
Frank Eugene Smith with his
students, Leipzig c. 1925
D.O.P.
Metropolitan Museum of Art.
Rogers Fund, 1972 (1972.633.184)

making enough improvements to his department to
later attract some famous names to the Academy.[89]
The new demand for photographic illustrations and the
emergence of a new type of photo-reportage were in
no way reflected in the teaching curriculum at the
Academy. Frank Eugene Smith did not allow himself
to be unsettled in any way by Goetz's activities, which
must have further decreased the attractiveness of his
own classes. Unwaveringly, he continued his master
class and workshop activities in nature photography,
neglecting to undertake any alterations in the content
or direction of his art photography courses.[90] A brief
new profile of the workshop merely repeated the guide-
lines laid down at the time of its establishment.[91] Smith's
pupils were still practicing how to produce high-grade
artistic photographic prints, atmospheric landscapes and
interiors.

During inflation in 1923 the Saxon state government
issued one emergency decree after another, and the
monthly salaries of teachers were speedily driven into
their millions. The only thing which in itself seemed to
represent a guarantee of value and a pledge of social
survival was a civil service post as professor, and any
such post was defended at all costs and with the help
of various individual strategies. In 1923, Frank Eugene
Smith's position finally fell under the so-called Staff

Reduction Decree of the Deutsche Reich, which led to
him being summoned in quite blunt terms to give up
his post at the Academy. "You are requested, therefore,
to declare by December 28 of this year whether you
yourself intend to initiate an application to be superan-
nuated. In the case of a refusal, the Ministry of Eco-
nomic Affairs must reserve the right to have you super-
annuated provisionally, while granting the legal inactive
status salary – possibly as of February 1."[92] Smith did
not react to this offer although it included quite a gen-
erous pension arrangement.

The 1924 "Nature Photography Exhibition"

As a countermove, and as proof of a strong and self-
assertive will, in 1924 Smith initiated the "Exhibition of
Nature Photography and Reproductions from Professor
Frank Eugene Smith's Nature Photography Department
and Professor Fritz Goetz's Technical Reproduction De-
partment at the State Academy of Graphic Arts and
Book Design in Leipzig." This touring exhibition made
numerous stops throughout Germany, among others in
Frankfurt/Main, Stuttgart, Dresden, Freiburg and Mu-
nich.[93] The whole enterprise came to an end early in
1926. The exhibition catalogue, which is preserved in
the Kunstgewerbemuseum Frankfurt/Main, makes refer-

244. Class party of Smith's
students, Leipzig c. 1925
D.O.P.
Private collection

Smith ging auf das Angebot nicht ein, obwohl ihm für
das Ruhegehalt eine recht großzügige Regelung angeboten wurde.

Die ›Ausstellung von Naturphotographien‹ 1924

Im Gegenzug startete 1924, zur Bekräftigung seines
Selbstbehauptungswillens, die ›Ausstellung von Naturphotographien und Reproduktionen der Abteilungen
für Naturphotographie Prof. Frank-Eugene Smith und
Reproduktionstechnik Prof. Fritz Goetz an der Staatlichen Akademie für Graph. Künste und Buchgewerbe
zu Leipzig‹ mit zahlreichen Stationen in ganz Deutschland, u.a. in Frankfurt/Main, Stuttgart, Dresden, Freiburg
und München.[93] Erst Anfang 1926 war die Ausstellungsaktion beendet. Der Katalog der Ausstellung im Kunstgewerbemuseum Frankfurt/Main weist 181 Arbeiten
von Smith und 67 Schülerarbeiten aus. Die reproduktionstechnische Abteilung stellte sich mit 43 Arbeitsproben vor.
Obwohl Smith sichtlich bemüht war, seine öffentliche
Präsenz und damit seine Stellung als Akademieprofessor
zu verbessern, spiegelte die Ausstellung sehr deutlich
die Stagnation wider, in der seine Lehre und sein persönliches Werk seit längerem befangen waren. Der Anteil
neuerer Photographien aus der Leipziger Zeit war klein,
und der ständige Rückgriff auf ältere Arbeiten mußte
immer unglaubwürdiger erscheinen.[94]
Obgleich der konservative Geist der Ausstellung und der
Photograph selbst auswärts vielfach positiv gewürdigt
wurden,[95] waren die Verhältnisse an der Akademie und in
Leipzig für Smith nicht günstiger geworden.
Während sich in den zahlreichen reprotechnischen Fächern[96] mehr als 50 Studenten drängten, waren bei Smith
zuletzt weniger als zehn Schüler eingetragen.[97] Es war
allzu offensichtlich, daß Smith auf der einmal eingenommenen Position verharrte und nicht willens bzw. nicht in
der Lage war, sich neueren Entwicklungen zu öffnen.

In einem Fall gelang Smith ein erstaunlicher und wahrscheinlich eher zufälliger Brückenschlag zu einer unabhängigen Künstlergruppe, die in Leipzig auf Erneuerung
drängte. Der 1913 von Max Klinger gegründete Verein Leipziger Jahres-Ausstellung (L.I.A.) hatte zu seiner zehnten
Jahresausstellung eine Vielzahl von Künstlern eingeladen,
deren Werke in Deutschland und Europa als Ausdruck
avantgardistischer Bestrebungen gelten konnten.[98]
Zu den Teilnehmern gehörten u.a. mehrere Meister vom
Bauhaus Weimar, aber auch Georges Braque, André
Derain und Juan Gris. Smith hatte die Jury der Ausstellung
porträtiert, zu der auch der Akademieprofessor Georg
Mathéy und der spätere Rektor der Hochschule für Grafik
und Buchkunst, Kurt Massloff,[99] zählten. Unter den
Textbeiträgen war ein Aufsatz von Laszlo Moholy-Nagy,
der sich stellenweise wie ein unbewußter Kommentar zur

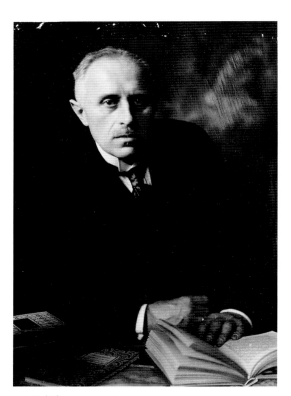

245. Karl Klingspor, c. 1916
D.O.P., 17.0 x 11.8 cm
Fotomuseum im Münchner Stadtmuseum (88/27-13)

Situation von Smith liest: »Auf die schöpferischen Möglichkeiten des Neuen machen meist langsam solche alten
Formen, diejenigen alten Instrumente und Gestaltungsgebiete – mit einer durch die Existenz des Neuen noch einmal aufblühenden Frische – aufmerksam, welche durch
das Erscheinen des Neuen im Grunde schon erledigt
sind.«[100]

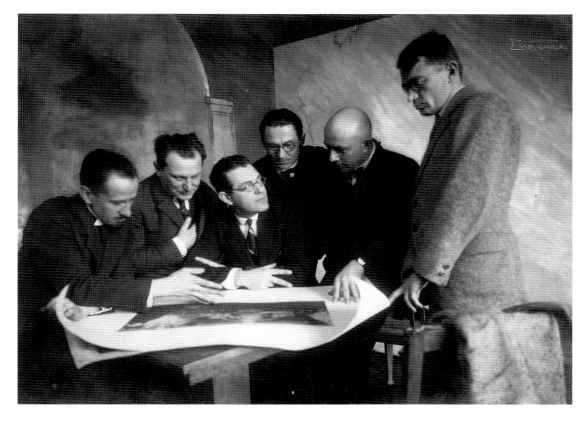

246. Jury of the "Leipziger Jah-
res-Ausstellung," 1925
D.O.P., 16.3 x 22.8 cm
Fotomuseum im Münchner
Stadtmuseum (88/26-30)

ence to 181 works by Smith and 67 by his pupils. The
department of technical reproduction processes contrib-
uted 43 samples of its work.

Although Smith was obviously concerned with improv-
ing his public reputation and thus his position as a pro-
fessor at the Academy, the exhibition itself was a clear
reflection of the stagnation in which his classes and his
personal work had been embroiled for some time. The
percentage of new photographs dating from his time in
Leipzig was small.[94] The constant recourse made to
older works could not fail to appear more and more
implausible. Although the conservative spirit of the ex-
hibition and the photographer himself received much
praise and recognition from outsiders,[95] conditions at
the Academy and in Leipzig had not become more ad-
vantageous for Smith.

While more than 50 students were scrambling for admis-
sion to the numerous courses on technical reproduction,[96]
towards the end of his time in Leipzig Smith had less than
ten enrollments for his classes.[97] It was more than obvious
that he was sticking stubbornly to the position he had
formerly taken and was not willing or in a position to ac-
knowledge and integrate new developments.

In one particularly astonishing, and more than likely
chance case, Smith succeeded in making contact with

an independent artists' group which was pushing for
renewal in Leipzig. The so-called Verein Leipziger
Jahres-Ausstellung (Leipzig Annual Exhibition Associa-
tion), founded in 1913 by Max Klinger, had invited a
number of artists, whose works could be regarded in
Germany and Europe as an expression of avant-garde
aspirations, to participate in its tenth annual exhibi-
tion.[98]

Among the participants in this exhibition were several
masters from the Bauhaus movement in Weimar, and
Georges Braque, André Derain and Juan Gris. Smith
had taken a portrait of the exhibition jury which also
included Georg Mathey, professor at the Academy, and
Kurt Massloff, who was later to become dean of the
Hochschule für Graphik und Buchkunst (College of
Graphic Arts and Book Design).[99]

The exhibition catalogue contained an essay by Laszlo
Moholy-Nagy which, in parts, reads like an uninten-
tional commentary on Smith's personal situation:"Our
attention is often drawn, if usually only gradually, to
the creative potential of the New by such old forms,
such old tools and formal procedures which are once
again endowed with a fresh hue by the very existence
of the New, only to be then made basically obsolete
by it."[100]

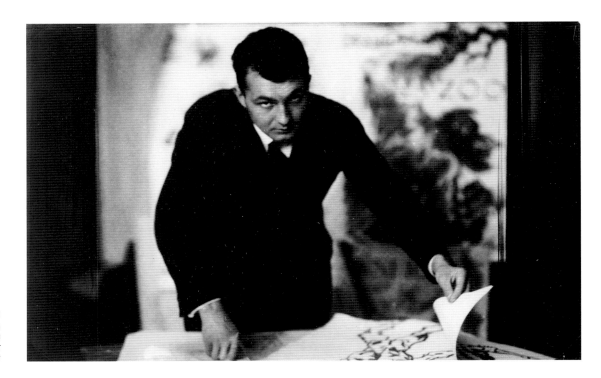

247. Portrait of an unknown
graphic designer, c. 1914
D.O.P., 11.4 x 17.9 cm
Fotomuseum im Münchner
Stadtmuseum (88/27-78)297

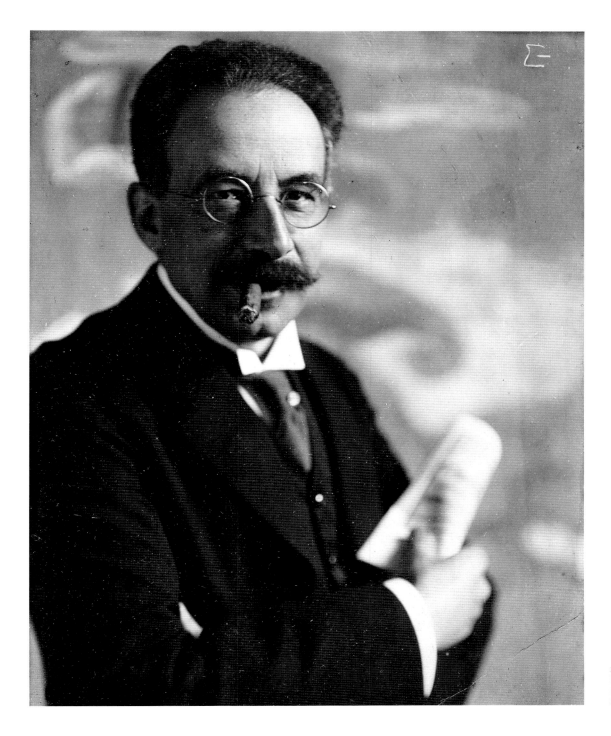

248. Georg Witkowski, 1916
D.O.P., 17.3 x 12.8 cm
Fotomuseum im Münchner
Stadtmuseum (88/27-3)

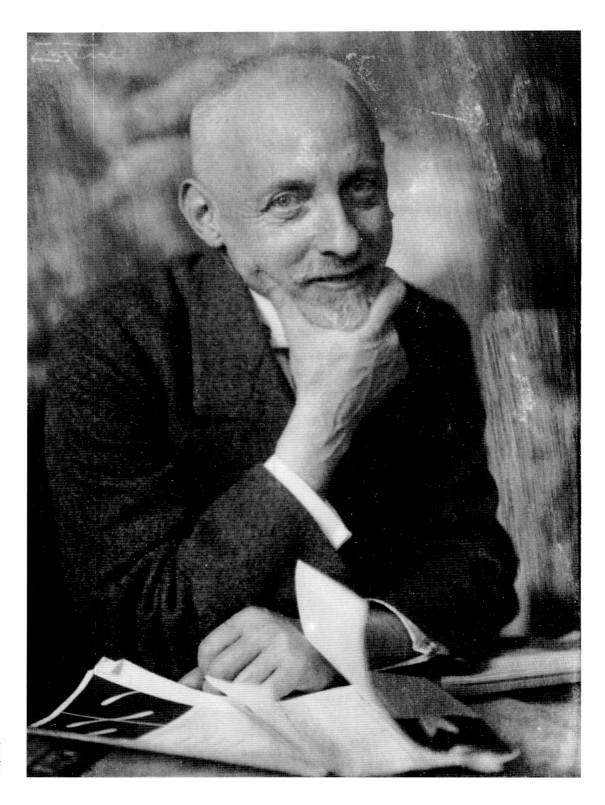

249. Prof. Alf Doren, c. 1915
D.O.P., 17.2 x 12.2 cm
Fotomuseum im Münchner
Stadtmuseum (88/26-20)

The Discontinuation of the Nature Photography Class

In February 1927 a letter was sent by the Saxon Ministry of Economic Affairs to the director of the Academy announcing the final abolition of the department of nature photography.[101] Smith's reaction was one of indignant surprise. Without much hope of success he tried to intervene, but the Academy management had itself provided the impetus for the termination of his courses. Even his insistence on the threat of a loss of quality in photographic training was of little avail:[102] the class was discontinued in September 1927.

In the following two years, teaching contracts were allocated to replace Smith's classes. In the summer semester of 1928 Laszlo Moholy-Nagy gave a class on the theme of "Photomontage and related areas, with practical demonstrations." The following year Hugo Erfurth was invited to give a course on "Figurative Photography, with practical exercises." This was followed by an exhibition in the Academy of works from the course. From 1930 onwards the drawing teacher Professor Heinz Dörffel and Professor Carl Blecher, Goetz's successor at the photomechanical institute, shared responsibility for the creative classes as well as for the technical realization of their results.

In 1926/1927 the departments of process photography, intaglio printing and offset printing were again brought up to the latest technical standards, and the following years were clearly marked by a "purely technical interpretation"[103] of photography. Photography as a free and artistic form of expression had not proved itself to be viable within the context of the Academy curriculum.

Die Schließung der Klasse
für Naturphotographie

Im Februar 1927 erging an die Akademiedirektion ein
Schreiben des Sächsischen Wirtschaftsministeriums, das
die endgültige Abschaffung der Abteilung für Natur-
photographie ankündigte.[101] Smith reagierte hoch-
betroffen und versuchte zu intervenieren, jedoch ohne
Aussicht auf Erfolg, da die Akademieleitung selbst den
Impuls zur Aufkündigung seiner Stellung gegeben hatte.
Auch sein Hinweis auf den drohenden Niveauverlust
der photographischen Ausbildung nutzte nichts.[102] Es
blieb bei der Auflösung der Fachklasse zum Septem-
ber 1927.

In den beiden nächsten Jahren wurden anstelle des Un-
terrichts von Smith Lehraufträge vergeben. Im Sommer-
semester 1928 unterrichtete Laszlo Moholy-Nagy zum
Thema: ›Photomontage und verwandte Gebiete mit
praktischen Vorführungen‹. Im Jahr darauf wurde Hugo
Erfurth eingeladen, ›Gegenständliche Photographie mit
praktischen Übungen‹ zu vermitteln. In der Akademie
schloß sich eine Ausstellung mit Arbeiten aus diesem
Kursus an. Ab 1930 teilten sich der Zeichenlehrer Prof.
Heinz Dörffel und der Nachfolger von Goetz am Photo-
mechanischen Institut, Prof. Carl Blecher, die gestalteri-
sche Unterweisung sowie die drucktechnische Realisie-
rung ihrer Ergebnisse.

In den Jahren 1926/27 waren die Abteilungen Reproduk-
tionsphotographie, Tiefdruck und Offsetdruck noch
einmal auf den neuesten technischen Stand gebracht
worden. Die »rein technische Interpretation«[103] der Photo-
graphie bestimmte die folgenden Jahre. Die Photographie
als freie künstlerische Ausdrucksform hatte sich im Kontext
der Akademieausbildung als nicht lebensfähig erwiesen.

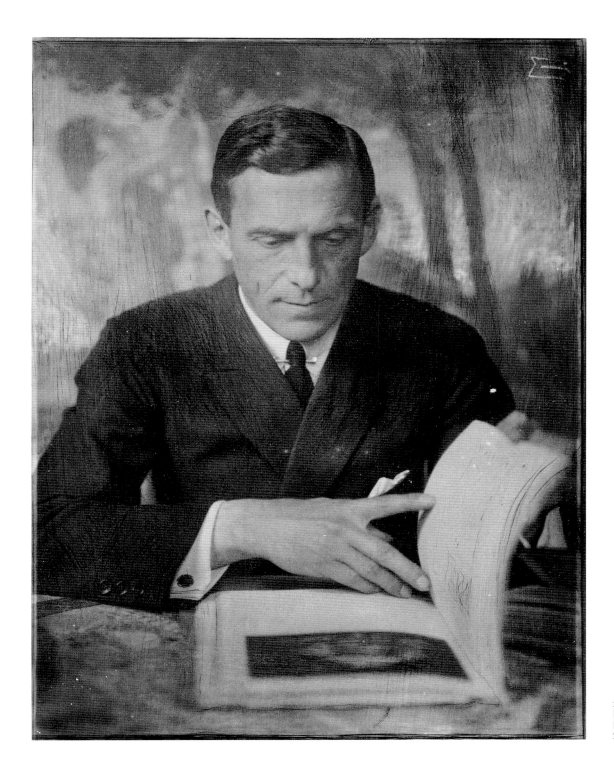

250. Carl Ernst Poeschel, c. 1915
D.O.P., 17.4 x 12.6 cm
Fotomuseum im Münchner
Stadtmuseum (88/26-92)

251. Studio wall with paintings
by Frank Eugene Smith, c. 1895
Albumen print, 18.0 x 12.9 cm
Fotomuseum im Münchner
Stadtmuseum (88/27-113)

239

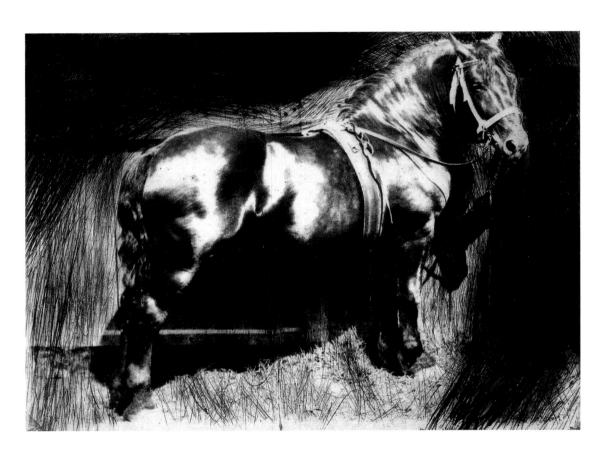

252. The Horse, c. 1898
Platinum print, 8.3 x 10.9 cm
Fotomuseum im Münchner
Stadtmuseum (88/27-125)

Frank Eugene: On the Borderline between Painting and Photography

by Axel Effner

A solo exhibition in the New York Camera Club in 1899 made Frank Eugene internationally famous practically overnight. The daring with which this amateur photographer, who was in fact a trained artist, disregarded all the conventions, completely altering the character of photographs by manipulating them with etching needles, wax crayons or paintbrushes, was looked upon almost as revolutionary. The reactions, however, were contradictory, as can be seen from an article by the renowned art critic Sadakichi Hartmann in the December 1889 issue of the journal *Photographic Times*.[1]

In the manipulations undertaken by Frank Eugene, Hartmann saw above all an expression of his self-understanding as a painter. In his search for new techniques and possibilities of expression, photography, according to Hartmann, served Eugene as an experimental laboratory, as did the other graphic arts. The specific features of the photographic medium itself were of only secondary interest to him. It is no coincidence that Hartmann gave Smith, who was already a well-known portrait painter, the title of "painter-photographer." Hartmann regarded the conspicuous cross-hatching and etching merely as a corrective by means of which Smith intended to conceal weaknesses in his photographic technique. Although Hartmann does in fact give recognition to Smith's pioneering achievements and his considerable creative virtuosity as a photographer, he saw no future for the photographs as such.

A general change in attitude can be observed only two years later in a book entitled *Photography as a Fine Art* which made an essential contribution towards gaining recognition for American art photography. The author, Charles H. Caffin, saw in Eugene's procedure a high degree of individual expression. It was Caffin's conviction that only a trained and gifted photographer was in a position to create such delicate images and alter their power of expression so masterfully by manipulating them. He attributes a very special quality to the photograph "The Horse," characterizing it in the following way: "Well, to myself, that print, printed as it is on Japan paper, conveys every impression of an etching, having the beautiful characteristics that one looks for therein: spontaneousness of execution, vigorous and pregnant suggestive-

ness, velvety color, and the delightful evidence of the personal touch."[2] Almost twenty-six years later, when he was already a professor at the Staatliche Akademie in Leipzig, Frank Eugene expressed his own views on this photograph: "It has often been said that the photograph was reminiscent of an etching. But that was in no way intended. The banal surroundings which were inessential and disruptive to the photograph as a whole were removed from the negative with a retouching knife, but nothing else was changed, neither the light, nor the shadows, nor the form and line of the animal's body."[3]

With reference to the artist Adolph von Menzel, he goes on to talk about his method: "Drawing means leaving out. Applied to photography, this statement has a slightly altered meaning: photography means taking things out. To make a partial drawing, as with a pencil or paintbrush, is something even the best camera lens cannot do. This is where manual dexterity or photomechanical handling comes into play. But woe betide you thrice, if this is allowed to interfere with the documentary value! It is only justified where the aim is to suppress the inessential in favor of the essential."[4]

A comparison between Smith's early works and those of his Munich period, for example his portraits of various artists, reveals that however much this form of manipulation of the negative may at first have been technically motivated, according as he perfected his technique he used it more and more as a consciously individual stylistic means, as a type of visiting card, so to speak, a distinguishing feature. That he was successful in this is proved by the numerous attempts made by other art photographers to imitate him.

Frank Eugene's significance lies above all in his dual role of painter and link between the American and European art photographers. It is a well-known fact that the whole movement had an international propensity which took the form of exhibitions, simultaneous membership in several clubs, and a series of publications, among them the famous *Camera Work*. The motifs and creative features in Eugene's work clearly demonstrate the influences exercised upon him by the artistic environment in America and Munich. Yet despite the variety

253. Elisabeth Blanche Walsh (Mrs. Hartmann), c. 1898 from: Harry W. Lawton and George Knox (ed.), *The Valiant Knights of Daguerre. Selected Critical Essays on Photography by Sadakichi Hartmann*, Los Angeles 1978, p. 179

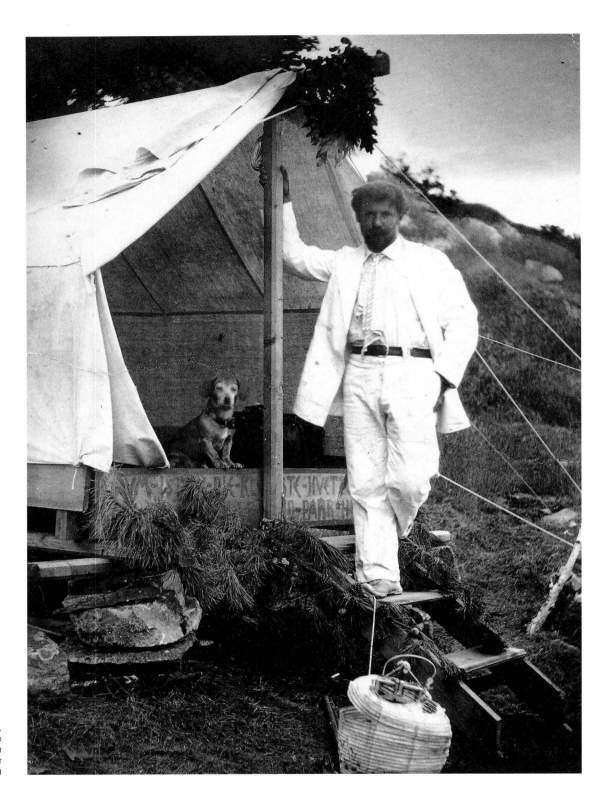

254. Self portrait with dog,
c. 1900
Platinum print, 16.5 x 11.8 cm
Fotomuseum im Münchner
Stadtmuseum (94/734)

Frank Eugene Smith: Grenzgänger zwischen Malerei und Photographie

von Axel Effner

Die Einzelausstellung im New Yorker Camera Club machte Frank Eugene Smith 1899 praktisch über Nacht international bekannt. Fast revolutionär mutete die Kühnheit an, mit der sich ein als Maler ausgebildeter Photoamateur über alle Konventionen hinwegsetzte und den Charakter einer Photographie durch massive Eingriffe mit der Radiernadel, mit Ölwachsstift oder Pinsel völlig veränderte. Das Echo war widersprüchlich, wie der Artikel des renommierten Kunstkritikers Sadakichi Hartmann in der Dezemberausgabe der Fachzeitschrift *Photographic Times* (1899) belegt.[1]

Hartmann sah in den Manipulationen von Frank Eugene vor allem einen Ausdruck von dessen Selbstverständnis als Maler. Die Photographie diente ihm – parallel zu Versuchen in anderen graphischen Künsten – als Experimentierfeld für neue Techniken und Ausdrucksmöglichkeiten. Die spezifischen Eigenheiten des Mediums selbst interessierten ihn erst in zweiter Linie. Nicht umsonst verlieh Hartmann dem bereits als Porträtmaler bekannten Smith den Titel »Painter-Photographer«. Die deutlichen Schraffuren und Einzeichnungen betrachtete der Kunstkritiker vor allem als korrigierenden Eingriff, mit dem Smith aufnahmetechnische Mängel überdecken wollte. Hartmann erkannte zwar die Pionierleistung von Smith und ein gewisses Maß an künstlerisch geprägter Virtuosität an, gab den Photographien aber keine Zukunftschance.

Ein Einstellungswandel zeigte sich nur zwei Jahre später in dem Buch *Photography as a Fine Art*, das ganz wesentlich zur Anerkennung der amerikanischen Kunstphotographie beitrug. Der Autor Charles H. Caffin erkannte in Eugenes Vorgehensweise bereits ein Höchstmaß an individuellem Ausdruck. Nur ein künstlerisch ausgebildeter Photograph, so lautet sein Credo, sei imstande, derart delikate Bilder zu schaffen und den Ausdrucksgehalt durch die Bearbeitung virtuos zu verändern. Der Photographie ›The Horse‹ schrieb er eine besondere Qualität zu und charakterisierte sie mit folgenden Worten: »Nun, für mich vermittelt dieser Druck, so wie er ist, nämlich auf dünnes Japanpapier gedruckt, sämtliche Eindrücke einer Radierung, die alle wunderbaren Eigenschaften aufweist, die man darin sucht: Spontanität bei der Ausführung, Stärke und Prägnanz einer suggestiven Erzähl-

weise, samtartige Weichheit der Farbe und den bezaubernden Ausdruck einer persönlichen Handschrift.«[2]

Gut 26 Jahre später, als er bereits Professor an der Staatlichen Akademie in Leipzig war, nahm Frank Eugene selbst zu diesem Bild Stellung: »Man hat oft gesagt, das Bild erinnere an eine Radierung. Das war aber keinesfalls die Absicht. Es wurde nur auf dem Negativ die für das Bildganze unwesentliche und störende banale Umgebung mit dem Retuschiermesser entfernt, aber kein Licht, kein Schattenfleckchen, nichts an Form und Linienführung des Tierkörpers verändert.«[3]

Zu seiner Verfahrensweise führt er weiter aus, bezugnehmend auf den Künstler Adolph von Menzel: »Zeichnen heißt weglassen. Dieser Ausspruch, auf die Photographie übertragen, zeigt hier etwas geänderten Sinn: Photographieren heißt wegmachen. Nur partiell zu zeichnen wie ein Stift oder Pinsel vermag auch das beste photographische Objektiv nicht. Hier muß die manuelle Geschicklichkeit oder die photomechanische Behandlung auf den Plan treten. Aber dreimal wehe, wenn sie sich einen Eingriff in den Urkundenwert erlaubt! Sie hat nur Berechtigung, wo es gilt, das Unwesentliche zugunsten eines Wesentlichen zu unterdrükken.«[4]

Ein Vergleich von frühen Arbeiten und solchen aus der Münchner Zeit, etwa den Künstlerporträts, zeigt, daß Smith den anfänglich wohl technisch bedingten Eingriff ins Negativ im Laufe zunehmender Perfektion immer mehr als bewußt individuelles Stilmittel und sozusagen als eine Art Visitenkarte oder persönliches Erkennungsmerkmal einsetzte. Daß er damit Erfolg hatte, beweisen die zahlreichen Nachahmungsversuche anderer Kunstphotographen.

Frank Eugenes Bedeutung ist vor allem in seiner Doppelfunktion als Maler und als Bindeglied zwischen den amerikanischen und europäischen Kunstphotographen zu sehen. Bekanntlich war die ganze Richtung durch Ausstellungen, Mehrfachmitgliedschaften in Clubs und durch eine Reihe von Publikationsorganen, darunter etwa die berühmte *Camera Work*, international ausgerichtet. Die Motive und Gestaltungsmerkmale im Werk Eugenes zeigen ganz deutlich die Einflüsse des künstlerischen Umfelds in Amerika und in München, wodurch

255. Sadakichi Hartmann, c. 1898
from: *Camera Notes*, 3,
April 1900, p. 193

243

man – trotz der Vielfalt der einzelnen Sujets – eine gewisse Stilentwicklung ablesen kann: von einer dunklen, an Rembrandt erinnernden, vornehmen Motivgestaltung hin zur stilisierenden Jugendstilornamentik. Welche Einflüsse dabei eine Rolle spielten, wird im folgenden zu zeigen sein.

Amerikanische Künstler in München

Seine künstlerische Ausbildung erhielt Frank Eugene Smith an der Königlichen Akademie der Bildenden Künste in München. Laut Zeugnis studierte der Deutsch-Amerikaner aus New York von Dezember 1886 bis Juli 1894 mit Ausnahme von drei Semestern in der Naturzeichenklasse von Karl Raupp und Johann Herterich sowie in der Mal- und Komponierklasse von Wilhelm von Diez.[5]

München war – neben Paris – bereits früh zum Mekka für amerikanische Künstler geworden, die nach Höherem strebten. Die 1856 erfolgte Berufung des Delaroche-Schülers Karl von Piloty als Professor an die Akademie

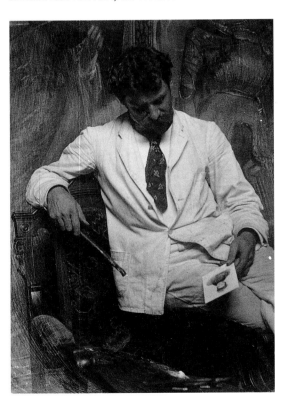

256. Self portrait as a painter, 1895
Platinum print
Fotomuseum im Münchner Stadtmuseum

1856 und seine Ernennung zu deren Leiter im Jahr 1874 wurde – bereits von Zeitgenossen – als Anbruch einer neuen Ära gesehen. Ein neuartiger, von intensiver Farbigkeit geprägter und monumental-dekorativ auftreten-

der ›Münchner Realismus‹ hielt damit Einzug. Er legte nicht nur den Grundstein für den Gründerzeitstil der bekannten Pilotyschüler Makart, Lenbach, Defregger oder Grützner, sondern mehrte auch den Ruhm der Akademie im Ausland.

Ein weiterer Magnet war die Komponierklasse von Wilhelm von Diez, der seit 1872 Professor an der renommierten Anstalt war. Bei ihm trafen sich progressive Maler der damaligen Zeit, die um die Jahrhundertwende die Schwelle zum Impressionismus und zum Jugendstil überschritten. Eine Reihe von Diez-Schülern wie Bruno Piglhein und Paul Höcker gehörte sogar zu den Gründungsmitgliedern der Münchner Secession.

Die hohe Anziehungskraft der Akademie nach der Berufung Pilotys bescherte ihr eine Flut von Neuanmeldungen: Von 1872/73 bis 1884 stieg die Zahl der Schüler von 240 auf 552. In etwa dem gleichen Zeitraum absolvierten allein 275 amerikanische Studenten dort ihre Ausbildung.[6] München, das hieß für amerikanische Künstler vor allem Lebensstil und Studium der alten Meister in der Pinakothek. Man traf sich im 1874 gegründeten American Artists' Club, im Max-Emanuel Cafe oder den Pollinger Künstlerkolonien, malte für Kostümfeste und war offen für Experimente.

Frank Duveneck und Frank Currier, die bereits 1869 bzw. 1871 nach München gekommen waren und dort eigene Schulzirkel gebildet hatten, wurden in den 1870er Jahren zu Leitbildern für die Neuankömmlinge aus den USA. Als einer der meistgefeierten kehrte Duveneck 1888 in die USA zurück. Ebenso wie andere Kunst-Pilger aus München wurde er in überregionalen Magazinen wie *Scribener's* oder *Century* als neue Gattung amerikanischer Bildnismaler stürmisch gefeiert und mit Aufträgen bedacht.

Paradigmatisch für den Erfolg der amerikanischen Künstler, die im Ausland studiert hatten, steht auch William Merritt Chase. Nach einem mit Unterbrechungen sechsjährigen Aufenthalt in München kehrte er 1878 nach New York zurück. Stilistische Kunstfertigkeit in der Tonmalerei und die mitgebrachten Kopien alter Meister öffneten dem Piloty-Schüler die Türen des finanzstarken Großbürgertums für einträgliche Porträtaufträge. Sein Kosmopolitentum dokumentierte sich in einem üppig dekorierten Gründerzeit-Atelier voller Kunstschätze und eigener Bilder, das den später errichteten Palästen von Lenbach, Kaulbach oder Stuck in München in nichts nachstand.[7] Für die nötige Aufmerksamkeit sorgten reichbebilderte Berichte über die New Yorker Studios im *Cosmopolitan* und anderen Magazinen. Zusätzlichen Ruhm erwarb sich Chase in den 1880er Jahren durch seine Lehrtätigkeit am Institut der Arts Students League,

of the individual subjects, a certain development in his own particular style can be observed – from a dark, elegant treatment of motifs reminiscent of Rembrandt, to stylized ornamentation typical of Art Nouveau. Precisely what the various influences were which played a role in this development will be examined in the following.

American Painters in Munich

Frank Eugene Smith, a German-American from New York, underwent his art training at the Königliche Akademie der Bildenden Künste (Royal Academy of Fine Arts) in Munich. According to his college report, he studied there from December 1886 to July 1894, with the exception of three semesters, participating in the nature drawing classes given by Karl Raupp and Johann Herterich, and in the painting and composition classes given by Wilhelm von Diez.[5]

For American artists with high aspirations, Munich – alongside Paris – very soon became a type of Mecca. The appointment of the Delaroche pupil Karl von Piloty as professor at the Academy in 1856 and his subsequent nomination as its head in 1874 were looked upon, even by contemporaries, as heralding the dawning of a new era. With him "Munich Realism," a new, intensively colorful and monumentally decorative phenomenon, made its appearance. Not only did this lay the foundations for the so-called Gründerzeit style of the renowned Piloty pupils Makart, Lenbach, Defregger and Grützner, it also enhanced the fame of the Academy abroad.

The composition classes given by Wilhelm von Diez also exerted a great magnetism. Diez had been professor at the famous school since 1872. His classes attracted the progressive painters of the time, who by the turn of the century were to cross the threshold to Impressionism and Art Nouveau. Some of Diez' students, for example Bruno Piglhein and Paul Höcker, were among the founder-members of the Munich Secession.

The attractiveness of the Academy after Piloty's appointment brought it a flood of new applications: from 1872/73 to 1884 the number of students increased from 240 to 552. Within about the same period, 274 American students alone completed their training there.[6] What Munich signified for American artists was, above all, lifestyle and the opportunity to study the Old Masters in the Pinakothek. Their meeting places used to be the American Artists' Club, founded in 1874, the Max-Emanuel Café, or the artists' colony

at Polling. They painted for fancy-dress balls, and they were open-minded about experimentation.

In the 1870s, Frank Duveneck and Frank Currier had the function of role-models for the newcomers from the USA. They had come to Munich in 1869 and 1871 respectively, and had formed their own circles there. Duveneck, who became one of the most celebrated among them, returned to the USA in 1888. Like other art pilgrims returning from Munich, he was given a tumultuous welcome home and was even characterized in such supra-regional magazines as *Scribener's* or *Century* as belonging to a new genre of American portrait painter. He subsequently received ample commissions.

William Merritt Chase is another example of the success enjoyed by American artists who had studied abroad. After a six-year sojourn in Munich, which also included a few interruptions, he returned to New York in 1878. His stylistic skills in tone painting, plus the copies of the Old Masters he had brought back with him, opened the doors of the wealthy *haute bourgeoisie* to this Piloty pupil and brought him lucrative portrait commissions. His cosmopolitan flair was also expressed in his studio interior: decorated sumptuously in the Gründerzeit style, full of art treasures and samples of his own work, it was in no way inferior to the palaces which Lenbach, Kaulbach and Stuck created later in Munich.[7] Richly illustrated reports on such New York studios in *Cosmopolitan* and other magazines attracted the necessary public attention. Chase also won additional fame in the 1880s through his classes at the institute of the Arts Students League, the Brooklyn Art Association, and in his own school, which he founded in 1896.

Chase's success is of importance for Frank Eugene Smith in as far as it prepared the ground for him in advance of his own return to the metropolis of New York. After his studies at the Academy in Munich Eugene worked in New York as a portrait painter from 1895 onwards, painting famous actors and actresses, doing sketches for stage settings and, most probably, directing his own school of painting.

Wilhelm von Diez' Studio

Although the Americans in Munich, like the art students from other countries, had their own artists' colonies in this "Athens on the Isar," they still maintained close contacts to the Munich art community. Chase painted portraits of Eduard von Grützner and Hugo von Habermann, even trying to imitate Habermann's

der Brooklyn Art Association und seiner eigenen Schule, die er 1896 eröffnete.

Für Frank Eugene Smith ist der Erfolg von Chase insofern von Bedeutung, weil für ihn damit bereits der Boden vorbereitet war, als er nach seinem Akademiebesuch in München in die Metropole New York zurückkehrte. Ab 1895 arbeitete er dort als Porträtmaler für Schauspielberühmtheiten, erstellte Entwürfe für Bühnendekorationen und leitete – vermutlich – eine Malschule.

Das Atelier von Wilhelm von Diez

Obwohl die Amerikaner, Maler wie anderer Nationen auch, im ›Isar-Athen‹ eigene Künstlerkolonien hatten, pflegte man zur Münchner Künstlerschaft enge Kontakte. Chase malte Porträts von Eduard von Grützner oder Hugo von Habermann, wobei er versuchte, Habermanns Stil in einer Art Hommage nachzuahmen. Wilhelm Leibl andererseits, Anfang der 1870er Jahre das große Vorbild für viele Amerikaner, inspirierte mit seiner alla-prima-Technik und skizzenhaften Malweise z.B. deutlich Werke von Frank Currier.[8] Nicht vergessen werden darf allerdings, daß die Hauptmeister der neuen Malerei in Amerika mit der noblen Münchner Tonmalerei dort zwar ihren Ruhm begründeten, sich später aber weiterentwickelten und – wie etwa Chase und Duveneck – zu führenden Vertretern des Impressionismus wurden, dessen französische Variante sich der ›neuen Welt‹ erstmals 1886 bei einer Ausstellung in New York präsentiert hatte.[9]

Zum lockeren Umgangsstil, der von bohemienhafter Atmosphäre und Offenheit für Experimente geprägt war, trug mit Sicherheit auch die Art des Unterrichts bei Wilhelm von Diez bei, der während seines knapp vierzigjährigen Lehramtes an die 1000 Studenten unterrichtet hat. Seine Schule, in der Traditionsbewußtsein und Fortschrittlichkeit zusammentrafen, gehörte zur progressivsten der damaligen Zeit. Georg Jacob Wolf bezeichnete sie sogar als »Wiege der gesamten modernen Malerei in München«.[10]

Mit seinem Unterricht bezweckte Diez, die Schüler für genaue Licht- und Farbbeobachtung auf der Basis unmittelbarer Naturbeobachtung zu sensibilisieren. Zu diesem Zweck holte er markante ›Charakterköpfe‹ aus dem Volk in das Atelier und ließ die Schüler immer neue Skizzen verschiedener malerischer Posen anfertigen. Stellung, Beleuchtung und Hintergrund wechselten dabei in immer neuen Kombinationen, die mit Improvisationsgeschick arrangiert und ausprobiert wurden.[11]

Andererseits versuchte man, mit Hilfe von Photographien oder Reproduktionen die Posen bekannter Bilder auf das Genaueste nachzuahmen. Dabei ging der Maler manchmal sogar soweit, sein Modell in einen eigens angefertigten Rahmen zu setzen, um die Illusion zu haben, ein Bild abzumalen.[12] Leibls Werke wurden als Vorbild für meisterhafte Malkunst hingestellt. Neben der Modellmalerei im Atelier war Diez das intensive Studium alter Meister in der Pinakothek ein zentrales Anliegen, das ihm selbst den Weg zum Erfolg geebnet hatte. Holländische und flämische Maler des 16. und 17. Jahrhunderts wie Hals, van Dyck oder Rembrandt sowie die Spanier Ribera und Zurbaran waren Leitbilder, deren Methodik es zu verinnerlichen galt.

Wichtig war es für Diez, die Schüler ihren eigenen Stil entwickeln zu lassen und nur von Fall zu Fall korrigierend einzugreifen. Über die Lust am Probieren neuer Möglichkeiten berichtet Faber du Faur: »Ob man von der Farbe, der Fläche oder der Linie ausging, ob man auf absorbierender Leinwand, auf Ölgrund oder geleimter Pappe, auf hellem, dunklem, roten oder schwarzen Grund malte, alles mochte man versuchen; die Schule war da, sich auszuprobieren, zu lernen.«[13] Bei aller Freiheit hatte Diez allerdings konkrete Vorstellungen über die Technik. Der ohne Vorzeichnung übertragene, ›malerische‹ Pinselstrich sollte als solcher erkennbar bleiben und nicht – wie bei Piloty – durch glatte Lasur einen oberflächlichen und rein auf dekorative Wirkung abzielenden Realismus vortäuschen.

Die Ausbildung in der Diez-Klasse blieb auf Frank Eugene nicht ohne Wirkung. Hartmann erwähnt in dem Artikel über den »Painter-Photographer«, daß seine Schauspielerporträts mehr Genreszenen als »normalen« Darstellungen ähneln und sich die Reichhaltigkeit an Farben der Harmonie des Tons unterordnet. Die Darstellung der Schauspieler in bestimmten Rollen kam Smith insofern gelegen, da auch im Atelier von Diez zeitgenössische Modelle mit Kostümen à la van Dyck gemalt wurden oder als Edelfräulein, Bauern, Marodeure und Ritter aus der Zeit des Dreißigjährigen Krieges auftraten. Joe Jefferson etwa, so schreibt Hartmann, malte der »Painter-Photographer« mehr als ein Dutzend Mal in verschiedenen Rollen. Der Autor erwähnt auch, daß Smith sich bereits vor der Jahrhundertwende intensiv mit der Kunstphotographie auseinandergesetzt hatte und über mehrere hundert Aufnahmen verfügte.[14] Möglicherweise arbeitete er hier ähnlich wie Lenbach, Stuck, Kaulbach, Leibl, Slevogt und eine ganze Reihe anderer Maler, die sich der Photographie als Vorlage bedienten, wobei die Photographie für Smith bedeutend mehr war als reine Arbeitsvorlage.

own style as a type of homage. Wilhelm Leibl on the other hand, who at the beginning of the 1870s was the great role-model for many Americans, obviously influenced the works of Frank Currier, for example, especially through his alla prima technique and sketch-like method of painting.[8]

What must not be forgotten, however, is that although the outstanding masters of the new style of painting in America may have gained their fame there on the basis of their elegant Munich tone painting, they did go on to develop further and — like Chase and Duveneck — became leading representatives of Impressionism, the French version of which had been first introduced to the New World in 1886 in an exhibition in New York.[9]

257. Joseph Jefferson as Caleb Plummer, c. 1895
Oil on canvas
from: *New York Tribune Illustrated Supplement*, 1898, p. 3

Something which surely contributed to these artists' more informal overall style, marked as it was by a somewhat bohemian air and an openness for experimentation, was Wilhelm von Diez' teaching method. During his almost forty years as a teacher, he put a good 1,000 students through his hands. His school, which coupled an awareness for tradition with progressiveness, was one of the most advanced of the time. Georg Jacob Wolf even designated it the "birthplace of all of modern painting in Munich."[10]

Through his particular style of teaching, Diez aimed at sensitizing his students to an exact treatment of light and color based on a direct observation of nature. For this purpose he brought "striking heads" chosen from among the general public into his studio and instructed his students to do series of sketches of different artistic poses. Position, lighting and background were altered in ever new combinations, each of them arranged and tried with great powers of improvisation.[11] On the other hand, with the aid of photographs or reproductions, attempts were also made to imitate as exactly as possible poses from well-known paintings. To do this Diez often went as far as to sit his model in a specially constructed frame so as to create the illusion of painting from a picture.[12]

Leibl's works were also looked upon as models of masterly painting. In addition to painting models in the studio, Diez was also concerned with promoting an intensive study of the Old Masters in the Pinakothek, something which had helped in paving his own path to success. He regarded the Dutch and Flemish painters of the 16th and 17th centuries such as Hals, van Dyck and Rembrandt, as well as the Spaniards Ribera and Zurbaran, as models whose methods it was essential to internalize.

Diez also felt it was important to allow his students to develop their own individual style, only intervening from case to case to make corrections. Faber du Faur describes the delight experienced by the class in trying out new possibilities: "It did not matter whether you began with the color, the surface or the line, whether on absorbent canvas, oil ground or sized cardboard, on a bright, dark, red or black priming. We wanted to try everything; the school was there for us to try things out, to learn."[13] Yet despite all the freedom he allowed, Diez had some very strict views about technique. The "artistic" brush stroke applied without a preparatory sketch should be recognizable as such, and not simulate by means of a smooth varnish a superficial realism intended purely for decorative effect — as in the case of Piloty.

Attendance at Diez's class certainly had its effects on Frank Eugene. In the article by Hartmann, with its reference to the "painter-photographer," the critic claims that Smith's portraits of actors are more like genre studies than "normal" portraits, and that the richness of the colors is subordinate to the harmony of the tone. The depiction of actors in specific roles was something which was very much in Smith's line. In Diez' studio too, models were painted in costumes à la van Dyck, or as noble maidens, peasants, maraud-

Frank Eugene Smith und die Malerei

Über den Wert der Malerei von Smith kann man nur bedingt Aussagen machen. So gut wie alle Werke lassen sich lediglich aufgrund von Schwarzweiß-Aufnahmen aus dem Atelier beurteilen, von wenigen Bildern liegen Einzelphotos vor. Die Vielfalt der Motive und der Stile sowie die Bandbreite der Werke von der Skizze bis zum fertigen Gemälde als auch die fehlende zeitliche Zuordnung machen ein Urteil äußerst schwierig. Akt-, Kinder- und Landschaftsszenen wechseln mit christlichen Motiven, Kopf- und Brustporträts in Rembrandtmanier und pastosem Pinselstrich stehen neben zart impressionistisch angehauchten Ganzfigurendarstellungen. Glücklicherweise sind für eine Beurteilung von Frank Eugenes Malerei wenigstens eine Reihe von Schauspielerporträts aus seiner New Yorker Zeit von etwa 1895 bis 1900 vorhanden. Ein Vergleich zeigt, daß Smith bei diesen Bildnissen vor allem auf die Dramaturgie der Lichtführung setzte, wie sie Rembrandt und Lenbach mit Erfolg vorexerzierten. Im Gegensatz zu den ›dunklen‹ Photoporträts aus dieser Zeit (Alfred Stieglitz, Miss Cushing, Master Frank Jefferson) zeichnet die Schauspielergemälde – auch durch die Farbwirkung – ein höheres Maß an Leuchtkraft aus, obwohl das Licht im Wesentlichen auf Oberkörper/Kopf und Hände gelenkt wird.[15] Die Szenendramatik des Lichts wird durch die rollenbedingte Gestik noch verstärkt, wie die Beispiele von Emma Calvé als verführerischer ›Carmen‹, Mrs. James Brown Potter als stolzer ›Marie Antoinette‹ und Joe Jefferson als betagter ›Rip van Winkle‹ zeigen. Durch dunkle Hintergründe und die formatfüllende Nähe der Dreiviertelporträts gelingt Smith eine weitere Konzentration auf die Dargestellten.

Mit seinem Eindruck von genrehaften Szenen hat Hartmann nicht ganz unrecht, zumal wenn man den skizzenhaft-realistischen Malstil des ›Painter-Photographer‹ in Betracht zieht. Smiths Bildern fehlt die repräsentative Kühle, die die feinlasierten Porträts der amerikanischen ›Starmaler‹ William Merritt Chase oder John Singer Sargent auszeichnet. Auch auf einem Ganzfiguren-Porträt von James McNeill Whistler wirkt der englische Schauspieler Sir Henry Irving – dargestellt als Philipp II. von Spanien – distanziert, kühl und kostümiert, aber nicht in seinem Element, dem Theater. Smith dagegen versteht es in seinen beiden vorliegenden Porträts, Irving durch Farbgebung und Lichtregie eine warme Note zu geben bzw. die Vornehmheit ironisch zu überspitzen. Eine Photographie von Irving legt zudem den Schluß nahe, daß Smith zumindest eines der beiden Porträts nach einer Photovorlage gestaltet hat.

Haltung, Ausschnitt und Lichtführung stimmen auf Gemälde und Photo überein.

Ähnliche Unterschiede lassen sich auch bei Münchner Malern feststellen. Friedrich August von Kaulbach etwa stellt die Schauspielerin Rosario Guerrero auf einer Bilderserie von 1903/04 vor allem in anmutsvoller, idealisierter Schönheit dar, während Albert von Keller in seinen Gemälden von Madelaine Guipet (als ›Kassandra‹, 1904) und Camilla Eibenschütz (als ›Lysistrata‹, o. Datum) sehr effektvolle Szenendramatik zu inszenieren weiß.[16] Tendenziell läßt sich feststellen, daß sich die Motivgestaltung bei Smith im Laufe der Zeit von einem abgedunkelten oder rein dekorativen zu einer Art ›interpretierendem‹ Hintergrund entwickelt hat. Beispiele dafür sind einzelne Photographien aus der Reihe der Münchner Künstlerporträts (Emanuel von Seidl, Hugo von Habermann, Siegmund von Hausegger, Rudolf von Seitz und Adolf Hengeler), Damenporträts mit einer Gemäldekopie nach Hans von Marées ›Drei Jünglinge unter Orangenbäumen‹ (1875-1880) als Bildgrund oder ein Halbfigurenporträt mit der Silhouette der Frauenkirche als Hintergrund, die Julius Diez für ein Plakat der Münchner Kunstgewerbeausstellung von 1908 entworfen hatte.[17] Großen Sinn für überzeugende Bildwirkung beweisen auch die Porträtphotos des Schachweltmeisters Dr. Emanuel Lasker mit Schachbrett im Hintergrund und das ›Jugendstil‹-Porträt von Willi Geiger.

Die Photographie bei Lenbach und Stuck

Wenn man auf das Wechselverhältnis von Malerei und Photographie im Werk von Frank Eugene Smith eingeht, sollte auch ein Blick auf die Stellung der Münchner Künstlerschaft zur Photographie geworfen werden. Zieht man beispielsweise den Fall des Künstlerfürsten Franz von Lenbach heran, so ist zu vermuten, daß Frank Eugene von ihm Anstöße für seine eigene Arbeit erhielt. So finden sich im Nachlaß des Bismarckmalers mit ›Eugene‹ signierte Photographien von Kostümfesten und umgekehrt in der Sammlung des Fotomuseums München historisierende Aufnahmen der Lenbachtochter Gabriele, die Smith vor oder um 1908, also einige Jahre nach Lenbachs Tod, aufgenommen haben dürfte. Weiter weisen Lenbach-Porträtaufnahmen des amerikanischen Kunstphotographen und Malers Edward Steichen aus dem Jahr 1901 auf ein Interesse des Malerfürsten an der Kunstphotographie. Bereits 1898 hatte Lenbach bei einem Besuch der Sonderausstellung der Secession am Königsplatz, in der führende Kunstphotographen ihre Werke präsentierten, großes Interesse für die neue Richtung bekundet. Schmoll gen. Eisenwerth sieht zudem in Lenbachs Ganzfigurenbildnis der Kronprin-

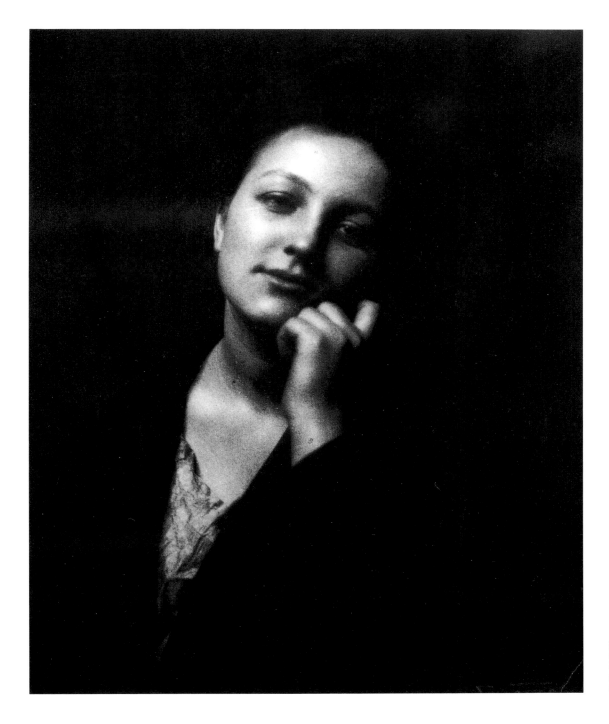

258. Miss Cushing, c. 1900
Platinum print, 14.8 x 18.8 cm
Metropolitan Museum of Art,
Alfred Stieglitz Collection, 1933
(33.43.377)

ers or knights from the time of the Thirty Years War. We learn from Hartmann that the "painter-photographer" painted Joe Jefferson, for example, more than a dozen times in different roles. However, he also mentions that before the turn of the century Smith was already intensively preoccupied with art photography and had several hundred photographs in his possession.[14] He possibly worked in a similar manner to Lenbach, Stuck, Kaulbach, Leibl, Slevogt and a number of other painters who used photographic studies as models. For Smith, however, the photograph was much more than just a working model.

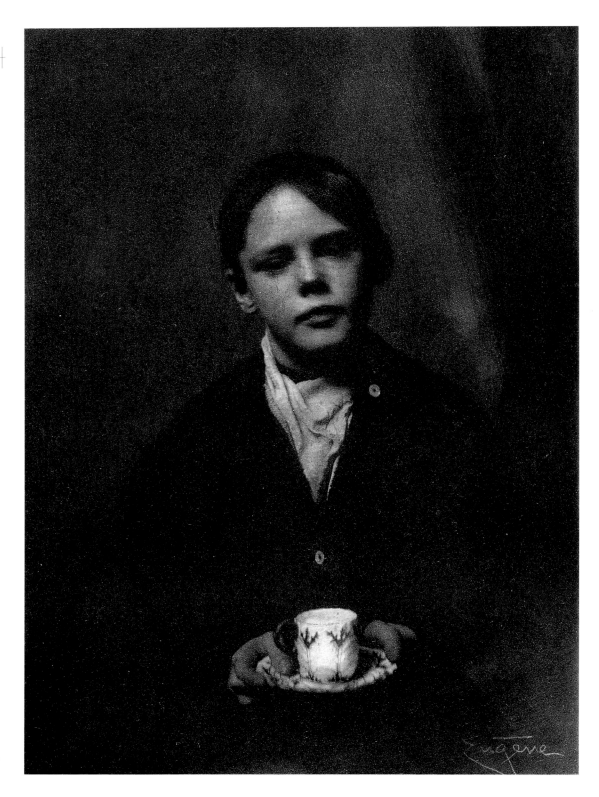

259. A cup of tea – Master Frank
Jefferson, 1898
Photogravure, 17.4 x 12.6 m
Fotomuseum im Münchner
Stadtmuseum (88/26-70)

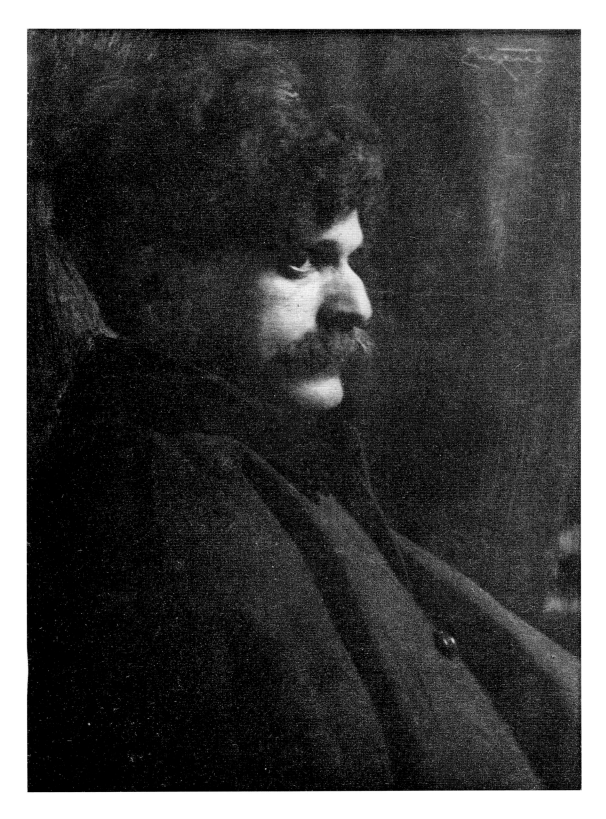

260. Alfred Stieglitz, c. 1899
Photogravure, 16.2 x 11.3 cm
Fotomuseum im Münchner
Stadtmuseum (88/26-18)

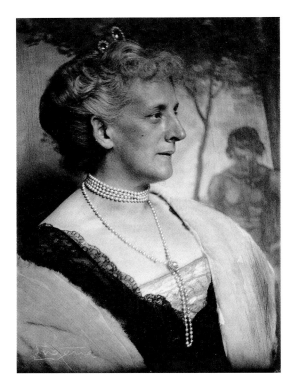

261. Portrait, 1890
Platinum print on tissue,
16.8 x 12.0 cm
Fotomuseum im Münchner
Stadtmuseum (88/26-33)

262. Mrs. Faber du Faur,
c. 1906/07
Platinum print, 17.0 x 12.0 cm
Fotomuseum im Münchner
Stadtmuseum (88/26-31)

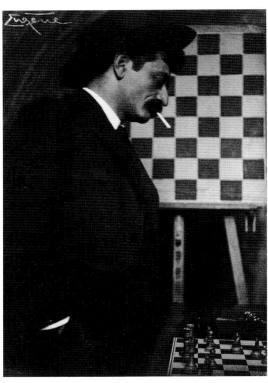

263. Dr. Emanuel Lasker, 1908
Platinum print, 16.8 x 11.6 cm
Metropolitan Museum of Art,
(33.43.85)

264. Fritz von Miller, c. 1907
Platinum print, 17.0 x 12.0 cm
Fotomuseum im Münchner
Stadtmuseum (93/631-1)

Frank Eugene Smith and Painting

Only a relative assessment of Smith's painting would seem appropriate, given that all we have got to judge most of his painted works on are black and white photographic impressions of his studio. Individual photographs exist of only very few of his paintings. The variety of motifs and styles, and the wide range of his works, from the sketch to the finished painting, not to mention the absence of any chronological order, make classification extremely difficult. Nude, child and landscape studies alternate with Christian motifs. Head and shoulder portraits in the style of Rembrandt and using impasto brushwork stand alongside full-length figures painted with a slightly impressionistic touch.
Fortunately, a series of portraits exists of actors and actresses painted in his New York period, i.e., around 1895 and 1900, and these are crucial to any judgement of Frank Eugene's painting. For the most part the portraits comply with the description given by Sadakichi Hartmann in 1899 in his "painter photographer" article. A comparison shows that in his portraits of actors Smith's main emphasis was on the dramatic use of light, as successfully demonstrated already by Rembrandt and Lenbach. Contrary to the "dark" photographic portraits of the time (Alfred Stieglitz, Miss Cushing, Master Frank Jefferson), Smith's paintings display a high degree of luminosity – also through the color effects – even though the light is mainly directed to the upper part of the body and the hands.[15] The dramatic effect of the light on the scene is further intensified by the gestures appropriate to the specific role, as in the case of Emma Calvé as the seductive "Carmen," Mrs. James Brown Potter as the proud "Marie Antoinette," and Joe Jefferson as the aged "Rip van Winkle." Smith achieved an even greater concentration of attention on the sitters through the dark backgrounds and the proximity of the three-quarter length portraits which avail themselves of the whole surface of the canvas.
The impression Hartmann had of "genre studies" is not far wrong, especially if one considers the "painter-photographer's" sketch-like, realistic painting style. Smith's paintings lack the representative aloofness which characterize the finely varnished portraits of the American "star painters" William Merritt Chase or John Singer Sargent. In a full-length portrait by James McNeill Whistler, the English actor Sir Henry Irving – in the role of Philip II of Spain – appears reserved, cool and costumed, but somehow not in his element, namely the theater. In both of Smith's surviving portraits of Irving in a sitting position, he has succeeded in giving the

actor a touch of warmth while at the same time ironically exaggerating his elegance by means of the coloring and the lighting. What is more, a photograph we have of Irving suggests that Smith painted at least one of the two portraits from a photographic study. Pose, composition and lighting are the same in the painting as in the photograph. Similar divergences in style can also be found between other Munich artists. In a series of paintings dating from 1903/04, Friedrich August von Kaulbach, for example, depicts the actress Rosario Guerrero primarily as a graceful and idealized beauty, whereas Albert von Keller managed to stage very effective and dramatic scenes in his paintings of Madelaine Guipet (as "Cassandra," 1904) and Camilla Eibenschütz (as "Lysistrata," no date).[16]

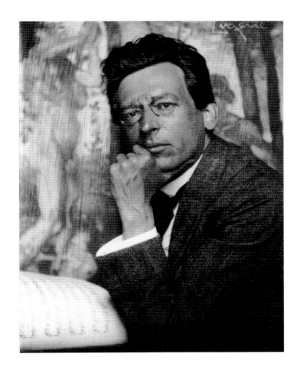

265. Siegmund von Hausegger,
c. 1908
Platinum print
Metropolitan Museum of Art,
Rogers Fund, 1972 (1972.633.126)

In the course of time Smith's treatment of motifs undergoes a process of development – from a darkened or purely decorative background to a type of "interpretative" background. There is ample evidence of this in a number of individual photographs from the series of portraits of artists which he undertook in Munich (Emanuel von Seidl, Hugo von Habermann, Siegmund von Hausegger, Rudolf von Seitz and Adolf Hengeler), in his portraits of women featuring a copy of a painting after Hans von Marées' "Drei Jünglinge unter Orangenbäumen" (1875–1880) in the background, and in his

zessin Louisa von Sachsen Anklänge an die Kunst-photographie gegeben.[18]

Lenbach bediente sich verstärkt seit 1880 der Photographie, um der anschwellenden Auftragsflut aus den Kreisen der Aristokratie und hochgestellter Persönlichkeiten Herr zu werden. In enger Zusammenarbeit mit dem Berufsphotographen Carl Hahn, der auch für Stuck und Kaulbach arbeitete, ließ er ganze Serien von bis zu 250 Aufnahmen (Bismarck) anfertigen. Die fast industriell anmutende Produktionsweise diente dazu, Zeit für Anreisen und langwierige Porträtsitzungen zu sparen, verschiedene Eindrücke und Perspektiven der Porträtierten optisch festzuhalten und die Arbeit bei Zweitbestellungen zu vereinfachen. Die Übertragung auf die Leinwand fand statt mit Hilfe von projizierten Großdiapositiven, Durchpausen mittels Griffel und Kohlestift oder durch die Direktbelichtung auf eine lichtempfindliche Emulsion, die auf der Leinwand aufgetragen wurde. Zahlreiche der im Fließbandverfahren produzierten Bilder lassen heute noch unter der Lasur die Schraffuren erkennen. Die Por-trätierten nahmen an der seit 1890 öffentlich bekannten Produktionsweise der auf ›altmeisterlich‹ getrimmten Gemälde, bei denen der Schwerpunkt auf dem Gesichts-bzw. Augenausdruck lag, keineswegs Anstoß, sondern bewunderten Lenbachs Virtuosität bei der Darstellung des individuellen Ausdrucks.[19]

Anders gelagert war der Fall bei Franz von Stuck, der Schmoll zufolge erst ab etwa 1895 über Lenbach mit der Photographie als Hilfsmittel für die Gemäldeproduktion bekannt wurde und sie in weit geringerem Maße nutzte als der Großproduzent Lenbach.[20] Mit Hilfe von Bleistift-skizzen komponierte Stuck den Aufbau seiner Photos in stilisierend-ornamentaler Weise als Vorlage für seine Gemälde. Exemplarisch kann man dies an penibel insze-nierten Studienaufnahmen eines Aktmodells für das Bild ›Verwundete Amazone‹ (1904) oder an Photos für das Gemälde ›Selbstbildnis mit Gattin im Atelier‹ (1902) nachvollziehen.[21]

Interessant im Hinblick auf die Vorgehensweise des etwa gleichaltrigen Frank Eugene Smith sind auch zwei

266. Lolo and Gabriele von Lenbach, c. 1908
Platinum print, 12.0 x 14.3 cm
Fotomuseum im Münchner Stadtmuseum (88/26-32)

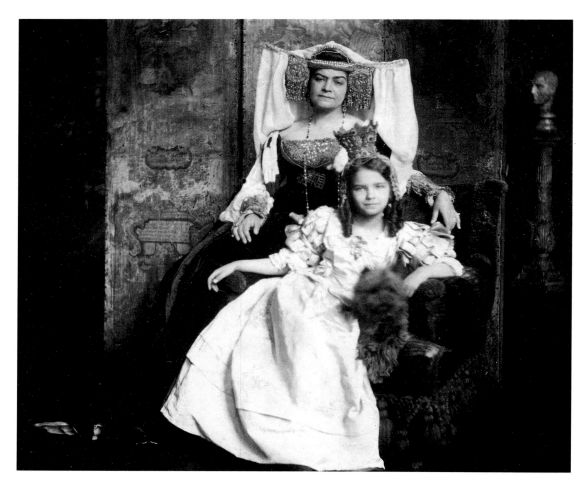

half-length portrait with a silhouette of Munich's Frauenkirche in the background which Julius Diez had done for a poster for the Munich arts and crafts exhibition of 1908.[17] His strong sense of compelling pictorial effect is displayed in his photographic portraits of the world chess champion Dr. Emanuel Lasker, with a chess board in the background, and his "Art Nouveau" portrait of Willi Geiger.

Lenbach, Stuck and Photography

When dealing with the interaction between painting and photography in the work of Frank Eugene Smith it is imperative to take a look at the attitude of the Munich art world to photography. If for example the very prince among artists, Franz von Lenbach, is taken into consideration then it can be safely assumed that Frank Eugene drew inspiration from him for his own work. The estate of the Bismarck-painter Lenbach contains photographs of fancy-dress balls which are signed "Eugene," and vice versa, in the collection of the Fotomuseum in the Münchner Stadtmuseum there are photographs of Lenbach's daughter Gabriele in historical costume which Smith must have taken before or around 1908, that is to say, some years after Lenbach's death.

Furthermore, photographic portraits of this prince among painters taken by the American art photographer and painter Edward Steichen (dating from 1901) point to Lenbach's interest in art photography. He had already made known his particular interest in this new art form in 1898 during a visit to the special Secession exhibition on the Königsplatz in which leading art photographers showed their works. Schmoll gen. Eisenwerth sees evocations of art photography in Lenbach's full-length painting of crown princess Louisa of Saxony.[18]

Lenbach had been making increasing use of photography since 1880 so as to be able to keep up with the rising flood of commissions from aristocratic circles and from other high-ranking personalities. In close cooperation with the professional photographer Carl Hahn, who also worked for Stuck and Kaulbach, he had whole series of up to 250 photographs (Bismarck) taken. This quasi industrial production method was intended not only to save time, which would otherwise have been squandered on travel and lengthy portrait sittings, but also to fix different impressions of, and perspectives on the sitter and to simplify the work involved in repeat orders. Transposition to the canvas was achieved by projecting large-format slides, by tracings done with stylus and charcoal, or by direct exposure onto a photo-

sensitive emulsion applied to the canvas. Today it is still possible to recognize the hatching beneath the varnish on many of the paintings done in this production-line manner. The people portrayed did not take exception to this method of production, which had been public knowledge since 1890 and by means of which the paintings were made to look somewhat like "Old Masters," with the main emphasis being placed on the facial expression or the eyes. On the contrary, Lenbach was highly praised for his virtuosity in depicting individual expression.[19]

267. *Franz Grainer*
Franz von Lenbach, c. 1900
D.O.P., 26.1 x 20.3 cm
Fotomuseum im Münchner
Stadtmuseum (81/8)

In the case of Franz von Stuck things were a little different. According to Schmoll, Stuck only became acquainted with photography as a support in the production of paintings around 1895 through Lenbach, and used it to a much lesser extent than the latter did in his large-scale production.[20] Stuck composed the photographs which he intended for use as studies for his paintings well in advance and with the help of pencil sketches done in a stylized, ornamental manner. One can study this procedure on the basis of the painstakingly staged studio photographs of a nude model taken as studies for the painting "Wounded Amazon" (1904), or the photographs for the painting "Self-portrait with Wife in Studio" (1902).[21]

There are two other details in Stuck's procedure which are of interest when considering the work of his peer Frank Eugene Smith. For example, Stuck made corrections

255

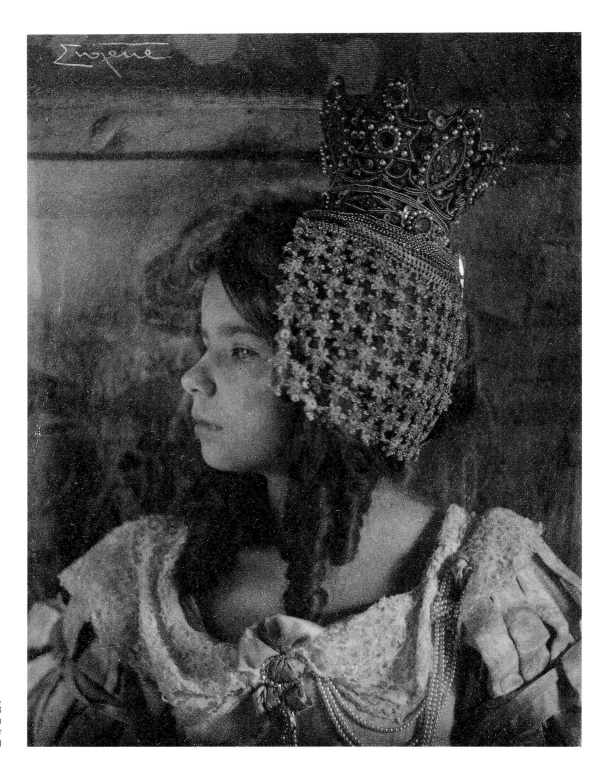

268. Gabriele von Lenbach,
c. 1908
Platinum print, 16.8 x 11.9 cm
Fotomuseum im Münchner
Stadtmuseum (88/26-93)

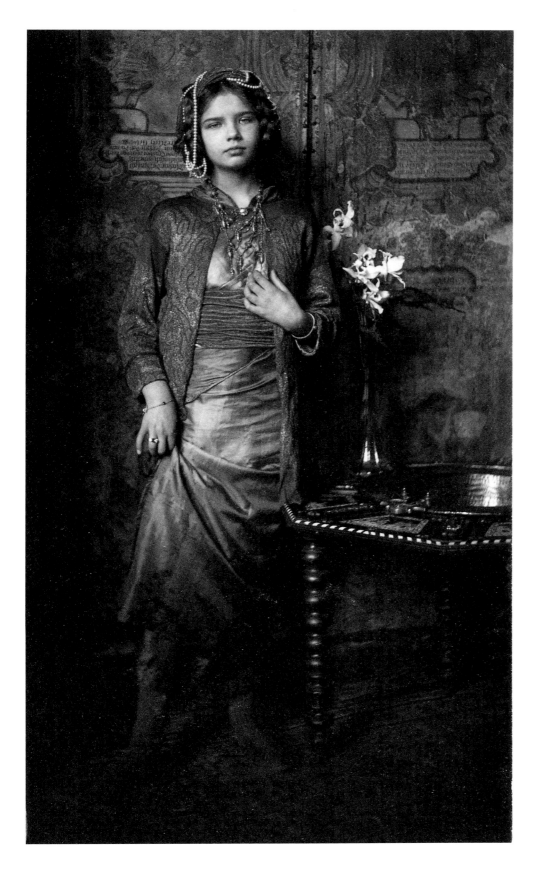

269. Gabriele von Lenbach,
c. 1908
Platinum print, 16.7 x 9.7 cm
Fotomuseum im Münchner
Stadtmuseum (88/27-28)

257

andere Details bei Stuck. Mit Bleistift und Feder nahm er beispielsweise Korrekturen auf Modellaufnahmen vor, während er Photoreproduktionen seiner eigenen Werke mit Farbe und Tusche regelrecht übermalte, um neue Wirkungen zu studieren. Eine ähnliche Vorgehensweise findet sich bei Smith, der das gleiche Motiv durch die Wahl anderer Techniken bzw. durch unterschiedliche Überzeichnungen mit der Tuschefeder virtuos in seiner Wirkung zu verändern wußte. Beispiele dafür sind ›The Horse‹, das Bildnis von Willi Geiger und die Aufnahmeserie der ›Lady of Charlotte‹.

Bereits während seines Studiums an der Akademie in München hatte Smith reichlich Gelegenheit gehabt, in der Alten Pinakothek die Kunst der alten Meister zu studieren. Publikationen der Münchner Verlage Bruckmann und Hanfstaengl sowie die internationalen Kunstausstellungen im Glaspalast und eine ansehnliche Zahl von Kunstzeitschriften bzw. -magazinen taten das übrige, einen regen Informationsaustausch über das aktuelle und vergangene Kunstgeschehen zu fördern. In den Photozeitschriften wurde zudem in einer wahren Artikelflut das Verhältnis zwischen Photographie und Malerei in immer neuen Aspekten untersucht und wurden praktische Tips gegeben.

Auch im elitären Kreis der Kunstphotographen um Alfred Stieglitz in New York wurde immer wieder auf die Notwendigkeit hingewiesen, die Werke von Rembrandt, Velázquez, Hals, Dürer oder Holbein zu studieren, um daraus Gesetzmäßigkeiten für die Photographie abzuleiten.[22] Neben Frank Eugene hatten beispielsweise auch Edward Steichen und Gertrude Käsebier eine Ausbildung als Maler durchlaufen. Sie erklärten wiederholt, daß es auf die Umsetzung nach eigenen Ideen ankomme und nicht auf das gedankenlose Kopieren fremder Werke.[23]

In einem Artikel in den *Camera Notes*, dem Publikationsorgan des Camera Club of New York, kritisierte Sadakichi Hartmann den exzentrischen Kunstphotographen Fred Holland Day wegen der frappierenden Ähnlichkeit von manchen seiner Bilder mit Abbildungen von Werken moderner Maler in den aktuellen Kunstzeitschriften.[24] An Gertrude Käsebier hob er lobend hervor, das sie es »vortrefflich versteht, Gemälde alter Meister aufzunehmen, so daß man nicht glaubt, daß es Photographien, sondern Reproduktionen sind«.[25] Bei Frank Eugene wiederum vermerkte er negativ, in den Bildern einen allzu deutlichen Einfluß der Malerei zu spüren.[26]

Wir wollen diesen Gedanken nun nachgehen und einige Werke von Frank Eugene einer näheren Betrachtung unterziehen.

Präraffaelitische Kunst als Vorbild

Geradezu auffällig sind die Parallelen zur präraffaelitischen Kunst bei zwei Selbstbildnissen von Frank Eugene. Sein ›Man in Armor‹, in dem er sich selbst von der linken Seite her als Halbfigurenbild in Ritterrüstung präsentiert, ist eine spiegelbildliche Interpretation des Selbstbildnisses des Malers George Frederick Watts als junger Mann in Rüstung, das sich beispielsweise 1904 in der Werkmonographie von Otto Schleinitz aus der Reihe der Künstlermonographien von Heinrich Knackfuß wiederfindet. Ausleuchtung des Bildraums, Spitzlichter, Körperhaltung, Bildausschnitt und das Alter der Porträtierten entsprechen sich in etwa. Anregungen hatte Smith möglicherweise von Steichen erfahren, der Watts um 1900 mehrmals porträtiert hatte.

Denkbar ist aber auch ein anderer Weg, der uns auf eine neue Spur führt. Watts stand dem Künstlerkreis der Präraffaeliten sehr nahe, zu dem ebenfalls die englische Photographin Julia Margaret Cameron eine enge Beziehung hatte. In ihren großteils Ende der 1860er Jahre entstandenen Albuminbildern griff sie bewußt die verträumt-idealisierte Bildsprache der Präraffaeliten auf, die sich ihrerseits, wie Beispiele von Watts und Dante Gabriel Rossetti belegen, photographischer Porträtstudien bedienten.[27] Charakteristisch für die Photos von Cameron sind ein an Rembrandt erinnerndes Hell-Dunkel in der Lichtführung, eine leichte Unschärfe und der Eindruck eines sehr persönlichen und privaten Aufnahmeambientes. Die Frische einer spontan aufgenommenen Momentsituation verbindet sich dabei mit der anmutsvollen Würde einer einstudierten Porträthaltung.

Ähnlich wie die Bilder von David Octavius Hill aus der Frühzeit der Photographie galten auch die Werke von Cameron wegen ihres Ausdrucks als vorbildhafte Ikonen, die auf Ausstellungen 1890 im Camera Club London, 1894 im Photo-Club de Paris und 1898 in der Hamburger Kunsthalle gezeigt und in öffentliche Sammlungen aufgenommen wurden.

Daß Smith sich mit den präraffaelitischen Bildmotiven intensiv auseinandersetzte, belegten eine ganze Reihe von Photos, die den idealistisch-verträumten Duktus aufgreifen. Möglicherweise war er in den 1890er Jahren durch Ausstellungen von Cameron oder Rossetti, von denen Gemälde und Photographien in der Pennsylvania Academy of Fine Arts und im Century Club New York gezeigt wurden, mit der Thematik bekannt geworden.[28] Der direkte Einfluß von Cameron-Werken läßt sich an mindestens drei Arbeiten von Smith festmachen. Eine direkte Übereinstimmung weist ein Selbstporträt von Smith mit der als ›Beatrice Cenci‹ betitelten Aufnahme

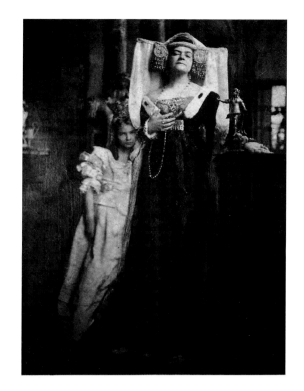

271. Lolo and Gabriele von
Lenbach, c. 1908
Platinum print, 16.8 x 12.0 cm
Estate of Franz von Lenbach,
Alfred Neven DuMont, Cologne

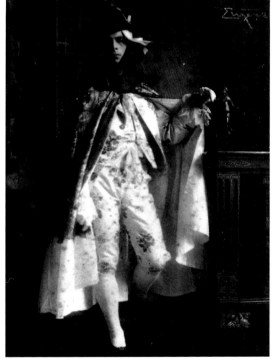

270. Page, c. 1908
Platinum print, 16.8 x 12.0 cm
Estate of Franz von Lenbach,
Alfred Neven DuMont, Cologne

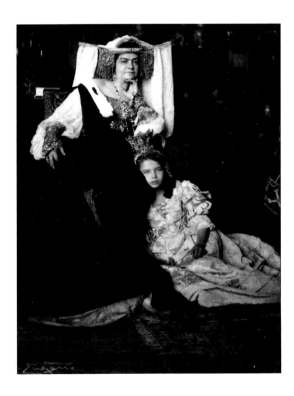

272. Lolo and Gabriele von
Lenbach, c. 1908
Platinum print, 16.0 x 12.0 cm
Estate of Franz von Lenbach,
Alfred Neven DuMont, Cologne

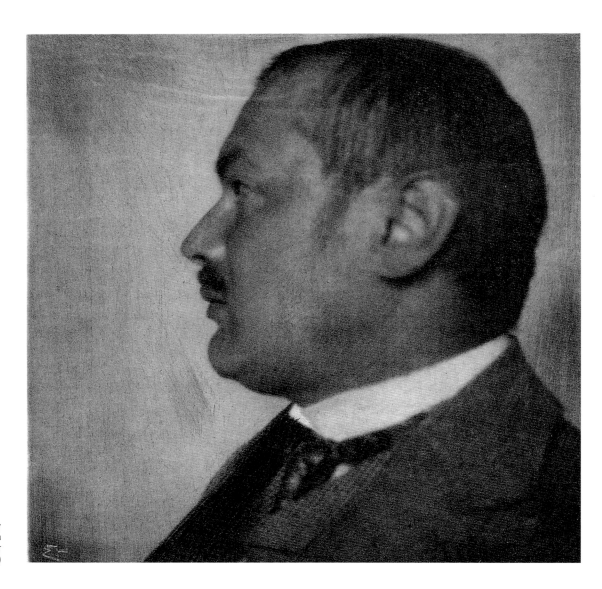

273. Franz von Stuck, c. 1907
Photogravure, 12.2 x 12.0 cm
Fotomuseum im Münchner
Stadtmuseum (88/26-4)

to his photographic studies using a pencil and quill, and even painted over photographic reproductions of his own paintings with paint and India ink in order to study the new effects which this produced. Smith used a similar procedure and with great virtuosity succeeded in altering the effect which one and the same motif can have by selecting different techniques or by drawing over parts of it using an India ink pen. Examples of this are "The Horse," the portrait of Willi Geiger, and the series of photographs entitled "Lady of Charlotte."

During his training at the Academy in Munich Smith already had sufficient opportunity to study the art of the Old Masters in the Alte Pinakothek. A lively debate and exchange of information and views on current and past events in the world of art was being carried on at the time in publications from the Munich publishing houses Bruckmann and Hanfstaengl, in the international art exhibitions in the Glaspalast and in a considerable number of art journals and magazines. A veritable flood of articles in photographic journals dealt with the relationship between photography and painting, highlighting it from ever new perspectives and proffering practical tips.

Even in the elitist circle of art photographers around Alfred Stieglitz in New York constant emphasis was placed on the necessity of studying the works of Rembrandt, Velázquez, Hals, Dürer or Holbein so as to deduce principles for photography from their works.[22] Not only Frank Eugene, but also Edward Steichen, and Gertrude Käsebier had trained as painters. They were to declare again and again that the point of such a study of the Old Masters was to be in a position to carry out a transposition in accordance with one's own ideas and not merely an unthinking copy of another artist's work.[23]

In an article published in *Camera Notes*, the official medium of the Camera Club of New York, Sadakichi Hartmann criticized the eccentric art photographer Fred Holland Day for the striking resemblance many of his photographs had with reproductions of works by modern painters in art journals of the time.[24] On the other hand, Hartmann praised Gertrude Käsebier for her excellent understanding of "how to photograph paintings by Old Masters so that one believed they were reproductions and not photographs."[25] Of Frank Eugene he remarked negatively that his photographs betrayed an all too obvious influence of painting.[26] Let us now, therefore, deal with this criticism by taking a closer look at some of the works of Frank Eugene.

Pre-Raphaelite Art as a Model

There are two self-portraits by Frank Eugene in which the parallels to Pre-Raphaelite painting are more than striking. His "Man in Armor," a half-length self-portrait in knight's armor viewed from the left, is a mirror-image interpretation of a self-portrait by the artist George Frederick Watts also as a young man in armor, as it is reproduced, for example, in the 1904 monograph by Otto Schleinitz, one of a series of monographs of artists published by Heinrich Knackfuß. The lighting of the scene, the highlights, pose, composition and age of the persons portrayed more or less correspond. Smith possibly drew his inspiration from Steichen who had taken several portraits of Watts around 1900.

However, another avenue of approach is also conceivable and leads us in quite a different direction. Watts was very close to the Pre-Raphaelite circle of artists, with which the English photographer Julia Margaret Cameron also had close connections. For her albumin prints, taken for the most part at the end of the 1860s, she consciously adapted the dreamy, idealized pictorial language of the Pre-Raphaelites, who for their part made use of photographic portrait studies, as proved by examples of works by Watts and Dante Gabriel Rossetti.[27] Cameron's photographs are often characterized by transitions in the lighting from bright to dark, reminiscent of Rembrandt, by a slight blur, and by the impression they communicate of a very personal and private atmosphere. Thus the freshness of a spontaneously photographed momentary situation is mingled with the gracious dignity of a studied portrait pose. Like the photographs of David Octavius Hill from the early years of photography, Cameron's works also qualified as exemplary icons on the basis of their great power of expression. They were shown in exhibitions in the Camera Club London in 1890, in the Photo-Club de Paris in 1894 and in the Hamburg Kunsthalle in 1898, and were also acquired for public collections.

A whole series of photographs by Smith which adopt a similar idealistic, dreamy mode prove that he was intensively preoccupied with Pre-Raphaelite pictorial motifs. He possibly became acquainted with the themes in the 1890s through exhibitions of the works of Cameron or of Rossetti, whose paintings and photographs were shown in the Pennsylvania Academy of Fine Art and in the Century Club in New York.[28]

A direct influence by Cameron can be observed in at least three of Smith's works. One of his self-portraits betrays direct correspondences with a photograph by Cameron entitled "Beatrice Cenci," taken in 1870 and

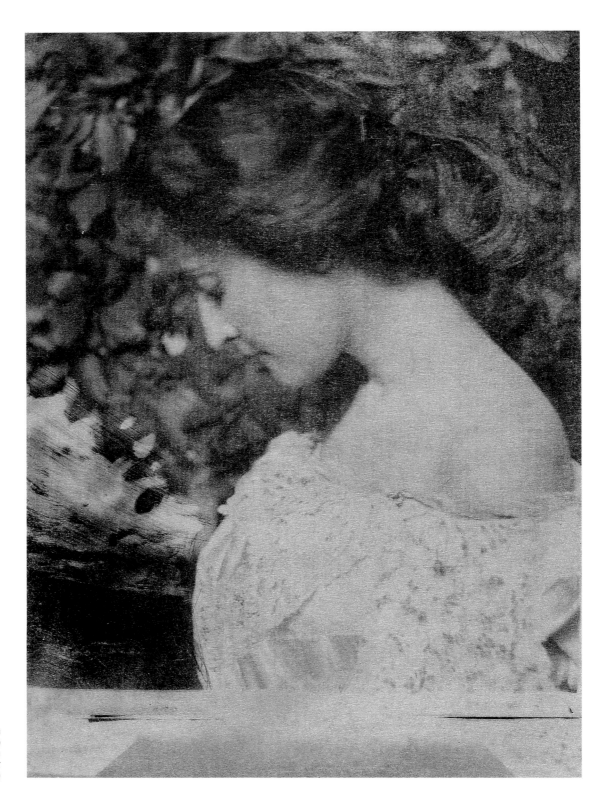

274. Portrait from
"A decorative Panel," 1899
Platinum print, 16.5 x 11.8 cm
Fotomuseum im Münchner
Stadtmuseum (88/26-97)

275. Decorative Panel, 1899
from: *Camera Notes*, April 1900,
p. 191

existing both as an albumen print and as a silver print.[29]
The dramatic lighting, the composition, the inclination
of the head, and the expression in the eyes correspond
almost exactly, only that the light is from the opposite
side. An interesting fact is that Cameron too had a
model for her photograph, as Jeremy Howard points
out: the painting of Beatrice Cenci, which had become
famous through graphic reproductions and was still
being attributed at the time to Guido Reni. It had
gained additional attention through Shelley's work
"The Cenci" (1819).[30] Another example of how Smith
adapted motifs is a photograph of his entitled "Lady
of Charlotte." It was reproduced in the *Photographic
Times* of December 1899, and again in the April 1900
edition of *Camera Notes*, the December 1901 issue of
the *Photographischer Rundschau*, and in January 1909
in *Camera Work*. This photograph, alongside "Adam
and Eve," is regarded with some justification as one of
his most important early works.

The title of the photograph is a pointed reference to the
ballad "The Lady of Shalott" by the romantic poet Al-
fred Lord Tennyson which touches on the themes of
the mediaeval Arthurian saga. After its first edition, sev-
eral re-prints of the ballad appeared from 1842 onwards,
followed by an illustrated version in 1857. Of the 45
graphic works in this illustrated version, 30 are by the
Pre-Raphaelites William Holman Hunt, John Everett
Millais and Dante Gabriel Rossetti, who were all close

to Tennyson. The ballad's popularity is also reflected in
the world of photography where from the early 1860s
attempts were already being made to capture the mysti-
cal atmosphere of the tragic love story in a photo-
graphic image.

Smith's photograph shows a young woman in profile,
her head wrapped in grey linen cloth. She has her head
thrown back slightly so that her long dark hair falls
loosely down over her shoulder. On her face is an ex-
pression of passionate yearning. Her half open lips and
eyes, and her hand laid upon her breast – a familiar
iconographic gesture of humility – clearly externalize
her inner conflict, drawn as she is between desire and
duty. The conflict is expressed in the ballad in her long-
ing for Lancelot as he rides by her window and the task
imposed upon her of weaving unwaveringly a mystical
rug. The whole lower right section of the photograph
is covered with black hatching lines which conceal the
model's left shoulder.

That this manipulation of the photograph was not only
graphically attractive but also meaningful for the work's
iconography becomes clear when it is compared to a
work of Hunt's which was reproduced as a wood en-
graving on page 67 of a new edition of "The Lady of
Shalott" published in 1857.[31] The image, which Hunt
worked into a painting between 1886 and 1905, shows
the "Lady of Shalott" with wildly tossed loose hair
which – in anticipation of Art Nouveau – "laps along"

Camerons auf, die 1870 entstand und sowohl als Albumindruck als auch als Silberdruck vorliegt.[29] Die dramatische Beleuchtung, der Bildausschnitt, der seitlich gebeugte Kopf und der Augenausdruck stimmen fast gänzlich überein, nur das Licht kommt von der anderen Seite. Interessant ist, daß das Cameron-Bild seinerseits ein Vorbild hatte, wie Jeremy Howard nachweist: das besonders von Druckgraphiken her bekannte Bild der Beatrice Cenci, das damals noch Guido Reni zugeschrieben wurde und durch Shelleys Werk ›The Cenci‹ (1819) zusätzliche Aufmerksamkeit erfuhr.[30]

Ein weiteres Beispiel für motivische Übernahmen weist die als ›Lady of Charlotte‹ betitelte Aufnahme von Smith auf. Sie war in der *Photographic Times* im Dezember 1899 abgebildet und in weiteren Reproduktionen in der April-Ausgabe der *Camera Notes* 1900, der Dezember-Nummer der *Photographischen Rundschau* 1901 und im Januar 1909 in *Camera Work*. Mit einigem Recht darf man sie wohl neben ›Adam und Eve‹ als eines seiner frühen Hauptwerke sehen.

Der Titel nimmt in pointierter Weise Bezug auf die Ballade der ›Lady of Shalott‹ des romantischen Dichters Alfred Lord Tennyson, die den Themenkreis der mittelalterlichen Arthussage berührt. Nach einer ersten Fassung erschienen ab 1842 mehrere Neuauflagen, bis 1857 eine illustrierte Version folgte. Von den 45 Graphiken stammen allein 30 aus den Händen der Präraffaeliten William Holman Hunt, John Everett Millais und Dante Gabriel Rossetti, die Tennyson nahestanden. Die Popularität schlug sich auch in der Photographie nieder, wo man bereits seit den frühen 1860er Jahren versuchte, die mystische Atmosphäre der tragisch endenden Liebesgeschichte einzufangen.

Die Aufnahme von Smith zeigt als Kopfstück die Profilansicht einer in graues Tuch gehüllten jungen Frau. Das Haupt hat sie, den Ausdruck sehnsuchtsvollen Strebens im Gesicht, leicht nach hinten geworfen, wobei das dunkle lange Haar geöffnet nach hinten über die Schulter fällt. Die halbgeöffneten Lippen und Augen sowie die an die Brust gelegte Hand – ikonographisch als Demutsgeste bekannt – machen den inneren Zwiespalt zwischen Wunsch und Pflicht deutlich. Er drückt sich in der Ballade aus durch das Sehnen nach dem am Fenster vorbeireitenden Lancelot und der Aufgabe, unbeirrt an einem mystischen Teppich weiterzuweben. Der ganze untere rechte Teil der Photographie ist mit schwarzen Strichschraffuren überzogen, die die linke Schulter des Modells verdecken.

Daß dieser Eingriff neben dem graphischen Reiz auch ikonographisch einen Sinn ergibt, wird ersichtlich, wenn man eine Arbeit von Hunt heranzieht, die in der 1857

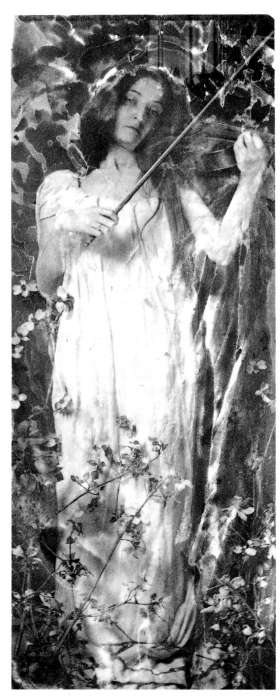

276. Summer, 1898
Platinum print, 17.0 x 6.3 cm
Metropolitan Museum of Art, Alfred Stieglitz
Collection, 1933 (33.43.70)

veröffentlichten Neuausgabe der ›Lady of Shalott‹ als Holzschnitt auf Seite 67 abgebildet war.[31] Das Bild, das der Maler zwischen 1886 und 1905 zu einem Gemälde ausarbeitete, zeigt die ›Lady of Shalott‹ mit wirr aufgelö-

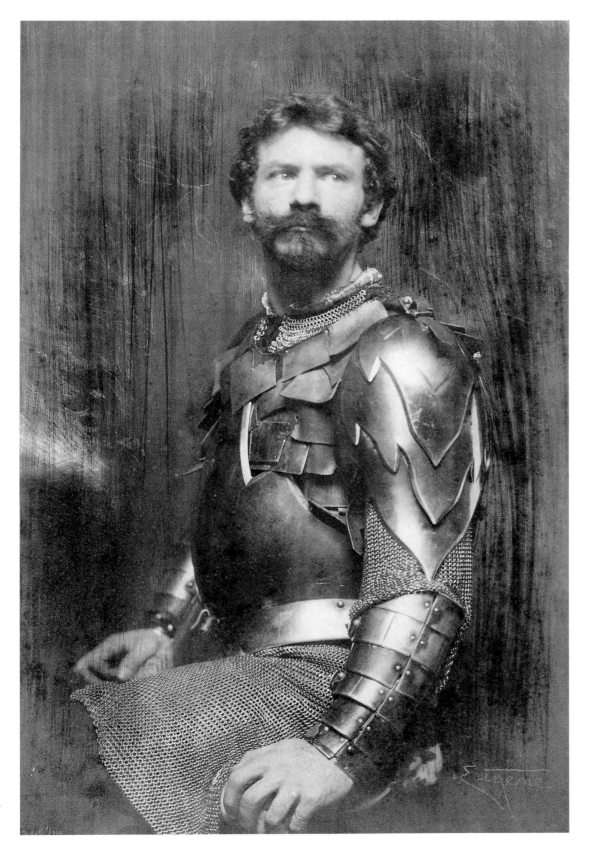

277. Man in Armor
(Self portrait), c. 1899
Platinum print, 19.4 x 13.6 cm
Fotomuseum im Münchner
Stadtmuseum (88/26-71)

265

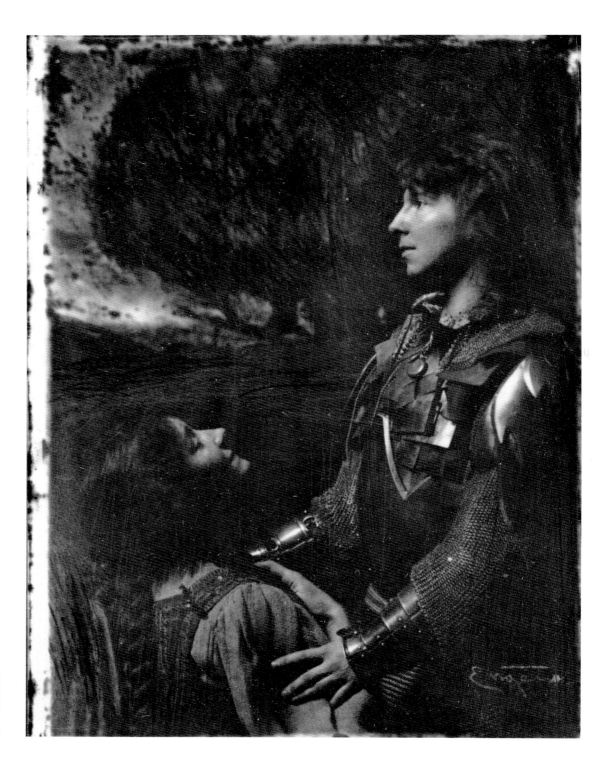

278. Arthur and Guinevere
(Illustration for a poem by Lord
Tennyson), 1899
Platinum print, 11.9 x 8.8 cm
Fotomuseum im Münchner
Stadtmuseum (88/27-96)

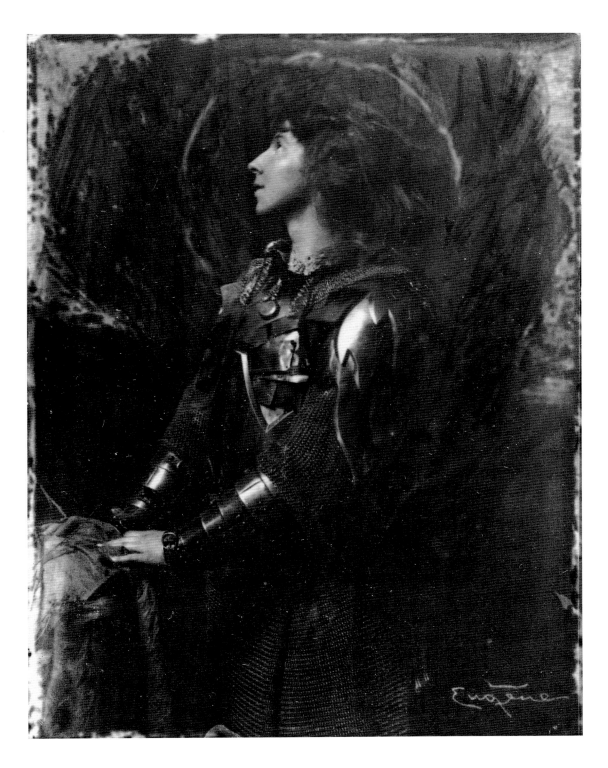

279. Arthur (Illustration for a
poem by Lord Tennyson). 1899
Platinum print. 11.9 x 8.8 cm
Fotomuseum im Münchner
Stadtmuseum (88/27-95)

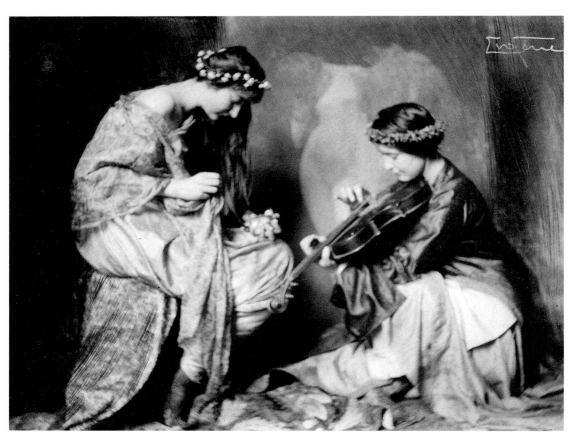

280. Study, c. 1910
Platinum print, 12.3 x 15.8 cm
Fotomuseum im Münchner
Stadtmuseum (88/27-10)

stem Haar, das – ein Vorgriff auf den Jugendstil – mit wellenartigen Bewegungen wie von einem Windstoß erfaßt, am ganzen oberen Bildrand ›entlangflattert‹. Sie steht inmitten eines Webrahmens, von dem aus sich kokonartig einzelne Webfäden in einer Kreiselbewegung um sie herumzuspinnen beginnen.

Auf dieses Motiv spielt Smith mit seiner auffälligen Schraffur an. Bei näherem Hinsehen zeigen sich außerdem im Bereich des Halsansatzes weiße Schraffuren in Wellen- und Kreisbewegung, die sich bis an den rechten Bildrand hinziehen. Ähnlich wie bei Hunt ist auch bei der ›Lady of Charlotte‹ von Smith das Haar gelöst und etwas wirr, wenn auch nicht so dramatisch übersteigert wie bei Hunt. Die Schraffuren, die sich bei Smith über Hals und Schulter ausbreiten, sind – neben dem phonetischen Gleichklang des Titels – die Pointe des Bildes.

Inspiriert wurde Smith möglicherweise von Cameron-Aufnahmen, die auffällige Übereinstimmungen in Körperhaltung und Gesichtsausdruck zeigen. So etwa von dem Bild ›The kiss of peace‹ (1869) oder ›Call, I follow; I follow let me die‹ (1867). Einen ähnlichen Gesichtsausdruck weist auch das bekannte Rossetti-Gemälde ›Beata Beatrix‹ (1877) auf.[32] Einen Einfluß übte die ›Lady of

Charlotte‹ möglicherweise auf seinen Kollegen Edward Steichen aus, der seine Frau auf einem Photo, das 1906 in der Photozeitschrift *Apollo* veröffentlicht wurde, in ähnlicher Pose aufnahm.[33]

Im Fotomuseum München liegen von Frank Eugenes Photo vier verschiedene Fassungen vor, die in ihrer Unterschiedlichkeit die Experimentierfreude und das Ringen um den bestmöglichen Ausdruck erkennen lassen. Eine Arbeit, die vermutlich als Platindruck abgezogen wurde, ähnelt durch das starke Hervortreten der Papierstruktur einer Rötelzeichnung. Klebepunkte auf der Rückseite und die stark ausgeblichene Farbzeichnung legen den Schluß nahe, daß sie als Wandschmuck diente.

Der Einfluß von Velázquez' Malerei

Beweist Smith bereits am Beispiel der ›Lady of Charlotte‹ seine Virtuosität, ein Thema bzw. ein Vorbild mit Geist und Stil zu variieren, so trifft dies erst recht auf seine Velázquez-Rezeption zu, der wir am Beispiel der mit ›Menuett‹ betitelten Aufnahme nachgehen wollen. Seit der Wiederentdeckung durch den Impressionisten Edouard Manet erlebte der spanische Hofmaler Diego Velázquez in der Malerei eine Renaissance. Carl Justi

268

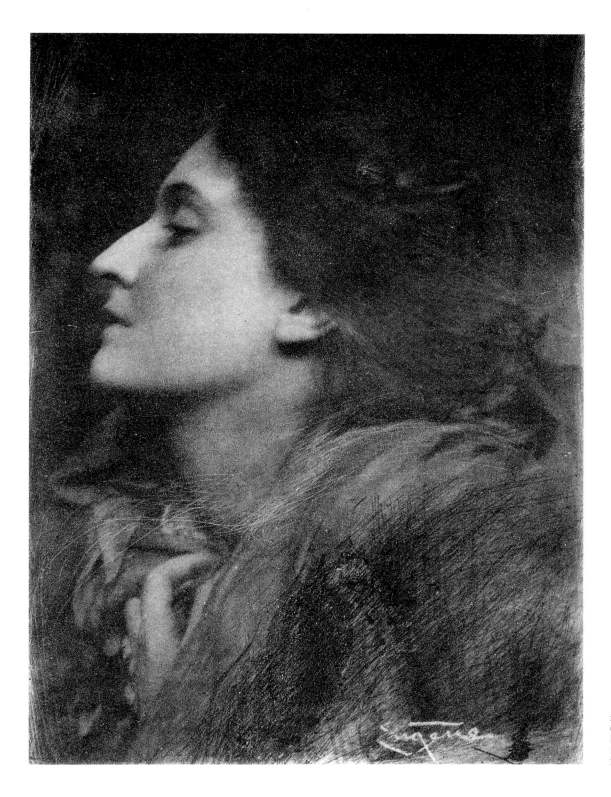

281. Lady of Charlotte
(Miss Convere Jones), c. 1899
Platinum print, 23.8 x 17.7 cm
Fotomuseum im Münchner
Stadtmuseum (92/418)

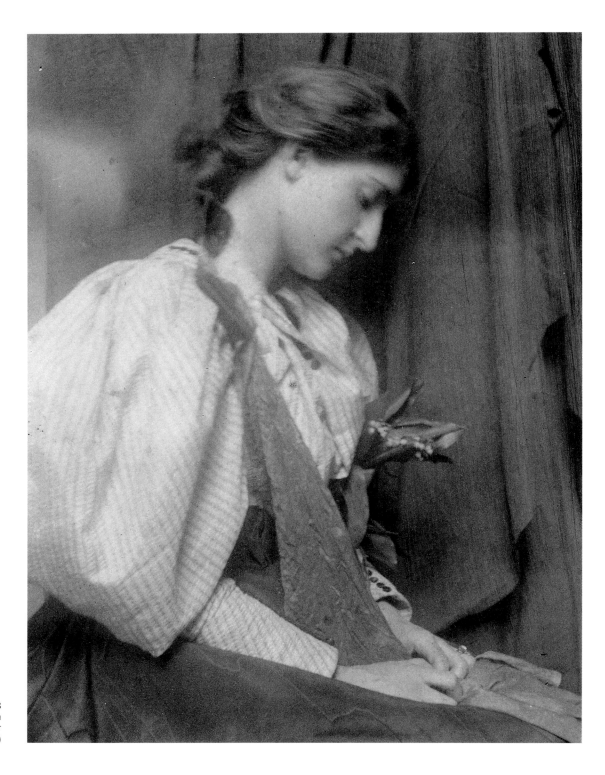

282. Portrait, c. 1908
Platinum print, 14.5 x 11.0 cm
Fotomuseum im Münchner
Stadtmuseum (88/27-72)

the whole top edge of the picture in wave-like movements as if buffeted by the wind. She is standing at the center of a weaving frame from out of which individual threads emerge in a circular movement, enveloping her as if in a cocoon.

The striking hatching added by Smith is a reference to this motif. What is more, on closer scrutiny it is possible to make out white hatching in wavy and circular movements at the base of the model's neck and extending out to the right edge of the photograph. Similar to Hunt, Smith's "Lady of Charlotte" also has loose tousled hair, although not so dramatically exaggerated as in Hunt's depiction. In addition to the phonetic similarity of the photograph's title, this hatching spread over her neck and shoulder is essential to Smith's whole point.

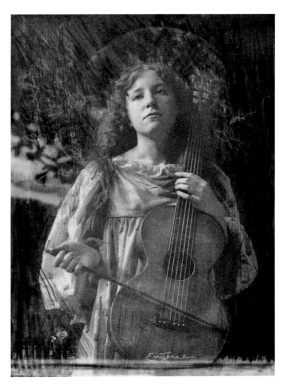

283. Untitled, c. 1905
D.O.P., 17.5 x 12.3 cm
Fotomuseum im Münchner Stadtmuseum (88/27-66)

Smith was possibly inspired by photographs of Cameron's which show a striking resemblance in pose and facial expression, for example, "The kiss of peace" (1869) or "Call, I follow; I follow let me die" (1867). A similar facial expression is also to be found in the famous Rossetti painting "Beata Beatrix" (1877).[32] Smith's "Lady of Charlotte" may also have exerted an influence on his colleague Edward Steichen who portrayed his wife in a similar pose in a photograph published in 1906 in the photographic magazine *Apollo*.[33] There are four different versions of this Frank Eugene photograph in the Fotomuseum in the Münchner Stadtmuseum, and the differences between them give us an impression of the delight he must have experienced in experimenting and in striving for the best possible expression. Due to the prominence of the paper's structure in one of the versions, presumably a platinotype, it almost resembles a red chalk drawing. Adhesive points on the back and the strongly faded color lends weight to the suspicion that the print served to decorate a wall.

The Influence of the Painting of Velázquez

If the "Lady of Charlotte" is evidence of Smith's virtuosity in varying a theme or a model with intelligence and style, then his reception of Velázquez provides even more convincing proof of this. Let us now turn to this reception, taking as our example the photograph entitled "Menuett." Since being rediscovered by the Impressionist Edouard Manet, the Spanish court painter Diego Velázquez had been enjoying quite a renaissance. In the second issue of a monograph which first appeared in 1888, Carl Justi described Velázquez as the "first character painter of his century" and waxed enthusiastic about his "understanding of forms," his "fine modelling" and his psychological sensitivity.[34] In particular his full-length portraits of the regent and his sensitivity for tone gradations assumed model character for the renowned American painters Whistler, Sargent and Chase.[35] The photogravure "Menuett" in the Fotomuseum in the Münchner Stadtmuseum shows a woman in a ball gown. Not only does this gown clearly emphasize her hips, it is also made out of exquisitely precious and brightly gleaming silk on which there is an irregular, jagged, striped pattern similar to forked lightning. The woman is standing with her back to the viewer, her body inclined slightly forward as if curtseying after an invitation to dance, or as if executing a particular dance figure — hence the title "Menuett." She is raising the sides of her gown with gracefully held fingertips. The background is made up of blossom motifs which are indistinct and blurred. At just one point, to the right of her head, a piece of the Gobelin shimmers through which Smith used as a backdrop in numerous photographs. The bright reflections of the tapestry are subdued by means of some swiftly applied black lines. Below and above the woman's right sleeve the covering of a sofa can just about be made out standing in the background.

bezeichnete ihn in der zweiten Auflage seiner 1888 erschienen Monographie als »ersten Charakteristiker seines Jahrhunderts« und schwärmte von seinem »Verständnis der Formen«, seiner »feinen Modellierung« und seinem psychologischen Gespür.[34] Für die renommierten amerikanischen Maler Whistler, Sargent und Chase wurden besonders seine Regentenporträts als Ganzfigur und sein Feingefühl für Tonwertabstufungen zum Vorbild.[35]

Die Photogravüre aus dem Münchner Fotomuseum zeigt uns eine Frau in einem kostbaren hellen, seidigglänzenden Ballkleid mit betonter Hüfte, auf dem ein unregelmäßig verlaufendes, blitzartig gezacktes Streifenmuster zu sehen ist. Sie steht mit dem Rücken zum Betrachter und macht wie bei einem Knicks nach der Aufforderung zum Tanz oder einer bestimmten Tanz-

hingeworfenen schwarzen Strichen sind die hellen Reflexe des Wandteppichs gedämpft. Unter und über dem rechten Ärmel ist andeutungsweise noch der Bezug eines dahinterstehenden Sofas zu erkennen.

Dadurch, daß er das Modell in Rückenansicht zeigt, macht Frank Eugene deutlich, wie er das Bild verstanden wissen will: Nur der optisch und quasi sinnlich greifbare Reiz des Stoffes haben zu interessieren. Jede gefühlsmäßige Beeinflussung durch einen bestimmten Gesichtsausdruck wird durch den abgewandten Kopf unterbunden. Virtuos gesetzte Glanzlichter auf dem Stoff unterstreichen dies noch. Als Pointe tritt nun zu dem stofflichen Reiz des Kleides das Streifenmuster. Durch die Stricheinzeichnungen im rechten oberen Bildbereich könnte man auf den ersten Blick annehmen, daß die Linienmuster auf dem Kleid nachträglich einge-

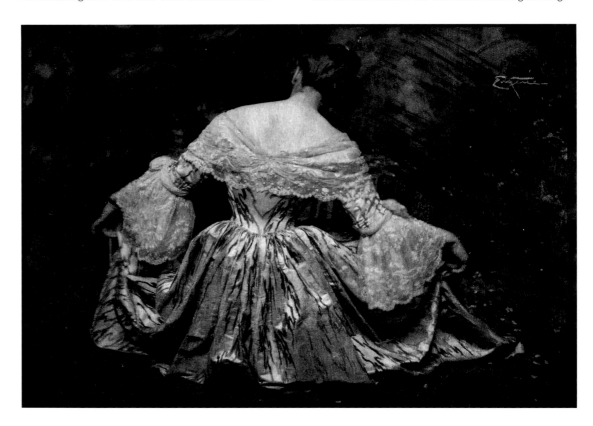

figur – deshalb der Titel ›Menuett‹ – eine leichte Vorwärtsbewegung mit dem Oberkörper. Mit grazil gehaltenen Fingerspitzen hebt sie dabei an beiden Seiten das Kleid an. Den Hintergrund bilden Blütenmotive, die nur undeutlich und verschwommen wahrnehmbar sind. Nur an einer Stelle rechts neben dem Kopf schimmert ein Stück des Gobelins durch, den Smith in zahlreichen Photos als Hintergrund verwendete. Mit einigen rasch

zeichnet sind. Eine Nahbetrachtung zeigt hingegen daß sie in das Kleid selbst eingewoben sind, da die gezackten Streifenmuster an den Rändern des Kleides unscharf werden.

Der Bezug auf Velázquez wird ersichtlich, wenn man als Vergleich dessen bekanntes Bildnis der Margarethe von Spanien aus dem Prado heranzieht, das in zahlreichen Kunstbüchern und ›Klassiker‹-Reihen der damali-

By presenting the woman from the rear, Frank Eugene makes quite clear how he wants the image to be understood: our interest is to be concentrated exclusively on the optically striking and almost sensually perceptible attractiveness of the gown's fabric. Any emotional influence which might be exerted by a particular facial expression is avoided by having the head turned away. The fabric is emphasized even more by masterfully placed catchlights. The fascination of this fabric is even more intensified by the stripped pattern. The lines drawn in the upper right section of the photograph could, at first glance, lead the viewer to conclude that the line pattern on the gown was also drawn in at a later stage. On closer observation it becomes obvious that they are woven into the fabric itself, as the jagged striped pattern becomes blurred at the edges of the gown. The allusion to Velázquez becomes quite apparent when

left corner of the painting, the infanta's face seems to be of secondary importance, although through a compositional trick Velázquez succeeds in making it the focal point of the painting. That the infanta motif is not all that far-fetched is proved by Smith's child study entitled "Brigitta Wenz" in which the young girl is also enveloped in precious silk. This photograph was most probably taken around the same time as "Menuett."

Presumably the "Menuett" photograph can be dated around or just before 1908, as Weston Naef refers to a color version which is possibly connected with Smith's experiments with autochromes around that time.[36] What is more, the painter and Stuck-pupil Willi Geiger, who was also a friend of Smith's, had made numerous Velázquez copies during a trip to Spain in 1906. Geiger's heliogravures "Infanta" and "Philip IV of Spain's Court

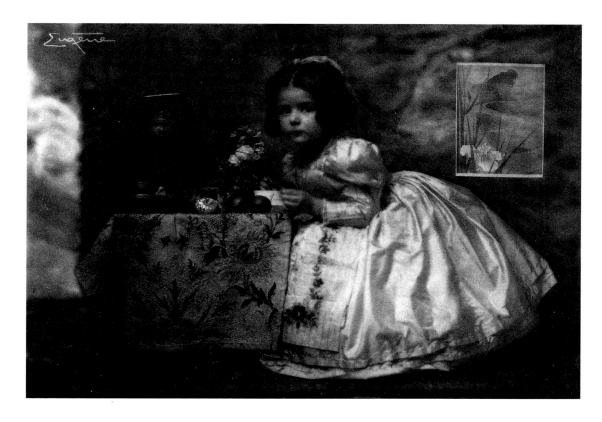

285. Brigitte Wenz, c. 1908
Photogravure, 12.0 x 17.0 cm
Fotomuseum im Münchner
Stadtmuseum (88/26-50)

we turn to his famous painting of Margarethe of Spain, now in the Prado. In Smith's time, this painting was reproduced in numerous art books and "Classics" series. Here too, the infanta, her body supported by a corset, spreads out the exquisite fabric of her dress before the eyes of the observer, the painter leaving us in no doubt as to the costliness of the fabric. Given the sheer volume of the dress' fabric and the threateningly ballooning curtain in the upper

Jester," which were made after these Velázquez copies on English copperplate printing paper, and Smith's "Menuett" (sic!), also reproduced as a heliogravure, were published together in 1909 in the portfolio of the Lehr- und Versuchsanstalt für Photographie and in the special catalogue for the "Internationale Photographische Ausstellung" (International Photographic Exhibition in Dresden).

gen Zeit abgebildet war. Die Infantin breitet ebenfalls vor dem Betrachter, unterstützt durch ein Stützkorsett, den Stoff ihres Kleides aus, über dessen Kostbarkeit der Maler keinen Zweifel läßt. Angesichts der Proportionen der Stoffmasse und des bedrohlich aufgebauschten Vorhangs im linken oberen Bildteil erscheint das Gesicht der Infantin eher nebensächlich, wenngleich es durch einen kompositorischen Trick von Velázquez doch wieder zum Mittelpunkt des Bildes gemacht wird. Daß die Übernahme des Infantinnen-Motivs nicht so abwegig ist, zeigt das mit ›Brigitta Wenz‹ betitelte Kinderbildnis von Smith, in dem die junge Dame ebenfalls in kostbaren Seidenstoff eingehüllt ist. Es entstand höchstwahrscheinlich um die gleiche Zeit wie das ›Menuett‹.

Die Entstehungszeit des Bildes ›Menuett‹ ist vermutlich um oder vor 1908 anzusetzen, da Weston Naef auf eine farbige Fassung verweist, die möglicherweise mit Smiths Autochrome-Experimenten zusammenhängt, die er um diese Zeit anstellte.[36] Zudem hatte der mit Smith befreundete Maler und Stuckschüler Willi Geiger auf einer Spanienreise 1906 zahlreiche Velázquezkopien gemacht. Die nach diesen Kopien auf englischem Kupferdruckpapier entstanden Heliogravüren ›Infantin‹ und ›Hofnarr Philipps IV. von Spanien‹ veröffentlichte Geiger 1909 zusammen mit Smith ebenfalls als Heliogravüre reproduziertem ›Menuett‹ (sic!) in der Studienmappe der Lehr- und Versuchsanstalt für Photographie und dem Sonderkatalog für die »Internationale Photographische Ausstellung« in Dresden.

Interessant ist in diesem Zusammenhang, daß auch Franz von Stuck 1908 und 1909 Gemälde von seiner Tochter Mary im Velázquez-Kostüm gemalt hat (einzeln oder als Familienbild), zu denen eine oder mehrere Photostudien angefertigt wurden. Sie entstanden wahrscheinlich vor dem ›Kinderkostümfest 1908‹, auf das ein kleines Schild auf dem Einzelbildnis der Tochter von 1908 hinweist.[37] Deutliche Anklänge an das Werk von Smith läßt wiederum ein 1916/17 in der Zeitschrift *Photographische Kunst* erschienenes Photo des Münchner Berufsphotographen Heinrich Traut erkennen, dem das ›Menuett‹ mit Sicherheit bekannt war und als Vorlage gedient haben könnte.

Betrachtet man das photographische Werk von Frank Eugene Smith als Ganzes, so fällt immer wieder auf, daß es fast keinen Motiv- oder Stilbereich gibt, in dem er nicht Versuche unternommen hat. Ob Japonismus oder Symbolismus in böcklinscher Manier, präraffaelitische Motive und Aktdarstellungen sowie Porträts in repräsentativem oder bohemienhaftem Ambiente bzw. im Rembrandt-Stil: Smith holte sich von vielen Seiten her Anregungen.

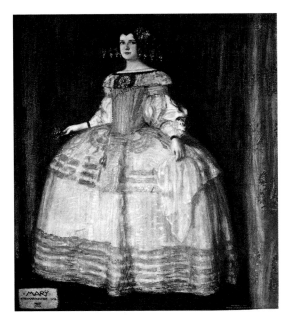

286. *Franz von Stuck*
Mary Stuck in Velázquez costume, 1908/09
from: *Franz von Stuck Gesamtwerk*, Munich, c. 1910, p. 127

Verbindungen zur Malerei des Jugendstils

Angesichts der Vielseitigkeit von Smith ist es kein Wunder, daß der Münchner Jugendstil ebenfalls Niederschlag in seinen Photos fand. Bereits während seiner Studienzeit hatte sich die Bildung der Münchner Secession von 1892 vorbereitet, die sich die Verteidigung der Kunst gegen das ›Glaspalastgenre‹ und den ›Gefälligkeitsstil‹ sowie die damit verbundene Kommerzialisierung der internationalen Kunstausstellungen mit ihrer Unzahl ausgestellter Werke auf die Fahnen geschrieben hatte.[38]

Einer der führenden Köpfe der neuen Richtung war Franz von Stuck, der bereits 1895 als 32jähriger Professor an die Akademie wurde. Er läßt sehr früh das Aufgreifen der Profil- und Sihouettendarstellung als Mittel der Stilisierung erkennen, beispielsweise in der Gestaltung des Minervakopfes für das Plakat der ersten Secessionistenausstellung 1893. In dessen oktogonaler Form und der stilisierenden Kopfgestaltung kann man einen Einfluß auf Smiths Variation des Bildes ›A Profile‹ erkennen, das ebenfalls in der ungewöhnlichen Form des Achtecks wiedergegeben ist.[39]

Besonders gut läßt sich die Stilisierungskunst Frank Eugenes an dem Porträt des mit ihm befreundeten Malers und Grafikers Willi Geiger studieren, der zwischen 1902 und 1905 Stucks Klasse besucht hatte. Das vorliegende Bild dürfte im Zeitraum zwischen 1906 und 1908

274

In this context it is also interesting to note that in 1908 and 1909 Franz von Stuck had painted his daughter Mary in Velázquez costumes (alone or in a family portrait), for which one or more photographic studies were made. They were probably taken before the "Children's Fancy Dress Ball 1908" to which a small label on the individual portrait of his daughter painted in 1908 makes reference.[37] In a photograph by the professional Munich photographer Heinrich Traut which appeared in 1916/17 in the magazine *Photographische Kunst* there is an obvious reference to Smith's work. Presumably Traut knew his "Menuett," which may even have served him as a model.

Looking at Frank Eugene Smith's photographic oeuvre as a whole, it becomes evident that there is almost no motif, no stylistic feature, with which he did not experiment. Whether Japonism or Symbolism in the Böcklin manner, Pre-Raphaelite motifs or nude studies, portraits in a representative, bohemian style or à la Rembrandt, Smith gleaned inspiration from all sides.

Links to Art Nouveau Painting

Given Smith's versatility, it comes as no surprise that Munich's Art Nouveau also found expression in his photographs. While he was studying there, preparations were already underway for the formation of the Munich Secession in 1892, a movement which pledged itself to defend art against the "Glaspalast genre" and the "Pleasant style," as well as against the commercialization associated with the international art exhibitions and their plethora of exhibited works.[38]

One of the leading figures behind this new movement was Franz von Stuck who had become professor at the Academy in 1895 at the age of 32. At a very early stage in his work we can see him already using the depiction of profiles and silhouettes as a stylistic means, for example, in his head of Minerva for the poster for the first Secession exhibition in 1893. Its octagonal shape and the stylized treatment of the head possibly influenced Smith's variation on this theme in "A Profile" which is also in the unusual shape of an octagon.[39]

Frank Eugene's stylistic ability can be best examined in his portrait of the painter and graphic artist Willi Geiger who was a friend of his and who had attended Stuck's classes between 1902 and 1905. The portrait in question must have been done in the period between 1906 and 1908, as Naef refers to the fact that in an exhibition in Buffalo it was dated 1907. The Fotomuseum in the Münchner Stadtmuseum is in possession both of a matt black platinum print of the work in which the paper structure is clearly recognizable, and of a darker

photogravure on thin Japanese tissue. Geiger is presented to the viewer in a half-length portrait, the background of which is taken up by a heavy glistening brocade curtain embroidered with gold circular and lute shaped patterns. Through being slightly blurred, the background of the photograph resolves into a mosaic-like gleaming expansive ornament constituted by brightly mirroring reflections of light. Geiger's torso is viewed from the side, whereby it is unclear in what kind

287. *Franz von Stuck*
Poster for the first "Internationale Kunstausstellung der Secession," Munich 1893
Lithograph, 61.5 x 36.5 cm
Graphiksammlung, Münchner Stadtmuseum

of a room he is. As almost every outline of his jacket has been suppressed, the upper part of his body appears not so much to be three-dimensional as flat, like a silhouette in a poster or magazine illustration of the time. His face, shown in a three-quarter view with a hint of a moustache, is, by contrast, gently modelled as a result of a finely accentuated stray light from the right. The dazzling white stand-up collar which forms a transition from the flat jacket to the sculpturally emphasized head acts as a counterpoise to the impenetrable black. At the bottom of the portrait a strip the width of the print and about half a centimeter high has been left free and on this the name "Willi Geiger" can be made out in unclear lettering.

The mere description of the portrait already betrays Smith's stylistic intention. He contrasts the expansive flat jacket surface and the sculptured face, the dissolved background of swirling eddies of light on the left and the concentrated peace on the right-hand side of the

entstanden sein. Naef verweist darauf, daß das Bild bei einer Ausstellung in Buffalo mit 1907 datiert ist. Im Fotomuseum München sind von dem Werk ein mattschwarzer Platindruck mit deutlich erkennbarer Papierstruktur und eine dunklere Photogravüre auf dünnem Japanpapier vorhanden.

Geiger wird dem Betrachter in einem Brustporträt vorgestellt, dessen Hintergrund ein mit kreis- und lautenförmigen Goldmustern bestickter, schwerer Vorhang aus glitzerndem Brokatstoff bildet. Durch die leichte Unschärfe ist der Bildgrund in ein mosaikartig glänzendes Flächenornament aus hell spiegelnden Lichtreflexen aufgelöst. Geigers Oberkörper ist in Seitenansicht gezeigt, wobei die eigentliche Raumsituation unklar bleibt. Da in dem schwarzen Sakko fast jegliche Zeichnung unterdrückt ist, erscheint der Oberkörper weniger plastisch als vielmehr wie eine flächenhafte Silhouette einer zeitgenössischen Plakat- und Zeitschriftenillustration. Im Gegensatz dazu ist das in Dreiviertelansicht gezeigte Gesicht mit dem angedeuteten Oberlippenbart durch feinakzentuiertes Streulicht von rechts zart durchmodelliert. Eine kräftige Note gegenüber dem undurchdringlichen Schwarz setzt der blendend weiß hervortretende Stehkragen, der vom flächigen Sakko zum plastisch betonten Kopf überleitet. Unter dem Bild ist eine etwa einen halben Zentimeter dicke, helle Rahmenleiste angefügt, auf der in unscharfer Schrift der Name ›Willi Geiger‹ zu lesen ist.

Bereits aus der Beschreibung geht die Stilisierungsabsicht von Smith hervor. Dem Flächenornament setzt er das plastische Gesicht gegenüber, der Auflösung des Bildgrundes in unruhige Lichtwirbel links stellt er im rechten Bildteil die konzentrierte Ruhe gegenüber. Mit seinem Vorgehen verweist Smith nicht nur auf Stuck, von dem ebenfalls die Rahmenleiste mit dem Namen abgeschaut ist, sondern auch auf Gustav Klimt, dem Jugendstilmeister aus Wien. Die Kombination von Körperdarstellung und mosaikartig aufgelöstem Goldgrund läßt sich in zahlreichen Klimt-Porträts, etwa dem von Adele Bloch-Bauer 1907, und seiner bekannten ›Judith‹-Darstellung erkennen, die 1901 auf der VIII. Internationalen Kunstausstellung in München zu sehen war.[40]

Der glitzernd-reflektierende Goldgrund, der an frühchristliche und byzantinische Mosaiken erinnert, taucht auch bei Stuck als gemaltes Mosaik auf, etwa auf dem Plakat zur ersten Secessionsausstellung 1893 oder dem von ihm gestalteten Umschlag eines Heftes der *Jugend* von 1897.

Das Geiger-Porträt von Smith ist aber noch aus einem anderen Grund bemerkenswert. Durch Eingriffe mit der Radiernadel auf dem Haupthaar und den Barthaaren – die allerdings nur auf der Photogravüre zu erkennen

288. Taka, before 1908
Platinum print, 16.5 x 9.8 cm
Fotomuseum im Münchner Stadtmuseum (88/26-23)

sind – akzentuiert der Photograph diese und stilisiert, gleichermaßen zusätzlich, das Gesicht. Mit Kringelzeichnungen rechts neben und über dem Kopf stilisiert er ebenfalls das mosaikartige Hintergrundmuster. Dazu kommt noch ein weiterer Punkt, der das Bild interessant macht. In Kopfhaltung, Kragen mit Krawatte, Anzug, Schnurrbart und Frisur ist deutlich eine Anlehnung an Stucks Selbstbildnis von 1906 zu sehen, was vielleicht auf das Schüler-Lehrer-Verhältnis von Stuck und Geiger anspielen soll.

Anregungen aus dem Ausdruckstanz

Wesentlich drastischer als beim Geiger-Bildnis geht Frank Eugene in der Bearbeitung bei einer als ›Mosaik‹ betitelten Bewegungsstudie einer Tänzerin vor, zu der es zwei weitere Motivvarianten im Fotomuseum München gibt. Die mit dunklen und hellen, zum Teil reflektierenden Seidengewändern gekleidete Tänzerin steht in seitlicher, leicht zum Betrachter hin geöffneter Schritt-

289. Willi Geiger, c. 1907
Platinum print, 16.4 x 12.0 cm
Fotomuseum im Münchner
Stadtmuseum (88/26-9)

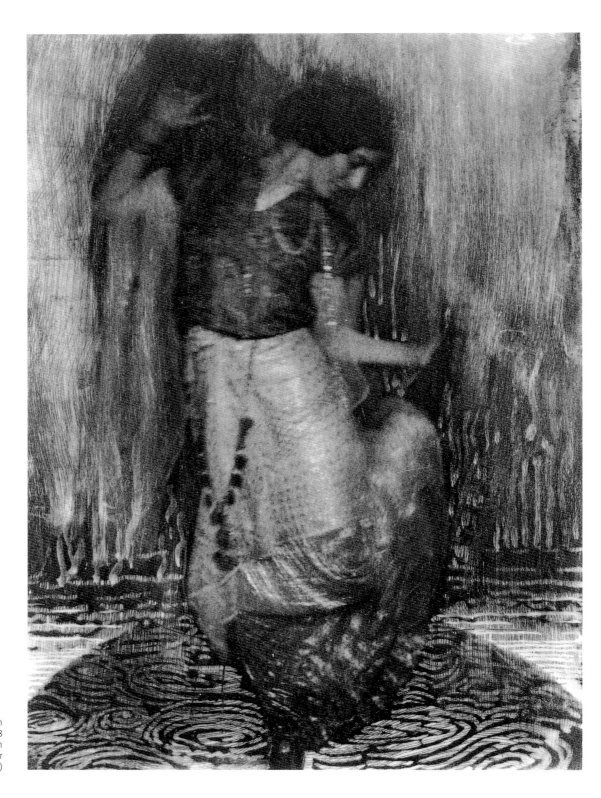

290. Dance study Dora Gedon
as Salomé, c. 1908
Platinum print, 16.9 x 12.2 cm
Fotomuseum im Münchner
Stadtmuseum (88/27-65)

picture. In doing this, Smith not only alludes to Stuck, from whom he also copied the strip across the bottom with the name, but also to Gustav Klimt, the master of Art Nouveau in Vienna. This combination of a figure depicted against a mosaic-like dissolved golden background can be found in many of Klimt's portraits, as in that of Adele Bloch-Bauer, (1907), or his famous "Judith," which was on show during the seventh International Art Exhibition in Munich in 1901.[40]

The glistening, reflecting gold background reminiscent of early Christian and Byzantine mosaics also turns up in Stuck's work in the form of a painted mosaic, for example in the poster for the first Secession exhibition in 1893, or in his design for the cover of the 1897 issue of the magazine *Jugend*.

Smith's portrait of Geiger is remarkable for yet another reason. By manipulating Geiger's hair and moustache with an etching needle – only recognizable on the photogravure – the photographer accentuates these while at the same time stylizing the face. By drawing in circles to the right of and above Geiger's head he also stylizes the mosaic-like background pattern. And there is yet another feature which makes this portrait interesting. The position of the head, the collar and necktie, suit, moustache and hairstyle are clearly reminiscent of a self-portrait by Stuck dated 1906, so that Smith's portrait is possibly a reference to the relationship between the pupil Geiger and his teacher Stuck.

Inspiration from Expressive Dance

In his study of a dance movement entitled "Mosaik," technically Frank Eugene proceeds in a more drastic manner than in the Geiger portrait. The Fotomuseum in the Münchner Stadtmuseum has two variations of this motif. Draped in partially reflecting dark and bright silks, the dancer is standing sideways to the observer, her legs apart in a mid-step position, the upper part of her body and her head twisted backwards. Her arms are raised to the level of her head and bent at an angle and she is holding a transparent veil in her hands. On the platinum print in the museum it is just about possible to make out a curtain hung up behind the dancer. While the floor above which she seems to hover is made up of heart-shaped luminous patterns, the whole photograph is framed by bright dot patterns. In this version, the dancer's body is only perceivable as a silhouette against a totally stylized background.[41] Smith goes a step further in a variation of the same motif which is in the Stieglitz Collection in the Metropolitan Museum in New York.[42] Here there are clear white dot

patterns arranged around the dancer which have been greatly toned down and blurred in the Munich version. These dots, forming circles and spirals and applied to the photographic plate using an emulsion impervious to light, are reminiscent of rotating fireballs or fireworks. Through them the photograph receives an overwhelmingly dynamic charge, and the dance motif takes on a completely new dimension.

This image is evidence of Smith's preoccupation with the phenomenon of expressive dance which under the influence of the American dancer Loïe Fuller had been conquering the stages since the 1890s and opening up totally new possibilities for the interplay of modern music, light and costume effects.[43] Stuck had demonstrated his enthusiasm for these new expressive forms

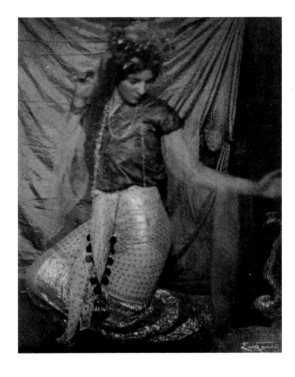

291. Snakecharmer, c. 1908
Platinum print
Metropolitan Museum of Art,
Rogers Fund, 1972 (1972.633.67)

in his motifs "The Dance" and "Dancers" in 1894 and 1896, but had still clothed his figures in mythological robes. Then contemporaries took up the theme, Hugo von Habermann in his "Veil Dance," and Friedrich Kaulbach in his "Ruth St. Denis." The motif of the dancer as a femme fatale turns up yet again in Stuck's "Salome" in 1906, having already been anticipated in 1895 by Slevogt in his "Salome." In the "Flame Dance" by Ludwig von Hofmann, which was reproduced in the magazine *Jugend* and clearly drew its inspiration from Stuck, we see a type of synchronized depiction of five different dance figures in gently flowing forms.

279

stellung. Ihren Oberkörper und den Kopf hat sie schraubenförmig nach hinten gedreht, wobei die Arme in Kopfhöhe abgewinkelt sind und die Hände einen durchsichtigen Schleier halten.

Auf dem Platindruck des Fotomuseums ist hinter der Tänzerin undeutlich ein aufgespannter Vorhang zu erkennen. Während der Boden, auf dem die Tänzerin zu schweben scheint, von herzförmigen Leuchtmustern gebildet wird, zieht sich ein aus hellen Punktmustern gebildeter Rahmen um das ganze Bild herum. Hier ist der Körper vor einem gänzlich stilisiertem Hintergrund nur noch als Silhouette wahrzunehmen.[41] Ein Stück weiter geht Smith bei einer Variante des gleichen Bildes in der Stieglitz-Sammlung des Metropolitan Museums in New York.[42] Hier sind um die Tänzerin herum deutlich weiße Punktmuster angeordnet, die in der Münchner Fassung stark abgemildert und unscharf sind. Mit ihren Kreis- und Spiralformen erinnern die mit lichtundurchlässiger Emulsion auf der Fotoplatte aufgetragenen Punkte an rotierende Feuerbälle oder Feuerwerkskörper, wodurch das Bild eine ungeheure dynamische Aufladung erfährt und das Tanzmotiv eine neue Dimension erhält.

Das Bild deutet auf die Auseinandersetzung von Smith mit dem Ausdruckstanz hin, der nach dem Vorbild der Amerikanerin Loïe Fuller seit den 1890er Jahren die Bühnen erobert hatte und völlig neue Möglichkeiten des Zusammenspiels von moderner Musik, Licht und Kostümeffekten vor Augen führte.[43] Stuck hatte sich den neuen Ausdrucksformen in den Motiven ›Der Tanz‹ und ›Tänzerinnen‹ 1894 und 1896 begeistert zugewandt, sie aber noch in ein mythologisches Gewand gekleidet. In der Folge entdeckten Zeitgenossen wie Hugo von Habermann in seinem ›Schleiertanz‹, August von Kaulbach in ›Ruth St. Denis‹ das Thema. Als Femme fatale taucht das Motiv der Tänzerin dann bei Stuck in der ›Salome‹ von 1906 noch einmal auf, das Slevogt bereits 1895 mit seiner ›Salome‹ vorweggenommen hatte. Eine Art Synchrondarstellung fünf verschiedener Tanzfiguren in weichfließenden Formen zeigt Ludwig von Hofmann in seinem ›Flammentanz‹, der in der Zeitschrift *Jugend* abgebildet war und sich an das Vorbild Stucks anlehnt.

Mit diesem Exkurs zum Thema Ausdruckstanz beschließen wir unsere Betrachtungen über Frank Eugene Smith. Die Einbettung ausgewählter Arbeiten in motivgeschichtliche Zusammenhänge sollte dazu dienen, am konkreten Beispiel von Smith den engen Wechselbeziehung von zeitgenössischer und vergangener Kunst auf die Kunstphotographie nachzugehen. Obwohl bereits eine Reihe von Arbeiten zu diesem Thema veröffentlicht

sind, ist der Zeitraum, in dem die Kunstphotographie zur Blüte gelangte, also etwa von 1890 bis 1910, ikonographisch noch in weiten Teilen unerforscht. Dies gilt besonders für Photographen wie Anne W. Brigman oder Paul Pichier, der überdeutlich Böcklinsche Motive nachbildete. Vielleicht gibt dieser Aufsatz einen Anstoß dazu.

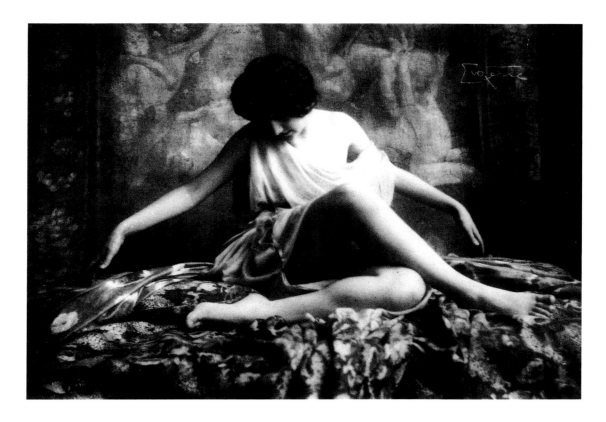

292. Frederica Derra de Moroda
("Fritzi von Derra"), c. 1908
Platinum print
Institut für Musikwissenschaft,
Salzburg

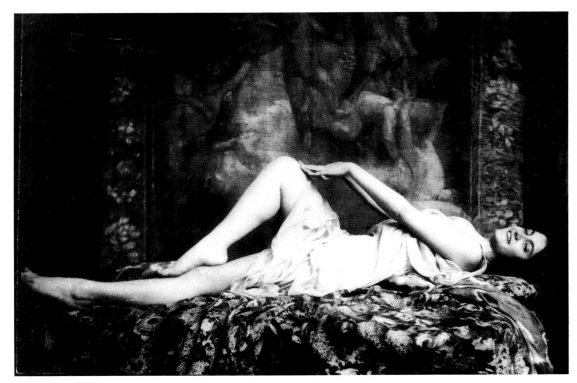

293. Frederica Derra de Moroda
("Fritzi von Derra"), c. 1908
Platinum print
Institut für Musikwissenschaft,
Salzburg

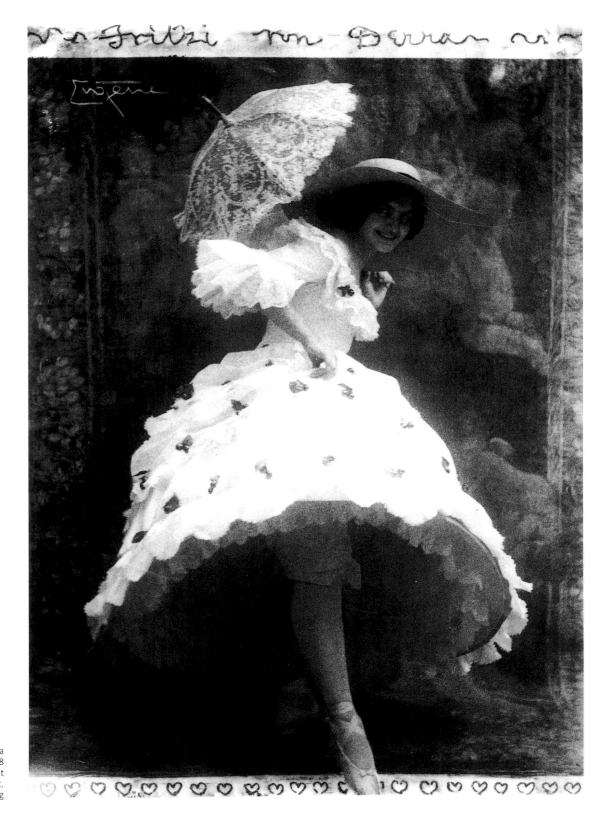

294. Frederica Derra de Moroda
("Fritzi von Derra"), c. 1908
Platinum print
Institut für Musikwissenschaft,
Salzburg

295. Dance study Dora Gedon, c. 1908
Modern print from original negative, 12.0 x 9.0 cm
Fotomuseum im Münchner Stadtmuseum

Let us conclude our examination of the works of Frank
Eugene Smith with this brief excursion into the world of
expressive dance. The attempt undertaken here to an-
chor selected works within the framework of the history
of motifs was intended to assist an inquiry into the
close relationship which existed between art photogra-
phy and both the painting of the time and of bygone
eras, a relationship of which Smith's works provide
concrete evidence. Although a number of relevant stud-
ies have already been completed, the period in which
art photography reached its flowering, that is to say
from approximately 1890 to 1910, is more or less still
awaiting in-depth research into its specific iconography.
This applies in particular to such photographers as
Anne W. Brigman or Paul Pichier who very obviously
adapted motifs of Böcklin's. Perhaps this present essay
may provide an impetus in that direction.

Chronologie

19.9.1865 Frank Eugene Smith wird in New York City, King Street 13, als Sohn deutscher Einwanderer, des Bäckers Frederick Smith und der Sängerin Hermine geb. Selinger geboren.

1886–1894 Studium an der Königlichen Akademie der bildenden Künste in der Zeichenklasse bei Karl Raupp und Johann Caspar Herterich und in der Mal- und Komponierklasse bei Wilhelm von Diez in München. *August–November 1890* Abmeldung nach New York; *August 1893–März 1894* Aufenthalt in New York.

Oktober 1894 Rückkehr nach New York, wo er als Bühnenbildner und Porträtmaler von Schauspielern und Sängern lebt und arbeitet. Vermutlich auch Leitung einer Malschule.

30.10.1900 Eugene wird als siebter Amerikaner Mitglied des Linked Ring in London. Sein Deckname lautet ›Dachshund‹.

Dezember 1900 Über Paris Rückkehr nach München; *von Februar bis April 1901* gemeinsam mit Fred Holland Day Reise nach Ägypten (Kairo).

Juli 1901–Februar 1902 Auf Reisen in London, Paris und New York.

Februar 1902–Februar 1906 Mit Unterbrechungen in München. In der Folgezeit unternimmt Eugene verschiedene Studienreisen nach Holland, Frankreich, Griechenland, Italien und Rußland.

Februar 1902 Gründungsmitglied der Photo-Secession in New York unter Leitung von Alfred Stieglitz.

Juli-August 1904 Aufenthalt in Tirol und Treffen mit Stieglitz; *Oktober 1904* in Schleißheim.

April-August 1905 Aufenthalt in Italien; *September 1905 bis Februar 1906* in München.

1905 Eugene wird Mitglied der Internationalen Vereinigung von Kunstphotographen, der u.a. James Craig-Annan, Alfred Stieglitz, Heinrich Kühn, Robert Demachy, Joseph Keiley, Edward Steichen und Hugo Henneberg angehören.

März 1906–Januar 1907 Aufenthalt in New York. *Februar 1907* Rückkehr nach München.

Juli 1907 In Tutzing erste Versuche mit dem Autochrome-Verfahren gemeinsam mit Alfred Stieglitz, Edward Steichen und Heinrich Kühn.

September 1907 Berufung als Lehrer an die Lehr- und Versuchsanstalt für Photographie, Lichtdruck und Gravüre in München-Schwabing, wo Eugene bis zum Sommersemester 1913 Porträtphotographie unterrichtet.

1908 Austritt aus dem Linked Ring gemeinsam mit Kühn, Coburn, de Meyer, Steichen, Stieglitz und Keiley. Jurymitglied anläßlich der 8. Jahresausstellung des Klub der Amateurphotographen in München vom *19. bis 27. Oktober 1908.* Aufnahme Eugenes in den Süddeutschen Photographen-Verein gemeinsam mit den Fachlehrern W. Urban, R. Lähnemann, E. Fichtl und R. Rothmaier.

1909 Verleihung der Dührkoop (Fortschritts)-Medaille (gestaltet von Kgl. Prof. Maximilian Dasio) durch den Süddeutschen Photographen Verein gemeinsam mit Hugo Erfurth, Dresden, Gebr. Lützel-München und dem Schweizerischen Photographen-Verein in Winterthur. Treffen mit Heinrich und Walter Kühn, E. Steichen, Baron de Meyer in München im *August 1909.*

1911 Eugene wird zum korrespondierenden Mitglied der Münchner Gesellschaft zur Pflege der Photographie ernannt.

1913 Anläßlich seines Abschiedes aus der Münchner Schule erhält Eugene von Franz Grainer als Anerkennung für seine Verdienste die Fortschrittsmedaille in Gold des Süddeutschen Photographen-Vereins. Im Sommer Reise mit Francis Bruguière nach Venedig; Besuch von Marsden Hartley in München.

September 1913 Berufung an die Königliche Akademie für graphische Künste und Buchgewerbe in Leipzig an den Lehrstuhl für Naturphotographie als Nachfolge für den verstorbenen Felix Naumann. Eugene leitet die Klasse bis zu ihrer Schließung im Jahre *1927.*

Oktober 1914 Verleihung des Professorentitels.

Juni 1915 Aufgabe der amerikanischen Staatsbürgerschaft und Annahme der sächsischen Staatsbürgerschaft.

1916 Vergrößerung und Umbau der Photoabteilung in der Leipziger Hochschule.

Ostern 1922 Heirat mit Johanna Trietschler, Scheidung der Ehe im *Juni 1923.*

1927/28 Rückkehr nach München und Aufkirchen am Starnberger See.

16.12.1936 Eugene stirbt an den Folgen eines Herzleidens im Münchner Krankenhaus rechts der Isar. Sein Grab befindet sich auf dem Münchner Ostfriedhof.

Chronology

September 19, 1865 Frank Eugene Smith was born in New York City, King Street 13, son of the German immigrants Frederick Smith, a baker, and Hermine Smith née Selinger, a singer.

1886–1894 Studied at the Royal Academy of Fine Arts in Munich; among other subjects, drawing under Karl Raupp and Johann Caspar Herterich, and painting and composition under Wilhelm von Diez. Ex-matriculated temporarily *from August–November 1890* and *from August 1893–March 1894*, spending these periods in New York.

October 1894 Return to New York where he lived and worked as a stage designer and portraitist, painting mainly actors and singers. It is also probable that he was head of an art school at the time.

October 30, 1900 Eugene is the seventh American to become a member of the Linked Ring in London. His code name was "Dachshund."

December 1900 Return to Munich via Paris; *from February to April 1901* he traveled to Egypt (Cairo) with Fred Holland Day.

July 1901–February 1902 Travels to London, Paris and New York.

February 1902–February 1906 Based mainly in Munich, but undertaking various study trips to Holland, France, Greece, Italy and Russia.

February 1902 Founder-member of the Photo-Secession in New York, which was directed by Alfred Stieglitz.

July–August 1904 Sojourn in Tyrol and meeting with Stieglitz; *October 1904* in Schleissheim.

April–August 1905 Sojourn in Italy; in Munich *from September 1905 to February 1906*.

1905 Eugene became a member of the International Association of Art Photographers. Other members included James Craig-Annan, Alfred Stieglitz, Heinrich Kühn, Robert Demachy, Joseph Keiley, Edward Steichen and Hugo Henneberg.

March 1906–January 1907 Sojourn in New York. Returned to Munich in *February 1907*.

July 1907 First experiments with the autochrome process in Tutzing, together with Alfred Stieglitz, Edward Steichen and Heinrich Kühn.

September 1907 Appointed to the teaching staff of the Institute of Photography in Munich-Schwabing where he taught portrait photography until the 1913 summer term.

1908 Resigned from the Linked Ring, along with Kühn, Coburn, de Meyer, Steichen, Stieglitz and Keiley. Member of a jury for the eighth annual exhibition of the Club of Amateur Photographers in Munich *from October 19–17, 1908*. Eugene was admitted to the South German Photographers Association together with the teachers W. Urban, R. Lähnemann, E. Fichtl and R. Rothmaier.

1909 Awarded the Dührkoop Medal (designed by Prof. Maximilian Dasio) by the South German Photographers Association jointly with Hugo Erfurth, Dresden, the Lützel brothers, Munich and the Swiss Photographers Association in Winterthur. Meeting with Heinrich and Walter Kühn, E. Steichen, Baron de Meyer in Munich in *August 1909*.

1911 Eugene became a corresponding member of the Münchner Gesellschaft zur Pflege der Photographie, a Munich society, the aim of which was to foster photography.

1913 On the occasion of his departure from the Munich Institute of Photography, Franz Grainer presented Eugene with the Gold Medal of the South German Photographers Association in recognition of his services to photography. That summer, Eugene traveled to Venice with Francis Brugière. Marsden Hartley visited Eugene in Munich.

September 1913 Appointed to the chair of nature photography at the Royal Academy of Graphic Arts and Book Design in Leipzig, succeeding the deceased Felix Naumann. Eugene was head of the photography department until its closure in *1927*.

October 1914 Received the title of professor.

June 1915 Eugene gave up his American citizenship and received citizenship of the German State of Saxony.

1916 Expansion and reconstruction of the photography department at the Leipzig Academy.

Easter 1922 Marriage to Johanna Trietschler. The couple were divorced in *June 1923*.

1927/28 Return to Munich and purchase of a house in Aufkirchen on Lake Starnberg.

December 16, 1936 Eugene died of a heart condition in a Munich hospital on the right bank of the Isar. He is buried in Munich's Ostfriedhof.

Biographien

Benno Becker

(*3.4.1860 Memel, † nach 1934)
Landschaftsmaler und Kunstschriftsteller. 1884–85 Studium der
Malerei bei Otto Frölicher in München und Studium der Archäo-
logie und Kunstgeschichte. Seit 1886 unternahm Becker wieder-
holt Reisen nach Italien. Gründungsmitglied der Münchner
Secession und Verfasser zahlreicher Aufsätze für die *Freie Bühne*
und *Pan*. Die Gemälde stellen gewöhnlich Motive von der Ost-
seeküste und italienische Landschaften dar, deren Malstil von
Böcklin und Corot beeinflußt ist.
Veröffentlichung von Porträts in *Photographische Kunst*, 6,
1907/08, Tafel 55 und Tafel 57.

Carl Johann Becker-Gundahl

(*4.4.1856 Ballweiler, † 16.11.1925 München)
Maler und Illustrator. Ab 1875 Studium an der Münchner Akade-
mie bei Strähuber, Diez und Löfftz; Unterbrechung des Studi-
ums aus finanziellen Gründen, um als Zeichenlehrer an der
städtischen Gewerbeschule in Kiel zu arbeiten. 1882, nach sei-
ner Rückkehr nach München, Studium bei Gabriel von Max. In
der Frühzeit realistische Malweise, Tätigkeit als Illustrator für die
Fliegenden Blätter. 1910–25 Professor (Nachfolge R. v. Seitz) an
der Münchner Kunstakademie, wo er naturalistische Bauernmale-
rei und christliche Monumentalmalerei lehrte.

Friedrich Adolph Brandenburg

(Lebensdaten unbekannt)
Schriftsteller. Vater von Hans Brandenburg, u.a. Verfasser von
Vor dem Feinde – Kriegserinnerungen, München 1914.

Hans Brandenburg

(*18.10.1885 Barmen, † 8.5.1968 Bingen)
Schriftsteller und Publizist. Seit 1902/03 in München; 1911 Heirat
mit Dora Polster. Freundschaft mit dem Schriftsteller Otto Julius
Bierbaum, Veröffentlichung von Bierbaums gesammelten Wer-
ken (gemeinsam mit Michael Georg Conrad). Beschäftigung mit
dem modernen Ausdruckstanz und dem Theater, Zusammenar-
beit mit Rudolf von Laban und Mary Wigman (H.B., *Der mo-
derne Tanz*, München 1913). Sein literarischer Nachlaß befindet
sich in der Monacensia, München.

Mrs. James Brown Potter (geb. Cora Urquhart)

(*15.5.1857 New Orleans, † 12.2.1936)
Schauspielerin. 1887 professionelles Debut im Haymarket Theatre
in London, ab 1887 enge Zusammenarbeit mit Kyrle Bellew in New
Yorker und Londoner Theateraufführungen. 1898 Mitwirkung als
Charlotte Corday im Adelphi. Bis 1903 verheiratet mit dem New
Yorker Banker James Brown Potter. 1933 publizierte Cora Urquhart
ihre Erinnerungen unter dem Titel *The Age of Innocence and I*.

Emma Calvé

(*15.8.1858 Délazeville, Frankreich, † 6.1.1931 Millau)
Sängerin. Nach dem Debut 1882 in Brüssel zahlreiche Auftritte in
Covent Garden, London, und an der Metropolitan Opera in
New York. 1907–08 Sängerin am Manhattan Opera House in
New York. Emma Calvé ist als herausragende Carmen-Interpre-
tin berühmt geworden. Ihre Memoiren *My Life* erschienen 1922
in New York.

Alvin Langdon Coburn

(*11.6.1882 Boston, † 23.11.1966 Awen, Rhos-on-Sea, North
Wales)
Photograph. Ab 1898 intensive Auseinandersetzung mit der
künstlerischen Photographie durch den Einfluß von Fred Holland
Day. 1900 Mitarbeit bei der von Day konzipierten Ausstellung
›New School of American Photography‹ in der Royal Photogra-
phic Society (R.P.S.) in London und Paris. 1902 Eröffnung eines
Photostudios in New York; Besuch der Summer School of Art von
Arthur Wesley Dow in Ipswich, Massachusetts. 1903 erste Einzel-
ausstellung im New Yorker Camera Club und Ernennung zum
Mitglied des Linked Ring und der Photo-Secession. Ab 1904 Por-
träts von englischen und französischen Künstlern und Schriftstel-
lern wie George Bernard Shaw, G.K. Chesterton, George Meredith,
H.G. Wells und Rodin. 1906 Einzelausstellung in der R.P.S. und
Studium der Photogravüre an der London County Council School
of Photo-Engraving. 1907 Einzelausstellung in der Galerie der Pho-
to-Secession in New York; auch zahlreiche Versuche im Auto-
chrome-Verfahren. Im Januar 1908 Veröffentlichung von zwölf
Gravüren in der *Camera Work*. 1909 Einzelausstellung in den
Photo-Secession Galleries. Veröffentlichung der Portfolios *Lon-
don* und *New York*. 1911 Photographien des Grand Canyon, Yo-
semite. 1912 Rückkehr nach England, 1913 Veröffentlichung des
Buches *Men of Mark*. 1917 entstanden durch den Kontakt mit
Ezra Pound die ersten Vortographien, die im selben Jahr ausge-
stellt werden. Ab 1919 Hinwendung zur Freimaurerei und intensi-
ve Beschäftigung mit der christlichen Mysthik und Esoterik.

Franz von Defregger

(*30.4.1835 Stronach bei Dölsach/Tirol, † 2.1.1921 München)
Maler. 1859 Studium der Bildhauerei bei Michael Stolz in Inns-
bruck, 1861 auf Anraten von Karl von Piloty Studium bei Her-
mann Dyck an der Münchner Kunstgewerbeschule und bei
Anschütz an der Akademie. Nach Paris-Aufenthalt von 1864
bis 1870 Arbeit im Atelier Piloty neben Makart und Gabriel von
Max. 1878 Berufung als Professor für Historienmalerei an die
Münchner Akademie, wo er bis 1910 lehrte. Spezialisierung auf
Historien- und Genremalerei, zumeist Alltagsszenen aus dem
Tiroler Volksleben oder historische Ereignisse wie die Tiroler
Bauernaufstände Anfang des 19. Jahrhunderts.
Veröffentlichung von Porträts in *Photographische Kunst*,
6, 1907/08, Tafel 56; *Berliner Illustrirte Zeitung*, Nr. 18, 1915,
S. 232.

Friderika Derra de Moroda

(*2.6.1897 Poszony, † 19.6.1978 Salzburg)
Ungarische Ballettänzerin und Choreographin. Von 1903 bis

Biographies

Benno Becker
(*April 3, 1860 Memel, † after 1934)
Landscape painter and author of essays on art. 1884–85 studied painting under Otto Frölicher, also archaeology and art history in Munich. From 1886, repeated trips to Italy. Founder-member of the Munich Secession and author of numerous essays for the *Freie Bühne* and *Pan*. He frequently painted motifs related to the Baltic Sea coast and Italian landscapes. His style was influenced by Böcklin and Corot.
Portraits published in *Photographische Kunst*, 6, 1907/08, plate 55 and plate 57.

Carl Johann Becker-Gundahl
(*April 4, 1856 Ballweiler, † November 16, 1925, Munich)
Artist and illustrator. Studied at the Munich Academy under Strähuber, Diez and Löfftz from 1875. For financial reasons he interrupted his studies to work as a drawing teacher at a vocational school in Kiel. Returned to Munich 1882, studied under Gabriel von Max. His early style of painting was realistic. Also active as an illustrator for *Fliegende Blätter*. From 1910–1925 professor (succeeding R. v. Seitz) at the Munich Academy of Arts where he taught naturalistic naive art and Christian monumental art.

Friedrich Adolph Brandenburg
(Dates unknown)
Writer. Father of Hans Brandenburg, author of *Vor dem Feinde – Kriegserinnerungen*, Munich 1914.

Hans Brandenburg
(*October 18, 1885 Barmen, † May 8, 1968 Bingen)
Writer and publicist. Arrived in Munich 1902/03. Married Dora Polster in 1911. A friend of the writer Otto Julius Bierbaum whose collected works he published jointly with Michael Georg Conrad. Devoted his attentions to modern, expressive dance and theatre. Cooperation with Rudolf von Laban and Mary Wigman (H.B., *Der moderne Tanz*, Munich 1913). His estate is in the Monacensia Library in Munich.

Mrs. James Brown Potter (née Cora Urquhart)
(*May 15, 1857 New Orleans, † February 12, 1936)
Actress. 1887 professional debut in London's Haymarket Theatre. From then on she worked closely with Kyrle Bellew in theatre performances in New York and London. 1898 played Charlotte Corday in the Adelphi. Married to the New York banker James Brown Potter until 1903. 1933 published her memoirs entitled *The Age of Innocence and I*.

Emma Calvé
(*August 15, 1858 Délazeville, France, † January 6, 1931 Millau)
Opera singer. 1882 debut in Brussels, then numerous performances at London's Covent Garden and the New York Metropolitan Opera. 1907–1908 engaged at the Manhattan Opera House in New York. Emma Calvé was famous for her outstanding interpretation of Carmen. Her memoirs *My Life* were published in New York in 1922.

Alvin Langdon Coburn
(*June 11, 1882 Boston, † November 23, 1966 Awen, Rhos-on-Sea, North Wales)
Photographer. From 1889, intensively involved with art photography under the influence of Fred Holland Day. 1900 participation in the "New School of American Photography" exhibition, conceived of by Day, in the Royal Photographic Society (R.P.S.) in London and Paris. 1902 opened a photographic studio in New York. Attended the Arthur Wesley Dow Summer School of Art in Ipswich, Massachusetts. 1903 first solo exhibition in the New York Camera Club and nomination as member of the Linked Ring and the Photo-Secession. From 1904 onwards portraits of English and French artists and writers, such as George Bernard Shaw, G. K. Chesterton, George Meredith, H.G. Wells and Rodin. 1906 solo exhibition at the R.P.S. and studies in photo-engraving at the London County Council School of Photo-Engraving. 1907 solo exhibition at the gallery of the Photo-Secession in New York. Numerous famous experiments with the autochrome process. 1908 publication of 12 engravings in *Camera Work*. 1909 solo exhibition in the Photo-Secession galleries. In 1909 he also published his *London* portfolio, followed in 1910 by his *New York* portfolio. 1911 photographs of the Grand Canyon, Yosemite. 1912 return to England. 1913 he published his book *Men of Mark*. Through his contact with Ezra Pound his first Vortographs 1917, exhibited the same year. In 1919 he turned to Freemasonry and developed profound interest in Christian mysticism and esoterics.

Franz von Defregger
(*April 30, 1835 Stronach near Dölsach in Tyrol, † January 2, 1921 Munich)
Painter. 1859 studied sculpture under Michael Stolz in Innsbruck. On the advice of Karl von Piloty, studied under Hermann Dyck in 1861 at the Munich School of Arts and Crafts and under Anschütz at the Munich Academy. 1864–1870 sojourn in Paris, then work in Piloty's studio alongside Makart and Gabriel von Max. 1878 appointed Professor of History Painting at the Munich Academy where he taught until 1910. Specialized in history and genre painting, mostly everyday scenes from Tyrolean life or historical events such as the peasants uprising in Tyrol at the beginning of the 19th century.
Portrait published in *Photographische Kunst*, 6, 1907/08, plate 56; *Berliner Illustrirte Zeitung*, no. 18, 1915, p. 232.

Friderika Derra de Moroda
(*June 2, 1897 Poszony, † June 19, 1978 Salzburg)
Hungarian ballet dancer and choreographer. In Munich from 1903 to 1912/13. 1912 successful dancing debut in Vienna. She later appeared in London and was leader of the Sadler's Wells Ballet. From 1941, leader of the "KdF-Ballet" in Berlin, performing behind the war fronts.

1912/13 in München; nach erfolgreichem Debut als Tänzerin in Wien 1912 trat sie ab 1913 in London auf und leitete das Sadler's Wells Ballet; ab 1941 Leitung des ›KdF-Balletts‹ in Berlin und an den Kriegsfronten.

Julius Diez
(*18.9.1870 Nürnberg, † 13.3.1957 München)
Maler und Illustrator. Neffe des Malers Wilhelm von Diez; Studium an der Münchner Kunstgewerbeschule bei Ferdinand Barth, von 1889 bis 1892 an der Kunstakademie bei Gabriel von Hackl und Rudolf Seitz. Ab 1896 bei der von Georg Hirth herausgegebenen Münchner Wochenzeitschrift *Die Jugend* als Illustrator und Zeichner tätig. Diez entwarf Exlibris, Plakate, Gebrauchsgraphik, Buchschmuck; bekannt sind auch zahlreiche Gemälde symbolistischer Stilrichtung. Seit 1901 Beteiligung an den Kunstausstellungen im Münchner Glaspalast sowie ab 1904 an den Jahresausstellungen der Münchner Secession. 1907 Berufung als Professor an die Kunstgewerbeschule München; 1924–38 Professor für Malerei an der Münchner Kunstakademie.

Alfred Jakob Doren
(*15.5.1869 Frankfurt am Main, † ?)
Philologe. Nach dem Universitätsstudium längerer Aufenthalt in Florenz. Diverse Veröffentlichungen zu den mittelalterlichen Handwerkszünften und Kaufmannsgilden in Deutschland und Florenz. Mitglied der deutschen Orient-Gesellschaft, der Gesellschaft der Bibliophilen; Sammler von Ex-Libris. Doren lebte in Leipzig-Gohlis.

Martin von Feuerstein
(*6.1.1856 Barr im Elsaß, † 13.2.1931 München)
Bildhauer. Ab 1874 Studium an der Münchner Akademie bei Alexander Strähuber, Ludwig von Löfftz und Wilhelm von Diez. 1878 Übersiedlung nach Paris und Studium bei Luc Olivier Merson; ab 1883 wieder in München. Neben Motiven aus dem Elsässer Volksleben schuf er auch wiederholt Werke zu religiösen Themen wie der Legende der Heiligen Magdalena. Als Nachfolger von Alexander von Liezen-Mayer übernahm er 1898 die Professur für religiöse Malerei an der Münchner Kunstakademie, die er bis 1924 ausübte. Im Gegensatz zu Fritz von Uhde vertrat Feuerstein eine akademische Darstellung religiöser Stoffe mit kräftigem Kolorismus.

Dora (Dorothea) Gedon
(*23.3.1883 München, † 7.1.1972 Kirchheim bei Tittmoning)
Jüngste Tochter von Lorenz und Mina Gedon; verheiratet mit dem Bildhauer Josef Rauch (1867–1921), dem ersten Mann ihrer Schwester Elisa Augusta (›Gogo‹).

Mina (Wilhelmine) Gedon (geb. Böheim)
(*7.2.1849 München, † 3.10.1929 München)
Ehefrau des bekannten bayerischen Bildhauers, Kunstgewerblers und Gestalters Lorenz Gedon, mit dem sie seit 1869 verheiratet war.

Rudolf Gedon
(*21.4.1872 München, † 22.1.1935 München)
Bildhauer. Erstgeborener Sohn von Lorenz und Mina Gedon; verheiratet mit Emma Schreiner.

Clara Geiger (geb. Weiß)
Veröffentlichung eines Porträts in *Photographische Kunst*, 8, 1909/10, Tafel 6.

Rupprecht Geiger
(*26.1.1908 München, lebt in München)
Maler. 1926–29 Studium der Architektur an der Kunstgewerbeschule München. 1949 Mitbegründer der Gruppe ZEN 49. 1965–75 Professor an der Staatlichen Kunstakademie, Düsseldorf. Mitglied der Akademie der Künste, Berlin, und der Bayerischen Akademie der Schönen Künste. Zahlreiche Einzelausstellungen im In- und Ausland.

Willi (Wilhelm) Geiger
(*27.8.1878 Schönbrunn/Landshut, † 11.2.1971 München)
Maler, Lithograph und Radierer. Ab 1898/98 in München Studium an der Kunstgewerbeschule und dem Polytechnikum, Ausbildung zum Zeichenlehrer. 1901–05 Studium der Malerei an der Münchner Akademie bei Franz von Stuck und in der Radierklasse von Peter von Halm. Nach Auszeichnung mit dem Graf Schack-Preis der Akademie 1905 bis 1907 Studienreisen nach Italien, Nordafrika, Frankreich und Spanien; 1907–09 Rückkehr nach München, wo er vor allem als Illustrator von Exlibris und Büchern wirkte. Ab 1908 mit Clara Weiß verheiratet. 1910 erhielt er den Villa-Romana-Preis in Florenz mit einjährigem Aufenthalt. 1920–22 Leiter der Naturklasse an der Kunstgewerbeschule in München. Ab 1928 Professor an der Akademie für Buchgewerbe und Graphik in Leipzig bis zur fristlosen Entlassung im Jahre 1933 durch die Nationalsozialisten. Nach 1945 Rehabilitierung und von 1946 bis 1950 Professor an der Akademie der bildenden Künste in München. 1951 Kulturpreis der Stadt München.
Veröffentlichung des Porträts in *Camera Work*, Juli 1910, Nr. 31, S. 13.

Josef Geis
(*19.4.1867, † 28.3.1941 München)
Opernsänger. Sohn des deutschen Sängers und Theaterregisseurs Jakob Geis (1840–1908); königlicher Hofopernsänger (Bass-Bariton) in München.

Frederick (Fritz) Goetz
(*23.1.1861 New York, † 17.9.1927 München)
Zeichner, Photograph, Chemigraph. Stammte aus der Pfalz und emigrierte als Kind mit den Eltern nach New York; Mitte der 70er Jahre Rückkehr nach Deutschland. Ab 1889 in München und Studium an der Kunstakademie. Mitarbeit bei Dr. Eugen Albert in der 1883 gegründeten Kunst- und Verlagsanstalt. 1901–19 Technischer Direktor bei der Kunstanstalt Bruckmann in München, 1919–26 Professor an der Akademie für Buchgewerbe und Graphik in Leipzig.
Veröffentlichungen von Porträts in *Camera Work*, Juli 1910, Nr. 31, S. 63; *Photographische Korrespondenz*, 63, 1927, S. 349.

Hugo von Habermann, Freiherr von
(*14.6.1849 Dillingen, † 27.2.1929 München)
Maler. Ausbildung an der Münchner Akademie bei Strähuber, Anschütz, Barth und Otto seit 1871, von 1873 bis 1879 bei Piloty. Gründung einer kurzlebigen Malschule mit Piglhein und v. Uhde. 1892 Gründungsmitglied der Secession und Wahl zum Vizepräsidenten, ab 1904 erster Präsident der Vereinigung. Ab 1905 Professor für Malerei an der Münchner Akademie, wo er bis 1924 lehrte. Zu den herausragenden Werken im sozialrealistischen Genre zählen ›Judith‹ (1872), ›Sorgenkind‹ (1885), ›Krankenstube‹ (1887). Seit den 90er Jahren auch als Porträtist von Damen der ›besseren‹ Münchner Gesellschaft wie Gräfin Torri (1886), E. Knorr (1897) oder Gräfin Hoyos (1907) tätig.

Julius Diez

(*September 18, 1870 Nuremberg, † March 13, 1957 Munich)
Artist and illustrator. Nephew of the artist Wilhelm von Diez. Studied at the Munich School of Arts and Crafts under Ferdinand Barth and from 1889 to 1892 at the Academy under Gabriel von Hackl and Rudolf Seitz. From 1896 illustrations and drawings for the Munich weekly *Die Jugend* published by Georg Hirth. Diez designed book-plates, posters, and commercial art works. He also produced numerous paintings in a symbolist style. From 1901 he participated in the art exhibitions in Munich's Glaspalast and from 1904 in the annual exhibitions of the Munich Secession. 1907 nominated professor at the Munich School of Arts and Crafts. 1924–38 Professor of Art at the Munich Academy.

Alfred Jakob Doren

(*May 15, 1869 Frankfurt am Main, † ?)
Philologist. After university studies longer sojourn in Florence. Various publications on the medieval craft and merchant guilds in Germany and Florence. Member of the German Oriental Society, the Society of Bibliophiles. Collector of book-plates. Lived in Leipzig-Gohlis.

Martin von Feuerstein

(*January 6, 1856 Barr, Alsace, † February 13, 1931 Munich)
Sculptor. From 1874 studied at the Munich Academy under Alexander Strähuber, Ludwig von Löfftz and Wilhelm von Diez. 1878 moved to Paris and studied under Luc Olivier Merson. 1883 return to Munich. Motifs from peasant life in Alsace, numerous works on religious themes such as the legend of Saint Magdalena. Professor of religious painting at the Munich Academy 1898–1924, succeeding Alexander von Liezen-Mayer. Contrary to Fritz von Uhde, Feuerstein represented an academic colourist depiction
of religious themes.

Dora (Dorothea) Gedon

(*March 23, 1883, Munich, † January 7, 1972, Kirchheim near Tittmoning)
Youngest daughter of Lorenz and Mina Gedon. Married to the sculptor Josef Rauch (1867–1921), the first husband of her sister Elisa Augusta ("Gogo").

Mina (Wilhelmine) Gedon (née Böheim)

(*February 7, 1849 Munich, † October 3, 1929 Munich)
Married the renowned sculptor, commercial artist and designer Lorenz Gedon in 1869.

Rudolf Gedon

(*April 21, 1872 Munich, † January 22, 1935 Munich)
Sculptor. First-born son of Lorenz and Mina Gedon. Married to Emma Schreiner.

Clara Geiger (née Weiß)

Portrait published in *Photographische Kunst*, 8, 1909/10, plate 6.

Rupprecht Geiger

(*January 26, 1908 Munich, lives in Munich)
Painter. Studied architecture at the School of Arts and Crafts in Munich. 1949 co-founder of the group ZEN 49. 1965–75 professor at the Academy of Arts, Dusseldorf. Member of the Academy of Arts, Berlin, and the Bavarian Academy of Fine Arts. Numerous solo exhibitions in Germany and abroad.

Willi (Wilhelm) Geiger

(*August 27, 1878 Schönbrunn, Landshut, † February 11, 1971 Munich)
Painter, lithographer and etcher. From 1898, studies in Munich at the School of Arts and Crafts and the Polytechnikum, training as a drawing teacher. 1901–05 art studies at the Munich Academy under Franz von Stuck, and in Peter von Hahn's etching class. Awarded the Academy's Graf Schack Prize. 1905–07 study trips to Italy, North Africa, France and Spain. 1907–09 return to Munich, mainly active as a book-plate illustrator and book designer. Married Clara Weiß in 1908. In 1910 he received the Villa Romana-Prize in Florence which included a one-year sojourn there. 1920–22 head of the nature class at the Munich School of Arts and Crafts. 1928–33 professor at the Academy of Graphic Arts and Book Design in Leipzig. Dismissed without notice by the National Socialists, rehabilitated in 1945. From 1946–1950 professor at the Academy of Arts in Munich. He received the cultural prize of the City of Munich in 1951.
Portrait published in *Camera Work*, July 1910, no. 31, p. 13.

Josef Geis

(*April 19, 1867 Munich, † March 28, 1941 Munich)
Opera singer. Son of the German singer and theatre director Jakob Geis (1840–1908). Royal Court Opera singer (Bass-Baritone) in Munich.

Frederick (Fritz) Goetz

(*January 23, 1861 New York, † September 17, 1927 Munich)
Graphic artist, photographer, process engraver. His family came from the German Palatinate and emigrated to New York when he was a child. He returned to Germany in the mid 1870s. Lived in Munich from 1889 onwards studying at the Academy. He worked with Dr. Eugen Albert in the Kunst- und Verlagsanstalt, founded 1883. 1901–1919 technical director at the Kunstanstalt Bruckmann in Munich, and from 1919–26 professor at the Leipzig Academy of Graphic Arts and Book Design.
Portrait published in *Camera Work*, July 1910, no. 31, p. 63; *Photographische Korrespondenz*, 63, 1927, p. 349.

Hugo von Habermann, Freiherr von

(*June 14, 1849 Dillingen, † February 27, 1929 Munich)
Artist. Trained at the Munich Academy under Strähuber, Anschütz, Barth and Otto from 1871, and from 1873–1879 under Piloty. Founded a short-lived school of art with Piglhein and v. Uhde. 1892 founder-member of the Secession of which he was elected vice-president, and in 1904 president. 1905–1924, professor of art at the Munich Academy. Among his most striking works, painted in a social-realistic genre, are "Judith" (1872), "Sorgenkind" (1885), "Krankenstube" (1887). He was also active in the 1890s and after as a portraitist of ladies from Munich's "higher" circles, such as Countess Torri (1886), E. Knorr (1897) and Countess Hoyos (1907).

Sadakichi Hartmann

(* 1867 Nagasaki, † November 21, 1944 St. Petersburg, Florida)
Writer, dancer, actor. Son of a German merchant. Childhood in Hamburg then emigration to Philadelphia. 1885–1893 several trips to Europe where be became acquainted with Stéphane Mallarmé. Articles for different journals in Philadelphia, Boston and New York. Founded the magazine *The Art Critic*. His first articles on art photography began to appear from 1898. His friendship with Alfred Stieglitz also dates from this time. Numerous articles in *Camera Notes* and *Camera Work*, also under

Sadakichi Hartmann

(* 1867 Nagasaki, † 21.11.1944 St.Petersburg, Florida)
Schriftsteller, Tänzer, Schauspieler. Sohn eines deutschen Kauf-
mannes, Kindheit in Hamburg, dann Auswanderung nach Phil-
adelphia. Zwischen 1885 und 1893 mehrere Reisen nach Europa,
Bekanntschaft mit Stéphane Mallarmé. Journalistische Tätigkeit
für diverse Journale in Philadelphia, Boston und New York;
Gründung der Zeitschrift *The Art Critic*. Ab 1898 erste Beiträge
zur künstlerischen Photographie; Freundschaft mit Alfred Stieg-
litz und zahlreiche Veröffentlichungen in *Camera Notes* und
Camera Work, auch unter Pseudonymen wie Sidney Allan,
Klingspor etc. Neben Charles H. Caffin ist Sadakichi Hartmann
der bedeutendste Kritiker der internationalen Kunstphotographie,
der auch verschiedene Publikationen zur japanischen und ame-
rikanischen Kunst aufzuweisen hat.
Veröffentlichung des Porträts in *The American Annual of*
Photography and Photographic Times Almanach, 1900, S. 107;
Camera Notes, April 1900, S. 193.

Siegmund von Hausegger

(*16.8.1872 Graz, † 10.10.1948 München)
Komponist, Dirigent. Sohn des Musikschriftstellers Friedrich von
Hausegger; Studium der Musik in Graz. 1896 Berufung zum
Opernkapellmeister an der Grazer Theatern; 1897 musikalischer
Regieassistent der Bayreuther Bühnenfestspiele; 1899 neben
Felix Weingartner im Kaimorchester in München 2. Kapellmei-
ster der Volkssymphoniekonzerte und der Modernen Abende.
1903–06 Dirigent der Museumskonzerte in Frankfurt am Main;
1910–20 Dirigent der Philharmonischen Konzerte in Hamburg.
Seit 1920 Präsident der Staatlichen Akademie der Tonkunst in
München und Dirigent des Konzertvereins-Orchesters (Münch-
ner Philharmoniker), seit 1926 Vorsitzender des Allgemeinen
Deutschen Musikvereins. Freundschaft mit Max Reger, Hans
Pfitzner und Richard Strauss. Vertreter der sogenannten neu-
deutschen Schule; zu seinen bekanntesten musikalischen Kom-
positionen zählen die Märchenoper ›Helfried‹ (1893), die Oper
›Zinnober‹ nach einer Erzählung von E.T.A. Hoffmann (1898 von
Richard Strauß in München uraufgeführt) sowie zahlreiche Lie-
der, symphonische Dichtungen und Orchesterwerke.

Adolf Hengeler

(*11.2.1863 Kempten, † 4.12.1927 München)
Maler, Zeichner. Ausbildung als Lithograph, ab 1881 Ausbildung
an der Kunstgewerbeschule bei Ferdinand Barth; ab 1885 Studi-
um an der Münchner Akademie bei Johann Leonhard Raab und
v. Diez. Seit 1885 Zeichner für die *Fliegenden Blätter* (circa 4.000
Zeichnungen); populärer Karikaturist insbesondere von Tier-
motiven. Um 1890 erste Gemälde, die dekorative Land-
schaftsidyllen mit Putten und Fabelwesen darstellen; Mitglied
der Allotria und Freundschaft mit Lenbach und Stuck. 1912–26
Professor an der Akademie der Künste München als Nachfolger
von Otto Seitz.
Veröffentlichung des Porträts in *Camera Work*, Juli 1910, Nr. 31,
S. 9; *Deutsche Kunst und Dekoration*, 1910, S. 53.

Alfred Walter Heymel

(* 6.3.1878 Dresden, † 26.11.1914 Berlin)
Verleger und Schriftsteller. 1898 Gründung der Monatsschrift *Die*
Insel in München. Zwischen 1903 und 1909 Mitbesitzer des
Inselverlages in Bremen und einer der Hauptförderer moderner
deutscher Buchkunst im Jugendstil und Literatur. In seinem
Münchner Domizil verkehrten Max Reinhardt, Dichter wie
Dehmel, Hofmannsthal und Rilke.

Veröffentlichung des Porträts in Manuel Gasser (Hg.), *München*
um 1900, Bern/Stuttgart 1977, S. 63.

Paul Heyse

(*15.3.1830 Berlin, † 2.4.1914 München)
Schriftsteller. Sohn eines Berliner Sprachforschers und Gelehr-
ten, studierte ab 1847 klassische Philologie in Berlin und Bonn.
1854 Berufung durch König Maximilian II. nach München. Erster
deutscher Nobelpreisträger für Literatur 1911. Wohnte in einer
pompösen Villa an der Luisenstraße in München.
Veröffentlichung von Porträts in *Reclams Universum*, 1910; *Deut-*
sche Kunst und Dekoration, 1911, S. 272; *Berliner Illustrirte Zei-*
tung, Nr. 15, 1914, S. 270.

Adolf von Hildebrand

(*6.10.1847 Marburg, † 18.1.1921 München)
Bildhauer, Kunstschriftsteller. Sohn des Nationalökonomen Bru-
no Hildebrand. Nach der Ausbildung bei K. v. Zumbusch in
München 1866/67 Aufenthalt in Rom mit Zumbusch; Freund-
schaft mit Konrad Fiedler und Hans von Marées. 1872–97 lebte
und arbeitete er in Italien; Mitarbeit bei den Fresken von H. v.
Marées in der Zoologischen Station in Neapel. 1874 Kauf des
Klosters San Francesco di Paola bei Florenz. 1891 erster Großauf-
trag ›Wittelsbacher Brunnen‹ in München, der 1894 vollendet
wurde. In der Folgezeit zahlreiche Aufträge für Porträtbüsten
prominenter Zeitgenossen, Brunnenanlagen oder Grab- und
Denkmäler (z.B. Johannes Brahms, Prinzregent Luitpold, Otto
von Bismarck, Friedrich Schiller, Hans von Bülow, Wilhelm
Hertz) 1897 Errichtung seiner Künstlervilla und eines Ateliers in
München-Bogenhausen, die heute das städtische Literaturarchiv
und die Bibliothek der Monacensia beherbergen. Hildebrand ist
einer der bedeutendsten deutschen Bildhauer im 19. Jahrhun-
dert.

Georg Hirth

(*13.7.1841 Gräfentonna/Gotha, † 28.3.1916 München)
Kunstsammler, Kunsthistoriker, Schriftsteller, Verleger. 1858
Mitarbeit an *Westermanns Monatsheften*, 1859 Schrift über *Fried-*
rich Schiller als Mann des Volkes; universelle Bildung und schrift-
stellerische Tätigkeit zu nationalökonomischen, naturwissen-
schaftlichen und künstlerischen Themen. 1870/71 Herausgeber
der *Augsburger Allgemeinen Zeitung*; 1875 mit Thomas Knorr –
Hirth war mit seiner Schwester verheiratet – Gründung einer
Buchdruckerei. Die zahlreichen Publikationen von Hirth beschäf-
tigen sich mit der Kunstphysiologie und dem Zeichenunterricht,
aber auch mit der Medizin und Psychologie; Herausgeber von
Das deutsche Zimmer der Renaissance und ab 1878 des
Hirthschen Formenschatzes, *Das deutsche Zimmer vom Mittel-*
alter bis zur Gegenwart, *Ideen über Zeichenunterricht* und *Pla-*
stisches Sehen. Hirths Schriften sind für die Wiederbelebung
des Renaissance-Stils durch Seitz, Gedon, Seidl und Lenbach
von zentraler Bedeutung. 1881 Übernahme des Verlages *Münch-*
ner Neueste Nachrichten durch Knorr & Hirth nach dem Tode
von Julius Knorr. 1892 Beteiligung an der Gründung der Münch-
ner Secession; 1896 Herausgabe der *Jugend*, die für den Jugend-
stil namengebend wurde. Mitarbeiter an der *Jugend* waren u.a.
F. A. von Kaulbach, Fritz von Uhde, Julius Diez, Stuck, Albert
Weisgerber, Lenbach.
Veröffentlichung des Porträts in *Camera Work*, Juli 1910, Nr. 31, S. 17.

Frau Ludwig Hohlwein (geborene Léonie Jeannette Dürr)
(26.6.1876 Wiesbaden, † 1951 Berchtesgaden)
Tochter eines Schneidermeisters, seit 1901 verheiratet mit dem

pseudonyms such as Sidney Allan, Klingspor etc. Alongside Charles H. Caffin, Sadakichi Hartmann is one of the most important writers on international art photography. He also wrote on Japanese and American art.
Portrait published in *The American Annual of Photography and Photographic Times Almanach*, 1900, p. 107; *Camera Notes*, April 1900, p. 193.

Siegmund von Hausegger

(*August 16, 1872 Graz, † October 10, 1948 Munich)
Composer, conductor. Son of Friedrich von Hausegger who wrote about music. Studied music in Graz. 1896 appointed conductor of operas performed at the Graz theatres. 1897 assistant producer at the Bayreuth Festspiele. 1899, alongside Felix Weingartner, 2nd conductor of the Kaim Orchestra for the People's Symphony Concerts and the "Modern Evenings" in Munich. 1903–06 conductor of the Museum's Concerts in Frankfurt am Main. 1910–20 conductor of the Philharmonic Concerts in Hamburg. From 1920 president of the State Academy of Music in Munich and conductor of the Munich Philharmonic. From 1926 chairman of the Allgemeine Deutsche Musikverein. Friendships with Max Reger, Hans Pfitzner and Richard Strauss. Representative of the so-called New German school. Among his most important compositions are the fairy-tale opera "Helfried" (1893), the opera "Zinnober" based on an E. T. A. Hoffmann story (premier in Munich in 1898 under Richard Strauss) and numerous songs, symphonic poems and orchestral works.

Adolf Hengeler

(*February 11, 1863 Kempten, † December 4, 1927 Munich)
Painter, graphic artist. Trained as a lithographer. From 1881, training at the School of Arts and Crafts under Ferdinand Barth, from 1885 at the Munich Academy under Johann Leonhard Raab and W. v. Diez. From 1885 illustrator for the *Fliegende Blätter* (approx. 4,000 drawings). A popular caricaturist, in particular for his animal drawings. His first paintings date from around 1890 and are of idyllic, decorative landscapes with putti and fabulous creatures. Member of the Allotria group and a friend
of Lenbach's and Stuck' s. 1912–26 professor at the Munich Academy of Arts, succeeding Otto Seitz.
Portrait published in *Camera Work*, July 1910, no. 31, p. 9; *Deutsche Kunst und Dekoration*, 1910, p. 53.

Alfred Walter Heymel

(*March 6, 1878 Dresden, † November 26, 1914 Berlin)
Publisher and writer. Founded the monthly magazine *Die Insel* in Munich in 1898. 1903–09 co-owner of the Insel publishing house in Bremen. One of the main promoters of modern German book design in the art nouveau style, and of modern literature. Personalities such as Max Reinhardt and poets such as Dehmel, Hofmannsthal and Rilke were visitors at his Munich home.
Portrait published in Manuel Gasser (ed.), *München um 1900*, Berne/Stuttgart, 1977, p. 63.

Paul Heyse

(* March 15, 1830 Berlin, † April 2, 1914 Munich)
Writer. Son of a Berlin linguist and scholar. 1847 studied classical philology in Berlin and Bonn. Called to Munich in 1854 by King Maximilian II. First German to win the Nobel Prize for Literature in 1911. He lived in a somewhat pompous villa in Luisenstrasse in Munich.
Portraits published in *Reclams Universum*, 1910; *Deutsche Kunst und Dekoration*, 1911, 1, p. 272; *Berliner Illustrirte Zeitung*, no. 15, 1914, p. 270.

Adolf von Hildebrand

(*October 6, 1847 Marburg, † January 18, 1921 Munich)
Sculptor, author. Son of the political economist Bruno Hildebrand. Having trained under K. v. Zumbusch in Munich, he spent some time in Rome with Zumbusch (1866/67). Friendship with Konrad Fiedler and Hans von Marées. 1872–97 lived and worked in Italy, cooperating on Marées' frescos in the Zoological Station in Naples. 1874 purchased a monastery, San Francesco di Paola, near Florence. His first large-scale commission was the "Wittelsbacher Brunnen" in Munich in 1891, completed in 1894. There followed numerous commissions for busts of prominent contemporaries, fountains, tombs and other monuments (for example, to Johannes Brahms, Prince Regent Luitpold, Otto von Bismarck, Friedrich Schiller, Hans von Bülow, Wilhelm Hertz). His artist's villa and studio in Munich-Bogenhausen was completed in 1897. Today it houses the municipal literary archives and the Monacensia Library. Hildebrand was one of the most prominent 19th century German sculptors.

Georg Hirth

(*July 13, 1841 Gräfentonna, Gotha, † March 28, 1916 Munich)
Art collector, art historian, writer, publisher. 1858 cooperation on *Westermann's Monatshefte*. 1859 publication on *Friedrich Schiller als Mann des Volkes*. A man of wide knowledge, he wrote on political economy, science and the arts. 1870–71 editor of the *Augsburger Allgemeine Zeitung*. 1875 set up a printing house with Thomas Knorr, whose sister he married. Hirth's many publications are concerned with the physiology of art, the teaching of drawing, with medicine and psychology. Editor of *Das deutsche Zimmer der Renaissance* and from 1878 of his own study of forms, *Hirths Formenschatz, Das deutsche Zimmer vom Mittelalter bis zur Gegenwart, Ideen über Zeichenunterricht* and *Plastisches Sehen*. Hirth's writings were of great importance for the revival of the Renaissance style by artists such as Seitz, Gedon, Seidl and Lenbach. 1881 Knorr & Hirth took over the *Münchner Neueste Nachrichten* publishing house after the death of Julius Knorr. 1892 active in the foundation of the Munich Secession.
1896 publication of *Die Jugend* which lent its name to the Jugendstil movement. Collaborators on *Die Jugend* were F. A. von Kaulbach, Fritz von Uhde, Julius Diez, Stuck, Albert Weisgerber, and Lenbach.
Portrait published in *Camera Work*, July 1910, no. 31, p. 17.

Frau Ludwig Hohlwein (née Léonie Jeannette Dürr)

(*June 26, 1876 Wiesbaden, † 1951 Berchtesgaden)
Daughter of a master tailor. 1901 marriage to the graphic artist and architect Ludwig Hohlwein (1874–1949), one of Germany's most renowned poster designers. He studied architecture under Friedrich Thiersch at the Munich Polytechnikum. Assistant to the architect Paul Wallot at the Dresdner Art Academy in 1898. From 1897 he worked occasionally for *Die Jugend*. 1906 moved to Munich, active there as an interior designer for private homes, cafés, hotels and ocean steamers. He also produced innumerable posters.
Portrait of Frau Hohlwein published in *Camera Work*, July 1910, no. 31, p. 39; *Deutsche Kunst und Dekoration*, 1910, p. 47.

Graphiker, Maler und Architekten Ludwig Hohlwein (1874–1949), einem bedeutenden deutschen Plakatkünstler. Er studierte Architektur bei Friedrich Thiersch am Polytechnikum München; 1898 Assistent bei dem Architekten Paul Wallot an der Dresdner Kunstakademie; seit 1897 auch gelegentlicher Mitarbeiter für die *Jugend*; 1906 Übersiedlung nach München und Tätigkeit als Gestalter und Innenarchitekt von Privathäusern, Cafés, Hotels und Ozeandampfern sowie ausgiebige Tätigkeit als Plakatgestalter.
Veröffentlichung des Porträts von Frau Hohlwein in *Camera Work*, Juli 1910, Nr. 31, S. 39; *Deutsche Kunst und Dekoration*, 1910, S. 47.

Misses Ide
(Lebensdaten unbekannt)
Töchter des amerikanischen Rechtsanwalts und Diplomaten Henry Clay Ide (1844–1921), u.a. Anne Ide, verheiratet seit 1906 mit William Bourke Cockran (1854–1923), Politiker und Kongressabgeordneter für die demokratische Partei. H. C. Ide war von 1882 bis 1886 Mitglied des Senates von Vermont, 1884 Präsident des Republican State Committee. 1891 Ernennung zum Land Commissioner in Samoa, Zusammentreffen mit dem Schriftsteller Robert Louis Stevenson. 1893–97 oberster Richter, 1906 Gouverneur des Inselstaates Samoa. 1909–13 außerordentlicher Minister mit besonderen Machtbefugnissen in Spanien.
Veröffentlichung eines Doppelporträts der Schwestern Ide in *Deutsche Kunst und Dekoration*, 15, Oktober 1911, S. 81.

Sir Henry (Brodribb) Irving
(*6.2.1838 Keinton/Glastonbury in England, † 1905)
Schauspieler. Erster professioneller Auftritt 1856, spielte in zahlreichen Londoner Theatern und unternahm ausgedehnte Tourneen durch Großbritannien und Nordamerika; bekannt für seine aufwendigen und sorgfältigen Shakespeare-Interpretationen und Inszenierungen; 1889 Mitglied des New Yorker Players Club; als erster Schauspieler 1895 zum Ritter geschlagen, Verfasser des Buches *The Drama* (1893). Zwischen 1883 und 1903 sechs Aufenthalte in den Vereinigten Staaten. Irving wurde zwischen 1876 und 1885 von James McNeill Whistler in einem eindrucksvollen Gemälde mit dem Titel ›Arrangement in Black, No. 3: Sir Henry Irving as Philip II of Spain‹ porträtiert, heute im Metropolitan Museum of Art, New York.
Veröffentlichung des Porträts in *The Photographic Times*, 1899, S. 557; *Camera Work*, April 1910, Nr. 30, S. 13.

Joseph Jefferson
(*20.2.1829 Philadelphia, † 23.4.1905 Palm Beach)
Schauspieler. Sohn des gleichnamigen Schauspielers und Bühnenmalers; schauspielerisches Debüt bereits mit 4 Jahren gemeinsam mit ›Jim Crow‹ Rice. Nach dem Tode seines Vaters 1842 war er als 13-jähriger für den Lebensunterhalt der Familie verantwortlich; Tourneen in den Südstaaten und Mexico; 1856 erste Reise nach Europa; ab 1856 Mitglied der Laura Keene Company in New York; 1859 Zusammenarbeit mit Dion Boucicault als Schauspieler in ›The Cricket on the Hearth‹ und in ›The Octoroon‹. 1861–65 Aufenthalt in Australien. Rückkehr nach London und Auftritt als Vagabund Rip van Winkle in dem von Dion Boucicault adaptierten Bühnenstück im Adelphi Theatre London. Rip van Winkle spielte er seitdem häufig in Europa und Nordamerika; 1866 Aufführung von ›The Rivals‹ in der Rolle des Bob Acres, die ihm ähnlichen Erfolg brachte; auch in der Rolle des Caleb Plummer in dem Stück ›Dot‹ war Jefferson sehr erfolgreich. Jefferson war einer der beliebtesten

amerikanischen Schauspieler im 19. Jahrhundert, der 71 Jahre auf der Bühne stand und tragische wie komische Rollen verkörperte. Ab 1889 lebte er im Sommer in ›Crow's Nest‹ bei Buzzards Bay, Massachusetts. Ab 1893 Nachfolger von Edwin Booth als Präsident des Players Club in New York City.
Veröffentlichung des Porträts von Frank Jefferson, Enkel von Joseph Jefferson, in *Camera Work*, April 1910, No. 30, S. 11; *Deutsche Kunst und Dekoration*, 1911, S. 275.

Frida von Kaulbach geb. Frida Schytte (Frida Scotta)
Geigerin. Ab 1897 verheiratet mit dem Maler Friedrich August von Kaulbach.

Friedrich August von Kaulbach
(*2.6.1850 München, † 26.7.1920 Ohlstadt/Murnau)
Maler. Sohn des Historien- und Bildnismalers Friedrich Kaulbach (1822–1903), Großneffe von Wilhelm von Kaulbach. Ausbildung bei seinem Vater in Hannover und in Nürnberg auf der Kunstschule bei August von Kreling und Karl Raupp. 1871 Übersiedlung nach München, verkehrte mit Diez, Lenbach, Makart. 1873–74 Studium der venezianischen Malerei in Italien. 1883 Verleihung des Professorentitels. 1883–85 Aufenthalt in Italien. 1886–91 Nachfolger von Karl Theodor von Piloty als Direktor der Akademie der Künste München. Während Kaulbach anfänglich Genre- und Porträtdarstellungen altdeutscher Charaktere im Stile der deutschen Renaissance malte, wurde er vor allem berühmt für seine eleganten dekorativen Bildnisse von Damen der Hochfinanz und des Hochadels, aber auch von Tänzerinnen wie Isadora Duncan und Guerrero. Kaulbach lebte und arbeitete in seiner Villa in München und in Ohlstadt bei Murnau.
Veröffentlichung von Porträts in *Photographische Kunst*, 6, 1907/08, Tafel 54 und Tafel 58.

Karl Klingspor
(*25.6.1868 Gießen, † 1.1.1950 Offenbach am Main)
Schriftgestalter, Fabrikant. Seit 1892 Mitinhaber der Firma Gebrüder Klingspor für Schriftgießerei in Offenbach am Main, die er seit 1895 mit seinem Bruder Wilhelm leitete. Bedeutender Gestalter von Schrifttypen; gewann als Mitarbeiter so bedeutende Kräfte wie Behrens, Eckmann, Tiemann. Ehrenmitglied des Vereins Deutscher Buchkünstler Leipzig und des Vereins für Kunstpflege in Offenbach; 1.Vorsitzender des Vereins Deutscher Schriftgießereien e.V.; wohnte in Kronberg im Taunus. Eine Dokumentation seiner Tätigkeit befindet sich im Klingspor-Museum in Offenbach.

Thomas Knorr
(*1851 München, † 13.12.1911 München)
Verleger, Kunstsammler. Seit 1881 Mitherausgeber der *Münchner Neuesten Nachrichten*.

Emanuel Lasker
(* 24.12.1868 Berlinchen, † 11.1.1941 New York)
Philosoph, Mathematiker, Schachspieler und Dichter. Sohn eines jüdischen Kantors und jüngerer Bruder des Mediziners Dr. Berthold Lasker (1861–1928). Lernte mit 10 Jahren von seinem Bruder Berthold, der 1894–99 mit der Dichterin Else Lasker-Schüler verheiratet war, das Schachspielen. Studium der Mathematik, 1902 Promotion in Erlangen. Schachweltmeister von 1894 bis 1921, der seinen Titel erfolgreich gegen Marshall, Tarrasch, Janowski und Schlechter verteidigte. Zu Laskers wichtigsten Veröffentlichungen zählen *Das Begreifen*

The Misses Ide
(Dates unknown)
Daughters of the American lawyer and diplomat Henry Clay Ide (1844–1921). In 1906 Anne Ide married William Bourke Cockran (1854–1923), politician and Congress deputy for the Democratic Party. 1882–86 Henry C. Ide was a member of the Vermont Senate, in 1884 he became president of the Republican State Committee. He was appointed Land Commissioner in Samoa in 1891 where he met the writer Robert Louis Stevenson. 1893–97 supreme court judge. 1906 governor of the island state of Samoa. 1909–13 extraordinary minister with special powers in Spain. Double portrait of the Ide sisters published in *Deutsche Kunst und Dekoration*, 15, October 1911, p. 81.

Sir Henry (Brodribb) Irving
(*February 6, 1838 Keinton, Glastonbury, England, † 1905)
Actor. 1856 first professional appearance. Played in numerous London theatres, extensive tours in Great Britain and North America. Famous for his complex and meticulous Shakespeare interpretations and productions. 1889 membership in the New York Players Club. 1895 first actor to be knighted. 1893 published *The Drama*. Between 1883 and 1903 six visits to the United States. 1876–85 James McNeill Whistler painted an impressive portrait of Irving entitled "Arrangement in Black, no. 3: Sir Henry Irving as Philip II of Spain," now in the collection of the New York Metropolitan Museum of Art.
Portrait published in *The Photographic Times*, 1899, p. 557; *Camera Work*, April 1910, no. 30, p. 13.

Joseph Jefferson
(*February 20, 1829 Philadelphia, † April 23, 1905 Palm Beach)
Actor. Son of the actor and scene painter of the same name. Stage debut at the age of 4, together with "Jim Crow" Rice. After his father's death in 1842 he was responsible for the family, although only 13 year of age. Tours in the southern States and Mexico. 1856 first trip to Europe. 1856 member of the Laura Keene Company in New York. 1859 worked together with Dion Boucicault in "The Cricket on the Hearth" and "The Octoroon." In Australia from 1861–65. Return to London where he played the vagabond Rip van Winkle at the Adelphi Theatre in a piece adapted for stage by Dion Boucicault. He later played Rip van Winkle regularly in Europe and North America. His performance of Bob Acres in "The Rivals" in 1866 was of equal success, as was his interpretation of the role of Caleb Plummer in "Dot." Jefferson was one of the most loved American actors of the 19th century. He worked on stage for 71 years in both tragic and comic roles. After 1889 he spent his summers in "Crow's Nest" near Buzzards Bay, Massachusetts. 1893 he succeeded Edwin Booth as president of the New York City Players Club.
Portrait of Frank Jefferson, grandson of Joseph Jefferson, published in *Camera Work*, April 1910, no. 30, p. 11; *Deutsche Kunst und Dekoration*, 1911, p. 275.

Frida von Kaulbach (née Frida Schytte – Frida Scotta)
Violinist. Married to the artist Friedrich August von Kaulbach from 1897.

Friedrich August von Kaulbach
(*June 2, 1850 Munich, † July 26, 1920 Ohlstadt, Murnau)
Painter. Son of the history and portrait painter Friedrich Kaulbach (1822–1903), grand-nephew of Wilhelm von Kaulbach. Trained under his father in Hannover, and in the Nuremberg school of art under August von Kreling and Karl Raupp. 1871 moved to Munich. Acquainted with Diez, Lenbach, Makart. 1873–74 studied Venetian painting in Italy. Appointed professor in 1883. Sojourn in Italy 1883–85. Succeeded Karl Theodor von Piloty as director of the Munich Academy of the Arts, 1886–91. Although Kaulbach at first preferred genre and portrait paintings of old-German characters in the German Renaissance style, he was mainly famous for his elegantly decorative portraits of ladies from high financial circles and of high birth, but also of dancers such as Isadora Duncan and Guerrero. Kaulbach lived and worked in his villa in Munich and in Ohlstadt near Murnau.
Portraits published in *Photographische Kunst*, 6, 1907/08, plate 54 and plate 58.

Karl Klingspor
(*June 25, 1868 Giessen, † January 1, 1950 Offenbach am Main)
Type-designer, type-founder. 1892 joint owner of the Gebrüder Klingspor type-foundry in Offenbach am Main which he managed with his brother Wilhelm from 1895 onwards. Outstanding designer of types. Among his more famous collaborators were Behrens, Eckmann and Tiemann. Honorary member of the Association of German Book Designers, Leipzig, and of the Association for the Cultivation of the Arts, Offenbach. First chairman of the Association of German Type-Foundries. Lived in Kronberg im Taunus. There is a documentation on his life in the Klingspor Museum in Offenbach.

Thomas Knorr
(*1851 Munich, † December 13, 1911 Munich)
Publisher and art collector. Co-editor of the *Münchner Neueste Nachrichten* from 1881.

Emanuel Lasker
(*December 24, 1868 Berlinchen, † November 11, 1941 New York)
Philosopher, mathematician, chess player and poet. Son of a Jewish cantor and younger brother of the doctor Berthold Lasker (1861–1928). He learned chess from his brother, Berthold, who was married to the poet Else Lasker-Schüler from 1894 to 1899. Studies in mathematics. World chess champion from 1894 to 1921. He defended the title successfully against Marschall, Tarrasch, Janowski, and Schlechter. Among his most important publications are *Das Begreifen der Welt*, Berlin 1913 and *Lehrbuch des Schachspiels*, Berlin 1925. 1933 emigrated to New York.
Double portrait with Berthold Lasker published in *Photographische Kunst*, 8, 1909/10, plate 2; *Camera Work*, July 1910, no. 31, p. 19 . Portrait published in *Deutsche Kunst und Dekoration*, 1910, p. 52. One Lasker portrait has been wrongly attributed to Heinrich Kühn. Cf. Peter Weiermair, *Heinrich Kühn (1866–1944) Photographien*, Innsbruck 1978, p. 69.

Lolo von Lenbach (née Charlotte von Hornstein)
(*1861, † 1941)
Eldest daughter of the musician and composer Robert von Hornstein. Studied singing and painting, among others, under Nikolaus Gysis. Lively contact with Munich artist circles. 1896 married the painter Franz von Lenbach (1836–1904). 1924 she made a considerable donation from the artist's estate and in 1925 sold the Lenbach House to the City of Munich.

Gabriele von Lenbach
(*April 25, 1899 Munich, † 1978)
Only child from the second marriage of the artist Franz von Lenbach with Lolo von Hornstein. Gabriele Lenbach was mar-

der Welt (1913); *Vom Menschen die Geschichte* (1925) (gemeinsam mit Berthold Lasker), *Lehrbuch des Schachspiels*, (1925). 1933 Emigration nach New York.
Veröffentlichung des Doppelporträts mit Berthold Lasker in *Photographische Kunst*, 8, 1909/10, Tafel 2; *Camera Work*, Juli 1910, Nr. 31, S. 19. Veröffentlichung eines Porträts in *Deutsche Kunst und Dekoration*, 1910, S. 52. Ein Lasker-Porträt wurde irrtümlich als Photographie Heinrich Kühns in: Peter Weiermair, *Heinrich Kühn (1866–1944) Photographien*, Innsbruck 1978, S. 69, veröffentlicht.

Gabriele von Lenbach

(*25.4.1899 München, † 1978)
Einziges Kind aus der zweiten Ehe des Malers Franz von Lenbach mit Lolo von Hornstein. Gabriele Lenbach war mit dem Kölner Verleger Kurt Neven DuMont verheiratet.
Veröffentlichung von Porträts in *Photographische Kunst*, 10, 1911/12, Tafel 5; *Deutsche Kunst und Dekoration*, 1910, S. 44 und S. 45.

Lolo von Lenbach (geb. Charlotte von Hornstein)

(*1861, † 1941)
Älteste Tochter des Musikers und Komponisten Robert von Hornstein. Unterricht in Gesangslehre und Malerei, u.a. bei Nikolaus Gysis; pflegte rege Kontakte zu Münchner Künstlerkreisen, seit 1896 verheiratet mit dem Maler Franz von Lenbach (1836–1904). 1924 umfangreiche Stiftung aus dem Künstlernachlass und 1925 Verkauf des Lenbach-Hauses an die Stadt München.

Marion von Lenbach

(*30.1.1892 München, † 1947)
Zweite Tochter aus erster Ehe des Malers Franz von Lenbach mit Gräfin Magdalena von Moltke. Nach der Scheidung 1896 wurde Lenbach die Tochter Marion zugesprochen. Marion Lenbach war mit Otto Graf de la Rosée verheiratet.
Veröffentlichung eines Porträts in *Deutsche Kunst und Dekoration*, 15, Oktober 1911, S. 76; Veröffentlichung eines Porträts von Otto Graf de la Rosée in *Deutsche Kunst und Dekoration*, 15, Oktober 1911, S. 77.

Fritz von Miller

(*11.4.1840 München, † 1921 München)
Goldschmiedekünstler, Bildhauer. Sohn des Erzgießers Ferdinand von Miller; Eigentümer der Königlichen Erzgießerei in München gemeinsam mit seinem Bruder Ferdinand v. Miller; Studium an den Akademien in München und Berlin; arbeitete in Paris, London und Rom. 1868–1912 Professor an der Kgl. Kunstgewerbeschule in München für Modellieren, Ziselieren, Emaillieren. Erfolgreiche Beteiligung an diversen Ausstellungen u.a. der ›Kunstgewerbeausstellung München‹ 1876, der ›Internationalen Kunstausstellung‹ in München 1883, den Weltausstellungen in St. Louis 1904 und Brüssel 1910.
Veröffentlichung des Porträts in *Deutsche Kunst und Dekoration*, 17, 1913, S. 64.

Bertha Morena (eigentlich Berta Meyer)

(*27.1.1878 Mannheim, † 7.10.1952 Rottach-Egern)
Sängerin. Debüt als Agathe im ›Freischütz‹ von Carl Maria von Weber; als Sopranistin Mitglied des Ensembles der Münchner Oper bis 1927. Zahlreiche Konzertreisen in Europa, Rußland und Nordamerika. Bertha Morena ist als Wagner-Interpretin berühmt geworden.

Adolf Oberländer

(*1.10.1845 Regensburg, † 29.5.1923 München)
Zeichner, Maler. Studium der Historienmalerei an der Münchner Akademie bei Anschütz und Piloty 1861; ab 1863 Zeichner für die *Fliegenden Blätter*, ab 1869 für den *Münchner Bilderbogen*. Neben Wilhelm Busch zählt Oberländer zu den bedeutendsten Karikaturisten und Humoristen in Deutschland in der 2.Hälfte des 19.Jahrhunderts. Laut Thieme-Becker war er »am bekanntesten durch seine anthropomorphischen Tierzeichnungen«; ab 1904 Hinwendung zur Malerei.
Veröffentlichung des Porträts in *Photographische Kunst*, 8, 1909/10, Tafel 4.

Gustav Otto

(*12.1.1883 Mühlheim an der Ruhr, † März 1926)
Flugzeugpionier, Erfinder, Industrieller. Sohn des Erfinders des Viertaktmotors Nicolaus Otto; gemeinsam mit Gabriel Letsch Konstruktion wassergekühlter Motoren für den Doppeldecker ›Ago‹, der serienmäßig in den Berliner Ago-Flugzeugwerken (Aviatiker Gustav Otto-Werke) gebaut wurde und als Militärflugzeug in Bayern weithin Verbreitung fand. 1909 Gründung einer eigenen Flugzeugfabrik in München-Puchheim, die später in die Bayerischen Flugzeugwerke aufging. Gemeinsam mit den Brüdern Eversbusch Begründer der kriegswichtigen Pfalz-Flugzeugwerke in Speyer; 1916 mit Josef Schrittisser Gründung einer Gesellschaft zum Bau von Flugzeugteilen für die Rüstungsindustrie, die nach 1918 Automobile herstellte. Nach Ausscheiden aus der Firma Leitung einer Versuchswerft am Starnberger See.
Veröffentlichung eines Porträts in *Braunbeck's Sportlexikon* 1912/13, Berlin 1913.

Joseph Pennell

(*4.7.1860 Philadelphia, † 23.4.1926 New York)
Graphiker, Aquarellmaler, Illustrator und Kunstschriftsteller. Zu seinen bekanntesten Werken gehören Architekturansichten von London, Philadelphia und New York. Verheiratet mit der Schriftstellerin Elizabeth Robins; Biograph des Malerfreundes James MacNeill Whistler. Pennell äußerte sich wiederholt ausführlich über die Photographie (z.B. in *The Studio*, 1893), die er als künstlerisches Gestaltungsmittel ablehnte.
Veröffentlichung des Porträts in *Deutsche Kunst und Dekoration*, 18, 1914, S. 204.

Carl Ernst Poeschel

(*1874, † 1944)
Buchgestalter, Druckereibesitzer. »Die angesehenste Druckerpersönlichkeit in der ersten Hälfte des 20.Jahrhunderts war Carl Ernst Poeschel (1874–1944), welcher der 1870 gegründeten Druckerei Poeschel & Trepte vorstand. Er trug die hohen Anschauungen von William Morris, Emery Walker, Eric Gill, Edward Johnston und Sidney Cockerell nach Deutschland. Er war ein Erwecker und Entdecker, ein Mittler und Anreger, sein Haus galt als der Inbegriff des Druckwesens in Leipzig, und zwar von der Jahrhundertwende bis zum Zweiten Weltkrieg. Mit seinem Freund Walter Tiemann gründete er 1907 die erste deutsche Privatpresse (Janus-Presse) und war später noch einmal an einem gleichgearteten Unternehmen beteiligt, der Insel-Presse (1919–1922).« Georg Kurt Schauer (Hrsg.), *Internationale Buchkunst im 19.–20. Jahrhundert*, Ravensburg 1969, S.336.

Dora Polster-Brandenburg

(*9.8.1884 Magdeburg, † 18.3.1958 Böbing)
Buchillustratorin, Textilkünstlerin, Kunstgewerblerin. Nach dem

ried to the Cologne publisher Kurt Neven DuMont.
Portrait published in *Photographische Kunst*, 10, 1911/12, plate 5;
Deutsche Kunst und Dekoration, 1910, p. 44 and p. 45.

Marion von Lenbach

(*January 30, 1892, Munich † 1947)
Second daughter from the first marriage of the artist Franz von
Lenbach to Countess Magdalena von Moltke. After the divorce in
1896 Lenbach got custody of his daughter. She later married Otto
Graf de la Rosée.
Portrait published in *Deutsche Kunst und Dekoration*, 15, Octo-
ber 1911, p. 76; portrait of Otto Graf de la Rosée in *Deutsche
Kunst und Dekoration*, 15, October 1911, p. 77.

Fritz von Miller

(*April 11, 1849 Munich, † 1912 Munich)
Goldsmith, sculptor. Son of the ore-founder Ferdinand von
Miller. Owner of the Royal Ore-Foundry in Munich jointly with
his brother Ferdinand. Studied at the Munich and Berlin Acad-
emies. Worked in Paris, London and Rome. 1868–1912 professor
of modelling, engraving, and enamelling at Munich's Royal
College of Arts and Crafts. Successful participation in numerous
exhibitions, among them the 1876 arts and crafts exhibition in
Munich, the 1883 International Art Exhibition in Munich, and the
world fairs in St. Louis 1904 and Brussels 1910.
Portrait published in *Deutsche Kunst und Dekoration*, 17, 1913, p.64.

Bertha Morena (originally Berta Meyer)

(*January 27, 1878 Mannheim, † October 7, 1952 Rottach-Egern)
Opera singer, soprano. Debut as Agathe in Carl Maria von We-
ber's "Freischütz." Member of the Munich Opera House ensemble
until 1927. Numerous concert tours in Europe, Russia and North
America. Bertha Morena was famous as a Wagner interpreter.

Adolf Oberländer

(*October 1, 1845 Regensburg, † May 29, 1923 Munich)
Graphic artist, painter. Studied history painting at the Munich
Academy under H. Anschütz and Piloty in 1861. From 1863 illus-
trator for the *Fliegende Blätter* and from 1869 for the *Münchner
Bilderbogen*. Alongside Wilhelm Busch, Oberländer is regarded
as the most outstanding caricaturist and humorist in Germany in
the second half of the 19th century. According to Thieme-Becker,
he was "best known for his anthropomorphic drawings of ani-
mals." He turned to painting in 1904.
Portrait published in *Photographische Kunst*, 8, 1909/10, plate 4.

Gustav Otto

(*January 12, 1883 Mühlheim an der Ruhr, † March 1926)
Aircraft pioneer, inventor, industrialist. Son of the inventor of the
four-stroke engine Nicolaus Otto. Together with Gabriel Letsch
he constructed water-cooled engines for the double-decker "Ago"
which went into series production at the Berlin Ago-Flugzeug-
werken (Aviatiker Gustav Otto-Werke) and was in widespread
use as a military plane in Bavaria. 1909 he founded his own air-
craft factory in Munich-Puchheim, later absorbed into the Bayer-
ische Flugzeugwerke. Jointly with the Eversbusch brothers he
founded the Pfalz-Flugzeugwerke in Speyer, of importance during
the war. In 1916 he founded a company manufacturing aircraft
parts for the armaments industry, and producing cars after the
war. After leaving that company he managed an experimental
wharf on the lake at Starnberg.
Portrait published in *Braubeck's Sportlexikon* 1912/13, Berlin 1913,
p. 304.

Joseph Pennell

(*July 4, 1860, Philadelphia, † April 23, 1926, New York)
Graphic artist, watercolorist, illustrator and writer. His most
famous works are architectural views of London, Philadelphia
and New York. He was married to the writer Elizabeth Robins.
Biographer of his painter-friend James MacNeill Whistler.
Pennell wrote extensively on photography (for example in *The
Studio*, 1893) which he rejected as an artistic means of expres-
sion.
Portrait published in *Deutsche Kunst und Dekoration*, 18, De-
cember 1914, p. 204.

Carl Ernst Poeschel

(*1874, † 1944)
Book designer, owner of a printing works. "Carl Ernst Poeschel,
who headed the Poeschel & Trepte printers, founded in 1870,
was the most admired personality in printing in the first half of
the 20th century. He introduced the progressive views of
William Morris, Emery Walker, Eric Gill, Edward Johnston and
Sidney Cockerell to Germany. He was a source of inspiration
and stimulation, a discoverer and a mediator. His company was
regarded as the essence of printing in Leipzig from the turn of
the century to the Second World War. With his friend Walter
Tiemann he founded the first private press (Janus Presse) in
Germany in 1907 and was later involved in another similar enter-
prise, Insel Presse (1919–1922)." G. Kurt Schauer (ed.),
Internationale Buchkunst im 19.–20. Jahrhundert, Ravensburg
1969, p. 336.

Dora Polster-Brandenburg

(*August 9, 1884 Magdeburg, † March 18, 1958 Böbing)
Book illustrator, textile designer and graphic artist. After studies
at the Grand Ducal School of Drawing in Eisenach, one of the
first students at the Debschitz-Schule founded in Munich in
1902. On completion of her training, first designs for book deco-
rations, advertising posters, and furniture. Designed figures and
scenery for the Schwabing shadow plays put on by Alexander
von Bernus and Rolf von Hoerschelmann. Married the writer
Hans Brandenburg in 1911. Studio in the forest colony in Pasing
from 1911 to the First World War, later moved to Böbing near
Peissenberg. Commissions for book illustrations and textile
designs. Drawings of dancers. Preoccupied with water-color
painting after 1918. Participation in the 1934 "Great German Art
Exhibition" in the Haus der Kunst.

Prince Albrecht of Bavaria

(*May 3, 1905, lives in Munich)

Prince Luitpold of Bavaria

(*May 8, 1901, Bamberg, † August 27, 1914, Berchtesgaden)
First son of Prince Rupprecht of Bavaria and Marie Gabriele.
Double portrait of Prince Luitpold and Prince Albrecht of Bavaria
(octagon) published in the catalogue of the International Pho-
tography Exhibition in Dresden, 1909; *Photographische Kunst*,
10, 1911/12, plate 4; *Apollo*, 17, no. 383, Dresden 1911. A portrait
published in *Deutsche Kunst und Dekoration*, 15, October 1911,
p. 78.

Crown Prince Rupprecht of Bavaria

(*May 18, 1869, Munich, † July 2, 1955, Leutstetten)
Portrait published in *Camera Work*, July 1910, no. 31, p. 5;
Deutsche Kunst und Dekoration, 1910, p. 40. Portrait published
on the occasion of the outbreak of the First World War in 1914

Besuch der Großherzoglichen Zeichenschule in Eisenach eine der ersten Schülerinnen der 1902 gegründeten Debschitz-Schule in München. Nach der Ausbildung erste graphische Skizzen für Buchschmuck, Werbeplakate, Möbel; Entwürfe von Figuren und Szenen für die Schwabinger Schattenspiele von Alexander von Bernus und Rolf von Hoerschelmann. 1911 Heirat mit dem Schriftsteller Hans Brandenburg; von 1911 bis zum 1. Weltkrieg Atelier in der Pasinger Waldkolonie, später Umzug nach Böbing bei Peißenberg. Aufträge für Buchillustrationen und Textilgestaltung; Tanzzeichnungen; nach 1918 Beschäftigung mit der (Aquarell)-Malerei. 1934 Beteiligung an der ›Großen Deutschen Kunstausstellung‹ im Haus der Kunst.

Prinz Albrecht von Bayern

(*3.5.1905, lebt in München)

Prinz Luitpold von Bayern

(*8.5.1901 Bamberg, † 27.8.1914 Berchtesgaden)
Erster Sohn aus der Ehe von Prinz Rupprecht von Bayern und Marie Gabriele.
Veröffentlichung eines Doppelporträt von Prinz Luitpold und Prinz Albrecht von Bayern (Oktagon) im Katalog *Internationale Photographische Ausstellung zu Dresden*, Dresden, 1909, o.S.; *Photographische Kunst*, 10, 1911/12, Tafel 4; *Apollo*, 17, Nr. 383, Dresden 1911. Veröffentlichung eines Porträts in *Deutsche Kunst und Dekoration*, 15, Oktober 1911, S. 78.

Kronprinz Rupprecht von Bayern

(*18.5.1869 München, † 2.7.1955 Leutstetten)
Veröffentlichung des Porträts in *Camera Work*, Juli 1910, Nr. 31, S. 5; *Deutsche Kunst und Dekoration*, 1910, S. 40. Veröffentlichung des Porträts anläßlich des Ausbruchs des 1. Weltkrieges 1914 als Photogravüre und Wanddruck bei F. Bruckmann in München mit der Aufschrift ›Handeln nicht trauern‹ (Chronik 1914, Stadtarchiv München; Graphische Sammlung im Münchner Stadtmuseum).

Kronprinzessin Rupprecht (Marie Gabriele)

(*9.10.1878 Tegernsee, † 24.10.1912 Sorrent)
Tochter von Herzog Carl Theodor, verheiratet mit Prinz Rupprecht von Bayern seit 1900. Winter 1902–03 Reise nach Indien, China und Japan, die in den ostasiatischen Reiseerinnerungen von Prinz Rupprecht festgehalten wurde. Großes Interesse an den bildenden Künsten, insbesondere für die Musik; erfreute sich großer Beliebtheit in Bayern.
Veröffentlichung des Porträts in *Camera Work*, April 1910, Nr. 30, S. 7.

Prinzregent Ludwig von Bayern (König Ludwig III.)

(*7.1.1845 München, † 18.10.1921 Schloß Sárvár in Ungarn)
Studium der Volkswirtschaft und Juristerei in München; verheiratet mit Maria Therese. 1912 Prinzregent als Nachfolger von Luitpold von Bayern; 1913–18 König von Bayern. Nach der Revolution November 1918 Abdankung der Wittelsbacher und Flucht Ludwigs III. aus München.
Veröffentlichung des Porträts in *Deutsche Kunst und Dekoration*, 17, Oktober 1913, S. 63.

Jesko von Puttkamer

Identität ungeklärt, möglicherweise der älteste Sohn (*16.8.1867) der Schriftstellerin Alberta von Puttkamer, die mit dem Kaiserlichen Staatssekretär Maximilian von Puttkamer verheiratet war.

Fritz Raab

(*1.11.1849 Wien, † 20.3.1927 Meran)
Mediziner. Sohn des ersten Kustos der K.k. Hofbibliothek in Wien. Nach dem Studium der Medizin arbeitete er als Arzt in Böhmen, Wien und in den USA. Arztpraxis in Meran-Untermais und Haus in Tutzing am Starnberger See, wo Raab von Frank Eugene, Alfred Stieglitz, Heinrich Kühn und Leopold von Glasersfeld besucht wurde. Raab zeichnete und photographierte auch.
Veröffentlichung eines photographischen Silhouettenbildes von Fritz und Käti Raab in *Deutsche Kunst und Dekoration*, 17, 1913, S. 89.

Katherina Raab (geborene Nagel)

(*24.5.1861, † 17.10.1923)
Verheiratet mit Fritz Raab seit 1899. Ihre Tochter Käti Raab wurde am 1.1.1901 in Meran geboren und starb 1973 in München.

Heinrich Scherrer

(*6.3.1865 Eckernförde, † 3.10.1937 München)
Gitarrist, Flötist, Komponist. 1891–1916 als Flötist an der Hofoper in München tätig; Gitarrenlehrer mit großem Einfluß auf die Entwicklung des Gitarrenspiels; zahlreiche Kompositionen für Laute und Gitarre. Autor der populären Gitarrenschule *Kunst des Gitarrespiels* in 10 Heften und der volkstümlichen Liedersammlung *Zupfgeigenhansl*, die bis zum 2. Weltkrieg mehr als 50 Auflagen erlebte.

Anton Seidl

(*7.5.1850 Pest, † 28.3.1898 New York)
Dirigent. Einer der bedeutendsten Wagner-Interpreten im 19. Jahrhundert. Assistent von Richard Wagner für den ›Ring der Nibelungen‹ in Bayreuth; 1879–82 Dirigent der Leipziger Oper, ab 1883 in Bremen. 1885–91 Dirigent an der Metropolitan Opera in New York City, dann von 1895 bis 1897 als Dirigent an dem New York Philharmonic Orchestra, abschließend in Bayreuth und Covent Garden.

Emanuel von Seidl

(*22.8.1856 München, † 25.12.1919 München)
Architekt. Wie sein älterer Bruder Gabriel von Seidl Sohn des Großbäckers Anton Seidl (1806–69). 1875 Studium an der Technischen Hochschule in München; Ende der 70er Jahre Mitarbeit bei seinem Bruder in der Firma für Inneneinrichtung Seitz & Seidl. Errichtung des Ausstellungspalastes für die deutsch-nationale Kunstgewerbe-Ausstellung in München 1888 im italienischen Barockstil; Ausstattung von Räumen anläßlich der Weltausstellung Paris 1900; Kostümbälle und Aufführungen des Münchner Orchestervereines sowie Errichtung von Festbauten für das Münchner Schützenfest 1906. Bedeutendster Villenarchitekt in Süddeutschland; Errichtung bzw. Umbau zahlreicher komfortabler Schloßbauten im Stil der englischen Landhausarchitektur wie Schloß Sigmaringen, Schloß Lilienhof, Schloß Ramholz, Schloß Seeleiten in Murnau, Schloß Bodman, Schloß Senger am Tegernsee und Villen u.a. für Alfred Keetmann, Elberfeld; Ernst Faber, Nürnberg; Wilhelm Kestranek, St. Gilgen; Dr. Georg Wolf, Stein im Erzgebirge; Umbau der Villen von Adolf von Hildebrand, Starnberg, und von Thomas Knorr, München; Höhepunkt seines Schaffens sein Landhaus mit Parkanlage in Murnau. In Seidls Werk finden sich Einflüsse des Barock, der englischen Villenarchitektur und der römischen Antike.
Veröffentlichung des Porträts in *Deutsche Kunst und Dekoration*, 1910, S. 51.

as a photo-engraving by F. Bruckmann in Munich in the form of a wall poster with the caption "Handeln nicht trauern" (action not sorrow) (Chronik 1914, Municipal Archives Munich; Graphic Collection, Munich Stadtmuseum)

Crown Princess Rupprecht (Marie Gabriele)

(*October 9, 1878 Tegernsee, † October 24, 1912 Sorrento)
Daughter of Duke Carl Theodor, married Prince Rupprecht of Bavaria in 1900. Trips to India, China and Japan in winter 1902/03, described by Prince Rupprecht in his East-Asian travel diaries. Like her husband, greatly interested in the arts, especially music. Enjoyed wide popularity in Bavaria.
Portrait published in *Camera Work*, April 1910, no. 30, p. 7.

Prince Regent Ludwig of Bavaria (King Ludwig III)

(*January 7, 1845 Munich, † October 18, 1921 Sárvár Castle, Hungary)
Studied economics and law in Munich. Married Maria Therese. 1912 Prince Regent, succeeding Luitpold of Bavaria. 1913–18 King of Bavaria. After the November 1918 revolution abdication of the Wittelsbachers. Ludwig III fled Munich.
Portrait published in *Deutsche Kunst und Dekoration*, 17, October 1913, p. 63.

Jesko von Puttkamer

Identity not quite clear, possibly the eldest son (*August 16, 1867) of the writer Alberta von Puttkamer who was married to the imperial under-secretary Maximilian von Puttkamer.

Fritz Raab

(*November 1, 1849 Vienna, † March 20, 1927 Meran)
Doctor. Son of the first curator of the K.k. Hofbibliothek in Vienna. After studying medicine, he worked as a doctor in Bohemia, Vienna, and in the United States. Medical practice in Meran-Untermais and house in Tutzing on the Starnberg lake where he was visited by Frank Eugene Smith, Alfred Stieglitz, Heinrich Kühn and Leopold von Glasersfeld. Raab also did drawings and took photographs.
Photographic silhouette of Fritz Raab and his daughter Käti Raab published in *Deutsche Kunst und Dekoration*, 1913, p. 89.

Katherina Raab (née Nagel)

(*May 24, 1861, † October 17, 1923)
Married to Fritz Raab from 1899. Her daughter Käti Raab was born on 1.1.1901 in Meran and died 1973 in Munich.

Heinrich Scherrer

(*March 6, 1865 Eckernförde, † October 3, 1937 Munich)
Guitarist, composer. Flautist at the Munich Hofoper until 1916. As a guitar teacher exercised considerable influence on the development of guitar playing. Numerous compositions for lute and guitar. Author of the popular book on guitar-playing *Kunst des Gitarrenspiels* in ten exercise books and of the collection of folk songs *Zupfgeigenhansl* which was re-printed 50 times up until the Second World War.

Anton Seidl

(*May 7, 1850 Pest, † March 28, 1898 New York)
Conductor. One of the 19th century's greatest Wagner interpreters. Assistant to Richard Wagner for the "Ring of the Nibelungs" in Bayreuth. 1879–92 conductor of the Leipzig Opera, from 1883 in Bremen. 1885–91 conductor of the Metropolitan Opera in New York City, from 1895 to 1897 conductor at the New York Philharmonic Orchestra, later in Bayreuth and Covent Garden.

Emanuel von Seidl

(*August 22, 1856 Munich, † December 25, 1919 Munich)
Architect. Son of the wholesale baker Anton Seidl (1806–69). 1875 studied at the technical highschool in Munich. End of the 1870s worked with his brother Gabriel for the interior decorating company Seitz & Seidl. Construction in the Italian baroque style of the exhibition palace for the 1888 Arts and Crafts Exhibition in Munich. Design and decoration of rooms for the 1900 world fair in Paris. Design of fancy-dress ball costumes and performances of the Munich orchestral association, as well as construction of festival buildings for the 1906 Munich shooting festival and fair. South Germany's most outstanding architect of stately homes. Construction and renovation of numerous luxurious castles in the style of English stately mansions, such as Schloß Sigmaringen, Schloß Lilienhof, Schloß Ramholz, Schloß Seeleiten in Murnau, Schloß Bodman, Schloß Senger on the Tegernsee, and houses for, among others, Alfred Keetmann in Elberfeld, Ernst Faber in Nuremberg, Wilhelm Kestranek in St. Gilgen, Dr. Georg Wolf in Stein in the Erzgebirge. Renovation of the homes of Adolf von Hildebrand in Starnberg and Thomas Knorr in Munich. His own country home surrounded by parks in Murnau represents a high point in his career. Seidl's work combines elements of the Baroque period, of the architecture of English stately homes, and of Roman antiquity.
Portrait published in *Deutsche Kunst und Dekoration*, 1910, p. 51.

Gabriel von Seidl

(*December 9, 1848 Munich, † April 27, 1913 Bad Tölz)
Architect. 1871–74 studies in architecture at the technical highschool in Munich. 1876–77 sojourn in Rome. From 1878 free-lance architect and founder of the Seidl & Seitz company together with Rudolf von Seitz. 1873 co-founder of the artists group Allotria. Among his main works in Munich are the artists house on Lenbachplatz, the Bavarian National Museum (1896/1900), the Deutsche Museum (old section, 1906), St. Anne's church, villas and residential homes of Franz Lenbach, Friedrich August von Kaulbach, Toni Stadler, Julius Böhler and Albert Freiherr von Schrenk-Notzing. 1881 festival building for the VII. German shooting festival and fair in Munich, together with R. von Seitz. Preference for Romantic, Early Gothic, and in particular German Renaissance style which he linked with the "cosy" Bavarian and Tyrolean regional styles.
Portrait published in obituary by Eugen Kalkschmidt in *Die Kunst*, 14, 1912/13, p. 420; *Reclams Universum*, 1913; *Berliner Illustrirte Zeitung*, no. 7, 1913, p. 132 and no. 18, 1913, p. 372.

Rudolf von Seitz

(*June 15, 1842, Munich, † June 18, 1910, Munich)
Graphic artist, interior designer, fresco and miniature painter. Son of the artist and former technical director of the Bavarian court theatre Franz von Seitz. 1857 studies at the Munich Academy under Anschütz and v. Piloty. Design, in the Renaissance style, of the 1876 Art and Industrial Exhibition in Munich, with Ferdinand von Miller and Lorenz Gedon. 1878 foundation of an interior design studio with G. von Seidl. 1888–1910 professor of "higher decorative art" at the Munich Academy. 1883 (honorary) curator of the Bavarian National Museum. Important designer of Munich (artists) festivals, such as the VII. German shooting festival and fair in 1881, the 1888 Arts and Crafts Exhibition in Munich, and the memorial celebrations for Otto von

Gabriel von Seidl

(*9.12.1848 München, † 27.4.1913 Bad Tölz)
Architekt. 1871–74 Studium der Architektur an der Technischen Hochschule München. 1876/77 Aufenthalt in Rom; ab 1878 freischaffender Architekt und Gründung der Firma Seidl & Seitz gemeinsam mit Rudolf von Seitz; Mitbegründer der Künstlervereinigung Allotria 1873. Zu seinen Hauptwerken in München zählen das Künstlerhaus am Lenbachplatz, das Bayerische Nationalmuseum (1896/1900), das Deutsche Museum (1906, alter Teil), die St. Anna-Kirche, Villen und Wohnhäuser von Franz Lenbach, Friedrich August von Kaulbach, Toni Stadler, Julius Böhler und Albert Freiherr von Schrenk-Notzing. 1881 Festbauten für das VII. Deutsche Bundesschießen in München gemeinsam mit R. v. Seitz. Vorliebe für Bauformen der Romanik, Frühgotik und insbesondere der deutschen Renaissance in Verbindung mit ›gemütlichem‹ bayerischen bzw. Tiroler Heimatstil.
Veröffentlichung von Porträts im Nekrolog von Eugen Kalkschmidt in *Die Kunst*, 14, 1912/13, Bd. 28, S. 420; *Reclams Universum*, 1913; *Berliner Illustrirte Zeitung*, Nr. 7, 1913, S. 132 und Nr. 18, 1913, S. 372.

Rudolf von Seitz

(*15.6.1842 München, † 18.6.1910 München)
Kunstgewerbler, Innenarchitekt, Fresko- und Miniaturmaler. Sohn des Malers und ehemaligen technischen Direktors der bayerischen Hofbühne Franz von Seitz; 1857 Studium an der Münchner Akademie bei Anschütz und v. Piloty. 1876 mit Ferdinand von Miller d.Ä. und Lorenz Gedon Ausschmückung der Kunst- und Industrie-Ausstellung 1876 in München im Renaissance-Stil; 1878 Gründung des Ateliers für Innendekoration mit G. v. Seidl. 1888–1910 Professor für ›höhere decorative Kunst‹ an der Kunstakademie München; ab 1883 (Ehren)Konservator des bayerischen Nationalmuseums. Wichtiger Ausstatter von Münchner (Künstler) Festen wie dem VII. deutschen Bundesschießen 1881, der Deutsch-Nationalen Kunstgewerbeausstellung in München 1888 oder der Gedächtnisfeier für Otto von Bismarck. Zahlreiche Deckengemälde für die Münchner Residenz, Villa Knorr und St. Anna-Kirche.
Veröffentlichung von Porträts in *Photographische Kunst*, 6, 1907/08, Tafel 53; *Reclams Universum*, 1910, S. 297; *Camera Work*, Juli 1910, Nr. 31, S. 15; *Deutsche Kunst und Dekoration*, 17, Oktober 1913, S. 65. In der Handschriftenabteilung der Bayerischen Staatsbibliothek München befindet sich in den ›Seitziana‹, XII, das Porträt von Seitz; auch der Nachlaß Max Lehrs, ehemaliger Direktor des Kupferstichkabinetts von Dresden, beinhaltet Eugenes Porträt von Seitz, irrtümlich als Bildnis von Arnold Böcklin bezeichnet. (Vgl. Lehrs Nachlaß, Handschriftenabteilung Bayerische Staatsbibliothek, München.)

Max Seliger

(*12.5.1865 Bublitz in Pommern, † 10.5.1920 Leipzig)
Maler. 1894–1901 Lehrer an der Berliner Kunstgewerbeschule; 1901–20 Direktor der Königlichen, später Staatlichen Akademie für graphische Künste und Buchgewerbe in Leipzig; dort Reformierung der Akademieausbildung; einer der Mitorganisatoren der Weltausstellung für Buchgewerbe und Graphik in Leipzig (Bugra) 1914.

Toni (Anton) von Stadler

(*9.7.1850 Göllersdorf/Niederösterreich, † 17.9.1917 München)
Maler. Ab 1873 Studium der Malerei in Berlin bei Paul Meyersheim, 1878 Übersiedlung nach München. Dort enge Bindungen zu Louis Neubert, Gustav Schönleber und Adolf Stäbli. Malte

vor allem Landschaftsmotive aus dem bayerischen Voralpenland, beeinflußt von der französischen Freilichtmalerei im Stile der Schule von Barbizon. 1893 Mitbegründer der Münchner Secession; 1912–14 Generaldirektor der Münchner Museen als Nachfolger von Hugo von Tschudi.
Veröffentlichung des Porträts anläßlich Stadlers 60.Geburtstages in *Reclams Universum*, 1910, S. 297; Veröffentlichung eines Porträts in der *Berliner Illustrirten Zeitung*, Nr. 50, 1912, S. 1236.

Alfred Stieglitz

(*1.1.1864 Hoboken, New Jersey, † 13.7.1946 New York)
Photograph, Publizist, Galerist. Nach der Schulausbildung in New York Besuch des Realgymnasiums in Karlsruhe; 1882–90 Studium an der Polytechnischen Hochschule in Berlin und Zusammenarbeit mit dem Chemiker und Photographen Wilhelm Vogel; 1883 erste Photographien; 1890–95 Teilhaber und Leitung eines Unternehmens für Photogravüre in New York. 1893 Heirat mit Emmeline Obermeyer, gemeinsame Tochter Katherine. 1897–1902 Herausgeber von *Camera Notes*, die Zeitschrift des New Yorker Camera Club; 1902 Gründer der Photo-Secession als Zusammenschluß der bedeutendsten nordamerikanischen Kunstphotographen; 1903–1917 Herausgeber der *Camera Work*. 1905–17 Leitung der ›Little Galleries‹ der Photo-Secession. Mitgliedschaft im Linked Ring (1894–1908) und der Royal Photographic Society (ab 1905); 1924 Heirat mit der Malerin Georgia O'Keeffe; 1925–29 Leitung der ›Intimate Gallery‹, 1929–46 Gründung und Leitung von ›An American Place‹ in New York. 1933 Übergabe seiner umfangreichen Sammlung künstlerischer Photographien an das Metropolitan Museum of Art, New York. Stieglitz zählt zu den einflußreichsten Vertretern und Mentoren der internationalen künstlerischen Photographie im Zeitraum von 1895 bis 1946.
Veröffentlichung von Porträts in *The American Photographer*, Juli 1900; *Photographische Rundschau*, Januar 1900, S. 20; *Camera Work*, Januar 1909, Nr. 25, S. 41.

Franz von Stuck

(*23.2.1863 Tettenweis, † 30.8.1928 München)
Graphiker, Plakatgestalter, Maler, Bildhauer und Architekt. 1878–81 Studium an der Kunstgewerbeschule München bei Ferdinand Barth; 1881–85 Studium an der Münchner Kunstakademie bei Lindenschmit dem Jüngeren und Löfftz. 1887–92 Zeichnungen für die *Fliegenden Blätter* und die Zeitschrift der Allotria, Mitarbeit an M.Gerlachs *Allegorien und Embleme*; 1889 erfolgreiche Beteiligung an der ersten internationalen Jahresausstellung München mit ›Wächter des Paradieses‹, ›Innocentia‹ und ›Kämpfende Faune‹; 1896–1901 Zeichnungen für die *Jugend*; 1892 Gründungsmitglied der Secession, 1893 Verleihung des Professorentitels; 1898 Errichtung der Villa Stuck als architektonisches Gesamtkunstwerk. 1895–1928 Professor an der Münchner Kunstakademie; zu seinen Schülern zählten Kandinsky, Klee, Kubin, Purrmann und Albers. Wichtigster Vertreter einer symbolistischen Jugendstilmalerei in Deutschland, die durch mythologische Aktdarstellungen und Fabelwesen geprägt war. Zu seinen Hauptwerken zählen ›Wächter des Paradieses‹, ›Die Sünde‹, ›Die Sphinx‹, ›Das Verlorene Paradies‹, ›Der Krieg‹, ›Das Böse Gewissen‹.
Veröffentlichung des Porträts in *Camera Work*, Juli 1910, Nr. 31, S. 11.

Walter Tiemann

(*29.1.1876 Delitzsch, † 12.9.1951 Leipzig)
Maler, Graphiker, Buch- und Schriftkünstler. Nach dem Studium der Malerei in Leipzig, Dresden und Paris Beschäftigung mit

Bismarck. Numerous ceiling paintings for the Munich Residence, Villa Knorr and the church of St. Anna. Motif published in *Photographische Kunst*, 6, 1907/08, plate 53; *Reclams Universum*, 1910, p. 297; *Camera Work*, July 1910, no. 31, p. 15; *Deutsche Kunst und Dekoration*, 17, October 1913, p. 65. Portrait of Seitz in the manuscript section of the Bavarian State Library in Munich in the "Seitziana". The estate of Max Lehr, former director of the copper engraving cabinet in Dresden, contains Frank Eugene Smith's portrait of Seitz wrongly identified as a portrait of Arnold Böcklin (cf. Lehr's estate, Handschriftenabteilung, Bayerische Staatsbibliothek, Munich).

Max Seliger
(*May 12, 1865 Bublitz in Pommerania, † May 10, 1920 Leipzig)
Artist. 1894–1901 teacher at the Berlin School of Arts and Crafts. 1901–20 director of the Royal, later State Academy of Graphic Arts and Book Design in Leipzig where he restructured the training courses. One of the organisers of the 1914 world book design and graphics exhibition in Leipzig (Bugra).

Toni (Anton) von Stadler
(*July 9, 1850 Göllersdorf, Lower Austria, † September 17, 1917 Munich)
Artist. From 1873 art studies in Berlin under Paul Meyersheim. Moved to Munich in 1878 where he had close contact with Louis Neubert, Gustav Schönleber and Adolf Stäbli. Painted mainly Bavarian Alpine landscapes, influenced by the French plein air movement in the style of the Barbizon school. 1893 co-founder of the Munich Secession. 1912–14 director general of the Munich museums, succeeding Hugo von Tschudi. Portrait published on the occasion of Stadler's 60th birthday in *Reclams Universum*, 1910, p. 297; *Berliner Illustrirte Zeitung*, no. 50, 1912, p. 1236.

Alfred Stieglitz
(*January 1, 1864 Hoboken, New Jersey, † July 13, 1946 New York)
Photographer, publicist, gallery-owner. Attended school in New York and then in Karlsruhe. 1882–90 studies at the polytechnic in Berlin and co-operation with the chemist and photographer Wilhelm Vogel. 1883 first photographs. 1890–95 co-owner and manager of a photo-engraving company in New York. 1893 married Emmeline Obermeyer with whom he had a daughter, Katherine. 1897–1902 editor of *Camera Notes*, the magazine of the New York Camera Club. 1902 founded the Photo-Secession, an association of leading North American art photographers. 1903–17 editor of *Camera Work*. 1905–17 head of the "Little Galleries," or "291," which belonged to the Photo-Secession. Member of the Linked Ring (1894–1908) and of the Royal Photographic Society (from 1905). 1924 married the artist Georgia O'Keeffe. 1925–29 head of the "Intimate Gallery." 1929–46 foundation and management of "An American Place" in New York. 1933 donated his extensive collection of art photography to the Metropolitan Museum of Art, New York. Stieglitz is regarded as the most influential representative and mentor of art photography internationally in the period between 1895 and 1946.
Portraits published in *Photographische Rundschau*, January 1900, p. 20; *Camera Work*, January 1909, no. 25, p. 41.

Franz von Stuck
(*February 2, 1863 Tettenweis, † August 30, 1928 Munich)
Graphic artist, poster designer, painter, sculptor and architect.

1878–81 studies at the Munich School of Arts and Crafts under Ferdinand Barth. 1881–85 studies at the Munich Academy under Lindenschmit the Younger and Löfftz. 1887–1892 illustrations for the *Fliegende Blätter* and the magazine of the Allotria group. Worked on Gerlach's *Allegories and Emblems*. Successful participation in the 1889 first international annual exhibition in Munich with "Wächter des Paradieses," "Innocentia" and "Kämpfende Faune." 1896–1901 illustrations for *Die Jugend*. 1892 founder-member of the Secession. 1893 received the title of professor. 1898 construction of the Villa Stuck as an architectural "Gesamtkunstwerk." 1895–1928 professor at the Munich Academy. Among his pupils were Kandinsky, Klee, Kubin, Purrmann and Albers. Most important representative of a symbolist Jugendstil painting in Germany, known for its depictions of mythological nudes and fabulous creatures. Among his most important works are "Der Wächter des Paradieses," "Die Sünde," "Die Sphinx," "Das Verlorene Paradies," "Der Krieg," "Das Böse Gewissen." Stuck portrait published in *Camera Work*, July 1910, no. 31, p. 11.

Walter Tiemann
(*January 29, 1876 Delitzsch, † September 12, 1951 Leipzig)
Painter, graphic artist, book and type designer. Art studies in Leipzig, Dresden and Paris. 1898 preoccupation with book design. 1907 founded the "Janus-Presse" with Carl Ernst Poeschel. From 1903 onwards, teacher of a master drawing class. 1909 professor at the Leipzig Academy of Graphic Arts and Book Design and year of issue of his first antiqua typeface "Medieval," which was cut at the Klingspor type-foundry in Offenbach am Main. 1920 appointed director of the Leipzig Academy, succeeding Max Seliger. Chairman of the Association of German Book Designers. Outstanding book and cover designs for publishers such as Insel-Leipzig, S. Fischer-Berlin, Julius Zeitler-Leipzig and Albert Langen-Munich.

Johanna Trietschler
(*April 12, 1895 Leipzig, † October 13, 1983 Dippoldiswalde)
Daughter of district court director Paul Trietschler and his wife Margarete Caspari. Studied at the Leipzig Academy of Graphic Art and Book Design 1914–1917. From 1917 assistant to Frank Eugene Smith whom she married Easter 1922. Divorce 1923. In 1931 she married the dentist Dr. Victor Heisig.

Fritz von Uhde
(*May 22, 1848 Wolkenburg, Saxony, † February 2, 1911 Munich)
Painter. 1866/67 studied at the Academy in Dresden. 1868–78 served as an army officer. 1879–80 art studies under Milhály von Munkácsy in Paris. Return to Munich. 1880 friendship with Max Liebermann through whom he became familiar with plein air painting and naturalism. From 1884 numerous paintings with religious themes. 1892 founder-member of the Munich Secession. 1899 elected first chairman, succeeding Ludwig Dill. His most important works are "Bergpredigt," "Predigt am See," "Lasset die Kindlein zu Mir kommen" (1884), "Komm Herr Jesu sei unser Gast" (1885), "Abendmahl" (1886), "Heilige Nacht," "Tischgebet." Portrait published in *Camera Work*, July 1910, no. 31, p. 7; Georg Jacob Wolf, Obituary, in: *Die Kunst*, 12, 1910/11; *Deutsche Kunst und Dekoration*, 15, October 1911.

Margaretha Willer (née Ottmann)
(*July 20, 1859 Sulzbach/Oberpfalz, † March 26, 1936 Munich)
Daughter of the master rope-maker and agriculturist Johann Albrecht Ottmann. 1881–99 married to paymaster Tobias Willers

dem Buchgewerbe seit 1898. 1907 Gründung der ›Januspresse‹
mit Carl Ernst Poeschel. Seit 1903 Lehrer einer Zeichen- und
Meisterklasse, 1909 Professor an der Leipziger Akademie für
graphische Künste und Buchgewerbe und Veröffentlichung
seiner ersten Antiqua-Schrift ›Mediäval‹, die bei Klingspor in
Offenbach geschnitten wurde. 1920 Berufung als Direktor der
Leipziger Akademie als Nachfolger von Max Seliger. Vorsitzen-
der des Vereins Deutscher Buchkünstler. Bedeutender Buch-
künstler, der für zahlreiche Verlage wie Insel-Leipzig, S.
Fischer-Berlin, Julius Zeitler-Leipzig oder Albert Langen-Mün-
chen Buchumschläge entwarf und Bücher gestaltete.

Johanna Trietschler

(*12.4.1895 Leipzig, † 13.10.1983 Dippoldiswalde)
Tochter des Amtgerichtsdirektors Paul Trietschler und Margarete
Caspari; Studium an der Akademie für graphische Künste und
Buchgewerbe 1914–17; ab Ende 1917 Assistentin von Frank Eugene
Smith, den sie Ostern 1922 heiratete; Scheidung der Ehe 1923;
heiratete 1931 in zweiter Ehe den Zahnarzt Dr. Victor Heisig.

Fritz von Uhde

(*22.5.1848 Wolkenburg in Sachsen, † 25.2.1911 München)
Maler. 1866/67 Studium an der Dresdner Akademie; 1868–78
Dienst als Armeeoffizier; 1879–80 Studium der Malerei bei
Milhály von Munkácsy in Paris; Rückkehr nach München. 1880
Freundschaft mit Max Liebermann, wodurch sich Uhde der
Freilichtmalerei und dem Naturalismus zuwandte. Ab 1884 zahl-
reiche Gemälde religiöser Themen; 1892 Mitbegründer der
Münchner Secession, 1899 Wahl zum 1.Vorstand als Nachfolger
von Ludwig Dill. Zu den wichtigsten Arbeiten zählen ›Bergpre-
digt‹, ›Predigt am See‹, ›Lasset die Kindlein zu Mir kommen‹
(1884), ›Komm Herr Jesu sei unser Gast‹ (1885), ›Abendmahl‹
(1886), ›Heilige Nacht‹, ›Tischgebet‹ u.v.a.
Veröffentlichung des Porträts in *Camera Work*, Juli 1910, Nr. 31,
S. 7; Georg Jacob Wolf, ›Nekrolog‹, in: *Die Kunst*, 12, 1910/11;
Deutsche Kunst und Dekoration, 15. Oktober 1911.

Margaretha Willer (geb. Ottmann)

(*20.7.1859 Sulzbach/Oberpfalz, † 26.3.1936 München)
Tochter des Seilermeisters und Landwirts Johann Albrecht
Ottmann, von 1881 bis 1899 verheiratet mit dem Zahlmeister
Tobias Willer (1822–99) in München. Sie war eine enge Freun-
din Eugenes, bei der er vor 1907 und nach seiner Rückkehr nach
München 1927 häufig wohnte.

Georg Witkowski

(*11.9.1863 Berlin, † 1939 Amsterdam)
Germanist. Sohn eines jüdischen Kaufmannes. 1896–1933 Pro-
fessor für deutsche Literaturgeschichte in Leipzig; 1909–33 Her-
ausgeber der *Zeitschrift für Bücherfreunde*. Er beschäftigte sich
insbesondere mit dem Werk Goethes und publizierte u.a. *Goe-
thes Faust für die Bühne eingerichtet* (1906) und *Das Leben Goe-
thes* (1932). Weitere Veröffentlichungen sind *Ludwig Tiecks Leben
und Werk* (1903), *Das Deutsche Drama des 19. Jahrhunderts*
(1903), *Die Kunst und das Leben* (1905), *Miniaturen (Gesammelte
Aufsätze)* (1922); Herausgeber von Werken Schillers und Lessings.
Herausgeber der *Meisterwerke der deutschen Bühne*. Vorstands-
mitglied der Gesellschaft für Theatergeschichte, 2.Vorsitzender
der Gesellschaft der Bibliophilen; lebte in Leipzig.
Eugene bezeichnete Georg Witkowski fälschlicherweise als
Bruder des Essayisten und Publizisten Maximilian Harden
(urspr. Felix Ernst Witkowski, 1861–1927). (Vgl. Bildliste 1925,
Archiv Fotomuseum im Münchner Stadtmuseum.)

(1822–99) in Munich. A close friend of Frank Eugene Smith's, he stayed regularly at her home both before 1907 and after his return to Munich in 1927.

Georg Witkowski

(*September 11, 1863 Berlin, † 1939 Amsterdam)
Germanist. Son of a Jewish merchant. 1896–1933 professor of the History of German literature in Leipzig. 1909–33 editor of *Zeitschrift für Bücherfreunde*. Mainly concerned with the works of Goethe. Published, among others, *Goethes Faust für die Bühne eingerichtet* (1906) and *Das Leben Goethes* (1932). Other publications: *Ludwig Tiecks Leben und Werk (1903), Das Deutsche Drama des 19. Jahrhunderts* (1903), *Die Kunst und das Leben* (1905), *Miniaturen (Gesammelte Aufsätze)* (1922). Editor of the works of Schiller and Lessing. Editor of *Meisterwerke der deutschen Bühne.* On the board of the Society for the History of Theatre, deputy chairman of the Society of Bibliophiles. Witkowski lived in Leipzig.
Frank Eugene Smith wrongly called Georg Witkowski the brother of the essayist and publicist Maximilian Harden (originally Felix Ernst Witkowski, 1861–1927). (Cf. Bildliste 1925, Collection of the Fotomuseum in the Munich Stadtmuseum.)

Ausstellungen 1897–1931

New York 1897

Einzelausstellung von 22 Gemälden in den Blakeslee Galleries, New York City, vom 8. bis 27. März. Ausgestellt waren Rollenporträts von Schauspielern und Sängern, Historienbilder, Stilleben sowie Gemälde mythologischer und christlicher Ikonographie. ›Joseph Jefferson als »Rip van Winkle«‹ (Nr. 1), ›Sir Henry Irving als »King Arthur«‹ (Nr. 2), ›Emma Calvé als »Carmen«‹ (Nr. 3), ›Anton Seidl‹ (Nr. 4), ›Connie Jackson als »Tilly Slowboy«‹ (Nr. 5), ›Mrs. Potter als »Charlotte Corday«‹ (Nr. 6), ›Joseph Jefferson als »Rip van Winkle«‹ (Nr. 7), ›E pur si muove‹ (Nr. 8), ›Un Depute, 1789‹ (Nr. 9), ›The Echo‹ (Nr. 10), ›Flight into Egypt‹ (Nr. 11), ›Harmony‹ (Nr. 12), ›Christus‹ (Nr. 13), ›Joseph Jefferson als »Bob Acres«‹ (Nr. 14), ›Study of a little Girl‹ (Nr. 15), ›The Little Girl's Mother‹ (Nr. 16), ›Leda and Cupid‹ (Nr. 17), ›Leda and Cupid‹ (Nr. 18), ›Leda and her Children‹ (Nr. 19), ›St. George Oak Tree‹ (Nr. 20), ›Still Life‹ (Nr. 21), ›Joseph Jefferson als »Rip van Winkle«‹ (Nr. 22).
Lit.: Katalog *Paintings by Frank Eugene*, Blakeslee Galleries, 353 Fifth Avenue, Cor. 34th Street, New York, March 3 to 27, 1897.

Philadelphia 1898

Eugene stellte im Art Club of Philadelphia aus.
Lit.: *The Critic*, 33. Juli/August 1898.

New York 1898

Ausstellung von Gemälden, darunter Bildnisse von Joseph Jefferson und Anton Seidl, in Knoedler's Gallery, New York.
Lit.: *New York Tribune Supplement*, 1898, S. 3; *The Critic*, 33, Juli/August 1898, S. 17–19.

London 1899

Beteiligung mit 3 Aufnahmen an dem 7. Salon des Linked Ring vom 22. September bis 4. Oktober. Es handelte sich um die Arbeiten ›Sunlight Effect: A Study‹ (Nr. 9) £3, ›A Study‹ (Nr. 58) £3, ›A Portrait‹ (Nr. 181) £3.
»Wir müssen zugeben, daß wir die drei Porträtstudien von dem New Yorker Frank Eugene mögen, auch wenn er einem vagen Mystizismus gefrönt hat, besonders in ›A Study‹ (Nr. 58), das dem Werk Holland Days, unter dem es auch hängt, ähnelt. Das Modell für seine Medusa Dame ist jedoch in einer vielsagenden Pose dargestellt, und der Charakter des Werkes ist ganz anders als alles übrige in der Ausstellung. ›A Portrait‹ (Nr. 181) zeugt von einer gekonnten Nuancierung verschiedener Weißtöne. Die flauschige Feder des Hutes, die Blässe des Gesichts, das Pikée-Halstuch und die weißen Flecken auf der Jacke sind fein abgestuft, wobei wir gern ähnliche Abstufungen in dem vollen schwarzen Haar gesehen hätten, wodurch das Porträt in zwei Teile zerfällt.«
Lit.: A. C. R. Carter, ›The Two Great Photographic Exhibitions. The Photographic Salon‹, in: *Photograms of the Year 1899*, London 1899. p. 83–112, hier S. 95; *Catalogue of the Seventh Annual Exhibition Photographic Salon*, London 1899, S. 33.

New York 1899

Einzelausstellung von 77 Photographien im Camera Club, New York, 3 West 29th Street, vom 15. bis 30. November. Unter den ausgestellten Werken befanden sich zahlreiche Sänger-, Schauspieler- und Künstlerporträts.
Laut Katalog waren folgende Photographien ausgestellt: ›Glen McDonough's Baby‹ (Nr. 1), ›Joseph Jefferson‹ (Nr. 2), ›Sir Henry Irving‹ (Nr. 3), ›Kyrle Bellew‹ (Nr. 4), ›Robert Loftus Newman‹ (Nr. 5), ›Daniel Chester French‹ (Nr. 6), ›William Winter Jefferson‹ (Nr. 7), ›Victor Guglielmo‹ (Nr. 8), ›The Misses Joachim‹ (Nr. 9), ›Sadakichi Hartmann‹ (Nr. 10), ›Gretchen‹ (Nr. 11), ›Emma Calvé (Study)‹ (Nr. 12), ›Robert Stuart Piggott‹ (Nr. 13), ›Mrs. Potter‹ (Nr. 14), ›Miss J.‹ (Nr. 15), ›Master Howard Keim‹ (Nr. 16), ›Master Frank Jefferson‹ (Nr. 17), ›Mr. S.‹ (Nr. 18), ›Professor Emerson‹ (Nr. 19), ›Dr. Waterman‹ (Nr. 20), ›Mr. Selzer‹ (Nr. 21), ›Miss S.‹ (Nr. 22), ›The Misses H.‹ (Nr. 23), ›Miss B.‹ (Nr. 24), ›Miss W.‹ (Nr. 25), ›Anton Seidl‹ (Nr. 26), ›Miss M.W.‹ (Nr. 27), ›Lila Couvère‹ (Nr. 28), ›Decorative Panel‹ (Nr. 29), ›Miss Couvère‹ (Nr. 30), ›Miss S.‹ (Nr. 31), ›Miss Bertha Cushing‹ (Nr. 32), ›Decorative Panel‹ (Nr. 33), ›Profile‹ (Nr. 34), ›Study‹ (Nr. 35), ›St. Cecilia‹ (Nr. 36), ›Decorative Panel‹ (Nr. 37), ›Miss C.‹ (Nr. 38), ›The Lady of Charlotte, N.C.‹ (Nr. 39), ›The Rose‹ (Nr. 40), ›The Novice‹ (Nr. 41), ›Devotion‹ (Nr. 42), ›Summer‹ (Nr. 43), ›Cassandra‹ (Nr. 44), ›Dogwood‹ (Nr. 45), ›Magdalen‹ (Nr. 46), ›Reflection‹ (Nr. 47), ›Fairy-tale‹ (Nr. 48), ›Nydia‹ (Nr. 49), ›Juliet‹ (Nr. 50), ›Me and my Mother‹ (Nr. 51), ›Joan of Arc‹ (Nr. 52), ›Rest‹ (Nr. 53), ›Marinello‹ (Nr. 54), ›The Song of the Lily‹ (Nr. 55), ›Madonna‹ (Nr. 56), ›Evening‹ (Nr. 57), ›Study‹ (Nr. 58), ›Launcelot and Guinevere‹ (Nr. 59), ›Mrs. S. H.‹ (Nr. 60), ›S. H. and family‹ (Nr. 61), ›Mrs. F.‹ (Nr. 62), ›There exists no beauty but what hath some strangeness in its proportion‹ (Nr. 63), ›De Scott Evans‹ (Nr. 64), ›O'Connor's Baby‹ (Nr. 65), ›Charles W. Warner‹ (Nr. 66), ›Nirvana‹ (Nr. 67), ›Nude (Study for a painting)‹ (Nr. 68), ›Marion‹ (Nr. 69), ›Halali‹ (Nr. 70), ›La Cigale‹ (Nr. 71), ›Mr. P.‹ (Nr. 72), ›Mr. B.‹ (Nr. 73), ›Mr. C.‹ (Nr. 74), ›Frank Eugene‹ (Nr. 75), ›A Man in Armor‹ (Nr. 76), ›Glen McDonough‹ (Nr. 77).
»Aus rein technischer Sicht ist Mr. Eugene ein Amateur und er wäre selbst der letzte, der von sich behauptete, sämtliche Kniffe der Phototechnik zu beherrschen. Er ist vor allem Maler und betrachtet die Photographie lediglich als ein neues Medium, mit dem er seiner künstlerischen Individualität Ausdruck verleiht. (...) In seinem Werk sind alle jedem angehenden Maler bekannten Qualitäten zu finden: die Ausstrahlung be- und anerkannter Techniken sowie die geheimnisvolle Art suggestiver Kunst, verspielt Dekoratives und strenge Würde, natürliche Anmut der Pose und gestalterische Unbekümmertheit. Sein Kompositionsstil, sein Umgang mit Stofflichem und Beiwerk, sein Einsatz von Licht und Schatten – all das ist lehrreich. Seine eigenwilligen Methoden, die Platten zu bearbeiten – eine entschiedene Innovation in dem sonst eher mechanischen Feld der Photographie – ist das Charakteristikum seines Werkes und verdient, genau

Exhibitions 1897–1931

New York 1897

Solo exhibition of 22 paintings at Blakeslee Galleries, New York City, from March 8–27 including portraits of actors and singers, history and still-life paintings, and paintings with mythological and christian motifs.

"Joseph Jefferson as 'Rip van Winkle'" (no. 1), "Sir Henry Irving as 'King Arthur'" (no. 2), "Emma Calvé as 'Carmen'" (no. 3), "Anton Seidl" (no. 4), "Connie Jackson as 'Tilly Slowboy'" (no. 5), "Mrs. Potter as 'Charlotte Corday'" (no. 6), "Joseph Jefferson as 'Rip van Winkle'" (no. 7), "E pur si muove" (no. 8), "Un Depute, 1789" (no. 9), "The Echo" (no. 10), "Flight into Egypt" (no. 11), "Harmony" (no. 12), "Christus" (no. 13), "Joseph Jefferson as 'Bob Acres'" (no. 14), "Study of a little Girl" (no. 15), "The Little Girl's Mother" (no. 16), "Leda and Cupid" (no. 17), "Leda and Cupid" (no. 18.), "Leda and her Children" (no. 19), "St. George Oak Tree" (no. 20), "Still Life" (no. 21), "Joseph Jefferson as 'Rip van Winkle'" (no. 22).

Lit.: Catalogue *Paintings by Frank Eugene*, Blakeslee Galleries, 353 Fifth Avenue, Cor. 34th Street, New York, March 8–27, 1897.

Philadelphia 1898

Eugene exhibited at the Art Club of Philadelphia.
Lit.: *The Critic*, 33, July/August 1898.

New York 1898

Exhibition of paintings, including portraits of Joseph Jefferson and Anton Seidl, at Knoedler's Gallery, New York.
Lit.: *New York Tribune Supplement*, Sunday, June 26, 1898, p. 3.; *The Critic*, 33, July/August 1898, pp. 17–19.

London 1899

Participation with 3 photographs at the seventh salon of the Linked Ring from September 22 to October 4. Included were "Sunlight Effect: A Study" (no. 9) £3, "A Study" (no. 58) £3, "A Portrait" (no. 181) £3.

"We must confess also to a liking for the three portrait studies by Frank Eugene, of New York, even if he has indulged in a vague mysticism in a 'A Study' (no. 58), which seems to fit in with Holland Day's work, under which it is placed. But the model of his Medusa-like lady has been posed in a very telling attitude, and in character is quite unlike anything else in the exhibition.

'A Portrait' (no. 181) evinces a knowledge of correct adjustment of varying tones of white. The fluffy feather in the hat, the pallid face, the piqué tie, and spots of white on the sitter's jacket are finely discriminated, but we would fain have seen more graduation in the mass of black hair that seems to break the portrait in two."

Lit.: A.C.R. Carter, "The Two Great Photographic Exhibitions. The Photographic Salon," in: *Photograms of the Year 1899*, London, 1899, pp. 83–112, here p. 95; *Catalogue of the Seventh Annual Exhibition Photographic Salon*, London, 1899, p. 33.

New York 1899

Solo exhibition of 77 photographs at the Camera Club, New York, 3 West 29th Street, from November 15–30. Among the works exhibited were a number of portraits of singers, actors and artists. According to the catalogue, the following photographs were exhibited: "Glen McDonough's Baby" (no. 1), "Joseph Jefferson" (no. 2), "Sir Henry Irving" (no. 3), "Kyrle Bellew" (no. 4), "Robert Loftus Newman" (no. 5), "Daniel Chester French" (no. 6), "William Winter Jefferson" (no. 7), "Victor Guglielmo" (no. 8), "The Misses Joachim" (no. 9), "Sadakichi Hartmann" (no. 10), "Gretchen" (no. 11), "Emma Calvé (Study)" (no. 12), "Robert Stuart Piggott" (no. 13), "Mrs. Potter" (no. 14), "Miss J." (no. 15), "Master Howard Keim" (no. 16), "Master Frank Jefferson" (no. 17), "Mr. S." (no. 18), "Professor Emerson" (no. 19), "Dr. Waterman" (no. 20), "Mr. Selzer" (no. 21), "Miss S. " (no. 22), "The Misses H." (no. 23), "Miss B." (no. 24), "Miss W." (no. 25), "Anton Seidl" (no. 26), "Miss M.W." (no. 27), "Lila Couvère" (no. 28), "Decorative Panel" (no. 29), "Miss Couvère" (no. 30), "Miss S." (no. 31), "Miss Bertha Cushing" (no. 32), "Decorative Panel" (no. 33), "Profile" (no. 34), "Study" (no. 35), "St. Cecilia" (no. 36), "Decorative Panel" (no. 37), "Miss C." (no. 38), "The Lady of Charlotte, N.C." (no. 39), "The Rose" (no. 40), "The Novice" (no. 41), "Devotion" (no. 42), "Summer" (no. 43), "Cassandra" (no. 44), "Dogwood" (no. 45), "Magdalen" (no. 46), "Reflection" (no. 47), "Fairy-tale" (no. 48), "Nydia" (no. 49), "Juliet" (no. 50), "Me and my Mother" (no. 51), "Joan of Arc" (no. 52), "Rest" (no. 53), "Marinello" (no. 54), "The Song of the Lily" (no. 55), "Madonna" (no. 56), "Evening" (no. 57), "Study" (no. 58), "Launcelot and Guinevere" (no. 59), "Mrs. S. H." (no. 60), "S. H. and family" (no. 61), "Mrs. F." (no. 62), "There exists no beauty but what hath some strangeness in its proportion" (no. 63), "De Scott Evans" (no. 64), "O'Connor's Baby" (no. 65), "Charles W. Warner, (no. 66), "Nirvana" (no. 67), "Nude (Study for a painting)" (no. 68), "Marion" (no. 69), "Halali" (no. 70), "La Cigale" (no. 71), "Mr. P." (no. 72), "Mr. B." (no. 73), "Mr. C." (no. 74), "Frank Eugene" (no. 75), "A Man in Armor" (no. 76), "Glen McDonough" (no. 77).

"From a mere technical point of view, Mr. Eugene is an amateur, and he himself would be the last to claim an expert knowledge of the intricacies of photographic technique. He is essentially a painter, and looks at photography merely as a new medium to express his artistic individuality.... We can find in his work all those qualities known to every student of painting, the glamour of broad and straightforward effects and the mysterious manner of suggestive art, decorative treatment, and statuesque dignity, as well as natural grace of pose and pictorial nonchalance. His style of composition, his arrangement of drapery and accessories, his application of light and shade, all teach their lesson. His peculiar methods of manipulating the plates, a decided innovation in the otherwise somewhat mechanical realm of photography, is however the keynote of his work, and worthy of

studiert zu werden, da sie helfen könnten, ein Problem zu lösen, mit dem sich künstlerische Photographen seit Jahren auseinandergesetzt haben. Mr. Eugenes Stil ist das Ergebnis einer Mischung von Malerei und Photographie. Inspiriert durch die malerischen Elemente seiner Kunst hat er versucht, sie in die Photographie zu integrieren, und es ist ihm gelungen, neue Formen zu schaffen, über deren Wert erst die Zukunft entscheiden kann.« (Sadakichi Hartmann, in: *An Exhibition of Prints by Frank Eugene*, New York City 1899).

Lit.: Katalog *An Exhibition of Prints by Frank Eugene*, New York City, 1899 (mit einem Text von Sadakichi Hartmann); J. Wells Champney, ›Reviews of the Exhibition of Prints by Frank Eugene by a Painter‹, in: *Camera Notes*, 3, April 1900, Nr. 4, S. 207; Dallett Fuguet, ›Reviews of the Exhibition of Prints by Frank Eugene by a Photographer‹, in: *Camera Notes*, 3, April 1900, Nr. 4, S. 208–213.

New York 1899/1900

Beteiligung an der ersten ›Loan Exhibition‹ im Camera Club, wo insgesamt 110 Arbeiten von amerikanischen und europäischen Photographen aus Privatsammlungen präsentiert wurden. Die Aufnahmen von Frank Eugene waren Leihgaben von Joseph Keiley.

Lit.: Joseph T. Keiley, ›Loan Exhibition‹, in: *Camera Notes*, 3, April 1900, Nr. 4, S. 214–215.

London 1900, Paris 1901 (I)

Beteiligung mit 14 Aufnahmen an der von Fred Holland Day organisierten Ausstellung ›The New School of American Photography‹, die 1900 in den Räumen der Royal Photographic Society in London vom 10. Oktober bis 8. November und 1901 im Photo-Club de Paris gezeigt wurde. Es handelte sich um ›Launcelot and Guinevere‹ (Nr. 68), ›The Velvet Gown‹ (Nr. 69), ›Portrait of Mrs. F.W.L.‹ (Nr. 70), ›Portrait of Mrs. G.B.S.‹ (Nr. 71), ›Portrait of Sadikichi (sic) Hartmann, Esq.‹ (Nr. 72), ›Portrait of J.H.B., Esq.‹ (Nr. 73), ›Portrait of Miss L.M.C.‹ (Nr. 74), ›Study from the Nude‹ (Nr. 75), ›Portrait of Daniel C. French, Esq.‹ (Nr. 76), ›Portrait of Mrs. O.P.C.‹ (Nr. 77), ›Madonna of the Vine‹ (Nr. 78), ›Adam and Eve‹ (Nr. 79), ›Madonna‹ (Nr. 80), ›The Man in Armor‹ (Nr. 81).

»Der avantgardistischste Akt der Ausstellung war vielleicht ›Adam and Eve‹ von Frank Eugene. Die sensible Ausleuchtung der beiden großartigen Figuren ist ein vortreffliches Beispiel wie er der Mystik des Themas in diesem Motiv gerecht wird. Die zurückweichende Figur der Eva ist markant konzipiert und die männliche ›Rodin-Figur‹ stellt einen vielsagenden Kontrast dazu dar. Alles in allem zeugt dieses Beispiel von einer gewaltigen Vorstellungskraft – höchstes Lob verdient ebenfalls der überaus kraftvolle ›Man in Armor‹.« (A.C.R. Carter, ›The New American School of Photography‹, in: *The Photogram*, 8, Nr. 86, Februar 1901, S. 33–42, hier S. 38–39).

»In der ganzen Ausstellung gibt es kein bemerkenswerteres Werk als ›Adam and Eve‹ von Frank Eugene: das Mysterium und die Würde der Aktfiguren, die Keuschheit der Darbietung, die künstlerische Aufrichtigkeit, mit der das Ganze gestaltet ist, die Tonalität des Abzuges und die Schönheit des Entwurfes sind Ausdruck eines wahren Künstlers. Dieses Bild stellt die Photographie gleichberechtigt neben die bildenden Künste. Und dieser Erfolg wird in der Aktfigur der Eva, ›Study from the Nude‹, im Großen und Ganzen wiederholt. Im Werk dieses Mannes zeigen sich Geschmack und Zurückhaltung und die Schönheit einer Komposition, die weit über das reine Handwerk wie auch über die Leistungen eines Bond-Street-Photographen hinausgeht

- und auch über dessen geistigen Horizont.« (Hal Dane, ›Some thoughts on an exhibition of American Photographic Prints‹, in: *The Amateur Photographer*, 26.10.1900, S. 313).

In der Ausstellung befand sich auch ein Porträt Eugenes von Fred Holland Day: »Holland Days ›Portrait of Frank Eugene‹ ist eine seiner stärksten Arbeiten. Der Ausdruck der Augen und Hände ist bemerkenswert; es ist jene eigenartige Konzentration, die man in den Augen des Künstlers wahrnimmt, wenn er, die Pinsel halb erhoben, eine fein geschwungene Kurve im Gesicht seines Modells studiert. Beim Porträtieren scheint Mr. Day der Hand eine große Bedeutung beizumessen, und dies zurecht. Die Hand spricht eine Sprache, die sonst schwer auszudrücken ist, das wissen viele Photographen und Maler zu genau, und allzu viele wissen auch, sich dieser Schwierigkeit zu entziehen.« (Demachy 1901, S. 42).

Lit.: Katalog *An Exhibition of Prints by the New School of American Photography supplemented by an additional collection of the work of F. Holland Day of Boston*, London 1900, S. 5; A.C.R. Carter, ›The New American School of Photography‹, in: *The Photogram*, 8, February 1901, Nr. 86, S. 33–42; Hal Dane, ›Some Thoughts on an Exhibition of American Photographic Prints‹, in: *The Amateur Photographer*, 26.10.1900, S. 313; *Bulletin du Photo-Club de Paris*, 2, 1901, S. 121–122, mit 2 Illustrationen ›La Robe de velours‹ und ›Portrait de Mlle B.C.‹; Robert Demachy, ›The New American School of Photography in Paris‹, in: *Camera Notes*, 5, Juli 1901, Nr. 1, S. 33–42, hier S. 36–39; Anonym, ›The American School‹, in: *The Photogram*, 8, März 1901, S. 60–64.

London 1900 (II)

Beteiligung mit 4 Arbeiten an dem 8. Salon des Linked Ring vom 21. September bis 3. November Es handelte sich um die Aufnahmen ›Miss Z.‹ (Nr. 3) £3, ›Miss B.C.‹ (Nr. 11) £5, ›Mrs. C.‹ (Nr. 21) und ›Mr. P.‹ (Nr. 31).

»In diesem Jahr ist die Sehweise Frank Eugenes weniger launisch, ausgenommen die Verdrießlichkeit der Miss B.C. (Nr. 11) mit der abweisenden Hand. Aber Lob gebührt Miss Z. (Nr. 3) mit den niedergeschlagenen Augen und dem Ausdruck leichter Anmut. Noch ein alphabetischer Titel, Mrs. C. (Nr. 21) ist einer tragischen Porträtierten zugewiesen, die auch im Falle von Mr. P. (Nr. 31), bei dem die graphischen Hinzufügungen ungerechtfertigt sind. Dies scheint ein Porträt von Alfred Stieglitz zu sein, was den Titel etwas rätselhaft macht.« (A.C.R. Carter, ›The Two Great Exhibitions. The Photographic Salon‹, in: *Photograms of the Year 1900*, London 1900, S. 128).

»Wir stellen fest, daß die Porträts von Frank Eugene zu Meinungsverschiedenheiten führten. Ganz gleich wie künstlerisch sie auch sind, leiden sie unserer Meinung nach an einem Mangel an Licht, wie viele Arbeiten in dieser Galerie. Nr. 3 ist das beste von allen, finden wir. Es heißt ›Miss Z‹ und ist sehr tonreich, insgesamt dunkel gehalten, sodaß sich die Schulter der Dame dank einem Spitzlicht deutlich hervorhebt. Das Bild wäre genau so schön ohne Figur, nur in satten Tönen gehalten, aufgelockert durch hellere Abstufungen und Lichtpunkte. Uns gefällt es einzig und allein aufgrund dieser Gestaltungsmomente – wir wissen aber nicht, ob es als Porträt den Verwandten der Dargestellten genügen würde. Egal ob die Dame groß ist oder nicht, der Künstler hätte ohne weitere einige Zentimeter mehr jener dunklen Farbmischung am unteren Rand zugeben können; so wäre der Eindruck einer imposanteren Figur gesichert gewesen. Die Verdrießlichkeit von ›Miss B.C.‹ (Nr. 11) ist, so hoffen wir, weder ein Spiegel ihrer seelischen Verfassung, noch ist der Ton und die Plastizität ihrer Hände eine realistische Darstellung ihres phy-

serious consideration and study, as it may help to solve a problem which for years has disturbed the minds of artistic photographers. Mr. Eugene's style is the result of a compact of painting and photography. Inspired by the pictorial elements of his art he has sought to convey them to photography, and has succeeded in creating new formulas, the value of which only the future can decide." (Sadakichi Hartmann, in: *An Exhibition of Prints by Frank Eugene*, New York City 1899).
Lit.: Catalogue *An Exhibition of Prints by Frank Eugene*, New York City 1899 (with a text by Sadakichi Hartmann); J.Wells Champney, "Reviews of the Exhibition of Prints by Frank Eugene by a Painter," in: *Camera Notes*, 3, April 1900, no. 4, p. 207; Dallett Fuguet, "Reviews of the Exhibition of Prints by Frank Eugene by a Photographer," in: *Camera Notes*, 3, April 1900, no. 4. pp. 208–213.

New York 1899/1900

Participation in the first "Loan Exhibition" at the Camera Club, where 110 works by American and European photographers from private collections were shown. The photographs by Frank Eugene were on loan from Joseph Keiley.
Lit.: Joseph T. Keiley, "Loan Exhibition," in: *Camera Notes*, 3, April 1900, no. 4. p. 214–215.

London 1900, Paris 1901 (I)

Participation with 14 photographs at the exhibition "The New School of American Photography," organized by Fred Holland Day, which was shown in 1900 at the Royal Photographic Society in London from October 10 to November 8 and in 1901 at the Photo-Club de Paris. Included were "Launcelot and Guinevere" (no. 68), "The Velvet Gown" (no. 69), "Portrait of Mrs. F.W.L." (no. 70), "Portrait of Mrs. G.B.S." (no. 71), "Portrait of Sadikichi (sic) Hartmann, Esq." (no. 72), "Portrait of J.H.B., Esq." (no. 73), "Portrait of Miss L.M.C." (no. 74), "Study from the Nude" (no. 75), "Portrait of Daniel C. French, Esq." (no. 76), "Portrait of Mrs. O.P.C." (no. 77), "Madonna of the Vine" (no. 78), "Adam and Eve" (no. 79), "Madonna" (no. 80), "The Man in Armor" (no. 81).
"Perhaps Mr. Frank Eugene's 'Adam and Eve' was the most ambitious nude in the collection. The evasive lighting of these two majestic figures is a treatment admirably suited to the mystery underlying the motive of the theme. The shrinking figure of Eve is a fine conception, to which the Rodin-like figure of the man makes a telling foil. Altogether, much force of imagination has been shown in this example, and high praise should also be given to the direct and forceful 'Man in Armor.'" (A.C.R. Carter, "The New American School of Photography," in: *The Photogram*, 8, February 1901, no. 86, pp. 33–42, here pp. 38–39).
"There is, in the whole range of the exhibition, no more striking work than the 'Adam and Eve,' by Frank Eugene; the mystery and the dignity of the nude figures, the chastity of treatment, and the very true art with which the whole is set down, the key in which it is printed, and the beauty of the conception are not, and could not be, the expression of any but that of a true artist. This is a picture which places photography amongst the arts. And this success is largely repeated in a nude figure of Eve, entitled 'Study from the Nude.' We have in this man's work that selection and restraint, that beauty of treatment, which is as far from mere craft as it is above the accomplishment of the Bond Street photographer – as, indeed, it is above his intelligence." (Hal Dane, "Some thoughts on an exhibition of American Photographic Prints," in: *The Amateur Photographer*, October 26, 1900, p. 313).

Also included in the exhibition was a portrait of Eugene by Fred Holland Day: "The 'Portrait of Mr. Frank Eugene' is one of his strongest works. The intensity of expression in the eyes and the clenched hands is most remarkable; it is the peculiar intensity one notices in the eye of the painter when he is studying, with brush half lifted, a delicate curve in the face of his model. Mr. Day seems to give a great importance to the hand in portraiture, and he is right. There is a language in the hand it is difficult to express and too many photographers and painters know too well how to elude the difficulty." (Demachy, 1901, p. 42).
Lit.: Catalogue *An Exhibition of Prints by the New School of American Photography supplemented by an additional collection of the work of F. Holland Day of Boston*, London, 1900, p. 5; A.C.R. Carter, "The New American School of Photography," in: *The Photogram*, 8, February 1901, no. 86, pp. 33–42; Hal Dane, "Some Thoughts on an Exhibition of American Photographic Prints," in: *The Amateur Photographer*, October 26, 1900, p. 313; *Bulletin du Photo-Club de Paris*, 2, 1901, pp. 121–122, with 2 illustrations "La Robe de velours" and "Portrait de Mlle B.C."; Robert Demachy, "The New American School of Photography in Paris," in: *Camera Notes*, 5, July 1901, no. 1, pp. 33–42, here pp. 36–39; Anonym, "The American School," in: *The Photogram*, 8, March 1901, pp. 60–64.

London 1900 (II)

Participation with 4 works at the eighth salon of the Linked Ring from September 21 to November 3. Included were the photographs "Miss Z." (no. 3) £3, "Miss B.C." (no. 11) £5, "Mrs. C." (no. 21) and "Mr. P." (no. 31).
"Frank Eugene's point of view is less moody this year, if we except the glumness of 'Miss B.C.' (no. 11) with the forbidding hand. Praise must be accorded to 'Miss Z.' (no. 3) of the downcast look and easy grace. Another alphabetical title, 'Mrs. C.' (no. 21), has been given to a tragic sitter, and again to 'Mr. P.' (no. 31), in which the suggestion of lines of cross hatching lacks justification. The last seems recognizable as a portrait of Alfred Stieglitz, so that the title is rather puzzling." (A.C.R. Carter, "The Two Great Exhibitions. The Photographic Salon," in: *Photograms of the Year 1900*, London 1900, p. 128).
"The portraits of Frank Eugene gave rise, we found, to some differences of opinion. To our minds, artistic as they are, they suffer from a want of light, like so many works at this gallery. no. 3 is the best of them all, we think. It is called 'Miss Z.,' and is a strip of rich tones, mostly very dark, but from which the lady's shoulder stands out with a very marked high light. It would be just as nice if it were no figure at all, but only so many juicy tones relieved by lighter gradations and a bright spot. We like it solely upon these decorative considerations, but as a portrait we do not see how it could satisfy the sitter's relatives. Whether the lady is tall or not, the operator's methods would have easily admitted of an inch more of his dark mixture at the bottom; the impression of a more commanding figure would then have been secured. The gloominess of 'Miss B.C.' (no. 11) is, we trust, not symbolic of her mental state, nor the tone and texture of her hands a truthful record of her physical condition. Why a photographer should allow one of the charms of the gentle sex, the hands, to appear with these frightful scratches, we cannot tell; an ugly striation, due to brush marks, apparently, that should warrant destruction to the print. It is impossible to deny the artistic power of the portrait, but the defect we have named, added to the all-over murkiness, discounts our pleasure in the work. Much the same must be said of 'Mrs. C.' (no. 21). There is still no light, and still the brush marks show. We wonder what is

sischen Zustands. Warum ein Photograph zuläßt, daß einer der Reize des zarten Geschlechts, die Hände nämlich, mit derart schrecklichen Kratzern dargestellt werden, bleibt uns ein Rätsel. Diese häßlichen Einzeichnungen lassen sich offensichtlich auf Pinselstriche zurückführen, die eigentlich die Zerstörung des Abzuges bewirken würden. Man kann unmöglich die künstlerische Kraft des Porträts leugnen, aber der von uns genannte Fehler – zusammen mit der allgemeinen Düsterkeit – schmälert unsere Freude an dem Werk. Dasselbe gilt für ›Mrs. C.‹ (Nr. 21). Hier ist immer noch kein Licht, und die Pinselstriche sind immer noch sichtbar. Wir fragen uns, was diese Dunkelheit bewirken soll – ein normaler heller Abzug wäre sicherlich viel interessanter. Nr. 31 ist ›Mr. P‹ – wahrscheinlich von vortrefflicher Ähnlichkeit, aber ohne den malerischen Charme der drei anderen Werke, obwohl es im Ton differenzierter ist. Die Ränder wurden überhaupt nicht beschnitten. Mag sein, daß es dem Leser so gefällt, uns aber nicht.« (Child Bayley, zit. nach *Camera Notes*, 4, Jan. 1901, Nr. 3, S. 171).
Lit.: *Catalogue of the Eighth Annual Exhibition of the Photographic Salon*, London 1900, S. 33; A.C.R. Carter, ›The Two Great Exhibitions. The Photographic Salon‹, in: *Photograms of the Year 1900*, London 1900, S. 109–150; Thos. Bedding, ›American Pictures at the London Salon‹, in: *British Journal of Photography*, zit. in *Camera Notes*, 4, Jan. 1901, Nr. 3, S. 163; ›The English Exhibitions and the »American Invasion«‹, *Camera Notes*, 4, Jan. 1901, Nr. 3, S. 162–175.

London 1900 (III)
Beteiligung mit 6 Aufnahmen an der ›45th Annual Exhibition‹ der Royal Photographic Society of Great Britain vom 1. Oktober bis 3. November. Es handelte sich um ›Hortensia‹ (Nr. 58, im Katalog abgebildet) Platinum, £3; ›Mr. R.N.‹ (Nr. 73), Platinum, £5; ›Hermione‹ (›Winter's Tale‹) (Nr. 75), Platinum, £5; ›The Misses T.‹ (Nr. 175), Platinum, £5; ›Madonna of the Vine‹ (Nr. 181) Rest., £3; ›Mr. W.‹ (Nr. 199), Platinum, £3.
Lit.: *The Photographic Journal*, 25, September 1900, Nr. 1, S. 52; A.C.R. Carter, ›The Two Great Exhibitions. The Royal‹, in: *Photograms of the Year 1900*, London 1900, S. 154, S. 168f.

Newark 1900
Beteiligung an der Ausstellung des Newark Camera Club in Newark, Ohio, vom 28. November bis 1. Dezember.
»Wir wissen, das Größte, was einem Künstler zu eigen ist, ist sein Gefühl, und wir wissen auch, daß er seinen Impulsen fast blind folgen sollte, aber es gibt Stunden intensiver geistiger Beschäftigung, deren Ergebnis, wenn gut angewandt, eine verständnisvollere Darbietung dieser Gefühle möglich machen würde. In der Aufnahme des Geige spielenden Mädchens zum Beispiel, läßt Mr. Eugene ziemlich viel ›Gefühl‹ in das Bild einfließen. Seine Technik ist vielfältig und subtil; sie ist ein wunderbares Medium zum Ausdruck solcher Gefühle, und das Ergebnis ist ein Streben nach Vervollkommnung. Ob es unter einem Vergleich mit den Bildern aus der Musik Mr. Whites leidet, bleibt jedermanns persönlichem Urteil überlassen. Meiner Meinung nach unterscheiden sich die geistigen Qualitäten der beiden Künstler sehr; desgleichen ihre Methoden, Gefühle darzustellen. Mr. Eugene macht ganz in Öl. Es ist für ihn so selbstverständlich, vor dem Modell zu arbeiten, daß er nicht genügend abstrahiert, um im Bild die Musik zum Ausdruck zu bringen, die – betrachtet man die Figur – beabsichtigt war. Mr. White gestaltet seine Wahrnehmungen mit großer Selbstkontrolle, sie sind kultiviert und verständlich und somit ansprechend für Menschen von normaler Gesundheit.«
Lit.: E.O. Beck, ›Newark (Ohio) Exhibition of Pictorial Photography‹, in: *Camera Notes*, 4, April 1900, Nr. 4, S. 263–267, hier S. 265–266.

Philadelphia 1900
Beteiligung mit 10 Aufnahmen am ›Third Salon‹ der Photographic Society of Philadelphia in der Pennsylvania Academy of Fine Arts vom 22. Oktober bis 18. November. Eugene gehörte mit Gertrude Käsebier, Clarence H. White, Eva Watson und Alfred Stieglitz zur Ausstellungsjury, deren Auswahl bei den konservativen Mitgliedern der Photographic Society of Philadelphia auf heftige Ablehnung stieß.
»Die zehn Aufnahmen von Mr. Frank Eugene sind meines Erachtens die Krönung seiner Kunst. Eine genaue Betrachtung zeigt, daß er eine sehr originelle Arbeitsweise hat und ein Künstler von unbestreitbarer Kompetenz und Kraft ist. Er liebt alles Starke, satte und leuchtende Farben, und auch wenn er einfarbig arbeitet, bevorzugt er Töne, die Stärke und Wärme suggerieren; folglich duldet er nichts, was für einen Mangel an Kraft oder blaße Färbung steht. Um ihm zu gefallen, muß ein Bild Körper haben. Nehmen wir zum Beispiel sein ›Dido‹, Nr. 67. Es ist eine nackte, weibliche Figur, sitzend, mit einem Ausdruck von Verzweiflung. Jede Kurve, jede Linie ist ganz Ausdruck von großartigem Leben, großartiger Kraft, großartiger Verzweiflung. Auch die Töne sind satt und kräftig. Das Ganze ist großangelegt und dem Thema angemessen – die heroische Verzweiflung der gedemütigten Königin Dido nach der Flucht des schwarzen Feiglings Pius Aeneas – die Fehler in der Zeichnung, die Schwächen in den subtileren Farbwerten und andere kleinere Unzulänglichkeiten, die das Bild aufweist, sind vergessen und vergeben. Was bleibt, ist unser Eindruck von der großartigen Ausstrahlung des Bildes. Auf dem im Salon ausgestellten Abzug ist das Inkarnat nicht so prächtig und differenziert wiedergegeben wie auf dem Abzug, den Mr. Eugene in seiner Einzelausstellung zeigte, und der auch später in Camera Notes veröffentlicht wurde. Dieser hier ist nicht so tonreich, aber dennoch ein prächtiger Abzug.
Sein ›Evening‹, Nr. 70, hat die gleiche eigenwillige Kraft und Tonalität, aber auch ähnliche Schwächen wie sein ›Adam and Eve‹, Nr. 73. Dies gilt sowohl für sein Porträt wie auch für seine anderen Arbeiten. Seine Porträtstudie ›Alfred Stieglitz‹, Nr. 72 ist ein gutes Beispiel dafür. Das Bild hat fast etwas Grobes. Die Linienführung des Stirnprofils ist so verzeichnet, daß es fast etwas von einer Verunstaltung hat. Die Tonwerte des Umhangs in ihrer Ausgewogenheit und Stimmigkeit – da wo sie Übergänge von Licht und Schatten mit einem einzigen Farbwert, eine ebene Fläche durch beschreibende oder bezeichnende Umrisse markieren, und ihr dadurch eine zusammenhängende Bedeutung, Lebendigkeit, und sinnlichen Reiz geben – sind bei weitem nicht das, was sie sein könnten – jedoch - gäbe es noch grobere Fehler, so würden Stärke und Energie des Bildes sie bei weitem überwiegen und überschatten. Das gilt auch für ›Anton Seidl‹ Nr. 71 und für fast alle seine Porträts. Im Hinblick auf einen gelungenen und gefälligen Bildaufbau ist ›Mrs. D and Family‹, eines der schönsten Beispiele im Salon – und dazu noch eine gute Porträtarbeit. Seine ›Madonna of the Vine‹ Nr. 75 stellt eine seiner poetischsten und schönsten Konzeptionen dar. In Form und Linie klassisch, erinnert es unwiderstehlich an die liegende weibliche Figur Arianna aus der Sammlung antiker römischer und griechischer Plastik im Vatikan. Ich möchte keinesfalls damit sagen, daß Mr. Eugenes Bild diese Statue kopiert, denn das tut er offensichtlich nicht. Was ich damit sagen möchte ist, daß dieses Bild im gleichen Geist konzipiert ist. Fein abgestuft bis zur Unschärfe vermittelt dieser Abzug ein Gefühl

supposed to be gained by the darkness; surely an ordinary bright print would be more interesting. no. 31 is 'Mr. P.' – probably a first-rate likeness, but without the pictorial charms of the other three works, although it has some contrasts of tone. The edges of the print are entirely untrimmed. Perchance the reader may like it so; we do not." (Child Bayley, Editor of *Photography* (London), quoted in *Camera Notes*, Jan. 4, 1901, no. 3, p. 171).
Lit.: *Catalogue of the Eighth Annual Exhibition of the Photographic Salon*, London 1900, p. 33; A. C. R. Carter, "The Two Great Exhibitions. The Photographic Salon," in: *Photograms of the Year 1900*, London 1900, pp. 109–150; Thos. Bedding, "American Pictures at the London Salon," in: *British Journal of Photography*, quoted in *Camera Notes*, 4, Jan. 1901, no. 3, p. 163; "The English Exhibitions and the 'American Invasion,'" *Camera Notes*, Jan. 4 1901, no. 3, pp. 162–175.

London 1900 (III)

Participation with 6 photographs at the "45th Annual Exhibition" of the Royal Photographic Society of Great Britain from October 1 to November 3. Included were "Hortensia" (no. 58, illustrated in the catalogue) Platinum, £3; "Mr. R. N." (no. 73), Platinum, £5; "Hermione" ("Winter's Tale") (no. 75), Platinum, £5; "The Misses T." (no. 175), Platinum, £5; "Madonna of the Vine" (no. 181) Rest., £3; "Mr. W." (no. 199), Platinum, £3.
Lit.: *The Photographic Journal*, XXV, no. 1, September 1900, p. 52; A. C. R. Carter, "The Two Great Exhibitions. The Royal," in: *Photograms of the Year 1900*, London, 1900, p. 154, p. 168f.

Newark 1900

Participation at the Newark Camera Club exhibition in Newark, Ohio, from November 28 to December 1.
"We recognize that the greatest thing an artist possesses is feeling, and we know that he should almost blindly follow his impulses at times, but there are hours of mental training that if well used will make a more intelligent rendering of feeling possible. Mr. Eugene, in his example of a girl playing the violin, fairly fills the picture with 'feeling.' His technique is so rich and subtle that it forms a beautiful medium for the expression of such feelings, and the result is a high endeavor. Whether it suffers by comparison with Mr. White's pictures of music is a matter of personal judgment. In my opinion the mental qualities of the two artists are greatly different; so is their method of rendering their feelings. Mr. Eugene has delved in oil colors, he is so used to rendering the model before him that he does not sufficiently detach himself from the human to fully render the music that – judging from the figure's action – he intended to express. Mr. White renders his perceptions with great self control, and they have a refinement and intelligibility appealing to those in normal health."
Lit.: E. O. Beck, "Newark (Ohio) Exhibition of Pictorial Photography," in: *Camera Notes*, 4, April 1900, no. 4, pp. 263–267, here pp. 265–266.

Philadelphia 1900

Participation with 10 photographs at the "Third Salon" of the Photographic Society of Philadelphia in the Pennsylvania Academy of Fine Arts from October 22 to November 18. Eugene was on the exhibition jury together with Gertrude Käsebier, Clarence H. White, Eva Watson and Alfred Stieglitz; their selection met with strong criticism from the conservative members of the Photographic Society of Philadelphia.
"The ten pictures shown by Mr. Frank Eugene are, in my judgment representative of his art at its best. Examination of them shows him to be a strongly original worker, and beyond dispute an artist of ability and power. He is clearly fond of strength and rich, strong coloring – and when working in monochrome of such tones as are most suggestive of strength and warm color; and correspondingly is he intolerant of that which suggests a lack of vigorous force or pale coloring. To appeal to him a picture must have body. Look, for example, at his 'Dido,' no. 67. It represents a nude female figure seated in an attitude of despair. Every curve, every line, is indicative of magnificent life, magnificent force, magnificent despair. Its tones, too, are rich and strong. The whole thing is big and fitting the theme – the heroic despair of the humiliated Queen Dido after the flight of Pius Aeneas, black coward that he was – and the errors of drawing, the faults in the subtle values of the tones, and other minor defects that the picture shows, are forgotten or forgiven. We are conscious only of the splendid power of the picture. The print of this picture shown at the Salon does not render the flesh values so splendidly as that shown at Mr. Eugene's one-man exhibition, and later reproduced in *Camera Notes*, and is less rich in tone, yet withal it is a splendid print. "In his 'Evening,' no. 70, will be found the same peculiarities of force and richness of tone, combined with similar faults. Such also is the case with the 'Adam and Eve,' no. 73. It is to be found just as strongly marked in his portait as in his other work. His portrait study entitled 'Alfred Stieglitz,' no. 72, is an excellent example of this. There are things about the picture that are almost crude. The line of the profiled brow is so exaggeratedly out of drawing as to amount almost to deformity; the tone values in the cloak, in their balance and harmony – in those transitions from light to shade in the single tones that break up a flat surface bounded by descriptive or explanatory outlines, and give to it coherent meaning, vibration and sensuous charm, are not all that they might be – yet had it far graver faults the force and vigor of the picture would outweigh and overshadow them. Thus too, it is with 'Anton Seidl,' no. 71, and nearly all of his portraits. For fine decorative composition, 'Mrs. D. and Family,' no. 74, is as splendid a thing as is shown in the Salon – besides being good as portrait work; while in the 'Madonna of the Vine,' no. 75, he shows one of the most poetic and beautiful of his conceptions. It is classic in form and line and irresistibly recalls the recumbent female figure entitled Arianna in the Vatican collection of antique Roman and Grecian sculpture. I do not mean to convey the idea that Mr. Eugene's picture is copied from this statue, for it is clearly not so. What I do mean to convey is that it was conceived in the same spirit. Delicate almost to indistinctness as this print is, it nevertheless conveys the feeling of strength in repose – of form, of color, and of the rhythm of flowing line. Mr. Eugene's work is often crude in certain respects; sometimes he scratches and streaks and excoriates the backgrounds of his negatives till they look like the maps of the tracks and switches of some great railroad yard in a condition of mad riot and confusion; and in certain instances his combination of the line-technique of the etcher with the tone-technique of the photographer is inharmonious, and even in bad taste, and anything but pleasing; and there are times when it displays a nonchalance of drawing that is positively naive. On the other hand, it is always strong and purposeful, invariably artistic, and at times masterful. It shows clearly that he sees form – that he feels the other side of the subject that engages his attention – that he has a great love for strong, brilliant color; that life in its most perfect form – robust, palpitating, glorious life – is the idol of his artistic shrine, the spirit of his artistic inspiration. His art is essentially,

von Stärke durch ruhige Formen, Farben, und rhythmisch fließende Linien. In mancher Hinsicht ist Mr. Eugenes Werk oft grob; manchmal ritzt er die Hintergründe seiner Negative ein, manchmal überzeichnet er sie völlig, bis sie aussehen wie die Pläne von Gleisen und Weichen einer großen Bahnanlage in einem Zustand wahnsinnigen Durcheinanders; in manchen Fällen verbindet er die Linientechnik des Radierers mit der Tontechnik des Photographen auf unharmonische, ja sogar geschmacklose Weise, die alles andere als gefällt; manchmal legt er eine zeichnerische Unbekümmertheit an den Tag, die völlig naiv ist. Andererseits ist sein Vorgehen immer stark und zielgerichtet, ausnahmslos künstlerisch und gelegentlich meisterhaft. Es ist der deutliche Beweis, daß er Form begreift, daß er auch die andere Seite des ihn beschäftigenden Sujets erspürt, daß er eine große Liebe für starke, leuchtende Farben hat, daß das Idol in seinem künstlerischen Schrein, der Geist seiner künstlerischen Inspiration das Leben in seiner vollkommensten Form ist – kräftig, pulsierend, herrlich. Seine Kunst ist im wesentlichen gesund und erhebend.« (Joseph T. Keiley, ›The Salon‹, in: Camera Notes, 4, Jan. 1901, Nr. 3, S. 189–227, hier S. 218–219).

»Frank Eugene ist einer der neuesten unter dem herausragenden Köpfen der neuen Schule. Er zeigt zehn Aufnahmen (das erlaubte Maximum für ein Jurymitglied). Wenn man Mr. Eugenes Werk sorgfältig betrachtet, dann wird es einen nicht wundern, warum es so wenig wirklich gute Bilder im Salon gibt – d.h., wenn auch die übrigen, die Auswahl bestimmenden Juroren, den gleichen Schund produzieren. Hoffen wir jedoch, daß nur wenige in der Lage sind, solche schrecklichen und bemerkenswerten Beispiele von photographischer ›Kunst‹ zu schaffen wie Mr. Eugene. Das Porträt einer Dame mit Hund unter dem Titel ›Mrs. D and Her Family‹ Nr. 74, (soll der Hund ihre Familie darstellen?) fällt nur auf durch seinen äußerst banalen Charakter. Das "künstlerische Gefühl" soll in dem sehr seltsamen und zerkratzten Hintergrund gegenwärtig sein, bestehend aus einigen Dutzend schwerer schwarzer Linien, die steil nach unten verlaufen. Das Bild sollte eher ›Home Portraiture Made Easy‹ heißen. Der Kopf von Alfred Stieglitz, Nr. 74, ist gut, warum aber sollte nur ein Drittel von Mr. Stieglitz' Zügen würdig sein, dargestellt zu werden, und warum sollte sich der Rest von ihm in einem undurchdringlichen Schwarz verlieren müssen? Das schlimmste von allen ist jedoch eine seltsame Aktstudie mit dem Titel ›Adam and Eve‹. Eva ist als eine kopflose Figur dargestellt, d.h. scheinbar kopflos, bis eine genauere Betrachtung zeigt, daß unsere erste Mutter doch einen Kopf hat, und daß ihre Enthauptung durch einen merkwürdigen und höchst unnatürlichen Schatten verursacht wird. Mehrere unregelmäßige Linien verlaufen quer über den Abzug, so als ob das Original-Glasnegativ während der Bearbeitung zersprungen wäre. Hätte Mr. E. doch nur das Negativ dorthin geworfen, wo sonst beschädigte Artikel normalerweise landen, nämlich in den Müll, so wäre der Sache der wahren Kunstphotographie kein Schaden zugefügt worden. Sein Porträt von Anton Seidl, Nr. 7, ist wirklich das einzige gute von ihm in dieser Ausstellung.« (Charles L. Mitchell, ›The Third Philadelphia Photographic Salon‹, in: The American Amateur Photographer, 12, Dec. 1900, S. 560–568, hier S. 562).
Lit.: Joseph T. Keiley, ›The Decline and Fall of the Philadelphia Salon‹, in: Camera Notes, 5, April 1902, Nr. 4, S. 279–299; Camera Notes, 4, Jan. 1901, Nr. 3, S. 191; Charles H. Caffin, ›The Philadelphia Photographic Salon‹, in: Harper's Weekly, 1900, S. 1061, mit Bildveröffentlichung von ›Joseph Jefferson's Son‹, das später ›A Cup of Tea‹ betitelt wird, zit. nach Estelle Jussim,

Slave to Beauty: The Eccentric Life and Controversial Career of F. Holland Day, Photographer, Publisher, Aesthete, Boston 1981, S. 131; Katalog Philadelphia Naturalistic Photography 1865–1906, bearbeitet von Mary Panzer, Yale University Art Gallery New Haven, Connecticut 1982; Alfred Stieglitz, Letter to the Editor of The American Amateur Photographer, 29.12.1900, in: The American Amateur Photographer, 13, Jan. 1901, Nr. 1, S. 41–42.

Glasgow 1901

Beteiligung mit 5 Aufnahmen an der ›International Exhibition‹ in Glasgow von Mai bis Oktober. Die Abteilung künstlerische Photographie wurde von James Craig Annan organisiert. Alfred Stieglitz hatte insgesamt 75 Photographien von 30 amerikanischen Ausstellern ausgewählt. Die Photographien wurden gemeinsam mit der Malerei, Skulptur und Graphik in der ›Fine Art section‹ gezeigt. Eugene war mit ›Adam and Eve‹, ›La Cigale‹, ›Portrait of Mr. Alfred Stieglitz‹, ›Dogwood‹ und ›Man in Armor‹ vertreten.
»Unter dem Photographien die Frank Eugene, aus New York, eingeliefert hat befinden sich das bemerkenswerte Porträt von Mr. Stieglitz, das Motiv ›Adam and Eve‹, und das außergewöhnliche Bild ›La Cigale‹, welches zu den meistbewundertsten Abzügen in der Sammlung zählt.« (Allan C. MacKenzie, ›American Pictorial Photography at Glasgow‹, in: Camera Notes, 5, 1901/02, Nr. 3, S. 197).
Lit.: The British Journal of Photography, 48, 3.7.1901, S. 280–281; Camera Notes, 4, April 1901, S. 273; Allan C. MacKenzie, ›American Pictorial Photography at Glasgow‹, in: Camera Notes, 5, Jan. 1902, Nr. 3, S. 197–198.

London 1901 (I)

Beteiligung von Eugene mit zwei Arbeiten an der 46. Jahresausstellung der Royal Photographic Society of Great Britain. Es handelte sich um ›Portrait of Lady C.‹ (Nr. 303), Platinum, und ›The Song of the Lily‹ (Nr. 310), Platinum; in der Ausstellerliste wurde Frank Eugene als wohnhaft in 152, West 13th Street, New York, angegeben.
»Für diejenigen, die wissen wollen, wie es einem gelingt, sich noch in den dunkelsten Tönen bildhaft zu artikulieren, sollten die beiden Bilder von Frank Eugene ein Exempel sein. Sein Porträt von Lady C. könnte man als Arrangement in Samt, schwarzer Kreide und Blei beschreiben. Jeder Ton läßt sich genau unterscheiden. Auch wenn das Ergebnis für manche Leute zu düster sein sollte, kann man nicht leugnen, daß der geplante Entwurf verwirklicht wurde. Das zweite Sujet, ›The Song of the Lily‹ (Nr. 310) ist eine bewundernswert dargestellte poetische Phantasie. Die hohe Qualität der verschiedenen Schwarztöne ist augenfällig – und wie stets bei einer guten Radierung auch hier nur ein Hauch von Farbe.« (A.C.R. Carter, ›The Two Great Exhibitions. The Royal‹, in: The Photogram, 8, 1901, S. 163, S. 175)
Lit.: The Photographic Journal, 25, Supplement, Sept. 1901, The Royal Photographic Society of Great Britain 46th Annual Exhibition 1901, S. 20, 21, 50; A.C.R. Carter, ›The Two Great Exhibitions. The Royal‹, in: The Photogram, 8, 1901, S. 163, S. 175.

London 1901 (II)

Beteiligung mit 2 Aufnahmen an dem 9. Salon des Linked Ring vom 20. September bis 2. November. Ausgestellt waren ›Portrait‹ (Nr. 13) und ›Master H.‹ (Nr. 33). Eugene wird erstmals im Katalog in der ›List of the General Committee of the Photographic Salon‹ genannt.

healthy and ennobling." (Joseph T. Keiley, "The Salon," in: *Camera Notes*, 4, Jan. 1901, no. 3, pp. 189–227, here pp. 218–219). "Frank Eugene is one of the newest lights of the new school. He shows ten pictures (the full quota allowed a judge). When one examines carefully the work which Mr. Eugene exhibits he ceases to wonder why there are so few real pictures in the Salon – that is, if the remainder of the Jury of Selection perpetrate the same kind of trash. But let us hope that there be few who can create such fearful and remarkable examples of photographic 'art' as Mr. Eugene. no. 74, a portrait of a lady and a dog, entitled 'Mrs. D. and Her Family' (is the dog supposed to be a 'family'?) is noteworthy only on account of its exceedingly commonplace character. The 'artistic feeling' is supposed to be represented by a very curious and scratchy background, composed of a couple of dozen heavy black lines extending perpendicularly down the print. It should be entitled 'Home Portraiture Made Easy.' The head of Alfred Stieglitz, no. 74, is good, but why should only about one third of Mr. S.'s features be deemed worthy of reproduction, and why should the rest of him be lost in impenetrable blackness? The worst of the lot however is a curious study of the nude, entitled 'Adam and Eve.' Here Eve is represented by a headless female figure – that is, it is apparently headless – until a close examination shows that our first mother really has a head after all, and that her decapitation is caused by a curious and most unnatural shadow. The print is crossed by several irregular lines, apparently as if the glass of the original negative had been cracked in its course of preparation. If Mr. E. had only thrown the negative where such damaged articles usually go – in the ash barrel – the cause of true photographic art would not have suffered much. His portrait of Anton Seidl, no. 7, is really the only good picture he exhibits." (Charles L. Mitchell, "The Third Philadelphia Photographic Salon," in: *The American Amateur Photographer*, 12, Dec. 1900, pp. 560–568, here p. 562).
Lit.: Joseph T. Keiley, "The Decline and Fall of the Philadelphia Salon," in: *Camera Notes*, 5, April 1902, no. 4, pp. 279–299; *Camera Notes*, 4, Jan. 1901, no. 3, p. 191; Charles H. Caffin, "The Philadelphia Photographic Salon," in: *Harper's Weekly*, 1900, p. 1061, with a reproduction of the portrait "Joseph Jefferson's Son," later titled "A Cup of Tea," quoted from Estelle Jussim, *Slave to Beauty: The Eccentric Life and Controversial Career of F. Holland Day, Photographer, Publisher, Aesthete*, Boston 1981, p. 131; Catalogue *Philadelphia Naturalistic Photography 1865–1906*, edited by Mary Panzer, Yale University Art Gallery New Haven, Connecticut 1982; Alfred Stieglitz, Letter to the Editor of *The American Amateur Photographer*, December 29, 1900, in: *The American Amateur Photographer*, 13, Jan. 1901, no. 1, pp. 41–42.

Glasgow 1901
Participation with 5 photographs at the "International Exhibition" in Glasgow from May to October. The art photography section was organized by James Craig Annan. Alfred Stieglitz selected a total of 75 photographs from 30 American exhibitors. The photographs were exhibited together with paintings, sculpture and graphics in the "Fine Art section." Eugene was represented with the works "Adam and Eve," "La Cigale," "Portrait of Mr. Alfred Stieglitz," "Dogwood" and "Man in Armor."
"Among the pictures sent by Frank Eugene, of New York, are his remarkable portrait of Mr. Stieglitz, his 'Adam and Eve' and his striking 'La Cigale,' which is one of the most admired prints in the collection." (Allan C. MacKenzie, "American Pictorial Photography at Glasgow," in: *Camera Notes*, 5, no. 3, 1901/02, p. 197).

Lit.: *The British Journal of Photography*, 48, July 3, 1901, pp. 280–281; *Camera Notes*, 4, April 1901, p. 273; Allan C. MacKenzie, "American Pictorial Photography at Glasgow," in: *Camera Notes*, 5, no. 3, 1901/02, pp. 197–198.

London 1901 (I)
Eugene participated with two works at the "46th Annual Exhibition of the Royal Photographic Society of Great Britain." Included were "Portrait of Lady C." (no. 303), platinum, and "The Song of the Lily" (no. 310), platinum; in the list of exhibitors Frank Eugene's address is given as 152, West 13th Street, New York.
"Frank Eugene's pair should be very instructive to those who seek to know how it is possible to be visibly articulate in the lowest tones. His portrait of Lady C. might be described as an arrangement in velvet, black chalk and lead. Each tone can be differenciated, and if the result is too sombre for most people, it cannot be denied that the scheme intended is fulfilled. The second subject, 'The Song of the Lily' (no. 310), is a poetic fancy admirably expressed. The rich quality of the varying blacks is at once noticeable and the suggestion of color is here, as it invariably is in a fine etching." (A.C.R. Carter, "The Two Great Exhibitions – The Royal," in: *The Photogram*, 8, 1901, pp. 163 and 175).
Lit.: *The Photographic Journal*, vol. XXV, Supplement, Sept. 1901, *The Royal Photographic Society of Great Britain 46th Annual Exhibition 1901*, pp. 20, 21, and 50; A.C.R. Carter, "The Two Great Exhibitions. The Royal," in: *The Photogram*, 8, 1901, pp. 163 and 175.

London 1901 (II)
Participation with 2 photographs at the 9th Salon of the Linked Ring from September 20 to November 2. Exhibited were "Portrait" (no. 13) und "Master H." (no. 33). Eugene is first mentioned in the catalogue in the "List of the General Committee of the Photographic Salon."
Lit.: *Catalogue of the Ninth Annual Exhibition of the Photographic Salon*, London, 1901, p. 32.

New York 1901
Participation with 5 photographs at the "Members' Exhibition" of the New York Camera Club. Exhibited were "Reflections" (no. 58), "Portrait" (no. 59), "Portrait" (no. 60), "Portrait Study" (no. 61), "Music" (no. 62).
Lit: *Camera Notes*, 5, Oct. 1901, no. 2, p. 142 (with a reproduction of "Music").

Leeds 1902
Participation at the "Fifteenth Annual Exhibition of Pictures" in the City Art Gallery. The exhibition was organized by the Yorkshire Union of Artists. On the international selection jury were James Craig Annan, Reginald Craigie, A. Horsley Hinton, Robert Demachy, Alfred Stieglitz und Ernst Juhl an.
Lit.: "The Leeds Camera Club Exhibition and Conversazione," in: *British Journal of Photography*, 50, 30 January 1903, pp. 91–92; *Camera Notes*, 5, 1902, no. 1.

New York 1902
Participation with 10 photographs at the exhibition in the National Arts, 37 West 34th Street, founded in 1898 with the aim of promoting the causes of the arts and crafts. It was orignally a Photo-Secession exhibition comprising 163 works, mounted at the initiative and under the direction of Stieglitz.

Lit.: *Catalogue of the Ninth Annual Exhibition of the Photographic Salon*, London 1901, S. 32.

New York 1901

Beteiligung mit 5 Aufnahmen an der ›Members' Exhibition‹ des New Yorker Camera Club. Ausgestellt waren die Arbeiten ›Reflections‹ (Nr. 58), ›Portrait‹ (Nr. 59), ›Portrait‹ (Nr. 60), ›Portrait Study‹ (Nr. 61), ›Music‹ (Nr. 62).

Lit.: *Camera Notes*, 5, Oct. 1901, Nr. 2, S. 142 (mit Abbildung von ›Music‹).

Leeds 1902

Beteiligung an der ›Fifteenth Annual Exhibition of Pictures‹ in der City Art Gallery. Die Ausstellung wurde von der Yorkshire Union of Artists veranstaltet. Der internationalen Auswahljury gehörten James Craig Annan, Reginald Craigie, A. Horsley Hinton, Robert Demachy, Alfred Stieglitz und Ernst Juhl an.

Lit.: ›The Leeds Camera Club Exhibition and Conversazione‹, in: *British Journal of Photography*, 50, 30.1.1903, S. 91–92; *Camera Notes*, 5, 1902, Nr. 1.

New York 1902

Beteiligung mit 10 Aufnahmen an der Ausstellung im National Arts, 37 West 34th Street, der 1898 zur Förderung des modernen Kunstgewerbes und der Kunst gegründet worden war. Es handelte sich um eine Ausstellung der Photo-Secession mit 163 Arbeiten, die auf Initiative und unter Leitung von Stieglitz zustande gekommen war.

Eugene war mit folgenden Aufnahmen vertreten: ›Adam and Eve‹ (Nr. 54), ›La Cigale‹ (Nr. 55), ›Portrait – Alfred Stieglitz‹ (Nr. 56), ›Dogwood‹ (Nr. 57), ›Nude‹ (Nr. 58), ›Man in Armor‹ (Nr. 59), ›A Portrait of Master H.‹ (Nr. 60), ›Portrait – Miss Jones‹ (Nr. 61), ›Nude‹ (Nr. 62), ›The Song of the Lily‹ (Nr. 63). Viele der Aufnahmen stammten aus Privatbesitz, waren nicht verkäuflich und bereits in Glasgow gezeigt worden.

Lit.: Vgl. *Camera Notes*, 6, Juli 1902, Nr. 1, S. 33–41; ›Exhibition of Pictorial Photography at the National Arts Club‹, in: *The American Amateur Photographer*, 14, April 1902, S. 171–173; Alfred Stieglitz, ›The Photo-Secession at the National Arts Club, New York‹, in: *Photograms of the Year 1902*, London 1902, S. 17–20.

Turin 1902

Beteiligung mit 2 Aufnahmen an der ›Esposizione Internazionale d'Arte Decorativa Moderna‹ in Turin. Alfred Stieglitz hatte eine Kollektion amerikanischer Kunstphotographien mit insgesamt 60 Arbeiten von 31 Photographen für die Ausstellung zusammengestellt, davon stammten 43 aus der Privatsammlung von Stieglitz. Bei der Präsentation handelte es sich um das erste Auftreten der 1902 gegründeten Photo-Secession. Eugene, der Porträts von Alfred Stieglitz und Miss Jones zeigte, wurde neben Clarence H. White, Alfred Stieglitz, William B. Dyer und Gertrude Käsebier mit einer Goldmedaille ausgezeichnet. Einige Aufnahmen der Ausstellung wurden von der Stadt Turin erworben, andere wiederum als Schenkung erbeten, um eine »kleine, aber wertvolle Sammlung bestimmt für den Unterricht« zusammenzustellen. Der Präsident der Jury, Edoardo Di Sambuy, hatte in einem Brief an den Sekretär des amerikanischen Komittees Roversi, den Wunsch geäußert, Eugenes Porträt von Alfred Stieglitz (Nr. 56) als Schenkung zu erhalten.

Lit.: Katalog *Esposizione Internazionale di Fotografia Artistica*, Torino 1902; ›Photography at Important Art Exhibitions. Turin Decorative and Fine Arts Exhibition‹, in: *Camera Work*, Januar 1903, Nr. 1, S. 60–61; Paolo Costantini, ›L'Esposizione internazio-

nale di fotografia artistica‹, in: *Esposizione Internazionale d'Arte Decorativa Moderna Torino 1902*, Torino 1994, S. 95–107.

Brüssel 1903

Beteiligung an dem III. Salon von L'Effort (Cercle d'Art Photographique) vom 20. Juni bis 5. Juli in den Galeries de la Société Royale La Grande Hermonie, Rue de la Madeleine 81.

Lit.: Weston J. Naef (Hrsg.), *The Collection of Alfred Stieglitz. Fifty Pioneers of Modern Photography*, New York 1978, S. 356.

Hamburg 1903

Beteiligung mit 2 Aufnahmen an der ›Zehnten Internationalen Jahres-Ausstellung von Kunstphotographien‹ in der Hamburger Kunsthalle, die im Rahmen der von Stieglitz arrangierten Gruppenschau der Photo-Secession gezeigt wurden. Es waren die Aufnahmen ›Portrait Alfred Stieglitz‹ (Nr. 162) Heliogravüre, $15, ›La Cigale‹ (Nr. 163) Platinabzug, $10.

Lit.: Katalog *Zehnte Internationale Jahres-Ausstellung von Kunstphotographien*, Kunsthalle, Hamburg 1903; Ernst Juhl, ›The Jubilee Exhibition at the Hamburg Art Galleries‹, in: *Camera Work*, Jan. 1904, Nr. 5, S. 46–49.

London 1903

Beteiligung mit 7 Aufnahmen an der ›48th Annual Exhibition‹ der Royal Photographic Society of Great Britain im September und Oktober. Von den präsentierten Photographien Eugenes waren 4 in der Sektion ›Selected Pictorial Photographs‹ und 3 in der ›Invitation Section‹ zu sehen. Es wurden gezeigt ›The Cup of Tea‹ (Nr. 307) 40/–, ›Study for a Portrait‹ (Nr. 326) £3, ›Dido‹ (Nr. 331) 40/–, ›Sir Henry Irving‹ (Nr. 332) £5 sowie in der ›Invitation Section‹, ›The Unhelmeted Knight‹ (Nr. 136), ›Rebeckah‹ (Nr. 141), ›Music‹ (Nr. 174). Im Ausstellerverzeichnis wurde als Wohnsitz Eugenes Landwehrstrasse 44/II, Rückgebäude, München, angegeben.

»Auch in Frank Eugenes Aufnahmen erfährt die Umgebung eine gewisse Distinguiertheit. Obwohl er mit dunklen Tönen arbeitet, ist immer eine Fülle an Farben vorhanden, und seine Vorliebe für dekorative Hintergründe entfaltet sich voll. ›The Cup of Tea‹ (Nr. 307) ist ziemlich charakteristisch für seine Methode, auch wenn eine unnötige Schwierigkeit dadurch geschaffen wurde, daß linker Arm und Hand in einem dunklen Handschuh stecken. Das Inkarnat des ›Dido‹-Aktes (Nr. 331) steht für Leben und nicht für Versteinerung, und das Porträt von Sir Henry Irving (Nr. 332) zeigt, wie tief man auf der Skala von dunklen Tönen hinabsteigen kann, ohne an Ausdruck zu verlieren.« (A. C. R. Carter, ›The Two Great Photographic Exhibitions. The Royal‹, in: *Photograms of the Year 1903*, London 1903, S. 161).

Lit.: *The Photographic Journal*, 43, Supplement, Sept. 1903. *The Royal Photographic Society of Great Britain 48th Annual Exhibition 1903*, S. 18, 19, 26, 27, 28, 58 (mit Abbildung von ›The Cup of Tea‹); A. C. R. Carter, ›The Two Great Photographic Exhibitions. The Royal‹, in: *Photograms of the Year 1903*, London 1903, S. 155–172.

Minneapolis 1903

Beteiligung mit drei Aufnahmen am ›First Minneapolis Photographic Salon‹ in den Art Galleries/Public Library Building, die von der Minneapolis Society Fine Arts und dem Minneapolis Camera Club veranstaltet wurde. Die Teilnahme erfolgte im Rahmen einer ›Loan Collection‹ der Photo-Secession mit 18 Arbeiten, deren Auswahl Stieglitz getroffen hatte. Gezeigt wurden ›Portrait Miss Jones‹ (Nr. 1), ›Portrait Alfred Stieglitz‹ (Nr. 2), ›La Cigale‹ (Nr. 18).

Eugene was represented with the following works: "Adam and Eve" (no.54), "La Cigale" (no.55), "Portrait – Alfred Stieglitz" (no.56), "Dogwood" (no.57), "Nude" (no.58), "Man in Armor" (no.59), "A Portrait of Master H." (no.60), "Portrait – Miss Jones" (no.61), "Nude" (no.62), "The Song of the Lily" (no.63).

A number of the works came from private collections, were not for sale, and had already been shown in Glasgow.

Lit: Vgl. *Camera Notes*, 6, July 1902, no.1, pp.33–41; "Exhibition of Pictorial Photography at the National Arts Club," in: *The American Amateur Photographer*, 14, April 1902, pp.171–173; Alfred Stieglitz, "The Photo-Secession at the National Arts Club, New York," in: *Photograms of the Year 1902*, London 1902, pp.17–20.

Torino 1902

Participation with 2 photographs at the "Esposizione Internazionale d'Arte Decorativa Moderna" in Turin. Alfred Stieglitz put together a total of 60 works by 31 American art photographers for the exhibition, of which 43 were from his own private collection. This represents the first appearance of the "Photo-Secession," founded in 1902. Eugene, who showed portraits of Alfred Stieglitz and Miss Jones, was awarded a gold medal, along with Clarence H. White, Alfred Stieglitz, William B. Dyer and Gertrude Käsebier. Some of the exhibits were acquired by the City of Turin, others requested as donations so as to compile "a small but valuable collection for teaching purposes." In a letter to the secretary of the American committee, Roversi, the jury president Edoardo Di Sambuy had expressed a wish to receive a donation of Eugene's portrait of Alfred Stieglitz (no.56).

Lit.: Catalogue *Esposizione Internazionale di Fotografia Artistica*, Torino 1902; "Photography at Important Art Exhibitions. Turin Decorative and Fine Arts Exhibition," in: *Camera Work*, January 1903, no.1, pp.60–61; Paolo Costantini, "L'Esposizione internazionale di fotografia artistica," in: *Catalogo Esposizione Internazionale d'Arte Decorativa Moderna Torino 1902*, Torino 1994, pp.95–107.

Brussels 1903

Participation at the seventh salon of L'Effort (Cercle d'Art Photographique) from June 20 to July 5 at the Galeries de la Société Royale La Grande Hermonie, Rue de la Madeleine, 81.

Lit.: Weston J. Naef (ed.), *The Collection of Alfred Stieglitz. Fifty Pioneers of Modern Photography*, New York 1978, p.356.

Hamburg 1903

Participation with 2 photographs at the "Zehnten Internationalen Jahres-Ausstellung von Kunstphotographien" (Tenth International Annual Art Photography Exhibition of Art Photography) in the Hamburger Kunsthalle, shown within the framework of the Photo-Secession group exhibition arranged by Stieglitz. Included were the works "Portrait Alfred Stieglitz" (no.162) heliograph, $15, "La Cigale" (no.163) platinum print, $10.

Lit.: Catalogue *Zehnte Internationale Jahres-Ausstellung von Kunstphotographien*, Kunsthalle, Hamburg 1903; Ernst Juhl, "The Jubilee Exhibition at the Hamburg Art Galleries," in: *Camera Work*, no.5, Jan. 1904, pp.46–49.

London 1903

Participation with 7 photographs at the 48th annual exhibition of the Royal Photographic Society of Great Britain in September und October. Four of Eugene's photographs were presented in the section "Selected Pictorial Photographs" and 3 in the "Invitation Section". Exhibited were "The Cup of Tea" (no.307) 40/–, "Study for a Portrait" (no.326) £3, "Dido" (no.331) 40/–, "Sir Henry Irving" (no.332) £5, and in the "Invitation Section," "The Unhelmeted Knight" (no.136), "Rebeckah" (no.141), "Music" (no.174). In the exhibition catalogue, Eugene's residence is given as Landwehrstrasse 44/II Rückgebäude, München.

"Frank Eugene's set likewise lend an air of distinction to their surroundings. Although working in a low key, the richness of the tones is always evident, and his love of decorative grounds finds full scope. 'The Cup of Tea' (no.307) is quite characteristic of his methods, although an unnecessary difficulty has been created by leaving the left arm and hand darkly gloved. The flesh of the nude Dido (no.331) suggests pulsation and not petrification, and the portrait of Sir Henry Irving (no.332) shows how far it is permissible to descend into a dark scheme and yet remain articulate." (A.C.R. Carter, "The Two Great Photographic Exhibitions. The Royal," in: *Photograms of the Year 1903*, London 1903, p.161).

Lit.: *The Photographic Journal*, vol.XLIII, Supplement, Sept. 1903. *The Royal Photographic Society of Great Britain 48th Annual Exhibition 1903*, pp.18, 19, 26, 27, 28, 58 (with a reproduction of "The Cup of Tea"); A.C.R. Carter, "The Two Great Photographic Exhibitions. The Royal," in: *Photograms of the Year 1903*, London 1903, pp.155–172.

Minneapolis 1903

Participation with 3 photographs at the "First Minneapolis Photographic Salon" in the Art Galleries/Public Library Building, organized by the Minneapolis Society of Fine Arts and the Minneapolis Camera Club. Participation took the form of a "Photo-Secession" "Loan Collection" of 18 works selected by Stieglitz. Exhibited were "Portrait Miss Jones" (no.1), "Portrait Alfred Stieglitz" (no.2), "La Cigale" (no.18).

Lit.: Catalogue *First Minneapolis Photographic Salon at the Art Galleries/Public Library Building 1903 by The Minneapolis Society Fine Arts and The Minneapolis Camera Club*, 1903, p.12.

Paris 1903

Participation with 2 photographs at the 8th salon of the Photo-Club of Paris" within the Photo-Secession group exhibition. Exhibited were "Portrait de M. Alfred Stieglitz" (no.237), "Dogwood" (no.238).

Lit.: *Catalogue des oeuvres exposés au huitième Salon international de photographie du 1 Mai au 1 Juin 1903 (Photo-Club des Paris)*, p.32.

Rochester 1903

Participation in the "First Exhibition" of the Rochester Camera Club at the Mechanics Institute from March 30 to April 11.

Lit.: Weston J. Naef (ed.), *The Collection of Alfred Stieglitz. Fifty Pioneers of Modern Photography*, New York 1978, p.356.

St. Petersburg 1903

Participation in the "International Photographic Exhibition" within a Photo-Secession made by Stieglitz and awarded a gold medal.

Lit.: *Camera Work*, Jan. 1904, no.5, p.51.

San Francisco 1903

Participation at the "Second San Francisco Photographic Salon" in the Mark Hopkins Institute of Art from January 9–23. The exhibition was organized by the California Camera Club and the San Francisco Art Association.

Lit.: Katalog *First Minneapolis Photographic Salon at the Art Galleries/Public Library Building 1903 by The Minneapolis Society Fine Arts and The Minneapolis Camera Club*, 1903, S. 12.

Paris 1903

Beteiligung mit 2 Arbeiten an dem 8. Salon des Photo-Club de Paris im Rahmen einer Gruppenausstellung der Photo-Secession. Ausgestellt waren ›Portrait de M. Alfred Stieglitz‹ (Nr. 237), ›Dogwood‹ (Nr. 238).

Lit.: *Catalogue des oeuvres exposés au huitième Salon international de photographie du 1 Mai au 1 Juin 1903 (Photo-Club de Paris)*, S. 32.

Rochester 1903

Beteiligung an der ›First Exhibition‹ des Rochester Camera Club im Mechanics Institute vom 30. März bis 11. April.

Lit.: Weston J. Naef (Hrsg.), *The Collection of Alfred Stieglitz. Fifty Pioneers of Modern Photography*, New York 1978, S. 356.

St. Petersburg 1903

Beteiligung an der Internationalen Photographischen Ausstellung im Rahmen einer von Stieglitz zusammengestellten Auswahl der Photo-Secession, die mit einer Goldmedaille ausgezeichnet wurde.

Lit.: *Camera Work*, Jan. 1904, Nr. 5, S. 51.

San Francisco 1903

Beteiligung am ›Second San Francisco Photographic Salon‹ im Mark Hopkins Institute of Art vom 9. bis 23. Januar. Die Ausstellung wurde von dem California Camera Club und der San Francisco Art Association veranstaltet.

Lit.: Weston J. Naef (Hrsg.), *The Collection of Alfred Stieglitz. Fifty Pioneers of Modern Photography*, New York 1978, S. 356; Vgl. *Camera Work*, Okt. 1903, Nr. 4, S. 57; Jan. 1904, Nr. 5, S. 50.

Toronto 1903

Beteiligung an der ›Twelfth Annual Exhibition (First Salon)‹ des Toronto Camera Club.

Lit.: Weston J. Naef (Hrsg.), *The Collection of Alfred Stieglitz. Fifty Pioneers of Modern Photography*, New York 1978, S. 356.

Wiesbaden 1903

Beteiligung mit 23 Aufnahmen an der ›Ersten Internationalen Ausstellung für künstlerische Bildnis-Photographie‹, die in Wiesbaden, Breslau, Krefeld, Hagen, Düsseldorf und Berlin (Salon Keller & Reiner) gezeigt wurde. Eugene beteiligte sich mit folgenden Platinabzügen: ›Porträt Miß Jones‹ (Nr. 79), 40 Mark; ›Porträt Master H.‹ (Nr. 80); ›Porträt eines Herrn‹, (Nr. 81) 75 Mark; ›The Man in Armor‹ (Nr. 82), 30 Mark; ›Porträt Mr. Willer‹ (Nr. 83), 30 Mark; ›Porträt Sir F. P. Koff, Esq.‹ (Nr. 84), 25 Mark; ›Porträt Mrs. Frank Carolau‹ (Nr. 85), 50 Mark; ›Porträt Mrs. J. Cushing Child‹ (Nr. 86), 30 Mark; ›Porträt Miß Ide‹ (Nr. 87), 25 Mark; ›Porträt Mrs. Jones‹ (Nr. 88), 25 Mark; ›Porträt Miß Curtis‹ (Nr. 89), 40 Mark; ›Hortensia‹ (Nr. 90), 50 Mark; ›Lady Charlotte‹ (Nr. 91), 25 Mark; ›Gretchen Guglielmo‹ (Nr. 92), 30 Mark; ›Porträt Master Samuel Nickerson‹ (Nr. 93), 25 Mark; ›Porträt Anton Seidl‹ (Nr. 94), 25 Mark; ›Porträt E.C.Converse, Esq.‹ (Nr. 95), 25 Mark; ›Porträt Mr. Alfred Stieglitz, Esq.‹ (Nr. 96), 25 Mark; ›Porträt Dr. Peder Bruguière‹ (Nr. 97), 25 Mark; ›Sir Henry Irving als Thomas Becket‹ (Nr. 98), 25 Mark; ›Porträt Miß Marie Struthers‹ (Nr. 99), 25 Mark; ›Porträt Mrs. Willer Tapau‹ (Nr. 100), 30 Mark; ›Porträt Master Bliß Lane‹ (Nr. 101), 25 Mark.

Eugene erhielt gemeinsam mit Mathilde Weil und Gertrude Käsebier die Silberne Medaille als Auszeichnung.

Lit.: Katalog *Erste Internationale Ausstellung für künstlerische Bildnis-Photographie*, Wiesbaden 1903, S. 18; Dr. von Grolmann, ›Die Erste Internationale Ausstellung für künstlerische Bildnis-Photographie in Wiesbaden im Juni 1903‹, in: *Deutsche Kunst und Dekoration*, 12, 1903, S. 473–496, (mit Abbildungen von Kinderbildnis, S. 473, und Gretchen Guglielmo, S. 488); *Photographische Chronik*, 10, 1903, S. 538.

Bradford 1904

Beteiligung an der ›Cartwright Exhibition‹ in Bradford, die in der Cartwright Memorial Hall im Mai stattfand. Die Ausstellung präsentierte Produkte von Bradfords Textilindustrie, historische und zeitgenössische Malerei sowie künstlerische Photographie, die von Alexander Keighley unter Mitwirkung von Alfred Stieglitz, Robert Demachy, Alfred Horsley-Hinton, Reginald Craigie und James Craig-Annan zusammengestellt worden war. Insgesamt wurden 220 Photographien gezeigt, davon 50 von der Photo-Secession.

Lit.: ›The Cartwright Exhibition at Bradford‹, in: *The Amateur Photographer*, 39, 1904, S. 368–369.

Den Haag 1904

Beteiligung an der Gruppenschau der Photo-Secession anläßlich der internationalen Einladungsausstellung (›Eerste Internationale Salon van Kunstfotografie te's Gravenhage‹), die von dem Photo-Club Daguerre in dem Pulchri Studio vom 20. Juni bis 28. Juli veranstaltet wurde. Die Ausstellung stellte erstmals in Holland die Leistungen der internationalen Kunstphotographie vor. An der internationalen Jury waren H.W. Mesdag, Ign. Bispinck, Maruice Bucquet, A. Horsley Hinton, Heinrich Kühn und Fritz Matthies-Masuren beteiligt, während Stieglitz wegen Krankheit in Berlin blieb.

Lit.: *The Amateur Photographer*, 39, 1904, S. 507–508.

Dresden 1904

Beteiligung mit 6 Aufnahmen an der ›Internationalen Photographischen Ausstellung im Park der Grossen Internationalen Kunstausstellung zu Dresden‹ von Mai bis Oktober. Die Ausstellung war von Hugo Erfurth zusammengestellt und betreut worden. Insgesamt waren 197 Arbeiten ausgestellt, davon 96 aus Deutschland und 30 aus Österreich, aus Amerika 46. Die Photo-Secession nahm unter Leitung von Stieglitz teil. Die Hängung der Ausstellungen der Photo-Secession und des Wiener Photo-Club hatte Fritz Matthies-Masuren übernommen.

»Neben Steichen (...) vertritt der seit einigen Jahren in München lebende Frank Eugene besonders beispielhaft den Stand der amerikanischen Photographie. Er zeigt fünf Aktstudien, die den Anspruch der Photographie auf diesen Bereich der Kunst voll rechtfertigen. Insbesondere ›Adam und Eva‹ ist eine meisterhafte Schöpfung. Das dekorative Paneel ›Musik‹ ist eine auf Schönste gearbeitete poetische Phantasie.« (*Photo-Era*, 13, 1904, S. 194).

»Eugene Frank muss ich wohl auch den Amerikaner zuzählen, wenn er auch augenblicklich noch in Deutschland weilt. Sein Hauptvorzug liegt in der Mannigfaltigkeit der kompositionellen Erfindung und in der Behandlung des Fleisches, so besonders in der Aktgruppe ›Adam und Eva‹ und ›Dido‹.« (Bruno Wiehr, ›Die Photographie auf der Dresdener Kunstausstellung‹, in: *Photographische Mitteilungen*, 41, 1904, S. 195).

Eugene, der zwei Platinabzüge für 100 Mark bzw. 200 Mark verkaufen konnte, war mit folgenden Werken vertreten: ›Rebeckah‹

Lit.: Weston J. Naef (ed.), *The Collection of Alfred Stieglitz. Fifty Pioneers of Modern Photography*, New York 1978, p. 356; Vgl. *Camera Work*, Oct. 1903, no. 4, p. 57; Jan. 1904, no. 5, p. 50.

Toronto 1903

Participation in the "Twelfth Annual Exhibition (First Salon)" of the Toronto Camera Club.
Lit.: Weston J. Naef (ed.), *The Collection of Alfred Stieglitz. Fifty Pioneers of Modern Photography*, New York 1978, p. 356

Wiesbaden 1903

Participation with 23 photographs at the "Erste Internationale Ausstellung für künstlerische Bildnis-Photographie," (First International Exhibition of Pictorial Photography) which was shown in Wiesbaden, Breslau, Krefeld, Hagen, Düsseldorf and Berlin. (Salon Keller & Reiner) Eugene participated with the following platinum prints: "Porträt Miß Jones" (no. 79), 40 Mark; "Porträt Master H." (no. 80); "Porträt eines Herrn," (no. 81) 75 Mark; "The Man in Armor" (no. 82), 30 Mark; "Porträt Mr. Willer" (no. 83), 30 Mark; "Porträt Sir F. P. Koff, Esq." (no. 84), 25 Mark; "Porträt Mrs. Frank Carolau" (no. 85), 50 Mark; "Porträt Mrs. J. Cushing Child" (no. 86), 30 Mark; "Porträt Miß Ide" (no. 87), 25 Mark; "Porträt Mrs. Jones" (no. 88), 25 Mark; "Porträt Miß Curtis" (no. 89), 40 Mark; "Hortensia" (no. 90), DM 50; "Lady Charlotte" (no. 91), 25 Mark; "Gretchen Guglielmo" (no. 92), 30 Mark; "Porträt Master Samuel Nickerson" (no. 93), 25 Mark; "Porträt Anton Seidl" (no. 94), 25 Mark; "Porträt E.C.Converse, Esq." (no. 95), 25 Mark; "Porträt Mr. Alfred Stieglitz, Esq." (no. 96), 25 Mark; "Porträt Dr. Peder Bruguière" (no. 97), 25 Mark; "Sir Henry Irving as Thomas Becket" (no. 98), 25 Mark; "Porträt Miß Marie Struthers" (no. 99), 25 Mark; "Porträt Mrs. Willer Tapau" (no. 100), 30 Mark; "Porträt Master Bliß Lane" (no. 101), 25 Mark.
Eugene, along with Mathilde Weil and Gertrude Käsebier was awarded the Silver Medal.
Lit.: Katalog *Erste Internationale Ausstellung für künstlerische Bildnis-Photographie*, Wiesbaden, 1903, p. 18; Dr. von Grolmann, "Die Erste Internationale Ausstellung für künstlerische Bildnis-Photographie in Wiesbaden im Juni 1903," in: *Deutsche Kunst und Dekoration*, 12, 1903, pp. 473–496, (mit Abbildungen von Kinderbildnis, p. 473, and Gretchen Guglielmo, p. 488); *Photographische Chronik*, 10, 1903, p. 538.

Bradford 1904

Participation in the "Cartwright Exhibition" in Bradford, shown in May at the Cartwright Memorial Hall. The exhibition presented products from Bradford's textile industry, historical and contemporary paintings as well as art photography, curated by Alexander Keighley with assistance from Alfred Stieglitz, Robert Demachy, Alfred Horsley-Hinton, Reginald Craigie and James Craig-Annan. A total of 220 photographs were shown, of which 50 were from the "Photo-Secession."
Lit.: "The Cartwright Exhibition at Bradford," in: *The Amateur Photographer*, 39, 1904, pp. 368–369.

The Hague 1904

Participation at the group exhibition of the Photo-Secession on the occasion of the international invitational exhibition (Eerste Internationale Salon van Kunstfotografie te's Gravenhage), organized by the Photo-Club Daguerre in the Pulchri Studio from June 20–July 28. This was the first time that the achievements of international art photography had been exhibited in Holland. The international jury included H.W. Mesdag. Ign. Bispinck,

Maruice Bucquet, A. Horsley Hinton, Heinrich Kühn and Fritz Matthies-Masuren beteiligt, while Stieglitz had to remain in Berlin due to illness.
Lit.: *The Amateur Photographer*, vol. 39, 1904, pp. 507–508.

Dresden 1904

Participation with 6 photographs at the "Internationalen Photographischen Ausstellung im Park der Grossen Internationalen Kunstausstellung zu Dresden" (International Photography Exhibition in the Park of the Great International Art Exhibition in Dresden) from May to October. The exhibition was entrusted to, and curated by, Hugo Erfurth. A total of 197 works were exhibited, of which 96 were from Germany, 30 from Austria, and 46 from America. The Photo-Secession participated under the direction of Stieglitz. The Photo-Secession and the Viennese Photo-Club exhibits were hung by Fritz Matthies-Masuren. "Aside from the work of Steichen ... America's photographic standard is most worthily upheld by Frank Eugene, now for a couple of years resident in Munich. He shows five nude studies which fully justify the right of photography to enter this field of art. 'Adam and Eve' in particular is a masterly creation. His decorative panel, 'Music,' is a poetic fancy beautifully worked out." (*Photo-Era*, vol. 13, 1904, p. 194).
"Eugene Frank is to be counted among the Americans, although at present he is living in Germany. His main quality is the scope of his compositional inventiveness and in his handling of the flesh, particularly in the nude studies 'Adam und Eva' and 'Dido.'" (Bruno Wiehr, "Die Photographie auf der Dresdener Kunstausstellung," in: *Photographische Mitteilungen*, 41, 1904, p. 195).
Eugene, who sold two platinum prints for 100 and 200 marks respectively, was represented with the following works: "Rebeckah" (no. 49) 100 marks, "Adam and Eve" (no. 50) 200 marks, "Dido" (no. 51) 100 marks, "The Song of the Lily" (no. 52) 150 marks, "Music" (no. 53) 150 marks, "Hortensia" (no. 53) 100 marks.
Lit.: Catalogue *Photographische Ausstellung im Park der Grossen Kunstausstellung zu Dresden Mai–Oktober 1904*, organized by Hugo Erfurth for the Great Art Exhibition in Dresden 1904, p. 9 (with a reproduction of "Dido"); Alfred Stieglitz, "Some Impressions of Foreign Exhibitions," in: *Camera Work*, 1904, Set 8, pp. 34–37; *Apollo*, Set 10, May 22, 1904, p. 110; Bruno Wiehr, "Künstlerische Photographien in der Dresdner Kunstausstellung," in: *Photographische Kunst*, no. 8, 1904/05, p. 140; Bruno Wiehr, "Die Photographie auf der Dresdener Kunstausstellung," in: *Photographische Mitteilungen*, no. 41, 1904, p. 195.

Pittsburg 1904

Participation in the Photo-Secession exhibition at the Carnegie Institute in February.
"Frank Eugene, who is a past-master in this art, is at present in Germany, and therefore only represented by work we have known from previous exhibitions, and as I have criticized his work more frequently than that of any other photographic artist, I have nothing new to say about him. Of course, to those who are not familiar with his work, it is as much a revelation as Steichen's work, and his 'Adam and Eve' is indisputably one of the gems of the exhibition." (S. Allan, 1904, pp. 102–103).
"Eugene has nothing new to show. Strange that a man with so much talent, with such an overabundance of talent – in his application of painter-like qualities he is second only to Steichen – should at times do such slovenly work. And yet one is forced to admire him, and his 'Adam and Eve,' in spite of its shortcom-

(Nr. 49) 100 Mark, ›Adam and Eve‹ (Nr. 50) 200 Mark, ›Dido‹
(Nr. 51) 100 Mark, ›The Song of the Lily‹ (Nr. 52) 150 Mark, ›Mu-
sic‹ (Nr. 53) 150 Mark, ›Hortensia‹ (Nr. 53) 100 Mark.
Lit.: Katalog *Photographische Ausstellung im Park der Grossen
Kunstausstellung zu Dresden Mai–Oktober 1904*, veranstaltet
von Hugo Erfurth für die Grosse Kunstausstellung Dresden 1904,
S. 9 (mit Abbildung von ›Dido‹); Alfred Stieglitz, ›Some Impres-
sions of Foreign Exhibitions‹, in: *Camera Work*, 1904, Nr. 8,
S. 34–37; *Apollo*, 10, 22.5.1904, S. 110; Bruno Wiehr, ›Künstleri-
sche Photographien in der Dresdner Kunstausstellung‹, in: *Pho-
tographische Kunst*, 3, 1904/05, S. 140; Bruno Wiehr, ›Die
Photographie auf der Dresdener Kunstausstellung‹, in: *Photogra-
phische Mitteilungen*, 41, 1904, S. 195.

Pittsburg 1904

Beteiligung an der Ausstellung der Photo-Secession im Carne-
gie-Institut im Februar.
»Frank Eugene, ein alter Meister dieser Kunst, lebt zur Zeit in
Deutschland und ist deshalb nur durch Arbeiten vertreten, die
wir schon aus vergangenen Ausstellungen kennen. Da ich über
sein Werk mehr geschrieben habe als über das irgendeines an-
deren Photokünstlers, habe ich nichts Neues über ihn zu sagen.
Aber für diejenigen, die ihn nicht kennen, ist er eine ähnliche
Offenbarung wie Steichen, und seine Aufnahme ›Adam and
Eve‹ ist unbestreitbar ein Juwel der Ausstellung.« (S. Allan, 1904,
S. 102–103).
»Eugene bringt nichts Neues. Seltsam, daß ein Mann von so
großer Begabung, von einem wahrhaften Überfluß an Talent (in
seinen künstlerischen Qualitäten steht er nur Steichen nach) gele-
gentlich derart schlampige Arbeit macht. Und doch muß man ihn
bewundern, und sein ›Adam and Eve‹ ist trotz seiner Schwächen,
eines der wenigen großen Bilder, die die Kunstphotographie bis
jetzt hervorgebracht hat. Seine Kunst ist wie eine Blume, die
ihren Duft behält, obwohl die Blätter schon verwelkt und ver-
schrumpelt sind.« (S. Hartmann, *Camera Work*, 1904, S. 50.)
Lit.: Sadakichi Hartmann, ›Ausstellung der amerikanischen Pho-
to Secession in dem Carnegie-Institut zu Pittsburg‹, in: *Photo-
graphische Rundschau*, 18, 1904, S. 111–116; Sidney Allan, ›The
Exhibition of the Photo-Secession‹, in: *The Photographic Times-
Bulletin*, 36, März 1904, Nr. 3, S. 97–105, (mit Abbildung von
›The Little Pet‹, S. 102); Sadakichi Hartmann, ›The Photo-Secessi-
on Exhibition at the Carnegie Art Galleries, Pittsburg, PA.‹, in:
Camera Work, April 1904, Nr. 6, S. 47–51.

Washington 1904

Beteiligung an der Ausstellung der Photo-Secession in der Cor-
coran Gallery of Art von Mitte bis Ende Februar.
Lit.: Charles E. Fairman, ›The Photo Secession Exhibition in Wa-
shington‹, in: *Photo-Era*, 12, February 1904, Nr. 2, S. 17–18; James
Henry Moser, ›A Painter's Impression of the Washington Exhi-
bition‹, in: *Camera Work*, April 1904, Nr. 6, S. 45–46.

Wien 1904

Beteiligung an der sechsten ›Ausstellung des Wiener Photo-
Clubs‹ im Rahmen der Präsentation der Photo-Secession mit 3
Arbeiten vom 16. April bis 15. Mai. Es handelte sich um die Auf-
nahmen ›Adam und Eva‹, ›Alfred Stieglitz‹, und ›Dogwood‹.
»Frank Eugene reisst einfach ein Blatt aus einem Skizzenbuche.
Es ist ein selbstbewusstes, launenhaftes Ding, dieses ›Adam
und Eva‹, aber es hat doch viel Reiz. In die weiche, verschwom-
mene Anlage der beiden Akte setzt er despotische Korrekturen
mit dem Kreidestift hinein.« (*Die Photographische Kunst im
Jahr 1904*, S. 150).

Lit.: *Katalog der sechsten Ausstellung Wiener Photo Club*, Wien
1904; Ludwig Schrank, ›Ausstellung des Wiener Photo-Klubs‹,
in: *Photographische Korrespondenz*, 41, 1904, Nr. 524, S. 231–
232.

Berlin 1905

Beteiligung an der ›Internationalen Ausstellung künstlerischer
Photographie‹ in der königlichen Akademie der Künste in Berlin
vom 8. April bis 8. Mai. Der Ausstellungsjury gehörten Walther
Leistikow, Max Liebermann, Prof. Hugo von Tschudi und Prof.
Heinrich Wölfflin an. Eugene war mit einer Photographie ›Por-
trät Alfred Stieglitz‹ (Nr. 9) in der Ausstellung der Photo-Seces-
sion vertreten, die von Stieglitz betreut wurde. Die Ausstel-
lungsexponate waren käuflich zu erwerben.
»Amerika ist natürlich wieder der ›Clou‹ und hat – wie das heu-
te dem Extraordinären gebührt – den besten Platz. Die Künstler
der Photo-Secession aus dem Land der unbegrenzten Möglich-
keiten treten mit äusserst wohlhabender Nonchalance gegen
das Begriffsvermögen des gemeinen Menschen auf, der da im
Staub der Arbeit lebt. Alle sehr nervös, sensibel bis in die Fin-
gerspitzen. Alle in jener weltmännisch lässigen Pose, die ein ge-
sichertes Leben verleiht, der aber der vorwärtsdrängende Ernst,
dieses ›mitten hinein ins Leben‹ fehlt. Alles Ästheten vom Os-
car Wildeschen Schlage, der seine Locken nach dem Nero des
Louvre frisieren liess. Dem Deutschen, der noch immer viel zu
plebejisch gesund ist, imponieren exotische Allüren grenzenlos.
Man sagt uns, dass die Photo-Secession nur ein kleiner Aus-
schnitt selbst der amerikanischen Photographie, eben jener ex-
klusive Kreis der Ästheten ist.« (*Photographische Mitteilungen*,
42, 1905, S. 149.)
Lit.: Katalog *Internationale Ausstellung künstlerischer Photogra-
phie*, Königliche Akademie der Künste, Berlin 1905, S. 11; ›Die
Berliner kunstphotographische Ausstellung und die Kritik‹, in:
Photographische Kunst, 4, 1905/06, S. 90–92; *Apollo*, 11, 1905,
Nr. 235, S. 74.

Dresden 1905

Beteiligung an der Kunst-Ausstellung. Erwähnung von »Eugen
Frank – München«, »welch' letzterer sich seine besondere Spezia-
lität, kleine Aktbilder in dämmeriger Beleuchtung, geschaffen hat.«
Lit.: Ernst Zimmermann, ›Die Photographie auf der Dresdner
Kunst-Ausstellung‹, in: *Deutsche Kunst und Dekoration*, 14, 1905/
06, S. 683; Bildveröffentlichung von ›Hortensia‹ in der *Photogra-
phischen Rundschau*, 19, 1905, S. 202.

London 1905

Beteiligung mit der Aufnahme ›Music‹, (Nr. 183) £7 10 Shillings,
an dem 13. Salon des Linked Ring.
»Es ist einige Zeit her, seit man Frank Eugene im Salon gesehen
hat, und die schöne Darstellung von ›Music‹ hätte sinnvoller-
weise durch weitere Beispiele seiner Kunst ergänzt werden sol-
len.« (A. C. R. Carter, ›The Two Great Exhibitions. The Salon‹, in:
The Photogram, 12, 1905, S. 107).
Lit.: Frederick H. Evans, ›The London Photographic Salon for
1905‹, in: *Camera Work*, Jan. 1906, Nr. 13, S. 46–51, S. 52; *Cata-
logue of the Thirteenth Annual Exhibition of the Photographic
Salon 1905*, London 1905, S. 28.

New York 1905

Beteiligung an der ersten Ausstellung der Photo-Secession in
den Little Galleries in New York, 291 Fifth Avenue vom 24. No-
vember 1905 bis 5. Januar 1906. Hier stellte Eugene ›La Cigale‹
(Nr. 22), ›Rebecca‹ (Nr. 23), ›The Song of the Lily‹ (Nr. 24) und

ings, is one of the few great pictures artistic photography has produced. His art is like a flower which, though its leaves are withered and crumpled, still retains its perfume." (S. Hartmann, *Camera Work*, 1904, p. 50.)
Lit: Sadakichi Hartmann, "Ausstellung der amerikanischen Photo Secession in dem Carnegie-Institut zu Pittsburg," in: *Photographische Rundschau*, 1904, pp. III–II6; Sidney Allan, "The Exhibition of the Photo-Secession," in: *The Photographic Times-Bulletin*, vol. XXXVI, March 1904, no. 3, pp. 97–105, (with a reproduction of "The Little Pet," p. 102); Sadakichi Hartmann, "The Photo-Secession Exhibition at the Carnegie Art Galleries, Pittsburg, PA," in: *Camera Work*, April 1904, no. 6, pp. 47–51.

Washington 1904
Participation in the Photo-Secession exhibition at the Corcoran Gallery of Art in the second half of February.
Lit.: Charles E. Fairman, "The Photo Secession Exhibition in Washington," in: *Photo-Era*, 12, February 1904, no. 2, pp. 17–18; James Henry Moser, "A Painter's Impression of the Washington Exhibition," in: *Camera Work*, April 1904, no. 6, pp. 45–46.

Vienna 1904
Participation in the sixth "Ausstellung des Wiener Photo-Clubs" (Exhibition of the Viennese Photo-Club) within a presentation by the Photo-Secession with 3 works from April 16 to May 15. Eugene exhibited "Adam and Eve," "Alfred Stieglitz" and "Dogwood."
"Frank Eugene simply tears a page out of a sketch pad. His 'Adam and Eve' is a self-assured, capricious item, but it has a lot of charm. To the soft, indistinct structure of the two nudes he despotically applies corrections in chalk." (*Die Photographische Kunst im Jahr 1904*, p. 150).
Lit.: *Katalog der sechsten Ausstellung Wiener Photo Club*, Wien 1904; Ludwig Schrank, "Ausstellung des Wiener Photo-Klubs," in: *Photographische Korrespondenz*, 41, 1904, no. 524, pp. 231–232.

Berlin 1905
Participation in the "Internationalen Ausstellung künstlerischer Photographie" (International Exhibition of Art Photography) at the Königlichen Akademie der Künste (Royal Academy of Arts) in Berlin from April 8 to May 8. The jury included Walther Leistikow, Max Liebermann, Prof. Hugo von Tschudi and Prof. Heinrich Wölfflin. Eugene was represented with "Porträt Alfred Stieglitz" (no. 9) in the exhibition of the "Photo-Secession," organized by Stieglitz. The exhibited works were available for purchase.
"Of course America is the 'highlight' and has pride of place, as befits the extraordinary. The Photo-Secession artists from the land of unlimited possibilities challenge the comprehension capacities of the ordinary dust-covered working man with an extremely opulent nonchalance. All of them nervous, sensitive right to their very fingertips, all with that worldly casual pose guaranteed by a secure source of income, but lacking that more aggressive sobriety, that element of 'forwards, into life.' All aesthetes of the Oscar Wilde type, who had his hair styled like the curls of Nero in the Louvre. Some Germans, still of a much too plebeian robustness, are totally impressed by these exotic airs and graces. We are told that the Photo-Secession represents only one small section of American photography, that is to say, that exclusive circle of aesthetes.' (*Photographische Mitteilungen*, Set, 42, 1905, p. 149).

Lit.: Catalogue *Internationale Ausstellung künstlerischer Photographie*, Königliche Akademie der Künste, Berlin 1905, p. II; "Die Berliner kunstphotographische Ausstellung und die Kritik," in: *Photographische Kunst*, 4, 1905/06, pp. 90–92; *Apollo*, II, 1905, no. 235, p. 74.

Dresden 1905
Participation in the "Kunst-Ausstellung" (Art Exhibition). Mention of "Eugene Frank – Munich" "which latter has depicted his particular specialty, small nude depictions, in a dim light."
Lit.: Ernst Zimmermann, "Die Photographie auf der Dresdner Kunst-Ausstellung," in: *Deutsche Kunst und Dekoration*, Set 14, 1905/06, p. 683; publication of "Hortensia" in *Photographischen Rundschau*, 19, 1905, p. 202.

London 1905
Participation with the photograph "Music," (no. 183) £7 10 Shillings, at the "Thirteenth Salon of the Linked Ring."
"It is some time since Frank Eugene was seen at the Salon, and the beautifully posed Music might reasonably have been accompanied by more of his decorative examples." (A.C.R. Carter, "The Two Great Exhibitions – The Salon," in: *The Photogram*, 12, 1905, p. 107).
Lit.: Frederick H. Evans, "The London Photographic Salon for 1905," in: *Camera Work*, Jan. 1906, no. 13, pp. 46–51, p. 52; *Catalogue of the Thirteenth Annual Exhibition of the Photographic Salon 1905*, London, 1905, p. 28.

New York 1905
Participation in the first exhibition of the Photo-Secession at the "Little Galleries" in New York, 291 Fifth Avenue from November 24, 1905 to January 5, 1906. Here Eugene exhibited "La Cigale" (no. 22), "Rebecca" (no. 23), "The Song of the Lily" (no. 24) and "Music" (no. 25); many of the exhibits were already shown in the exhibition of the Linked Ring and the "Lewis and Clark Exhibition" in Portland.
Lit.: "The Photo-Secession Galleries and the Press," in: *Camera Work*, April 1906, no. 14, pp. 33–40.

Portland 1905
Participation in the "Lewis and Clark Exposition," at which a total of 25 photographs were shown, with a maximum of 2 works per exhibitor. The jury consisted of A. Stieglitz, F. Benedict Herzog (President of the New Yorker Camera Club), E.J. Steichen and Joseph T. Keiley.
Lit.: *Camera Work*, July 1905, no. II, p. 57.

Richmond 1905
Participation in the "Ninth Annual Exhibition of the Art Association" of Richmond, Indiana.
Lit.: Weston J. Naef (ed.). *The Collection of Alfred Stieglitz. Fifty Pioneers of Modern Photography*, New York 1978, p. 356.

Vienna 1905
Participation with 4 portraits in the seventh "Internationalen Ausstellung des Wiener Photo-Clubs" (International Exhibition of the Viennese Photo Club) in from April 15 to May 21. Eugene exhibited the works "Miss Jones," (no. 10) 50 Kronen, "A Lady," no. 11) 100 Kronen, "A Man," (no. 12) 75 Kronen and "A Boy," no. 13) private collection.
Lit.: *Katalog der siebenten Ausstellung Wiener Photo Club*, Vienna 1905, pp. 9–10; Ernst Otto, "Stimmen über die Interna-

›Music‹ (Nr. 25) aus; viele Exponate der Ausstellung waren bereits in der Ausstellung des Linked Ring und der ›Lewis and Clark Exhibition‹ in Portland zu sehen gewesen.
Lit.: ›The Photo-Secession Galleries and the Press‹, in: *Camera Work*, April 1906, Nr. 14, S. 33–40.

Portland 1905

Beteiligung an der ›Lewis and Clark Exposition‹, in der insgesamt 25 Photographien gezeigt wurden, davon maximal 2 Arbeiten pro Aussteller. Die Jury bestand aus A. Stieglitz, F. Benedict Herzog (Präsident des New Yorker Camera Club), E. J. Steichen und Joseph T. Keiley.
Lit.: *Camera Work*, Juli 1905, Nr. 11, S. 57.

Richmond 1905

Beteiligung an der ›Ninth Annual Exhibition der Art Association of Richmond Indiana‹.
Lit.: Weston J. Naef (Hrsg.), *The Collection of Alfred Stieglitz. Fifty Pioneers of Modern Photography*, New York 1978, S. 356.

Wien 1905

Beteiligung mit 4 Porträtaufnahmen an der VII. Internationalen Ausstellung des Wiener Photoklubs vom 15. April bis 21. Mai. Es handelte sich um die Arbeiten ›Miss Jones‹ (Nr. 10) 50 Kronen, ›A Lady‹ (Nr. 11) 100 Kronen, ›A Man‹ (Nr. 12) 75 Kronen, ›A Boy‹ (Nr. 13) Privatbesitz.
Lit.: *Katalog der siebenten Ausstellung Wiener Photo Club*, Wien 1905, S. 9–10; Ernst Otto, ›Stimmen über die Internationale Ausstellung des Wiener Photoklubs 1905 (April–Mai)‹, in: *Photographische Korrespondenz*, 42, 1905, Nr. 536, S. 235–241.

Cincinnati 1906

Beteiligung an der ›Cincinnati Museum Exhibition of Photographic Art‹ vom 11. Februar bis 5. März.
Lit.: Weston J. Naef (Hrsg.), *The Collection of Alfred Stieglitz. Fifty Pioneers of Modern Photography*, New York, 1978, S. 356.

Paris 1906

Beteiligung an dem 11. Salon des Photo-Club in Paris.
»Et je ferai un reproche du même ordre à M. Frank Eugène, dont la Rébecca (212) choque et contraste nos connaissances historiques. J'avais toujours pensé – vous aussi peut-être – que c'était auprès d'un puit qu'Éliézer avait rencontré la fille de Bathuel. M. Eugène nous enseigne que c'est devant une tapisserie où gambadaient des guirlandes d'amours.«
Lit.: Jacques Crepet, ›Au XIe Salon International de Photographie‹, in: *La Revue de Photographie*, 4, 1906, S. 233.

München 1907 (I)

Einzelausstellung im Münchner Kunstverein im Mai.
»Im Parterresaal erregen die Künstler-Photographien von Frank Eugen Smith das regste Interesse des Publicums zunächst schon aus ›stofflichen‹ Gründen; hat Smith doch zu seinen Modellen eine imposante Reihe aus den Kreisen unserer ruhmvollsten Münchner Meister sich erwählt: Defregger, Gabriel und Emanuel v. Seidl, F. Aug. v. Kaulbach, Habermann, Oberländer, Hildebrand, Hengeler, Stuck, Benno Becker, Toni Stadler, Uhde, Possart, Georg Hirth, man weiß nicht, wer von ihnen am besten getroffen ist. Und nicht allein das, die Bilder sind als ›Bilder‹ im künstlerischen Sinn aufgefaßt, in der Licht- und Schattenverteilung, im Andeuten der warmen und kalten Töne und in dem Modelé der Gesichtsformen. Sie schließen sich darin den besten Schöpfungen an, welche die Photographie in der kurzen Zeit,

seit sie als wirkliche Kunst besteht und auch genommen wird, hervorgebracht. Nicht ganz auf der gleichen Höhe scheinen uns die landschaftlichen Versuche Smiths zu stehen und die Freilichtakte haben etwas Affektiertes und Spielerisches, vielleicht weil sie unwillkürlich an jene, zuweilen gar nicht schlechten sizilianischen Freilichtakt-Photographien erinnern, die aus undurchsichtigen Gründen für Gott weiß welches Publikum in den Schaukästen der Kunsthändler angeboten werden. Im übrigen verdienen Smiths Leistungen uneingeschränkte Anerkennung.«
Lit.: ›Kunstchronik‹, in: *Münchner Neueste Nachrichten*, 29.5.1907.

München 1907 (II)

Ausstellung von Aufnahmen des »Fachlehrers Herrn Kunstmaler Frank E. Smith, München, mit Begleitworten von Herrn Franz Grainer« im Rahmen der Sitzungen des Süddeutschen Photographen-Vereins am 18. Oktober. Vermutlich hatte Eugene bei dieser Gelegenheit seine Autochrome präsentiert, während gleichzeitig Hans Spörl das neue Farbverfahren der Gebrüder Lumière vorstellte.
Lit.: *Photographische Kunst*, 6, 1908, S. 392.

München 1907 (III)

Beteiligung mit 3 Gemälden an der Gedächtnisausstellung für den 1907 verstorbenen Maler und Professor der Münchner Kunstakademie Wilhelm von Diez, die 50 Arbeiten von Diez und 250 Werke von Diez-Schülern umfaßte. Eugene war mit den Gemälden ›Studienkopf‹, ›Der Pessimist‹ und ›Negermutter‹ vertreten.
Lit.: Katalog *Ausstellung von Werken der Diez-Schule aus den Jahren 1870–1890*, Galerie Heinemann, München 1907, Nr. 213–215.

New York 1907

Während der Jahresausstellung der Photo-Secession, an der Frank Eugene nicht beteiligt war, präsentierte Alfred Stieglitz Autochrome von Eugene, Steichen, White und Stieglitz.
Lit.: *Camera Work*, Jan. 1908, Nr. 21, S. 45; *Die Kunst der Photographie im Jahre*, 1908, S. 146–147.

Dresden 1908

Beteiligung an der Ausstellung des Plakatwettbewerbes für die Internationale Photographische Ausstellung in Dresden, dessen Resultate im Februar 1908 im Sächsischen Kunstvein auf der Brühlschen Terrasse vorgestellt wurden. Eugene war mit einem Plakatentwurf (Kennwort ›Weiß, Gold, Brau‹) beteiligt, der mit 100 Mark prämiert wurde. Insgesamt waren 355 Plakatentwürfe eingereicht worden, davon nur zehn mit photographischen Mitteln hergestellt worden. »Von allen photographischen Entwürfen ist einer, höchsten zwei künstlerisch verwertbar: der eine stammt von dem Lehrer der ›Lehr- und Versuchsanstalt für Photographie‹ in München, Frank Eugene Smith, und wurde, als einziger prämiierter photographischer Entwurf, mit einem Preise ausgezeichnet; eine sehr fein von einem stilisierten landschaftlichen Hintergrunde sich abhebende weibliche Gestalt, voll vornehm-ruhiger Schönheit, in der Hand ein Objektiv haltend, bildet das Mittelstück. Wenn dem in Linien und Tönen sehr reizvollen Bilde die Fernwirkung fehlt, so liegt dies eben im Halbton-Charakter des photographischen Bildes überhaupt, das zu breiten Wirkungen nur auf kunstwidrigen Wegen gezwungen werden kann.« (K. W. Czapek: ›Das Ergebnis des Dresdener Ausstellungsplakat-Wettbewerbes‹, in: *Photographische Kunst*, 6, 1908, Nr. 22, S. 385.)
Lit.: *Photographische Korrespondenz*, 48, 1908, Nr. 570, S. 143;

tionale Ausstellung des Wiener Photoklubs 1905 (April–Mai)," in: *Photographische Korrespondenz*, 1905, no. 536, pp. 235–241.

Cincinnati 1906

Participation in the "Cincinnati Museum Exhibition of Photographic Art" from February 11 to March 5.
Lit.: Weston J. Naef (ed.), *The Collection of Alfred Stieglitz. Fifty Pioneers of Modern Photography*, New York, 1978, p. 356.

Paris 1906

Participation in the eleventh Salon of the Photo-Club in Paris. "And I would make the same criticism of M. Frank Eugene whose 'Rebecca' (212) shocks and confuses our historical knowledge. I always thought – and you too perhaps – that Eliezer met the daughter of Bathuel beside a well. M. Eugene would like to persuade us that it was in front of a tapestry strewn with garlands of love."
Lit.: Jacques Crepet, "Au XIe Salon International de Photographie," in: *La Revue de Photographie*, 4, 1906, Paris, p. 233.

Munich 1907 (I)

Solo exhibition at the Münchner Kunstverein in May.
"On the ground floor Frank Eugene Smith's art photographs are eliciting the greatest interest among the public, if only by reason of their 'content'; as models Smith has chosen an impressive series of personalities from the circles of our most famous Munich masters: Defregger, Gabriel und Emanuel v. Seidl, F. Aug. v. Kaulbach, Habermann, Oberländer, Hildebrand, Hengeler, Stuck, Benno Becker, Toni Stadler, Uhde, Possart, Georg Hirth, and it is hard to say which of them is the best likeness. Not only that, the photographs are conceived of as 'paintings' in the artistic sense, in the distribution of light and shade, in the suggestion of warm and cold tones, and in the modelling of the facial features. In this they can be counted among the best creations which photography has given rise to in the short time it has existed and been accepted as a real art form. Smith's attempts at landscapes do not seem to us to be on the same level, and his open air nudes have something artificial, playful about them, perhaps because they remind us, involuntarily, of those sometimes passable Sicialian open air nude photographs on offer to God knows what public and for whatever reasons in the display cases of art dealers. Besides this, Smith's achievements deserve full recognition."
Lit.: "Kunstchronik," May 29, 1907, in: *Münchner Neueste Nachrichten*, May 29, 1907.

Munich 1907 (II)

Exhibition of photographs by the "teacher and artist Mr. Frank E. Smith, Munich, with an introduction by Mr. Franz Grainer" on the occasion of the meeting of the Süddeutsche Photographen-Verein (South German Photographers Association) on October 18. Presumably Eugene presented his autochromes while at the same time Hans Spörl introduced the new color processing developed by the Lumière brothers.
Lit.: *Photographische Kunst*, 6, 1908, p. 392.

Munich 1907 (III)

Participation with 3 paintings in the commemorative exhibition in honor of the deceased artist and professor at the Munich Academy Wilhelm von Diez. The exhibition included 50 works by Diez and 250 by Diez-pupils. Eugene was represented with the paintings "Studienkopf," "Der Pessimist" and "Negermutter."

Lit.: Catalogue *Ausstellung von Werken der Diez-Schule aus den Jahren 1870–1890*, Galerie Heinemann, Munich 1907, pp. 213–215.

New York 1907

During the annual exhibition of the Photo-Secession, in which Frank Eugene participated, Alfred Stieglitz presented autochromes by Eugene, Steichen, White and Stieglitz.
Lit.: *Camera Work*, Jan. 1908, no. 21, p. 45; *Die Kunst der Photographie im Jahre (?)*, 1908, pp. 146–147.

Dresden 1908

Participation in the exhibition of posters competing for the "Internationale Photographische Ausstellung" (International Photographic Exhibition) in Dresden, the results of which were presented in February 1908 in the Sächsischen Kunstverein (Saxon Art Association) on the Brühlsche Terrasse. Eugene entered a poster under the motto "white, gold, brown," which was awarded a prize of 100 marks. A total of 355 poster designes were entered, of which only ten were produced by photograhpic means. "Of all the photographic designs only one, at the most two, are of artistic value: one is by the teacher Frank Eugene Smith from the Munich Lehr- und Versuchsanstalt, which was the only photographic work to be awarded a prize; at the center of the poster is a delicate female figure standing out against a stylized landscape background, full of noble beauty, holding a lens in her hand. Should this poster lack depth, while being altogether attractive in its lines and tones, then it is due to the half-tone character of the photograhpic image which can only be made to achieve wider effects forcibly, by means contrary to art." (K.W. Czapek: "Das Ergebnis des Dresdener Ausstellungsplakat-Wettbewerbes," in: *Photographische Kunst*, Vol 6, 1908, no. 22, p. 385)
Lit.: *Photographische Korrespondenz*, 1908, no. 570, p. 143; Karl Weiß, "Photographie und Plakatkunst – ein Debacle," in: *Photographische Rundschau und Photographisches Centralblatt*, 22, 1908, pp. 72–73.

London 1908

Participation with 10 photographs at the annual exhibition of the Linked Ring in London, which took place on the premises of the gallery of the Royal Water-Colour Society in Pall Mall. Exhibited were "Prof. Emanuel von Seidl" (no. 61) £2 2p., "Music" (no. 62) £3 3p., "Rebeckah" (no. 63) £4 4p., "H.R.H. Prince Luitpold of Bavaria" (no. 64) £2 2p., "Minuette" (no. 65) £3 3p., "The Horse" (no. 66) £2 2p., "A Profile (Miss G.)" (no. 67) £2 2p., "Girl with Flowers" (no. 68) £3 3p., "Prof. Rudolf von Seitz" (no. 69) £2 2p., "Man in Armor" (no. 70) £3 3p.
Eugene had been nominated for the jury alongside J.C. Annan, M. Arbuthnot, Bennington, A. L. Coburn, G. Davison, E. Steichen, R. Demachy, H. Kühn, A. de Meyer, A. Stieglitz and C.H. White, but like Kühn, De Meyer, Stieglitz and White could not participate in the jury.
"The ten works by Frank Eugene vary considerably in merit. The portrait of 'Prof. Emanuel von Seidl' (61) and 'Prof. Rudolf von Seitz' (69) are fine in most ways, though the first is distinctly heavier in tone than it need have been, and the latter is over full of fussy accessories, which rob the face of its due importance. 'Music' (62) is a pre-Raphaelite sort of lady playing the violin; 'A Profile' (67) is more in a Pompadour style; 'Rebeckah' (63) is utterly satisfying. A charming model has been photographed in a beautiful pose and in a tasteful manner, with a tapestry background of delightful quality. 'H.R.H. Prince Luitpold of Bavaria' (64) is a child seated upon a chair. When we say that his socks

Karl Weiß, ›Photographie und Plakatkunst – ein Debacle‹, in: *Photographische Rundschau und Photographisches Centralblatt*, 22, 1908, S. 72–73.

London 1908

Beteiligung mit 10 Aufnahmen an der Jahresausstellung des Linked Ring in London, die in den Galerieräumen der Royal WaterColour Society in Pall Mall stattfand. Ausgestellt waren ›Prof. Emanuel von Seidl‹ (Nr. 61) £2 2p., ›Music‹ (Nr. 62) £3 3p., ›Rebeckah‹ (Nr. 63) £4 4p., ›H.R.H. Prince Luitpold of Bavaria‹ (Nr. 64) £2 2p., ›Minuette‹ (Nr. 65) £3 3p., ›The Horse‹ (Nr. 66) £2 2p., ›A Profile (Miss G.)‹ (Nr. 67) £2 2p., ›Girl with Flowers‹ (Nr. 68) £3 3p., ›Prof. Rudolf von Seitz› (Nr. 69) £2 2p., ›Man in Armor‹ (Nr. 70) £3 3p.

Eugene war neben J.C. Annan, M. Arbuthnot, Bennington, A.L. Coburn, G. Davison, E. Steichen, R. Demachy, H. Kühn, A. de Meyer, A. Stieglitz und C.H. White zum Jurymitglied ernannt worden, konnte jedoch wie Kühn, De Meyer, Stieglitz und White an der Jury nicht teilnehmen.

»Qualitativ weichen die zehn Aufnahmen von Frank Eugene erheblich voneinander ab. Die Porträts von ›Professor Emanuel von Seidl‹ (61) und von ›Professor Rudolf von Seitz‹ (69) sind in vielerlei Hinsicht gelungen, obwohl ersteres deutlich schwerer ist im Ton als nötig und letzteres überhäuft mit so vielen verspielten Accessoires, daß das Gesicht seiner wahren Bedeutung beraubt wird. ›Music‹ (62) stellt eine Dame im Stil der Präraffaeliten dar, die Geige spielt; ›A Profile‹ (67) ist eher im Pompadour-Stil gehalten. ›Rebeckah‹ (63) ist höchst zufriedenstellend - ein reizendes Modell in schöner Pose photographiert vor einem entzückenden Wandteppich-Hintergrund. ›H.R.H. Prince Luitpold of Bavaria‹ (64) zeigt ein Kind auf einem Stuhl sitzend. Wenn wir sagen, seine Socken sind ein ›totes Weiß‹ und seine Schuhe ein ›totes Schwarz‹, dann verstehen unsere Leser, welche Bedeutung den verschiedenen Techniken in diesem Salon zukommt. ›Minuette‹ (65) hat gewisse gute Eigenschaften; woher jedoch der Name der allem Anschein nach auf dem Boden sitzenden Dame in Rückenansicht kommt, weiß Mr. Eugene wohl am besten. ›Girl with Flowers‹ (68) ist eine gelungene Komposition. ›Man in Armor‹ (70) zeigt zu viel Hand am unteren Rand des Abzugs, ansonsten ist es gut.« (*The British Journal of Photography*, 18, 1908, S. 726.)

»Eugenes Beitrag bestand aus eine Gruppe von sehr schönen neuen Abzügen, von denen einige von alten Negativen stammen.« (Joseph T. Keiley, ›Impressions of the Linked Ring Salon of 1908‹, in: *Camera Work*, Jan. 1909, Nr. 25, S. 30.)

Lit.: *Catalogue of the Sixteenth Annual Exhibition of the Photographic Salon 1908*, Gallery of the Royal Society of Painters in Water Colours, London 1908, S. 26; Joseph T. Keiley, ›Impressions of the Linked Ring Salon of 1908‹, in: *Camera Work*, Jan. 1909, Nr. 25, S. 29–36; *The British Journal of Photography*, 18.9.1908, S. 726.

München 1908 (I)

Einzelausstellung mit 98 Aufnahmen im Rahmen der Kunstgewerbeausstellung ›München 1908‹, die anläßlich des 750jährigen Bestehens der Stadt stattfand. Die Ausstellung war in der Halle III in Raum 244 untergebracht, dessen Inneneinrichtung von Eugene und dem Architekten Otto Baur stammte. Ausgestellt wurden folgende Arbeiten: ›Prof. Fritz von Uhde‹ (Nr. 1), ›Prof. Becker-Gundahl‹ (Nr. 2), ›Kunstmaler Hugo Havenith‹ (Nr. 3), ›Prof. Ludwig Herterich‹ (Nr. 4), ›Prof. Landenberg und Direktor Goetz‹ (Nr. 5), ›Studie (Mosaik)‹ (Nr. 6), ›Prof. Julius Diez‹ (Nr. 7), ›Prof. Franz von Defregger‹ (Nr. 8), ›Prof. Gabriel

Schachinger‹ (Nr. 9), ›Prof. Adolf von Hildebrand‹ (Nr. 10), ›Prof. Adolf Oberländer‹ (Nr. 11), ›Prof. Emanuel von Seidl‹ (Nr. 12), ›Prof. Gabriel von Seidl‹ (Nr. 13), ›Prof. Emanuel von Seidl‹ (Nr. 14), ›Prinz Luitpold und Prinz Albrecht‹ (Nr. 15), ›Prof. Freiherr von Habermann‹ (Nr. 16), ›Prof. Franz von Stuck‹ (Nr. 17), ›Generalkonsul Alphons Bruckmann‹ (Nr. 18), ›Prof. Benno Bekker‹ (Nr. 19), ›Prof. Adolf Hengeler‹ (Nr. 20), ›Prof. Martin Feuerstein‹ (Nr. 21), ›Prof. Albert von Keller‹ (Nr. 22), ›Bildhauer Cyprian Adolf Bermann‹ (Nr. 23), ›Rebekha (Studie)‹ (Nr. 24), ›Prof. Rudolf von Seitz‹ (Nr. 25), ›Prof. Toni Stadler‹ (Nr. 26), ›Miß Olga Koerting‹ (Nr. 27), ›Kammersänger Ludwig Heß‹ (Nr. 28), ›Bildhauer Rudolf Gedon‹ (Nr. 29), ›Studienrat Dr. Georg Kerschensteiner‹ (Nr. 30), ›Reichsrat Ferdinand von Miller‹ (Nr. 31), ›Generalintendant Ernst von Possart‹ (Nr. 32), ›Direktor Fritz August von Kaulbach‹ (Nr. 33), ›Kunstmaler Heyligers mit Frau‹ (Nr. 34), ›Graf Friedrich zu Pappenheim‹ (Nr. 35), ›Prinz Rupprecht von Bayern‹ (Nr. 36), ›Prinzessin Rupprecht, Prinz Luitpold und Prinz Albrecht‹ (Nr. 37), ›Eden‹ (Nr. 38), ›Ein Profil‹ (Nr. 39), ›Prinzessin Rupprecht mit Kindern, rechts und links dekorative Figuren (Musik und Ritterlichkeit)‹ (Nr. 40), ›Prinz Luitpold‹ (Nr. 41), ›Gabriella Lenbach‹ (Nr. 42), ›Prinz Rupprecht von Bayern‹ (Nr. 43), ›Prinz Luitpold‹ (Nr. 44), ›Frl. von Schwarz‹ (Nr. 45), ›Brigitte Wenz‹ (Nr. 46), ›Graf Friedrich zu Pappenheim‹ (Nr. 47), ›Taka-‹ (Nr. 48), ›Prinz Luitpold und Prinz Albrecht‹ (Nr. 49), ›Mrs. Chauncey‹ (Nr. 50), ›Frau Prof. von Lenbach mit Tochter‹ (Nr. 51), ›Dr. Friedrich Schäfer‹ (Nr. 52), ›Master Bliss-Lane‹ (Nr. 53), ›Master Frank Jefferson (Tasse Tee)‹ (Nr. 54), ›Kitty O'Connor‹ (Nr. 55), ›Frl. Emmy Geiger‹ (Nr. 56), ›Baby Sedlmayr‹ (Nr. 57), ›Wolfgang Mottl‹ (Nr. 58), ›Gretchen Guglielmo‹ (Nr. 59), ›Frau Architekt Hans Klinke‹ (Nr. 60), ›Miß Marion Convere‹ (Nr. 61), ›Frl. Bertha Morena, Kgl. Hofopernsängerin‹ (Nr. 62), ›Baby Geiger‹ (Nr. 63), ›Frau Maria Geiger‹ (Nr. 64), ›Studie. M.C.J.‹ (Nr. 65), ›Hortensia‹ (Nr. 66), ›Maler Willi Geiger‹ (Nr. 67), ›Frl. Dora Polster‹ (Nr. 68), ›Georg Geiger‹ (Nr. 69), ›Dido‹ (Nr. 70), ›Badende‹ (Nr. 71), ›Clara Geiger‹ (Nr. 72), ›Samoanisches Lied‹ (Nr. 73), ›Mrs. James Brown Potter‹ (Nr. 74), ›Studie‹ (Nr. 75), ›Studie‹ (Nr. 76), ›The Song of the Lily‹ (Nr. 77), ›Adam und Eva‹ (Nr. 78), ›Studie‹ (Nr. 79), ›The Song of the Lily‹ (Nr. 80), ›Studie (Dekorative Figur)‹ (Nr. 81), ›Studie (Minuette)‹ (Nr. 82), ›Ein Profil‹ (Nr. 83), ›Juventas (Halbakt)‹ (Nr. 84), ›Arthur und Guinevere (Illustration zu einem Gedicht von Lord Tennyson)‹ (Nr. 85), ›Frl. Olga Lynen‹ (Nr. 86), ›Am Bach (Aktstudie)‹ (Nr. 87), ›Alfred Stieglitz, Esquire‹ (Nr. 88), ›Mrs. Burke Cockran‹ (Nr. 89), ›Frau Dr. R.‹ (Nr. 90), ›Eva Kohlermann‹ (Nr. 91), ›Vergrößerung nach demselben Negativ wie Nr. 37‹ (Nr. 92). Weiterhin waren sechs Autochrome ausgestellt: ›The Tennis-girl. Weißes Kleid‹ (Nr. 93), ›Mädchen mit rotem Mantel‹ (Nr. 94), ›Die Frls. Simson‹ (Nr. 95), ›Variation von Nr. 95‹ (Nr. 96), ›Eine Farbenphotographie‹ (Nr. 97), ›Eine Farbenphotographie‹ (Nr. 98).

»Ein in sich geschlossenes Aussehen und zweifellos auf hohem Niveau stehendes Schaffen bietet uns die Ausstellung von Frank Eugen Smith, der in einem kleinen Raum in der Nähe der photographischen Gruppe eine Einzelausstellung durchgesetzt hat. Es ist nur ein Ansporn für uns, wenn wir vor diese geschlossene Arbeit hintreten, und wenn wir verstehen, diese hohe Künstlerschaft, die aus diesen Erzeugnissen spricht, zu würdigen.« (Franz Grainer, ›Rückblick auf die Gruppe Photographie auf der Ausstellung »München 1908«‹, in: *Photographische Kunst*, 7, 1908, S. 263.)

Lit.: Katalog *Photographische Arbeiten von Frank Eugene Smith. Ausstellung München 1908*, Halle IV Raum 244, München 1908; *Amtlicher Führer durch die Ausstellung München 1908*, Mün

are dead white and his shoes dead black our readers will understand how much technicalities count for the Salon. 'Minuette' (65) has certain nice qualities; but why it should be so called and represent a lady at back view sitting on the ground, to all appearances, Mr. Eugene best knows. 'Girl with Flowers' (68) is good in arrangement; 'Man in Armor' (70) shows too much hand at the bottom of the print, otherwise it is good." (*The British Journal of Photography*, 18, 1908, p. 726).

"Eugene's consisted of a group of fine rich new prints, some of them from old negatives." (Joseph T. Keiley, "Impressions of the Linked Ring Salon of 1908," in: *Camera Work*, Jan. 1909, no. 25, p. 30).

Lit.: *Catalogue of the Sixteenth Annual Exhibition of the Photographic Salon 1908*, Gallery of the Royal Society of Painters in Water Colours, London, 1908, p. 26; Joseph T. Keiley, "Impressions of the Linked Ring Salon of 1908," in: *Camera Work*, Jan. 1909, no. 25, pp. 29–36; *The British Journal of Photography*, September 18, 1908, p. 726.

Munich 1908 (I)

Solo exhibition with 98 photographs within the framework of the arts and crafts exhibition "München 1908," mounted on the occasion of the city's 750th anniversary. The exhibition was located in Hall III, room 244 the interior decor was by Eugene and the architect Otto Baur. The following works were on show: "Prof. Fritz von Uhde" (no. 1), "Prof. Becker-Gundahl" (no. 2), "Kunstmaler Hugo Havenith" (no. 3), "Prof. Ludwig Herterich" (no. 4), "Prof. Landenberg und Direktor Goetz" (no. 5), "Studie (Mosaik)" (no. 6), "Prof. Julius Diez" (no. 7), "Prof. Franz von Defregger" (no. 8), "Prof. Gabriel Schachinger" (no. 9), "Prof. Adolf von Hildebrand" (no. 10), "Prof. Adolf Oberländer" (no. 11), "Prof. Emanuel von Seidl" (no. 12), "Prof. Gabriel von Seidl" (no. 13), "Prof. Emanuel von Seidl" (no. 14), "Prinz Luitpold und Prinz Albrecht" (no. 15), "Prof. Freiherr von Habermann" (no. 16), "Prof. Franz von Stuck" (no. 17), "Generalkonsul Alphons Bruckmann" (no. 18), "Prof. Benno Becker" (no. 19), "Prof. Adolf Hengeler" (no. 20), "Prof. Martin Feuerstein" (no. 21), "Prof. Albert von Keller" (no. 22), "Bildhauer Cyprian Adolf Bermann" (no. 23), "Rebekha (Studie)" (no. 24), "Prof. Rudolf von Seitz" (no. 25), "Prof. Toni Stadler" (no. 26), "Miß Olga Koerting" (no. 27), "Kammersänger Ludwig Heß" (no. 28), "Bildhauer Rudolf Gedon" (no. 29), "Studienrat Dr. Georg Kerschensteiner" (no. 30), "Reichsrat Ferdinand von Miller" (no. 31), "Generalintendant Ernst von Possart" (no. 32), "Direktor Fritz August von Kaulbach" (no. 33), "Kunstmaler Heyligers mit Frau" (no. 34), "Graf Friedrich zu Pappenheim" (no. 35), "Prinz Rupprecht von Bayern" (no. 36), "Prinzessin Rupprecht, Prinz Luitpold und Prinz Albrecht" (no. 37), "Eden" (no. 38), "Ein Profil" (no. 39), "Prinzessin Rupprecht mit Kindern, rechts und links dekorative Figuren (Musik und Ritterlichkeit)" (no. 40), "Prinz Luitpold" (no. 41), "Gabriella Lenbach" (no. 42), "Prinz Rupprecht von Bayern" (no. 43), "Prinz Luitpold" (no. 44), "Frl. von Schwarz" (no. 45), "Brigitte Wenz" (no. 46), "Graf Friedrich zu Pappenheim" (no. 47), "Taka" (no. 48), "Prinz Luitpold und Prinz Albrecht" (no. 49), "Mrs. Chauncey" (no. 50), "Frau Prof. von Lenbach mit Tochter" (no. 51), "Dr. Friedrich Schäfer" (no. 52), "Master Bliss-Lane" (no. 53), "Master Frank Jefferson (Tasse Tee)" (no. 54), "Kitty O'Connor" (no. 55), "Frl. Emmy Geiger" (no. 56), "Baby Sedlmayr" (no. 57), "Wolfgang Mottl" (no. 58), "Gretchen Guglielmo" (no. 59), "Frau Architekt Hans Klinke" (no. 60), "Miß Marion Convere" (no. 61), "Frl. Bertha Morena, Kgl. Hofopernsängerin" (no. 62), "Baby Geiger" (no. 63), "Frau Maria Geiger" (no. 64), "Studie.

M.C.J." (no. 65), "Hortensia" (no. 66), "Maler Willi Geiger" (no. 67), "Frl. Dora Polster" (no. 68), "Georg Geiger" (no. 69), "Dido" (no. 70), "Badende" (no. 71), "Clara Geiger" (no. 72), "Samoanisches Lied" (no. 73), "Mrs. James Brown Potter" (no. 74), "Studie" (no. 75), "Studie" (no. 76), "The Song of the Lily" (no. 77), "Adam und Eva" (no. 78), "Studie" (no. 79), "The Song of the Lily" (no. 80), "Studie (Dekorative Figur)" (no. 81), "Studie (Minuette)" (no. 82), "Ein Profil" (no. 83), "Juventas (Halbakt)" (no. 84), "Arthur und Guinevere (Illustration zu einem Gedicht von Lord Tennyson)" (no. 85), "Frl. Olga Lynen" (no. 86), "Am Bach (Aktstudie)" (no. 87), "Alfred Stieglitz, Esquire" (no. 88), "Mrs. Burke Cockran" (no. 89), "Frau Dr. R." (no. 90), "Eva Kohlermann" (no. 91), "Vergrößerung nach demselben Negativ wie no. 37" (no. 92). In addition, 6 autochromes were exhibited: "The Tennis-girl. Weißes Kleid" (no. 93), "Mädchen mit rotem Mantel" (no. 94), "Die Frls. Simson" (no. 95), "Variation von Nr. 95" (no. 96), "Eine Farbenphotographie" (no. 97), "Eine Farbenphotographie" (no. 98).

"The Frank Eugene Smith exhibition offers us an oeuvre of a unified appearance and doubtless of top quality. Smith managed to have a solo exhibition in a small room close to the photography group. It is an incentive to us when we approach this unified work and when we are in a position to appreciate the high artistry which speaks through these works." (Franz Grainer, "Rückblick auf die Gruppe Photographie auf der Ausstellung 'München 1908'," in: *Photographische Kunst*, 1908, p. 263).

Lit.: Catalogue *Photographische Arbeiten von Frank Eugene Smith. Ausstellung München 1908*, Hall IV, room 244, Munich 1908; *Amtlicher Führer durch die Ausstellung München 1908*, München, 1908 (3. Auflage), pp. 32–33; G.H. Emmerich, "Von der Ausstellung 'München 1908'," in: *Photographische Kunst*, Set VII, 1908, pp. 65–66, pp. 126–128, pp. 209–210; Franz Grainer, "Rückblick auf die Gruppe Photographie auf der Ausstellung 'München 1908'," in: *Photographische Kunst*, 7, 1908, pp. 281–284; *Münchner Neueste Nachrichten*, Sep. 19, 1908, *Archiv Hollandiana*, Münchner Staatsbibliothek.

Munich 1908 (II)

Participation in the exhibition mounted on the occasion of the meeting of the Süddeutsche Photographen-Verein in the banqueting hall of the Bavarian Arts and Crafts Association, jointly with W. Urban, R. Lähnemann, E. Fichtl und R. Rothmaier, who were also teachers at the Lehr- und Versuchsanstalt für Photographie.

Dresden 1909

Participation in the "Internationalen Photographischen Ausstellung" (International Photography Exhibition) in Dresden in three sections. In the section "commercial photography" in room 15, put together by G. H. Emmerich, alongside Franz Grainer, Rudolf Dührkoop, Carl Ruf and Hugo Erfurth, Eugene presented a solo exhibition of 59 works which included, according to the catalogue, numerous portraits: "Graf zu Pappenheim" (no. 1), "Prof. Fritz von Uhde" (no. 2), "Miss Marie Struthas" (no. 3), "Schachweltmeister Dr. Lasker und Bruder" (no. 4), "Fritz August von Kaulbach" (no. 5), "Prof. Julius Diez" (no. 6), "Prof. Toni Stadler" (no. 7), "Prof. Adolf v. Hildebrand" (no. 8), "Prof. Adolf Oberländer" (no. 9), "Aktstudie" (no. 10), "Prof. Gabriel v. Seidl" (no. 11), "Hortensia" (no. 12), "Hugo Freiherr v. Habermann" (no. 13), "Prof. Emanuel v. Seidl" (no. 14), "Prof. Adolf Hengeler" (no. 15), "Franz v. Stuck" (no. 16), "Prof. Rudolf v. Seitz" (no. 17), "Kleiner Faun" (no. 18), "Frau Dr. Ratka" (no. 19), "Master Mortimer Bliss-Lane" (no. 20), "Willy Geiger" (no. 21), "Miss Laurer Uselson" (no. 22), "Ludwig Hess"

chen, 1908 (3. Auflage), S. 32–33; G.H. Emmerich, ›Von der Ausstellung »München 1908«‹, in: *Photographische Kunst*, 7, 1908, S. 65–66, S. 126–128, S. 209–210; Franz Grainer, ›Rückblick auf die Gruppe Photographie auf der Ausstellung »München 1908«‹, in: *Photographische Kunst*, 7, 1908, S. 281–284; *Münchner Neueste Nachrichten*, 19.9.1908, *Archiv Hollandiana*, Bayerische Staatsbibliothek, München.

München 1908 (II)

Beteiligung an der Ausstellung anläßlich der Sitzung des Süddeutschen Photographen-Vereins im Festsaal des Bayerischen Kunstgewerbe-Vereins gemeinsam mit den anderen Fachlehrern der Lehr- und Versuchsanstalt für Photographie W. Urban, R. Lähnemann, E. Fichtl und R. Rothmaier.

Dresden 1909

Beteiligung an der ›Internationalen Photographischen Ausstellung‹ in Dresden innerhalb von drei Abteilungen. In der Abteilung Berufsphotographie im Raum 15, die von G.H. Emmerich zusammengestellt worden war, präsentierte Eugene neben Franz Grainer, Rudolf Dührkoop, Carl Ruf und Hugo Erfurth eine Einzelausstellung mit 59 Arbeiten. Darunter befanden sich laut Katalog zahlreiche Porträts: ›Graf zu Pappenheim‹ (Nr. 1), ›Prof. Fritz von Uhde‹ (Nr. 2), ›Miss Marie Struthas‹ (Nr. 3), ›Schachweltmeister Dr. Lasker und Bruder‹ (Nr. 4), ›Fritz August von Kaulbach‹ (Nr. 5), ›Prof. Julius Diez‹ (Nr. 6), ›Prof. Toni Stadler‹ (Nr. 7), ›Prof. Adolf v. Hildebrand‹ (Nr. 8), ›Prof. Adolf Oberländer‹ (Nr. 9), ›Aktstudie‹ (Nr. 10), ›Prof. Gabriel v. Seidl‹ (Nr. 11), ›Hortensia‹ (Nr. 12), ›Hugo Freiherr v. Habermann‹ (Nr. 13), ›Prof. Emanuel v. Seidl‹ (Nr. 14), ›Prof. Adolf Hengeler‹ (Nr. 15), ›Franz v. Stuck‹ (Nr. 16), ›Prof. Rudolf v. Seitz‹ (Nr. 17), ›Kleiner Faun‹ (Nr. 18), ›Frau Dr. Ratka‹ (Nr. 19), ›Master Mortimer Bliss-Lane‹ (Nr. 20), ›Willy Geiger‹ (Nr. 21), ›Miss Laurer Uselson‹ (Nr. 22), ›Ludwig Hess‹ (Nr. 23), ›Brigitta Wenz‹ (Nr. 24), ›Freifrau Ludovica v. Stumm‹ (Nr. 25), ›Klara Geiger‹ (Nr. 26), ›Prinz Luitpold von Bayern‹ (Nr. 27), ›Prinz Rupprecht von Bayern‹ (Nr. 28), ›Prinzessin Rupprecht mit Kindern, rechts und links »Musik und Ritterlichkeit«‹ (Nr. 29), ›Ein Profil‹ (Nr. 30), ›Prinzessin Rupprecht mit Kindern‹ (Nr. 31), ›Prinz Luitpold und Prinz Albrecht von Bayern, (Nr. 32), ›Max Graf von Moy‹ (Nr. 33), ›Frau Prof. v. Lenbach mit Gabriele‹ (Nr. 34), ›Miss Marion Convère Jones‹ (Nr. 35), ›Frl. Olga Lynen‹ (Nr. 36), ›Kunstmaler Hugo Havenith‹ (Nr. 37), ›Wolfgang Motte‹ (Nr. 38), ›Prof. Franz v. Defregger‹ (Nr. 39), ›Mrs. Chauncey‹ (Nr. 40), ›Dora Polster‹ (Nr. 41), ›Am Bach‹ (Nr. 42), ›Badende‹ (Nr. 43), ›Rebeckah‹ (Nr. 44), ›Kunstmaler Henri Heyligers und Frau‹ (Nr. 45), ›Adam und Eva‹ (Nr. 46), ›Sphinx‹ (Nr. 47), ›Dekorative Figur‹ (Nr. 48), ›Aktstudie E.Z.‹ (Nr. 49), ›Menuett‹ (Nr. 50), ›Psyche‹ (Nr. 51), ›Frau Wolf-Neger mit Sohn‹ (Nr. 52), ›Juventus‹ (Nr. 53), ›Frau Hubert Wilm‹ (Nr. 54), ›Mann in Rüstung‹ (Nr. 55), ›Mad. Adele Erica de Kroeger, (Nr. 56), ›Pferd‹ (Nr. 57), ›Frau Prof. v. Kaulbach‹ (Nr. 58), ›Samoan Song‹ (Nr. 59).
»Frank Eugen Smith – München bringt nebenan im Raum 15 seine schon von München her bekannten vortrefflichen Arbeiten, denen er eine Anzahl neue beigefügt hat; er ist ganz Naturalist und lässt den Menschen die grössten Warzen und Falten stehen, aber er ist der Menschenschilderer par excellence.« (G.H. Emmerich, in: *Photographische Kunst*, 8, 1909/10, S. 67)
»Die ›Lichtradierungen‹ von Frank Eugen Smith tragen den Stempel der künstlerischen Persönlichkeit. Befreit von jeder Fessel der Tradition in bezug auf Technik wie Konzeption, sprechen die erfrischenden Blätter dieses Malerphotographen ihre eigene, eindringliche Sprache.« (*Wiener Mitteilungen*, 21, 1909, S. 434)

Außerdem war Eugene in Dresden in der Ausstellung der International Society of Art Photographers mit 7 Arbeiten beteiligt, die von Heinrich Kühn organisiert wurde. Eugene stellte als Lehrer der Münchner Lehr- und Versuchsanstalt für Photographie in der Abteilung ›Unterrichtsanstalten-Schulen‹ aus, u.a. großformatige Fotogravüren aus der Mustermappe der Photoschule.
»In allen (Schüler-) Arbeiten sieht man den fördernden Antrieb, den besonders der feinfühlige Frank Eugène Smith auf die künstlerische Entwicklung der Schüler der Lehranstalt ausgeübt hat.« (*Die Photographische Industrie*, 7, 1909, Nr. 21, S. 654).
Eugene konnte mehrere Arbeiten in Dresden verkaufen und bekam gemeinsam mit Gebrüder Lützel und Franz Schensky die Medaille der Stadt Dresden als höchste Anerkennung verliehen.
Lit.: Katalog *Internationale Photographische Ausstellung in Dresden 1909*, Dresden 1909, S.186–187; ›The »International Group« at the Dresden Exposition‹, in: *Camera Work*, Oktober 1909, Nr. 28, S. 45–49; Charles H. Caffin, ›Some Impressions from the International Photographic Exposition, Dresden‹, in: *Camera Work*, Oktober 1909, Nr. 28, S. 33–39; ›Notes on the Dresden Exposition-Awards‹, in: *Camera Work*, Oktober 1909, Nr. 28, S. 47; *The British Journal of Photography*, 11.6.1909, S. 454; E.O. Hoppé, ›Die Amateur-Gruppe auf der Dresdner Ausstellung (II.Teil)‹, in: *Photographische Kunst*, 8, 1909, o.S.; Cesare Schiaparelli, *L'arte Fotografica all'Esposizione Internazionale di Fotografia, Dresda 1909*, Torino 1910, S. 14; *Il Progresso Fotografico*, 1909, S. 262.

New York 1909

Beteiligung mit 7 Aufnahmen an der ›International Exhibition of Pictorial Photography‹ im National Arts Club vom 2. bis 22. Februar. Ausgestellt waren ›Sir Henry Irving‹ (Nr. 112), ›Man in Armor‹ (Nr. 113), ›The White Cloud‹ (Nr. 114), ›Willi Geiger and Wife‹ (Nr. 115), ›Hortensia‹ (Nr. 116), ›Mr. Alfred Stieglitz‹ (Nr. 117), ›Madame Morena‹ (Nr. 118).
»... ganz zu schweigen von der bemerkenswerten Gruppe von Frank Eugene, mit der ich mich trotz Platzmangels an dieser Stelle ausführlich befassen muß. Diese Gruppe von Bildern, zu der sein bekanntes Porträt von Henry Irving aus dem Jahr 1898 gehört, und sein ›Man in Armor‹ aus dem gleichen Jahr und das nicht weniger bekannte Porträt von Alfred Stieglitz, ist wegen ihrer ungewöhnlichen Qualität sowohl in künstlerischer wie auch photographischer Hinsicht bemerkenswert; nicht zuletzt ist das Format der Aufnahmen von 5 x 7" wegen der ihr eigenen Auflösungsqualität Garant dafür.« (Laurvik, 1909)
Lit.: J. Nilsen Laurvik, ›International Photography at the National Arts Club‹, New York, in: *Camera Work*, April 1909, Nr. 26, S. 42; Katalog *International Exhibition Pictorial Photography*, New York 1909.

Budapest 1910

Beteiligung mit 73 Aufnahmen an der ›Nemzetközi Fényképkialutas‹ (Internationale Photographische Ausstellung) im Palast der bildenden Künste unter dem Protektorat des Erherzogs Josef und der Erzherzogin Augusta von Juni bis Juli. Eugene war in der Abteilung ›Künstlerische Photographie (Amateur- und Berufsphotographie)‹ mit einer großen Auswahl seiner Arbeiten (Kat.-Nr. 602–674) beteiligt, darunter auch mit elf Autochromen ›Die Gnädige‹, ›Die Zofe‹, ›Sonnenbad‹, ›Kaffee-Klatsch‹, ›Die Ruhende‹, ›Badende‹, ›Ahnungsloses Kind mit Storch‹, ›Misses Simson‹, ›Abendsonne‹, ›Die Insel‹, ›Prosit‹, die zwischen 50 und 400 Mark käuflich zu erwerben waren. Den umfangreichsten Teil der Ausstellung repräsentierten Porträts von Adeligen und Künstlern wie ›Dora Polster‹, ›Mrs. Chauncey‹,

(no. 23), "Brigitta Wenz" (no. 24), "Freifrau Ludovica v. Stumm" (no. 25), "Klara Geiger" (no. 26), "Prinz Luitpold von Bayern" (no. 27), "Prinz Rupprecht von Bayern" (no. 28), "Prinzessin Rupprecht mit Kindern, rechts und links 'Musik und Ritterlichkeit'" (no. 29), "Ein Profil" (no. 30), "Prinzessin Rupprecht mit Kindern" (no. 31), "Prinz Luitpold und Prinz Albrecht von Bayern, (no. 32), "Max Graf von Moy" (no. 33), "Frau Prof. v. Lenbach mit Gabriele" (no. 34), "Miss Marion Convère Jones" (no. 35), "Frl. Olga Lynen" (no. 36), "Kunstmaler Hugo Havenith" (no. 37), "Wolfgang Motte" (no. 38), "Prof. Franz v. Defregger" (no. 39), "Mrs. Chauncey" (no. 40), "Dora Polster" (no. 41), "Am Bach" (no. 42), "Badende" (no. 43), "Rebeckah" (no. 44), "Kunstmaler Henri Heyligers und Frau" (no. 45), "Adam und Eva" (no. 46), "Sphinx" (no. 47), "Dekorative Figur" (no. 48), "Aktstudie E.Z." (no. 49), "Menuett" (no. 50), "Psyche" (no. 51), "Frau Wolf-Neger mit Sohn" (no. 52), "Juventus" (no. 53), "Frau Hubert Wilm" (no. 54), "Mann in Rüstung" (no. 55), "Mad. Adele Erica de Kroeger, (no. 56), "Pferd" (no. 57), "Frau Prof. v. Kaulbach" (no. 58), "Samoan Song" (no. 59).

"Frank Eugen Smith – Munich, in the adjoining room 15, shows excellent works familiar to us already since Munich, to which he has added some new ones; he is a real naturalist and presents the people sitting for him with their biggest warts and wrinkles. But he is a portraitist par excellence." (G. H. Emmerich, in: *Photographische Kunst*, 8, 1909/10, p. 67)

"The 'photo-etchings' by Frank Eugene Smith bear all the marks of an artistic personality. Freed of all the shackles of tradition as regards technique and composition, this artist-photographer's refreshing images speak their own powerful language."(*Wiener Mitteilungen*, 21, 1909, p. 434)

Furthermore, Eugene was also included with 7 works in the exhibition of the International Society of Art Photographers in Dresden organized by Heinrich Kühn; as a teacher in the Munich Lehr- und Versuchsanstalt für Photographie, Eugene had exhibits in the section "Teaching Institutes," among others, large-format photo-engravings from the portfolio of the photography school. "All the (students') works on show provide evidence of the beneficial influence which the sensitive Frank Eugene Smith in particular has exercised on the artistic development of the pupils at the Lehranstalt." (*Die Photographische Industrie*, 7, 1909, no. 21, p. 654).

Eugene was able to sell several works in Dresden. He was also awarded the highest recognition in the form of the medal of the City of Dresden, as were the Lützel brothers and Franz Schensky.
Lit.: Catalogue *Internationale Photographische Ausstellung in Dresden 1909*, Dresden 1909, pp. 186–187; "The 'International Group' at the Dresden Exposition," in: *Camera Work*, October 1909, no. 28, pp. 45–49; Charles H. Caffin, "Some Impressions from the International Photographic Exposition, Dresden," in: *Camera Work*, October 1909, no. 28, pp. 33–39; "Notes on the Dresden Exposition-Awards," in: *Camera Work*, October 1909, no. 28, p. 47; *The British Journal of Photography*, June 11, 1909, p. 454; E.O. Hoppé, "Die Amateur-Gruppe auf der Dresdner Ausstellung (II. Teil)," in: *Photographische Kunst*, 8, 1909; Cesare Schiaparelli, *L'arte Fotografica all'Esposizione Internazionale di Fotografia, Dresda 1909*, Torino 1910, p. 14; *Il Progresso Fotografico*, 1909, p. 262.

New York 1909
Participation with 7 photographs at the "International Exhibition of Pictorial Photography" in the National Arts Club from February 2–22. Exhibited were "Sir Henry Irving" (no. 112), "Man in

Armor" (no. 113). "The White Cloud" (no. 114), "Willi Geiger and Wife" (no. 115), "Hortensia" (no. 116), "Mr. Alfred Stieglitz" (no. 117), "Madame Morena" (no. 118).
"... not to speak of the very notable group of Frank Eugene, which despite the limited space, I must refer to at greater length. This group, comprising his well-known portrait of Henry Irving, done in 1898, and the 'Man in Armor,' done in the same year, and the no less well-known portrait of Alfred Stieglitz, was notable because of its unusual excellence artistically as well as photographically, and by reason of the size of the prints, 5x7, which depended entirely upon their intrinsic merits for their appeal." (Laurvik, 1909)
Lit.: J. Nilsen Laurvik, "International Photography at the National Arts Club," New York, in: *Camera Work*, April 1909, no. 26, p. 42; Catalogue *International Exhibition Pictorial Photography*, New York 1909.

Budapest 1910
Participation with 73 photographs at the "Nemzetközi Fénykép-kialutas Budapesten" (International Photography Exhibition) in the Palace of the Plastic Arts, under the auspices of the Archduke Josef and Archduchess Augusta from June to July. Eugene had a large selection of his works (nos. 602–674) in the section "Art Photography" (amateur and professional photography) including eleven autochromes – "Die Gnädige," "die Zofe," "Sonnenbad," "Kaffee-Klatsch," "die Ruhende," "Badende," "Ahnungsloses Kind mit Storch," "Misses Simson," "Abendsonne," "Die Insel," "Prosit," which were on sale priced between 50 and 400 marks. Portraits of the nobility and of artists made up the largest portion of the exhibition, among them "Dora Polster," "Mrs. Chauncey," "Prinz Luitpold und Albrecht von Bayern," "Prinz Rupprecht von Bayern," "Mortimer Bliss-Lane," "Heyligers," "Frau Erich Erler Samaden", "Miss Convere Jones," "Miss Marie Struthers," "Lolo von Lenbach," "Gabriele von Lenbach," "Emanuel und Berthold Lasker," "Toni von Stadler," "Fritz August von Kaulbach," "Paul Heyse," "Adolph Hildebrand," "Adam Oberländer," "Gabriel von Seidl," "Franz von Defregger," "Hugo von Habermann," "Fritz Behn," "Franz von Stuck," "Emanuel von Seidl," "Max Graf von Moy," "Adolf Hengeler," "Julius Diez," "Rudolf von Seitz," "Fritz von Uhde," "Willi Geiger," "Mrs. James Brown Potter," "Josef Geis as 'Beckmesser'," "Lieselotte T.," "Brigitta Wenz" and "Miss Silver Convere." Furthermore, the nude photographs "Adam and Eve," "Schlafende Vestalinnen," "Rebeckah," "Die Badende," "Hortensia," "Kleiner Faun," "Psyche," "Dido," "Baby Bonsels" and "Am Bach" were on show and for sale during the exhibition for between 20 and 100 marks.
Lit.: Catalogue *Internationale Photographische Ausstellung*, Budapest 1910, pp. 28–30 (with reproductions of the Prince Luitpold and Albrecht Johann).

Buffalo 1910
Participation with 27 photographs in the "International Exhibition of Pictorial Photography" in November at the Albright Art Gallery, organized by the Buffalo Fine Arts Academy, with Stieglitz as curator. Eugene's works were shown in the "Invitation Section" and included "The Song of the Lily" (no. 286), "Master Frank Jefferson" (no. 287), "Sir Henry Irving" (no. 288), "Alfred Stieglitz" (no. 289), "The Man in Armor" (no. 290), "Portrait" (no. 291), "La Cigale" (no. 292), "Music" (no. 293), "Nude" (no. 294), "The Horse" (no. 295), "Self-Portrait" (no. 296), "Portrait" (no. 297), "Portrait" (no. 298), "The White Cloud" (no. 299), "The Sphinx" (no. 300), "Brigitta" (no. 301).

›Prinz Luitpold und Albrecht von Bayern‹, ›Prinz Rupprecht von Bayern‹, ›Mortimer Bliss-Lane‹, ›Heyligers‹, ›Frau Erich Erler Samaden›, ›Miss Convere Jones‹, ›Miss Marie Struthers‹, ›Lolo von Lenbach‹, ›Gabriele von Lenbach‹, ›Emanuel und Berthold Lasker‹, ›Toni Stadler‹, ›Fritz August von Kaulbach‹, ›Paul Heyse‹, ›Adolph Hildebrand‹, ›Adam Oberländer‹, ›Gabriel von Seidl‹, ›Franz von Defregger‹, ›Hugo von Habermann‹, ›Fritz Behn‹, ›Franz von Stuck‹, ›Emanuel von Seidl‹, ›Max Graf von Moy‹, ›Adolf Hengeler‹, ›Julius Diez‹, ›Rudolf von Seitz‹, ›Fritz von Uhde‹, ›Willi Geiger‹, ›Mrs. James Brown Potter‹, ›Josef Geis als »Beckmesser«‹, ›Lieselotte T.‹, ›Brigitta Wenz‹ und ›Miss Silver Convere‹. Weiterhin waren Aktaufnahmen wie ›Adam & Eve‹, ›Schlafende Vestalinnen‹, ›Rebeckah‹, ›Die Badende‹, ›Hortensia‹, ›Kleiner Faun‹, ›Psyche‹, ›Dido‹, ›Baby Bonsels‹ und ›Am Bach‹ ausgestellt, die für 20 bis 100 Mark in der Ausstellung angeboten wurden.

Lit.: Katalog *Internationale Photographische Ausstellung*, Budapest 1910, S. 28–30 (mit einer Abbildung von Prinz Luitpold und Albrecht Johann).

Buffalo 1910

Beteiligung mit 27 Aufnahmen an der ›International Exhibition of Pictorial Photography‹ im November in der Albright Art Gallery, ausgerichtet von der Buffalo Fine Arts Academy und von Stieglitz als Kurator betreut. Eugenes Arbeiten wurden in der ›Invitation Section‹ gezeigt. Er beteiligte sich mit ›The Song of the Lily‹ (Nr. 286), ›Master Frank Jefferson‹ (Nr. 287), ›Sir Henry Irving‹ (Nr. 288), ›Alfred Stieglitz‹ (Nr. 289), ›The Man in Armor‹ (Nr. 290), ›Portrait‹ (Nr. 291), ›La Cigale‹ (Nr. 292), ›Music‹ (Nr. 293), ›Nude‹ (Nr. 294), ›The Horse‹ (Nr. 295), ›Self-Portrait‹ (Nr. 296), ›Portrait‹ (Nr. 297), ›Portrait‹ (Nr. 298), ›The White Cloud‹ (Nr. 299), ›The Sphinx‹ (Nr. 300), ›Brigitta‹ (Nr. 301), ›Hortensia‹ (Nr. 302), ›Prof. J. Dietz‹ (sic) (Nr. 303), ›Gabriella Lenbach‹ (Nr. 304), ›Adam and Eve‹ (Nr. 305), ›Arthur and Guinevre‹ (Nr. 306), ›Minuet‹ (Nr. 307), ›Prof. Adolf Hengeler‹ (Nr. 308), ›Willi Geiger‹ (Nr. 309), ›Prof. Adolf von Seitz‹ (sic) (Nr. 310), ›Dr. Emanuel Lasker and His Brother‹ (Nr. 311), ›Dr. Georg Hirth‹ (Nr. 312). Nr. 305–312 stammten aus der *Camera Work*.

»Eugene, Frank, New York und München. Mr. Eugene fing in den 80iger Jahren an zu photographieren. Er führte die Praxis der Einzeichnungen im Negativ ein und war der erste, dem Platindrucke auf Japanpapier gelangen. Alle Beispiele dieser Platindrucke in der Ausstellung sind Originalabzüge auf Japanpapier; sie sind einzigartig und unübertroffen.« (*Catalogue of the International Exhibition Pictorial Photography*, Buffalo, 1910, S. 27.)

»In der gelungenen Zusammenstellung von Eugenes Werk, das stellenweise Parallelen zu Hill aufweist, erkennt man einen Maler, der satte Farben als solche liebt, der das Leben liebt, das schöne, gesunde, vollblütige Leben liebt und es glorifiziert, in dem er es porträtiert – ein wahrer Meistersinger der Lebenslust.« (Keiley, 1911, S. 27)

»Frank Eugene war der erste der Piktoralisten, der sich mit seinen Negativen Freiheiten erlaubte, indem er die Radiernadel einsetzte, wenn er es für nötig hielt, um die Ergebnisse des ›normalen Entwicklungsprozesses‹ zu korrigieren. Diese Praxis hat er inzwischen wieder eingestellt, und seine jetzigen Arbeiten sind frei von jeglichen Eingriffen nicht-photographischer Art. Aber die Richtung, in die einige Photographen sich seitdem entwickeln, könnte unter seinem Einfluß eingeschlagen worden sein. Die frühen Versuche des Franzosen Robert Demachy, seinen Abzügen den Anschein von Lithographien, Radier-

ungen oder Arbeiten in anderen Medien zu geben – was ihn veranlasste, sich das Gummi-Druckverfahren anzueignen, in dem er ein Meister ist und später das des Öldrucks, auf das sich in den letzten Jahren sein ganzes Interesse konzentriert hat - sind wahrscheinlich auf Eugenes Einfluß zurückzuführen. (Anm. P.H.: Erst in seinem späteren Werk zeigt Demachy gelegentlich einen Einfluß Eugenes. Seine früheren Abzüge sind ohne Kenntnis von Eugenes Werk entstanden. Ich bin es beiden Herren schuldig, die unbeabsichtigte Unachtsamkeit meines früheren Artikels zu korrigieren.) « (Paul B. Haviland, ›The Accomplishments of Photography and Contributions of the Medium to Art‹, in: *Academy Notes*, zit. nach *Camera Work*, Jan. 1911, Nr. 33, S. 67).

Die Albright Art Gallery hatte 12 Arbeiten aus der Ausstellung als Grundstock für eine ständige Photographie-Sammlung der Buffalo Fine Arts Academy erworben, darunter von Eugene den Platinabzug ›Arthur and Guinevere‹, 1900.

Lit.: Charles H. Caffin, ›The Exhibition at Buffalo‹, in: *Camera Work*, Jan. 1911, Nr. 33, S. 21–23; Joseph T. Keiley, ›The Buffalo Exhibition‹, in: *Camera Work*, Jan. 1911, Nr. 33, S. 23–29; ›The Exhibition at the Albright Gallery – Some Facts, Figures and Notes‹, in: *Camera Work*, Jan. 1911, Nr. 33, S. 61–71; S. Hartmann, ›International Exhibition of Pictorial Photography-Albright Gallery‹, in: *Wilson's Photographic Magazine*, 48, 1911, S. 3; *Wilson's Photographic Magazine*, 48, 1911, S. 96; Walter E. Bertling, ›The Albright Art Gallery Exhibition‹, in: *Photo-Era*, 1911, S. 16.; *Catalogue of the International Exhibition Pictorial Photography*, The Buffalo Fine Arts Academy (Ed.), Albright Art Gallery, Buffalo 1910, S. 27; Sadakichi Hartmann, ›What Remains‹, in: *Camera Work*, Jan. 1911, Nr. 33, S. 30–32.

Paris 1910

Beteiligung an einer nicht näher identifizierten Kunstgewerbe-Ausstellung.

Lit.: *Jahrbuch der Lehr- und Versuchsanstalt*, München 1910/11, S. 89.

Kiew 1911

Beteiligung am ›Internationalen Salon für Künstlerische Photographie‹, der vom Amateurphotographen-Verein Daguerre unter Leitung des Vorsitzenden Nikolaj Petrov anläßlich des 10jährigen Bestehens des Vereines veranstaltet wurde. Neben Frank Eugene nahmen auch Hugo Erfurth, Otto Erhardt, Robert Lehr, Rudolf Dührkoop, K. Blazek, E.O. Hoppé, Annie Brigman, Edward Steichen, Gertrude Käsebier, Frederick Evans, William Cadby, Robert Demachy, Puyo, Bouquet, Pierre Dubreuil, Leonard Misonne und Joseph Pécsi teil, deren Arbeiten den Leistungen russischer Photographen gegenübergestellt wurden.

Lit.: *Die Photographische Kunst im Jahre 1911/12*, hg. von Fritz Matthies-Masuren, S. 24–25; Elena Barkhatova, ›Pictorialism: Photography as Art‹, in: David Elliot (Hrsg.), *Photography in Russia 1840–1940*, London 1992, S. 54–55.

London 1911

Auf Einladung Beteiligung mit 3 Aufnahmen an der Ausstellung der London Secession, die sich 1909 von dem Linked Ring abgespalten hatte, in der Newman Art Gallery. Es handelte sich um die Arbeiten ›Slumbering Vestal-Virgins‹ (Nr. 22), ›Dawn‹ (Nr. 23) und ›Profile-The Lady of »Charlotte«‹ (Nr. 24). Als Gastaussteller waren neben Eugene auch die Mitglieder der Photo-Secession Annie W. Brigman, G. Käsebier, H. Kühn, E. Steichen, A. Stieglitz und C. White eingeladen worden.

Lit.: E.O. Hoppé, ›Der erste London Salon of Photography‹, in: *Photographische Korrespondenz*, 47, 1910, Nr. 602, S. 515–520;

"Hortensia" (no. 302), "Prof. J. Dietz" (sic) (no. 303), "Gabriella Lenbach" (no. 304), "Adam and Eve" (no. 305), "Arthur and Guinevre" (no. 306), "Minuet" (no. 307), "Prof. Adolf Hengeler" (no. 308), "Willi Geiger" (no. 309), "Prof. Adolf von Seitz" (sic) (no. 310), "Dr. Emanuel Lasker and His Brother" (no. 311), "Dr. Georg Hirth" (no. 312). Nos. 305–312 came from *Camera Work*.

"Eugene, Frank, New York and Munich. Mr. Eugene began photographing in the eighties. He introduced the practice of etching on the negative, and was the first to make successful platinum prints on Japan tissue. All examples of the latter in this exhibition are the original Japan tissue prints, and are unique, and have never been surpassed." (*Catalogue of the International Exhibition Pictorial Photography*, Buffalo, 1910, p. 27).

"In the fine collection of Eugene's work, which in certain aspects possesses some of the characteristic of Hill, one feels the painter, the man who loves rich color for itself, who loves life, beautiful, jovial, healthy, full-blooded life, and glories in portraying it – a very meistersinger of the joy of living." (Keiley, 1911, p. 27) .

"Frank Eugene was the first of pictorial photographers to take liberties with his negatives, using the etching needle where he felt it necessary to correct the values given by "straight development." He has since discontinued this practice, and his present work is as free as any of any intrusion of a non-photographic medium. His example, however, may be responsible for the direction in which certain workers have been developing. The Frenchman, Robert Demachy, probably owes to Eugene's influence (Anm. P.H. 'It is only in his later work that M.Demachy occasionally shows the influence of Frank Eugene. His earlier prints were made without any knowledge of the work of Eugene. I owe it to both gentlemen to correct the unintentional inadvertency of my article as originally printed.') his early efforts to make his prints look like lithographs, etchings, or works in other media, which led to his adoption of the gum-bichromate process of which he is a master, and later to the oil process on which his interests have been concentrated during the past few years." (Paul B. Haviland, "The Accomplishments of Photography and Contributions of the Medium to Art," in: *Academy Notes*, quoted after *Camera Work*, Jan. 1911, no. 33, p. 67).

The Albright Art Gallery purchased twelve works from the exhibition to form the basis of a permanent photography collection for the Buffalo Fine Arts Academy, among them Eugene's platinum print "Arthur and Guinevere," 1900.
Lit.: Charles H. Caffin, "The Exhibition at Buffalo," in: *Camera Work*, no. 33, January 1911, pp. 21–23; Joseph T. Keiley, "The Buffalo Exhibition," in: *Camera Work*, no. 33, January 1911, pp. 23–29; "The Exhibition at the Albright Gallery – Some Facts, Figures and Notes," in: *Camera Work*, Jan. 1911, no. 33, pp. 61–71; S. Hartmann, "International Exhibition of Pictorial Photography-Albright Gallery," in: *Wilson's Photographic Magazine*, 48, 1911, p. 3; *Wilson's Photographic Magazine*, 48, 1911, p. 96; Walter E. Bertling, "The Albright Art Gallery Exhibition," in: *Photo-Era*, Boston, 1911, p. 16.; *Catalogue of the International Exhibition Pictorial Photography*, The Buffalo Fine Arts Academy (Ed.), Albright Art Gallery, Buffalo 1910, p. 27; Sadakichi Hartmann, "What Remains," in: *Camera Work*, no. 33, Jan. 1911, pp. 30–32.

Paris 1910

Participation in an arts and crafts exhibition of which no details have survived.
Lit.: *Jahrbuch der Lehr- und Versuchsanstalt*, Munich 1910/11, p. 89.

Kiev 1911

Participation in the "Internationalen Salon für Künstlerische Photographie," (International Salon of Art Photography) organized by the amateur photographers group Daguerre under the direction of the chairman Nikokai Petrov on the occasion of the group's 10th anniversary. Also participating, alongside Eugene, were Hugo Erfurth, Otto Erhardt, Robert Lehr, Rudolf Dührkoop, K. Blazek, E.O. Hoppé, Annie Brigman, Edward Steichen, Gertrude Käsebier, Frederick Evans, William Cadby, Robert Demachy, Puyo, Bouquet, Pierre Dubreuil, Leonard Misonne and Joseph Pécsi teil, whose works were placed alongside the achievements of Russian photographers.
Lit.: *Die Photographische Kunst im Jahre 1911/12*, ed. by Fritz Matthies-Masuren, pp. 24–25; Elena Barkhatova, "Pictorialism: Photography as Art," in: David Elliot (Ed.), *Photography in Russia 1840–1940*, London 1992, pp. 54–55

London 1911

Participation in the exhibition of the London Secession, which had split from the Linked Ring in 1909. The exhibition, by invitation, in the Newman Art Gallery, showed three photographs by Eugene, "Slumbering Vestal-Virgins" (no. 22), "Dawn" (no. 23) and "Profile – The Lady of 'Charlotte'" (no. 24). Also invited to exhibit were the Photo-Secession members Annie W. Brigman, G. Käsebier, H. Kühn, E. Steichen, A. Stieglitz and C. White.
Lit.: E.O. Hoppé, "Der erste London Salon of Photography," in: *Photographische Korrespondenz*, 47, 1910, no. 602, pp. 515–520; H. Snowden Ward, "The Work of the Year," in: *Photograms of the Year 1911–1912*, London 1911, pp. 26–27, pp. 67–71, plate section; Catalogue *The London Secession, Spring Exhibition May 1911*, London.

Munich 1911

Participation in the photography section of the "Bayerischen Gewerbeschau "in Munich together with Hans Spörl and Rudolf Lähnemann, with a total of 29 works.

Turin 1911

Participation by Eugene in the "Internationalen Industrie- und Gewerbe-Ausstellung" (International Industry and Trade Exhibition) in Turin from April to October marking the 50th anniversary of the proclamation of the Kingdom of Italy. Photography was in Group III, class 15 and 16. The Süddeutscher Photographen-Verein (South German Photographers Association) was responsible for organizing the German exhibits. Eugene, Hugo Erfurth, Franz Grainer and Franz Schensky received the "major prize" for their participation.
Lit.: *Esposizione Internazionale Torino 1911. Catalogo ufficiale illustrato dell'Esposizione e del Concorso Internazionale di Fotografia, aprile ottobre*, Torino 1911, p. 33; *Photographische Kunst*, 10, no. 4, May 31 1911, p. 51.

Stuttgart 1912

Participation in the touring exhibition of photography portraits mounted by the Süddeutschen Photographen-Verein in the Stuttgart Landesgewerbe-Museum from March 4–31. Eugene showed both portraits and landscapes.
"Among these splendidly picturesque works, which almost seem like charcoal drawings on French hand-made paper, we find portraits of Prince Ruppreche, then the artist Otto Seitz (sic), Stuck, von Uhde and many more. Of the landscapes I would like most to mention the finely toned avenue of birches

H.Snowden Ward, ›The Work of the Year‹, in: *Photograms of the Year 1911–1912*, London 1911, S. 26–27, S. 67–71, Bildteil; Katalog *The London Secession, Spring Exhibition May 1911*, London.

München 1911

Beteiligung an der Bayerischen Gewerbeschau in München gemeinsam mit Hans Spörl und Rudolf Lähnemann in der Abteilung Photographie mit insgesamt 29 Arbeiten.

Turin 1911

Beteiligung von Eugene an der ›Internationalen Industrie- und Gewerbe-Ausstellung‹, Turin, die anläßlich des 50jährigen Bestehens der Proklamation des Königreiches Italien von April bis Oktober stattfand. Die Photographie war in der Gruppe III, Klasse 15 und 16 vertreten. Dem Süddeutschen Photographen-Verein war die Organisation der deutschen Abteilung übertragen worden. Eugene erhielt ebenso wie Hugo Erfurth, Franz Grainer und Franz Schensky für seine Teilnahme den ›Großen Preis‹.
Lit.: *Esposizione Internazionale Torino 1911. Catalogo ufficiale illustrato dell'Esposizione e del Concorso Internazionale di Fotografia, aprile ottobre*, Torino 1911, S. 33; *Photographische Kunst*, 10, 31.5.1911, Nr. 4, S. 51.

Stuttgart 1912

Beteiligung an der vom Süddeutschen Photographen-Verein organisierten Wanderausstellung photographischer Bildnisse im Stuttgarter Landesgewerbe-Museum vom 4. bis 31. März. Neben Porträts stellte Eugene auch Landschaften aus.
»Wir finden unter diesen prachtvoll malerischen Arbeiten, die wie Kohlenzeichnungen auf französischem Handpapier wirken, die Bildnisse von Prinz Rupprecht, dann der Maler Otto Seitz (sic), Stuck, v. Uhde u.a.m. Unter den Landschaften möchte ich die feintonige, auch im Raum sehr glücklich wirkende Birkenallee hervorheben.«
Lit.: *Photographische Kunst*, 10, 1912, S. 341; *Apollo*, 18, 22.4.1912, Nr. 404.

Nowgorod 1913

Beteiligung am ›Salon of Artistic Photography‹ des photographischen Zirkels von Nizhnii Nowgorod in Russland nahe St. Petersburg. Die Arbeiten von Eugene stammten aus der Privatsammlung von Nicolai Petrov.
Lit.: David Elliot (Hrsg.), *Photography in Russia 1840–1940*, London 1992, S. 55.

Leipzig 1914

Beteiligung an der ›Weltausstellung für Buchgewerbe und Graphik (Bugra)‹ in Leipzig im Rahmen der Ausstellung der Königlichen Akademie für graphische Künste und Buchgewerbe.
»Raum 5. Die eine Hälfte dieses Raumes ist mit Arbeiten aus der Fachklasse für Naturphotographie (Frank Eugène Smith) behängt. Hervorgehoben seien die in der Ecke, vom Eingang rechts, befindlichen Photographien, Aufnahmen vom Abendfest, das anlässlich des 150jährigen Jubiläums der Akademie am 6. März 1914 abgehalten wurde. Links vom Eingang sind meistenteils Porträtaufnahmen und Genrestudien zu sehen. Am Fenster sind Autochromaufnahmen und einige Negative mit und ohne Retouche aufgestellt.« (*Mitteilungen der Königlichen Akademie für graphische Künste und Buchgewerbe in Leipzig*, 1915, Nr. 5, S. 38).
Lit.: Katalog *Internationale Ausstellung für Buchgewerbe und Graphik*, Leipzig 1914.

London 1914

Beteiligung mit 5 Aufnahmen an der 59. Jahresausstellung der Royal Photographic Society in der Abteilung ›American Invitation Collection‹. Die Photographien stammten aus der Privatsammlung von Alvin Langdon Coburn. Es handelte sich um ›Nude‹ (Nr. 72), ›Prince Luitpold of Bavaria‹ (Nr. 73), ›Minuet‹ (Nr. 74), ›Portrait‹ (Nr. 75), ›Rebeckah‹ (Nr. 76).
»Frank Eugenes Arbeiten sind immer durchdacht und auf ihre Art gut. Man darf annehmen, daß seine ›Nude‹ (72) mit der gespannten, glänzenden Haut eine Frau darstellt, die gerade ins Wasser getaucht ist. Sie sieht aber eher so aus, als sei sie mit Vaseline eingecremt worden. Unsere Vettern scheinen eine Vorliebe für Aktstudien zu haben, am liebsten in der Abenddämmerung, nur mit einem Ball oder einer kleinen Statue zum Spielen oder Anbeten.« (*The British Journal of Photography*, 61, 28.8.1914, S. 660.)
Lit.: *The Photographic Journal*, 54, Supplement, Aug. 1914; *The Royal Photographic Society of Great Britain 59th Annual Exhibition 1914*, S. 6 und S. 40.

New Westminster 1923

Beteiligung mit 6 Aufnahmen an der ›International Exhibition of Pictorial Photography‹, New Westminster, British Columbia, Canada, in der Abteilung ›International Professional Portraits‹. Ausgestellt waren ›Professor S. and wife‹ (Nr. 156), ›The Twins‹ (Nr. 157), ›The Study‹ (Nr. 158), ›The Little Countess‹ (Nr. 159), ›Jesko v. Puttkamer‹ (Nr. 160), ›Prof. Miller‹ (Nr. 161).
Lit.: Katalog *International Exhibition of Pictorial Photography*, New Westminster, B.C., Canada 1923, S. 10.

New York 1923

Beteiligung am ›International Salon of Pictorial Photographers of America‹ im Art Center im Mai. Eugene zeigte u.a. das Porträt von F. v. Miller.

Frankfurt 1924

1924–26 Wanderausstellung mit 178 Aufnahmen von Frank Eugene in mehreren deutschen Städten, im März 1924 im Kunstgewerbemuseum in Frankfurt am Main, von Ende Dezember bis Januar 1925 in der Kunstgewerbebibliothek in Dresden, im April 1925 im Freiburger Kunstverein, im Juni/Juli 1925 im Münchner Kunstverein und im Januar und Februar 1926 im Buchgewerbesaal in der Bayerischen Landesgewerbeanstalt in Nürnberg. Die folgenden Werke waren ausgestellt: ›Graf von Bylandt‹ (Nr. 1), ›Dr. Friedrich Schäfer‹ (Nr. 2), ›Gräfin von Bylandt‹ (Nr. 3), ›Der kleine Faun‹ (Nr. 4), ›Yella von Lenbach‹ (Nr. 5), ›Dido‹ (Nr. 6), ›Gretchen Gulielmo‹ (Nr. 7), ›Gudrun Biagosch‹ (Nr. 8), ›Exlibris, Käthe Raab‹ (Nr. 9), ›Psyche‹ (Nr. 10), ›Heyligers Er und Sie‹ (Nr. 11), ›Die Badende‹ (Nr. 12), ›Danae‹ (Nr. 13), ›Pan im Schilf‹ (Nr. 14), ›Prof. Emanuel von Seidl und Frau‹ (Nr. 15), ›Andromache‹ (Nr. 16), ›Mrs. Cora Urquhardt Potter‹ (Nr. 17), ›Die Sennerin‹ (Nr. 18), ›Weisse Wolke‹ (Nr. 19), ›Baby Boy Bonsels‹ (Nr. 20), ›Studie, Gertrud G.‹ (Nr. 21), ›Menuett‹ (Nr. 22), ›Adam und Eva‹ (Nr. 23), ›Die Zwillinge‹ (Nr. 24), ›Juventas‹ (Nr. 25), ›Das Pferd‹ (Nr. 26), ›Dämmerung‹ (Nr. 27), ›Rebekah‹ (Nr. 28), ›Aegyptische Braut‹ (Nr. 29), ›Schlaf und Traum‹ (Nr. 30), ›Der Tanzende‹ (Nr. 31), ›Die Sphinx von Gizeh, Aegypten, Mitternacht‹ (Nr. 32), ›Potiphar‹ (Nr. 33), ›Buddha‹ (Nr. 34), ›Lady of Charlotte‹ (Nr. 35), ›Vestalinnen‹ (Nr. 36), ›Gudrun B.‹ (Nr. 37), ›Prof. Hugo Freiherr von Habermann, Maler‹ (Nr. 38), ›Robert F. Heuser‹ (Nr. 39), ›O.O.Kurz, Architekt‹ (Nr. 40), ›Siegmund von Hausegger, Kapellmeister‹ (Nr. 41), ›Jesko von Puttkamer‹

which also has lovely depth effects."
Lit.: *Photographische Kunst*, 10, 1912, p. 341; *Apollo*, 18, April 22, 1912, no. 404.

Novgorod 1913

Participation in the "Salon of Artistic Photography" mounted by the photography circle in Nizhnij Novgorod near St. Petersburg. The works by Eugene came from the private collection of Nicolai Petrov.
Lit.: David Elliot (ed.), *Photography in Russia 1840–1940*, London 1992, p. 55.

Leipzig 1914

Participation in the so-called Bugra, the "Weltausstellung für Buchgewerbe und Graphik" (World Exhibition of Book Design and Graphics) in Leipzig within the framework of the "Ausstellung der Königlichen Akademie für graphische Künste und Buchgewerbe" (Exhibition of the Royal Academy for Graphic Art and Book Design). "Room 5. One half of the room has been hung with works by the class for nature photographpy (Frank Eugene Smith). Special mention goes to the photographs hung right of the entrance in the corner, taken of the evening gathering to mark the 150th anniversary of the Academy on March 6, 1914. Left of the entrance are mainly portrait photographs and genre studies. At the window there are autochrome photographs and negatives, some retouched, some not."(*Mitteilungen der Königlichen Akademie für graphische Künste und Buchgewerbe in Leipzig*, no. 5, 1915, p. 38).
Lit.: Catalogue *Internationale Ausstellung für Buchgewerbe und Graphik*, Leipzig 1914.

London 1914

Participation with 5 photographs in the "59th Annual Exhibition of the Royal Photographic Society" in the section "American Invitation Collection." The photographs were from the private collection of Alvin Langdon Coburn. Exhibited were "Nude" (no. 72), "Prince Luitpold of Bavaria" (no. 73), "Minuet" (no. 74), "Portrait" (no. 75), "Rebeckah" (no. 76).
"The work of Frank Eugene is always clever and good of its sort. It is to be assumed that his tight-skinned, shiny 'Nude' (NO. 72) represents a lady who has just dipped in the water. She looks more as though she had been well vaselined. Nudes are favorite studies with our cousins, and they usually like them in the gloaming, with just a ball or a little statue to play with or pray to." (*The British Journal of Photography*, 61, August 28, 1914, p. 660.)
Lit.: Vgl. *The Photographic Journal*, 54, Supplement, Aug. 1914. *The Royal Photographic Society of Great Britain 59th Annual Exhibition 1914*, pp. 6 and 40.

New Westminster 1923

Participation with 6 photographs in the "International Exhibition of Pictorial Photography," New Westminster, British Columbia, Canada, in the section "International Professional Portraits." Exhibited were "Professor S. and wife" (no. 156), "The Twins" (no. 157), "The Study" (no. 158), "The Little Countess" (no. 159), "Jesko v. Puttkamer" (no. 160), "Prof. Miller" (no. 161).
Lit.: Catalogue *International Exhibition of Pictorial Photography*, New Westminster, B. C., Canada 1923, p. 10.

New York 1923

Participation in the "International Salon of Pictorial Photogra-

phers of America" at the Art Center in May. Eugene showed his portrait of F. von Miller, among others.

Frankfurt 1924

1924–26 travelling exhibition with 178 photographs by Frank Eugene in several German cities, in March 1924 at the Kunstgewerbemuseum in Frankfurt am Main, from the end of December to Januar 1925 in the Kunstgewerbebibliothek in Dresden, in April 1925 at the Freiburger Kunstverein, in June/July 1925 at the Münchner Kunstverein and in January and February 1926 at the Buchgewerbesaal in der Bayerischen Landesgewerbeanstalt in Nürnberg. The following works were exhibited: "Graf von Bylandt" (no. 1), "Dr. Friedrich Schäfer" (no. 2), "Gräfin von Bylandt" (no. 3), "Der kleine Faun" (no. 4), "Yella von Lenbach" (no. 5), "Dido" (no. 6), "Gretchen Gulielmo" (no. 7), "Gudrun Biagosch" (no. 8), "Exlibris, Käthe Raab" (no. 9), "Psyche" (no. 10), "Heyligers Er und Sie" (no. 11), "Die Badende" (no. 12), "Danae" (no. 13), "Pan im Schilf" (no. 14), "Prof. Emanuel von Seidl und Frau" (no. 15), "Andromache" (no. 16), "Mrs. Cora Urquhardt Potter" (no. 17), "Die Sennerin" (no. 18), "Weisse Wolke" (no. 19), "Baby Boy Bonsels" (no. 20), "Studie, Gertrud G." (no. 21), "Menuett" (no. 22), "Adam und Eva" (no. 23), "Die Zwillinge" (no. 24), "Juventas" (no. 25), "Das Pferd" (no. 26), "Dämmerung" (no. 27), "Rebekah" (no. 28), "Aegyptische Braut" (no. 29), "Schlaf und Traum" (no. 30), "Der Tanzende" (no. 31), "Die Sphinx von Gizeh, Aegypten, Mitternacht" (no. 32), "Potiphar" (no. 33), "Buddha" (no. 34), "Lady of Charlotte" (no. 35), "Vestalinnen" (no. 36), "Gudrun B." (no. 37), "Prof. Hugo Freiherr von Habermann, Maler" (no. 38), "Robert F. Heuser" (no. 39), "O.O.Kurz, Architekt" (no. 40), "Siegmund von Hausegger, Kapellmeister" (no. 41), "Jesko von Puttkamer" (no. 42), "Carl Schurz, Advokat" (no. 43), "Franklin Price Knott Esq., Maler" (no. 44), "Prof. Dr. Gabriel von Seidl, Architekt" (no. 45), "Prof. Dr. Emanuel von Seidl" (no. 46), "Dr. Emanuel Lasker und sein Bruder, Schachweltmeister" (no. 47), "Dr. Paul Heyse, Dichter" (no. 48), "Prof. Fritz von Miller, Kleinplastiker" (no. 49), "Prof. Adolf von Hildebrand, Bildhauer" (no. 50), "Prof. Rudolf von Seitz, Maler" (no. 51), "Prof. Fritz August von Kaulbach, Maler" (no. 52), "Prof. Julius Diez, Maler" (no. 53), "Der Lachende" (no. 54), "Prof. Adolf von Hengeler, Maler" (no. 55), "Mr. Chillingwort" (no. 56), "Joseph Pennell, Graphiker" (no. 57), "Prof. Dr. Georg Witkowski" (no. 58), "Generalkonsul Alphons von Bruckmann" (no. 59), "Feldkreuz, Oberbayern" (no. 60), "Frau Willi Geiger" (no. 61), "Ohne Krone, ohne Szepter, und: noch, ohne Sorgen" (no. 62), "Marie Struthers" (no. 63), "Prinz Luitpold von Bayern" (no. 64), "Mme. de Kröger" (no. 65), "Die Fussküssende" (no. 66), "Rupprecht, Prinz von Bayern" (no. 67), "Drei Schwestern, Hilde, Yvonne und Sissy B." (no. 68), "Ihre Kgl. Hoheit Prinzessin Rupprecht von Bayern und Kinder, rechts und links dekorative Figuren" (no. 69), "Frau M.W. von Ottmann" (no. 70), "S.M. Ludwig III. von Bayern" (no. 71), "Master Bliss-Lane" (no. 72), "Dora Gedon" (no. 73), "Die Prinzen Luitpold und Johann Albrecht von Bayern" (no. 74), "Gräfin Basselet de la Rosée, Marion Lenbach" (no. 75), "S.M. Friedrich August von Sachsen" (no. 76), "Graf Basselet de la Rosée" (no. 77), "Das schöne Buch" (no. 78), "Die Lesenden, Louise Boley und Schwester" (no. 79), "Samoa" (no. 80), "Emma Ley" (no. 81), "Miss Convère Jones" (no. 82), "Liselotte T." (no. 83), "Dora Polster, Malerin" (no. 84), "Miss Gladys Lawrence" (no. 85), "Hedwig Frankenberger" (no. 86), "Gräfin von Wendelstadt auf Neubeuern"

(Nr. 42), ›Carl Schurz, Advokat‹ (Nr. 43), ›Franklin Price Knott Esq., Maler‹ (Nr. 44), ›Prof. Dr. Gabriel von Seidl, Architekt‹ (Nr. 45), ›Prof. Dr. Emanuel von Seidl‹ (Nr. 46), ›Dr. Emanuel Lasker und sein Bruder, Schachweltmeister‹ (Nr. 47), ›Dr. Paul Heyse, Dichter‹ (Nr. 48), ›Prof. Fritz von Miller, Kleinplastiker‹ (Nr. 49), ›Prof. Adolf von Hildebrand, Bildhauer‹ (Nr. 50), ›Prof. Rudolf von Seitz, Maler‹ (Nr. 51), ›Prof. Fritz August von Kaulbach, Maler‹ (Nr. 52), ›Prof. Julius Diez, Maler‹ (Nr. 53), ›Der Lachende‹ (Nr. 54), ›Prof. Adolf von Hengeler, Maler‹ (Nr. 55), ›Mr. Chillingwort‹ (Nr. 56), ›Joseph Pennell, Graphiker‹ (Nr. 57), ›Prof. Dr. Georg Witkowski‹ (Nr. 58), ›Generalkonsul Alphons von Bruckmann‹ (Nr. 59), ›Feldkreuz, Oberbayern‹ (Nr. 60), ›Frau Willi Geiger‹ (Nr. 61), ›Ohne Krone, ohne Szepter, und: noch, ohne Sorgen‹ (Nr. 62), ›Marie Struthers‹ (Nr. 63), ›Prinz Luitpold von Bayern‹ (Nr. 64), ›Mme. de Kröger‹ (Nr. 65), ›Die Fussküssende‹ (Nr. 66), ›Rupprecht, Prinz von Bayern‹ (Nr. 67), ›Drei Schwestern, Hilde, Yvonne und Sissy B.‹ (Nr. 68), ›Ihre Kgl. Hoheit Prinzessin Rupprecht von Bayern und Kinder, rechts und links dekorative Figuren‹ (Nr. 69), ›Frau M.W. von Ottmann‹ (Nr. 70), ›S.M. Ludwig III. von Bayern‹ (Nr. 71), ›Master Bliss-Lane‹ (Nr. 72), ›Dora Gedon‹ (Nr. 73), ›Die Prinzen Luitpold und Johann Albrecht von Bayern‹ (Nr. 74), ›Gräfin Basselet de la Rosée, Marion Lenbach‹ (Nr. 75), ›S.M. Friedrich August von Sachsen‹ (Nr. 76), ›Graf Basselet de la Rosée‹ (Nr. 77), ›Das schöne Buch‹ (Nr. 78), ›Die Lesenden, Louise Boley und Schwester‹ (Nr. 79), ›Samoa‹ (Nr. 80), ›Emma Ley‹ (Nr. 81), ›Miss Convère Jones‹ (Nr. 82), ›Liselotte T.‹ (Nr. 83), ›Dora Polster, Malerin‹ (Nr. 84), ›Miss Gladys Lawrence‹ (Nr. 85), ›Hedwig Frankenberger‹ (Nr. 86), ›Gräfin von Wendelstadt auf Neubeuern‹ (Nr. 87), ›Selbstportrait‹ (Nr. 88), ›Bewegungsstudie‹ (Nr. 89), ›Madonna im Freien‹ (Nr. 90), ›Tänzerin‹ (Nr. 91), ›Marie, Tochter von Joachim‹ (Nr. 92), ›Bernhard Wenig in Maximilians-Rüstung‹ (Nr. 93), ›Photogravüre nach Bild 69‹ (Nr. 94), ›Rotations-Tiefdruck nach Bild 71‹ (Nr. 95), ›Eine gekaufte Postkarte. Beispiel einer ganz falschen Retouche zum Vergleich‹ (Nr. 95a), ›S.M. Ludwig von Bayern‹ (Nr. 96), ›Halali‹ (Nr. 97), ›Rohdruck von Bild 35‹ (Nr. 98), ›Studie zu einem Bild Leda‹ (Nr. 99), ›Mittagssonne, Murnau‹ (Nr. 100), ›Nacht, Schloss Neubeuerrn‹ (Nr. 101), ›Martinihof, grauer Tag‹ (Nr. 102), ›Gabriele Lenbach‹ (Nr. 103, 104), ›Prof. Dr. Gabriel von Seidl‹ (Nr. 105, 106, 107), ›Prof. Rudolf von Seitz‹ (Nr. 108), ›Dr. Paul Heyse, Schriftsteller‹ (Nr. 109), ›Prof. Fritz von Uhde, Maler‹ (Nr. 110), ›Prof. Martin Feuerstein, Maler‹ (No 111), ›Tasse Tee‹ (No 112), ›Alfred Stieglitz Esq., Photographer and Truthseeker‹ (Nr. 113), ›Erster Zustand von Bild 23‹ (Nr. 114), ›Platindruck von Bild 23‹ (Nr. 115), ›Frau Prof. Walter Tiemann‹ (Nr. 116), ›Prof. Walter Tiemann, Akademiedirektor‹ (Nr. 117), ›Frau Faber du Faur‹ (Nr. 118), ›Ausschnitt von Bild 4‹ (Nr. 119), ›Schleiertanzstudien‹ (Nr. 120 a, b), ›Emy Geiger‹ (Nr. 121), ›Dr. Georg Hirth‹ (Nr. 122), ›Captain Tarr, Maler‹ (Nr. 123), ›Prof. Willi Geiger, Maler-Radierer‹ (Nr. 124), ›Ministerialdirektor Geheimrat Dr. Klien‹ (Nr. 125), ›Bewegungsstudie, Schleiertanz‹ (Nr. 126), ›Grossmutter Puehn und Milla P.‹ (Nr. 127), ›Frau Max Seliger mit Gerda und Franz‹ (Nr. 128), ›Frohe Botschaft, Paul B. u. Frau‹ (Nr. 129), ›Taka‹ (Nr. 130), ›Der Dichter Gyellrup und seine Frau‹ (Nr. 131), ›Meine Hausmeistersleute‹ (Nr. 132), ›Baron und Baronin v. B.‹ (Nr. 133), ›The Daphne‹ (Nr. 134), ›Aegyptischer Hirt‹ (Nr. 135), ›Südfrüchte‹ (Nr. 136), ›Der Garten des Paradieses‹ (Nr. 137), ›Prof. Georg A. Mathéy‹ (Nr. 138), ›Prof. Fritz Goetz‹ (Nr. 139), ›Dr. Karl Klingspor‹ (Nr. 140), ›Frau Prof. Doren‹ (Nr. 141), ›Prof. Dr. Alfred Doren‹ (Nr. 142), ›Graf Max von Moy‹ (Nr. 143), ›Ein griechisches Mädchen‹ (Nr. 144), ›Gudrun B.‹ (Nr. 145), ›Jesko

von P.‹ (Nr. 146), ›Hugo von Havenith, Maler‹ (Nr. 147), ›Carl Ernst Poeschel‹ (Nr. 148), ›Eine lustige Sitzung‹ (Nr. 149), ›Adam Adolf Oberländer, Maler‹ (Nr. 150), ›Prof. Franz von Stuck, Maler‹ (Nr. 151), ›Daniel Ch. French, Bildhauer‹ (Nr. 152), ›Franz von Defregger, Maler‹ (Nr. 153), ›Bewegungsstudien aus der H.W. Mappe‹ (Nr. 154–161), ›Originalzustand des Negativs von Bild 68‹ (No 162), ›Frau Scherer‹ (Nr. 163), ›Studie zu einem Bild‹ (Nr. 164), ›Autotypie von Bild 22‹ (Nr. 165), ›Bei der Toilette‹ (Nr. 166), ›Kinder-Akte: Drei Geschwister‹ (Nr. 167), ›Adam (Ernst Z.)‹ (Nr. 168), ›Am Bach‹ (Nr. 169), ›Photogravure von Bild 93‹ (Nr. 170), ›Eva‹ (Nr. 171), ›Mädchen am Teetisch‹ (Nr. 172), ›Mosaik‹ (Nr. 173), ›Photogravure von Bild 28‹ (Nr. 174), ›Sir Henry Irving‹ (Nr. 175), ›Autotypie von Bild 9‹ (Nr. 176), ›Hortensia‹ (Nr. 177), ›Photogravure von Bild 69‹ (Nr. 178), ›Hortensia, Vergrösserung‹ (Nr. 178a), ›Geheimrat Dr. Praeger, Bayerns Gesandter in Berlin‹ (Nr. 178b), ›Frau Kurt Wolff‹ (Nr. 179). Begleitend waren Schülerarbeiten zu den Büchern *Der Dom zu Naumburg, Das Buch zum Tee* sowie photographische Kunstreproduktionen u.a. vom Isenheimer Altar von Matthias Grünewald zu sehen.
Lit.: Katalog *Ausstellung von Naturphotographien und Reproduktionen der Abteilung für Naturphotographie Prof. Frank Eugene Smith und Reproduktionstechnik Prof. Fritz Goetz an der Staatlichen Akademie für Graphische Künste und Buchgewerbe zu Leipzig*, Frankfurt am Main 1924. *Allgemeiner Anzeiger für Druckereien*, 51, 14.3.1924, Nr. 11, S. 331, Rubrik *Berichte aus dem In- und Auslandes;* ›Photographische Ausstellung im Kunstgewerbe-Museum‹, in: *Allgemeine Deutsche Zeitung*, 12.3.1924; H. Schwarzweber, ›Künstlerische Naturphotographie‹, in: *Freiburger Zeitung*, 29.4.1925.

Frankfurt 1926

Beteiligung der photographischen Abteilungen der Akademie für graphische Künste und Buchgewerbe in Leipzig an der ›Deutschen Photographischen Ausstellung‹ in Frankfurt am Main vom 14. August bis 5. September. Keine besondere Erwähnung von Eugene.

Basel 1927

Beteiligung an der Ausstellung ›Hundert Jahre Lichtbild‹ im Gewerbemuseum Basel mit nicht näher bezeichneten Werken (›Photographien und Photogravüren‹) in der Abteilung ›Beispiele zeitgenössischer Photographie‹ vom 9. April bis 8. Mai.
Lit.: Katalog *Hundert Jahre Lichtbild*, Gewerbemuseum Basel, 9. April bis 6. Mai 1927, S. 27.

New York 1931

Beteiligung an der von Julien Levy und Alfred Stieglitz organisierten Ausstellung ›American Photography‹ in der Galery Julien Levy, die einen retrospektiven Überblick der amerikanischen Photographie gab. Eugene war dort ebenso vertreten wie A. Stieglitz, E. Steichen, P. Strand, C. Sheeler, C. White, G. Käsebier, A. Brigman, E. Weston und Matthew Brady.
Lit.: Katalog *Photographs from The Julien Levy Collection Starting with Atget*, The Art Institute of Chicago, 1976, S. 15.

(no. 87), "Selbstportrait" (no. 88), "Bewegungsstudie"
(no. 89), "Madonna im Freien" (no. 90), "Tänzerin" (no. 91),
"Marie, Tochter von Joachim" (no. 92), "Bernhard Wenig in
Maximilians-Rüstung" (no. 93), "Photogravüre nach Bild 69"
(no. 94), "Rotations-Tiefdruck nach Bild 71" (no. 95), "Eine
gekaufte Postkarte, Beispiel einer ganz falschen Retouche zum
Vergleich" (no. 95a), "S. M. Ludwig von Bayern" (no. 96),
"Halali" (no. 97), "Rohrdruck von Bild 35" (no. 98), "Studie zu
einem Bild Leda" (no. 99), "Mittagssonne, Murnau" (no. 100),
"Nacht, Schloss Neubeuern" (no. 101), "Martinihof, grauer
Tag" (no. 102), "Gabriele Lenbach" (no. 103, 104), "Prof. Dr.
Gabriel von Seidl" (no. 105, 106, 107), "Prof. Rudolf von Seitz"
(no. 108), "Dr. Paul Heyse, Schriftsteller" (no. 109), "Prof. Fritz
von Uhde, Maler" (no. 110), "Prof. Martin Feuerstein, Maler"
(No 111), "Tasse Tee" (No 112), "Alfred Stieglitz Esq., Photogra-
pher and Truthseeker" (no. 113), "Erster Zustand von Bild 23"
(no. 114), "Platindruck von Bild 23" (no. 115), "Frau Prof. Walter
Tiemann" (no. 116), "Prof. Walter Tiemann, Akademiedirektor"
(no. 117), "Frau Faber du Faur" (no. 118), "Ausschnitt von Bild
4" (no. 119), "Schleiertanzstudien" (no. 120 a, b), "Emy Geiger"
(no. 121), "Dr. Georg Hirth" (no. 122), "Captain Tarr, Maler"
(no. 123), "Prof. Willi Geiger, Maler-Radierer" (no. 124), "Minis-
terialdirektor Geheimrat Dr. Klien" (no. 125), "Bewegungsstud-
ie, Schleiertanz" (no. 126), "Grossmutter Puehn und Milla P."
(no. 127), "Frau Max Seliger mit Gerda und Franz" (no. 128),
"Frohe Botschaft, Paul B. u. Frau" (no. 129), "Taka" (no. 130),
"Der Dichter Gyellrup und seine Frau" (no. 131), "Meine Haus-
meistersleute" (no. 132), "Baron und Baronin v. B." (no. 133),
"The Daphne" (no. 134), "Aegyptischer Hirt" (no. 135), "Süd-
früchte" (no. 136), "Der Garten des Paradieses" (no. 137).
"Prof. Georg A. Mathéy" (no. 138), "Prof. Fritz Goetz"
(no. 139), "Dr. Karl Klingspor" (no. 140), "Frau Prof. Doren"
(no. 141), "Prof. Dr. Alfred Doren" (no. 142), "Graf Max von
Moy" (no. 143), "Ein griechisches Mädchen" (no. 144),
"Gudrun B." (no. 145), "Jesko von P." (no. 146), "Hugo von
Havenith, Maler" (no. 147), "Carl Ernst Poeschel" (no. 148),
"Eine lustige Sitzung" (no. 149), "Adam Adolf Oberländer,
Maler" (no. 150), "Prof. Franz von Stuck, Maler" (no. 151),
"Daniel Ch. French, Bildhauer" (no. 152), "Franz von Defregger,
Maler" (no. 153), "Bewegungsstudien aus der H.W. Mappe"
(no. 154–161), "Originalzustand des Negativs von Bild 68"
(No 162), "Frau Scherer" (no. 163), "Studie zu einem Bild"
(no. 164), "Autotypie von Bild 22" (no. 165), "Bei der Toilette"
(no. 166), "Kinder-Akte: Drei Geschwister" (no. 167), "Adam
(Ernst Z.)" (no. 168), "Am Bach" (no. 169), "Photogravure von
Bild 93" (no. 170), "Eva" (no. 171), "Mädchen am Teetisch"
(no. 172), "Mosaik" (no. 173), "Photogravure von Bild 28"
(no. 174), "Sir Henry Irving" (no. 175), "Autotypie von Bild 9"
(no. 176), "Hortensia" (no. 177), "Photogravure von Bild 69"
(no. 178), "Hortensia, Vergrösserung" (no. 178a), "Geheimrat
Dr. Praeger, Bayerns Gesandter in Berlin" (no. 178b), "Frau Kurt
Wolff" (no. 179).
These were accompanied by works done by students for the
books Der Dom zu Naumburg, Das Buch zum Tee and by
photographic reproductions, among others, of the Isenheim
altar by Matthias Grünewald.
Lit.: Catalogue Ausstellung von Naturphotographien und Re-
produktionen der Abteilung für Naturphotographie Prof. Frank
Eugene Smith und Reproduktionstechnik Prof. Fritz Goetz an
der Staatlichen Akademie für Graphische Künste und Buch-
gewerbe zu Leipzig, Frankfurt am Main 1924; Allgemeiner An-
zeiger für Druckereien, 51, March 14, 1924, no. 11, p. 331, heading
Berichte aus dem In- und Auslandes; R. Diehl, "Photogra-

phische Ausstellung im Kunstgewerbe-Museum," in: Allgemeine
Deutsche Zeitung, Frankfurt am Main, March 12, 1924; H.
Schwarzweber, "Künstlerische Naturphotographie," in: Freiburg-
er Zeitung, April 29, 1925.

Frankfurt 1926

Participation by the photography departments of the Akademie
für graphische Künste und Buchgewerbe in Leipzig (Leipzig
Academy of Graphic Art and Book Design) in the "Deutsche
Photographische Ausstellung" (German Photography Exhibi-
tion) in Frankfurt am Main from August 14 to September 5.
No special mention is made of Eugene.

Bâle 1927

Participation in the exhibition "Hundert Jahre Lichtbild" in the
section "Beispiele zeitgenössischer Photographie" (Examples of
Contemporary Photography) from April 9 to May 6.
Lit: Catalogue Hundert Jahre Lichtbild, Gewerbemuseum Bâle,
April 9 to May 6 Mai 1927, p. 27.

New York 1931

Participation in the exhibition "American Photography" organ-
ized by Julien Levy and Alfred Stieglitz at Galery Julien Levy and
offering a retrospective survey of American photography. Eugene
was represented together with A. Stieglitz, E. Steichen, P.
Strand, C. Sheeler, C. White, G. Käsebier, A. Brigman, E. Wes-
ton and Matthew Brady.
Lit: Catalogue Photographs from The Julien Levy Collection
Starting with Atget, The Art Institute of Chicago, 1976, p. 15.

Schüler von Frank Eugene Smith / Students of Frank Eugene Smith 1907–1927

MÜNCHEN 1907–1913
Lehr- und Versuchsanstalt für Photographie, Chemigraphie, Lichtdruck und Gravüre in München

Die Angaben betreffen folgende Kategorien: Geburtsjahr, Geburtsort, Vorbildung, Staatsangehörigkeit, Jahrgang. Das Schülerverzeichnis wurde von Claus Kaelber erstellt.
The following categories are included: date of birth, place of birth, preparatory education, nationality, year(s) of attendance. The list of students was compiled by Claus Kaelber.

Aisenberg, Hassi
1881, Nicolajew, Gymnasium, Kaufmann, Rußland, 1913
Alt, Gustav
1886, Mönchsroth, Progymnasium, Pfarrer, Bayern, 1907
Alten, Ida
1878, Obornick, Höhere Töchterschule, Preußen, 1912
Bachmann, Käthe
1880, Weimar, Sophienstift, Preußen, 1909–10
Bär, Jakob
1892, Frauenfeld, Handelsschule, Schweiz, 1912–13
Bagg, Gita Lea
1883, Riga, Töchterschule, Rußland, 1907–8
Bahse, Lore
1881, Chemnitz, Höhere Töchterschule, 1912
Bartsch, Leo
1886, Diedenhofen, Mittelschule, Reichsland, 1907–8
Bauernschmidt, Marie
1891, München, Frauenarbeitsschule, Bayern, 1911–12
von Baumgarten, Sophie
1895, München, Volks- und Fortbildungsschule, Bayern, 1912
Baumgärtner, Adolf
1890, Treuchtlingen, Volksschule, Bayern, 1911–12
Bauschinger, Frdr.
1866, Nürnberg, Taubstummen- und Kunstschule, Bayern, 1911
Bauschinger, Helene
1887, Bayreuth, Institut der Englischen Fräulein, Bayern, 1912–13
Beck, Hilda
1892, Buenos Aires, Dt. Schule und Karolinensch., Preußen, 1912–13
Becker, Anna
1878, Barmen, Töchterschule, Preußen, 1908
Becker, Heinrich
1890, Ettlingen, Oberrealschule, Baden, 1913
Bednarz, Stanislav
1885, Bukarest, Gymnasium, Rumänien, 1908–9

Besser, Elisabeth
1880, Magdeburg, Akademie, Preußen, 1912
Bestvater, Marie
1888, Pr. Königsdorf, Privatunterricht, Preußen, 1913
Berger, Emil
1892, Solothurn, Gewerbeschule, Schweiz, 1910
Bernauer, Erw.
1886, Zell in Baden, Realschule, Baden, 1907–8
Bernhard, Herm
1893, München, Kreisrealschule, Bayern, 1909
Binder, Alex.
1888, Alexandrien, Industrieschule, Schweiz, 1909
Bindler, Alex.
1891, Jalta, Gymnasium, Rußland, 1910
von Blume, Hermann
1890, Colmar, Gymnasium, Preußen, 1910
Bobien, Georg
1891, Steinbach, Gymnasium, Preußen, 1913
von Böhm, Ruth
1889, München, Viktorialschule, Bayern, 1912–13
Böhme, Anna
1887, Wunsiedel, Volksschule, Bayern, 1913
Bogdanovic, Marie
1880, Ruma, Töchterschule, Ungarn, 1908–9
Boley, Luise
1894, München, Institut, Württemberg, 1912–13
Bollinger, Hermann
1884, Landstuhl, Gymnasium und Hochschule, Bayern, 1912–13
Bonetti, Hector
1891, Mailand, Industrieschule, Italien, 1910
Bopp, Fritz
1888, Vevey, Primar- und Sekundarschule, Schweiz, 1908
Bosanyi, Georg
1894, Budapest, Gymnasium, Handelsakademie, Ungarn, 1912
Brack, Oskar Hans
1896, Hamm, Lehr- und Erziehungsanstalt, Preußen, 1913
Braig, Alfons
1889, München, Volks- und Realschule, Bayern, 1907
Bransburg, Sch.
1880, Witebsk, Hochschule, Rußland, 1909–10
Braun, August
1876, Wangen, Kunstgewerbeschule, Württemberg, 1909
Brendle, Josef
1893, München, Simultanschule, Bayern, 1908–9
Brissy, Eduard
1882, Dyon, Gymnasium, Frankreich, 1908–9

Brühlmeyer, Hermann
1892, Passau, Gymnasium, Bayern, 1908–10
Buck, Ant.
1870, Kempten, Realschule, Bayern, 1910
Büchele, G.
1892, Kißlegg, Volksschule, Württemberg, 1910
von Bülow, Dorothea
1879, Breslau, Höhere Töchterschule, Preußen, 1910–11
Büngner, Richard
1883, Brandenburg, Volksschule, Preußen, 1908
Christ, Max
1892, München, Gymnasium, Bayern, 1908–09
Csallner, Robert
1887, Bistritz, Taubstummen-Anstalt, Österreich-Ungarn, 1907
Czlapinski, Piotr
1882, Kowal, Universität, Rußland, 1913
van Daalen, Fritz
1893, Heilbronn, Realschule, Württemberg, 1910–11
Dahl, Paul
1892, Ludwigshafen, Gymnasium, Bayern, 1910–12
Datz, Heinrich
1892, Berchtesgaden, Volksschule, Bayern, 1912–13
von Debschitz, Wanda
1870, Czarnikau, Töchterschule, Preußen, 1907
Decker, Alfred
1891, Budapest, Realschule, Ungarn, 1911–12
DeJongh, Gaston
1888, Lausanne, Sekundarschule, Schweiz, 1908–9
Detinoff, Eugenie
1878, Bogorodse, Gymnasium, Rußland, 1912
Detinoff, Paul
1884, Moskau, Realschule, Rußland, 1911
von Dewitz-Krebs, Hans-Elisabeth
1891, Wassersleben, Töchterschule, Preußen, 1909–10
Dick, Richard
1886, Ulm, Mittelschule, Württemberg, 1912
Dor, Josef
1891, München, Volksschule, Bayern, 1911
Drouin, Peter
1892, Belfort, Lyceum, Frankreich, 1911
Dühring, Elisabeth
1892, Görlitz, Höhere Töchterschule, Preußen, 1912–13
Eckhardt, Martha
1889, Prag, Bürgerschule, Österreich, 1911–12
Eisenberg, Alexander
1888, Leipzig, Realschule und Akademie Leipzig, Sachsen, 1911
Eisenbock, Karl
1870, Penzberg, Realschule, Bayern, 1907

Eisenschink, Otto
1893, München, Gymnasium, Bayern, 1910–11

Engelmann, Frieda
1888, Stendal, Luisenschule zu Berlin, Bayern, 1908–09

Engler, Luise
1879, Eberbach, Mittelschule, Baden, 1913

Entleitner, Ant.
1890, München, Volks- und Handelsschule, Bayern, 1907

Fancher, R.
1878, Fort Windgate, Privatinstitut, Amerika, 1910

Fehn, Vera
1896, London, Höhere Töchterschule, Preußen, 1913

Feistel, Heinrich
1889, Greiz, Realgymnasium, Preußen, 1908–10

Feleki, Friedrich
1889, Nagykikinda, Handelshochschule, Ungarn, 1912–13

Fenk, Josef
1893, München, Realschule, Bayern , 1909–10

Fleischhacker, Karl
1886, Elberfeld, Kunstgewerbeschule, Preußen, 1910–11

Foerster, Wilhelm
1892, Rothenburg o.T., Gymnasium, Bayern 1909–10

Fraisse, Hedwig
1881, Leipzig, Karolinenschule, Sachsen, 1909–10

Frank, Gustl
1885, Konstanz, Höhere Mädchenschule, Baden, 1908–9

Freilich, Mendel
1885, Lapusnya, Volksschule, Ungarn, 1910–11

Freytag, Alb.
1891, Nürnberg, Realschule, Bayern, 1907–8

Friedrich, Gottfried
1886, Metz, Volksschule, Reichsland, 1907–8

Fritz, Johannes
1893, Greiz, Gymnasium, Preußen, 1910–11

Fuchs, Rudolf
1894, Neustadt, Realschule, Bayern, 1913

Gebhard, Marie Elisabeth
1875, Commern, Höhere Töchterschule, Preußen, 1912

Gehm, Rud.
1890, Kaiserslautern, Volksschule, Bayern, 1910

Geist, Franz
1893, Eiselfing, Volks- und Präparandenschule, Bayern, 1911–12

Georgs, Bernhard
1891, Reithamm, Mittelschule, Preußen, 1912–13

Geyer, Josef
1897, Würzburg, Gymnasium, Bayern, 1912

Girard, Gaston
1896, Martes, Mittelschule, Frankreich, 1913

Glatz, Josef
1881, Feistritz, Volksschule, Österreich, 1907

Goldstein, Ernst
1887, Hamburg, Realschule Hamburg, 1907

Grießmann, Willy
1888, Taura, Volksschule, Sachsen, 1909–10

von Groschkovski, Mina
1890, Sijedletz, Privatunterricht, Rußland, 1910–11

Grubenbecher, Hans
1886, Essen, Gymnasium, Preußen, 1907–8

Grünbaum, Sophie
1889, Moskau, Gymnasium, Rußland, 1911–12

Grünbaum, Vera
1888, Moskau, Gymnasium, Rußland, 1911

Grünberg, Leon
1886, Moinesti, Lyceum, Rumänien, 1907–8

Grüning, Senta
1891, Polangen, Höhere Töchterschule, Rußland, 1913

Grunwald, Edwin
1888, Augsburg, Real- und Handelsschule, Bayern, 1911–12

Gruschmann, Etel
1884, Bessarabien, Gymnasium, Rußland, 1908

Gutmann, Klara
1887, Straßburg, Höhere Töchterschule, Elsaß, 1913

Gutsche, Gertrud
1887, Grätz, Töchterschule, Preußen, 1912–13

Haab, Albert
1886, Wädenswil, Oberschule, Schweiz, 1907

Haag, Berta
1894, München, Mädchenfortbildungsschule, Bayern, 1912–13

Händler, Ernst
1891, Schliestedt, Knabenschule Porto Alegre, Preußen, 1909

Hahn, Helene
1882, Salzungen, Bürgerschule, Preußen, 1908–10

Haldy, Ernst
1891, Lausanne, Knabeninstitut, Schweiz, 1909

Hanfstaengl, Erwin
1888, München, Gymnasium, Bayern, 1910

Harffen, Joh.
1881, Starnberg, Gymnasium, Bayern, 1909–11

Harnier, Heinrich
1864, Altstetten, Sekundarschule, Schweiz, 1907

Hauchmann, Sophie
1886, Witebsk, Gymnasium, Rußland, 1913

Hauner, Alfred
1892, Bernried, Volksschule, Bayern, 1907

Hauser, Valerie
1889, Bilin, Volks- und Bürgerschule, Österreich, 1912–13

Heigenmooser, Ernst
1893, München, Realgymnasium, Bayern, 1911–12

Heinhold, Paul
1892, München, Realschule, Bayern, 1907

Hensinger
1856, Stuttgart, Bürgerschule und Akademie, Württemberg, 1907

Hentschel, Schwanhilde
1882, Dresden, Mittelschule, Sachsen, 1913

Herkenhöner, Adam
1893, Köln, Elementar- und Fortbildungsschule, Preußen, 1911

Herold, Max
1891, München, Volksschule, Bayern, 1907–8

Herrmann, Johannes
1885, Magdeburg, Gymnasium, Sachsen, 1909–10

Hertel, Auguste
1884, Bad Kissingen, Institut Ilgen, Bayern, 1909–10

Herth, Anna
1875, Langen, Volksschule, Hessen, 1909–10

Hertwig, Günther
1887, Wanfried, Realschule, Preußen 1909–10

Hintermayer, Max
1895, München, Bürgerschule, Bayern, 1911–12

Hirth, Georg
1891, Heidingsfeld, Realgymnasium, Bayern, 1908–10

Hirth, Julius
1893, Heidingsfeld, Gymnasium, Bayern, 1909–10

Högl, Josef
1888, Niederfüßbach, Volks- und Fortbildungsschule, Bayern, 1911

Hölscher, Viktor
1895, München, Realgymnasium, Bayern, 1913

Hofer, Hans
1893, Augsburg, Realschule, Bayern, 1910

Hofer, Karl Friedrich
1868, Heidelberg, Realschule, Bayern, 1910–11

Hoffmann, Karl Joh.
1876, Berlin, Gymnasium, Bayern und Preußen, 1912

Hoffmann, Paul
1879, Berlin, Volksschule, Preußen, 1908

Hofmann, Karl
1892, Stuttgart, Volksschule, Bayern, 1910

Hofmann, Kurt
1895, Koburg, Realschule, Bayern, 1913

Hofner, Franz
1892, München, Volksschule, Bayern, 1908–9

Holdt, Hermann
1895, Niesky, Pädagogium, Preußen, 1913

Hoscheck, Elisabeth
1890, Pilchowitz, Seminar, Preußen, 1913

Hüttemann, Walter
1875, Barmen, Oberrealschule, Preußen, 1907–8

Huber, Leopold
1893, München, Kunstgewerbeschule, Bayern, 1911–12

Huber, Quirin
1878, Nürnberg, Volksschule, Bayern, 1907

Hugelshofer, Emil
1879, Illhart, Realgymnasium, Schweiz, 1913

Huppmann, Albert
1893, München, Real- und Drogistenschule, Bayern, 1911–12

Imsande, Paul
1887, Osnabrück, Bürgerschule, Preußen, 1909

Ineichen, Marie
1879, Muri, Primar- und Sekundarstufe, Schweiz, 1912–13

Jahr, Hans
1889, Kleingera, Gymnasium, USA, 1910–12

von Jan, M.
1882, Lautenbach Zell, Töchterschule, Reichsland, 1907–9

Janoff, Etel
1884, Bessarabien, Gymnasium, Rußland, 1909

Joelsohn, Fritz
1889, Schöneberg, Höhere Lehranstalt, Preußen, 1911–13

Jörgensen, Chr.
1873, Gloslunde, Volksschule, Dänemark, 1907

Jungnickel, Marg. Helene
1888, Lodz, Töchterschule, Sachsen, 1912–13

Kafieff, Nina
1869, Baku, Gymnasium, Rußland, 1910–11

Kaiser, Heinrich
1891, Ingolstadt, Gymnasium, Bayern, 1908

von Kananow, Maria
1870, Baku, Höhere Töchterschule, Rußland, 1910–11

Kaplan, Marie
1890, Minsk, Gymnasium, Rußland, 1912

Kasper, Alois
1889, Leipa, Bürgerschule, Böhmen, 1908–9

Katzen, Frieda
1887, Alexandrowsk, Gymnasium, Rußland, 1912

Kaufmann, Karl
1888, Landshut, Volks- und Kunstgewerbe-Schule, Bayern, 1907–9

Keller, Martha
1888, Pforzheim, Töchterschule, Baden, 1913

Kerber, Artur
1885, Garnsee, Mittelschule, Preußen, 1908

von Kerekgyarto, Stefan
1888, Budapest, Kunstgewerbeschule, Ungarn, 1910

Kestler, Ludwig
1896, München, Volksschule, Bayern, 1911–12

Keßler, Karl
1892, München, Fortbildungsschule, Bayern, 1909–10

Kiedaisch, Hch.
1886, Linz, Bürgerschule, Österreich, 1907

Kirschmann, Käthe
1891, Fentsch, Volksschule, Reichsland, 1909

Kissinger, Ludwig
1887, Bad Kissingen, Realschule, Bayern, 1913

Kittel, Reinhardt
1892, Berlin, Mittelschule, Preußen, 1913

Klempt, Meta
1888, Rostock, Fortbildungsschule, Preußen, 1912–13

Kley, Otto
1892, Salzungen, Volksschule, Preußen, 1911–12

Kling, Gustav
1890, Augsburg, Realschule, Bayern, 1913

Klob, Johanna
1868, Freising, Erziehungsinstitut, Bayern, 1912

von Knjaschewitisch, Vera
1869, Odessa, Gymnasium, Rußland, 1909

Knothe, Hans
1880, Königsberg, Gymnasium und Handelsschule, Preußen, 1911–12

Knothe, Walter
1888, Thorn, Realgymnasium, Preußen, 1911–12

Koch, Karl
1885, Schaffhausen, Realgymnasium, Schweiz, 1907

Kögel, Raph.
1882, München, –, Bayern, 1912

Köhle, Ernst
1894, Memmingen, Volksschule, Bayern, 1911–12

Königer, Anna
1890, München, Töchterschule, Bayern, 1909–10

Kofranyi, Anna
1885, Freiwaldau, Bürgerschule, Österreich, 1911–12

Kogan, Elsa
1884, Peskoyen, Höhere Töchterschule, Preußen, 1910

Kolb, Oskar
1890, Würzburg, Gymnasium, Bayern, 1907–8

Kollstede, Erna
1887, Oldenburg, Cäcilienschule, Preußen, 1910–11

Krah, Freya
1889, Eckernförde, Höhere Mädchenschule, Preußen, 1913

Krasinski, Eugen
1892, Stryj-Galic, Gymnasium, Österreich-Ungarn, 1912

Krepieff, Dimitre
1884, Küstendil, Gymnasium, Bulgarien, 1908

Krispenz, Marie
1891, Ujverbasz, Höhere Töchterschule, Ungarn, 1913

Kurz, Emil
1894, München, Kreisrealschule, Bayern, 1913

Kurzhals, Fritz
1891, Böllberg, Realschule, Preußen, 1910–11

Kussin, Fritz
1889, Barten, Privatrealschule, Preußen, 1911

Laszkiewicz, Bruno
1887, Cherwinsk, Gymnasium, Preußen, 1907

Lerman-Reiner, Hedwig
1876, Detkovac, Privatunterricht, Kroatien, 1912–13

von Levetzow, Emmy
1880, Lübben, Höhere Töchterschule, Preußen, 1910–12

Levinsohn, Isidor
1875, Mitau, Privatschule, Rußland, 1907–8

Ley, Emma
1881, Springfield, Privatschule, USA, 1911

Liehr, Wilhelm
1891, Groß-Walten, Bürgerschule, Österreich, 1912–13

Locher, Ida
1879, Winterthur, Primar- und Sekundarschule, Schweiz, 1912–13

Lodders, Emmy
1889, Harburg, Töchterschule, Preußen, 1911

Longerich, Frz.
1889, Elberfeld, Realschule, Preußen, 1907–8

Dr. Lossen, Otto
1875, Dresden, Gymnasium, Württemberg, 1910

Maier, Wilhelm
1893, Konstanz, Gewerbeschule, Baden, 1912

von Malewsky-Malevitsch
1868, Woisko-Danskoie, Gymnasium, Rußland, 1907

Manglberger, Anton
1891, München, Volksschule, Bayern, 1912

Marimer, Alb.
1891, Bruneck, Oberrealschule, Österreich, 1907

Mark, Emma
1891, Dornbirn, Höhere Töchterschule, Österreich, 1910–11

Marohn, Frieda
1882, Bielefeld, Mädchenschule, Preußen, 1909–10

Marthaler, Wilhelmine
1893, Einsiedeln, Höhere Töchterschule, Schweiz, 1911

Maulwurf, Rudolf
1890, München, Volksschule, Bayern, 1913

Mayer, Heinrich
1869, Eßlingen, Realschule, Württemberg, 1907

Meinel, Wilhelm
1895, Bad Kissingen, Realschule, Bayern, 1913

Meißer, Hans
1889, Teufen, Primar- und Kantonschule, Schweiz, 1908

Messaz, Henri
1890, Montreux, Mittelschule, Schweiz, 1913

Meyer, Anna
1895, Blankenese, Lyceum, Preußen, 1913

Meyer, Walter
1887, Jena, Volksschule, Bayern, 1908–9

Meyer zur Capellen, Ewald
1890, Winkelshütten, Realgymnasium, Preußen, 1910

Mödinger, Adolf
1884, Strümpfelbach, Volksschule, Württemberg, 1907

Moegle, Ernst Oskar
1890, Thun, Progymnasium und Handelsschule, Schweiz, 1909–10

Möritz, Karl
1896, München, Volksschule, Bayern, 1912

Morstadt, Josephine
1895, München, Fortbildungsschule, Bayern, 1913

Movschowitsch
1885, Melitopol, Privatschule, Rußland, 1907

Mühlberger, Karl
1890, Badgastein, Volks- und Bürgerschule, Österreich, 1912–13

Müller, Gottlieb
1884, Zweisimmen, Primarschule, Schweiz, 1910–11

Murmann, Wilhelm
1894, Lager-Lechfeld, Volksschule, Bayern, 1909

Negoesku, Valerika
1889, Ploeschti, Mädchengymnasium, Rumänien, 1911

Nell, Wilhelm
1880, Köln, Realschule, Preußen, 1907

Neuer, Rudolf
1885, Ocker a.H., Oberrealschule, Preußen, 1907

Nieberle, Hubert
1894, Rosenheim, Volks- und Fortbildungsschule, Bayern, 1912

Nießmann, Hugo
1887, Wattenscheid, Volksschule, Preußen, 1909

Nüßlein, Michael
1891, Höchstedt, Volksschule, Bayern, 1913

Nufer, Karl
1894, München, Gewerbeschule, Bayern, 1913

Odot, Germaine
1892, Lausanne, Gymnasium, Schweiz, 1912–13

Ohlhoff, Anna
1884, Wernigerode, Höhere Töchterschule, Preußen, 1910–11

Olsen, Harald
1887, Tromsø, Höhere Mittelschule, Norwegen, 1909

Ott, Albertine
1878, Würzburg, Kaufmännisches Institut, Bayern, 1912

Paaß, Franz
1888, Solingen, Realschule, Preußen, 1907–8

Pachmayer, Anton
1896, Unterhaching, Volks- und Präparandenschule, Bayern, 1912–13

Panthen, Karl
1888, Metz, Lyceum, Preußen, 1909–10

von Paschkewitsch, Boris
1890, St. Petersburg, Freie Schulgemeinde, Rußland, 1909–10

von Pawlowicz, Helene
1890, Warschau, Fachschule, Rußland, 1912–13

Pecsi, Josef
1889, Budapest, Gymnasium und Handelsakademie,
Österreich-Ungarn, 1909–10

Pellet, Paul
1892, Starnberg, Realschule, Bayern, 1911–12

Peters, Karl
1887, Hannover, Bürgerschule, Preußen, 1907–8

Pettinger, Josef
1895, München, Volksschule, Bayern, 1910–12

Pfaehler, Hans
1887, Leipzig, Realschule, Bayern, 1907–8

Pfalzgraf, Rudolf
1892, Freiburg, Gymnasium, Baden, 1913

Dr. von Philipsborn
1878, Albano/Italien, Gymnasium, Preußen, 1908–9

Piccot, Narc.
1875, Saignelegier, Sekundarschule, Schweiz, 1907

Pietsch, Gertr.
1881, Moskau, Bürgerschule, Österreich, 1908–9

Pilartz, Wolfgang
1890, Bad Kissingen, Gymnasium, Bayern, 1908

Pöhlmann, Ch.
1889, München, Volksschule, Bayern, 1907–8

Poluleit al Pohle, Alfred
1894, Riga, Realschule, Rußland, 1913

Prahl, Went.
1893, Marienwerder, Gymnasium und Wiesenbau-
schule, Preußen, 1912–13

Preibisz, Bronislaus
1879, Pleschen, Realgymnasium, Preußen, 1909–10

Putzar, Carl
1885, Greifswald, Realschule, Preußen, 1908

Räder, Paula
1893, Salzungen, Bürgerschule, Preußen, 1910

Rausch, Gustav
1881, Kaiserslautern, Städt. Gewerbeschule,
Bayern, 1909–10

Real, Paul
1891, Goncelin, Lyceum, Frankreich, 1912

Reichelt, Elfriede
1883, Breslau, Höhere Töchterschule, Preußen, 1907–8

Reichrath, Artur
1893, Kaiserslautern, Realschule, Bayern, 1911–12

Renggli, Albert
1890, Luzern, –, Schweiz, 1912–13

Renner, Otto
1895, Tutzing, Realschule, Bayern, 1912–13

Retter, Hildegard
1878, Brune, Töchterschule, Preußen, 1908–9, 1913

Reutlinger, John Leo
1891, Paris, Oberrealschule, USA, 1911

Reynier, Sophie
1882, Prag, Institut der Englischen Fräulein, Bayern, 1907

Riedmann, Michael
1888, Stetten, Volksschule, Bayern, 1910

Rietmann, Otto
1883, St. Gallen, Realschule, Schweiz, 1907–8

Rimathe, Samuel
1862, Spezzia, Industrieschule, Italien, 1907

Rintelen, Marie
1879, Berlin, Lehrerseminar, Preußen, 1909–10

Roeckelein, Eug
1892, München, Volksschule, Bayern, 1907–8

Dr. Roenwolt, Walter
1874, Sandersleben, Gymnasium, Preußen, 1910

Rosch, Peter
1883, Hortitz, Hausunterricht, Rußland, 1910–11

Roßkopf, Hans
1893, Regenstauf, Volks- und Fortbildungsschule,
Bayern, 1910–11

Rotter, Elisabeth
1885, Dresden, Töchterschule, Sachsen, 1913

Rupflin, Otto
1889, München, Kreis-Realschule, Bayern, 1907

Ruppel, Käte
1885, Groß Tauerlauken, Privatunterricht, Preußen,
1912–13

Sacker, Karolina
1890, Odessa, Gymnasium, Rußland, 1910–11

Sandberg, Erich
1886, Freistadt, Realgymnasium, Preußen, 1909

Sayle, Julius
1895, Neuburg, Realschule, Bayern, 1912–13

Schafgans, Theodor
1892, Bonn, Realgymnasium, Preußen, 1909–10

Schatt, Wilhelm
1891, Olbersdorf, Oberrealschule, Österreich, 1912–13

Scheerling, Meer
1885, Dvinsk, Gymnasium, Rußland, 1910–11

Scheuzenhammer, Max
1893, München, Volksschule, Bayern, 1908–9

Schifmanowitsch, Selma
1876, Hübbenetshof, Töchterschule, Rußland, 1913

Schiller, Friedrich
1895, Kaiserslautern, Realschule, Bayern, 1911–13

Schilling, Lothar
1887, Königstein, Volksschule, Preußen, 1907

Schlatter, Annie
1885, Herisau, High School for Girls, Schweiz, 1911

Schlesinger, Rosa
1884, Berlin, Luisenschule, Preußen, 1912

Schmid, Alois
1890, München, Volksschule, Bayern, 1907

Schmid, Josef
1892, München, Realschule, Bayern, 1908–9

Schmidt, Hermann
1887, Crotenlaide, Bürgerschule, Sachsen, 1910

Schneider, Herbert
1892, Dornbirn, Oberrealschule, Österreich-Ungarn,
1909–10

Schönfeld, Abram Jakob
1887, Lodz, Häusliche Bildung, Rußland, 1911–12

Schreiner, Arthur
1892, Schachen, Realschule, Bayern, 1909–11

Schroer, Am.
1886, Metz, Höhere Mädchenschule, Bayern, 1907–8

Schuberl, Alfons
1891, München, Drogistenschule, Bayern, 1911–12

Schulz, Friedrich Oskar
1872, Dorpat, Gymnasium, Rußland, 1908

Seefried, Val.
1889, München, Kreis-Realschule, Bayern, 1907

Seidl, Katharina
1895, München, Volksschule, Bayern, 1912

Seitz, Heinrich Wilhelm
1892, Heidenheim, Reallehrinstitut, Baden, 1909–10

Senn, Arthur
1894, Wil, Privatschule, Schweiz, 1913

von Seyffertitz, Wilhelm
1894, München, Volksschule, Bayern, 1911–12

Sieck, Auguste
1881, Rosenheim, Volksschule, Bayern, 1911

Siegel, Hildegard
1882, Arnstadt, Höhere Töchterschule, Sachsen,
1911–12

Siegl, Fritz
1888, Helsingfors, Realgymnasium, Sachsen, 1909

Sinner, Siegfried
1890, Freiburg, Volksschule, Schweiz, 1907

Sitzwohl, Hans
1888, Bilbao, Volksschule, Österreich-Ungarn, 1907

Smus, David
1892, Minsk, Handelsschule, Rußland, 1911–12

Sohl, Ludwig
1895, Maastricht, Gymnasium, Holland, 1912

Sontag, Pankraz
1893, Bregenz, Gymnasium, Österreich, 1910–11

Speisiger, Martha
1894, Birglau, Höhere Mädchenschule, Preußen,
1912

Spörl, Erich
1893, Berlin, Realgymnasium, Bayern, 1913

Starkiewicz, Felix
1881, Piotrkow, Gymnasium, Rußland, 1913

Stehelin, Eduard
1883, L'Isle, Oberrealschule, Schweiz, 1909–10

Stehle, Adelheid
1888, Saarunion, Höhere Mädchenschule, Reichs-
land, 1908–9

Steiger, Anna
1882, Bregenz, Volksschule und Institut, Bayern,
1911–12

Steinberg, Lea
1888, Miropol, Mädchengymnasium, Rußland, 1911

Steinle, Max
1894, Wiesbaden, Volksschule, Hessen, 1913

Stern, Nanny
1880, Kowno, Töchterschule, Rußland, 1908

Sternberg, Käthe
1883, Osterode, Pensionat, Preußen, 1909–10

Stiegler, Ludwig
1883, Ersekujvar, Gymnasium und Handelsakademie,
Ungarn, 1911–12

Stier, Louise
1867, Kolberg, Töchterschule, Preußen, 1910–11

Stolze, Clara
1881, Berlin, Höhere Mädchenschule, Preußen, 1912–13

Stumpf, Alfred
1887, Rudolfstein, Akademie der Künste, Bayern, 1913

Stutzmann, Franz
1877, Rokala, Finnland, Realschule, Bayern, 1913

Taponier, Pierre
1893, Reims, Lyceum, Frankreich, 1913

Teuscher, Johanna
1882, Plauen, Höhere Töchterschule, Sachsen,
1909–10

Thein, Mathilde
1888, Braunschweig, Töchter- u. Kunstgewerbesch.,
Preußen, 1909–10

Thiele, Emmy
1877, Neuwied, Höhere Töchterschule, Preußen, 1911–12

Tornow, Erika
1889, Pilla, Höhere Mädchenschule, Preußen, 1913

Trottmann, Alois
1891, Engelberg, Primar- und Sekundarschule, Schweiz, 1908–9

Tschernenko, Lea
1888, Miropol, Mädchengymnasium, Rußland, 1910

Uibeleisen, Emma
1880, Metz, Volksschule, Bayern, 1907–8

Ulitzsch, Emil Werner
1896, Mulde, Gewerbeschule, Sachsen, 1912

Ulrich, Karl
1889, München, Volksschule, Bayern, 1908–9

Umann, Agostinho
1877, St. Cruz, Volksschule, Brasilien, 1908–9

Vincenti, Otto
1893, Miesbach, Landwirtschaftliche Schule, Bayern, 1909–11

von Wasjutinsky, Boris
1880, Odessa, Realschule, Rußland, 1909

Wassermann, Hans
1896, Kleinsohrheim, Oberrealschule, Bayern, 1911–12

Wassiliew, Alexis
1873, Kharkow, Technologisches Institut, Rußland, 1909–10

Weise, Eugen
1886, Groß-Ekau, Höhere Schule, Preußen, 1909

Weißbrem, Dorothea
1882, Eydtkuhnen, Höhere Töchterschule, Preußen, 1909–10

Weißenstein, Grete
1893, Wien, Gymnasium, Österreich, 1913

Weitzenberg, Adolf
1882, Timmen, Realschule, Preußen, 1911–12

von Welden, Martha
1883, Wien, Bürger- und Lycealschule, Bayern, 1912

Werkmeister, Jakob
1893, Freising, Realschule, Bayern, 1909–10

Werndl, Moritz
1893, München, Volksschule, Bayern, 1908–9

Westenfeld, Hans Walter
1891, Leipzig, Bürger- und Gewerbeschule, Sachsen, 1911

Wiesberger, Fritz
1893, München, Volksschule, Bayern, 1910–11

Wiesinger, Karl
1894, München, Kreisrealschule, Bayern, 1911–12

Wießner, Johannes Albert
1893, Leipzig, Kunstgewerbeschule, Sachsen, 1911–12

Wildstein, Sundel
1890, Melitopol, Realschule, Rußland, 1913

Willich, Ilse
1890, Eschweiler, Töchterschule, Bayern, 1908

Winkler, Kurt
1894, Peterhof, Oberrealschule, Bayern, 1913

Wörz, Marie
1888, München, Institut der Englischen Fräulein, Bayern, 1912–13

Wojewodzka, Wanda
1887, Siedlee, Privatunterricht, Rußland, 1912–13

Worms, Hertha
1888, Berlin, Mittelschule, Preußen, 1913

Wunder, Friedrich
1883, München, Handelskurs, Bayern, 1910–11

Zabel, Albert
1884, Aschersleben, Mittelschule, Preußen, 1907

Zeller, Cornelia
1889, Biesenrode, Kunstgewerbeschule, Preußen, 1912–13

Zenkert, Edmund
1891, München, Volks- und Fortbildungsschule, Hessen, 1913

Ziegler, Heinrich
1866, Marktbreit, Volksschule, Bayern, 1907

Zimmer, Fritz
1893, München, Volksschule, Bayern, 1908–9

LEIPZIG 1913–1927
Akademie für graphische Künste und Buchgewerbe

Das Verzeichnis erfaßt nur Studenten, die länger als ein Semester die Klasse von Smith besuchten. Es wurde von Klaus Liebich, Liebertzwolkwitz, zur Verfügung gestellt.
This list only contains students who attended Smith's classes for more than one semester. This list was placed at our disposal by Klaus Liebich, Liebertzwolkwitz.

Becker, Madalene
1917–19

Bender, Margot
1921–23

Bosse, Esisabeth
1915–16

Brande, Ruby
1926–27

Briese, Annamarie
1916–17

Brinkmann, Hildegard
1917–19

Burger, Elfriede
1925–26

Cohn-Groß, Annelise
1920–22

Deutscher, Erich
Tschechoslowakei, 1922–23

Dietze, Max
1924–25

Dirks, Walter
1922–23

Edelmann, Sabine
1918–22

Eskreis, Edith
1926–28

Fiedler, Gertrud
1922–23

Gulden, Erna
1916–17

Halberstram, Edith
1925–27

Hege, Else
1924–25

Heidensleben, Hilde
1924–25

Hermer, Beile
1923–24

Hetzer, Franz
1916–17

Hornheim, Erna
1925–26

Kalesse, Käthe
1921–23

Kötz, Hermann
1915–16

Krömer, Hildegard
1925–26

Kühnemann, Heinz
1925–27

Lehmann, Charlotte
1914–16

Lindner, Elfriede
1925–26

Mavrodinova, Bojka
Bulgarien, 1923–24

Mertens, Elisabeth
1916–17

Mossig, Charlotte
1926–27

Müller, Gertraut
1926–27

Nitschke, Margarete
1917–20

Otto, Max
1916–17

Pabst, Elisabeth
1926–27

Riel, Werner
1924–25

Römling, Else
1919–20

Rothkegel, Max
1920–22/1926–27

Ryssel, Johanna
1915–17

Sandaldjian, Nevrik
Armenien, 1924–25

Selitrenny, Martha
Rußland, 1927–30

Sihlis, Johannes
1919–20

Storm, Aenne
1918–22

Struve, Johanna-Luise
1919–20

Taussig, Anna
Österreich, 1923–24

Trietschler, Johanna
1915–17

Vogel, Gertrud
1920–22

An Exhibition of Prints by Frank Eugene, Camera Club, New York 1899.

Ausstellung von Werken der Diez-Schule aus den Jahren 1870–1890, Galerie Heinemann, Munich 1907.

Bartram, Michael, *The Pre-Raphaelite Camera: Aspects of Victorian Photography*, London 1985.

Beaton, Cecil and Gail Buckland, *The Magic Image. The genius of photography from 1839 to the Present Day*, Boston 1975.

Böller, Susanne, *Amerikanische Maler an der Münchner Kunstakademie 1850–1920*, Master's Thesis, Stuttgart 1993.

Brandenburg, Hans, *München leuchtete. Jugenderinnerungen*, Munich 1953.

Buchanan, William (ed.), *J. Craig Annan. Selected Texts and Bibliography*, Oxford 1994.

Bunnell, Peter C. (ed.), *A Photographic Vision: Pictorial Photography, 1889–1925*, Salt Lake City 1980.

—— (ed.), "The Art of Pictorial Photography 1890–1925," in: *Record of the Art Museum*, Princeton University, 51, 1992, no. 2.

Caffin, Charles H., *Photography as a Fine Art. The achievements and possibilities of graphic art in America*, New York 1901 (Reprint 1971), pp. 87–110.

Catalogue of the International Exhibition Pictorial Photography, Buffalo 1910.

Champney, Wells J., "Reviews of the Exhibition of Prints by Frank Eugene: By a Painter," in: *Camera Notes*, 3, April 1900, p. 207.

Cliché-verre: Hand-Drawn, Light-Printed, A survey of the Medium from 1839 to the Present, edited by Elizabeth Glassmann and Marilyn F. Symmes, The Detroit Institute of Arts, Detroit 1980.

Crunden, Robert M., *American Salons. Encounters with European Modernism 1885–1917*, New York/Oxford 1993.

Dane, Hal, "Some Thoughts on an Exhibition of American Photographic Prints," in: *The Amateur Photographer*, October 26, 1900, p. 323.

Demachy, Robert, "Exhibition of the New American School of Artistic Photography at the Paris Photo-Club," in: *The Amateur Photographer*, 33, April 1901, p. 275.

Detlefsen, Carlos, "Zu den Bildern von Frank Eugene Smith," in: *Die Schönheit*, 8, 1910/11, p. 122f.

Dewitz, Bodo von and Karin Schuller-Procopovici (ed.), *Hugo Erfurth 1874–1948 Photograph zwischen Tradition und Moderne*, Cologne 1992.

Doty, Robert, *Photo-Secession. Stieglitz and the Fine-Art Movement in Photography*, New York 1960.

Downer, Alan S. (ed.), *The Autobiography of Joseph Jefferson (1890)*, Cambridge 1964.

Effner, Axel, *Kunstphotographie in München am Bei-*

spiel Frank Eugene Smith, Master's Thesis, Munich 1990.

Emmerich, Georg Heinrich (ed.), *Lexikon für Photographie und Reproduktionstechnik*, Vienna/Leipzig 1910, p. 696

Enyeart, James, *Francis Bruguière. His Photographs and His Life*, New York 1977.

Erfurth, Hugo, "Die Entwicklung der Bildnisphotographie," in: *Photographische Korrespondenz*, 1913, no. 631, pp. 182–193.

Fotografia Pittorica 1889/1911, Milano/Firenze 1979.

Fotomuseum im Münchner Stadtmuseum 1961–1991, edited by Ulrich Pohlmann, Heidelberg 1991.

Fuguet, Dallett, "Reviews of the Exhibition of Prints by Frank Eugene: By a Photographer," in: *Camera Notes*, 3, April 1900, pp. 208–213.

Gasser, Manuel (ed.), *München um 1900*, Bern/Stuttgart 1977.

Gebhardt, Heinz, *Königlich-bayerische Photographie 1838–1918*, Munich 1978.

Gelobtes Land. Emanuel von Seidl Parklandschaft in Murnau, Schloßmuseum, Murnau 1993.

Götz, Norbert und Clementine Schack-Simitzis (ed.), *Die Prinzregentenzeit*, Münchner Stadtmuseum, Munich 1988.

Grassinger, Peter, *Münchner Feste und die Allotria*, Dachau 1990.

Green, Jonathan (ed.), *Camera Work: A Critical Anthology*, New York 1973.

Grolman, Dr. von, "Die Erste Internationale Ausstellung für künstlerische Bildnis-Photographie in Wiesbaden Juni 1903," in: *Deutsche Kunst und Dekoration*, 12, 1903, pp. 473–496.

Hammond, Anne (ed.), *Frederick H. Evans. Selected texts and bibliography*, Oxford 1992.

Harker, Margaret F., *The Linked Ring. The Secession movement in photography in Britain 1892–1910*, London 1979.

Hartmann, Sadakichi, "Portrait Painting and Portrait Photography," in: *Camera Notes*, 3, July 1899, pp. 3–21.

——, "Frank Eugene. Painter-Photographer," in: *The Photographic Times*, 1899, pp. 555–561.

——, "Texture in Photography," in: *The American Annual of Photography and Photographic Times Almanac*, 1900, pp. 105–109.

——, "Color and Texture in Photography," in: *Camera Notes*, 4, July 1900, no. 1, pp. 9–14

——, "Ein Rückblick auf die Saison in Amerika 1900 bis 1901," in: *Photographische Rundschau*, 1901, pp. 237–240.

——, "A Photographic Enquête," in: *Camera Notes*, 5, 1901/02, pp. 233–238.

——, "On Genre," in: *Camera Notes*, 6, 1902, pp. 10–12.

——, "Amerikanische Kunstphotographie. Eine zeitgenössische Studie," in: *Dekorative Kunst*, 12, 1905, pp. 330–336.

Haus, Andreas, "Gesellschaft, Gesellgkeit, Künstlerfest. Franz von Lenbach und die Münchner 'Allotria'" in: *Catalogue Franz von Lenbach 1839–1904*, Städtische Galerie im Lenbachhaus, Munich 1986.

Heißerer, Dirk, *Wo die Geister wandern. Eine Topographie der Schwabinger Bohème um 1900*, Munich 1993.

Herz, Rudolf and Brigitte Bruns (ed.), *Hofatelier Elvira 1887–1928. Ästheten, Emanzen, Aristokraten*, Fotomuseum im Münchner Stadtmuseum, Munich 1985.

Hinrichs, Dieter, "Die Geschichte der Photoschule," in: *Lichtblick. Informationsblatt der Freunde und Förderer der Bayerischen Staatslehranstalt für Photographie in Munich 1985–1987*, Munich.

Hoerner, Ludwig, *Das fotografische Gewerbe in Deutschland 1839–1914*, Düsseldorf 1989.

Holme, Charles (ed.), *Art in Photography. With Selected Examples of European and American Work*, The Studio, London 1905.

—— (ed.), *Colour Photography and other recent developments of the Art of the camera*, The Studio, London 1908.

Homer, William Innes, *Alfred Stieglitz and the American Avant-Garde*, Boston 1977.

——, *Alfred Stieglitz and the Photo-Secession*, Boston 1983, pp. 97–101.

Honnef, Klaus (ed.), *Lichtbildnisse. Das Porträt in der Fotografie*, Cologne 1982.

Hummel, Rita, *Die Anfänge der Münchener Secession: Eine kulturpolitische Studie*, Dissertation, Munich 1982.

Jahrbücher der Lehr- und Versuchsanstalt für Photographie, Chemiegraphie, Lichtdruck und Gravüre zu München, Munich 1907–1914.

Juhl, Ernst, (ed.) *Camera Kunst: Eine internationale Sammlung von Kunst-Photographien der Neuzeit*, Berlin 1903.

Jussim, Estelle, *Slave to Beauty. The Eccentric Life and Controversial Career of F. Holland Day Photographer, Publisher, Aesthete*, Boston 1981.

Kaufhold, Enno, *Bilder des Übergangs. Zur Mediengeschichte von Fotografie und Malerei in Deutschland um 1900*, Marburg 1985.

——, "Künstler und Medien. Fragen nach den Ausdrucksmitteln um 1900," in: Gottfried Jäger, *Bildschaffende Konzepte: Janzer/Holzhäuser/Kammerichs/Sal*, Leinfelden-Echterdingen 1987, pp. 15–19.

——, *Heinrich Kühn und die Kunstfotografie um 1900*, Berlin 1988.

Keller, Ulrich F., "The Myth of Art Photography: A Sociological Analysis," in: *History of Photography*, 8, 1984, no. 4, pp. 249–275.

——, "The Myth of Art Photography: An Iconographic Analysis," in: *History of Photography*, 9, 1985, no.1, pp. 1–38.

Kemp, Wolfgang (ed.), *Theorie der Fotografie I 1839–1912*, Munich 1980.

Kempe, Erika und Fritz, Heinz Spielmann, *Die Kunst der Camera im Jugendstil*, Frankfurt am Main 1986.

Knapp, Fritz, "Der Symbolismus und die Grenzen der Photographie," in: Fritz Matthies-Masuren (ed.), *Die Photographische Kunst im Jahre 1905*, 4, Halle an der Saale 1905, pp.127–134.

Kunstmann, Joanna Waltraud, *Emanuel von Seidl (1856–1919) Die Villen und Landhäuser*, Munich 1993.

Kunstphotographie um 1900, Museum Folkwang/Museum für Kunst und Gewerbe, Essen/Hamburg 1964.

Kunstphotographie um 1900 in Deutschland, edited by Fritz Kempe, Institut für Auslandsbeziehungen, Stuttgart 1982.

Kunstphotographie um 1900. Die Sammlung Ernst Juhl, Museum für Kunst und Gewerbe, Hamburg 1989.

La photographie d'art vers 1900, edited by Margaret Harker, Brussels 1983.

Lawton, Harry W. and George Knox (ed.), *The Valiant Knights of Daguerre: Selected Critical Essays on Photography and Profiles of Photographic Pioneers by Sadakichi Hartmann*, Berkeley 1978.

Le Salon de Photographie – Les écoles pictorialistes en Europe et aux États-Unis vers 1900, Musée Rodin, Paris 1993.

Leypoldt, Winfried, "Münchens Niedergang als Kunststadt". Kunsthistorische, kunstpolitische und kunstsoziologische Aspekte der Debatte um 1900, Dissertation, Munich 1987.

Lichtwark, Alfred, "Bildniskunst und Bildnisphotographie," in: Alfred Lichtwark, *Aus der Praxis*, Berlin 1902, pp.138–144.

Limbacher, Sandra, *Fotografie als Medium gesellschaftlicher Repräsentation: Der Münchner Porträtfotograf Franz Grainer (1871–1948)*, Masters Thesis, Munich 1994.

Loescher, Fritz, *Die Bildnis-Photographie. Ein Wegweiser für Fachmänner und Liebhaber*, Berlin 1907.

Longwell, Dennis, *Steichen Meisterphotographien 1895–1914. Die Symbolistische Periode*, Tübingen 1978.

Lorenz, Richard, *Imogen Cunningham: ideas without end: a life in photographs*, San Francisco 1993.

Lowe, Sue Davidson, *Stieglitz. A Memoir/Biography*, New York 1983.

Maddow, Ben, *Faces. A narrative history of the portrait in photography*, Boston 1977.

Malerei und Photographie im Dialog von 1840 bis heute, edited by Erika Billeter with texts by J. A. Schmoll gen. Eisenwerth, Bern 1977.

Malerei nach Photographie. Von der Camera Obscura bis zur Pop Art, edited by J. A. Schmoll gen. Eisenwerth and Helga Hoffmann, Münchner Stadtmuseum, Munich 1971.

Matthies-Masuren, Fritz, *Künstlerische Photographie.*

Entwicklung und Einfluss in Deutschland, Berlin 1907.

Michaels, Barbara L., *Gertrude Käsebier. The Photographer and Her Photographs*, New York 1992.

M., W., "Neue Bildnis-Aufnahmen von Frank Eugène Smith"; Paul Fechter, "Das Porträt und die Photographie," in: *Deutsche Kunst und Dekoration*, 15, 1911/12, pp. 74–81.

M., W., "Frank Eugène Smith – Leipzig," in: *Deutsche Kunst und Dekoration*, 17, 1913/14, pp. 62–68.

Michel, Wilhelm, "Neue Photographische Kunstwerke von Frank Eugène Smith," in: *Deutsche Kunst und Dekoration*, 14, 1911, pp. 268–277.

Mühsam, Erich, *Unpolitische Erinnerungen*, Zurich 1962.

Naef, Weston J. (ed.), *The Collection of Alfred Stieglitz. Fifty Pioneers of Modern Photography*, New York 1978.

Norman, Dorothy, *Alfred Stieglitz: An American Seer*, New York 1973.

Offizieller Katalog der Internationalen Photographischen Ausstellung Dresden 1909, Dresden 1909.

Offizieller Katalog der I. Internationalen Elite-Ausstellung künstlerischer Photographien des Vereins Bildender Künstler der Münchener Secession 1898, Munich 1898.

Pachnicke, Peter and Klaus Liebich, "Reproduktion und Eigenausdruck – Geschichte der Abteilung Fotografie," in: *Hochschule für Grafik und Buchkunst Leipzig 1945–1989*, Leipzig 1989, pp. 48–57.

Paintings by Frank Eugene, Blakeslee Galleries, New York 1897.

Palazzoli, Daniela und Luigi Carlucci (ed.), *Combattimenti per un'immagine. Fotografi e pittori*, Museo Civico di Torino, Torino 1973.

Peters, Ursula, *Stilgeschichte der Fotografie in Deutschland 1839–1900*, Cologne 1979.

Peterson, Christian A., *Camera Work: Process and Image*, The Minneapolis Institute of Arts, Minneapolis 1985.

——, "American Arts and Crafts. The Photograph Beautiful 1895–1915," in: *History of Photography*, 16, 1992, No.3, pp.189–232.

——, *Alfred Stieglitz's Camera Notes*, Minneapolis Institute of Arts, London/New York 1993.

Photographie als Kunst 1879–1979 – Kunst als Photographie 1949–1979 (2 volumes), edited by Peter Weiermair, Innsbruck 1979.

Photographische Arbeiten von Frank Eugene Smith, catalogue, Munich 1908.

Photosammlung Stieglitz aus dem Metropolitan Museum New York, Museum Ludwig, Cologne 1980

Pictorial Photography in Britain 1900–1920, Arts Council of Great Britain, London 1978.

Pohlmann, Ulrich, "The Dream of Beauty or Truth is Beauty, Beauty Truth. Photography and Symbolism 1890–1914," in: Jean Clair (ed.), *Lost Paradise: Symbolist Europe*, Museum of Fine Arts, Montreal, pp.428–447.

——, "Der Kunstphotograph Leopold von Glaserfeld und München 1910–1918," in: Gunther Waibl (ed.), *Leopold von Glasersfeld (1871–1954) Photograph/Fotografo/Photographer*, Bozen 1995, pp. 20–31.

Poivert, Michel, *Le pictorialisme en France*, Paris 1992

Prinz, Friedrich und Marita Krauss (ed.), *München – Musenstadt mit Hinterhöfen. Die Prinzregentenzeit 1886–1912*, Münchner Stadtmuseum, Munich 1988.

Raphaels, Julius, "Die Photographie für Maler," in: *Die Kunst für Alle*, 12, 1896/97, pp. 361–364.

Rathje, Ulli (ed.), *Das Auge des Zyklopen. Photographie – Ihre Verfahren, Identifizierung, Bewahrung*, Fotomuseum im Münchner Stadtmuseum, Munich 1989.

Raupp, Karl, "Die Photographie für Maler," in: *Die Kunst für Alle*, 4, 1888/89, pp.325–326.

R., W., "Photographien von Frank Eugene Smith," in: *Dekorative Kunst*, 12, October 1908, pp. 1–8.

Rietzler, Willi, "Zu den Photographien von Frank Eugene Smith," in: *Die Kunst*, 12, 1908/09, pp. 1–8.

Rinker, Dagmar, *Die Lehr- und Versuchs-Ateliers für angewandte und freie Kunst (Debschitz-Schule) München 1902–1914*, Munich 1993.

Rohe, Maximilian K., "Frank Eugene Smith-München," in: *Deutsche Kunst und Dekoration*, 14, 1910, pp. 40–54.

——, "Erziehungsstätte für künstlerische Photographie," in: *Deutsche Kunst und Dekoration*, 14, 1910/11, pp.344–34.

Sachsse, Rolf, "Beginnen wir! Die photographischen Abteilungen der Hochschule für Graphik und Buchkunst in Leipzig zwischen 1890 und 1950," in: Catalogue *Fotografie. 100 Jahre Fotografie an der Hochschule für Grafik und Buchkunst Leipzig*, Leipzig 1993, pp. 7–15.

Schlagintweit, Felix, *Ein verliebtes Leben. Erinnerungen eines Münchner Arztes*, Munich 1967.

Schlittgen, Hermann, *Erinnerungen*, Munich 1926.

Schmitz, Walter (ed.), *Die Münchner Moderne*, Stuttgart 1990.

Schmoll gen. Eisenwerth, J.A., "Lenbach, Stuck und die Rolle der photographischen Bildnisstudie," in: J. A. Schmoll gen. Eisenwerth, Vom Sinn der Photographie, Munich 1980, pp.114–135.

——, "'Akademien' Fotografische Studien des nackten Körpers von Künstlern für Künstler," in: Michael Koehler, Gisela Barche (ed.), *Das Aktfoto. Ansichten vom Körper im fotografischen Zeitalter*, Münchner Stadtmuseum, Munich 1985, pp. 62–115.

——, "Lenbach und die Photographie," in: Rosel Gollek und Winfried Ranke (ed.), *Franz von Lenbach 1836–1904*, Städtische Galerie im Lenbachhaus, Munich 1987, pp. 63–97.

Schrick, Kirsten Gabriele, *Die Münchner Kunststadt-Diskussion 1781–1945*, Vienna 1994.

Seidl, Emanuel von, *Mein Landhaus. Die Erfüllung eines Künstlertraums*, Darmstadt 1910.

Smith, Frank Eugen, "Vom Werdegang der Photographie," in: *Photospiegel. Illustrirte Wochenschrift des Berliner Tageblatts*, 1927, no. 4.

——, "Photographie und Malerei," 1927, in: *Photospiegel. Illustrirte Wochenschrift des Berliner Tageblatts*, 1927, no. 9

——, "Über Linsen und Linsensysteme," in: *Photospiegel. Illustrirte Wochenschrift des Berliner Tageblatts*, 1927, no. 19.

Frank Eugene Smith – Photographische Arbeiten, edited

by Hochschule für Grafik und Buchkunst, Leipzig 1993.

"Frank Eugene Smith." Polizeimeldebogen der Stadt München Signatur PMB S 449, Stadtarchiv München

The Last Decade: The Emergence of Art Photography in the 1890s, edited by Janet E. Buerger, International Museum of Photography at George Eastman House, Rochester 1984.

Then and Now: The Camera Club of New York, 1888–1988, City Gallery, edited by Tony Troncale, New York 1988.

Warstat, Willi, *Die künstlerische Photographie. Ihre Entwicklung, ihre Probleme, ihre Bedeutung*, Leipzig/ Berlin 1913.

Weaver, Jane Calhoun (ed.), *Sadakichi Hartmann Critical Modernist. Collected Art Writings*, University of California Press, Berkeley, Los Angeles, Oxford 1991.

Weaver, Mike, *Alvin Langdon Coburn Symbolist Photographer 1882–1966*, New York 1986.

Wolff, Georg Jakob (ed.), *Münchner Künstlerfeste. Münchner Künstlerchroniken*, Munich 1925.

Wood, John, *The Art of the Autochrome: The Birth of Color Photography*, Iowa City 1993.

Wust, Klaus, *Guardian on the Hudson: the German Society of the City of New York 1784–1984*, New York 1984.

Zacharias, Thomas (ed.), *Tradition und Widerspruch. 175 Jahre Kunstakademie München*, Munich 1985.

Zeitler, Julius, "Neue Lichtbildkunst von Frank Eugene Smith," in: *Deutsche Kunst und Dekoration*, September 1917, no. 12, pp. 351–360.

——, "Frank Eugen Smith als Körperbildner," in: *Die Schönheit*, 16, 1920, pp. 530–536.

Zils, Wilhelm (ed.), *Geistiges und künstlerisches München in Selbstbiographien*, Munich 1913.

Zimmermanns, Klaus, *Friedrich August von Kaulbach 1850–1920. Monographie und Werkverzeichnis*, Munich 1980.

Zeitschriften / Journals

Camera Notes, 1897–1902
Camera Work, 1903–1917
Deutsche Kunst und Dekoration, 1899–1918
Photographische Korrespondenz, 1899–1927
Photographische Kunst, 1902–1917
Photographische Rundschau, 1899–1927
Reclams Universum, 1907–1920
Münchner Illustrirte Zeitung, 1903–1914
Leipziger Illustrierte Zeitung, 1907–1922

Documente / Documents

Ninety-three letters from Frank Eugene Smith to Alfred Stieglitz, 2 letters from Alfred Stieglitz to Frank Eugene Smith, 1900–1927, Stieglitz Archives, Collection of American Literature, Beinecke Rare Book and Manuscript Library, Yale University, New Haven Connecticut.

Private correspondence (letters, postcards) from Frank Eugene Smith to Johanna Trietschler 1914–1920, Estate of Johanna Heisig, Dippoldiswalde.

Correspondence between Prof. Heinrich Wieynck, Staatliche Kunstgewerbebibliothek Dresden, and Frank Eugene Smith, 1924/25 (4 letters, 2 postcards), Archive Germanisches Nationalmuseum, Nürnberg.

Letters from Adolf Hengeler and Frank Eugene Smith to Hugo von Habermann, 1907/08, Archive Städtische Galerie Würzburg.

Two letters from Alfred Walter von Heymel to Frank Eugene Smith, 1912, Deutsches Literaturarchiv/Schiller-Nationalmuseum, Marbach am Neckar.

Five letters from Frank Eugene Smith to Alfred Walter von Heymel, 1912/13, Deutsches Literaturarchiv/Schiller-Nationalmuseum, Marbach am Neckar.

Two letters from Frank Eugene Smith to Hubert Wilm, 1909 and 1912, Literaturarchiv Monacensia, München.

Five letters from Frank Eugene Smith to Oliva Kern, 1930–36, Private collection, Freiburg im Breisgau.

One postcard from Frank Eugene Smith to Fred Holland Day, 1904, The Norwood Historical Society, Archive F. H. Day, Norwood, Massachusetts.

List with 133 photographs, Department of Prints and Photographs, Metropolitan Museum of Art, New York.

Certificate of birth, passport, exhibitionlists, correspondence etc., Fotomuseum im Münchner Stadtmuseum.

Anmerkungen

Ulrich Pohlmann, Schönheit ist Seele, S. 17–114

1

Georg Heinrich Emmerich, ›Ästhetische Kultur in der Photographie‹, in: *Jahrbuch der Lehr- und Versuchsanstalt für Photographie, Chemigraphie, Lichtdruck und Gravüre zu München*, München 1907/08, S. 7.

2

Hermine Selinger wurde am 19.12.1838 in Gottenheim geboren; sie starb 1916 in New York City.

3

Der Stammbaum der Familie Selinger aus Gottenheim geht auf Joseph Selinger (*2.8.1710 Merdingen, †8.10.1787 Gottenheim), Bruder des bekannten, aus Merdingen stammenden Barockbildhauers Johann Baptist Selinger (1714–1779) und seine Frau Maria Anna Erhard aus Gottenheim zurück. Johann Selinger (*11.3.1807), seit dem 3.7.1831 mit Magdalena Stehle (*16.3.1811) verheiratet, hatte laut Taufregister neun Kinder. Brief von Franz Schmid, Merdingen 24.04.1989.

4

Frederick Smith war im Jahre 1831 geboren. Vgl. Kopie des Geburtszertifikates von Frank Eugene Smith, ausgestellt in New York am 4.12.1914. Archiv Fotomuseum im Münchner Stadtmuseum.

5

Zit. nach Christine Hansen, ›Die deutsche Auswanderung im 19. Jahrhundert. Ein Mittel zur Lösung sozialer und sozialpolitischer Probleme?‹, in: Günter Moltmann (Hrsg.), *Deutsche Amerikaauswanderung im 19. Jahrhundert*, Stuttgart 1976, S. 41.

6

Auswanderungsakte Hermine Selinger, Zugang B 694/1, Nr. 849, Staatsarchiv Freiburg.

7

In New York lebte mit Pius Selinger (*15.7.1849) auch ein Bruder von Hermine Selinger.

8

Karlina Smith (1860–1936) trat als Solosängerin in Kirchen auf und war als Deutschlehrerin in New York im öffentlichen Schuldienst tätig. Ihre jüngere Schwester Annie Smith (1862–1940) arbeitete im Kindergarten als Erzieherin. Robert F. Smith (1867–1954) lehrte Mathematik und Astronomie als Professor am City College in New York, während Frederick (›Fredy‹) Lorenz Smith (1875–1946) in seiner Jugend als Solosänger auftrat.

9

Laut Statistik des U.S. Bureau of the Census kamen von 2.814.554 Einwanderern von 1850 bis 1859 insgesamt 976.072 aus Deutschland (34.7%). Vgl. Klaus Wust und Heinz Moos, *Dreihundert Jahre Deutsche Einwanderer in Nordamerika 1683–1983*, dtsch./engl., Gräfelfing 1983, S. 110. Vgl. zur Auswanderung Klaus J. Bade (Hrsg.), *Deutsche im Ausland. Fremde in Deutschland. Migration in Geschichte und Gegenwart*, München 1992, S. 135–185.

10

Brief von Frances Smith Hendley an den Autor, New York 12.3.1994. Als sich Eugene als 21jähriger Student in der Münchner Akademie im Dezember 1886 einschrieb, gab er als Beruf seines Vaters ›Privatier‹ an.

11

Robert Ernst, *Immigrant Life in New York City 1825–1863*, New York 1979, S. 42. Vgl. auch Kenneth A. Scherzer, *The Unbounded Community. Neighbourhood Life and Social Structure in New York City, 1830–1875*, Durham/London 1992.

12

Vgl. Carl Wittke, *The German-Language Press in America*, University of Kentucky Press, 1957, S. 44–46.

13

Vgl. *History of the Liederkranz of the City of New York 1847 to 1947 and of the Arion*, New York 1948; Klaus Wust, *Guardian on the Hudson: the German Society of the City of New York 1784–1984*, New York 1984.

14

Christoph Ernst, ›Die Schleuse Lower East Side‹, in: *Süddeutsche Zeitung am Wochenende*, Nr. 66, 19./20.3.1988, S. 3.

15

Frank Eugene Smith an Oliva K., Dezember 1936, Privatsammlung. »Nun habe ich auch als kleiner Bua mit 13 Jahren in einer Jesuitenkirche in New York jeden Sonntag (Alt-Stimme) gesungen und die schönen, schlichten, alten Melodien gehen heute noch in meiner Erinnerung umanander!«

16

Zum Collegeleben in den 1870er Jahren vgl. Philip J. Mosenthal und Charles F. Horne, *The City College: Memories of Sixty Years*, New York 1907, S. 252–301.

17

List of Admissions City College of New York 1879, No. 86, Archiv City College of New York.

18

Frank Eugene Smith an Francis Bruguière, Winter 1935/36, Archiv George Eastman House, Rochester, New York.

19

Matrikelbuch der Königlichen Akademie der Bildenden Künste, München 1884–1920, Nr. 363. Archiv Akademie der Bildenden Künste München.

20

Vgl. Ekkehard Mai, ›Akademie, Sezession und Avantgarde. München um 1900‹, in: Thomas Zacharias (Hrsg.), *Tradition und Widerspruch. 175 Jahre Kunstakademie München*, München 1985, S. 160.

21

Andrea Grösslein, *Die internationalen Kunstausstellungen der Münchner Künstlergenossenschaft im Glaspalast in München von 1869 bis 1888*, München 1987, S. 163.

22

Susanne Böller, *Amerikanische Maler an der Münchner Kunstakademie 1850–1920*, Magisterarbeit, Stuttgart 1993.

23

Katalog *Ausstellung von Werken der Diez. Schule aus den Jahren 1870–1890*, Galerie Heinemann, München 1907, S. 4.

24

›Wilhelm von Diez‹, *Allgemeines Lexikon der Bildenden Künstler von der Antike zur Gegenwart*, hrsg. von Ulrich Thieme, Bd. 9, Leipzig 1913, S. 282.

25

Hermann Stockmann, ›Wilhelm von Diez zum Gedächtnis. Persönliche Erinnerungen von Diez-Schülern‹, in: *Allgemeine Zeitung* Nr. 208, 4.5.1907, S. 3.

26

Zahlreiche Aufnahmen des ›Waldfestes mit Erstürmung von Burg Schwaneck‹, photographiert von Johann Baptist Obernetter, sowie Aufnahmen von dem Künstlerfest ›Der Einzug Karls V. in Antwerpen‹ (1876), photographiert von Edgar Hanfstaengl, befinden sich in der Sammlung des Fotomuseums im Münchner Stadtmuseum.

27

Hermann Stockmann, Anm. 25.

28

Zit. nach Susanne Böller, Anm. 22, S. 54.

29

Alexander Heilmeyer, ›Ausstellung von Werken der Diez-Schule‹, in: *Allgemeine Zeitung*, 20.11.1907, Nachlaß Hyazinth Holland, Handschriften-Abteilung der Bayerischen Staatsbibliothek, München.

30

Vgl. Susanne Böller, Anm. 22, S. 61. Brigitte Langer, *Das Münchner Künstleratelier des Historismus*, Dachau 1992.

31

Emil Heibut, in: *Tag*, 1907, zit. nach *Münchner Neueste Nachrichten*, 28.2.1907.

32

»Wer hat wie Meister Diez Pferde gezeichnet? Vom Karrengaul und Postklepper bis zum breitrückigen Kavalleriepferd, das zu derselbigen Zeit noch alle Gangarten mit maßvoller Überlegung und Behaglichkeit vollführte? Mit ein paar sicheren Strichen gibt er jede Eigentümlichkeit, gibt er Stimmung. Bewegung mit einer Meisterschaft wieder, die nicht übertroffen werden kann.« Ludwig Thoma, ›Wilhelm von Diez‹, in: *März*, 1, Nr. 7, 1907.

33

Susanne Böller, Anm. 22, S. 16.

34

Postkarte von Frank Eugene Smith, ohne Datum, Archiv Fotomuseum im Münchner Stadtmuseum. Eugene hat die verwandtschaftlichen Beziehungen nach Baden zeit seines Lebens gepflegt.

35

Zeugnis der Königlich Bayerischen Akademie der Bildenden Künste in München vom 22.11.1907, Archiv Fotomuseum im Münchner Stadtmuseum.

36

Katalog Ausstellung, Anm. 23. Vgl. die ausführlichen, meist euphorischen Ausstellungsberichte, z.B. in *Allgemeine Zeitung*, Nr. 522, 10.10.1907, S. 5.

37

Klaus Bade, Anm. 9, S. 175.

38

Hermann Schlittgen, *Erinnerungen*, Hamburg 1947, S. 91.

39

Vgl. Markus Harzenetter, Zur

Notes

Ulrich Pohlmann, Beauty is Soul, pp. 15–115

1
Georg Heinrich Emmerich, "Ästhetische Kultur in der Photographie," in: *Jahrbuch der Lehr- und Versuchsanstalt für Photographie, Chemigraphie, Lichtdruck und Gravüre zu München*, Munich 1907/08, p. 7.

2
Hermine Selinger was born in Gottenheim on December 19, 1838; she died in 1916 in New York City.

3
The family tree of the Selingers from Gottenheim goes back to Joseph Selinger (*August 2, 1710 Merdingen, † October 8, 1787 Gottenheim), brother of the famous Baroque sculptor Johann Baptist Selinger (1714–1779) who was born in Merdingen, and his wife Maria Anna Erhard from Gottenheim. Johann Selinger (*March 11, 1807), married Magdalena Stehle (*March 16, 1811) on July 3,1831, and had nine children with her, according to the baptismal register. Letter from Franz Schmid, Merdingen April 24, 1989.

4
Frederick Smith was born in 1831. Cf. copy of Frank Eugene Smith's birth certificate, issued in New York on December 4, 1914, Archive Fotomuseum im Münchner Stadtmuseum.

5
Quoted from Christine Hansen, "Die deutsche Auswanderung im 19. Jahrhundert. Ein Mittel zur Lösung sozialer und sozialpolitischer Probleme?," in: Günter Moltmann (ed.), *Deutsche Amerikaauswanderung im 19. Jahrhundert*, Stuttgart 1976, p. 41.

6
Hermine Selinger's emigration file, Zugang B 694/1, no. 849, Staatsarchiv Freiburg.

7
A brother of Hermine Selinger also lived with Pius Selinger (*July 15, 1849) in New York.

8
Karlina Smith (1860–1936) performed as a soloist in churches and was a teacher of German in New York. Her younger sister Annie Smith (1862–1940) worked in a kindergarten. Robert F. Smith (1867–1954) taught mathematics and astronomy as Professor at the City College in New York. Their brother Frederick ("Fredy") Lorenz Smith (1875–1946) also performed as a soloist in his youth.

9
According to statistics of the U.S. Bureau of the Census, 976,072 of the 2,814,554 people who immigrated to the USA between 1850 and 1859 were German (34.7 %). Cf. Klaus Wust and Heinz Moos, *Dreihundert Jahre Deutsche Einwanderer in Nordamerika 1683–1983*, German/English, Gräfelfing 1983, p. 110.
On immigration cf. Klaus J. Bade (ed.), *Deutsche im Ausland. Fremde in Deutschland. Migration in Geschichte und Gegenwart*, Munich 1992, p. 135–185.

10
Letter from Frances Smith Hendley to the author, New York March 12, 1994. When Eugene enrolled in the Academy in Munich at 21 years of age, he gave his father's profession as "a man of private means."

11
Robert Ernst, *Immigrant Life in New York City 1825–1863*, New York 1979, p. 42. Cf. also *Kenneth A. Scherzer, The Unbounded Community. Neighbourhood Life and Social Structure in New York City, 1830–1875*, Durham/London 1992.

12
Cf. Carl Wittke, *The German-Language Press in America*, University of Kentucky Press, 1957, pp. 44–46.

13
Cf. *History of the Liederkranz of the City of New York 1847 to 1947 and of the Arion*, New York 1948; Klaus Wust, *Guardian on the Hudson: the German Society of the City of New York 1784–1984*, New York 1984.

14
Christoph Ernst, "Die Schleuse Lower East Side," in: *Süddeutsche Zeitung am Wochenende*, no. 66, March 19/20, 1988, p. 3.

15
Frank Eugene Smith to Oliva K., December 1936, private collection. "As a little lad of 13 I sang in a Jesuit church in New York every Sunday (alto) and the lovely simple old melodies still linger in my memory today!"

16
On college life in the 1870s cf. Philip J. Mosenthal and Charles F. Horne, *The City College: Memories of Sixty Years*, New York 1907, pp. 252–301.

17
List of Admissions City College of New York 1879, no. 86, Archive City College of New York.

18
Frank Eugene Smith to Francis Bruguière, winter 1935/36, Archive George Eastman House, Rochester, New York.

19
Matrikelbuch der Königlichen Akademie der Bildenden Künste, Munich 1884–1920, no. 363, Archive Akademie der Bildenden Künste München.

20
Cf. Ekkehard Mai, "Akademie, Sezession und Avantgarde. München um 1900," in: Thomas Zacharias (ed.), *Tradition und Widerspruch. 175 Jahre Kunstakademie München*, München 1985, p. 160.

21
Andrea Grösslein, *Die internationalen Kunstausstellungen der Münchner Künstlergenossenschaft im Glaspalast in München von 1869 bis 1888*, Munich 1987, p. 163.

22
Susanne Böller, *Amerikanische Maler an der Münchner Kunstakademie 1850–1920*, Master's Thesis, Stuttgart 1993.

23
Catalogue *Ausstellung von Werken der Diez. Schule aus den Jahren 1870–1890*, Galerie Heinemann, Munich 1907, p. 4.

24
"Wilhelm von Diez," *Allgemeines Lexikon der Bildenden Künstler von der Antike bis zur Gegenwart*, ed. by Ulrich Thieme, vol. 9, Leipzig 1913, p. 282.

25
Hermann Stockmann, "Wilhelm von Diez zum Gedächtnis. Persönliche Erinnerungen von Diez-Schülern," in: *Allgemeine Zeitung* no. 208, May 4, 1907, p. 3.

26
Numerous photographs of the "Waldfestes mit Erstürmung von Burg Schwaneck," taken by by Johann Baptist Obernetter, as well as photographs of the Künstlerfest "Der Einzug Karls V. in Antwerpen" (1876), taken by Edgar Hanfstaengl, can be found in the collection of the Fotomuseum in the Münchner Stadtmuseum.

27
Hermann Stockmann, footnote no. 25.

28
Quoted from Susanne Böller, footnote no. 22, p. 54.

29
Alexander Heilmeyer, "Ausstellung von Werken der Diez-Schule," in: *Allgemeine Zeitung*, 20.11.1907, Estate of Hyazinth Holland, Handschriften-Abteilung der Bayerischen Staatsbibliothek, München.

30
Cf. Susanne Böller, footnote no. 22, p. 61. Brigitte Langer, *Das Münchner Künstleratelier des Historismus*, Dachau 1992.

31
Emil Heibut, in: *Tag*, 1907, quoted from *Münchner Neueste Nachrichten*, Feb. 28, 1907.

32
"Who could paint horses like Master Diez? From a cart-horse to a mail coach nag to a wide-backed cavalry horse, that at one and the same time performed all his paces with measured consideration and comfort. In just a few confident strokes he reproduced each and every peculiarity, atmosphere, and movement with a mastery which is impossible to exceed." Ludwig Thoma, "Wilhelm von Diez," in: *März*, 1, no. 7, 1907.

33
Susanne Böller, footnote no. 22, p. 16.

34
Postcard from Frank Eugene Smith, not dated, Archive Fotomuseum in the Münchner Stadtmuseum. All through his life Eugene stayed in contact with his relatives in Baden.

35
Zeugnis der Königlich Bayerischen Akademie der Bildenden Künste in München vom 22.11.1907, Archive Fotomuseum in the Münchner Stadtmuseum.

36
Exhibition catalogue, footnote no. 23. Cf. the extensive, mostly enthusiastic exhibition reviews, for example in *Allgemeine Zeitung*, no. 522, October 10, 1907, p. 5.

37
Klaus Bade, footnote no. 9, p. 175.

38
Hermann Schlittgen, *Erinnerungen*, Hamburg 1947, p. 91.

39
Cf. Markus Harzenetter, *Zur*

Münchner Secession. Genese. Ursachen und Zielsetzungen dieser intentionellen neuartigen Münchner Künstlervereinigung, Dissertation, München 1992.

40
Berndt Ostendorf, ›»The Diluted Second Generation«. German-Americans in Music, 1870 to 1920‹, in: Hartmut Keil (Hrsg.), *German Workers' Culture in the United States 1850 to 1920*, Washington/London, S. 261–287; zum Einfluß der Deutschen auf die amerikanische Malerei und Bildhauerei vgl. Albert G. Faust, *Das Deutschtum in den Vereinigten Staaten in seiner Bedeutung für die amerikanische Kultur*, Leipzig 1912, S. 269–297.

41
Vgl. Chrysanthemum (d.i. Sadakichi Hartmann), ›The Players' Club‹, in: *Sonntagsblatt der New Yorker Staats-Zeitung*, 15. Oktober 1899, S.19.

42
Heute beherbergt der Club eine Bücherei und eine theaterhistorische Sammlung von Dokumenten, Gemälden, Photographien, Requisiten und Memorabilia. Vgl. Katalog *Edwin Booth's Legacy: Treasures from The Hampden-Booth Theatre Collection at The Players*, bearbeitet von Raymond Wemmlinger und Brooks McNamara, New York 1989; John Tebbel, *A Certain Club. One Hundred Years of The Players*, New York 1989.

43
Frank Eugene Smith an Francis Bruguière, 3.3.1933, 12.5.1936, Archiv George Eastman House, Rochester, New York.

44
The Critic, Vol. 22, No. 581, 1898, S. 220.

45
›Two Artists Pictured‹ in: *New York Tribune Illustrated Supplement*, Sunday June 26, 1898, S. 3.

46
Ebd.

47
Typeskript Gemälde der New York Historical Society, Nr. 1044, Archiv Fotomuseum im Münchner Stadtmuseum

48
Vgl. Marchal E. Landgren, *Robert Loftin Newman (1827–1912)*,

Smithsonian Institution, Washington D.C. 1973.

49
Vgl. William Innes Homer und Lloyd Goddrich, *Albert Pinkham Ryder Painter of Dreams*, New York 1989; Elisabeth Brown, *Albert Pinkham Ryder*, National Museum of American Art, Washington D.C. 1990.

50
Eugene erwähnt in einem Brief an Francis Bruguière seine Freundschaft mit Newman und Ryder, von denen er Zeichnungen und Gemälde besaß, die heute verschollen sind. Vgl. Frank Eugene Smith an Francis Bruguière, 12.5.1936, Archiv George Eastman-House, Rochester, New York.

51
Vgl. Katalog *Paintings by Frank Eugene*, Blakeslee Galleries, 353 Fifth Ave., Cor. 34th Street, New York, March 3 to 27, 1897.

52
Sadakichi Hartmann erwähnt als weiteres Rollenporträt Eugenes Mrs. Cora Potter als Marie Antoinette, in: Sadakichi Hartmann, ›Frank Eugene. Painter-Photographer‹, in: *The Photographic Times*, 31, 1899, S. 555. Cora Potter wurde auch von Fred Holland Day porträtiert. Vgl. Weston J. Naef (Hrsg.), *The Collection of Alfred Stieglitz. Fifty Pioneers of American Photography*, New York 1978, S. 316.

53
Berndt Ostendorf, Anm. 40.

54
Dieses Gemälde soll sich angeblich auch im Besitz von Joseph Jefferson befunden haben. Vgl. Sadakichi Hartmann, Anm. 52.

55
Reclams Opernlexikon von Rolf Fath, Stuttgart 1989, S. 102.

56
Typeskript, Anm. 47, Nr. 297, Archiv Fotomuseum im Münchner Stadtmuseum.

57
New York Tribune Illustrated Supplement, Sunday June 26, 1898, S. 3. Das Gemälde sollte von Freunden Seidls gekauft werden, verblieb jedoch im Besitz der Familie Smith. Vgl. *The Critic*, Juli–August 1898, Vol. 33, Nr. 854, S.19.

58
Catalogue of the International Exhibition Pictorial Photography, Albright Art Gallery, Buffalo 1910, S. 27.

59
Vgl. die Untersuchungen von J.A. Schmoll gen. Eisenwerth, ›Lenbach und die Photographie‹, in: Rosel Gollek, Winfried Ranke (Hrsg.), *Franz von Lenbach 1836–1904*, Lenbachhaus, München 1987, S. 63–97; ders., ›Lenbach, Stuck und die Rolle der photographischen Bildnisstudie‹, in: J. A. Schmoll gen. Eisenwerth, *Vom Sinn der Photographie. Texte aus den Jahren 1952–1980*, München 1980, S. 114–135. Auch bei den Münchner Künstlern Wilhelm Leibl und dem Bildhauer Adolf von Hildebrand wurde die Verwendung von Photostudien nachgewiesen.

60
Vgl. Andreas Meyer, *Annäherung ›Ein Sorgenkind‹ von Hugo von Habermann*, Städtische Galerie, Würzburg 1994.

61
Veröffentlichung von Photographien Paul Hoeckers in: *Photographisches Centralblatt*, 4, 1898, S. 185–195.

62
Karl Raupp, ›Die Photographie in der modernen Kunst‹, in: *Die Kunst für Alle*, 4, 1888/89, S. 326.

63
Ebd., S. 325–326.

64
Julius Raphaels, ›Die Photographie für Maler‹, in: *Die Kunst für Alle*, 12, 1896/97, S. 562–563.

65
Sadakichi Hartmann, ›Die Kunst-Photographie in ihrer Beziehung zur Malerei‹, in: *Sonntagsblatt der New Yorker Staats-Zeitung*, 30.1.1898, S. 17, cols 1–6, illustriert mit Zeichnungen nach Photographien von F. Holland Day und Alfred Stieglitz. Hartmann schrieb erstmals über Eugene als Maler in der Kolumne ›Art and Artists‹ in: *Musical America*, 1, October 22, 1898, S. 27, zit. nach Jane Calhoun Weaver (Hrsg.), *Sadakichi Hartmann Critical Modernist. Collected Art Writings*, Los Angeles, Oxford 1991.

66
Zu den zahlreichen Pseudony-

men von Sadakichi Hartmann zählten Chrysanthemum, Hogarth, Juvenal, Caliban, A. Chameleon und insbesondere Sidney Allan, das er ausschließlich für Artikel über Photographie verwendete. Außerdem verfaßte Hartmann die Bücher *Shakespeare in Art* (1901), *A History of American Art* (1902), *Japanese Art* (1903) und *The Whistler Book* (1910).

67
Sadakichi Hartmann, ›Texture in Photography‹, in: *The American Annual in Photography and Photographic Times Almanac*, 1900, S. 109.

68
Sadakichi Hartmann, ›Die Ausstellungen amerikanischer Kunst-Photographen im Camera-Klub zu New-York‹, in: *Photographischer Motivenschatz der Allgemeinen Photographen Zeitung*, 6, 1900, S. 87–88. In einem Brief Hartmanns an Stieglitz vom 2.9.1904 hieß es: »It was a similar case as once with Eugene whom you call ›the sloppy fellow with the black finger nails, I don't want him to come to my home‹ until he revealed himself as a fairly good photographer.« (zit. nach Harry W. Lawton, George Knox (Hrsg.), *The Valiant Knights of Daguerre: Selected Critical Essays on Photography and Profiles of Photographic Pioneers by Sadakichi Hartmann*, Berkeley 1978, S. 316)

69
Sadakichi Hartmann, Anm. 52, S. 555.

70
Vgl. Katalog *An Exhibition of Prints by Frank Eugene*, New York City, Nov. 15–30, 1899.

71
Sadakichi Hartmann, Anm. 52, S. 558.

72
Hugo Erfurth, ›Die Entwicklung der Bildnisphotographie‹, in: *Photographische Korrespondenz*, 50, 1913, Nr. 631, S. 191.

73
Vgl. *Cliché-verre: Hand-Drawn, Light-Printed. A Survey of the Medium from 1839 to the Present*, Detroit 1980, S. 27–44; Helmut Gernsheim, *Geschichte der Photographie. Die ersten hundert*

Jahre, Frankfurt am Main 1983, S. 301–303.

74
Vgl. Dallett Fuguet, ›By a photographer‹, in: *Camera Notes*, 3, April 1900, S. 208–213.

75
J. Wells Champney, ›Reviews of the Exhibition of Prints by Frank Eugene. By a painter‹, in: *Camera Notes*, 3, April 1900, S. 207.

76
Sadakichi Hartmann, Anm. 52, S. 555–561.

77
Sadakichi Hartmann, ›Color and Texture in Photography‹, in: *Camera Notes*, 4, Juli 1900, Nr. 1, S. 9–14. Sadakichi Hartmann, Anm. 67, S. 105–109, illustriert mit ›Dogwood‹, ›Summer‹, ›Portrait of Sadakichi Hartmann‹, ›The Sisters‹ und ›Man in Armor‹.

78
Sadakichi Hartmann, Anm. 52, S. 561. Michael Bartram, *The Pre-Raphaelite Camera*, Boston 1985, S. 178–179. Vgl. ausführlich den Beitrag von Axel Effner in diesem Buch.

79
Zum Einfluß japanischer Kunst auf die Kunstphotographie siehe Sidney Allan, ›The Influence of Artistic Photography on Interior Decoration‹, in: *Camera Work*, April 1903, Nr. 2, S. 31–33; Sadakichi Hartmann, ›Repetition, with slight variation‹, in: *Camera Work*, Januar 1903, Nr. 1, S. 30–34. Katalog *Le Japonisme*, Grand Palais, Paris 1988, S. 240–253.

80
Sadakichi Hartmann, Anm. 68, S. 87–88.

81
Vgl. *Photographische Rundschau*, 14, 1900, S. 88–89; *Photographischer Motivenschatz der Allgemeinen Photographischen Zeitung*, 7, 1900, S. 81ff., der mit ›The Hopkins Sisters‹ von Eugene illustriert war.

82
Vgl. Margaret Harker, *The Linked Ring. The Secession Movement in Photography in Britain, 1892–1910*, London 1979. Zu den Zielen des Salons vgl. auch Joseph T. Keiley, ›The Pictorial Movement in Photography and the Significance of the Modern Pho-

Münchner Secession. Genese, Ursachen und Zielsetzungen dieser intentionellen neuartigen Münchner Künstlervereinigung, Dissertation, Munich 1992.

40

Berndt Ostendorf, "'The Diluted Second Generation.' German-Americans in Music, 1870 to 1920," in: Hartmut Keil (ed.), *German Workers' Culture in the United States 1850 to 1920*, Washington/London, pp. 261–287; on the influence of the Germans on American painting and sculpture cf. Albert G. Faust, *Das Deutschtum in den Vereinigten Staaten in seiner Bedeutung für die amerikanische Kultur*, Leipzig 1912, pp. 269–297.

41

Cf. Chrysanthemum (i.e. Sadakichi Hartmann), "The Players' Club," in: *Sonntagsblatt der New Yorker Staats-Zeitung*, October 15, 1899, p. 19.

42

Today the Club houses a library and a collection of documents, paintings, photographs, props and memorabilia related to the history of the theater. Cf. Catalogue *Edwin Booth's Legacy: Treasures from The Hampden-Booth Theatre Collection at The Players*, ed. by Raymond Wemmlinger and Brooks McNamara, New York 1989; John Tebbel, *A Certain Club. One Hundred Years of The Players*, New York 1989.

43

Frank Eugene Smith to Francis Bruguière, March 3, 1933, May 12, 1936, Archive George Eastman House, Rochester, New York.

44

The Critic, vol. 22, No. 581, 1898, p. 220.

45

"Two Artists Pictured" in: *New York Tribune Illustrated Supplement*, Sunday, June 26, 1898, p. 3.

46

Ebd.

47

Typeskript Gemälde der New York Historical Society, no. 1044. Archive Fotomuseum im Münchner Stadtmuseum.

48

Cf. Marchal E. Landgren, *Robert Loftin Newman (1827–1912)*,

Smithsonian Institution, Washington D.C. 1973.

49

Cf. William Innes Homer and Lloyd Goddrich, *Albert Pinkham Ryder Painter of Dreams*, New York 1989; Elisabeth Brown, *Albert Pinkham Ryder*, National Museum of American Art, Washington D.C. 1990.

50

In a letter to Francis Bruguière Eugene mentions his friendship with Newman and Ryder, some of whose drawings and paintings he had in his possession but which have since gone missing. Cf. Frank Eugene Smith to Francis Bruguière, May 12, 1936, Archive George Eastman House, Rochester, New York.

51

Cf. catalogue *Paintings by Frank Eugene*, Blakeslee Galleries, 353 Fifth Ave., Cor. 34th Street, New York, March 3 to 27, 1897.

52

Sadakichi Hartmann mentioned another portrait by Eugene of the actress Mrs. Cora Potter in the role of Marie Antoinette, in: Sadakichi Hartmann, "Frank Eugene. Painter-Photographer," in: *The Photographic Times*, 31, 1899, p. 555. Cora Potter was also photographed by Fred Holland Day. Cf. Weston J. Naef (ed.), *The Collection of Alfred Stieglitz. Fifty Pioneers of American Photography*, New York 1978, p. 316.

53

Berndt Ostendorf, "'The Diluted Second Generation.' German-Americans in Music, 1870 to 1920," in: Hartmut Keil (ed.), *German Workers' Culture in the United States 1850 to 1920*, Washington/London, pp. 261–287.

54

This painting is said to have once been in the collection of Joseph Jefferson. Cf. Sadakichi Hartmann, footnote 52, p. 555.

55

Reclams Opernlexikon by Rolf Fath, Stuttgart 1989, p. 102.

56

Typeskript, footnote 47, no. 297, Archive Fotomuseum im Münchner Stadtmuseum.

57

New York Tribune Illustrated

Supplement, Sunday June 26, 1898, p. 3. Friends of Seidles intended to buy the painting, but it remained in the possession of the Smith family. Cf. *The Critic*, July–August 1898, vol. 33, no. 854, p. 19.

58

Catalogue of the International Exhibition Pictorial Photography, Albright Art Gallery, Buffalo 1910, p. 27.

59

Cf. the study by J.A. Schmoll gen. Eisenwerth, "Lenbach und die Photographie," in: Rosel Gollek and Winfried Ranke (ed.), *Franz von Lenbach 1836–1904*, Lenbachhaus, Munich 1987, pp. 63–97; by the same author, "Lenbach, Stuck und die Rolle der photographischen Bildnisstudie," in: J.A. Schmoll gen. Eisenwerth, *Vom Sinn der Photographie. Texte aus den Jahren 1952–1980*, Munich 1980, pp. 114–135. There is also evidence that the Munich artist Wilhelm Leibl and the sculptor Adolf von Hildebrand used photographic studies.

60

Cf. Andreas Meyer, *Annäherung "Ein Sorgenkind" von Hugo von Habermann*, Städtische Galerie, Würzburg 1994.

61

Publications of photographs by Paul Hoeckers in: *Photographisches Centralblatt*, 4, 1898, pp. 185–195.

62

Karl Raupp, "Die Photographie in der modernen Kunst," in: *Die Kunst für Alle*, 4, 1888/89, p. 326.

63

Ebd., pp. 325–326.

64

Julius Raphaels, "Die Photographie für Maler," in: *Die Kunst für Alle*, 12, 1896/97, pp. 562–563.

65

Sadakichi Hartmann, "Die Kunst-Photographie in ihrer Beziehung zur Malerei," in: *Sonntagsblatt der New Yorker Staats-Zeitung*, Jan. 30, 1898, p. 17, cols 1–6, illustrated with drawings from photographs by F. Holland Day and Alfred Stieglitz. Hartmann wrote for the first time on Eugene as a painter in the column "Art and Artists" in:

Musical America, 1, October 22, 1898, p. 27, quoted from Jane Calhoun Weaver (ed.), *Sadakichi Hartmann Critical Modernist. Collected Art Writings*, Los Angeles, Oxford 1991.

66

Among Sadakichi Hartmann's numerous pseudonyms were Chrysanthemum, Hogarth, Juvenal, Caliban, A. Chameleon and in particular Sidney Allan, which he used exclusively for articles about photography. Hartmann was also author of the following books: *Shakespeare in Art* (1901), *A History of American Art* (1902), *Japanese Art* (1903) and *The Whistler Book* (1910).

67

Sadakichi Hartmann, "Texture in Photography," in: *The American Annual in Photography and Photographic Times Almanac*, 1900, p. 109.

68

Sadakichi Hartmann, "Die Ausstellungen amerikanischer Kunst-Photographen im Camera-Klub zu New-York," in: *Photographischer Motivenschatz der Allgemeinen Photographen Zeitung*, 6, 1900, pp. 87–88. In a letter from Hartmann to Stieglitz on September 2, 1904 he wrote: "It was a similar case as once with Eugene whom you call 'the sloppy fellow with the black finger nails, I don't want him to come to my home' until he revealed himself as a fairly good photographer." (quoted from Harry W. Lawton and George Knox, (ed.), *The Valiant Knights of Daguerre: Selected Critical Essays on Photography and Profiles of Photographic Pioneers by Sadakichi Hartmann*, Berkeley 1978, p. 316)

69

Sadakichi Hartmann, footnote no. 52, p. 555.

70

Cf. catalogue *An Exhibition of Prints by Frank Eugene*, New York City, Nov. 15th to 30th, 1899.

71

Sadakichi Hartmann, footnote no. 52, p. 558.

72

Hugo Erfurth, "Die Entwicklung der Bildnisphotographie," in: *Photographische Korrespondenz*, 50, 1913, no. 631, p. 191.

73

Cf. *Cliché-verre: Hand-Drawn, Light-Printed. A Survey of the Medium from 1839 to the Present*, Detroit 1980, pp. 27–44; Helmut Gernsheim, *Geschichte der Photographie. Die ersten hundert Jahre*, Frankfurt am Main 1983, pp. 301–303.

74

Cf. Dallett Fuguet, "By a photographer," in: *Camera Notes*, 3, April 1900, pp. 208–213.

75

J. Wells Champney, "Reviews of the Exhibition of Prints by Frank Eugene. By a painter," in: *Camera Notes*, 3, April 1900, p. 207.

76

Sadakichi Hartmann, footnote 52, pp. 555–561.

77

Sadakichi Hartmann, "Color and Texture in Photography," in: *Camera Notes*, 4, July 1900, no. 1, pp. 9–14. Sadakichi Hartmann, Anm. 67, pp. 105–109, illustrated with "Dogwood," "Summer," "Portrait of Sadakichi Hartmann," "The Sisters" and "Man in Armor."

78

Sadakichi Hartmann, footnote no. 52, p. 561. Michael Bartram, *The Pre-Raphaelite Camera*, Boston 1985, pp. 178–179. Cf. the essay by Axel Effner in this book.

79

On the influence of Japanese art on art photography see Sidney Allan, "The Influence of Artistic Photography on Interior Decoration," in: *Camera Work*, April 1903, no. 2, pp. 31–33; Sadakichi Hartmann, "Repetition, with slight variation," in: *Camera Work*, January 1903, no. 1, pp. 30–34. Catalogue *Le Japonisme*, Grand Palais, Paris 1988, pp. 240–253.

80

Sadakichi Hartmann, footnote no. 68, pp. 87–88.

81

Cf. *Photographische Rundschau*, 14, 1900, pp. 88–89; *Photographischer Motivenschatz der Allgemeinen Photographischen Zeitung*, 7, 1900, pp. 8 ff., which was illustrated with Eugenes "The Hopkins Sisters."

82

Cf. Margaret Harker, *The Linked*

tographic Salon‹, in: *Camera Notes*, 4. Juli 1900, Nr. 1, S. 18–23.

83

Siehe ausführlich Estelle Jussim, *Slave to Beauty: The Eccentric Life and Controversial Career of F. Holland Day. Photographer, Publisher, Aesthete*, Boston 1981, S. 137–152. Eine Kritik zu Eugenes Arbeiten erschien in *The Photographic News*, 1900, S. 701.

84

Vgl. Ulrich Pohlmann, ›The Dream of Beauty, or Truth is Beauty, Beauty Truth. Photography and Symbolism, 1890–1914‹, in: Jean Clair (Hrsg.), *Lost Paradise: Symbolist Europe*, Montreal 1995, S. 428–447.

85

Charles L. Mitchell, ›The Third Philadelphia Photographic Salon‹, in: *The American Amateur Photographer*, 12, Dez. 1900, S. 568.

86

Ebd, S. 561.

87

Vgl. auch Joseph T. Keiley, ›The Decline and Fall of the Philadelphia Salon‹, in: *Camera Notes*, 5, April 1902, Nr. 4, S. 279–284, 287–299.

88

Alfred Stieglitz, ›Letter to the Editor of The American Amateur Photographer, December 29, 1900‹, in: *The American Amateur Photographer*, 13, Jan. 1901, Nr. 1, S. 41–42.

89

Vgl. *The Amateur Photographer*, 12.7.1900, S. 31.

90

Der englische Privatsammler von Kunstphotographien Harald Holcroft besaß neben Eugenes Aufnahme ›Menuett‹ auch zahlreiche Arbeiten von Julia Margaret Cameron, David Octavius Hill & Robert Adamson, Heinrich Kühn, Gertrude Käsebier, Alfred Horsley Hinton, Robert Demachy, C. Puyo, Clarence H. White, Henry P. Robinson, Edward Steichen, Alvin Langdon Coburn, James Craig Annan, Oscar Gustave Rejlander, Rudolf Dührkoop, Theodor und Oskar Hofmeister, Frederick Hollyer und Rudolf Eickemeyer. Vgl. *General Catalogue of Photographs including a historical collection of*

Pictorial Photographs in the possession of Harold Holcroft, 1910, Archiv Royal Photographic Society of Great Britain, Bath.

91

Zit. nach *Camera Work*, April 1906, Nr. 14, S. 33; Vgl. auch Joseph T. Keiley, ›Concerning the Photo-Secession‹, in: *Photo Era*, 11, 1903, S. 314–315; Jerome Mellquist, *Die amerikanische Kunst der Gegenwart*, Berlin 1950, S. 70–87.

92

Camera Work, April 1906, Nr. 14, S. 36.

93

Alfred Stieglitz an Frank Eugene Smith, 8.8.1904, Beinecke Library, New Haven, USA.

94

Eugenes Loyalität ging soweit, daß er nach Erhalt der höchsten Auszeichnung auf der Internationalen Photographischen Ausstellung in Dresden an Stieglitz schrieb, ob er die Medaille an die Organisatoren zurücksenden sollte. Frank Eugene Smith an Alfred Stieglitz, 24.9.1909, Beinecke Library, New Haven, USA.

95

Auskunft von Max Ottmann, Sulzbach-Rosenberg, an den Autor vom 10.3.1989.

96

Gespräch des Autors mit Rosel Kurz, München-Haar, Frühjahr 1989.

97

Vgl. zur Auseinandersetzung über München als ›Kunststadt‹ vor 1914: Winfried Nerdinger, ›Die »Kunststadt« München‹, in: Katalog *München Die zwanziger Jahre*, München 1979, S. 93–119; Kirsten Gabriele Schrick, *Die Münchner Kunststadt-Diskussion 1781–1945*, Wien 1994, S. 57–91.

98

F. v. Ostini, ›Allotria‹, zit. nach Peter Grassinger, *Münchner Feste und die Allotria*, Dachau 1990, S. 60. Vgl. zur Allotria auch den Aufsatz von Andreas Haus, ›Gesellschaft, Geselligkeit, Künstlerfest. Franz von Lenbach und die Münchner »Allotria«‹, in: Rosel Gollek und Winfried Ranke, Anm. 58, S. 99–116.

99

Zit. nach Winfried Leypolt,

›Münchens Niedergang als Kunststadt‹. Kunsthistorische, kunstpolitische und kunstsoziologische Aspekte der Debatte um 1900. Dissertation, München 1987, S. 187. An anderer Stelle schrieb Conrad: »Seidl, Seitz, Miller heißt das Kleeblatt, welches allein beschäftigt wird und wobei immer Einer den Anderen empfiehlt. Bürgermeister Widenmayer ist der Unterhändler dieses Kleeblattes.« M.G. Conrad, ›Aus dem Münchener Kunstleben‹, in: *Die Gesellschaft*, 9, Bd. 1, Leipzig 1893, S. 375, zit. nach Leypoldt, S. 178.

100

Franz Blei, *Erzählung eines Lebens*, Leipzig 1930, S. 350–351.

101

Hans Brandenburg, *München leuchtete. Jugenderinnerungen*, München 1953, S. 270–271.

102

Offizieller Katalog der I. Internationalen Elite-Ausstellung künstlerischer Photographien (...) des Vereins bildender Künstler Münchens (A.V.) ›Secession‹ 1898 im Kgl. Kunstausstellungsgebäude am Königsplatz gegenüber der Glyptothek, München 1898. Vgl. auch *Photographisches Centralblatt*, 4, 1898, S. 415–418, 442–450; 5, 1899, S. 8–15, 45–51. *Photographisches Wochenblatt*, 24, 1898, S. 401–402, 411–412.

103

Fritz Matthies-Masuren, in: Offizieller Katalog, Anm. 102, S. 14.

104

Fritz Matthies-Masuren an Alfred Stieglitz, 25.11.1898, Beinecke Library, New Haven, USA.

105

Vgl. auch den Jahresbericht für das Unterrichtsjahr 1901–02 der Lehr- und Versuchsanstalt für Photographie zu München, 8.7.1902, Archiv Fotomuseum im Münchner Stadtmuseum.

106

Georg Heinrich Emmerich, zit. nach Dieter Hinrichs, ›Die Geschichte der Photoschule (2)‹, in: *Lichtblick*, 3, München 1986.

107

Zu Emmerich vgl. Ulrich Pohlmann, ›Die vergessenen Fotomuseen‹, in: *Fotogeschichte*, 10,

1990, Nr. 35, S. 14–21.

108

Vgl. auch: Anonym, ›Die Lehr- und Versuchsanstalt für Photographie zu München: ihre Einrichtung, ihre Organisation und ihre künstlerischen Prinzipien‹, in: *Photographischer Motivenschatz der Allgemeinen Photographischen Zeitung*, o.Jg., (c. 1900), S. 129–148, Staatsarchiv für Oberbayern, RA Fasz., 3625, Nr. 56949.

109

Bruno Rauecker, *Das Kunstgewerbe in München*, aus: *Münchner Volkswirtschaftliche Studien*, 109, Stuttgart/Berlin 1911, S. 64.

110

Vgl. auch G.H. Emmerich, *Werkstatt des Photographen*, Wiesbaden 1904, S. 4–10, 339–340.

111

1903 war Eugene im zweiten Stock eines Rückgebäudes in der Schwanthalerstraße 41 in München-Schwabing gemeldet. Nach den Münchner Adressbüchern (1904–07) lebte Eugene 1904 in der Landwehrstraße 42, 2. Stock, Rückgebäude, 1905 in Schleißheim, 1906 in der Blütenstraße 9, 3. Stock, Gartenhaus.

112

Fritz Matthies-Masuren, ›Die künstlerische Photographie und Wir‹, in: *Photographische Rundschau und Photographisches Centralblatt*, 20, 1906, S. 3–4. Ähnlich äußerte sich auch Julius Stadler, ›Pinsel und Stift in der Kunstphotographie‹, in: *Photographische Rundschau und Photographisches Centralblatt*, 20, 1906, S. 99–100.

113

Eduard J. Steichen, ›Grenzen‹, in: *Camera-Kunst*, hrsg. von Ernst Juhl, Berlin 1903, S. 12–15.

114

Sadakichi Hartmann, ›Plea for straight photography‹, 1904, in: Harry W. Lawton, Anm. 68, S. 108–114.

115

Die Arbeiten von James Craig Annan und Joseph T. Keiley weisen in der Bildtechnik Einflüsse von Eugenes Methode der »Photoradierung« auf, vgl. Keileys Aufnahme ›A Bacchante‹ (1899) mit Eugenes ›Nirvana‹ (1898), abgebildet im Katalog

Photosammlung Stieglitz aus dem Metropolitan Museum New York, Köln 1980, S. 102–103.

116

Vgl. auch ›Frank Eugene‹, in: G.H. Emmerich (Hrsg.), *Lexikon der Photographie und Reproduktionstechnik*, Wien/Leipzig 1910, S. 696.

117

Allgemeine Zeitung, Nr. 244, 29.5.1907, S. 4.

118

Adolf Hengeler an Hugo von Habermann, 6.5.1907, Archiv Städtische Galerie Würzburg.

119

Vgl. Frank Eugene Smith an Hugo von Habermann, 22.6.1907, Archiv Städtische Galerie Würzburg.

120

Vgl. Bodo von Dewitz, Karin Schuller-Procopovici (Hrsg.), *Hugo Erfurth 1874–1948. Photograph zwischen Tradition und Moderne*, Köln 1992.

121

Vgl. Katalog *Exhibition of Camera-Portraits by E.O. Hoppé*, Royal Photographic Society of Great Britain, London, 6.4.–28.5.1910.

122

Wanda von Debschitz, Ehefrau des Mitbegründers der sogenannten ›Debschitz-Schule‹, Wilhelm von Debschitz, hatte um 1907 im Schulgebäude in der Hohenzollernstraße 21 ein Atelier eröffnet, das sie bis 1914 unterhielt. Als Malerin und Absolventin der Lehr- und Versuchsanstalt für Photographie hat sie »neuzeitliche« Porträts aus den »ersten Kreisen der Künstlerschaft und Gesellschaft Münchens« wie von Hans Pfitzner, L. v. Zumbusch, Franz v. Hösslin, Karl Schmoll von Eisenwerth aufgenommen. Sie beteiligte sich wiederholt erfolgreich an Ausstellungen. Vgl. Prospekt *Atelier Wanda von Debschitz*, Sammlung Hollandiana, Personen, Handschriften-Abteilung der Bayerischen Staatsbibliothek, München. Zu W. v. Debschitz-Kunowski (1870–1935) siehe *Fotografieren heißt teilnehmen. Fotografinnen der Weimarer Republik*, Museum Folkwang, Essen 1994, S. 313–314.

123

Stephanie Ludwig-Held (1871–

Ring. *The Secession Movement in Photography in Britain, 1892–1910*, London 1979. On the aims of the Salon cf. also Joseph T. Keiley, "The Pictorial Movement in Photography and the Significance of the Modern Photographic Salon," in: *Camera Notes*, 4, Juli 1900, no.1, pp.18–23.

83
For details see Estelle Jussim, *Slave to Beauty: The Eccentric Life and Controversial Career of F. Holland Day. Photographer, Publisher, Aesthete*, Boston 1981, pp.137–152. A review of Eugene's work appeared in *The Photographic News*, 1900, p.701.

84
Cf. Ulrich Pohlmann, "The Dream of Beauty, or Truth is Beauty, Beauty Truth. Photography and Symbolism, 1890–1914," in: Jean Clair (ed.), *Lost Paradise: Symbolist Europe*, Montreal 1995, pp.428–447.

85
Charles L. Mitchell, "The Third Philadelphia Photographic Salon," in: *The American Amateur Photographer*, 12, December, 1900, p.568.

86
Ebd., p.561.

87
Cf. also Joseph T. Keiley, "The Decline and Fall of the Philadelphia Salon," in: *Camera Notes*, 5, April 1902, no.4, pp.279–284, 287–299.

88
Alfred Stieglitz, "Letter to the Editor of The American Amateur Photographer, December 29, 1900," in: *The American Amateur Photographer*, 13, January 1901, no.1, pp.41–42.

89
Cf. *The Amateur Photographer*, July 12, 1900, p.31.

90
Alongside Eugene's "Menuett," the English private collector of art photographs Harald Holcroft also owned numerous works by Julia Margaret Cameron, David Octavius Hill & Robert Adamson, Heinrich Kühn, Gertrude Käsebier, Alfred Horsley Hinton, Robert Demachy, C. Puyo, Clarence H. White, Henry P. Robinson, Edward Steichen, Alvin Langdon Coburn, James

Craig Annan, Oscar Gustave Rejlander, Rudolf Dührkoop, Theodor and Oskar Hofmeister, Frederick Hollyer and Rudolf Eickemeyer. Cf. *General Catalogue of Photographs including a historical collection of Pictorial Photographs in the possession of Harold Holcroft*, 1910, Archive Royal Photographic Society of Great Britain, Bath.

91
Quoted from *Camera Work*, April 1906, no.14, p.33; Cf. also Joseph T. Keiley, "Concerning the Photo-Secession," in: *Photo Era*, 11, 1903, pp.314–315; Jerome Mellquist, *Die amerikanische Kunst der Gegenwart*, Berlin 1950, pp.70–87.

92
Camera Work, April 1906, no.14, p.36.

93
Alfred Stieglitz to Frank Eugene Smith, August 8,1904, Beinecke Library, New Haven, USA.

94
Eugene's loyalty went so far that when he was awarded the highest recognition at the International Photography Exhibition in Dresden he wrote asking Stieglitz whether he should return the medal to the organizors. Frank Eugene Smith to Alfred Stieglitz, September 24, 1909, Beinecke Library, New Haven, USA.

95
Information provided to the author on March 10, 1989 by Max Ottmann, Sulzbach-Rosenberg.

96
Conversation by the author with Rosel Kurz, Munich-Haar, spring 1989.

97
On the debate about Munich as an "art city" before 1914 cf. Winfried Nerdinger, "Die "Kunststadt" München," in: Catalogue *München Die zwanziger Jahre*, Munich 1979, pp.93–119; Kirsten Gabriele Schrick, *Die Münchner Kunststadt-Diskussion 1781–1945*, Vienna 1994, pp.57–91.

98
F. v. Ostini, "Allotria," quoted from Peter Grassinger, *Münchner Feste und die Allotria*, Dachau 1990, p.60. For further information on Allotria cf. Andreas Haus, "Gesellschaft, Geselligkeit,

Künstlerfest. Franz von Lenbach und die Münchner 'Allotria'," in: Rosel Gollek, footnote 59, pp.99–116.

99
Quoted from Winfried Leypolt, *"Münchens Niedergang als Kunststadt." Kunsthistorische, kunstpolitische und kunstsoziologische Aspekte der Debatte um 1900*. Dissertation, Munich 1987, p.187. Elsewhere Conrad wrote: "Seidl, Seitz, Miller is the name of the clover leaf which receives all the commissions, whereby the one always recommends the other. Mayor Widenmayer is the clover leaf's negotiator." M.G. Conrad, "Aus dem Münchener Kunstleben," in: *Die Gesellschaft*, 9, vol.1, Leipzig 1893, p.375, quoted from Leypoldt, p.178.

100
Franz Blei, *Erzählung eines Lebens*, Leipzig 1930, pp.350–351.

101
Hans Brandenburg, *München leuchtete. Jugenderinnerungen*, Munich 1953, pp.270–271.

102
Offizieller Katalog der I. Internationalen Elite-Ausstellung künstlerischer Photographien (...) des Vereins bildender Künstler Münchens (A.V.) ›Secession‹ 1898 im Kgl. Kunstausstellungsgebäude am Königsplatz gegenüber der Glyptothek, Munich 1898. Cf. also *Photographisches Centralblatt*, 4, 1898, pp.415–418, 442–450; 5, 1899, pp.8–15, 45–51. *Photographisches Wochenblatt*, 24, 1898, pp.401–402, 411–412.

103
Fritz Matthies-Masuren, in: Offizieller Katalog, footnote 102, p.14.

104
Fritz Matthies-Masuren to Alfred Stieglitz, 25.11.1898, Beinecke Library, New Haven, USA.

105
Cf. the annual report on the 1901–02 academic year at the Lehr- und Versuchsanstalt für Photographie zu München, July 8, 1902, Archive Fotomuseum in the Münchner Stadtmuseum.

106
Georg Heinrich Emmerich, quoted from Dieter Hinrichs, "Die Geschichte der Photoschule (2),"

in: *Lichtblick*, 3, Munich 1986.

107
Regarding Emmerich compare Ulrich Pohlmann, "Die vergessenen Fotomuseen," in: *Fotogeschichte*, 10, 1990, no.35, pp.14–21.

108
Cf. also: Anonymous, "Die Lehr- und Versuchsanstalt für Photographie zu München: ihre Einrichtung, ihre Organisation und ihre künstlerischen Prinzipien," in: *Photographischer Motivenschatz der Allgemeinen Photographischen Zeitung*, not dated, (c. 1900), pp.129–148, Staatsarchiv für Oberbayern, RA Fasz., 3625, no.56949.

109
Bruno Rauecker, *Das Kunstgewerbe in München*, from: *Münchner Volkswirtschaftliche Studien*, 109, Stuttgart/Berlin 1911, p.64.

110
Cf. also G.H.Emmerich, *Werkstatt des Photographen*, Wiesbaden 1904, pp.4–10, 339–340.

111
In 1903 Eugene's official address is given as on the second floor of the rear building of Schwanthalerstrasse 41 in Munich-Schwabing. According to Munich's official directories Eugene lived in Landwehrstrasse 42, second floor, rear building in 1904, in Schleissheim in 1905, and in 1906 in Blütenstrasse 9, third floor, rear building.

112
Fritz Matthies-Masuren, "Die künstlerische Photographie und Wir," in: *Photographische Rundschau und Photographisches Centralblatt*, 20, 1906, pp.3–4; Julius Stadler, "Pinsel und Stift in der Kunstphotographie," in: *Photographische Rundschau und Photographisches Centralblatt*, 20, 1906, p.99–100.

113
Eduard J. Steichen, "Grenzen," in: *Camera-Kunst*, ed. by Ernst Juhl, Berlin 1903, pp.12–15.

114
Sadakichi Hartmann, "Plea for straight photography," 1904, in: Harry W. Lawton, footnote no. 68, pp.108–114.

115
The pictorial technique in the works of James Craig Annan and

1943) stammte aus einer ostjüdischen Photographenfamilie. Verbreitung fanden ihre Porträts der Tänzerin Ruth St. Denis, Frau Ludwig Thoma, des Dichters C. Spitteler, Friedrich Naumann, Frau Muthesius, Dr. Kerschensteiner, Oswald Spengler und Paul LeSeur. Von 1900 bis 1910 war sie verheiratet mit dem Psychoanalytiker, Nervenarzt und Photographen Arthur Ludwig, in zweiter Ehe von 1911 bis 1923 mit dem Schriftsteller und Bibliotheksdirektor Hans Ludwig Held. Sie starb nach der Deportation in Theresienstadt 1943.

124

Franz Grainer (1871–1948) unterhielt ab 1903 in der Theatinerstraße 38/39 ein Porträtatelier. Bekannt sind Porträts u.a. von Rita Sacchetto, Gabriel von Seidl, Prinzregent Luitpold von Bayern, Georg Hirth, Frank Wedekind, Bertha Morena, Maude Fay, G.H. Emmerich. Vgl. Sandra Limbacher, *Fotografie als Medium gesellschaftlicher Repräsentation: Der Münchner Porträtfotograf Franz Grainer (1871–1948)*, Magisterarbeit, München 1994. Elias van Bommel, akademischer Maler, wandte sich erst als 35jähriger der Photographie zu. Sein Atelier befand sich in der Zieblandstraße 47. Bekannt wurde Bommel durch Aufnahmen aus dem Atelier von Nikolaus Gysis und Fritz von Uhde. Elisabeth Hecker führte ein Photoatelier in der Ohmstraße 8. Das Atelier der Gebrüder Lützel befand sich in der Maffeistraße. Die Photographen beteiligten sich in Dresden 1909 mit Porträts von Richard Strauss und Max Halbe.

125

Vgl. F. Matthies-Masuren, ›Zu meinen Porträts‹, in: *Photographische Mitteilungen*, 34, 1897/98, S. 365–372; ders., ›Die Kunst in der Photographie‹, in: *Deutsche Kunst und Dekoration*, 1899/1900, S. 141–154, illustriert mit Bildnissen von Georg Hirth, Hugo von Habermann und Fritz von Uhde.

126

Vgl. Helmut und Alison Gernsheim, *Alvin Langdon Coburn. An Autobiography*, New York 1978. Mike Weaver, *Alvin Langdon*

Coburn, Symbolist Photographer 1882–1966, New York 1986.

127

Klaus Zimmermanns, *Friedrich August von Kaulbach 1850–1920. Monographie und Werkverzeichnis*, München 1980, S. 31

128

Bericht über die Kuratoriumssitzung vom 9.7.1907. S. 7, Staatsarchiv München, Fasz. 3625. Nr. 56948.

129

Vgl. *Camera Work*, Okt. 1907, Nr. 20, S. 26.

130

Jahrbuch der Lehr- und Versuchsanstalt für Photographie (...), München 1907/08, S. 113.

131

Joseph Maria Eder, ›K.k. Lehr- und Versuchsanstalt für Photographie und Reproductionsverfahren in Wien‹, in: *Photographische Correspondenz*, 25, 1888, S. 19–25, 49–52. Vgl. auch Georg Heinrich Emmerich, Anm. 110, S. 4–10, 338–341, sowie den Aufsatz von Andreas Krase in diesem Buch.

132

»So far he's lots better than everybody said and I'm mighty glad to be able to say that he probably comes very near being just the right man for the place – one sign in his favor is that 95.5% out of 100 photographers here in Germany hate him like poison. If he can only succeed in getting the remaining 4.5% to join in the chorus – he can take a day off and I will help him celebrate.« Frank Eugene Smith an Alfred Stieglitz, 20.11.1907, Beinecke Library, New Haven, USA.

133

Jahrbuch der Lehr- und Versuchsanstalt für Photographie (...), München 1908/09, S. 52.

134

Friedmanns Einrichtungen standen der spezifisch Münchner Variante des Jugendstils nahe, wie sie von Karl Bertsch (1873–1933) oder Adelbert Niemeyer (1867–1932) in der 1902 gegründeten ›Münchener Werkstätten für Wohnungseinrichtungen‹ gepflegt wurde. Hinweis von Hans Ottomeyer; Vgl. Hans Ottomeyer und Alfred Ziffer, *Möbel des Neoklassizismus und*

der Neuen Sachlichkeit, München 1993, S. 176f, S. 186f.

135

Vgl. Anm. 133, S. 51.

136

Die Frequenz im Vollunterricht betrug 62 Schüler im Schuljahr 1907/08, 1908/09 (75), 1909/10 (85), 1910/11 (77), 1911/12 (90), 1912/13 (84) und 1913/14 (91).

137

Frank Eugene Smith an Alfred Stieglitz, 21.11.1907, Beinecke Library, New Haven, USA.

138

M. Lüty, ›Die Schülerausstellung der Lehr- und Versuchsanstalt für Photographie, Chemigraphie, Lichtdruck und Gravüre zu München‹, in: *Photographische Kunst*, 7, 1908, S. 160. - Vgl. auch *Münchner Neueste Nachrichten*, 19.9.1908, Archiv Hollandiana, Handschriften-Abteilung Bayerische Staatsbibliothek, München. 43.000 Kataloge und 50.000 Führer wurden während der Ausstellung verkauft. Vgl. *Geschäftsbericht über die Ausstellung München 1908*, München 1908, S. 42-43.

139

Frank Eugene Smith an Alfred Stieglitz, 15.9.1908, Beinecke Library, New Haven, USA.

140

Coburn photographierte anläßlich seines Aufenthaltes in München den Maler Franz von Stuck.

141

Vgl. *Der Photograph*, 19, 1909, S. 149; Vgl. auch *Internationale Photographische Ausstellung 1909 in Dresden*, Bayerisches Hauptstaatsarchiv MH No. 9428.

142

Vgl. Anm. 133, S. 63–64.

143

Münchner Neueste Nachrichten, Nr. 102, 3.3.1909.

144

Vgl. *The International Society of Pictorial Photographers. Articles of Agreement establishing the same*, 1905, Archiv Royal Photographic Society of Great Britain, Bath. Als Mitglieder der Vereinigung, deren Aufgabe es war, »die Photographie als eigenständiges künstlerisches Ausdrucksmittel zu bewahren und zu fördern«, wirkten mit Annan, Le Begue,

Coburn, Craigie, Davison, Demachy, Eugene, Evans, Henneberg, Horsley Hinton, Käsebier, Keighley, Keiley, Kühn, Moss, Puyo, Spitzer, Steichen, Stieglitz und White.

145

Die Photographische Industrie, 16, 1909, S. 654–655.

146

M.K. Rohe, ›Erziehungsstätte für Künstlerische Photographie‹, in: *Deutsche Kunst und Dekoration*, 14, 1910/11, S. 345-348, hier S. 348.

147

Eugenes Jahresgehalt betrug 3.000 Mark. Zum Vergleich verdienten die beiden hauptamtlichen Lehrer Lähnemann und Spörl im Jahre 1910 jeweils 4.260 Mark, Urban 5.610 Mark und Emmerich 5.500 Mark. Ein Porträtphotograph als Angestellter eines Atelierbetriebes verdiente 1910 circa 120 Mark im Monat bei einer täglichen Arbeitszeit von 10 Stunden. Vgl. Bruno Rauecker, Anm. 109, S. 66.

148

Die Umbaukosten in Höhe von 155.000 Mark teilten sich das Kgl. bayerische Staatsministerium des Innern für Kirchen- und Schulangelegenheiten und das Kgl. bayerische Staatsministerium des Äussern.

149

G.H. Emmerich, ›Zum zehnjährigen Bestehen der Lehr- und Versuchsanstalt für Photographie, Chemigraphie, Lichtdruck und Gravüre zu München‹, in: *Photographische Kunst*, 9, 1910, S. 114.

150

Jahrbuch der Lehr- und Versuchsanstalt für Photographie (...), München 1910/11, S. 16.

151

Für die Abteilung Chemigraphie standen 4 Räume, für Lichtdruck und Heliogravüre 10, für die gerichtliche Photographie inklusive Versuchsstation und Materialprüfungsstelle 6 und für Zeichen- und Hörsäle 5 Räume zur Verfügung. Die restlichen Räume wurden für die Sammlungen, Verwaltung und Lehrerzimmer verwendet. Vgl. *Photographische Kunst*, 9, 1910, S. 116.

152

Es handelte sich um Photo-

gravüren aus der *Camera Work*. Vgl. *Jahrbuch der Lehr- und Versuchsanstalt für Photographie (...)*. München 1912, S. 71. Auch im Ausland wurde die Eröffnung des Münchner Lehrinstitutes zur Kenntnis genommen. Vgl. ›London Letter‹ von E.O. Hoppé, in: *Photo-Era*, 1911, S. 261.

153

Vgl. *Der Photograph*, 22, 1912, S. 343.

154

Jahrbuch der Lehr- und Versuchsanstalt für Photographie (...), München 1913, S. 62.

155

Vgl. Joseph Pécsi, *Photo und Publizität*, Berlin 1930.

156

K.W. Wolf-Czapek, ›Die Münchener Lehr- und Versuchs-Anstalt für Photographie‹, in: *Deutscher Camera-Almanach*, 10, Berlin 1914, S. 172-191.

157

Anm. 150, S. 20.

158

Ebd., S. 31.

159

Jahrbuch der Lehr- und Versuchsanstalt für Photographie (...), München 1911/12, S. 58.

160

Jahrbuch der Lehr- und Versuchsanstalt für Photographie (...), München 1912/13, S. 56.

161

Vgl. Klaus Zimmermanns, Anm. 127, S. 102.

162

Vgl. z.B. *Münchner Illustrierte Zeitung*, 5, 22.12.1912; 6, 16.11.1913.

163

Vgl. Franz Grainers Aufnahme ›In Erbfolge des Hauses Wittelsbach‹, Stadtarchiv München.

164

Vgl. Rainer Schoch, *Das Herrscherbild in der Malerei des 19. Jahrhunderts*, München 1975, S. 105-107.

165

Vgl. *Photographische Kunst*, 6, 1907.

166

Vgl. W.R., ›Photographien von Frank Eugene Smith‹, in: *Dekorative Kunst*, 12, Oktober 1908, S. 1–8; Maximilian K. Rohe, ›Frank Eugene Smith München‹, in: *Deutsche Kunst und Dekoration*, 13, 1910, S. 40–54; Wilhelm

Joseph T. Keiley show influences of Eugene's method of "photo-etching." Cf. Keileys photograph "A Bacchante" (1899) with Eugenes "Nirvana" (1898), reproduced in the catalogue *Photosammlung Stieglitz aus dem Metropolitan Museum New York*, Cologne 1980, pp. 102–103.

116
Cf. also "Frank Eugene," in: G.H. Emmerich (Hrsg.), *Lexikon der Photographie und Reproduktionstechnik*, Vienna/Leipzig 1910, p. 696.

117
Allgemeine Zeitung, no. 244, May 29, 1907, p. 4.

118
Adolf Hengeler to Hugo von Habermann, May 6, 1907, Archive Städtische Galerie Würzburg.

119
Cf. Frank Eugene Smith to Hugo von Habermann, June 22, 1907, Archiv Städtische Galerie Würzburg.

120
Cf. Bodo von Dewitz, Karin Schuller-Procopovici (ed.), *Hugo Erfurth 1874–1948. Photograph zwischen Tradition und Moderne*, Cologne 1992.

121
Cf. catalogue *Exhibition of Camera-Portraits by E.O. Hoppé*, Royal Photographic Society of Great Britain, London, April 6–May 28, 1910.

122
Wanda von Debschitz, wife of the co-founder of the so-called "Debschitz-School" Wilhelm von Debschitz, opened a studio around around 1907 in the school building in Hohenzollernstrasse 21 which she kept until 1914. As a painter and graduate of the Lehr- und Versuchsanstalt für Photographie she took "modern" portraits of people from "Munich's top art and social circles," including Hans Pfitzner, L. v. Zumbusch, Franz v. Hösslin, and Karl Schmoll von Eisenwerth. She took part successfully in numerous exhibitions. Cf. *studio brochure of Wanda von Debschitz*, Hollandiana Collection, Manuscript section of the Bayerische Staatsbibliothek, Munich. For further information on Wan-

da von Debschitz-Kunowski (1870–1935) see *Fotografieren heißt teilnehmen. Fotografinnen der Weimarer Republik*, Museum Folkwang, Essen 1994, pp. 313–314.

123
Stephanie Ludwig-Held (1871–1943) came from an eastern Jewish family of photographers. Her portrait of the dancer Ruth St. Denis was widely known, as were her portraits of Mrs. Ludwig Thoma, the poet C. Spitteler, Friedrich Naumann, Mrs. Muthesius, Dr. Kerschensteiner, Oswald Spengler and Paul LeSeur. She was married to the psychoanalyst, neurologist and photographer Arthur Ludwig from 1900 to 1910, and from 1911 to 1923 with the writer and library director Hans Ludwig Held. She died after being deported to Theresienstadt in 1943.

124
Franz Grainer (1871–1948) had a portrait studio in Theatinerstraße 38/39 from 1902 onwards. He is known to have taken portraits of, among others, Rita Sacchetto, Gabriel von Seidl, Prinzregent Luitpold von Bayern, Georg Hirth, Frank Wedekind, Bertha Morena, Maude Fay, and G.H. Emmerich. Cf. Sandra Limbacher, *Fotografie als Medium gesellschaftlicher Repräsentation: Der Münchner Porträtfotograf Franz Grainer (1871–1948)*, Master's Thesis, Munich 1994. Elias van Bommel, academic painter, only turned to photography when he was 35 years old. His studio was in Zieblandstrasse 47. Bommel's fame is based on photographs taken in the studio of Nikolaus Gysis and Fritz von Uhde. Elisabeth Hecker had a photography studio in Ohmstrasse 8. The studio of the Lützel brothers was in Maffeistrasse. The brothers took part in the Dresden exhibition in 1909 with portraits of Richard Strauss and Max Halbe.

125
Cf. F. Matthies-Masuren, "Zu meinen Porträts," in: *Photographische Mitteilungen*, 34, 1897/98, pp. 365–372; by the same author, "Die Kunst in der Photographie," in: *Deutsche Kunst und Dekoration*, 1899/1900, pp. 141–154, illustrated with por-

traits of Georg Hirth, Hugo von Habermann and Fritz von Uhde.

126
Cf. Helmut and Alison Gernsheim, *Alvin Langdon Coburn. An Autobiography*, New York 1978. Mike Weaver, *Alvin Langdon Coburn, Symbolist Photographer 1882–1966*, New York 1986.

127
Klaus Zimmermanns, *Friedrich August von Kaulbach 1850–1920. Monographie und Werkverzeichnis*, Munich 1980, p. 31.

128
Report of the meeting of the advisory board on July 9, 1907, p. 7, Staatsarchiv München, Fasz. 3625, no. 56948.

129
Cf. *Camera Work*, October 1907, no. 20, p. 26.

130
Jahrbuch der Lehr- und Versuchsanstalt für Photographie (...), Munich 1907/08, p. 113.

131
Joseph Maria Eder, "K.k. Lehr- und Versuchsanstalt für Photographie und Reproductionsverfahren in Wien," in: *Photographische Correspondenz*, 25, 1888, pp. 19–25, 49–52. Cf. also Georg Heinrich Emmerich, footnote 110, pp. 4–10, 338–341 as well as the essay by Andreas Krase in this book.

132
"So far he's lots better than everybody said and I'm mighty glad to be able to say that he probably comes very near being just the right man for the place – one sign in his favor is that 95.5% out of 100 photographers here in Germany hate him like poison. If he can only succeed in getting the remaining 4.5% to join in the chorus – he can take a day off and I will help him celebrate." Frank Eugene Smith to Alfred Stieglitz, Nov. 20, 1907, Beinecke Library, New Haven, USA.

133
Jahrbuch der Lehr- und Versuchsanstalt für Photographie (...), Munich 1908/09, p. 52.

134
Friedmann's interiors were close in style to the specific Munich variation of Art Nouveau, as cultivated by Karl Bertsch (1873–1933) or Adelbert Niemeyer (1867–1932)

in the "Munich Workshop for Living Interiors" founded in 1902. Reference from Hans Ottomeyer; Cf. Hans Ottomeyer and Alfred Ziffer, *Möbel des Neoklassizismus und der Neuen Sachlichkeit*, Munich 1993, p. 176f, p. 186f.

135
Cf. footnote no. 133, p. 51.

136
The number of students attending classes full-time was 62 in the school year 1907/08, 1908/09 (75), 1909/10 (85), 1910/11 (77), 1911/12 (90), 1912/13 (84) and 1913/14 (91).

137
Frank Eugene Smith to Alfred Stieglitz, 21.11.1907, Beinecke Library, New Haven, USA.

138
M. Lüty, "Die Schülerausstellung der Lehr- und Versuchsanstalt für Photographie, Chemigraphie, Lichtdruck und Gravüre zu München," in: *Photographische Kunst*, 7, 1908, p. 160. Cf. also *Münchner Neueste Nachrichten*, 19.9.1908, Archive Hollandiana, Handschriften-Abteilung Bayerische Staatsbibliothek, Munich. 43.000 catalogues and 50,000 Führer were sold during the exhibition. Cf. *Geschäftsbericht über die Ausstellung München 1908*, Munich 1908, pp. 42–43.

139
Frank Eugene Smith to Alfred Stieglitz, 15.9.1908, Beinecke Library, New Haven, USA.

140
During his stay in Munich, Coburn photographed the painter Franz von Stuck.

141
Cf. *Der Photograph*, 19, 1909, p. 149; cf. also *Internationale Photographische Ausstellung 1909 in Dresden*, Bayerisches Hauptstaatsarchiv MH no. 9428.

142
Cf. footnote 133, pp. 63–64.

143
Münchner Neueste Nachrichten, no. 102, March 3, 1909.

144
Cf. *The International Society of Pictorial Photographers. Articles of Agreement establishing the same*, 1905, Archive Royal Photographic Society of Great Britain, Bath. As members of the Society,

whose aim was "to conserve and advance Photography as an independent medium of original pictorial expression," Annan, Le Begue, Coburn, Craigie, Davison, Demachy, Eugene, Evans, Henneberg, Horsley Hinton, Käsebier, Keighley, Keiley, Kühn, Moss, Puyo, Spitzer, Steichen, Stieglitz and White participated.

145
Die Photographische Industrie, 16, 1909, pp. 654–655.

146
M.K. Rohe, "Erziehungsstätte für Künstlerische Photographie," in: *Deutsche Kunst und Dekoration*, 14, 1910/11, pp. 345–348, here p. 348.

147
Eugene's annual salary was 3.000 marks. For comparative purposes, in 1910 the two full-time teachers Lähnemann and Spörl earned 4.260, Urban 5.610 and Emmerich 5.500 marks. In 1910, a portrait photographer employed by a commercial studio earned around 120 marks a month, for a 10-hour working day. Cf. Bruno Rauecker, footnote 109, p. 66.

148
The renovation costs amounting to 155,000 marks were shared by the Royal Bavarian State Ministry of Internal, Church and School Affairs, and the Royal Bavarian State Ministry of External Affairs.

149
G.H. Emmerich, "Zum zehnjährigen Bestehen der Lehr- und Versuchsanstalt für Photographie, Chemigraphie, Lichtdruck und Gravüre zu München," in: *Photographische Kunst*, 9, 1910, p. 114.

150
Jahrbuch der Lehr- und Versuchsanstalt für Photographie (...), Munich 1910/11, p. 16.

151
The chemigraphy department had 4 rooms at its disposal, light print and heliogravure 10, forensic photography, including experimental studio and material testing, 6, plus 5 rooms for drawing classes and lectures. The remaining rooms were used for the collections, administration and teaching. Cf. *Photographische Kunst*, 9, 1910, p. 116.

Michel, ›Neue Photographische Kunstwerke von Frank Eugène Smith‹, in: *Deutsche Kunst und Dekoration*, 14, 1911, S. 268–277; W.M., ›Neue Bildnis-Aufnahmen von Frank Eugène Smith‹, in: *Deutsche Kunst und Dekoration*, 15, 1911/12, Heft 11, S. 74–75; Paul Fechter, ›Das Porträt und die Photographie‹, in: *Deutsche Kunst und Dekoration*, 15, 1911/12, S. 76–81; W.M., ›Frank Eugène Smith. Leipzig‹, in: *Deutsche Kunst und Dekoration*, 17, 1913/14, S. 62–69; *Deutsche Kunst und Dekoration*, 18, 1914, S. 204.

167
Vgl. ›Our Illustrations‹, in: *Camera Work*, April 1910, Nr. 30, S. 59; Juli 1910, Nr. 31.

168
Vgl. *Jubiläumsfestschrift 100 Jahre Brücke zur Kunst. 100 Jahre Bruckmann*, München 1958. Im Archiv des Bruckmann-Verlages haben sich keine Originaldokumente oder Photogravüren von Eugene erhalten. Freundliche Mitteilung von Dr. Stiebner.

169
Zu Eugen Albert vgl. *Photographische Korrespondenz*, 62, 1926, S. 105–106.

170
Vgl. Christian A. Peterson, *Camera Work Process & Image*, The Minneapolis Institute of Arts, Minneapolis 1985, S. 26–29.

171
Camera Work, Juli 1910, Nr. 31, S. 54.

172
Frank Eugene Smith an Alfred Stieglitz, 8.10.1909, Beinecke Library, New Haven, USA.

173
Frank Eugene Smith an Alfred Stieglitz, 29.6.1910, Beinecke Library, New Haven, USA.

174
Frank Eugene Smith an Alfred Stieglitz, 21.11.1907, Beinecke Library, New Haven, USA.

175
Es handelte sich um eine Aufnahme von Anna Herth, veröffentlicht bei M.K.Rohe, Anm. 146, S. 345.

176
Stadtarchiv München, Nr. 3893–3898.

177
›Wie Dührkoop, Erfurth, Grainer,

Smith, Traut arbeiten?‹, in: *Photographische Kunst*, 9, 1910/11, S. 4.

178
Seit 1907/08 hatte sich Eugene in der Theresienstraße 76 eingemietet. 1910 lebte er in der Theresienstraße 52 auf dem selben Stockwerk wie seine langjährige Freundin Margaretha Willer. Von 1911 bis 1913 wohnte er wieder in seiner alten Wohnung in der Theresienstraße 76.

179
Vgl. Frank Eugene Smith an Hugo von Habermann, 5.4.1908, Archiv Städtische Galerie Würzburg.

180
Vgl. die Porträts von Dora Gedon.

181
Die Doppelporträts von Lolo und Gabriele von Lenbach sollen angeblich anläßlich des Don Juan-Festes 1902 entstanden sein. Dagegen spricht, daß Gabriele zu diesem Zeitpunkt erst drei Jahre alt gewesen ist. Vgl. Rosel Gollek, Anm. 59, S. 484. Eugene photographierte auch die Hochzeitsbilder von Marion von Lenbach und Graf Larosée, die im Metropolitan Museum of Art, New York, aufbewahrt werden (Rogers Fund 1972.633.170).

182
Vgl. Korrespondenz zwischen Frank Eugene Smith und Alfred Walter von Heymel vom 1.2.1912 bis 24.6.1913, Inv.-Nr. 62.1763/1-5; Nr. 62.1116/1-2, Deutsches Literaturarchiv Schiller Nationalmuseum, Marbach am Neckar.

183
Hans Brandenburg, Anm. 101, S. 270–271.

184
Ebd., S. 351.

185
Ebd., S. 348–349.

186
Vgl. Ulrich Pohlmann, ›Der Kunstphotograph Leopold von Glasersfeld und München 1910–1918‹, in: Gunther Waibl (Hrsg.), *Leopold von Glasersfeld 1871–1954. Photograph/Fotografo/Photographer*, Bozen 1995, S. 20–31.

187
Stieglitz stellte 1908 Radierungen von Willi Geiger in den Little Galleries der Photo-Secession

gemeinsam mit Arbeiten von D.S. McLaughlan und Pamela Coleman Smith aus. Außerdem besuchte Stieglitz Behn in seinem Münchner Atelier und lernte über Eugene auch Baron Alfred Walter von Heymel kennen, wie aus der Korrespondenz zwischen Eugene und Stieglitz ersichtlich wird.

188
Emanuel von Seidl, *Mein Landhaus*, Darmstadt 1910, S. 48.

189
Vgl. ausführlich Joanna Waltraud Kunstmann, *Emanuel von Seidl (1856–1919) Die Villen und Landhäuser*, München 1993. Dies., ›Der Landschaftspark Emanuel von Seidls in Murnau‹, in: Katalog *Gelobtes Land Emanuel von Seidl. Parklandschaft in Murnau*, Schloßmuseum Murnau 1993, S. 25–35.

190
Emanuel von Seidl, Anm. 188, S. 49.

191
Vgl. Brigitte Salmen, ›Gesellschaftliches Leben im Seidl-Park‹, in: Katalog *Gelobtes Land Emanuel von Seidl. Parklandschaft in Murnau*, Schloßmuseum Murnau 1993, S. 32–45.

192
Vgl. u.a. die Eintragungen in den Gästebüchern 21.5.1909, 16.9.1909, 31.12.1909, 28.8.1910, 31.12.1911, 1.1.1913, 22.8.1913, 1./2.8.1914, Ostern 1915, 22.8.1916, 4.8.1917, Handschriften–Abteilung Bayerische Staatsbibliothek München. Als Eugene nach Leipzig 1913 wechselte, hinterließ er als ›Abschiedsbild‹ die Aufnahme ›Menuett‹ im Gästebuch.

193
Gästebuch E. v. Seidl, Bd. 1, S. 49.

194
An der Inszenierung wirkten u.a. die Schauspieler Alexander Moissi und Friedrich Wilhelm Plumpe mit, der sich von dem Ereignis an Friedrich Wilhelm Murnau nannte und als Filmregisseur von ›Nosferatu‹ (1922) und ›Der letzte Mann‹ (1924) Weltruhm erlangen sollte.

195
Frank Eugene Smith an Alfred

Stieglitz, 16.1.1909, Beinecke Library, New Haven, USA.

196
Vgl. Gästebuch E. v. Seidl, Bd. 1, S. 110–123.

197
Vgl. Marie-Theres Arnbom, *Bürgerlichkeit nach dem Ende des bürgerlichen Zeitalters? Eine Wiener Familienkonfiguration zwischen 1900 und 1930*, Magisterarbeit, Wien 1990.

198
Frank Eugene Smith an Alfred Stieglitz, 18.11.1910, Beinecke Library, New Haven, USA.

199
Photographische Kunst, 8, 1910, S. 313, mit 4 Abbildungen der Villa und des Parkes in Murnau, Tafel 97–100.

200
Innen-Dekoration, 21, 1910, S. 12.

201
Joseph T. Keiley, ›Landscape. A Reverie‹, in: *Camera Work*, Okt. 1903, Nr. 4, S. 45–46.

202
Vgl. *Jahrbuch der Lehr- und Versuchsanstalt für Photographie (...)*, München 1909/10, S. 73.

203
Vgl. die Veröffentlichung Fritz von Ostini, ›Franz von Stuck und sein Haus‹, in: *Innen-Dekoration*, 20, 1909, S. 397–428, ohne Nennung des Photographen; *Villa Franz von Stuck*. Begleittext von Fritz von Ostini (Sonderdruck der Zeitschrift *Innen-Dekoration*, Verlags-Anstalt Alexander Koch), Darmstadt 1912.

204
Gästebuch E. v. Seidl, Bd. 3, S. 90. Vgl. auch Salmen, Anm. 191, S. 44.

205
Vgl. James Enyeart, *Bruguière: His Photographs and His Life*, New York 1977. W. Warstat, ›Lichtphantasien von Francis Bruguière‹, in: *Deutsche Kunst und Dekoration*, 31, Oktober 1927, S. 424–428.

206
Frank Eugene Smith an Alfred Stieglitz, 15.1.1913, Beinecke Library, New Haven, USA.

207
Zu Erbslöh vgl. Hans Wille, *Adolf Erbslöh*, Recklinghausen 1982.

208
Vgl. Marsden Hartley an Alfred Stieglitz, Februar 1913, Beinecke

Library, New Haven, USA. Siehe ausführlich zu Hartleys Aufenthalt in Deutschland und München: Robert M. Crunden, *American Salons. Encounters with European Modernism 1885–1917*, New York/Oxford 1993, S. 314f. »I see Frank Eugene nearly every day and he is helping me all he can to make me known here. He is fine (...).« Marsden Hartley an Alfred Stieglitz, April/Mai 1913, Beinecke Library, New Haven, USA.

209
Der genaue Zeitraum des Treffens ist ungeklärt. Während Ulrich Knapp, *Heinrich Kühn Photographien*, Salzburg/Wien 1988, S. 173, als Datum den 9. Juli nennt, hielt sich Stieglitz nach Sue Davidson Lowe, *Stieglitz: A Memoir/Biography*, London 1983, S. 384, vom 18. Juli bis 9. August 1907 in Tutzing auf. Der in der *Camera Work* veröffentlichte Brief von Stieglitz stammte aus Tutzing und war am 31. Juli 1907 datiert. Vgl. zu den Autochrome-Experimenten in Tutzing: Alfred Stieglitz, ›The New Color Photography. A Bit of History‹, in: *Camera Work*, Oktober 1907, Nr. 20, S. 20–25; Brian Coe, *Colour Photography. The first hundred years 1840–1940*, London 1978, S. 52–63; John Wood, *The Art of the Autochrome. The Birth of Color Photography*, Iowa City 1993, S. 10–11.

210
Vgl. zur Technik B. Haldy, ›Moderne Silhouetten‹, in: *Photographische Rundschau und Mitteilungen*, 50, 1913, S. 108–111.

211
Vgl. Sarah Greenough u.a., *On the Art of Fixing a Shadow*, Boston 1989, S. 197; Weston J. Naef, Anm. 52, 1978, S. 356–357. Jeweils 2 Autochrome Eugenes von Alfred, Emmy und Kitty Stieglitz werden im Art Institute in Chicago und im Metropolitan Museum of Art in New York aufbewahrt.

212
Vgl. Ulrich Pohlmann, ›Stieglitz, Steichen, Smith and Kuehn admiring the work of Frank Eugene‹, in: *Bilder für Timm*, Marburg 1989, S. 28–29.

213
Alfred Stieglitz, Anm. 209, S. 24.

152

These were photogravures from *Camera Work*. Cf. *Jahrbuch der Lehr- und Versuchsanstalt für Photographie (...)*, Munich 1912, p. 71. The opening of the Munich institute was also taken note of abroad. Cf. "London Letter" from E.O. Hoppé, in: *Photo-Era*, 1911, p. 261.

153

Cf. *Der Photograph*, 22, 1912, p. 343.

154

Jahrbuch der Lehr- und Versuchsanstalt für Photographie (...), Munich 1913, p. 62.

155

Cf. Joseph Pécsi, *Photo und Publizität*, Berlin 1930.

156

K.W. Wolf-Czapek, "Die Münchener Lehr- und Versuchs-Anstalt für Photographie," in: *Deutscher Camera-Almanach*, 10, Berlin 1914, pp. 172-191.

157

Footnote 150, p. 20.

158

Ebd., p. 31.

159

Jahrbuch der Lehr- und Versuchsanstalt für Photographie (...), Munich 1911/12, p. 58.

160

Jahrbuch der Lehr- und Versuchsanstalt für Photographie (...), Munich 1912/13, p. 56.

161

Cf. Klaus Zimmermanns, footnote 127, p. 102.

162

Compare, for example, *Münchner Illustrierte Zeitung*, 5, Dec. 22, 1912; 6, 16.11.1913.

163

Cf. Franz Grainers Aufnahme "In Erbfolge des Hauses Wittelsbach," Stadtarchiv München.

164

Cf. Rainer Schoch, *Das Herrscherbild in der Malerei des 19. Jahrhunderts*, Munich 1975, pp. 105-107.

165

Cf. *Photographische Kunst*, 6, 1907.

166

Cf. W.R., "Photographien von Frank Eugene Smith," in: *Dekorative Kunst*, 12, Oct. 1908,

pp. 1-8; Maximilian K. Rohe, "Frank Eugene Smith München," in: *Deutsche Kunst und Dekoration*, 13, 1910, pp. 40-54; Wilhelm Michel, "Neue Photographische Kunstwerke von Frank Eugène Smith," in: *Deutsche Kunst und Dekoration*, 14, 1911, pp. 268-277; W.M., "Neue Bildnis-Aufnahmen von Frank Eugène Smith," in: *Deutsche Kunst und Dekoration*, 15, 1911/12, pp. 74-75; Paul Fechter, "Das Porträt und die Photographie," in: *Deutsche Kunst und Dekoration*, 15, 1911/12, pp. 76-81; W.M., "Frank Eugène Smith. Leipzig," in: *Deutsche Kunst und Dekoration*, 17, 1913/14, pp. 62-69; *Deutsche Kunst und Dekoration*, 18, 1914, p. 204.

167

Cf. "Our Illustrations," in: *Camera Work*, April 1910, no. 30, p. 59; July 1910, no. 31.

168

Cf. *Jubiläumsfestschrift 100 Jahre Brücke zur Kunst, 100 Jahre Bruckmann*, Munich 1958. Dr. Stiebner was kind enough to inform us that there were no original documents or photogravures of Eugene's in the archives of Bruckmann Verlag.

169

For information on Eugen Albert cf. *Photographische Korrespondenz*, 62, 1926, pp. 105-106.

170

Cf. Christian A. Peterson, *Camera Work Process & Image*, The Minneapolis Institute of Arts, Minneapolis 1985, pp. 26-29.

171

Camera Work, July 1910, no. 31, p. 54.

172

Frank Eugene Smith to Alfred Stieglitz, October 8, 1909, Beinecke Library, New Haven, USA.

173

Frank Eugene Smith to Alfred Stieglitz, June 29, 1910, Beinecke Library, New Haven, USA.

174

Frank Eugene Smith to Alfred Stieglitz, November 21, 1907, Beinecke Library, New Haven, USA.

175

Reference is to a photograph of Anna Herth, published M. K. Rohe, footnote no. 146, p. 345.

176

Stadtarchiv München, no. 3893-3898.

177

"Wie Dührkoop, Erfurth, Grainer, Smith, Traut arbeiten?," in: *Photographische Kunst*, 9, 1910/11, p. 4.

178

Eugene had been renting accommodation in Theresienstrasse 76 since 1907/08. In 1910 he lived at Theresienstraße 52 on the same floor as his friend of several years, Margaretha Willer. From 1911 to 1913 he lived in his old apartment at Theresienstraße 76.

179

Cf. Frank Eugene Smith to Hugo von Habermann, 5.4.1908, Archive Städtische Galerie Würzburg.

180

Cf. the portraits of Dora Gedon.

181

The double portraits of Lolo and Gabriele von Lenbach are said to have been taken on the occasion of the Don Juan Festival in 1902. The fact that at that time Gabriele was only three years of age would seem to contradict this. Cf. Rosel Gollek, footnote no. 59, p. 484. Eugene also took the wedding photographs of Marion von Lenbach and Graf Larosée which are preserved in the Metropolitan Museum of Art, New York (Rogers Fund 1972.633.170).

182

Cf. correspondence between Frank Eugene Smith and Alfred Walter von Heymel from Feb. 1 to June 24, 1913, Inv.-no. 62.1763/1-5; no. 62.1116/1-2, Deutsches Literaturarchiv Schiller Nationalmuseum, Marbach am Neckar.

183

Hans Brandenburg, footnote no. 101, pp. 270-271.

184

Ebd., p. 351.

185

Ebd., pp. 348-349.

186

Cf. Ulrich Pohlmann, "Der Kunstphotograph Leopold von Glasersfeld und München 1910-1918," in: Gunther Waibl (ed.), *Leopold von Glasersfeld 1871-1954. Photograph/Fotografo/Photographer*, Bozen 1995, p. 20-31.

187

In 1908 Stieglitz exhibited etchings by Willi Geiger in the Little Galleries of the Photo-Secession

along with works by D.S. McLaughlan and Pamela Coleman Smith. Stieglitz also visited Behn in his Munich studio and got to know Baron Alfred Walter von Heymel through Eugene, as can be seen from the correspondence between Stieglitz and Eugene.

188

Emanuel von Seidl, *Mein Landhaus*, Darmstadt 1910, p. 48.

189

For details cf. Joanna Waltraud Kunstmann, *Emanuel von Seidl (1856-1919) Die Villen und Landhäuser*, Munich 1993. Cf. by the same author, "Der Landschaftspark Emanuel von Seidls in Murnau," in: catalogue *Gelobtes Land Emanuel von Seidl. Parklandschaft in Murnau*, Schloßmuseum Murnau 1993, pp. 25-35.

190

Emanuel von Seidl, footnote. 188, p. 49.

191

Cf. Brigitte Salmen, "Gesellschaftliches Leben im Seidl-Park," in: catalogue *Gelobtes Land Emanuel von Seidl. Parklandschaft in Murnau*, Schloßmuseum Murnau 1993, pp. 32-45.

192

Cf. entries in the guest books May 21, 1909, Sep. 16, 1909, Dec. 31, 1909, Aug. 28, 1910, Dec. 31, 1911, Jan. 1, 1913, Aug. 22, 1913, Aug. 1/2, 1914, Easter 1915, Aug. 22, 1916, Aug. 4, 1917. Handschriften-Abteilung Bayerische Staatsbibliothek München. When Eugene left Munich for Leipzig in 1913 he left "Menuett" behind in the guest book as a "farewell photograph."

193

Guest books E. v. Seidl, vol. 1, p. 49.

194

Among the people active in staging the event were the actors Alexander Moissi and Friedrich Wilhelm Plumpe, who later called himself Friedrich Wilhelm Murnau and attained world fame as the director of the films "Nosferatu" (1922) and "Der letzte Mann" (1924).

195

Frank Eugene Smith to Alfred Stieglitz, Jan. 16, 1909, Beinecke

Library, New Haven, USA.

196

Cf. *Gästebuch E. v. Seidl*, vol. 1, pp. 110-123.

197

Cf. Marie-Theres Arnbom, *Bürgerlichkeit nach dem Ende des bürgerlichen Zeitalters? Eine Wiener Familienkonfiguration zwischen 1900 und 1930*. Master's Thesis, Vienna 1990.

198

Frank Eugene Smith to Alfred Stieglitz, Nov. 18, 1910, Beinecke Library, New Haven, USA.

199

Photographische Kunst, 8, 1910, p. 313 with 4 illustrations of the villa and the park in Murnau, plates 97-100.

200

Innen-Dekoration, 21, 1910, p. 12.

201

Joseph T. Keiley, "Landscape. A Reverie," in: *Camera Work*, Oct. 1903, no. 4, pp. 45-46.

202

Cf. *Jahrbuch der Lehr- und Versuchsanstalt für Photographie (...)*, Munich 1909/10, p. 73.

203

Cf. Fritz von Ostini, "Franz von Stuck und sein Haus," in: *Innen-Dekoration*, 20, 1909, pp. 397-428, where the photographer is not named; *Villa Franz von Stuck*. Text from Fritz von Ostini (off-print of the magazine *Innen-Dekoration*, Verlags-Anstalt Alexander Koch), Darmstadt 1912.

204

Guest book E. v. Seidl, Bd. 3, p. 90. Cf. also Salmen, footnote no. 191, p. 44.

205

Cf. James Enyeart, *Bruguière: His Photographs and His Life*, New York 1977. W. Warstat, "Lichtphantasien von Francis Bruguiere," in: *Deutsche Kunst und Dekoration*, 31, Oct. 1927, pp. 424-428.

206

Frank Eugene Smith to Alfred Stieglitz, Jan. 15, 1913, Beinecke Library, New Haven, USA.

207

For more on Erbslöh, see Hans Wille, *Adolf Erbslöh*, Recklinghausen 1982.

208

Cf. Marsden Hartley to Alfred Stieglitz, Feb. 1913, Beinecke Li-

214
Frank Eugene Smith an Alfred Stieglitz, 18.7.1907, Beinecke Library, New Haven, USA.

215
Charles Holme (Hrsg.), *Colour Photography and other recent developments of the art of the camera*, The Studio, London 1908, S. 45. Im selben Band wurde auch Eugenes Aufnahme ›Menuett‹ veröffentlicht.

216
F.C.Tilney, ›Where we stand in pictorial colour photography‹, in: Supplement colour photography, *The British Journal of Photography*, Sept. 4, 1908, S. 67.

217
Frank Eugene Smith an Alfred Stieglitz, Herbst 1910, Beinecke Library, New Haven, USA. John Wood erwähnt insgesamt 7 Autochrome von Eugene, die sich erhalten haben. Vgl. John Wood, Anm. 209, Preface, S. XIII.

218
Frank Eugene Smith an Alfred Stieglitz, 15.9.1908, Beinecke Library, New Haven, USA.

219
Vgl. John Wood, Anm. 209, S. 84, S. 151.

220
F. v. Ostini, ›Beiblatt zur HAWE-Mappe‹, Archiv Fotomuseum im Münchner Stadtmuseum. Um eine Meinung gebeten waren auch Josef Popp, Richard Riemerschmid sowie die deutschen Kunstkritiker Robert Diehl, Siegfried Kracauer, Julius Zeitler, Wilhelm Michel, von Graevenitz, W. Junius, Kuhfahl und H. Schwarzeder.

221
Zu den populärsten Büchern von C.H. Stratz zählten: *Die Schönheit des weiblichen Körpers*, Stuttgart 1898; *Die Darstellung des menschlichen Körpers in der Kunst*, Berlin 1914.

222
Frank Eugene Smith an Alfred Stieglitz, 21.11.1907, Beinecke Library, New Haven, USA.

223
Katalog *Androgyn. Sehnsucht nach Vollkommenheit*, Neuer Berliner Kunstverein, Berlin 1984.

224
Adolf von Hildebrand, Unveröf-

fentlichter Brief an Hans Wittmann, Archiv Fotomuseum im Münchner Stadtmuseum.

225
Carlos Detlefsen, ›Zu den Bildern von Frank Eugene Smith‹, in: *Die Schönheit*, 8, 1910/11, S. 122–124 mit 4 Illustrationen; Julius Zeitler, ›Frank Eugen Smith als Körperbildner‹, in: *Die Schönheit*, 16, 1920, S. 529–536 mit 9 Illustrationen.

226
Die Sendung wurde an die Staatsanwaltschaft Berlin zur Verfolgung »unzüchtiger Bilder« gesandt, wo man aber auf ein juristisches Einschreiten verzichtete. Vermerk auf Paketsendung c. 1914, mit handschriftlichem Vermerk von Stieglitz »Great! Isn't it!«, Korrespondenz Eugene-Stieglitz, Beinecke Library, New Haven, USA.

227
Münchner Zeitung, 24.7.1913, Archiv Hollandiana, Handschriften-Abteilung Bayerische Staatsbibliothek, München.

228
Vgl. den Beitrag von Andreas Krase in diesem Buch.

229
Für eine Freundschaft zwischen Franz Roh und Frank Eugene, wie von Krichbaum behauptet, gibt es keine Anhaltspunkte. Vgl. Jörg Krichbaum, *Lexikon der Fotografen*, Frankfurt am Main 1981, S. 60.

230
Vgl. *Photo-Woche*, 20, 1929/30, S. 1127. Katalog *Internationale Ausstellung Das Lichtbild*, München 1930. Die Aufnahmen der Kunstphotographie blieben von der Ausstellung nahezu vollständig ausgeschlossen.

231
Frank Eugene Smith an Francis Bruguière, 3.3.1933, Archiv George Eastman House, Rochester, USA.

232
Archiv Fotomuseum im Münchner Stadtmuseum.

233
Nachlaßakte Margaretha Willer geb. Ottmann, AG München Nr.1936/1086, Staatsarchiv München.

234
Nach dem Tode von Margaretha

Willer lebte Eugene mit Frl. Emilie Strobel in der Leopoldstr. 53 in München. Er verstarb im Städtischen Krankenhaus rechts der Isar in München. Laut Testament vom 6.11.1930 hatte er den Rechtsanwalt Karl Laun in München und seine Haushälterin Emilia Strobel als Erben eingesetzt. Während Emilia Strobel das 1927/28 erbaute Haus Nr. 13 in Aufkirchen erhielt, erbte der Rechtsanwalt die Aktien und Wertpapiere. Seine Geschwister hatte Eugene jeweils mit 1.000 Reichsmark bedacht. Nachlaßakte Frank Eugene Smith, AG Nr. 260, Nr. 4263, Staatsarchiv München.

brary, New Haven, USA. For details on Hartley's sojourn in Germany and Munich, see: Robert M. Crunden, *American Salons. Encounters with European Modernism 1885–1917*, New York/Oxford 1993, p. 314f. "I see Frank Eugene nearly every day and he is helping me all he can to make me known here. He is fine...." Marsden Hartley to Alfred Stieglitz, April/May 1913, Beinecke Library, New Haven, USA.

209
The exact date of the meeting is not certain. Whereas Ulrich Knapp gives the date as July 9 in his *Heinrich Kühn Photographien*, Salzburg/Vienna 1988, p. 173, according to Sue Davidson Lowe, *Stieglitz: A Memoir/Biography*, London 1983, p. 384. Stieglitz stayed in Tutzing from July 18 to Aug. 9, 1907. The letter from Stieglitz published in *Camera Work* was written in Tutzing and dated July 31, 1907. On the autochrome experiments in Tutzing, see: Alfred Stieglitz, "The New Color Photography. A Bit of History," in: *Camera Work*, Oct. 1907, no. 20, pp. 20–25; Brian Coe, *Colour Photography. The first hundred years 1840–1940*, London 1978, pp. 52–63; John Wood, *The Art of the Autochrome. The Birth of Color Photography*, Iowa City 1993, pp. 10–11.

210
For technical details, cf. B. Haldy, "Moderne Silhouetten," in: *Photographische Rundschau und Mitteilungen*, 50, 1913, pp. 108–111.

211
Cf. Sarah Greenough and others, *On the Art of Fixing a Shadow*, Boston 1989, p. 197; Weston J. Naef, footnote 52, pp. 356–357. Two autochromes each of Alfred, Emmy and Kitty Stieglitz are in the collections of The Art Institute of Chicago and The Metropolitan Museum of Art in New York.

212
Cf. Ulrich Pohlmann, "Stieglitz, Steichen, Smith and Kuehn admiring the work of Frank Eugene," in: *Bilder für Timm*, Marburg 1989, pp. 28–29.

213
Alfred Stieglitz, footnote 209,

p. 24.
214
Frank Eugene Smith to Alfred Stieglitz, July 18, 1907, Beinecke Library, New Haven, USA.

215
Charles Holme (ed.), *Colour Photography and other recent developments of the art of the camera*, The Studio, London 1908, p. 45. In the same volume Eugene's photograph "Menuett" was published.

216
F. C. Tilney, "Where we stand in pictorial colour photography," in: Supplement colour photography, *The British Journal of Photography*, Sept. 4, 1908, p. 67.

217
Frank Eugene Smith to Alfred Stieglitz, fall 1910, Beinecke Library, New Haven, USA. John Wood mentions that a total of 7 autochromes by Eugene were preserved. Cf. John Wood, footnote. 209, Preface, p. XIII.

218
Frank Eugene Smith to Alfred Stieglitz, Sept. 15, 1908, Beinecke Library, New Haven, USA.

219
Cf. Wood, footnote no. 209, p. 84, p. 151.

220
F. v. Ostini, "Beiblatt zur HAWE-Mappe," Archive Fotomuseum in the Münchner Stadtmuseum. Opinions were also requested of Josef Popp, Richard Riemerschmid and the German art critics Robert Diehl, Siegfried Kracauer, Julius Zeitler, Wilhelm Michel, von Graevenitz, W. Junius, Kuhfahl and H. Schwarzeder.

221
Among the most popular books by C. H. Stratz were: *Die Schönheit des weiblichen Körpers*, Stuttgart 1898; *Die Darstellung des menschlichen Körpers in der Kunst*, Berlin 1914.

222
Frank Eugene Smith to Alfred Stieglitz, Nov. 21, 1907, Beinecke Library, New Haven, USA.

223
Catalogue *Androgyn. Sehnsucht nach Vollkommenheit*, Neuer Berliner Kunstverein, Berlin 1984.

224
Adolf von Hildebrand, unpublished letter to Hans Wittmann,

Archive Fotomuseum in the Münchner Stadtmuseum.

225
Carlos Detlefsen, "Zu den Bildern von Frank Eugene Smith," in: *Die Schönheit*, 8, 1910/11, p. 122–124 with 4 illustrations; Julius Zeitler, "Frank Eugen Smith als Körperbildner," in: *Die Schönheit*, 16, 1920, p. 529–536 with 9 illustrations.

226
The package was returned to the Berlin District Attorney's Office marked "obscene pictures" for prosecution proceedings, but no legal measures were taken. A hand-written remark by Stieglitz on the package, dated c. 1914, reads: "Great! Isn't it!." Correspondence Eugene-Stieglitz, Beinecke Library, New Haven, USA.

227
Münchner Zeitung, July 24, 1913, Archive Hollandiana, Handschriften-Abteilung Bayerische Staatsbibliothek, Munich.

228
Cf. the essay by Andreas Krase in this book.

229
There is no evidence for the friendship claimed by Kirchbaum to have existed between Franz Roh and Frank Eugene. Cf. Jörg Krichbaum, *Lexikon der Fotografen*, Frankfurt am Main 1981, p. 60.

230
Cf. *Photo-Woche*, 20, 1929/30, p. 1127. Catalogue *Internationale Ausstellung Das Lichtbild*, Munich 1930. The works of art photography were almost totally excluded from the exhibition.

231
Frank Eugene Smith to Francis Bruguière, March 3, 1933. Archive George Eastman House, Rochester, USA.

232
Archive Fotomuseum in the Münchner Stadtmuseum.

233
File on the estate of Margaretha Willer née Ottmann, AG München no. 1936/1086, Staatsarchiv München.

234
After the death of Margaretha Willer Eugene lived with Frl. Emilie Strobel on Leopoldstrasse. 53 in Munich. He died in the

municipal hospital on the right bank of the Isar in Munich. According to his will and testament, dated Nov. 6, 1930, he had named his lawyer Karl Laun in Munich and his housekeeper Emilia Strobel as his beneficiaries. Emilia Strobel inherited his house, no. 13, in Aufkirchen, which was built in 1927/28, while the lawyer inherited his stocks and securities. Eugene left his brothers and sisters 1,000 Reichsmarks each. File on the estate of Frank Eugene Smith, AG no. 260, no. 4263, Staatsarchiv München.

Anmerkungen

Andreas Krase, Frank Eugene Smith an der Leipziger Akademie 1913–1927, S. 201–236

1
Frank Eugene Smith an das Sächsische Wirtschaftsministerium Dresden, 7.3.1927, Sächsisches Staatsarchiv Leipzig, fortlaufend unter der Abkürzung ›SSL‹ aufgeführt.

2
Z.B. Gerhard Ihrke, *Zeittafel zur Geschichte der Fotografie*, Leipzig 1982, S.124f; Axel Effner, *Kunstphotographie in München am Beispiel Frank Eugene Smith*, München 1990 (Magisterarbeit), S.100.

3
Zum Thema Neuanfänge und Modifikationen der photographischen Ausbildung: Rolf Sachsse, ›Beginnen wir! Die photographischen Abteilungen der Hochschule für Grafik und Buchkunst in Leipzig zwischen 1890 und 1950‹, in: *Fotografie. Einhundert Jahre Fotografie an der Hochschule für Grafik und Buchkunst Leipzig. Arbeiten von Absolventen und Studenten 1980–1993*, Leipzig 1993, S. 7–15.

4
Gemeint war die ›Internationale Ausstellung für Buchgewerbe und Graphik Leipzig‹ (Bugra), 1914.

5
Max Seliger, Leipzig, an Hermann Muthesius, Berlin, 26.3.1913, SSL. Prof. Felix Naumann war am 23.3.1913 verstorben. Muthesius antwortete mit dem knappen Hinweis, keine persönliche Empfehlung aussprechen zu können: »Ob es aber doch nicht angebracht wäre, sich einmal an Professor Schulze-Henke (...) zu wenden, der ja Direktor der photographischen Schule im Lette-Haus ist und jedenfalls einen guten Ueberblick über die jüngeren tüchtigen Kräfte hat. (...) Evtl. könnte man auch bei der photographischen Lehranstalt in München anfragen, doch habe ich über den dortigen Direktor persönlich nicht immer Empfehlenswertes gehört.« Hermann Muthesius an Max Seliger, 2.4.1913, SSL.

6
Antrag von Dr. Morton Bernath beim Kgl. Ministerium, des Innern, Dresden, zur Genehmigung der Reisekosten nach München, 27.3.1913, SSL.

7
Postkarte von Dr. Morton Bernath, München, an Prof. Max Seliger, 3.4.1913, SSL.

8
Frank Eugene Smith an Alfred Stieglitz, 4.7.1913, Beinecke Library, New Haven, USA.

9
Max Seliger an den Verlagsbuchhändler Wilhelm Knapp, Halle, 7.4.1913, SSL.
Hierin teilt er ihm mit, daß er »mit einem ausserordentlich tüchtigen Mann Verhandlungen betreffs Uebernahme des Lehrstuhls angeknüpft« habe und deshalb Knapps Empfehlung, den ebenfalls renommierten Wilhelm Weimer, Darmstadt, in das Lehramt zu berufen, einstweilen nur wohlwollend registrieren könne.
Bewerbung von Alfred Thiel, Assistenz an der k.u.k. höheren Graphischen Lehr- und Versuchsanstalt, Wien, um Anstellung als Lehrer für Photographie, 27.6.1913, SSL.

10
Josef Maria Eder, Direktor der Wiener Anstalt, war außerordentliches Mitglied des kunstphotographisch orientierten Klub der Amateurphotographen in Wien. Der Direktor der Münchner Anstalt, Georg Heinrich Emmerich (1870–1923) war zugleich Vorsitzender des Süddeutschen Photographen-Vereins zu München. Felix Neumann war sowohl im Sächsischen Photographen-Bund als auch im Süddeutschen Photographen-Verein vertreten. Der Gründungstitel der zunächst vereinseigenen Unterrichtsanstalt in München lautete: Lehr- und Versuchsanstalt für Photographie des Südd. Photographen-Vereins zu München, privilegiert von der Kgl. Bayer. Staatsregierung.

11
R.A. Schlegel an Prof. M. Seliger, 10.4.1913, SSL.

12
Verfassung und Schulgesetz der Königlichen Akademie für graphische Künste und Buchgewerbe zu Leipzig, Leipzig 1902.

13
1871 bis 1901 existierte die Akademie unter dem Titel Königlich Sächsische Kunstakademie und Kunstgewerbeschule zu Leipzig.

14
Max Seliger, Denkschrift ›Grundsätze, Lehrpunkte, Lehrplan, Klassenberichte, Kursusplan‹ für das Kgl. Ministerium des Innern, 1902, SSL.

15
Eingabe des Sächsischen Photographenbundes vom 4. Juli 1904 an das Kgl. Ministerium des Innern, Dresden, Abschrift, SSL.

16
Adolf Sander an das Kgl. Ministerium des Innern, 19.7.1904, SSL.

17
Rolf Sachsse, ›Beginnen wir!‹, in: *Fotografie*, Anm.3, S.10.

18
Der Rat der Königlichen Haupt- und Residenzstadt, Dr. Beuth, Verleihungsurkunde des Stadt Dresden, 15.10.1909, Sächsisches Hauptstaatsarchiv Dresden.

19
Max Seliger an R.A. Schlegel, 14.4.1913, SSL.
»Wie ich Ihnen, sehr geschätzter Herr Schlegel, bereits einmal vertraulich mitteilte, hat Prof. Naumann in künstlerischer Hinsicht vollkommen versagt. (...) Ich habe es innerlich Professor Aarland und Herrn Sander nie recht verzeihen können, daß sie mir Herrn Naumann empfohlen (und in seiner Gegenwart) geradezu aufgedrängt haben.«

20
F.E. Smith an Max Seliger, 19.4.1913, SSL.
Smith verlangte neben einem Einkommen von 6000 RM jährlich u.a., daß seine Lehre als Abschlußausbildung im künstlerischen Sinne und nicht als elementare Grundausbildung verstanden werde, daß seine Vorstellungen zum Ausbau der Abteilung akzeptiert würden, daß er mit Antritt der Stellung zum kgl. Professor ernannt und für seine Pensionsansprüche die Zeit an der Münchner Anstalt berücksichtigt und ihm ein Lehrbeistand zugestanden würde.

21
Max Seliger an das Kgl. Ministerium des Innern, Dresden, 22.4.1913, SSL.

22
Max Seliger an das Kgl. Ministerium des Innern, Dresden, 22.4.1913, SSL.
»Und weil andererseits gerade durch diese Berufung wir unserer gefährlichen Rivalin in München eine sehr empfindliche Schwächung bereiten. – Das ist von mir nicht Absicht gewesen. Aber Smith' Fortgang wäre für die Münchener Lehr- und Versuchsanstalt ein harter Schlag, und er wäre unser grösster Triumph. (...) Die Elementarlehre der Technik kann aber nicht unsere Aufgabe sein und den künstlerischen Oberbau der Lehre könnte Herr Spörl nicht beschaffen. Deshalb muss die Herüberziehung derjenigen erprobten Lehrkraft, die der eigentliche Magnet der Münchener Schule war, deren Schülerarbeiten auf den Ausstellungen und in den Publikationen der Münchener Schule stets die stärkste Empfehlungs- und Werbekraft wirkten, mein größtes Bemühen sein.«

23
Kgl. Sächsisches Ministerium des Innern an die Direktion der Akademie, 23.5.1913, SSL.

24
Bewerbung Georg Bobiens vom 12.7.1913.
Bewilligung seiner Einstellung durch das Kgl. Sächsische Ministerium des Innern, 27.8.1913, SSL.
Georg Bobien, geboren am 7. Juli 1891 in Königsberg, stammte aus einer Kaufmannsfamilie. Er war offiziell in München seit dem 2.7.1912 gemeldet und gab seine Abmeldung nach Königsberg am 19.7.1913 bekannt. Meldebogen Georg Bobien, Stadtarchiv München.

25
Kgl. Sächsisches Ministerium des Innern an die Akademieleitung, 26.9.1914, SSL.

26
Siehe Standesamt der Stadt Leipzig, Heiratsregister Eheurkunde vom 12.4.1922.
Als Wohnsitz von Smith ist die Beethovenstraße 14 angegeben. Siehe Eintragung im Adressbuch Leipzig, Jg 1927.

27
F.E. Smith an Max Seliger, 21.9.1913, SSL.

28
Eleonore Schleif, Garmisch-Partenkirchen, Brief an den Autor, 30.8.1991.

29
Schriftliche Auskunft von Herrn K. Nebrig, Lützschena, 15.5.1991.

30
Telefongespräch des Autors mit Arthur Wenzel, Minusio/Schweiz, am 12.4.1995.

31
Friederike Lina Johanna Trietschler (12.4.1895 Leipzig–13.10.1983 Dippoldiswalde), Tochter des späteren Amtgerichtsdirektors am Reichsgericht Paul Trietschler (1859–1948) und seiner Frau Margarete, geb. Caspari (1869–1944).

32
Akademie für graphische Künste und Buchgewerbe, Leipzig, 24.9.1924, Privatarchiv und SSL.

Notes

Andreas Krase, Frank Eugene Smith at the Leipzig Academy 1913–1927, pp. 199–235

1
Frank Eugene Smith to the Saxon Ministry of Economics, Dresden, March 7, 1927. Saxon State Archives, Leipzig, listed chronologically under "SSL."

2
For example, by Gerhard Ihrke, *Zeittafel zur Geschichte der Fotografie*, Leipzig 1982, p. 124f. Axel Effner, *Kunstphotographie in München am Beispiel Frank Eugene Smith*, Munich 1990 (Master's thesis), p. 100.

3
On the theme of new beginnings and modifications in photographic training cf. Rolf Sachsse, "Beginnen wir! Die photographischen Abteilungen der Hochschule für Grafik und Buchkunst in Leipzig zwischen 1890 und 1950," in: *Fotografie. Einhundert Jahre Fotografie an der Hochschule für Grafik und Buchkunst Leipzig. Arbeiten von Absolventen und Studenten 1980–1993*, Leipzig 1993, pp. 7–15.

4.
Reference is to the "Internationale Ausstellung für Buchgewerbe und Graphik Leipzig" ("Bugra") in 1914, a book design and graphics exhibition.

5
Max Seliger, Leipzig, to Hermann Muthesius, Berlin, March 26, 1913, SSL. Professor Felix Naumann died on March 23, 1913. Muthesius replied in brief that he could make no personal recommendation: "Perhaps it would be appropriate to approach Professor Schulze-Henke ... who is director of the photography school in the Lette-Haus and has first-hand knowledge of the younger, more industrious staff members.... Inquiries could also be made at the Munich Lehranstalt, although I personally have not always heard praise of the director there." Hermann

Muthesius to Max Seliger, April 2, 1913, SSL.

6
Application by Dr. Morton Bernath to the Royal Ministry of the Interior, Dresden, for approval of travel expenses for the trip to Munich, March 27, 1913, SSL.

7
Postcard from Dr. Morton Bernath, Munich, to Professor Max Seliger, April 3, 1913, SSL.

8
Frank Eugene Smith to Alfred Stieglitz, July 4, 1913, Beinecke Library, New Haven, USA.

9
Max Seliger to the publisher Wilhelm Knapp, Halle, April 7, 1913, SSL. In this letter, Seliger informs Knapp that he has "begun negotiations with an extraordinarily talented man about the appointment to the chair" and can therefore only register with thanks Knapp's recommendation to nominate the equally renowned Wilhelm Weimer, Darmstadt, for the teaching post. Application by Alfred Thiel, assistant at the Vienna K.u.K. höhere Graphische Lehr- und Versuchsanstalt, for a teaching position in photography, June 27, 1013, SSL.

10
Josef Maria Eder, director of the Vienna academy, was an extraordinary member of the Klub der Amateurphotographen in Vienna which tended towards art photography. The director of the Munich academy, Georg Heinrich Emmerich (1870–1923), was also chairman of the Süddeutsche Photographen-Verein, a photographers' association in Munich. Felix Neumann was in both the Sächsischer Photographen-Bund and in the Süddeutscher Photographen-Verein. At the time of its foundation, the

association's school in Munich was called: Lehr- und Versuchsanstalt für Photographie des Süddeutschen Photographen-Vereins zu München, privilegiert von der Königlichen Bayerischen Staatsregierung.

11
R. A. Schlegel to Professor Max Seliger, April 10, 1913, SSL.

12
Constitution and statutes of the then Königliche Akademie für graphische Künste und Buchgewerbe zu Leipzig, Leipzig 1902.

13
From 1871 to 1901 the Academy functioned under the title: Königlich Sächsische Kunstakademie und Kunstgewerbeschule zu Leipzig.

14
Max Seliger, Denkschrift "Grundsätze, Lehrpunkte, Lehrplan, Klassenberichte, Kursusplan" for the Royal Ministry of the Interior, 1902, SSL.

15
Proposal made by the Sächsische Photographen-Bund dated July 4, 1904, to the Royal Ministry of the Interior, Dresden, copy SSL.

16
Adolf Sander to the Royal Ministry of the Interior, July 19, 1904, SSL.

17
Rolf Sachsse, "Beginnen wir!" in: *Fotografie*, footnote 3, p. 10.

18
Council of the Royal Capital and Residential City, Dr. Beuth, certificate accompanying the award of the City of Dresden, October 15, 1909, Saxon State Archives, Dresden.

19
Max Seliger to R. A. Schlegel, April 14, 1913, SSL. "As I have already informed you in confidence, dear Mr. Schlegel, from the creative point of view Professor Naumann has completely

failed.... In my heart I have never been really able to forgive Professor Aarland and Mr. Sander for recommending Mr. Naumann and, (in his presence), practically forcing him upon me."

20
F. E. Smith to Max Seliger, April 19, 1913, SSL. In addition to an annual salary of 6,000 Reichsmark, Smith demanded, among other things, that his classes be understood as a complete training course in the artistic sense and not as one element in a basic photographic training course; that his ideas on the extension of the department be accepted; that he be officially nominated professor upon taking up the position; that his time at the Munich school be taken into account as regards his pension entitlements, and that he be allocated an assistant.

21
Max Seliger to the Royal Ministry of the Interior, Dresden, April 22, 1913, SSL.

22
Max Seliger to the Royal Ministry of the Interior, Dresden, April 22, 1913, SSL. "And on the other hand, because through this very appointment we are inflicting on our dangerous rival in Munich a considerable weakness. – Which was not my intention. But Smith's departure would be a hard blow for the Munich Lehr- und Versuchsanstalt, and it would be our greatest triumph.... Our objective cannot just be elementary technical training, and Mr. Spörl is not in a position to deal with the artistic superstructure of the training. My greatest efforts, therefore, must go into attracting an experienced teaching personality who was the real magnet of the Munich school, and the works of whose students have always exercised the strongest

affirmative and advertising force at the exhibitions and in the publications of the Munich school."

23
Royal Saxon Ministry of the Interior to the director of the Academy, May 23, 1913, SSL.

24
Georg Bobien's application of July 12, 1913. Approval of his appointment by the Royal Saxon Ministry of the Interior, August 27, 1913 SSL. Georg Bobien, born July 7, 1891 in Steinbeck near Königsberg, came from a family of merchants. He had been officially registered in Munich since July 2, 1912 and gave notice of moving from Königsberg on July 19, 1913. Georg Bobien's registration form, Municipal Archives, Munich.

25
Royal Saxon Ministry of the Interior to the director of the Academy, September 26, 1914, SSL.

26
Cf. Registry Office of the City of Leipzig, Marriage Register, Marriage Certificate April 12, 1922. Smith's domicile is given as Beethovenstrasse 14. Cf. Entry in the 1927 Leipzig directory of addresses.

27
F. E. Smith to Max Seliger, September 21, 1913, SSL.

28
Eleonore Schleif, Garmisch-Partenkirchen, letter to the author, August 30, 1991.

29
Written information received from Mr. K. Nebrig, Lützschena, May 15, 1991.

30
Telephone conversation with Arthur Wenzel, Minusio, Switzerland, April 12, 1995.

31
Friederike Lina Johanna Trietsch-

»Abgangszeugnis Fräulein Johanna Trietschler, geboren am 12.4.1895 in Leipzig, studierte an der Akademie vom 2.3.1914 bis 14.7.1917 als ordentliche Schülerin. Zeugnisinhaberin hat an nachstehendem Unterricht mit regem Fleiss und mit gutem Erfolge teilgenommen: Reproduktionsphotographie (Prof. Dr. Goldberg) 2 Sem.: Bildmäßige Photographie, Retuschieren (Prof. Smith) 5 Sem. (u.a.)«.

33
Smith schenkte ihr eine Photogravüre des Porträts von Sir Henry Irving, mit der handschriftlichen Widmung: »Johanna Trietschler from Frank Eugene Smith with every good wish«, 12.7.1914, Privatarchiv.

34
Auskunft von Frau Ruth Würdig, Dippoldiswalde, am 10.12.1992. Johanna Trietschler soll sich unbestätigten Angaben zufolge 1912/13 zum Sprachunterricht in England aufgehalten haben.

35
F.E. Smith an Johanna Trietschler, 5.12.1917, Privatarchiv.
»Ich halte es für das Beste, was überhaupt passieren konnte – und Du darfst Dir dessen sicher sein, daß ich alles in meiner Macht tun werde, damit es Dir hier gefällt. Ich bin überzeugt, daß Du viele Gelegenheiten haben wirst, Deine eigenen Kenntnisse zu erweitern und viele Dinge zu machen, die für Dich, für mich, für die Klasse selbst und für die Akademie interessant sein werden.«

36
Siehe: Über die jetzige Tätigkeit der Lehrbeistände, Bericht der Akademie an das Arbeits- und Wirtschaftsministerium zu Dresden, 14.1.1919, SSL.
»Hilfslehrbeistand Johanna Trietschler, 1600 M Vergütung. Lebensalter 23. Dienstjahre 1. Ehemalige Schülerin. Beihilfe Prof. Smiths beim Unterricht in Naturphotographie«

37
F.E. Smith an Johanna Trietschler, 16. August 1918, Privatarchiv.
»Franz und Gerda Seliger haben mich begleitet und wollten von mir wissen, warum ich die ganze Zeit über ›Schatz! Oh Schatz, reise nicht zu weit von mir' sänge. Sie fanden es köstlich und fragten, ob ich denn beim Spazierengehen

immer so fröhlich wäre? Ich hätte ihnen sagen können, daß ich überglücklich bin, wenn ich an Dich denke – aber niemand außer mir braucht das zu wissen.«

38
Heiratsbuch des Standesamtes I. Leipzig, Nr. 540, Aufgebotsverzeichnis 612, 12.4.1922. Standesamt Leipzig.
Als Trauzeugen fungierten der Vater Paul Trietschler und ein hochgestellter Vorgesetzter aus Dresden, Ministerialrat Geheimer Justizrat Georg Haupt.

39
Gespräch des Autors mit Frau Margarete Müller, Dresden-Radebeul, am 27.3.1995.
Margarete Müller, geb. Wenzel (geb. 1909) arbeitete 1929–31 zusammen mit Johanna Smith und durch ihre Vermittlung in der Redaktion des Baedecker-Verlages Leipzig. Sie kannte Johanna Trietschler-Smith schon seit einigen Jahren und kann sich bezüglich der Verbindung von Smith und J. Trietschler an entsprechende Äußerungen ihrer Schwester Martha Goetz, geb. Wenzel (1894–1978) zur Zeit des Geschehens erinnern. Martha Goetz arbeitete seit 1911 in der Kanzlei der Akademie und gehörte zu den Vertrauten Johanna Trietschlers. Die Lebensführung und das Zusammenleben von Frank Eugene Smith und Johanna Trietschler wurden als unkonventionell und deshalb als mit einer förmlichen Eheschließung unvereinbar angesehen.

40
Über die Ursachen der endgültigen Trennung ist nichts bekannt. Johanna Trietschler, die wahrscheinlich gleichzeitig ihre Anstellung an der Akademie aufgab, hinterließ in Leipzig kaum Spuren, abgesehen von der Ausstellung des Reichsbundes Deutscher Kunsthochschüler, Leipzig 1927 und der Juryfreien Kunstausstellung Leipzig 1927, in deren Katalogen sie namentlich (mit Schreibabweichungen) auftaucht. Johanna Smith, geb. Trietschler, heiratete 1931 wieder und war danach nicht mehr künstlerisch tätig. Erst nach ihrem Tod im Jahre 1983 tauchten die Briefe von Smith in ihrem Nachlaß auf und

wurden 1994 anläßlich der Ausstellungsrecherche in einem Privatarchiv zugänglich.

41
Telefongespräch des Autors mit Arthur Wenzel, Minusio/Schweiz, am 12.4.1995.
Arthur Wenzel berichtet. Johanna Smith an der Akademie nur unter ihrem Mädchennamen gekannt zu haben.

42
Martha Wenzel war seit 1911 als Sekretärin von Max Seliger, später von Walter Tiemann in der Kanzlei der Akademie tätig. Nach dem Amtsantritt von Fritz Goetz arbeitete sie außerdem halbtags als seine Sekretärin am Photomechanischen Institut. 1926 erfolgte die Vermählung von Fritz Goetz und Martha Wenzel.

43
Martha Goetz, geb. Wenzel (1894–1978); Arthur Wenzel, geb. 1900; Margarete Müller, geb. Wenzel, geb. 1909.

44
Gespräch des Autors mit Margarete Müller, Dresden-Radebeul, am 27.3.1995.
Margarete Müller wurde von Smith anläßlich ihrer Kommunion im Akademieatelier porträtiert. Die Aufnahmen der drei Geschwister Wenzel entstanden kurze Zeit später. Arthur Wenzel gab im Sommer 1924 seine Anstellung an der Akademie auf und ging für vier Jahre nach Südamerika. Dem Bericht von Frau Müller zufolge erweckte das Atelier den Eindruck eines großbürgerlichen Salons. Smith soll ihn gelegentlich auch zu Wohnzwecken genutzt haben. Die zeitlich ausgedehnten Aufnahmesitzungen wurden von Smith mit großer Sorgfalt in der Wahl von Accessoires und der figürlichen Positionierung vorgenommen.

45
Frank Eugene Smith an Alfred Stieglitz, 28.3.1916, Beinecke Library, New Haven, USA:
»Natürlich möchte ich alles so praktisch wie möglich haben und auch ›auf dem neusten Stand‹ und würde mich deshalb sehr glücklich schätzen, Dich und Deinen gesunden Menschenverstand und Deine guten

Ideen hier zu haben.«

46
›Die Königliche Akademie für graphische Künste und Buchgewerbe zu Leipzig‹, in: Photographische Chronik und allgemeine Photographen-Zeitung. Beiblatt zum Atelier des Photographen, 10.9.1905, S. 123.
»Die neue Klasse wird die Herstellung der Bildnisphotographie besonders pflegen (Aufnahmen im Atelier, im Zimmer, im Freilicht), ferner die bildmässige Landschaft, die Aufnahme von Werken der Plastik, der Architektur u.s.w. die Herstellung der Abzüge von solchen Aufnahmen erfolgt in allen älteren und neuzeitlichen Kopiertechniken, so dass der Schüler mit allen in Frage kommenden Herstellungsweisen vertraut wird.«

47
Lehr- und Stundenplan der Königlichen Akademie für graphische Künste und Buchgewerbe zu Leipzig für das Winterhalbjahr 1913/14. Sächsisches Hauptstaatsarchiv Dresden.
Die Akademie war unterteilt in I. Vorschule (Hauptunterricht); II. Fachschule (Hauptunterricht: Vorwerkstätten, Werkstätten); III. Abendschule (auch Ergänzungsunterricht für Vor- und Fachschüler); IV. Hilfsschule (Ergänzungsunterricht). Weitere Angaben siehe: Max Seliger, Kurze Geschichte der Leipziger Akademie, Leipzig, o.D. (1914).

48
Rolf Sachsse, ›Beginnen wir!‹, in: Fotografie, Anm. 3.

49
›Königliche Akademie für graphische Künste und Buchgewerbe, Leipzig‹, in: Archiv für Buchgewerbe, 53, 1916, S. 100.
(Dort auch weitere Angaben zu den Ausbildungsstrukturen und -zeiten sowie den Lehrzielen an der Akademie.)

50
Siehe entsprechende Angaben: ›K.k. Graphische Lehr- und Versuchsanstalt in Wien‹, in: Photographische Korrespondenz, August 1913, Nr. 635, S. 29ff. G.H. Emmerich, ›Zum zehnjährigen Bestehen der Lehr- und Versuchsanstalt für Photographie, Chemiegraphie, Lichtdruck und

Gravüre zu München‹, in: Photographische Kunst, 9, 15.8.1910, S. 113ff.

51
Siehe Ute Eskildsen und Jan-Christopher Horak (Hrsg.), Film und Foto der zwanziger Jahre. Eine Betrachtung der Internationalen Werkbundausstellung ›Film und Foto‹ 1929, Stuttgart 1979.
Die genannten Schulen waren mit Exponaten vertreten. Die in Klammern gesetzten Angaben bezeichnen, soweit zutreffend, den Anfang des eigenständigen photographischen Unterrichts und ihre Leiter: Bauhaus Dessau (1929, Walter Peterhans), Folkwangschulen für Gestaltung. Handwerker- und Kunstgewerbeschule der Stadt Essen, (1927/29, Max Burchartz), Staatlich-Städtische Kunstgewerbeschule Burg Giebichenstein, Halle/Saale (1926/27, Hans Finsler), Lette-Verein. Lehr- und Versuchsanstalt für Bildnisphotographie, wiss. Photographie und photomechanisches Verfahren (1890, Dankmar Schultz-Hencke), Württembergische Staatliche Kunstgewerbeschule, Stuttgart. In die Ausstellung wurden ergänzend mit einbezogen: Akademie der bildenden Künste zu Dresden, Schule Reimann. Private Kunst- und Kunstgewerbeschule (1931, Werner Graeff), Kunstgewerbe- und Handwerkerschule Magdeburg (1914/1927, Johann Graf).

52
1. mündliche Mitteilung über ein Telefongespräch zwischen Johannes Widmann, München, und Wolfgang G. Schröter, Leipzig, im September 1992.
Johannes Widmann (1904–1993) war 1922–27 als Student an der photomechanischen Abteilung eingeschrieben und 1947–61 Professor für Photographie an der Hochschule für Graphik und Buchkunst. Widmann lobte die außerordentliche Qualität der photomechanischen und drucktechnischen Ausbildung und konnte zum Unterricht von Smith keine Mitteilung machen.
2. Telefonat des Autors mit Arthur Wenzel, Minusio/Schweiz, am 12.4.1995.
Arthur Wenzel war 1922–24 als Hilfslehrbeistand von Prof. Fritz

ler (April 12, 1895 Leipzig–October 13, 1983 Dippoldiswalde), daughter of Paul Trietschler (1859–1948), later district court director at the Imperial Court, and his wife Margareta, née Caspari (1869–1944).

32
Akademie für graphische Künste und Buchgewerbe, Leipzig, September 24, 1924, private archive and SSL. Leaving certificate of Ms. Johanna Trietschler: born April 12, 1895 in Leipzig; attended the Academy from March 2, 1914 to July 14, 1917 as a regular student. The holder of this certificate took part with constant diligence and considerable success in the following classes: Process Photography (Professor Dr. Goldberg) 2 semesters Pictorial Photography, Retouching (Professor Smith) 5 semesters.

33
Smith gave her a present of a photogravure portrait of Sir Henry Irving, with a hand-written dedication: "Johanna Trietschler from Frank Eugene Smith with every good wish," July 12, 1914, private archive.

34
Information received from Mrs. Ruth Würdig, Dippoldiswalde, December 10, 1992: According to unconfirmed reports, Johanna Trietschler is said to have spent some time in England in 1912/13 to improve her knowledge of the language.

35
F. E. Smith to Johanna Trietschler, December 5, 1917, private archive. "I really think it is the very best thing that could possibly happen – and you may rest assured that I shall do everything in my power to make you like it and I am sure you'll find every opportunity of expanding your own knowledge and doing a lot of interesting work for yourself, for me and for the class itself and for the academy."

36
Cf. Report of the Academy to the Ministry of Employment and Economics in Dresden on the current activities of the staff assistants, January 14, 1919, SSL: "Assistant Johanna Trietschler, salary 1,600 marks. Age: 23. Years

of service: 1. Former student. Assistant to Professor Smith for his classes in nature photography."

37
F. E. Smith to Johanna Trietschler, August 16, 1918, private archive. "Franz and Gerda Seliger accompanied me and they wondered why I was singing most of the time 'Schatz, oh Schatz reise nicht zu weit von mir.' They found it delightful and asked whether I am always so joyful when I go for a walk? I might have told them that I am more than happy when I think of you – however, nobody but I need know that...."

38
Marriage Register of the Registry Office I, in Leipzig, no. 540, notice of intended marriage 612, April 12, 1922, Registry Office Leipzig. Witnesses were Johanna's father Paul Trietschler and a high-ranking superior from Dresden, Ministerial Counselor and Privy Court Councillor Georg Haupt.

39
Conversation with Mrs. Margarete Müller, Dresden-Radebeul, March 27, 1995. Margaret Müller, née Wenzel (1909), worked with Johanna Smith, and through her recommendation, for the editorial office of the publishers Baedecker in Leipzig from 1929 to 1931. She had known Johanna Trietschler-Smith already for some years and can recall corresponding remarks made by her sister Martha Goetz, née Wenzel (1894–1978) on the relationship between Smith and Trietschler at the time of the event. Martha Goetz worked in the office of the Academy from 1911 and was a close friend of Johanna Trietschler's. The life style and the whole liaison between Frank Eugene Smith and Johanna Trietschler were regarded as highly unconventional and therefore irreconcilable with the formality of marriage.

40
Nothing is known of the reasons for their final separation. Johanna Trietschler, who probably gave up her post at the Academy at the same time, left

very little evidence of her activities in Leipzig, apart from the exhibition of the Imperial Association of German Art School Students, Leipzig 1927, and the Art Exhibition Leipzig 1927. She is mentioned by name in both the catalogues (with slight differences in the spelling). Johanna Smith, née Trietschler, married again in 1931 and after that was no longer artistically active. It was only after her death in 1983 that Smith's letters turned up in her estate. They were made available in 1994 from a private archive for my research into the exhibition.

41
Telephone conversation with Arthur Wenzel, Minusio, Switzerland, April 12, 1995. Arthur Wenzel says that he only knew Johanna Smith at the Academy under her maiden name.

42
Martha Wenzel had been secretary to Max Seliger, and later Walter Tiemann, in the office of the Academy since 1911. When Fritz Goetz took up his post she also worked part-time for him as a secretary in the Photo-Mechanical Institute. Fritz Goetz and Martha Wenzel were married in 1926.

43
Martha Goetz, née Wenzel (1894–1978); Arthur Wenzel, born 1900; Margarete Müller, née Wenzel, born 1909.

44
Conversation with Margarete Müller, Dresden-Radebeul, March 27, 1995.
Margarete Müller was photographed by Smith in his studio on the occasion of her First Communion. The photographs of the three Wenzel children were taken a short time later. Arthur Wenzel gave up his position at the Academy in 1924 and went to South America for four years.
According to Mrs. Müller's account, the studio looked very much like a bourgeois living room. It is said that Smith occasionally used to use it as such. The sittings were prolonged as Smith prepared the takes with great care, giving a lot of atten-

tion to the selection of the accessories and the positioning of the sitters.

45
Frank Eugene Smith to Alfred Stieglitz, March 28, 1916, Beinecke Library, New Haven, USA. "Naturally I desire to make it as practical and 'up to date' as ever possible – and: I should intensely appreciate having you here with all your common sense and clear ideas."

46
"Die Königliche Akademie für graphische Künste und Buchgewerbe zu Leipzig," in: *Photographische Chronik und allgemeine Photographen-Zeitung. Beiblatt zum Atelier des Photographen*, Halle, September 10, 1905, p. 123: "The new class will deal in particular with the production of pictorial photography (photographs taken in the studio, indoors, outdoors), also with landscape photography, photographs of sculptural works, of architecture etc. The production of prints of such photographs will be done in all the traditional and the more recent copying techniques so that the students will become familiar with all the relevant production methods."

47
Syllabus and timetable of the Leipzig Academy for the winter semester 1913/14. Saxon State Archives, Dresden. The Academy was divided into four sections: I. Preparatory Courses (main classes) II. Major Courses (main classes: preliminary workshops, workshops) III. Evening Courses (also supplementary classes for students from I. and II.) IV. Minor Courses (supplementary classes) For further details cf. Max Seliger, *Kurze Geschichte der Leipziger Akademie*, Leipzig, not dated (1914).

48
Rolf Sachsse, "Beginnen wir!," in: *Fotografie*, footnote 3.

49
"Die Königliche Akademie für graphische Künste und Buchgewerbe, Leipzig," in: *Archiv für Buchgewerbe*, 53, 1916, p.100 (also contains further information on the training structure and

course duration, as well as on the pedagogical aims of the Academy).

50
Cf. respective data for: "K.k. Graphische Lehr- und Versuchsanstalt in Wien," in: *Photographische Korrespondenz*, no. 635, August 1913, pp. 29 ff. G. H. Emmerich, "Zum zehnjährigen Bestehen der Lehr- und Versuchsanstalt für Photographie, Chemiegraphie, Lichtdruck und Gravüre zu München," in: *Photographische Kunst*, 9, August 15, 1910, p. 113 ff.

51
Cf. Ute Eskildsen and Jan-Christopher Horak (ed.) *Film und Foto der zwanziger Jahre. Eine Betrachtung der Internationalen Werkbundausstellung "Film und Foto" 1929*, Stuttgart 1979. The schools named were represented with exhibits. Wherever relevant, the data in brackets indicate when independent photography courses began and who was responsible for them: Bauhaus Dessau (1929, Walter Peterhans) Folkwangschulen für Gestaltung. Handwerker- und Kunstgewerbeschule der Stadt Essen (1927/29, Max Burchartz) Staatlich-Städtische Kunstgewerbeschule Burg Giebichenstein, Halle/Saale (1926/27, Hans Finsler) Lette-Verein. Lehr- und Versuchsanstalt für Bildnisphotographie, wissenschaftliche Photographie und photomechanisches Verfahren (1890, Dankmar Schultz-Hencke) Württembergische Staatliche Kunstgewerbeschule, Stuttgart. Also included in the survey were: Akademie der bildenden Künste zu Dresden Schule Reimann. Private Kunst- und Kunstgewerbeschule (1931, Werner Graeff) Kunstgewerbe- und Handwerkerschule Magdeburg (1914/27, Johann Graf).

52
1. Oral account relating to a telephone conversation between Johannes Widmann, Munich, and Wolfgang G. Schröter, Leipzig, in September 1992. Johannes Widmann (1904–1993) was enrolled as a student in the photo-mechanical department between 1922 and 1927. From 1947 to 1961 he was Professor of

Goetz (insbesondere für die drucktechnische Reproduktion der Manessischen Liederhandschrift) an der Akademie angestellt.

Arthur Wenzel bestätigte, daß außerhalb des Ateliers nur wenig von Smiths Tätigkeit zu spüren war und die Klasse für Naturphotographie wegen der fehlenden Verbindung auch zum photomechanischen Institut im Bewußtsein der Akademieangehörigen kaum noch existierte. Nach seiner Meinung hatte Smith einen nicht unbeträchtlichen Teil seiner Lehraufgaben an Johanna Trietschler delegiert.

53

Tatsächlich fanden diese Porträts nur eine geringe Verbreitung. In den *Mitteilungen der Königlichen Akademie für graphische Künste und Buchgewerbe zu Leipzig*, die in den Jahren 1914/15 erschienen, wurden nur drei Porträts von Smith abgedruckt: Heft 1, Porträt Prof. Franz Hein; Heft 2, Porträt Prof. Max Seliger; Heft 3, Porträt Dr. Ludwig Volkmann, 1. Vorsteher des Deutschen Buchgewerbevereins und Präsident der Weltausstellung für Buchgewerbe und Graphik in Leipzig 1914.

54

Siehe *Die Königliche Akademie für graphische Künste und Buchgewerbe in Leipzig. Zum Gedächtnis des 150jährigen Bestehens der Leipziger Akademie im Jahre der Weltausstellung für Buchgewerbe und Graphik in Leipzig 1914.*
Eine Photographie, die stilistisch deutlich von Smiths Entwürfen abweicht, zeigt eine Gitarrenspielerin, die zweite Photographie einen sonnenbeschienenen Flußlauf mit darüberhängenden Baumästen. Diese Photographie wurde von Smith zusammen mit anderen eigenen Bildern im folgenden Aufsatz abgebildet: Frank Eugen Smith, ›Über Linsen und Linsensysteme‹, in: *Photo-Spiegel. Illustrierte Wochenschrift des Berliner Tageblattes*, 12.5.1927: ›Landschaft, aufgenommen mit Monocle-Linse‹.

55

Am Schluß des Festaktes wurde ein von Dr. Julius Zeitler verfaß-

tes Festspiel über den Gründungsdirektor der Akademie im Jahre 1764 aufgeführt: ›Oeser und die Seinen – Zeitbilder aus den Gründungsjahren der Akademie‹. Siehe *Archiv für Buchgewerbe*, 51, 1914, Nr. 3, S. 111f.

56

Archiv für Buchgewerbe, 51, 1914, Nr. 3, S. 111f.

57

Die ›Bugra‹ wurde am 6. Mai eröffnet und am 18. Oktober wegen der Kriegsereignisse vorzeitig geschlossen. Nur die ›Kriegsausstellung‹ blieb weiterhin zugänglich.

58

Siehe Dr. Julius Zeitler, ›Die Ausstellung der Königlichen Akademie für graphische Künste und Buchgewerbe auf der Bugra 1914‹ in: *Archiv für Buchgewerbe*, 52, 1915, S. 128–130.

59

›Die Akademie auf der internationalen Ausstellung Buchgewerbe und Graphik‹, in: *Mitteilungen der Königlichen Akademie für graphische Künste und Buchgewerbe zu Leipzig*, 1914, Nr. 5, S. 38/39.

60

»Während die grossen Ausstellungen des ›Süddeutschen Photographen-Vereins‹, einschließlich der in Dresden, ausdrücklich als Propagandamittel anzusehen waren und unendlich viel Gutes stifteten, zeigt die Leipziger Ausstellung kein Gesicht, keine neuen Gruppierungen, sie bietet wenig Anregungen, löst keine Probleme; durch und durch nüchtern ist sie, ich möchte fast behaupten, dass sie ohne Begeisterung geschaffen worden ist.« Arthur Ranft, ›Bugra 1914. Die photographische Ausstellung in Leipzig‹, in: *Photographische Kunst*, 15. Juli 1914, Nr. 7.

61

Max Seliger an das Kgl. Ministerium des Innern, 28.10.1913, Sächsisches Hauptstaatsarchiv Dresden.
»Wegen der Beschickung der ›Bugra‹ bleibt uns für eine zweite Beschickung der Cölner Ausstellung nicht genügend Material. (...) Ich bemerke aber schon jetzt, dass eine Ausstellung, die das Wesen der Akademie erschöpfend zum Ausdruck bringt, nicht möglich ist, dass es sich also nur um die Hingabe einer Abteilung der Akademie handeln kann, die wo-

möglich in Cöln durch Konkurrenzschulen nicht überwunden wird. Es käme für Cöln in Betracht eine Hinsendung der Erzeugnisse unserer Reproduktionsabteilung (Dr. Goldberg) und unserer neuen Werkstatt für Naturphotographie (Smith). Ich bitte um eine Entscheidung, ob in Cöln ausgestellt werden soll (...)«.

62

Siehe *Deutsche Werkbund Ausstellung Cöln 1914. Offizieller Katalog*, Köln-Berlin 1914, Reprint Köln 1981. Sächsisches Haus, Raum der Stadt Leipzig, Exponate von Steiner-Prag, Tiemann, Kolb und Belwe.

63

Siehe Ute Eskildsen, ›Die Abteilung Fotografie‹, in: *Der westdeutsche Impuls 1900–1914. Die Deutsche Werkbund-Ausstellung Cöln 1914*, Köln 1984.

64

F.E. Smith an die Direktion der Akademie, 12.8.1914, SSL.
»Deutschlands viele Feinde zu bekämpfen möchte ich mithelfen und bitte eine hochverehrliche Direktion über mich verfügen zu wollen – für eine Anregung in welcher Weise ich der grossen Sache am besten dienen kann wäre ich herzlich dankbar und froh ergebenst Frank Eugene Smith«.

65

Frank Eugene Smith an Alfred Stieglitz, 29.8.1914, Beinecke Library, New Haven, USA.
»Die Soldaten ziehen, prachtvolle Lieder singend – Helme und Gewehre mit Blumen üppig geschmückt, in die Gewehrläufe sind Rosen und allerlei schöne Blumen und im Herzen die Sieges – sichere Freude Ihr Leben für eine grosse herrliche Sache einzusetzen. Deutschland muss siegen! Wir alle helfen mit - Eher geben wir keine Ruh! Und hauen sackisch zu – Die Englische + Französische Armee habe ich kolossal verprügelt – (...) Endlich muss die Schweinepack an 2te Stelle treten und Eine Ehrlicheres gesünderes Volk – Die Deutschen voran lassen.«

66

Max Seliger an die Kgl. Staatsanwaltschaft in Merseburg, 7.5.1915, Sächsisches Hauptstaatsarchiv

Dresden.

67

Bescheinigung des Consuls der Vereinigten Staaten über den Verzicht von F.E. Smith auf die Amerikanischen Bürgerrechte, 9.5.1915. Sächsisches Hauptstaatsarchiv Dresden.

68

Staatsangehörigkeitsbescheinigung der Kgl. Sächsischen Kreishauptmannschaft Leipzig, 11.6.1915, Sächsisches Hauptstaatsarchiv Dresden.

69

Prof. G.H. Emmerich (1870–1923), Direktor der Lehr- und Versuchsanstalt in München an F.E. Smith, 13.9.1917, Sächsisches Hauptstaatsarchiv Dresden.
»Ich weiss allerdings nicht, ob es zutrifft was ich nun öfter gehört habe, nämlich dass Sie sich in Leipzig nicht recht wohl fühlen sollen. Ich möchte Ihnen daher die Frage nahe legen, ob Sie nicht am Ende an unsere Anstalt zurückkehren möchten.« Emmerichs Stellung war zu dieser Zeit bereits erschüttert. Es ist nicht bekannt, ob sein Angebot realistisch war oder ob er selbst lediglich um Unterstützung nachsuchte.

70

Dr. Morton Bernath an die Schriftleitung der *Deutschen Kunst und Dekoration* (Briefentwurf), 8.7.1913, SSL.
»Seine Porträtaufnahmen aus den Kreisen der Münchener Gesellschaft und Künstlern gehören zum Besten was auf diesem Gebiete geleistet wurde. Seine letzte hervorragende Arbeit ist eine Ganzfiguraufnahme des neuen Prinzregenten, die für die Bayrischen Mittelschulen bestimmt ist.«

71

Deutsche Kunst und Dekoration, 33, Oktober 1913–März 1914, S. 62–68.
»Alles spricht hier von einer kräftigen, vollsaftigen und ›reizsamen‹ Natur, so wie sie diesmal in seinem Selbstbildnis gefaßt hat: zuckende, sprühende Laune, genießerisch ausgebildete Gesichtsformen, beweglicher Geist und überlegenes Temperamemt.«

72

Dr. Julius Zeitler, ›Neue Lichtbild-

kunst von Frank Eugen Smith‹, in: *Deutsche Kunst und Dekoration*, September 1917, S.350–360.

73

Ebd. »Und so ist es in Smith der Künstler, der für den Vorgang der Bildwerdung den Grundton angibt. Er formt die Menschen, die Gestalten, die Szenen mit seinem eigenen Künstlergeist, bevor er den Apparat arbeiten läßt, und ein Kunstprozeß ist es auch, wie er ihn in Wirksamkeit bringt und endlich ist auch sein Umgehen mit der Platte von reifster künstlerischer Erkenntnis diktiert.«

74

Fotomuseum im Münchner Stadtmuseum.
Genaue Angaben zu den Zeitungstiteln und Publikationsdaten sind überwiegend nicht erhalten, da die Zeitungsausschnitte diese Verweise nicht enthalten.

75

Frank Eugen Smith, ›Vom Werdegang der Photographie‹, in: *Photo-Spiegel. Illustrierte Wochenschrift des Berliner Tageblatts*, 27.1.1927.
»Heute befindet sich Deutschland im Wiederaufbau. Noch immer sind England und Amerika auf dem Gebiete der Photographie führend. Der Geschmack und die rein sinnliche Schönheit des Tones stehen bisher unerreicht da. Während des Krieges hat das Ausland mit Erfolg weiterarbeiten können; Deutschland nicht. Um so stärker muss die Mahnung an unsere Regierung sein, auf dem Weg vor dem Krieg fortzufahren und Plätze an unseren staatlichen Schulen zu schaffen, die die künstlerische Erziehung unserer heutigen Photographen im Auge haben.«

76

Ebd.

77

Frank Eugen Smith, ›Photographie und Malerei‹, in: *Photo-Spiegel. Illustrierte Wochenschrift des Berliner Tageblatts*, 3.3.1927.

78

Frank Eugen Smith, ›Über Linsen und Linsensysteme‹, in: *Photo-Spiegel. Illustrierte Wochenschrift des Berliner Tageblattes*, 12.5.1927.

Photography at the Hochschule für Graphik und Buchkunst. Widmann praised the extraordinary quality of the training in photo-mechanics and printing but could make no comment on Smith's classes.

2. Telephone conversation with Arthur Wenzel, Minusio, Switzerland, April 12, 1995. Arthur Wenzel was an assistant teacher to Professor Fritz Goetz at the Academy from 1922 to 1924 (in particular in connection with the reproduction of the Manesse illuminated book). Arthur Wenzel confirmed that outside of the studio little notice was taken of Smith's activities and that the class for nature photography scarcely existed in the minds of the the other Academy students because of the absence of any contacts with the photo-mechanical institute. What is more, according to Wenzel Smith had delegated a considerable part of his teaching duties to Johanna Trietschler.

53
In fact these portraits were only rarely published. In the *Mitteilungen der Königlichen Akademie für graphische Künste und Buchgewerbe zu Leipzig*, which appeared in 1914/15, only three portraits by Smith were reproduced: vol. 1, "Portrait of Professor Franz Hein"; vol. 2, "Portrait of Professor Max Seliger"; vol. 3, "Portrait of Dr. Ludwig Volkmann," first chairman of the Deutsche Buchgewerbeverein, a book design association, and president of "Bugra," the World Exhibition of Book Design and Graphics in Leipzig 1914.

54
Cf. *Die Königliche Akademie für graphische Künste und Buchgewerbe in Leipzig. Zum Gedächtnis des 150jährigen Bestehens der Leipziger Akademie im Jahre der Weltausstellung für Buchgewerbe und Graphik in Leipzig 1914*. One photograph which deviates clearly from the Smith mode shows a woman playing a guitar, a second shows a sunlit river with hanging tree branches. This photograph, along with others of his, was used by Smith

in the following essay: "Frank Eugen Smith, Über Linsen und Linsensysteme," in: *Photo-Spiegel. Illustrierte Wochenschrift des Berliner Tageblattes*, May 12, 1927. "Landschaft, aufgenommen mit Monocle-Linse."

55
At the end of the ceremony there was a performance of a festival production written by Dr. Julius Zeitler about the 1764 founding director of the Academy: "Oeser und die Seinen – Zeitbilder aus den Gründungsjahren der Akademie," cf. *Archiv für Buchgewerbe*, 51, 1914, no. 3, pp. IIIf.

56
Archiv für Buchgewerbe, 51, 1914, no. 3, pp. IIIf.

57
The exhibition known as "Bugra" was opened on May 6 and closed prematurely on October 18 due to the war. Only the "War Exhibition" continued to be shown.

58
Cf. Dr. Julius Zeitler, "Die Ausstellung der Königlichen Akademie für graphische Künste und Buchgewerbe auf der Bugra 1914," in: *Archiv für Buchgewerbe*, 52, 1915, p. 128–130.

59
"Die Akademie auf der internationalen Ausstellung Buchgewerbe und Graphik," in: *Mitteilungen der Königlichen Akademie für graphische Künste und Buchgewerbe zu Leipzig*, 1914, no. 5, p.38–39.

60
"Whereas the large-scale exhibitions mounted by the 'Süddeutscher Photographen-Verein,' including that in Dresden, were definitely to be regarded as a means of propaganda, providing much that was extremely good, the Leipzig exhibition has no individual profile, no new groupings, offers little stimulus, solves no problems; it is thoroughly sober. I would almost be tempted to say that it has been mounted without enthusiasm." Arthur Ranft, "Bugra 1914. Die photographische Ausstellung in Leipzig," in: *Photographische Kunst*, July 15, 1914, no. 7.

61
Max Seliger to the Royal Ministry of the Interior, 28. Oct. 1913,

Saxon State Archives, Dresden. "Having sent exhibits to the 'Bugra' there is not enough material left for us to send a second batch to the Cologne exhibition.... It is already evident to me that an exhibition which would provide an exhaustive presentation of the Academy is thus not possible. What would be possible would be the presentation of just one of the Academy's departments, and one which would perhaps not be outdone in Cologne by competitor schools. What could be considered for Cologne is the despatch of products from our reproduction department (Dr. Goldberg) and from our new workshop for nature photography (Smith). I request a decision on whether we should participate in the exhibition in Cologne....."

62
Cf. *Deutsche Werkbund Ausstellung Cöln 1914. Offizieller Katalog*, Cologne-Berlin 1914, reprint Cologne 1981, Saxon House, City of Leipzig, exhibits by Steiner-Prag, Tiemann, Kolb and Belwe.

63
Cf. Ute Eskildsen, "Die Abteilung Fotografie," in: *Der westdeutsche Impuls 1900–1914. Die Deutsche Werkbund-Ausstellung Cöln 1914*, Cologne 1984.

64
F. E. Smith to the Director of the Academy August 12, 1914, SSL. "My wish is to help fight Germany's many enemies and I ask the honored director to dispose of me as desired – I would be more than grateful for an indication as to how I can best serve the great cause, gladly your most humble Frank Eugene Smith."

65
Frank Eugene Smith to Alfred Stieglitz, August 29, 1914. Beinecke Library in New Haven, USA. "The soldiers march off singing wonderful songs – their helmets and weapons lavishly decorated with flowers, roses and all kinds of lovely flowers in the barrels of their rifles, and in their hearts, confident of victory, the joy of risking their life for a great and glorious thing. Germany must be victorious! We are all willing to help in this – and

will not let up before it is achieved! We are striking out at the double – we have given the English and the French armies a colossal thrashing ... In the end, the pack of bastards will have to fall into second place and allow a more honorable and healthy people – the Germans – to the fore."

66
Max Seliger to the Royal Public Prosecutor's Office in Merseburg, May 7, 1915, Saxon State Archives, Dresden.

67
Confirmation by the Consul of the United States of F. E. Smith's renunciation of his American civil rights, May 9, 1915, Saxon State Archives, Dresden.

68
Confirmation of nationality by the Royal Saxon District Chancellery Leipzig, June 11, 1915, Saxon State Archives, Dresden.

69
Professor G. H. Emmerich (1870–1923), Director of the Lehr- und Versuchsanstalt in Munich, to F.E. Smith, September 13, 1917, Saxon State Archives, Dresden. "However, I do not know whether what I often hear is correct, namely, that you may not be feeling very happy in Leipzig. I would like, therefore, to ask you whether you would not like to return to our institute after all." Emmerich's own position at this time was already shaky. It is not known whether his offer was a realistic one or whether he was just looking for support for himself.

70
Dr. Morton Bernath to the editorial office of *Deutsche Kunst und Dekoration* (draft of a letter), July 8, 1913, SSL. "His portrait photographs of members of Munich's social and art circles are among the best there are in this sector. His most recent, excellent work is a full-length portrait of the new prince regent, destined for distribution to Bavaria's secondary schools."

71
Deutsche Kunst und Dekoration, 33, October 1913 – March 1914, p. 62–68: "Here, as he has succeeded in capturing himself in

this self-portrait, everything points to a powerfully mature and 'excitable' nature: a sparkling, ebullient disposition, sensuous well-formed facial features, agile spirit and superior temperament."

72
Dr. Julius Zeitler, "Neue Lichtbildkunst von Frank Eugen Smith," in: *Deutsche Kunst und Dekoration*, September 1917, p. 350–360.

73
Dr. Julius Zeitler, in: *Deutsche Kunst und Dekoration*, Darmstadt, September 1917. "And thus in Smith's case it is the artist who dictates the prevailing mood in which the image proceeds to emerge. He informs the people, the shapes, the scenes with his own artistic spirit before letting the apparatus go to work, and the way in which he brings that apparatus into effect is also an artistic process. Finally, his handling of the plate is dictated by the most mature of artistic insight."

74
Fotomuseum in the Münchner Stadtmuseum. For the most part, exact details of the titles of the newspapers and the dates of publication have not been preserved as the newspaper clippings do not contain these references.

75
Frank Eugene Smith, "Vom Werdegang der Photographie," in: *Photo-Spiegel. Illustrierte Wochenschrift des Berliner Tageblatts*, January 27, 1927: "Today, Germany is in the process of reconstruction. England and America are still leaders in the field of photography. The taste and sheer sensual beauty of the tone they have achieved are as yet still unequalled. During the war, other countries were able to continue to develop successfully; not so Germany. All the more urgent must the admonition to our government be, therefore, to continue on the path taken before the war and, with a view to the artistic training of our contemporary photographers, create places at our state schools."

Beigefügt waren folgende Aufnahmen: ›Gräfin von B.‹, ›Schach‹, ›Dr. Emanuel Lasker und Dr. Bertold‹, ›Sir Henry Irving‹, ›Maler-Radierer Willy Geiger‹, ›Landschaft‹, ›Menuett‹.

79
Prof. Toni Stadler, *BIZ* 50/1912, S. 1236; Prof. Gabriel von Seidl, *BIZ* 7/1913, S. 132; Prof. Gabriel von Seidl, *BIZ* 19/1913, S. 372; Paul Heyse, *BIZ* 15/1914, S. 270; Franz von Defregger, *BIZ* 18/1915, S. 232.

80
untersucht wurden die Jahrgänge 1912–1923.

81
›Der Weltschachmeister Dr. Emanuel Lasker‹, *Reclams Universum*, Dezember 1918, S. 384; ›Zwei Glückliche (Bildnis eines Paares, d. A.)‹, *Reclams Universum*, Dezember 1919, S. 219; ›Die Zigarette (Frauenbildnis, d. A.)‹, *Reclams Universum*, März 1920, o. S. Prof. Dr. Julius Zeitler, ›Frank Eugen Smith als Körperbildner‹, in: *Die Schönheit. Mit Beiblättern geschmückte Zeitschrift*, 12/1920, S. 529–536, 9 Abbildungen.

82
F.E. Smith an die Leitung der Akademie, 26.1.1920, Sächsisches Hauptstaatsarchiv Dresden. Zusammenstellung zum Bestand der Abteilung für Naturphotographie und die nötigen Ergänzungen der Einrichtung nach dem demnächst beendigten Umbau.

83
Kgl. Landbauamt Leipzig, Bericht des Herrn Prof. Smith über Beschaffung von Einrichtungsgegenständen und Lehrmitteln, 20.5.1920, Sächsisches Hauptstaatsarchiv Dresden.

84
Siehe Anneliese Hübscher, ›Walter Tiemann 1876–1951‹, in: Albert Kapr (Hrsg.), *Traditionen Leipziger Buchkunst*, Leipzig 1989. Tiemann leitete die Akademie bis 1940 und verstand es, das ungebremste Vordringen der Nazis an der Akademie für einige Zeit abzumildern. 1945/46 wurde er erneut als kommissarischer Leiter eingesetzt und danach endgültig verdrängt.

85
Siehe Walter Tiemann, ›Verfassung der Staatlichen Akademie für gra-

phische Künste und Buchgewerbe zu Leipzig‹, 17.11.1921, SSL.

86
Akademie für graphische Kunst und Buchgewerbe in Leipzig, 26.11.1921, Sächsisches Hauptstaatsarchiv Dresden.

87
Fritz Goetz an Max Seliger, 9.5.1919, SSL. »Wir haben hier Schweres durchleben müssen! Unter Maschinengewehr-Geknatter und Strassenkämpfen in nächster Nachbarschaft hatte ich zweimal angesetzt Ihnen zu schreiben.«

88
Fritz Goetz an die Akademieleitung, 31.12.1925, SSL. »Leider konnte der Gedanke der Gründung einer lebendigen Werkstatt, aus der im fortlaufend Meister der Reproduktionstechniken hervorgehen sollten, nicht in wünschenwertem Maße zur Durchführung gelangen.« Der häufig kränkelnde Goetz trat zum 1.4.1926 offiziell in den Ruhestand, nachdem im Vorjahr seine Frau, die Malerin Martha Goetz, geborene Singer, verstorben war. Im Juni 1926 vermählte er sich in Leipzig mit seiner früheren Mitarbeiterin und Kanzleiangestellten an der Akademie, Martha Wenzel (1894–1978). Wenige Monate nach der Geburt der gemeinsamen Tochter Dorothea Goetz (1927–1970) verstarb Goetz in München. Seine Witwe Martha Goetz lebte zunächst in Leipzig, ab 1936 in Radebeul bei Dresden. Sie blieb über Jahrzehnte hinweg im persönlichen Kontakt mit der ehemaligen Frau von Frank Eugene Smith, die im nahegelegenen Dippoldiswalde wohnte. Dorothea Goetz wanderte 1948 nach Chile aus und blieb dort bis zum Ende ihres Lebens.

89
U.a. Walter Peterhans 1925/26 als Student der Reproduktionsphotographie, siehe Jeanine Fiedler (Hrsg.), *Fotografie am Bauhaus*, Berlin 1990, S. 352.

90
Siehe Kgl. Landbauamt Leipzig, Bericht des Herrn Prof. Smith, 20.5.1920, Sächsisches Hauptstaatsarchiv Dresden. Darauf weisen die Existenz eines Heimateliers mit gutbürgerlicher

Wohnraumausstattung sowie die Anforderungen von Smith für den Hauptaufnahmeraum hin: »Zur Schmückung des Dunkelkammereinganges ein paar lebende Schlingpflanzen in dazu geeigneten Kästen und einige Gipse zur Belebung des Raumes. Am anderen Fenster einige Geranien oder ähnliche Pflanzen mit Kästen.«

91
Staatliche Akademie für graphische Künste und Buchgewerbe zu Leipzig, Juli 1922, SSL. »Die Werkstatt für Naturphotographie vornehmlich Porträtphotographie hat den Zweck, ausreichend vorgebildeten Photographen eine Abschlussausbildung zu geben, die nur in der Richtung des künstlerischen Geschmackes liegt. (...) Als Aufgaben werden ausser den verschiedensten Bildnisaufnahmen Landschafts-, Tier- und Pflanzenstudien, Architektur- und Städtebilder usw. gestellt.«

92
Sächsisches Wirtschaftsministerium Dresden an F.E. Smith, 22.12.1923, Sächsisches Hauptstaatsarchiv Dresden.

93
Folgende Ausstellungsstationen sind genauer bekannt: Kunstgewerbemuseum Frankfurt a.M., März–April 1924; Landesgewerbemuseum Stuttgart; Staatliche Kunstgewerbe-Bibliothek Dresden, Dezember 1924; Kunstverein Freiburg i. Breisgau, April 1925; Kunstverein/Kunstgewerbeschule München; Nürnberger Buchgewerbesaal in der Bayerischen Landesgewerbeanstalt, Januar–Februar 1926.

94
U.a. Porträts des Königs Friedrich August v. Sachsen, von den Familien der Akademiedirektoren Seliger und Tiemann und einigen weiteren Akademielehrern.

95
Z.B. Dr. von Graevenitz, ›Photographischer Vortrag im Kunstverein‹, in: *Breisgauer Zeitung*, 28.4.1925.

96
Carl Blecher, ›Die Einrichtungen und Unterrichtsziele der photomechanischen Werkstätten der Staatl. Akademie für graphische

Künste und Buchgewerbe zu Leipzig‹, in: *Deutscher Drucker. Illustrierte Monatsschrift für die Graphischen Künste und die Reproduktionstechnik*, Juli 1927, Nr. 10, S. 848–853. Blecher nannte die Lehrabteilungen Originalbehandlung, Reproduktionsphotographie, Tiefdruck, Formenherstellung für Offsetdruck, Offsetdruck, Buchdruckklischeeherstellung, Lichtdruck sowie verschiedene Vorträge und Praktika.

97
Schülerverzeichnis der Akademie, Sommerhalbjahr 1927 SSL.

98
Verein Leipziger Jahres-Ausstellung, Katalog der zehnten Jahres-Ausstellung L.I.A. im Staedtischen Museum am Augustusplatz zu Leipzig vom 22. Febr. bis 31. Maerz, Leipzig 1925.

99
Kurt Massloff war 1947–1958 Rektor der Leipziger Hochschule und galt als harter Dogmatiker des ›Sozialistischen Realismus‹.

100
Ladislaus Moholy-Nagy, ›Von der Pigmentmalerei zur Farbigen Lichtgestaltung‹, in: *Verein Leipziger Jahres-Ausstellung*, Leipzig 1925, S. 38.

101
Sächsisches Wirtschaftsministerium, Abt. für Handel und Gewerbe, Dresden an die Direktion der Akademie für graph. Künste und Buchgewerbe, 26.2.1927, Sächsisches Hauptstaatsarchiv Dresden. »Da nach den früheren Darlegungen der Akademiedirektion und dem Bericht vom 18. d. Mts. ein Bedürfnis für das Fortbestehen der Abteilung für Naturphotographie nicht mehr anerkannt werden kann, was vor allem die dauernd unverhältnismäßig niedrige Schülerzahl beweist, so hat das unterzeichnete Ministerium beschlossen, die Klasse abzubauen.«

102
Frank Eugene Smith an das Sächsische Wirtschaftsministerium Dresden, 7.3.1927, Sächsisches Hauptstaatsarchiv Dresden. »Die bisherige Klasse hat der Akademie selbst, aber auch den von ihr beeinflussten Umkreis,

die Stadt Leipzig oder den Freistaat Sachsen, oder sonstige grössere Teile von Deutschland, insoweit auf dem in Betracht kommenden Gebiete befruchtet, als sie den beruflich oder nichtberuflich mit Photographie beschäftigten Personen den dauernden Impuls zur Hebung ihres Niveaus hat zu Teil werden lassen. Denn die mannigfach bestehenden Fachschulen können selbst bei besten Leistungen das nicht erreichen, was die bisher an der staatl. Akademie bestehende Klasse für Natur-Photographie, besonders nach der reinkünstlerischen Seite hin geleistet hat.«

103
Walter Tiemann, ›Die Staatliche Akademie für graphische Künste und Buchgewerbe, Leipzig‹, in: *Deutscher Drucker*, Juli 1927, Nr. 10, S. 845. »Die Forderung des Tages zielt auf eine immer größere Vielseitigkeit der Ausbildung der jungen Künstler, die sich mit den Aufgaben der angewandten Graphik beschäftigen wollen hin, und die Akademie strebt danach, sich diesen Bedürfnissen raschestens anzupassen. Deshalb betrachtet sie es als ihre Aufgabe, das ganze Lehrprogramm möglichst frei zu gestalten und in einer ständigen Wechselwirkung von Kunst und Technik zu erhalten. Von diesem Gesichtspunkt aus wird auch die Brücke zur Photographie und zum photomechanischen Reproduktionsverfahren leicht gefunden, und diese Abteilung fügt sich in den Rahmen unserer Aufgaben logischer ein, als wie vielleicht die rein technische Interpretation den Anschein erwecken könnte. Ich erinnere nur an die Aufgaben der Photomontagen, die noch sehr der künstlerischen Durchdringung bedürfen und die jetzt auch an der Akademie eine Pflegestätte gefunden haben.«

76
Frank Eugene Smith, in: *Photo-Spiegel*, January 27, 1927.
77
Frank Eugen Smith, "Photographie und Malerei," in: *Photo-Spiegel. Illustrierte Wochenschrift des Berliner Tageblatts*, March 3, 1927.
78
Frank Eugen Smith, "Über Linsen und Linsensysteme," in: *Photo-Spiegel. Illustrierte Wochenschrift des Berliner Tageblatts*, May 12, 1927. The following photographs were included: "Countess von B.," "Chess. Dr. Emanuel Lasker and Dr. Bertold," "Sir Henry Irving," "the painter Willy Geiger," "Landscape," "Menuett."
79
Professor Toni Stadler, *BIZ* 50/1912, p. 1236; Professor Gabriel von Seidl, *BIZ* 7/1913, p. 132; Professor Gabriel von Seidl, *BIZ* 19/1913, p. 372; Paul Heyse, *BIZ* 15/1914, p. 270; Franz von Defregger, *BIZ* 18/1915, p. 232.
80
An examination was undertaken of the years 1912–1923.
81
"The World Chess Champion Dr. Emanuel Lasker," *Reclams Universum*, December 1918, p. 384; "Portrait of a Happy Couple," *Reclams Universum*, December 1919, p. 219; "The Cigarette (portrait of a woman)," *Reclams Universum*, March 1920, no page number given. Prof. Dr. Julius Zeitler, "Frank Eugen Smith als Körperbildner," in: *Die Schönheit. Mit Beiblättern geschmückte Zeitschrift*, 1920, no. 12, p. 529–36, 9 reproductions.
82
F. E. Smith to the director of the Academy, January 26, 1920, Saxon State Archives, Dresden. Compilation of the stocks of the nature photography department and the additional equipment required after completion of the reconstruction work.
83
Royal Planning Department Leipzig, report by Professor Smith on the acquisition of equipment and teaching materials, May 20, 1920, Saxon State

Archives, Dresden.
84
Cf. Anneliese Hübscher, "Walter Tiemann 1876–1951," in: Albert Kapr (ed.), *Traditionen Leipziger Buchkunst*, Leipzig 1989. Tiemann was director of the academy until 1940 and even managed to stem the surge of Nazis into the academy for a while. He was appointed again as acting director in 1945/46 and then completely ousted.
85
Cf. Walter Tiemann, *Verfassung der Staatlichen Akademie für graphische Künste und Buchgewerbe zu Leipzig*, November 17, 1921, SSL.
86
Akademie für graphische Kunst und Buchgewerbe in Leipzig, November 26, 1921, Saxon State Archives, Dresden.
87
Fritz Goetz to Max Seliger, May 9, 1919, SSL. "We have had to bear up in difficult times here! I had twice begun to write to you, to the sound of machine gun fire and street fighting in the neighborhood close by."
88
Fritz Goetz to the director of the Academy, December 31, 1925, SSL. "Unfortunately the concept of establishing a lively workshop from out of which masters of reproduction technology would emerge, could not be implemented as desired." Goetz, who was often ailing, officially retired on April 1, 1926, after his wife, the artist Martha Goetz, née Singer, had died. In June 1926 he married his former colleague and employee at the Academy Martha Wenzel (1894–1978) in Leipzig. A few months after the birth of their daughter Dorothea (1927–1979) Goetz died in Munich. His widow Martha Goetz lived on in Leipzig and then from 1936 in Radebeul near Dresden. For decades she remained in personal conact with the former wife of Frank Eugene Smith, who lived nearby in Dippoldiswalde. Dorothea Goetz emigrated to Chile in 1948 where she remained till the end of her life.
89
Among others, Peterhans 1925/26

as a student of process photography, cf. Jeanine Fiedler (ed.), *Fotografie am Bauhaus*, Berlin 1990, p. 352.
90
Cf. "Royal Planning Department Leipzig, Report by Professor Smith, May 20, 1920," Saxon State Archives, Dresden. Proof of this is the existence of a private studio with a comfortable bourgeois interior décor, as well as Smith's requirements for the main room of the studio: "A few creepers in suitable plant pots to decorate the entrance to the dark-room and some plaster figures to liven up the room itself. Some geraniums or similar plants in pots for the other window."
91
Staatliche Akademie für graphische Künste und Buchgewerbe zu Leipzig, July 1922, SSL. "The workshop for nature photography, primarily portrait photography, aims at providing adequately experienced photographers with a final qualification pointing exclusively in the direction of artistic taste.... The tasks set, apart from the most varied of pictorial photographs, include studies of landscapes, animals and plants, architecture and townscapes etc."
92
Saxon Ministry of Economics, Dresden, to F. E. Smith, December 22, 1923, Saxon State Archives, Dresden.
93
The following stops made by the exhibition are documented: Kunstgewerbemuseum Frankfurt am Main, March–April 1924; Landesgewerbemuseum Stuttgart; Staatliche Kunstgewerbe-Bibliothek Dresden, December 1924; Kunstverein, Freiburg i. Breisgau, April 1925; Kunstverein/Kunstgewerbeschule, Munich; Nüremberger Buchgewerbesaal in der Bayerischen Landesgewerbeanstalt, January-February 1926.
94
Among others, portraits of King Friedrich August of Saxony, of the families of the Academy directors Seliger and Tiemann, and several other teachers at the Academy.

95
For example Dr. von Graevenitz' lecture on photography at the Art Association, in: *Breisgauer Zeitung*, April 28, 1925.
96
Carl Blecher, "Die Einrichtungen und Unterrichtsziele der photomechanischen Werkstätten der Staatl. Akademie für Graphische Künste und Buchgewerbe zu Leipzig," in: *Deutscher Drucker. Illustrierte Monatsschrift für die Graphischen Künste und die Reproduktionstechnik*, July 1927, no. 10, p. 848–853. Blecher mentions the departments specialising in the handling of originals, process photography, intaglio printing, plate production for offset printing, offset printing, block production for book printing, phototypes, as well as various lectures and practicals.
97
Students enrollment register for the 1927 summer semester at the Academy, SSL.
98
Verein Leipziger Jahres-Ausstellung, catalogue of their tenth Annual Exhibition in the Municipal Museum on Augustus-Platz in Leipzig, from February 22 to March 31, Leipzig 1925.
99
Kurt Massloff was principal of the Leipzig Highschool from 1947–1958 and was regarded as a strict dogmatist of "Socialist Realism."
100
Ladislaus Moholy-Nagy, "Von der Pigmentmalerei zur Farbigen Lichtgestaltung," in: *Verein Leipziger Jahres-Ausstellung*, Leipzig 1925, p. 38.
101
Saxon Ministry of Economic Affairs, Department of Trade and Crafts, Dresden, to the director of the Leipzig Academy, February 26, 1927, Saxon State Archives, Dresden. "Given that according to the earlier expositions of the director of the Academy and the report dated the 18th of this month, a need for the continuation of the department of nature photography can no longer be perceived, a fact proved above all by the persistent unusually low

number of students enrolled, the undersigned Ministry has decided to discontinue the class."
102
Frank Eugene Smith to the Saxon Ministry of Economics Dresden, March 7, 1929, Saxon State Archives, Dresden. "The class to date has had a stimulating effect on the Academy itself as well as on the circles in its sphere of influence, the City of Leipzig, the Free State of Saxony and other large parts of Germany, to the extent that it has provided a constant impetus to persons professionally or not professionally concerned with photography to improve the standard of their work. For even with their best achievements, the many existing technical colleges cannot come near to what the class for nature photography at the State Academy has achieved, especially when judged according to purely artistic criteria."
103
Walter Tiemann, "Die Staatliche Akademie für Graphische Künste und Buchgewerbe, Leipzig," in: *Deutscher Drucker*, July 1927, no. 10, p. 845: "Today's requirements point in the direction of an ever greater versatility in the training of young artists who wish to devote themselves to the tasks of applied graphics, and the Academy is striving to adapt to these needs as swiftly as possible. It thus considers it its duty to structure the whole curriculum as freely as possible, and to maintain a constant interaction between art and technology. From this point of view, it is easy to find a bridge to photography and photomechanical reproduction processes, and this department fits more logically into the framework of our tasks than might possibly seem to be the case when viewed purely technically. I refer particularly to the tasks involved in creating photomontages which require a high degree of artistic penetration. These are now being fostered at the Academy."

Anmerkungen

Axel Effner, Frank Eugene Smith: Grenzgänger zwischen Malerei und Photographie, S. 243–280

1
Der Aufsatz ›Frank Eugene: Painter-Photographer‹ ist wieder abgedruckt in: *The Valiant Knights of Daguerre. Selected Critical Essays on Photography and Profiles of Photographic Pioneers by Sadakichi Hartmann*, hrsg. von Harry W. Lawton und George Knox, Los Angeles 1978, S. 173–179.

2
Charles H. Caffin, *Photography as a Fine Art. The Achievements and Possibilities of Graphic Art in America*, New York 1901, Repr. 1971, S. 108.

3
Photo-Spiegel, Illustrierte Wochenschrift des Berliner Tagblatts, 3.3.1927, Nr. 9.

4
Ebd.

5
Zeugnis der Königlich Bayerischen Akademie der Bildenden Künste in München vom 22.11.1907, Archiv Fotomuseum im Münchner Stadtmuseum.

6
Die Zahl der Klassenstärke ist entnommen: Ekkehard Mai, ›Kunstakademien im Wandel: Zur Reform der Künstlerausbildung im 19. Jahrhundert‹ in: Hans Wingler (Hrsg.), *Kunstschulreform 1900–1930*, Berlin 1977, S. 22–43, hier S. 34.
Einen Überblick über namhafte amerikanische Studenten an der Münchner Kunstakademie gibt: Eberhard Ruhmer, ›München um 1875: Schnittpunkt internationaler Kunstbeziehungen‹, in: *Die Münchner Schule 1850–1914*, Ausst.-Kat. München 1979, S. 75–88.
Speziell auf die Wechselbeziehungen Münchner und amerikanischer Künstler sowie die Bedeutung der Diez-Schule geht ein: Michael Quick, ›Munich and American Realism‹, in: *Munich and American Realism in the 19th Century*, Ausst.-Kat. Cincinnati 1978, S. 21–36.
Den Einfluß deutscher Hochschulprofessoren und Museumsleute in Amerika sowie die Wechselbeziehungen auf dem Kunstsektor beleuchtet ein lesenswertes Kapitel in: Albert B. Faust, *Das Deutschtum in den Vereinigten Staaten in seiner Bedeutung für die amerikanische Kultur*, Leipzig 1912, besonders S. 269–297.

7
Sarah Burns, ›The Price of Beauty: Art, Commerce, and the late Nineteenth-Century American Studio Interior‹. In: David C. Miller (Hrsg.), *American Iconology. New Approaches to Nineteenth-Century Art and Literature*, London 1993, S. 210–216.
Zu Chase: Ronald G. Pisano, *A Leading Spirit in American Art: William Merritt Chase 1849–1916*, Seattle 1983.

8
Michael Quick, Anm. 6, S. 21 und 27f.

9
Milton Brown, *American Painting from the Armory Show to the Depression*. Princeton 1955, S. 3.
Siehe auch Eberhard Ruhmer, ›Leibl als Vorbild‹, in *Wilhelm Leibl*, Ausst.-Kat. München 1994, S. 156.

10
Georg Jacob Wolf, ›Wilhelm von Diez und seine Schule‹, in: *Die Kunst*, 19, 1917, S. 18.

11
Stefanie Kamm, *Wilhelm von Diez 1839–1907. Ein Künstler zwischen Historismus und Jugendstil*, München 1991, S. 142.

12
Robert Neuhaus, *Bildnis-Malerei des Leibl-Kreises. Untersuchungen zur Geschichte und Technik der Malerei der zweiten Hälfte des 19. Jahrhunderts*, Marburg 1953, S. 42.

13
Otto von Faber du Faur: ›Erinnerungen an Maler, Kunst und Künstler‹, in: *Illustrierte Monatsschrift für Kunst und Kunstgewerbe*, 24, 1926, S. 279.

14
Hartmann, Anm. 1, S. 173.

15
Abbildungen Nr. 253, 261 und 272–275 bei Weston J. Naef, (Hrsg.), *The Collection of Alfred Stieglitz. Fifty Pioneers of Modern Photography*. New York 1978, S. 345–357.

16
Zu den genannten Bildern vergleiche: David P. Curry, *James McNeill Whistler at the Freer Gallery of Art*, New York 1984, S. 26. Klaus Zimmermanns, *Friedrich August von Kaulbach 1850–1920*, München 1980, S. 27. Oskar von Müller, *Albert von Keller 1844–1920*, München 1981, S. 84–85 und 137.

17
Das Motiv war zur damaligen Zeit recht bekannt und wurde sogar als Postkarte vertrieben. Vgl. *Vom Ausstellungspark zum internationalen Messeplatz München 1904 bis 1984*, Ausst.-Kat., München 1984, S. 95.

18
Josef A. Schmoll gen. Eisenwerth, ›Lenbach und die Photographie‹, in: Rosel Gollek und Winfried Ranke (Hrsg.), *Franz von Lenbach 1836–1904*, Ausst.-Kat. München 1987, S. 63–98, insbes. S. 80 und 90.

19
Ebd., S. 93.

20
Josef A. Schmoll gen. Eisenwerth, ›Lenbach, Stuck und die Rolle der photographischen Bildnisstudie‹, in: Ders., *Vom Sinn der Photographie*. München 1980, S. 114–135.

21
Ebd., S. 134.

22
So erteilte beispielsweise Otto

Walter Beck, Kompositionslehrer am Pratt Institute in New York, in der *Camera Work*, dem exklusiven Publikationsorgan des Stieglitz-Kreises in New York, ›Lessons from the Old Masters‹ (Ausgaben Januar und Juli 1903). Vergleiche dazu: Jonathan Green, *Camera Work. A Critical Anthology*, New York 1973.

23
Ein Beispiel dafür ist das 1871 entstandene Bild von James McNeill Whistler ›Porträt der Mutter‹, das heute im Louvre hängt und auf dessen Rezeptionsgeschichte Fritz Matthies-Masuren in einem Beitrag der *Photographischen Rundschau* (21, 1907, S. 3–5) hinweist. Sadakichi Hartmann stellte in einem Artikel direkte Bezüge zu den amerikanischen Kunstphotographen fest. Siehe: *Die Kunst*, 8, 1904/05, S. 336.

24
Sadakichi Hartmann, ›A Few Reflections on Amateur and Artistic Photography‹, in: *Camera Notes*, 2, Okt. 1898, Nr. 2 S. 41–45, abgedruckt bei: Peter Bunnell (Hrsg.), *A photographic vision: Pictorial photography 1889–1923*, Salt Lake City 1980, S. 88–91.

25
Sadakichi Hartmann, ›Über die amerikanische Kunstphotographie‹, in: *Photographische Rundschau*, 14, 1900, S. 93.

26
Hartmann, Anm. 1, S. 179.

27
Julia Fagan-King, ›Cameron, Watts, Rossetti: Influence of Photography on Painting‹, in: *History of Photography*, 10, Jan.–März 1986, Nr. 1, S. 19–29.

28
Alicia Craig Faxon, ›D.G. Rossetti's Use of Photography‹. In: *History of Photography*, 16, Herbst 1992, Nr. 3, S. 254–262,

hier S. 255.

29
Der Albumindruck ist abgebildet bei Jeremy Howard, *Whisper of the Muse. The World of Julia Margaret Cameron*, Ausst.-Kat. London 1990, S. 47. Den in den Kontrasten härteren Silberdruck aus dem Agfa Foto-Historama in Köln zeigt Helmut Gernsheim, *Julia Margaret Cameron*, New York 1975, S. 129.

30
Auf den Zusammenhang des Vorbilds von Reni mit Cameron weist Jeremy Howard, Anm. 29, S. 26 und S. 28 hin.

31
Gisela Zick, ›Alfred Lord Tennysons »Lady of Shalott« in der Malerei des Präraffaeliten‹, in: *Bildwelten des Symbolismus. Symposion am 19./20. Okt. 1984 im Clemens-Sels-Museum, Neuss*, Neuss 1984, S. 15–24, hier S. 18.

32
Ein ähnlicher Ausdruck ließe sich anhand weiterer Bilder bei Cameron nachweisen. Vgl. Jeremy Howard, Anm. 29.

33
Apollo, 12, 1906, vor S. 521.

34
Carl Justi: *Diego Velázquez und sein Jahrhundert*, II. Band. Bonn 1903², S. 3.

35
Die Ähnlichkeit läßt sich etwa beim Vergleich von Whistlers Porträt von F.R. Leyland und einem Velázquez-Porträt von Philipp IV. gut nachweisen, von dem Whistler eine großformatige Photoreproduktion besaß. Vgl. David P. Curry, Anm. 16, S. 113.

36
Weston J. Naef, Anm. 15, S. 351.

37
Heinrich Voss, *Franz von Stuck 1863–1928*, München 1973, S. 171. Das Photo, das Stuck als Vorlage diente, ist abgebildet in dem Katalog *Fotografische Bild-*

Notes

Axel Effner, Frank Eugene: On the Borderline between Painting and Photography, pp. 241–283

1
Hartmann's essay "Frank Eugene: Painter-Photographer" is reprinted in: *The Valiant Knights of Daguerre. Selected Critical Essays on Photography and Profiles of Photographic Pioneers by Sadakichi Hartmann*, ed. by Harry W. Lawton and George Knox, Los Angeles 1978, pp. 173–179.

2
Charles H. Caffin, *Photography as a Fine Art. The Achievements and Possibilities of Graphic Art in America*, New York 1901, reprinted 1971, p. 108.

3
Photo-Spiegel, Illustrierte Wochenschrift des Berliner Tagblatts, 3.3.1927, no. 9.

4
Ibid.

5
Reference from the Königlich Bayerische Akademie der Bildenden Künste in Munich, dated November 22, 1907, Fotomuseum im Münchner Stadtmuseum.

6
These figures are taken from the essay: Ekkehard Mai, "Kunstakademien im Wandel: Zur Reform der Künstlerausbildung im 19. Jahrhundert," in: Hans Wingler (ed.), *Kunstschulreform 1900–1930*, Berlin 1977, pp. 22–43, here p. 34.
A survey of noted American students at the Munich Art Academy is to be found in: Eberhard Ruhmer, "München um 1875: Schnittpunkt internationaler Kunstbeziehungen," in: *Die Münchner Schule 1850–1914*, exhibition catalogue, Munich 1979, pp. 75–88.
The following article pays special attention to the inter-relations between Munich and American artists and the importance of the Diez school: Michael Quick, "Munich and American Realism," in: *Munich and American Realism in the 19th Century*, exhibition catalogue, Cincinnati 1978, pp. 21–36.
The influence of German college professors and museum curators in America and inter-relations in the art sector are dealt with in a useful chapter in: Albert B. Faust, *Das Deutschtum in den Vereinigten Staaten in seiner Bedeutung für die amerikanische Kultur*, Leipzig 1912, in particular pp. 269–297.

7
Sarah Burns, "The Price of Beauty: Art, Commerce, and the late Nineteenth-Century American Studio Interior," in: David C. Miller (ed.), *American Iconology. New Approaches to Nineteenth-Century Art and Literature*, London 1993, pp. 210–216.
On Chase: Ronald G. Pisano, *A Leading Spirit in American Art: William Merritt Chase 1849–1916*, Seattle 1983.

8
Michael Quick, footnote no. 6, pp. 21 and 27 ff.

9
Milton Brown, *American Painting from the Armory Show to the Depression*, Princeton 1955, p. 3.
Also Eberhard Ruhmer, "Leibl als Vorbild," in: *Wilhelm Leibl*, exhibition catalogue, Munich 1994, p. 156.

10
Georg Jacob Wolf, "Wilhelm von Diez und seine Schule," in: *Die Kunst*, 19, 1917, p. 18.

11
Stefanie Kamm, *Wilhelm von Diez 1839–1907. Ein Künstler zwischen Historismus und Jugendstil*, Munich 1991, p. 142.

12
Robert Neuhaus, *Bildnis-Malerei des Leibl-Kreises. Untersuchungen zur Geschichte und Technik der Malerei der zweiten Hälfte des 19. Jahrhunderts*, Marburg 1953, p. 42.

13
Otto von Faber du Faur, "Erinnerungen an Maler, Kunst und Künstler," in: *Illustrierte Monatsschrift für Kunst und Kunstgewerbe*, 24, 1926, p. 279.

14
Hartmann (footnote no. 1), p. 173.

15
Plates no. 253, 261 and 272–275 in Weston J. Naef (ed.), *The Collection of Alfred Stieglitz. Fifty Pioneers of Modern Photography*, New York 1978, pp. 345–357.

16
On the works mentioned cf.: David P. Curry, *James McNeill Whistler at the Freer Gallery of Art*, New York 1984, p. 26. Klaus Zimmermanns: *Friedrich August von Kaulbach 1850–1920*, Munich 1980, p. 127. Oskar von Müller, *Albert von Keller 1844–1920*, Munich 1981, pp. 84–85 and 137.

17
This motif was quite well-known at the time and was even satirised on postcards. Cf. *Vom Ausstellungspark zum internationalen Messeplatz München 1904 bis 1984*, exhibition catalogue, Munich 1984, p. 95.

18
Josef A. Schmoll gen. Eisenwerth, "Lenbach und die Photographie," in: Rosel Gollek and Winfried Ranke (ed.), *Franz von Lenbach 1836–1904*, exhibition catalogue, Munich 1987, pp. 63–98, in particular pp. 80 and 90.

19
Ibid., p. 93.

20
Josef A. Schmoll gen. Eisenwerth, "Lenbach, Stuck und die Rolle der photographischen Bildnisstudie," in: *Vom Sinn der Photographie*, Munich 1980, pp. 114–135.

21
Ibid., p. 134.

22
For example, Otto Walter Beck, teacher of composition at the New York Pratt Institute, gave "Lessons from the Old Masters" in *Camera Work*, the exclusive publication of the Stieglitz circle in New York (1903, January and July issues). Cf.: Jonathan Green, *Camera Work. A Critical Anthology*, New York 1973.

23
One example of this is the "Portrait of his Mother" by James McNeill Whistler painted in 1871 which today is in the Louvre. Fritz Matthies-Masuren refers to the history of its reception in a contribution to the *Photographische Rundschau* (21, 1907, pp. 3–5). Sadakichi Hartmann deals with direct references to the American art photographers in his essay in: *Die Kunst*, 8, 1904/05, p. 336.

24
Sadakichi Hartmann, "A Few Reflections on Amateur and Artistic Photography," in: *Camera Notes*, 2, Oct. 1898, no. 2, pp. 41–45, reprinted in: Peter Bunnell (ed.), *A Photographic Vision: Pictorial Photography 1889–1923*, Salt Lake City 1980, pp. 88–91.

25
Sadakichi Hartmann, "Über die amerikanische Kunstphotographie," in: *Photographische Rundschau*, 14, 1900, p. 93.

26
Hartmann, footnote no. 1, p. 179.

27
Julia Fagan-King, "Cameron, Watts, Rossetti: Influence of Photography on Painting," in: *History of Photography*, 10, Jan–March 1986, no. 1, pp. 19–29.

28
Alicia Craig Faxon: "D.G. Rossetti's Use of Photography," in: *History of Photography*, 16, Autumn 1992, no. 3, pp. 254–262.

29
The albumen print is reproduced in Jeremy Howard, *Whisper of the Muse. The World of Julia Margaret Cameron*, exhibition catalogue, London 1990, p. 47. The silver print from the Agfa Foto-Historama in Cologne, in which the contrasts are harder, is reproduced in Helmut Gernsheim, *Julia Margaret Cameron*, New York 1975, p. 129.

30
This connection between Reni and Cameron is referred to by Jeremy Howard, footnote no. 29, pp. 26 and 28.

31
Gisela Zick, "Alfred Lord Tennysons 'Lady of Shalott' in der Malerei der Präraffaeliten," in: *Bildwelten des Symbolismus. Symposium on 19./29. Oct. 1984 in the Clemens-Sels-Museum, Neuss*, Neuss 1984, pp. 15–24.

32
A similar expression is to be found in several other Cameron photographs. Cf. Jeremy Howard, footnote no. 29.

33
Apollo, 12, 1906, before p. 521.

34
Carl Justi: *Diego Velázquez und sein Jahrhundert*, II. vol. Bonn 1903, (2nd ed.), p. 3.

35
The similarity can be clearly seen by comparing Whistler's portrait of F.R. Leyland and a Velázquez portrait of Philipp IV of which Whistler possessed a large-format photographic reproduction. Cf. David P. Curry, footnote no. 16, p. 113.

36
Weston J. Naef, footnote no. 15, p. 351.

37
Heinrich Voss, *Franz von Stuck 1863–1928*, Munich 1973, p. 171.
The photograph which Stuck used as a model is reproduced in the catalogue *Fotografische Bildnisstudien zu Gemälden*

nisstudien zu Gemälden von Lenbach und Stuck, Essen 1969, Nr.334.

38

Markus Harzenetter, *Zur Münchner Secession. Genese, Ursachen und Zielsetzungen dieser intentionell neuartigen Münchner Künstlervereinigung*, (Miscellanea Bavarica Monacensia, Bd.158). München 1992.

39

Der Minervakopf von Stuck war seit 1892 das Signet der Münchner Secession. Auf die Oktogonform griff Stuck auch in den Folgejahren immer wieder zurück, vgl. Heinrich Voss, Anm.37.

40

Christian M. Nebenhay, *Gustav Klimt*, München 1976, S.303.

41

Eine ähnliche Reduzierung auf die Silhouettenform im Sinne des Jugendstils läßt sich vermehrt auch bei Bildern von Edward Steichen (Ausstellungsplakat: ›First Prize Goerz Company‹, 1906) oder von Hugo Erfurth feststellen.

42

Abgebildet im Katalog *Photosammlung Stieglitz aus dem Metropolitan Museum New York*, Köln 1980, S.69.

43

Zum Thema Ausdruckstanz oder seinem amerikanischen Pendant, dem Modern Dance, liest man in dem von Manfred Brauneck und Gérard Schneilin herausgegebenem *Theaterlexikon* (Hamburg 1986, S.96): »Die amerikanische Tänzerin Isadora Duncan (1877–1927), die um 1902/03 in Berlin gastierte, gilt als Pionierin der deutschen Reformtanzbewegung. Sie lehnt die klassisch-akademische Ballett-Technik als Verfestigung ab. Die Duncan tritt barfuß in leicht wehendem Gewand vor das Publikum. Ihre Tänze drängen expressiv-vehement auf Emotionen und Stimmungen. (...) Sie nutzt expressive Stilmittel, glaubt aber, im Sinne antiken Geistes- und Lebensgefühls zu gestalten.« David P. Curry (Anm.16, S.278) weist darauf hin, daß die Tänzerinnen in den von ungewöhnlichen Lichteffekten begleiteten Aufführungen dem Bild der Femme fatale nahekamen. Eine Begleiterscheinung des neuen Tanzes war zudem ein reger Handel mit Plakaten und Statuetten.

von Lenbach und Stuck, Essen 1969, no. 334.

38

Markus Harzenetter, *Zur Münchner Secession. Genese, Ursachen und Zielsetzungen dieser intentionell neuartigen Münchner Künstlervereinigung* (Miscellanea Bavarica Monacensia, vol. 158), Munich 1992.

39

Stuck's head of Minerva was used as the imprint of the Munich Secession from 1892 onwards. In the following years Stuck repeatedly returned to the octagonal form, cf. Heinrich Voss, footnote no. 37.

40

Christian M. Nebenhay, *Gustav Klimt*, Munich 1976, p. 303.

41

A similar reduction to the silhouette form, a feature of Art Nouveau, can also be frequently noticed in photographs by Edward Steichen (exhibition poster: "First Prize Goerz Company," 1906) or Hugo Erfurth.

42

Reproduced in *Photosammlung Stieglitz aus dem Metropolitan Museum New York*, exhibition catalogue, Cologne 1980, p. 69.

43

On the theme of expressive dance, or its American pendant modern dance, the *Theaterlexicon* edited by Manfred Brauneck and Gérard Schneilin (Hamburg 1986, p. 96) has the following to say: "The American dancer Isadora Duncan (1877–1927), who made a guest appearance in Berlin around 1902/02, is regarded as a pioneer of the German reform dance movement. She rejected classical, academic ballet technique as rigid. Duncan appeared before her audiences in bare feet and light flowing robes. Her vehemently expressive dancing forced itself upon the emotions and the spirit.... She availed herself of expressive stylistic means but believed her art to be in the spirit of a classical understanding of and feeling for life." David P. Curry (footnote no. 16, p. 278) remarks that during their performances, which were accompanied by unusual lighting effects, the dancers came close to the image of the femme fatale. A concomitant of the new dance movement was a lively trade in posters and statuettes.

Glossar

von Christine Rottmeier

Bromsilbergelatinetrockenplatten (1871–heute)

Gelatinetrockenplatten waren das am meisten gebrauchte Negativmaterial von 1880 bis ca. 1920. Richard Leach Maddox stellte als erster 1871 eine Emulsion aus Bromsilbergelatine her.

Gelatine wird aus Tierknochen- und knorpeln gewonnen und ist ein tierisches Protein. Gelatine ist hygroskopisch, bei Erwärmung (60° C) schmilzt es und beim Abkühlen wird es wieder gelartig fest. Man benutzt diese klare Substanz als Bindemittel und löst darin die lichtempfindlichen Silbersalze. Diese Emulsion wird dann auf das Trägermaterial Glas gegossen. Im Gegensatz zu den seit 1852 gebräuchlichen Kollodium-Glasplattennegativen, die kurz vor der Belichtung hergestellt und wenige Minuten nach der Belichtung verarbeitet werden mußten, konnten Gelatinetrockenplatten länger aufbewahrt werden. Deshalb werden sie in Fabriken hergestellt, gelagert und in Geschäften vertrieben. Es entstanden die Fabriken Agfa, Ilford, Eastman Kodak und Lumière.

Gelatine-Entwicklungspapier (1880–heute)

Seit ca. 1890 ist das Gelatine-Entwicklungspapier das am meisten benutzte Material für Schwarzweißabzüge. Kenntnisse aus der Herstellung von Gelatinetrockenplatten (s.o.) ermöglichten seit Mitte der 1880er Jahre die Beschichtung von Papier mit Silbergelatineemulsionen. Das Papier wird in Fabriken hergestellt, wobei Papierrollen maschinell beschichtet werden. Unter die Emulsion fügt man eine Baryt-Zwischenschicht, aus dem weißen Pigment Bariumsulfat und Gelatine ein, die dem Photo mehr Kontrast gibt und die Papierfasern verdeckt. Durch die Bearbeitung der Barytschicht können viele Oberflächenarten hergestellt werden, matt und glänzend oder strukturiert. Das Papier wird in der Dunkelkammer wenige Sekunden unter einem Negativ belichtet und anschließend entwickelt.

Entwicklungspapiere lösten die Auskopierverfahren nach der Jahrhundertwende ab. Auskopierpapiere wie das Albuminpapier, das das verbreitetste Abzugsmaterial des 19. Jahrhunderts war, wurden im Kontakt mit einem Negativ so lange dem Licht ausgesetzt, bis das Bild sichtbar wurde. Das photographische Bild besteht aus photolytischem Silber, sehr kleinen, kugelförmigen Silberpartikeln. Bei Entwicklungspapieren besteht das Bild aus größeren Silberpartikeln unregelmäßig zusammengesetzten Teilchen, dem sogenannten Filamentsilber. Die unterschiedliche Größe und Struktur der Silberpartikel ergeben unterschiedliche Reflexionseigenschaften: Auskopierpapiere zeigen warme, rotbraune Farbtönungen, Entwicklungspapiere weisen neutral-schwarze bis bräunlich/olivschwarze Farbnuancen auf.

Entwicklungspapiere kamen in einer Vielzahl von Varianten auf den Markt. Je nach den verwendeten Silbersalzen unterscheidet man zwischen Chloridpapier und Bromsilberpapier. Chlorsilberpapiere werden auch als ›Gaslichtpapiere‹ bezeichnet, da die Papiere lichtempfindlich genug sind, um bei künstlicher Beleuchtung kopiert werden zu können.

Gummidruck (1894–ca. 1920)

Die drei Hauptkomponenten bei der Herstellung von Gummidrucken sind Gummi arabicum, Pigmente und die lichtempfindliche Substanz Kaliumdichromat. Belichtet man ein so beschichtetes Papier in Kontakt mit einem Negativ, so werden die Bereiche hoher Dichte mehr und die Schattenbereiche kaum gehärtet. Das ›Entwickeln‹ erfolgt mit bloßem Wasser, das die unbelichteten Teile herauslöst. Zurück bleibt als Positiv ein Auswaschrelief aus gefärbtem, chromsalzhaltigem Gummi arabicum auf Papier. Die Technik kann durch die Wahl der Farbpigmente, durch das Verändern des Kontrastes durch mehrschichtiges Drucken oder durch Hineinmalen sehr stark variiert werden.

Autochrome (1907–1936)

Als erstes Farbverfahren wurden Autochrome 1904 von den Gebrüdern Lumière patentiert und 1907 auf den Markt gebracht. Autochromeplatten gehören zu den Farbrasterverfahren, die auf dem Prinzip der additiven Grundfarben beruhen. Kartoffelstärkekörnchen werden orangerot, grün und violettblau eingefärbt und anschliessend auf eine mit Klebstoff beschichtete Glasplatte gestaubt und angepreßt. Der Raum zwischen den Stärkekörnern wird mit Ruß ausgefüllt. Zum Schutz vor

Glossary

von Christine Rottmeier

Silver Gelatin Dry Plates (1871–present)

Gelatin dry plates were the most commonly used negative material from 1880 to about 1920. Richard Leach Maddox was the first person to make an emulsion out of silver bromide gelatin in 1871. Gelatin is an animal protein got from animal bones and cartilage. Gelatin is hygroscopic: it melts on being heated (60 degrees C) and becomes jelly-like again on cooling. This clear substance is used as a binder on which the photosensitive silver salts are dispersed. This emulsion is then applied to the glass plates. Contrary to the collodion glass plate negative in use since 1852, which had to be produced shortly before exposure and processed shortly after, gelatin dry plates could be preserved for a longer time. They were produced in factories, stored and then marketed, by such manufacturers as Agfa, Ilford, Eastman, Kodak and Lumière.

D.O.P./Gelatin Developing-Out Paper (1880–present)

The most widely used medium for black and white prints since about 1890 has been gelatin developing-out paper. Since the mid-1880s knowledge of the production of gelatin dry plates (see above) has made it possible to sensitize paper with silver gelatin emulsions. The paper is manufactured industrially and the emulsion applied to the paper rolls by machine. An intermediary baryta layer made out of the white pigment of barium sulfate and gelatin is applied under the emulsion. This gives the photographs more contrast and conceals the fibers of the paper. By altering the baryta layer, many different types of surfaces can be produced ranging from matte to glossy to surfaces with a relief effect. The paper is exposed for a few seconds in the dark room under a negative and then developed.

After the turn of the century, developing-out papers replaced printing-out processes. Printing-out papers such as albumen paper, which was the most widely used printing paper in the 19th century, were exposed to light in contact with a negative long enough for the image to become visible. The photographic image is made up of photolytic silver, minute spherical silver particles. In developing papers the image is made up of larger, irregularly dispersed silver particles known as filamentary silver. The different size and structure of the silver particles result in different reflection features: printing-out papers have warm reddish-brown tones, developing-out papers have intense black to brownish/olive-black tones. Developing-out papers came onto the market in a variety of types. Depending on which silver salts are used, a distinction is made between chloride paper and bromide silver paper. Silver chloride papers are also called "gas-light papers" because they are sensitive enough to be processed in artificial light.

Gum Prints (1894–ca. 1920)

The three main ingredients in the production of gum prints were gum Arabic, pigments and the photosensitive potassium bichromate. A paper treated with this emulsion and exposed in contact with a negative resulted in the high density areas becoming more, and the shadow areas less hardened. "Developing" was done by washing with ordinary water which dissolved the unexposed parts. After washing, a relief of colored gum Arabic, containing chromic salt, remained on the paper as a positive. This technique could be greatly varied by using different color pigments, by reinforcing the contrasts through re-coating and re-exposing, or by painting over parts.

Autochrome (1907–1936)

Autochrome, the first color process, was patented in 1904 by the Lumière brothers and first marketed in 1907. Autochromes were one of the color screen processes based on the principle of an additive system of color formation. Potato starch grains were dyed red, green and blue and then applied to a glass plate which had been covered with a layer of glue. The space between the starch grains was filled with soot and the plate then coated with a pan-chromatic gelatin-silver emulsion. The plate was exposed with the glass side towards the lens so that before reaching the emulsion the light was

Entwicklungschemikalien wurde Lack aufgetragen. Darauf wird eine feinkörnige, panchromatische Silbergelatineemulsion gegossen. Die Platte wird dann durch das Glas, also mit der Schichtseite nach hinten, belichtet. damit das Licht zuerst durch die eingefärbten Stärkekörner gefiltert wird. Auf diese Weise gelangt nur Licht der Eigenfarbe auf die Schwarzweißemulsion. Durch anschließende Umkehrentwicklung entsteht ein schwarz/weiß Diapositiv, das durch den Farbfilter farbig erscheint. Eine zweite Glasplatte wird zum Schutz der Schicht mit einem schwarzen Papierband festgeklebt.

Platinotypien (1871–ca. 1920)

1873 meldete der Engländer William Willis einen neuen photographischen Druckprozeß zum Patent an. Bei diesem Verfahren verwendete er Platin- und Eisensalze als lichtempfindliche Substanz. Diese lichtempfindliche Substanz wird direkt auf den Schichtträger Papier aufgestrichen. Da kein Bindemittel vorhanden ist, liegt das Bild auf der Oberfläche und leicht im Papierfilz. Das Papier wird im Kontakt mit einem Negativ belichtet und anschließend in einer Kaliumoxalatlösung entwickelt. Eine verdünnte Salzsäure fixiert das Bild.
Aus Kostengründen wurde Platin zeitweise, vor allem während des Ersten Weltkrieges, als Platin nicht mehr verfügbar war, durch Palladium ersetzt oder gestreckt. Palladiumabzüge zeichnen sich durch einen wärmeren, bräunlichen Bildton aus. Da aber der Farbton bei Platindrucken variieren kann, indem man dem Entwickler Quecksilber beifügt und der erwärmt wird, sind die beiden Techniken visuell kaum voneinander zu unterscheiden. Aufgrund ihrer matten Oberfläche, der neutral bis stahlgrauen Farbe und des großen Tonwertumfanges wurden dieser Bilder Technik oft mit künstlerischer Photographie gleichgesetzt.

Photogravüre (1879–heute)

Photogravüre oder auch Heliogravüre ist eine Tiefdrucktechnik, die zur Reproduktion von Photographien Verwendung fand. Obwohl die Technik auf Talbot zurückgeht. wurde das Photogravüreverfahren, wie wir es heute kennen, 1879 von Karl Klič entwickelt: Um ein Aquatintkorn zu erzeugen, wird auf eine Kupferplatte Asphaltstaub verteilt und durch Erhitzen aufgeschmolzen. So entsteht ein unregelmäßiges Raster, das die Wiedergabe von Halbtönen ermöglicht. Anschließend wird ein Gelatinepigmentpapier mit Kaliumdichromat lichtempfindlich gemacht und im Kontakt mit einem Positiv belichtet. Das Pigmentpapier wird dann kurz eingeweicht und mit

der Gelatineseite auf die Kupferplatte gepreßt. Die ungehärtete und deshalb lösliche Gelatine wird mit warmen Wasser herausgewaschen, so daß eine dickere Schicht in den hellen Bereichen und eine dünnere Gelatineschicht in den Schatten zurückbleibt. Beim Ätzvorgang fungiert die Gelatine und Asphaltlack als Ätzwiderstand. Zum Drucken wird die Platte erwärmt, Kupferdruckfarbe mit dem Handballen aufgetragen und überschüssige Farbe wieder abgewischt. Anschließend wird die Druckfarbe in der Kupferdruckpresse auf ein angefeuchtetes Tiefdruckpapier (Japanpapier bei Frank Eugene Smith) übertragen.

Bromöldruck (1907–ca. 1950)

Die Technik des Bromöldruckes wurde 1907 von dem Engländer E. J. Wall publiziert und gehörte für ca. zwei Jahrzehnte zum Standardrepertoire der Kunstphotographie. Bromöldrucke sind nachträglich eingefärbte Quellreliefs auf Papier. Die Technik beruht auf dem Prinzip, daß Wasser und Öl sich nicht vermischen. Als Ausgangsmaterial für einen Bromöldruck fungiert eine Vergrößerung auf einem Bromsilbergelatinepapier. Durch Ausbleichen wird anschließend das Silberbild entfernt und statt dessen eine Gelatinequellung auf dem Photopapier in der Dichte des vorherigen Silberbildes hervorgerufen. Der chemische Prozeß härtet die Emulsion proportional zum Silberbild. Auf dieses Quellrelief wird Ölfarbe aufgetragen, wobei die gegerbten, trockenen Stellen die Farbe annehmen und die feuchten gequollenen Partien abweisen.

Literatur

Albert, August, *Technischer Führer durch die Reproduktionsverfahren und deren Bezeichnung*, Halle, 1908.
Crawford, W., *The Keepers of the Light*, Dobbs Ferry, N.Y. 1979.
Dobrusskin, Sebastian, ›Autochrome im Photomuseum Bad Ischl‹, in: *Erhaltung von Photographischem Material. Postprints*, Hrsg. von G. Banik, Stuttgart 1994.
Eder, Josef Maria, *Ausführliches Handbuch der Photographie. Geschichte der Photographie*, Erster Band, erster Teil, zweite Hälfte, 4. Auflage, Halle 1932.
Heidtmann, Frank, *Kunstphotographische Edeldruckverfahren heute*, Berlin 1991.
Hendriks, Klaus, *Fundamentals of Photograph Conservation: A Study Guide*, Toronto 1991.
Knodt, Robert und Klaus Pollmeier, *Verfahren der Photographie*, Essen 1989.
Koshofer, Gert, *Farbfotografie*, Band 1, Alte Verfahren, München 1981.
Krause, Peter, ›The Conservation of Autochrome Plates in the Collection of the National Geographic Society‹ in: *Journal of the Imaging Science*, 29, 1985, No. 5.
Lavedrine, Bertrand, *La Conservation des Photographies*, Paris 1990.
Reilly, James M., *Care and Identification of 19th-Century Photographic Prints*. Kodak Publication, No. G-2S, Rochester, N.Y. 1986.

first filtered through the colored starch grains. A reverse devel opment process then followed, producing a black and white positive image which appeared colored through the color filter. To protect this layer a second glass plate was placed over it and covered with black paper.

Platinum Prints (1871–ca. 1920)

In 1873 the Englishman William Willis announced a new photographic printing process using platinum and iron salts to sensitize the paper. These substances were applied directly to the paper. As no binder was used the image appeared on the surface and to an extent in the paper fibers. The paper was exposed in contact with a negative and then developed in a solution of potassium oxalate. The ima ge was fixed with diluted hydrochloric acid. For financial reasons, palladium was often used as a substitute, or mixed with platinum, especially during the First World War when platinum was not easily available. Palladium prints were characterized by a warmer, brownish tone. However, as the tone of platinum prints can be varied by adding mercury to the developer and/or by heating it, the products of the two techniques can scarcely be distinguished from one another. Thanks to their matte surface, the neutral to silvery-gray tones, and the wide range of tone values, prints made using this technique were often put on a par with art photography.

Photogravure (1879–present)

Photogravure or heliogravure is an etching process used to reproduce photographs. Although the technique is often attributed to Talb ot, the photogravure process as we know it today was developed in 1879 by Karl Klič: In order to produce an aquatint grain, a copper-plate is dusted with minute grains of bitumen and then heated so that the powder is fixed to the surface. In this way an irregular pattern emerges which makes the reproduction of half-tones possible. Then a pigmented gelatin tissue is sensitized using potassium chromate and exposed in contact with a positive. The pigment paper is then dampened briefly and pressed onto to the copperplate gela tin side down. The non-hardened and thus soluble gelatin is washed away with warm water so that a thick layer remains in the highlights and a thinner one in the shadow areas. During the etching phase the gelatin and bitumen varnish function as resist to the corros ive medium. For printing purposes the plate is warmed. Copper-printing ink is applied with the ball of the

thumb and the superfluous ink washed away. In the copper-printing press the printing ink is then transferred to a dampened intaglio printing paper (in the case of Frank Eugene Smith, Japanese tissue).

Bromoil Process (1907–ca. 1950)

The technique of bromoil printing was first publicized in 1907 by the Englishman E. J. Wall, and for almost two decades it was part of the standard repertoire of art photography. The technique is based on the principle that water and oil do not mix. Bromoil prints were raised reliefs on paper which were inked at a later stage. The point of departure for a bromoil print was an enlargement on silver bromide gelatin paper. The silver image was removed by bleaching and this resulted in a gelatin raised relief produced on the paper as thick as the former silver image. The chemical process hardens the emulsion proportional to the silver image. Oil paint was then applied to this raised relief, whereby the tanned dry areas absorbed the color and the damp raised parts resisted it.

Literature

Albert, August, "Technischer Führer durch die Reproduktionsverfahren und deren Bezeichnung," Halle 1908.

Crawford, W.,"The Keepers of the Light," Dobbs Ferry, N.Y. 1979.

Dobrusskin, Sebastian, "Autochrome im Photomuseum Bad Ischl" in: "Erhaltung von Photograhischem Material. Postprints," ed. by G. Banik, Stuttgart 1994.

Eder, Josef Maria, "Ausführliches Handbuch der Photographie. Geschichte der Photographie," vol. 1, Part 1, second half, 4th edition, Halle 1932.

Heidtmann, Frank, "Kunstphotographische Edeldruckverfahren heute," Berlin 1991.

Hendriks, Klaus, "Fundamentals of Photograph Conservation: A Study Guide," Toronto 1991.

Knodt, Robert and Pollmeier, Klaus, "Verfahren der Photographie," Essen 1989.

Koshofer, Gert, "Farbfotografie," vol. 1, Alte Verfahren, Munich 1981.

Krause, Peter, "The Conservation of Autochrome Plates in the Collection of the National Geographic Society" in: *Journal of the Imaging Science*, 29, 1985, no. 5.

Lavedrine, Bertrand, "La Conservation des Photographies," Paris 1990.

Reilly, James M., "Care and Identification of 19th Century Photographic Prints," Kodak Publication, no. G-2S, Rochester, N.Y. 1986.

Zu den Autoren / About the Authors

Axel Effner

Geboren 1964 in Traunreut. Studium der Kunstgeschichte, Geschichte und Neueren Deutschen Literatur in München und Hamburg. Sein Magisterexamen in Kunstgeschichte schloß er mit einer Arbeit über Frank Eugene Smith und die Kunst des Jugendstils in München ab. Lebt und arbeitet seit 1992 als Journalist und Redakteur im Chiemgau.

Andreas Krase

Geboren 1958 in Malchow/Mecklenburg. Studium der Kunstwissenschaft an der Humboldt-Universität zu Berlin. Vorlesungen zur Photographiegeschichte an der Hochschule für Grafik und Buchkunst Leipzig und Gastvorlesungen; lebt als freiberuflicher Photohistoriker, Autor und Ausstellungskurator in Berlin. Zahlreiche Veröffentlichungen zur historischen und zeitgenössischen Photographie, u.a. *Xanti Schawinsky. Magdeburg 1929–31. Fotografien*, Dessau 1993; *Die Fotografiesammlung von Moritz Alphons Stübel und Wilhelm Reiß aus Südamerika 1868–1877*, Münster 1994; *›In jeder Äußerung liegt eine Kraft‹: Annäherungen an das Porträtwerk von Konrad Hoffmeister*, Berlin 1995.

Ulrich Pohlmann

Geboren 1956 in Schönberg/Holstein. Studium der Kunstgeschichte, Ethnologie und Kunsterziehung in München. Seit 1991 Leiter des Fotomuseums im Münchner Stadtmuseum. Zahlreiche Veröffentlichungen zur historischen und zeitgenössischen Photographie, u.a. veröffentlichte er die Bücher *Wilhelm von Gloeden. Sehnsucht nach Arkadien*, Berlin 1987; *Kultur, Technik und Kommerz: Die photokina-Bilderschauen 1950–1980*, Köln 1990; *Viktorianische Photographie 1840–90*, Heidelberg 1993.

Christine Rottmeier

Geboren 1961 in Dachau. Studium der Geschichte und Photographie in München und den USA. Ausbildung in ›Photographic Preservation and Archival Practice‹ am International Museum of Photography/George Eastman House und Image Permanence Institute in Rochester, NY. Ab 1992 freiberufliche Tätigkeit in ›Photographic Conservation‹, und seit November 1993 teilzeitbeschäftigt als Photorestauratorin im Fotomuseum des Münchner Stadtmuseums. Veröffentlichung verschiedener Artikel zu konservatorischen Themen in *Rundbrief Fotografie*.

Axel Effner

Born in 1964 in Traunreut. Studied Art History, History and Modern German Literature in Munich and Hamburg. For his Magister examination in Art History he wrote a thesis on Frank Eugene Smith and Art Nouveau in Munich. He has been living and working as a journalist and editor in Chiemgau since 1992.

Andreas Krase

Born in 1958 in Malchow, Mecklenburg. Studied Aesthetics and Art History at the Humboldt University in Berlin. He lectured on the History of Photography at the College of Graphic Arts and Book Design in Leipzig and as a guest lecturer at other venues. He lives and works in Berlin as a free-lance historian of photography, a writer and an exhibition curator. He has published extensively on historical and contemporary photography, including *Xanti Schawinsky, Magdeburg 1929–31, Photographs*, Dessau 1993; *Die Fotografiesammlung von Moritz Alphons Stübel und Wilhem Reiß aus Südamerika 1868–1877*, Münster 1994; *'In jeder Äußerung liegt eine Kraft': Annäherungen an das Porträtwerk von Konrad Hoffmeister*, Berlin 1995.

Ulrich Pohlmann

Born 1956 in Schönberg, Holstein. Studied Art History, Ethnology and Art Education in Munich. He has been director of the Fotomuseum in the Munich Stadtmuseum since 1991. Numerous publications on historical and contemporary photography, including the books *Wilhelm von Gloeden. Sehnsucht nach Arkadien*, Berlin 1987; *Kultur, Technik und Kommerz: Die photokina-Bilderschauen 1950–1980*, Cologne 1990; *Viktorianische Photographie 1840–90*, Heidelberg 1993.

Christine Rottmeier

Born 1961 in Dachau. Studied History and Photography in Munich and the USA. Trained in Photographic Preservation and Archival Practice at the International Museum of Photography, George Eastman House, and at the Image Permanence Institute in Rochester, NY. She has been working free-lance in photographic conservation since 1992 and since November 1993 as a part-time restorer of photographs at the Fotomuseum in the Munich Stadtmuseum. She has published numerous articles on the theme of conservation in *Rundbrief Fotografie*.

Impressum / Colophon

Fotomuseum im Münchner Stadtmuseum
27. Oktober 1995–7. Januar 1996

Österreichische Fotogalerie
Salzburger Landessammlungen Rupertinum
März–April 1997

Konzeption von Ausstellung und Katalog
Exhibition and catalogue conception
Ulrich Pohlmann

Lektorat / Editorial Advisor
Ludger Derenthal

Sekretariat / Secretariat
Monika Gallasch

Übersetzung / Translations
Pauline Cumbers

Reproduktion / Reproductions
Marianne Franke, Roman Franke, Julia Köbel

Gestaltung / Design
Chris Pichler, Peter Langemann

Lithographie / Separations
Dörfel GmbH, Munich; *Scantec GmbH*, Göttingen

Druck und Bindung / Printing and binding
Sellier GmbH, Freising

© 1995 Münchner Stadtmuseum,
St. Jakobs-Platz 1, D-80331 Munich

© 1995 Nazraeli Press, Munich

Order address:
Nazraeli Presss, Siegfriedstr. 17 Rgb, D-80803 Munich
In the US:
Nazraeli Press, 1955 W. Grant Road, Suite 230,
Tucson, AZ 85745

Die Publikation entstand in Zusammenarbeit
mit der Benno und Therese Danner-Stiftung.
This publication was made possible with the support
of the Benno and Therese Danner-Foundation.

Printed and bound in Germany.

ISBN 3-923922-33-7 (Hardcover)
ISBN 3-923922-41-8 (Softcover)